We Are in Open Circuits

Writing Art series

edited by Roger Conover

Art after Philosophy and After: Collected Writings, 1966–1990, by Joseph Kosuth [out of print]

Rock My Religion: Writings and Projects 1965–1990, by Dan Graham [out of print]

Continuous Project Altered Daily: The Writings of Robert Morris (October Books), by Robert Morris [out of print]

Remote Control: Power, Cultures, and the World of Appearances, by Barbara Kruger

The Daily Practice of Painting: Writings 1960–1993, by Gerhard Richter

Reasons for Knocking at an Empty House: Writings 1973–1994, by Bill Viola

Out of Order, Out of Sight. Volume I: Selected Writings in Meta-Art 1968–1992, by Adrian Piper

Out of Order, Out of Sight. Volume II: Selected Writings in Art Criticism 1967–1992, by Adrian Piper

Imaging Desire, by Mary Kelly

Destruction of the Father/Reconstruction of the Father: Writings and Interviews, 1923–1997, by Louise Bourgeois

Critical Vehicles: Writings, Projects, Interviews, by Krzysztof Wodiczko

Two-Way Mirror Power: Selected Writings by Dan Graham on His Art, by Dan Graham

Imaging Her Erotics: Essays, Interviews, Projects, by Carolee Schneemann

Essays on Art and Language, by Charles Harrison

Conceptual Art and Painting: Further Essays on Art and Language, by Charles Harrison

Leave Any Information at the Signal: Writings, Interviews, Bits, Pages (October Books), by Ed Ruscha

Foul Perfection: Essays and Criticism, by Mike Kelley

Please Pay Attention Please: Bruce Nauman's Words: Writings and Interviews, by Bruce Nauman

Decoys and Disruptions: Selected Writings, 1975–2001 (October Books), by Martha Rosler

Minor Histories: Statements, Conversations, Proposals, by Mike Kelley

The AIDS Crisis Is Ridiculous and Other Writings, 1986–2003, by Gregg Bordowitz

Cuts: Texts 1959–2004, by Carl Andre

Museum Highlights: The Writings of Andrea Fraser, by Andrea Fraser

Language to Cover a Page: The Early Writings of Vito Acconci, by Vito Acconci

Feelings Are Facts: A Life, by Yvonne Rainer

Solar System & Rest Rooms: Writings and Interviews: 1965–2007, by Mel Bochner

Ai Weiwei's Blog: Writings, Interviews, and Digital Rants, 2006–2009, by Ai Weiwei

Dissolve into Comprehension: Writings and Interviews, 1964–2004, by Jack Burnham

Working Conditions: The Writings of Hans Haacke, by Hans Haacke

On the Camera Arts and Consecutive Matters: The Writings of Hollis Frampton, by Hollis Frampton

We Are in Open Circuits: Writings by Nam June Paik, by Nam June Paik

We Are in Open Circuits

Writings by Nam June Paik

edited by John G. Hanhardt, Gregory Zinman, and Edith Decker-Phillips

WRITING**ART** SERIES

The MIT Press
Cambridge, Massachusetts
London, England

This book was set in Neue Haas Grotesk and Courier Std by the MIT Press. Printed and bound in the United States of America.

Library of Congress Cataloging-in-Publication Data

Names: Paik, Nam June, 1932-2006, author. | Hanhardt, John G., editor. | Zinman, Gregory, editor. | Decker-Phillips, Edith, 1953- editor.

Title: We are in open circuits : writings by Nam June Paik / Nam June Paik ; edited by John G. Hanhardt, Gregory Zinman, and Edith Decker-Phillips.

Description: Cambridge, MA : The MIT Press, 2019. | Series: Writing art series | Includes bibliographical references and index.

Identifiers: LCCN 2018036776 | ISBN 9780262039802 (hardcover : alk. paper)

Subjects: LCSH: Paik, Nam June, 1932-2006--Written works.

Classification: LCC N7369.P35 A35 2019 | DDC 700.92--dc23 LC record available at https://lccn.loc.gov/2018036776

10 9 8 7 6 5 4 3 2 1

In usual compositions, we have first the approximate vision of the completed work, (the pre-imaged ideal. or "IDEA" in the sense of Plato). Then, the working process means the torturing endeavour to approach to this ideal "IDEA". But in the experimental TV, the thing is completely revised.. Usually I don't, or cannot have any pre-imaged VISION before working. First I seek the " WAY ", of which I cannot forsee where it leads to. The "WAY" ,,,,,,that means, to study the circuit, to try various "FEED BACKS", to cut some places and feed the different waves there, to change the phase of waves etc.

—Nam June Paik, from "Afterlude to the Exposition of Experimental Television" (1964)

Contents

Acknowledgments xiii

Editors' Note on Paik's Previously Unpublished Work xvii

THE TEXTUAL WORLDS OF NAM JUNE PAIK: THE TIME OF WRITING AND READING 1
by John G. Hanhardt

PART 1: MUSIC AND THE AVANT-GARDE: PERFORMING FLUXUS 21

a: Speculative Writings

Formal Development of the Pre-classical Symphony (1957) ??
Postmusic (1963) 24
The Age of Slow-motion (1964) 26
Robot Opera Program (1964) 27
Untitled/Most of my So-Said "Action Music" Pieces (1967) 29
Charlotte Moorman: Chance and Necessity (c. 1992) 29
TV Bra for Living Sculpture (1969) 33
My Jubilee ist Unverhemmet (1977) 33
George Maciunas And Fluxus + Wiesbaden 62 (1978) 34
On Cagean interpretation Of Cage 34
B.C./A.D. John Cage (1993) 35

b: Scores

Seven Fluxus Scores (all c. 1962) 38
Omnibus-Music No. 1 (1961) 39
Half-Time (1962) 40
Symphonie No. 5 (c. 1965) 41
Etude platonique No. 3 63
Suite for transistor radio (1963) 63
Sinfonie for 20 Rooms (1961) 65

To The "Symphony For 20 Rooms" (c. 1963) 66

Bagatelles americaine (1962) 67

Metro-Music and *Bagatelles Americaine* (1962) 69

Sonatine foe Radio (1963) 70

Moving Theater No. 2 (1963) 71

My Symphonies (1973) 72

"THIS SCRIPT IS NOT FINAL, AND IS SUBJECT TO CHANGES": NAM JUNE PAIK BETWEEN PAGE AND SCREEN 73
by Gregory Zinman

PART 2: TRANSFORMING VIDEO AND TELEVISION: MEDIA ART PRACTICES 87

a: Speculative Writings

Exposition of Music (1963) 89

About the Exposition of the music (1963) 91

Electronic TV & Color TV Experiment (1964) 92

Afterlude to the Exposition of Experimental Television (1963) 94

Electronic Video Recorder (1965) 97

Projects for Electronic Television (1965) 98

Untitled/"Cybernated art is very important..." (1965) 99

Sonata quasi una fantasia for Billie Kluver (c. 1965) 100

Utopian Laser-TV Station (1966) 115

Computer Programming for Visual Arts and Electronic Opera (1967) 116

Flykingen Bulletin (1967) 117

World First Video-Tape Monthly Magazine (1967) 122

Norbert Wiener and Marshall McLuhan (1967) 123

Comparative Aesthetics—cybernetics of arts (1967) 126

Machine Show essay (1968) 127

Expanded Education For The Paper-less Society (1968) 130

Versatile Color TV Synthesizer (1969) 142

Global Groove and Video Common Market (1970) 142

Simulation of Human Eyes by 4-Channel Stereo Video Taping (1970) 144

Video Synthesizer Plus (1970) 145

Sonsbeek catalogue essay (1971) 146

Binghamton Letter (1972) 147

Communication-Art (1972) 152

Media Planning For The Post Industrial Age (1974) 154

Input-time and Output-time (1976) 166

Interfacing two different media 167

Feedback Americana 170

Why is Television Dumb? (1976) 172

Random Access Information (1980) 173

Video déjà vu? (1982) 177

Art & Satellite (1984) 179

Rendez-vous Celeste (1984/1986/1988) 182

Context Is Content...Content Is Context (1985) 185

A Satellite—The light of the future Asatte—literally, the day
 after tomorrow (1987) 187

Nostalgia Is The Extended Feedback ('30-'60-'90) (1992) 192

For a Deer (1992) 194

Mediatique Memory (1992) 196

b: Scripts and Plans

Scenario (1962-1963) 198

Electronic Opera (1967) 201

A Day Project (1972-1973) 204

Selling of New York 207

Suite 212 211

Don't Lick Stamps in China 216

Media Shuttle: New York-Moscow/You Cannot Lick Stamps in China (1978)
 216

Sattelite Piano Duette Beuys-Paik (1981) 217

Notes by Nam June Paik: *Brandenburg Concerto No. 7* (1981) 219

First script for *Good Morning, Mr. Orwell* (1983) 222

Proposal for *Bye Bye Kipling* (1986) 230

Chip Olympics [*Wrap Around the World*] (c. 1988) 235

PART 3: CULTURE AND POLITICS: LOCAL AND GLOBAL 241

Untitled/"Why philosophy is (has) not changed, as much as art" 243

Untitled/"After the necessary-nonsense of moon race..." 244

The First Oil War (1941-45) (first draft) (1979) 246

How to Make Oil Obsolete 251

Untitled/"As Kandinsky and Mondrian etc discovered abstract SPACE..."
 254

Proposal two/Walt Disney a radical interpretation/Some other
 proposals (1971) 255

I Lived only one year in Munich (1972) 258

Beuys weeds—Beuys creeds (1984) 260

From Horse to Christo (1981) 263

DNA is not racism (1988) 266

Sohm decided to collect ONLY information on art and not ART itself
 (1991) 270

Fluxus ≥ Picasso (c. 1992) 272

Venice—Turtleship—a Trial Of Mr. Picasso... (1993) 274

Untitled (Politics and Comics) (c. 1969) 278

Avant Garde on Trial (c. 1967) 323

The Confession of "topless" (?) Cellist 327

Aesthetics of Bibim-bab [a rice hash]—The Art of Post Industry Era
 (1995) 329

PART 4: ANNOTATIONS TO A LIFE: COMMENTARIES AND LETTERS 333

a: Commentaries

My Projects in 1966-67 334
Mary Bauermeister or "I accept the universe" (B. Fuller) 335
George Maciunas (1990) 337
Spirit-Media-Kut (1991) 340
2x Mini Giants (1991) 342
Two Rails Make One Single Track (1996) 343

b: Letters

Letter to Wolfgang Steinecke (1959) 346
Letter to John Cage, "excuse me" (1961) 348
Letter to Wolf Vostell (1965) 350
Letter to Howard Klein (1967) 350
Letter to Norman Lloyd (1967) 352
Letter to Ralph Burgard (1967) 353
Letter to Ralph Burgard (1967) 355
Postcard to John Cage (1968) 357
Letter to John Cage 358
Letter to John Cage 359
Letter to David C. Stewart (1968) 360
Letter to Ralph Burgard (1969) 362
Letter to Norman Lloyd and Howard Klein (1971) 364
Letter to Mike Rice (1971) 365
Letter to Porter McCray (1971) 367
Letter to the TV Lab (1973) 369
Letter to TV Lab, Quarterly Report (1973) 370
Letter to John J. O'Connor (c. 1976) 372
Letter to John J. O'Connor (1978) 373
Letter to Howard Klein: re Peace Correspondent (1979) 374
Letter to John J. O'Connor (c. 1986) 379
Letter to John J. O'Connor (1988) 380
Letter to John J. O'Connor (1988) 382

NAM JUNE PAIK'S CHINESE MEMORIES 383
by Edith Decker-Phillips

PART 5: CHINA TEXTS: "SCRUTABLE CHINESE" 395

Horse 1 395
Art (?) 396
A man and his wife went to a temple to pray for fortune. 396
Horse 2 396
Dream 1 397

Ecology of Forgetting 398

Here is a survival kit. 399

Death 399

Teacher 399

Life 399

Friends and Rivals 400

"Half the Peach" 404

Nail-Salon-Sting 404

How to edit the videotape. 404

Smart Man 405

A General 405

Communication Theory No. 1 406

Solo and Orchestra 406

Hostage Drama 407

Painted Dragon, Pointed Eyes 407

Arts / Music 410

Music 2 411

Study 412

Law and Order 415

2 million Dollar trees 416

General 417

Case Studies and Abstraction 417

The Palm of Duchamp 418

The Role of Blacks 419

Names Cited in Nam June Paik's Writings 423

Index 431

Acknowledgments

Nam June Paik often expressed to me his wish that I would put together an English-language edition of his writings. His hope was that it would be published by the MIT Press. I am honored and delighted to acknowledge here the many people and institutions that helped realize this plan. First and foremost, I want to express my appreciation to Ken Hakuta, Nam June's nephew, who returned to help his uncle through the last ten years of his life after he suffered a stroke in 1996. His unwavering support of this project was essential. His commitment to Nam June's legacy has been extraordinary. I also want to thank the curator of the Paik Estate, Jon Huffman. Jon was for many years Nam June's studio assistant and worked closely with the artist; he was so supportive of Nam June during the difficult times of his later years. He was able to track down key texts in the Estate as well as direct us to other sources. I want also to thank Elizabeth Broun, former director of the Smithsonian American Art Museum, for making possible the establishment of the Nam June Paik Archive at the Museum. This resource is the foundation for research into Paik's large body of work and his working methods. It is the place for a new generation of scholars, curators, artists, and critics to gain access to this large body of art, materials, and ideas.

This book could not have been realized without the brilliant support of my coeditor, Gregory Zinman. He is the finest scholar among a new generation of researchers and students of Paik's contribution to the history of late twentieth-century art. Greg's mastery of the material and his research and writing skills were crucial to assembling this large body of diverse writings. My other coeditor is Edith Decker-Phillips, whom I have been privileged to know for many years. Her book *Paik: Video* remains the foundational study of the artist. Edith's German and French editions of Nam June's writings, *Niederschriften eines Kulturnomaden. Aphorismen, Briefe, Texte* and *Du cheval à Christo et autres écrits*, were the inspiration for this book. Her expert knowledge was essential to our efforts.

Jean Dykstra brought her great writing and editorial skills to preparing this material for the publisher. Her patience and attention to detail and wise advice on all editorial matters were important to this undertaking. I want also to express my appreciation to Roger Conover, the legendary editor at the MIT Press and the series Writing Art. He has made the Press a beacon for the finest scholarship and I thank him for all he has done for this book and on behalf of scholars and artists around the world.

A number of institutions and individuals provided the editors with advice and access. We are deeply appreciative of the extra effort they made to track down and provide material, leading us through the often labyrinthian world of the archives and sources for the international avant-gardes of late twentieth-century art. We are thus extremely grateful to the staff at the Sohm Archive, the Beuys Archive, and at the International Music Institute Darmstadt. We would also like to extend our thanks to the staff at the Archives of the Museum of Modern Art and in particular to Jon Hendricks, Curator of the Silverman Collection, for his knowledge of Paik's Fluxus works; to Michele Hiltzik Beckerman, the Assistant Director and Head of Reference at the Rockefeller Archive Center; and to Scott Krafft, Curator of the Charles Deering McCormick Library of Special Collections at Northwestern University Library, who, along with his colleagues Nick Munagian and Gregory MacAyeal, Curator of the Music Library at Northwestern, provided invaluable guidance with regard to the archives of Charlotte Moorman and John Cage. Paik's former assistant Stephen Vitiello provided tapes and other materials to the archive at the Smithsonian.

Particular mention must be made of the endless patience, tireless efforts, and thoroughgoing expertise of Christine Hennessey, Chief, Research & Scholars Center at the Smithsonian American Art Museum, and Hannah Pacious, Collections Coordinator for the Nam June Paik Archive. The organization and cataloguing of the archive was an enormous undertaking. SAAM's Associate Registrar Lynn Putney oversaw its arrival in late 2009; Hannah and Claire Denney came on board in 2010 as contractors to help inventory and catalogue the three-dimensional artifacts; and archivist Kathleen Brown was hired on contract to help Christine with its papers portion. Kay Kim, a family friend of the Hakutas, volunteered to help sort and summarize the Asian-language materials. The archive opened to the public in 2013. Christine and Hannah's help in assembling the materials for this volume cannot be overstated – this book simply would not exist without their deep knowledge of the Paik archive, and it has been significantly enriched by that knowledge.

Relatedly, many additional people at SAAM helped shape our thinking in and around that archive. We are grateful for the many hours spent in fruitful conversation with Michael Mansfield, the former media and film curator at the museum, who offered many insights into the material that was brought into the archive. Amelia Goerlitz, the museum's Fellowship & Academic Programs Manager, made possible Greg's postdoctoral fellowship at SAAM and fostered an environment of collective endeavor and shared learning among the assembled scholars.

Greg is particularly indebted to his fellow fellows Catherine Holochwost and Michael Maizels for their generous and conscientious feedback and encouragement while researching the Paik archive. Others who provided advice, crucial contexts, archival leads, interpretive strategies, and platforms for research related to the book include Lauren Klein, Leo Goldsmith, Thomas Elsaesser, Jihoon Kim, Andrew Johnston, A. Michael Noll, Jane Gaines, Reinhild Steingröver, Douglas Kahn, Mike Epstein, Jacob Eisenstein, Eamon Johnson, Dean Winkler, Joe Ketner, Graham Weinbren and the *Millennium Film Journal*, Brett Kashmere and Astria Stupak at *INCITE!*, Carol Brandenburg, La Frances Hui, Hanna Hölling, Lisa Zaher, Zabet Patterson, Louise Sandhaus, Claire Henry, Steve Beck, Soo Yun Lee, Dan Streibel, Joshua Yumibe, and Malcolm Turvey and *October*.

A number of people helped prepare this manuscript in a variety of ways. Garrett Stache helped build a database of Paik's extant writing, a tool that has proved an invaluable resource to everyone who has worked on this book. Rory Leahy helped transcribe a great number of Paik's original and previously published writings into manuscript form. Sven Osterkamp and Jimi Nam-Osterkamp of Bochum provided translations of several of Paik's Korean-language illustrations. Mary Bauermeister generously provided a number of letters from Paik for the book, as did Seymour Barofsky, who gifted Paik's letters to television critic John J. O'Connor to the Smithsonian American Art Museum. Peter Wenzel graciously allowed us access to his unparalleled collection of Paik's published writings. Oliver Schneller and Heather O'Donnell translated Paik's early student writing on music, while Jenna Lee at Gagosian Gallery translated several of Paik's Korean texts and helped facilitate Yayoi Shionoiri's translation of a crucial Paik essay published in Japanese.

When it came time to pare down our selections of Paik's writings for this publication, Lori Zippay and her staff at Electronic Arts Intermix generously opened their offices to us, providing the time and space we needed to do so.

Finally, we'd like to thank the editorial team at the MIT Press, especially Matthew Abbate for his careful copyediting of a difficult and detail-oriented manuscript, and Yasuyo Iguchi for her work designing this book.

John G. Hanhardt

Editors' Note on Paik's Previously Unpublished Work

For the numerous previously unpublished materials in this volume, every effort has been made to preserve Paik's creative use of line spacing and placement on the page. These works have not appeared in public nor have they gone through any earlier editorial process – they are original works by Paik, and we felt that they should appear as such. We did not wish to "clean up" or smooth out his approach to writing and its effects, but rather to preserve the vibrancy and experimentation of his writerly process. Paik embraced chance and "error" in his media work, seeking to upend the conventions and strictures of broadcast and production practices. He similarly sought to empower the interpretive and collaborative capacities of his audience at every turn, These methods and strategies were also applied to his writing. In presenting these previously unpublished writings, we have preserved the grammatical and spelling errors found in their original forms, including the misspellings of proper names. We hope this approach will grant readers the opportunity to engage with Paik's writings as they were in their original – at times messy – states, and to interpret his choices as they see fit.

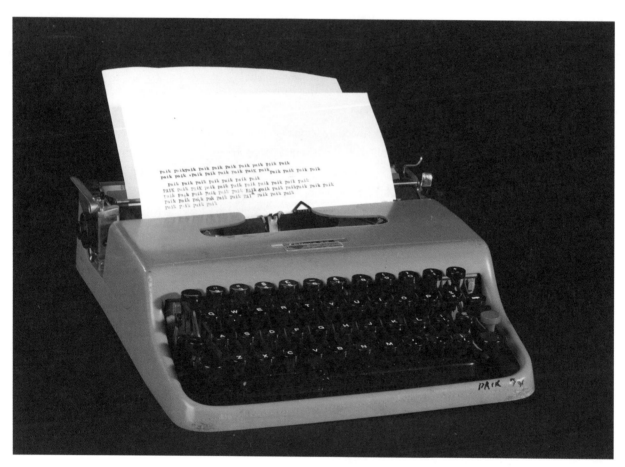

Nam June Paik, *Ego machine*, 1974. Portable typewriter, which only writes the word "Paik."
3.94 × 11.81 × 15.75 in. Photo © mumok — Museum moderner Kunst Stiftung Ludwig Wien,
formerly Sammlung Hahn, Cologne.

The Textual Worlds of Nam June Paik: The Time of Writing and Reading

by John G. Hanhardt

Writing was an important part of Nam June Paik's life. He corresponded with friends around the world, sending drawings, postcards with cryptic notes, and letters giving his opinions on technology, the state of the world, and his plans for new projects. He also wrote papers on his current interests and on issues that he felt needed to be addressed.

Paik is rightly celebrated for his visionary development of new artistic tools and for his treatment of the media of video and television as means for creative expression. But his writings, some of which are collected here, speak to Paik's interest in probing deeper into history and politics, social and cultural change, and the importance of ideas. We see this in his treatment of language, and in the ways he used the typewriter to fashion sentences that he broke apart and reassembled as he edited the written word, rendering the pages of his writing both a poetic text and an aesthetic object. Emphasizing the formal aspects of typewritten texts, he manipulated the typewriter as he did the television set, to push and break apart the mechanical format of typewriting, to release his thought experiments.

THE ARCHIVE

I understood the quantity and range of Paik's writings when I looked closely at the enormous trove of material that makes up the Nam June Paik Archive established at the Smithsonian American Art Museum in Washington, D.C. The creative chaos of the truckloads of material gathered from his studios confirmed how important writing was to Paik. He wrote incessantly, honing his ideas in English, German, Korean, and Japanese. He would write in his studio, on trains, in planes – in other words, everywhere. In conversation, he would turn whatever was at hand into a surface on which to draw and write. Writing and critical thinking were central to his life as an artist, activist, and intellectual engaged with the world around him.

The archive was Paik's memory/image bank, the place he would go to fashion new pieces and set in motion associations between objects, memories, and history. The archive was a twentieth-century *Wunderkammer* for an artist who traveled the world and used it as a stage to recreate himself through his art. The archive expresses the lifelong search of the exile who moves from colonial places to urban centers. Paik's work incorporates memories of his youth and his family, as well as his quest to reinvent himself as the Other at the center of the modern world. As we look more closely at his writings, we can see ghosts of projects he might have realized and fragmented texts that weave a language of tireless inquiry.

The archive represents the artist's process; random objects fit different categories and became reminders, placeholders, and "action figures" in Paik's imagination. The archive itself is, in fact, a work of art, a multidimensional and multifaceted project that remains unfinished. It also serves as a conceptual frame for his collected writings. Organizing his archive and preparing this selection of texts were both complex undertakings of assembling, ordering, and interpreting diverse materials. The collections that Paik assembled were constantly evolving in the ordered chaos of his studios. Over the years, many documents were given away or sold to collectors, and other objects became part of artworks in a continuing process of incorporation. This material was not catalogued. What remained of his collections became the Nam June Paik Archive, which was ultimately brought to Washington, D.C., in seven trailer trucks. These items represent different periods in the history of technology, including radios, televisions, video projectors, cameras, and audio and videotape decks that are no longer manufactured but were part of his creative process, or were cast off from previous projects to be included in new pieces. The many magazines, toys, artifacts, and antiques capture his ongoing interest in icons of the entertainment industry, stars and celebrities to whom he returned in his artwork. The remains of incomplete works or works in progress provide insight into his working methods. His process was direct and hands-on, with decisions made quickly and intuitively.

In addition to art materials and artworks, the archive is made up of correspondence, writings, clippings, plans for exhibitions and commissions, scripts, and production schedules that offer multiple entry points into his working methods over a 50-year period. They also lend insight into the issues he revisited, including cybernetics, new developments in technology, and current events. His memories and associations became tangible in the objects he collected and the notes he kept, all of which shed light on the issues that inform his work. In looking through this material, I was struck by the significance of memory, history, and nostalgia captured in old magazines and relics from different eras. This material reflects Paik's yearning for a sense of place and belonging as he moved around the world, motivated by a desire to forge his own path through the avant-garde and the changing culture of the late twentieth-century art world. Paik was aware that he was part of a large change in culture and politics, and this informed his sense of history and his way of perceiving and representing the world in his videotapes and writings. Throughout his life, Paik sought to be his own person, a self-made creative being, able to hold together a world that he viewed in both critical and utopian terms.

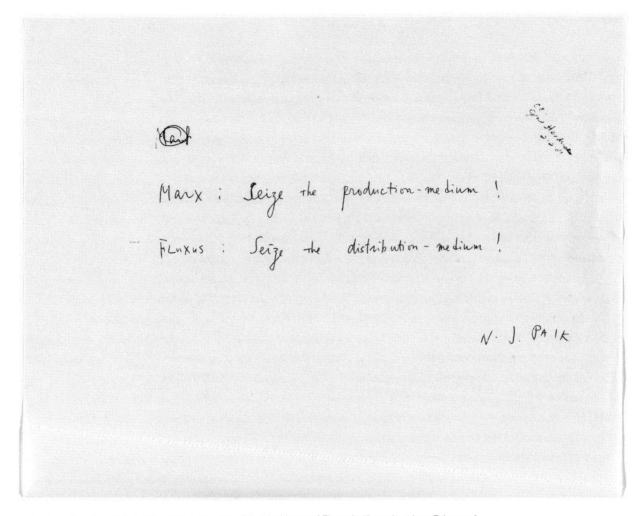

Letter from Nam June Paik to Gilbert Silverman describing the history of Fluxus in 10 words or less, February 2, 1981. Ink on paper, 8½ × 11 in. (21.6 × 27.9 cm). The Gilbert and Lila Silverman Fluxus Collection Archives, VII.A.602. The Museum of Modern Art Archives, New York. The Museum of Modern Art, New York, NY, U.S.A. Digital Image © The Museum of Modern Art/Licensed by SCALA/Art Resource, NY.

REFLECTIONS ON THE LIFE OF AN ARTIST

The last large exhibition for which Paik created a major artwork, *Modulation in Sync,* was "The Worlds of Nam June Paik," which opened at the Guggenheim Museum in New York in 2000 and toured to Seoul and the Guggenheim Museum Bilbao. As that title suggests, there was no single place that defined Paik's artwork, not to mention his life. Rather, he embraced the multitude of places where he had lived and worked. There was a structural tension between the global and the local in his life, his artwork, and his writings. The "worlds" of the title also refers to the multiple discourses in which he engaged as an artist: film, video, television, live satellite transmission, performance, music, drawing, prints, sculpture, and installation art. Paik drew from his interest in film, television, and video as well as his lifelong interest in performance and music. He wrote constantly about globalism, multiple moving-image media, performance, and music.

Paik traversed the globe, from his birth in Seoul to his time in Japan during the Korean War, where he studied at Tokyo University, and to West Germany via Cairo. He began to be recognized as a member of the avant-garde while in Germany, where he became affiliated with the Fluxus group, and in 1963 he had the important one-artist exhibition "Exposition of Music–Electronic Television" at the Galerie Parnass. Paik was known in Europe largely through his performances, but the Galerie Parnass exhibition allowed him to realize the potential of video and television. With his array of televisions, prepared pianos, mannequins in bathtubs, and a bull's head suspended above a doorway, he brought a sense of the visceral into his art.

Paik's life was characterized by constant change, both geographically and in terms of his chameleon-like personality. Having spent time in his home on Mercer Street in New York and in his various studios in SoHo, having traveled with him through Germany to meet Fluxus friends, and having spent time with him in Korea, I was on the receiving end of a constant flow of broken language whose gaps I filled by association. This composite approach to language is also reflected in the way he assembled diverse materials in his artwork. We can see this in the *Audiotapes* (1959–1962), recorded by Paik and used in *Hommage à John Cage: Musik für Tonbänder und Klavier* (1959); *Dichtung und Wahrheit* (1961–1972), a suitcase filled with a license plate, toy car, and autobiographical notes; *Random Access/Paper TV* (1978–1981); a random display of two sets of playing cards with silkscreened images of John Cage and Merce Cunningham; and the elaborate installation in the XLV Biennale di Venezia (1993), including *Junk Room* (1993) and *Room for Charlotte Moorman* (1993), rooms filled with objects that evoked the material culture of places he had lived as well as memories of friendships. The installation was part of the German pavilion at the Biennale, in which Paik represented a country that had been so important to him. In filling these spaces within the historically charged German pavilion with the material of the past, Paik was rebuilding his identity and reconsidering his own journey from Asia, echoed in the robot sculpture *Tangun as a Scythian King* (1993), which stood outside the pavilion and looked out across the Gulf of Venice to the Adriatic Sea.

The artist's studio spaces in SoHo, with their changing collection of materials, objects, and little-known texts, shed light on Paik's thinking, his reflections on history and technology, television and education. The contents evoke the idea of Paik the bricoleur, the constantly moving spirit sifting through his things to create works out of his imagination. As David Heald's 1999 photographs of Paik's studio show, it was jam-packed with a vast array of materials that functioned as his own memory palace, fragments of things representing places he had lived and experiences he had had which made both past and present tangible. Heald's photographs also evoke the urban feel of Seoul, where there were buildings with floor after floor of small shops packed with goods of all kinds. It struck me that the place of one's birth imprints on one's being a map of how to live. Paik grew up in Seoul and Tokyo and spent most of his life in Düsseldorf and Manhattan. He was an artist who thrived and felt at home in the cities of the world.

The cities in which he lived also map the people who were important to him, including George Maciunas, John Cage, Joseph Beuys, and Charlotte Moorman. Paik's performances and exhibitions were on the margins of a changing postwar European art world, and the friendships he established within artistic communities of shared purpose, including the Fluxus avant-garde, provided him with camaraderie and sustained his continuing metamorphosis from musician, composer, and performer to media artist.

Political and cultural themes from post-World War II Europe, Asia, and the United States circulated in his work, from the videotapes *Guadalcanal Requiem* (1977) to *Living with the Living Theatre* (1989), *Allan 'n' Allen's Complaint* (1982), and *The More the Better* (1988), composed of 1,003 monitors in honor of the October 3 celebration of Korea's independence. *The More the Better* is an explosive architectural celebration of Paik's life and Korean folk culture. He was essentially in exile from his family: he missed them but needed distance from them. As he traveled the globe, he fashioned a persona that was polyglot in speech and attire. Perceived as strange and foreign, he was also charismatic. His otherness, his inviting openness and candor, and his nonthreatening appearance made him and his artwork strangely approachable to Westerners. His exoticism, as a Korean moving through Japan, Europe, and the United States, was nourished and supported by his friends and the community of avant-garde artists. Fluxus founder George Maciunas, himself in exile from Lithuania, was open to artists from around the world. Coming under the tent of Fluxus, Paik found an attitude of hospitality that welcomed his strangeness in appearance and speech and created a stage for him to perform on, individually or with others.

The most important artists to Paik were Joseph Beuys in Germany, whom he met early on and who attacked with an axe the "prepared pianos" in Paik's first exhibition in 1963, and John Cage, whom he also met in Germany in the late 1950s. Paik never forgot their early recognition. They were anchors for his creative exploration. For while he was being recognized for his performances, it was his video work that became his greatest and most sustained achievement. He also remained tied to Cage and Beuys through Charlotte Moorman, his great collaborator. They both composed work for Moorman,

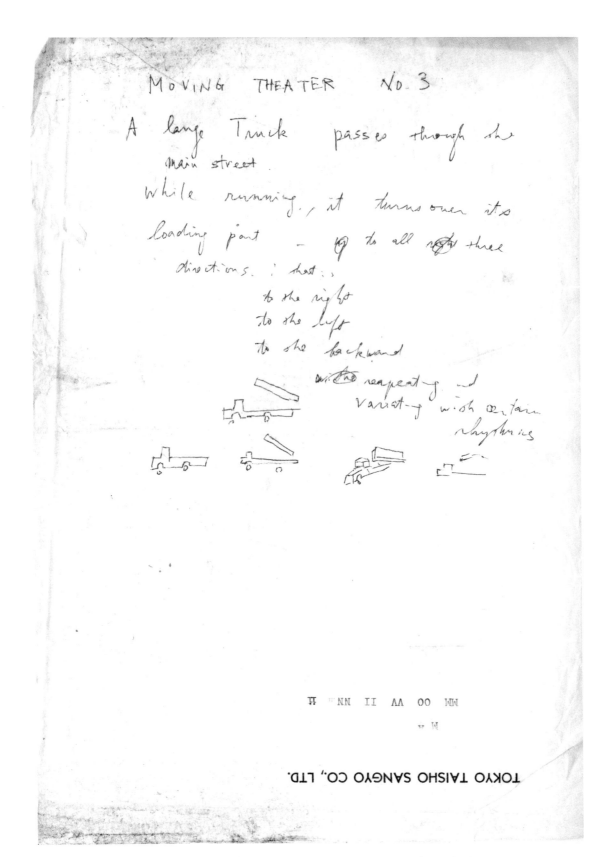

Nam June Paik, *Moving Theater No. 3*, ca. 1964. Typescript on onionskin with additions in ink (9 pages), 11⅝ × 8¼ in. Smithsonian American Art Museum, Nam June Paik Archive (Box 13, Folder 17); Gift of the Nam June Paik Estate.

and she valued them for giving her the space to create work and make her name in the art world.

Paik recreated, in his friends, the family he had left behind. Consider the fact that, in his later videotapes and live satellite transmissions, Paik focused on the family of the Living Theatre in *Living with the Living Theatre* and on the fathers of Allen Ginsberg and Allan Kaprow in *Allan 'n' Allen's Complaint.* He also created tributes to Cage and Beuys. These are all part of a discourse of memory and celebration; his friends were a source of inspiration, and they contributed to his sense of self in a world that was constantly changing. Shigeko Kubota, his Japanese-born wife of many years, a participant in Fluxus and an artist whose work was included in a one-artist show at the Whitney Museum of American Art and a Whitney Biennial, among other exhibitions, also collaborated with Paik on videotapes. These personal stories, together with the importance of history expressed in such videotapes as *Guadalcanal Requiem* and in his writings on information technology and the history of China, create a complex map of connections that awaits further study. One link is his attempt to understand the role of Asia as he looked back at a changing geopolitical world over the course of the Cold War and forward toward the end of the millennium. These concerns are explored in his last great project, "The Worlds of Nam June Paik" at the Guggenheim, in which his broadcast productions held center stage; they were projected on the edge of the rotunda and were picked up in the installation of monitors on the rotunda floor.

As Paik began to lose his health and strength, he created a large body of work that I have described as his "Late Style." A selection of this work was exhibited at the Gagosian Gallery in Hong Kong in 2015.[1] His ability to travel was sharply curtailed at that point, and his last visit to Berlin in 2004, for the exhibition "Nam June Paik: Global Groove 2004" at the Deutsche Guggenheim Berlin, was an occasion of celebration and reunion. He reimagined his art with the paintbrush, reworking old televisions, toys, and antiques that he had amassed in his studio in such works as *Chinese Memory* (2005), created just before his death. Through these found and collected elements, he created works that evoked his interest in abstraction and figuration, the modeling of materials and the application of paint, and the exploration of his own past. Much of this late work was developed in dialogue with his studio assistant, Jon Huffman, who remained at his side. Paik's nephew, Ken Hakuta, who had lived with him in the 1960s, came back to provide assistance after his stroke and bring the artist's home into financial order, creating a secure and sustaining environment for Paik and Kubota. Paik died in Miami in 2006; a memorial service was held at the Guggenheim Museum, the site of his great triumph six years earlier.

THE ROLE OF FLUXUS

Paik's speculations about place run through his writing and his artwork. In a real sense, he placed his body into the tradition of Asian writing. In the performance piece *Zen*

for Head (1962), Paik's interpretation of La Monte Young's *Composition #10* (1960), the artist transformed his body into an instrument for writing by dipping his head into a can of paint and using it to draw a line. His "writing" the endless scroll of being with his body links with the action of his head striking the keyboard in performances around that time. Similarly, in *Violin with String* (1961–1965), in which Paik dragged the violin on the ground, or *One for Violin Solo* (1962), in which the violin was raised above the performer's head and smashed on the table, he created work that explores a different materiality in the object and releases the "ghosts" of performances past from the instrument. *Urmusic* (1961), fashioned out of a crate with strings, evokes music's origins in found objects transformed into instruments. These performances, composed out of chance encounters and sounds from diverse sources, were traced out in his scores, such as *Omnibus Music No. 1* (1961), which gives elaborate and precise directions to the audience to move about the city and engage with the public space and the people they encounter. Other works are sites of memory and reflection, such as *Prepared Scroll* (1974), a Japanese scroll with a photograph of Charlotte Moorman wearing the *TV Bra for Living Sculpture*.

The early performance pieces signaled Paik's role in Fluxus, and he gained notoriety in Europe as he performed them throughout the continent. These performances were opportunities for Paik to express himself not through conventionally articulated language but through aphoristic, haiku-like scores that described specific actions. This was not an unfamiliar mode of performance scoring within Fluxus; it was linked to Cage's use of an open score, which made chance and the everyday audio environment part of the performance. Paik's scores were visual, a set of directions that resulted in actions open to chance, and they emphasized the body as the site for the action. Karlheinz Stockhausen described Paik's contribution to *Originale*:

> Paik came onto the stage in silence and shocked most of the audience by his actions as quick as lightning. (For example he threw beans against the ceiling which was above the audience and into the audience.) He then hid his face behind a roll of toilet paper which he unrolled infinitely slowly in breathless silence. Then, sobbing softly, he pressed the paper every now and then against his eyes so it became wet with tears. He screamed as he suddenly threw the roll of paper into the audience, and at the same moment he switched on two tape recorders which was a sound montage typical of him, consisting of women's screams, radio news, children's noise, fragments of classical music and electronic sounds. Sometimes he also switched on an old gramophone with a record of Haydn's string quartet version of the *Deutschlandlied*. Immediately back at the stage ramp he emptied a tube of shaving cream into his hair and smeared its contents over his face, over his dark suit and down to his feet. Then he slowly shook a bag of flour or rice over his head. Finally, he jumped into a bathtub filled with water and dived completely underwater, jumped soaking wet to the piano and began a sentimental salon piece. He then fell forward and hit the piano keyboard several times with his head.[2]

In my reading, these actions describe his movement from Asia to Europe, struggling to make himself "white" in Europe, crossing oceans and continents, playing sentimental music to entice his listeners, and futilely hitting the piano keyboard in a mix of despair and rebellion. These performances were heralded in New York when *Originale* was performed there.

In 1964, Paik met Charlotte Moorman; she became the female agent in Paik's scores and actions, and the female body took on a sexualized, Pop fantasy form in Paik's later work. In placing himself on stage in nonviolent and coy sexual scenarios with Moorman, he opposed the graphic and unambiguous assaults of the Viennese action artists and of Gutai in Japan. Against this background, it is important to remember Paik's *Cutting My Arm* (1967), in which he sliced his arm with a razor. Paik was not pleased when I included photographic documentation of this performance in the catalogue for his 1982 show at the Whitney Museum, "Nam June Paik." His displeasure pointed to his ambivalence toward real violence. *TV Penis* (1972), which premiered at The Kitchen, features a male performer holding a monitor against his body. In *Cutting My Arm* and *TV Penis*, Paik once again imagined the medium as an extension of the body, and video as a prosthetic means to embody the instrumentality of the body. In the notorious performance of *Opera Sextronique* in 1967 in New York City, which led to Moorman's arrest for indecency, she protested that the performance was not salacious, that she was "only performing Paik's score."[3] This set in motion Paik's own concern for how he was being received, with the court case generating publicity and leading to Moorman's arrest. The archive contains a large correspondence on Paik's part responding to this arrest and protesting against censorship. The complete transcript of the hearing is also part of the archive.

Fluxus was the "junction box" through which Paik pivoted from the East to the West. The position of Germany – or, I should say, West Germany – and its proximity to Eastern Europe made it also a bridge for Paik to the United States. In the late 1950s and 1960s, there was an openness in Germany to the avant-garde, an interest in collecting art from the United States, and a focus on reassembling the fragmented and destroyed culture of prewar modernity. In a sense, Paik's prepared piano and smashed violin enacted the destruction of German classicism and reimagined a new culture through the prepared television. Within Germany's postwar culture, Paik and Fluxus seemed to open up another culture of possibilities. Paik's appeal to the avant-gardes of Europe and to Fluxus artists encouraged his affiliations with the galleries of Jean-Pierre Wilhelm, Mary Bauermeister, Rolf Jährling, and René Block. On the margins of the art world but open to its possibilities, Paik moved with a crafty confidence as he pursued his compositions and performances.

One of the artists whom Paik worked with early on was Wolf Vostell. They coedited the artist publication *Décollage* and shared an early interest in television. In his direct, raw work, Vostell was engaging in a critique of the Vietnam War and confronting the Holocaust. It is interesting to contrast Vostell's direct approach with Paik's often brutal immediacy in the destruction of culturally coveted icons such as pianos and violins, or his inclusion of an ox head in the entryway to his Galerie Parnass exhibition as he confronted the sensibilities and norms of the society. Although Paik's work can be read as implicitly engaging the political landscape, it has always been more playful and anarchic in spirit than antagonistic. Vostell's treatment of television in his "6 TV Dé-coll/age" exhibition at the Smolin Gallery in New York City and its accompanying text lays out a direct engagement with the apparatus of the television, as does his contribution to the Yam

Festival in 1964 on George Segal's farm in New Jersey, where he buried a television, and that same year at the You Festival on Long Island, where he burned a TV. However, Vostell did not remain focused on television as a means of transmission, or video as a complex of options by which to pursue a variety of strategies. Paik, on the other hand, actively pursued his interest in all aspects of video production and television transmission after he moved to New York City in 1964, a move supported by his Fluxus friends and made possible by the fame he had gained in performing throughout Europe.

The time of Paik's arrival in the United States was a period of transition for him as an artist. In contrast to his friends, mentors, and colleagues, Paik brought television and video into the center of his creative life. The abstract films of the German artist K. O. Götz certainly inspired him. In the archive, there is a 1963 letter from Götz to Paik in which he mentions an article in which Paik described Götz's early work with the electronic image. Götz adds details about his experiments from 1945 and 1959, which were not recorded. It is a fascinating document and lends insight into the creative forces working with oscilloscopes and other instruments at this time.[4] In Paik's prepared television, the received broadcast signal was disrupted, and Paik attempted to transform the television set into an interactive musical instrument that generated sound and imagery specific to the electronic medium. Many artists recognized the potential of video and television, but none embraced this potential in such an all-encompassing way as Paik. In his first one-artist exhibition, "Exposition of Music–Electronic Television," the transformed televisions were only a part of the exhibition, and their potential wasn't recognized. A German newspaper review from the period (which is in the archive) provides a description of the installation in which the writer, who clearly did not know what to make of the television pieces, merely notes that the room with eight different televisions had fewer sounds than the other spaces. The television images are characterized as randomly disturbed, and some are described as distorted as if by concave mirrors.[5] The significance of the televisions was recognized only after Paik moved to the United States and began to invest his full energies in video. In a sense, the Galerie Parnass exhibition linked the instrumentality of television to musical composition through the destruction of both. The televisions were then rebuilt into interactive, audience-activated tools in the United States. *Random Access* (1963) became the key work in linking these interests, because it allowed the visitor to place the audio recording head of the tape recorder onto the strips of audiotape on the wall. As Paik wrote in a text about his Galerie Parnass exhibition entitled "Future Program," it "let all the audience play freely and make their own 'Symphonia.' They liked it extremely, because they could at last 'touch' . . . what they liked. . . . The electronic Television will multiply these possibilities immensely."[6] Paik's drawing describing the layout of the exhibition is similar to his *Symphony for 20 Rooms* (1961), which enjoins the performer and visitor to experience different effects, typologies of performance, and interactivity in different spaces. In a sense the two texts, the score and the layout for the exhibition, mirror each other in charting/scoring a mix of the music, prepared pianos, performance, and prepared TVs.

It was only after his move to the United States in 1964, though, that Paik began to deepen his investment in video and television. The crucial moment was his first one-artist exhibition in New York at the New School, which included *Electromagnet (or Life Ring)* (1965) and *Magnet TV* (1965), as well as an array of interactive media. Subsequent exhibitions at the Galeria Bonino and Howard Wise Gallery began to garner wider attention in the New York art world. The late 1960s was a time of extraordinary personal development and acclaim for Paik: he was learning about computer technology from Mike Noll of Bell Labs; he created, with Shuya Abe, the innovative Paik-Abe Video Synthesizer in 1968; *Global Groove*, produced at WNET-TV Lab with the synthesizer, premiered in 1973; his exhibition opened at the Everson Museum in 1974, and a catalogue was published; and Calvin Tomkins's profile of Paik was published in the *New Yorker* in 1975.[7]

An important work from this time is *Zen for Film* (1962–1964). Like *Zen for TV* (1963), it is a conceptual piece exploring a minimalist image. In this case, the film is clear celluloid, resulting in a clear beam of light on the screen. "Be sure," Paik noted, "to throw the film on the floor and step on it," because it was meant to pick up dirt over time, and the repeated screenings added scratches and dust particles that flitted across the screen in the projection. In Peter Moore's famous photograph of the event, we see Paik at Anthology Film Archives standing in front of the projector, casting his shadow onto the screen. Often likened to John Cage's *4'33"*, *Zen for Film* is also related to Paik's own *TV Clock* in its rendering of time as an empty signifier. It challenges the cinema, emptying it of its content while recognizing its difference from video. In treating film as an installation and performance medium, he rejected its recorded and processed history.

Paik's early image-processing pieces convey the changes he was making to his video art, articulated in his 1969 videotape *Experiment with David Atwood*, which grounds the figure in shifting perceptual fields, points of view, and treatments of black and white and color. In the archive, there is a photocopy from the New York Public Library of the *Book of Curves*, published in 1961.[8] A catalogue of plane curves, it describes the geometry behind the construction of a medley of forms. It's an interesting source to consider in light of Paik's *Magnet TV* and the curves displayed on the screen that he later applied to the image-processing techniques. Paik's processed moving image explores the workings of perception, the transaction between the viewer and the electronic particles composing the moving image on the cathode ray tube. Paik's image processor turns the television studio into a reflective and multidimensional space of fantasy and a resource for a complex and interactive image making. Unlike his image processing from the 1980s and 1990s, the work from the 1960s and 1970s, which used the Paik-Abe video synthesizer, has a depth of field and less of the decorative surface that derived from later digital-image processors.

There is an extensive body of writing in the archive on the potential of television, ranging from texts addressed to the Public Broadcasting System to opinion pieces for the Rockefeller Foundation, broadsides on television, and statements outlining his plans

for television projects and funding for the production of his videotapes. Some of these texts are known, such as the 1974 report he wrote for the Rockefeller Foundation in which he coined the term "electronic superhighway." But in general his texts have not been appreciated enough for their breadth of knowledge and prescience in terms of our media culture. One of the least examined areas in Paik's body of work is the relationship between his single-channel videotapes and global satellite telecast pieces and his other creative work.

Paik's videotapes are deeply speculative and personal texts on the importance of politics and history. *Guadalcanal Requiem* is a reflection on global conflict in World War II; *Living with the Living Theatre* explores the nature of avant-garde collectivism; and *Allan 'n' Allen's Complaint*, on Allan Kaprow's and Allen Ginsberg's relationships to their respective fathers, considers the relationship of art to real estate value, and the way artists relate to the past as embodied in their fathers. His portrait of John Cage (*A Tribute to John Cage*) and his engagement with Merce Cunningham (*Merce by Merce by Paik*, 1975) convey the distinctive features of both of these artists' work, in which Paik also visualizes relationships and explores the movement of dance.

Paik celebrated his friendships in the videotapes. In the early work, from *Global Groove* to *Tribute to John Cage*, Paik worked with Russell Connor, a key figure in the early years of video and television. Connor was a narrator and the straight man to Paik's eccentric presence on camera. Written and delivered with a fine sense of play and irony, Connor's commentary was a perfect foil for Paik, enabling him to bring his ideas to a larger audience without conforming to standard television practice. Connor played a crucial role in getting Paik on television. Paik was in a perpetual self-imposed exile from all of his homes except New York City. The city's diversity was a source of inspiration, and he often spoke of the heterogeneity of New York as being the great strength and possibility of the United States. It is clear that he could never have accomplished what he did in video and television anywhere else. New York was the center of the art world, in terms of the market and the emerging avant-garde; it was home to major foundations as well as the financially strongest state arts council with a major media arts program; and the television and communications industries were centered in Manhattan. The time was right, and Paik's charismatic presence, developed over years of performances and encounters with artists in Europe, had taken hold in the public cultural sphere. He became part of the video art community that was emerging not only in New York but around the country.

Paik's plans to come to the United States were supported by the arts community, as we see in his letters, now in the archive, asking for support from the Rockefeller Fund. Paik was looking for financial support, describing his efforts and goals, and becoming an active presence in the country. While teaching at CalArts and elsewhere, he made contacts and forged ties with Howard Klein, head of the Arts Program at the Rockefeller Foundation, and with John J. O'Connor, the TV critic at the *New York Times*. These two men were important contacts and friends of Paik's: In describing Paik's piano pieces, Klein, himself a piano player, fondly called Paik, as Paik often described himself, the "world's worst piano player." O'Connor, the leading television critic of his

time, responded favorably to Paik's telecast tapes. Paik kept O'Connor's reviews, and O'Connor treasured his notes from Paik. In addition, Paik maximized his role in the TV Labs established by the Rockefeller Foundation at WNET and WGBH. The four-hour telecast of *Video Commune* in 1972, from the WGBH studio in Boston, is a landmark in the history of television and video art. It was innovative and interactive, using video with performance linked by the Paik-Abe Video Synthesizer. WNET, the flagship of the PBS system, became his "local" public television station, the studio for his post-production, for the broadcast of his tapes, and the base for later global satellite television pieces. *Experiment with David Atwood* at WGBH, *Global Groove* at WNET, *Guadalcanal Requiem*, and *Good Morning, Mr. Orwell* are a remarkable set of experiments across narrative and genre lines, blending documentary, performance, image processing, collage, and music.

One of the most significant developments that we see in these tapes was Paik's editing technique, which was loose and free-ranging, relying less on montage than on collage, a slipping together and over of image sequences, a time-based layering of images that create a soft, electronic, and non-filmic look. Paik liked to leave edit timers – the numbers that count the frames, which are usually removed in the editing process – visible on the tape, acknowledging the workings of the medium and giving the process a handmade feel. In *Global Groove*, he likened the various segments that compose the tape to changing channels on a global television. In other works, he would combine footage from different sources. Continuity was of little importance; rather, sequences were joined through the capacity of the Paik-Abe Video Synthesizer to change color, mix sources of footage, drop out information, deploy chroma-keying, isolate and layer multiple image sources. There is little in the way of narrative; time of day and point in time shift and change.

Paik's writings focus on the idea of television as a global distribution network and on questions of how to secure a place for artists' innovative work on television. His writings comprise a complex web of ideas.

> Information is no longer a means to get something live and concrete, but has become an end in itself. The age of "Information for Information's Sake" is dawning after a hundred years of "Art for Art's Sake." Communications flow is the new metabolism of homo sapiens. Constant change in taste and fashion is an organic input/output process equivalent to the transformation of food in protoplasm; as natural as breathing in our body, waves in the sea, or the waning of the moon. Someday brain-power must prevail over oil-power and petrol will become as obsolete as the dinosaur.[9]

This is an excerpt from "How to Make Oil Obsolete," a text attached to a letter written by Paik in 1980 to the *New York Times* after videotaping in Israel for *Allan 'n' Allen's Complaint*. In 1966 Paik wrote that the "whole movie, TV technique will be revolutionized, the scope of electronic music will be widened to the new horizon of electronic opera, painting and sculpture will be shaken up, intermedia art will be further strengthened, bookless lieterature, paperless poem will be born."[10] Paik's thinking embraced a range of changes, inevitable though not necessarily utopian. He firmly believed in the power of media and popular culture to transform how we see and value art. This hybrid mix

(1944)

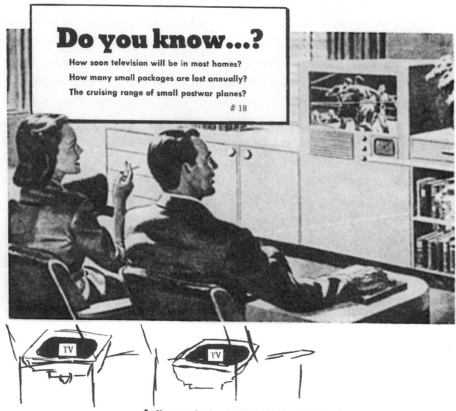

Do you know...?

How soon television will be in most homes?

How many small packages are lost annually?

The cruising range of small postwar planes?

18

TV TV

Q. How soon after the war will television be available for the average home?

☐ 6 months ☐ 1 year ☐ 2 years

A. Experts estimate that television will be ready in about six months after civilian production resumes. And one of the important production techniques that will help speed delivery of

DO YOU KNOW...?

 How soon TV-chair will be available in most museums ?

 How soon artist will have their own TV channels ?

 How soon wall to wall TV for video-art will be installed
 in most homes ?

A new design for TV-chair

 (dedicated to the great
 communication-artist Ray
 Johnson)

A New Design for TV Chair, 1973. Silkscreen on paper, 12 × 9 in. (30.5 × 22.9 cm).
Edition of 25. Courtesy of John G. Hanhardt.

of strategies informed his approach to television, which blended avant-garde film, TV commercials, and folk dances (*Global Groove*) and the grand mix in his global satellite performance projects, linking countries, cities, cultures, the avant-garde, and popular culture, from David Bowie and Laurie Anderson to Joseph Beuys and Merce Cunningham. Paik's energy and commitment to these projects, reflected in his personal financial investment and the great risk in managing and cajoling these projects into being, derived in part from the many dislocations in his own life. In creating these productions, he was moving his installation projects into the arena of television with multiple stations around the world. He followed a script-driven but chance-animated production process. Paik's ambition was to transform global television and make it a true communications medium with instant access to all of the world's programming. In "Global Groove and Video Common Market," written in 1970 and published in the *WNET-TV Lab News* in 1973, Paik observed that "videoland on this spaceship earth resembles the devided state of European countries before 1957. . . . Or, this videoland, so-called communications media, is so dis-communicativ each other that practically no one knows, what to buy, to import or export."[11] Paik connected nationalist and protectionist ideology to a world that helped promote World War II. "World Peace and Survival of Earth is the public interest Number I, and needless to say, public interest Number I must be the Interest number I of Public Television," he wrote. "What we need now is a champion of free trade like J.F. Kennedy, who will form a Video Common Market modelled after the Eurupean Common Market in its spirit and procedure which would strip the hieratic monism of TV culture, and promote the free flow of video information through inexpensive bartar system, or convenient free market."[12] As Caitlin Jones, executive director of the Western Front Society in Vancouver, notes, "beyond Marshall McLuhan's philosophy of the global village, the Video Common Market articulates a practice."[13] This is a key insight into Paik's working methods and the way his writing informed his practice. "While there may be critiques of the European Common Market in both its original and contemporary forms," added Jones, "it is the utopian spirit of economic and cultural free trade that is ubiquitous in Paik's work. Today there is an unprecedented amount of visual material being generated in the form of home videos, satellite television, video games, Web sites and surveillance systems. Restrictions of use, however – be they through the tightening of copyrights, rights clearances, or market monopolization – keep these images from being used as the Video Common Market envisions."[14] Paik's argument for television's power to be enhanced through access and openness predicts recent developments in social media and the immediate circulation of opinion and expression across national borders as a means to enhance activism.

Paik's immersion in a variety of media discourses, while making him an exemplar for the future of art and cultural production, has resulted in his single-channel videotapes and performance-based satellite pieces being largely ignored. A close analysis of any of these pieces will reveal a genre-busting approach to storytelling, point of view, editing style, shooting, and image-processing techniques that effectively shift the narrative ground.

One of the most misunderstood aspects of Paik's creative output, perhaps as under-appreciated as the single-channel video essays, is his development of the Paik-Abe Video Synthesizer. Both of these developments are closely related to his video sculptures and installations, and both are connected to his early performance and first interactive pieces. Writing in 1966, Paik noted:

> In almost 10,000 essays reviewed in the <u>Computing Review</u> (1960 - 1966), there are very few contributions to visual art, as compared to a dozen or more to music, literature and to history. In spite of interesting work done [by] Peter Denes, Michael Noll, [Bela] Julesz, K.O.Goetz, and Stuttgarter Group, many new possibilities are left open for further development, especially if the extreme importance of the cathode ray tube and video tape recorder to the arts is considered. On the other hand, computerized video experiments derived from the unorthodox instinct of the artist will surely bring forth some unusual results in the research of pure science and applied technology.[15]

The archive contains texts related to Michael Noll's work at Bell Labs as well as computer cards and printouts, since Paik was exploring computer technology in the 1960s. It will be interesting to place this material alongside his creative output and explore the tension between artistic intention and technology and the way they enhance and challenge each other. The videotapes were the medium in which Paik refined his distinctive editing and image-processing technique, and these moving images were deployed in his sculptures and installations as well.

In the late 1970s a number of artists were developing image processors, all of which had their distinctive uses, including Steven Rutt, Steina and Woody Vasulka, and Dan Sandin. Working with his longtime engineer and friend Shuya Abe, Paik brought a new dimension to the image processor and a distinctive feel and look to the editing and image making. The large body of image-processed video being created by artists around the country came to be called "video wallpaper," connoting a style that conveyed a monotonous visual field composed of mandalas and a New Age aesthetic and soundtrack. One of the distinctive features of video as an art form was that it quickly developed its own visual language, which derived in part from film but maintained its own distinctive styles, complex graphic forms, and history. Paik is important to that history because his art encompassed the entire discourse of the medium, from image processing to television, and resisted categorization.

Paik's transformations of the television set – the manipulated monitors, which became interactive screens – were the first works to change the way the medium was viewed. Initially, the received broadcast image was disrupted and transformed, creating a wholly distorted visual pattern. The deployment of the magnet in *Magnet TV* created another look to the television set and the patterns created on the cathode ray tube, images that were specific to the properties of the medium. The Paik-Abe Video Synthesizer developed its own distinctive visual language, vividly demonstrated in *Experiment with David Atwood*, produced at WGBH in Boston in 1969. The flowing and richly textured color and the materialization of the transformed image make this a virtual glossary of the possibilities of video as an artist's medium. One of the most important artworks of the

twentieth century, it attests to Paik's infinite capacities for invention and his subtle and sophisticated treatment of the electronic moving image.

Paik began reshaping the television set in the late 1960s, and during the 1970s, 1980s, and 1990s he produced an enormous range of work, including the closed-circuit video made possible with the portable video recorder. These include his *TV Chair* (1974), in which the seat of the chair is replaced with a monitor, while a video camera is aimed from above onto the chair, so that when you sit in the chair you cannot see the monitor; *One Candle, Candle Projection* (1988–2000), in which a closed-circuit video camera records a burning candle, and projectors display the live flame on the surfaces of the wall and ceiling; and the *TV Buddha*, which features a statue of a Buddha contemplating himself through a closed-circuit video camera on a monitor placed in front of the statue. All of these pieces are examples of the way Paik explored the relationship of the camera's point of view to the image on the screen.

In the early 1980s, Paik created his *Robot Family*, fashioned out of old televisions and radios. These pieces are directly related to his *Robot K-456* and *TV Cello* as strategies of acknowledging technology and communication media as things that embody the self, not as abstract instruments. The fact that the first robots described a family returns us to Paik's efforts to humanize technology as well as to evoke the ways media link us to each other. The many robot sculptures he created included portraits such as *Merce* of Merce Cunningham. These pieces were fashioned in Carl Solway's Gallery in Cincinnati, Ohio. Solway had access to old televisions and monitors, and the early work bore the mark of Paik's involvement in their making. Among the most popular of Paik's works, they were exhibited and collected extensively.

Paik's increasing use of multiple channels of video in large video walls could be seen most dramatically at the Smithsonian American Art Museum, in *Electronic Superhighway: Continental U.S., Alaska, Hawaii* (1995) and *Megatron/Matrix* (1995). In *Electronic Superhighway*, Paik considers the United States through the popular culture of the movies, while also reshaping his earlier video wall piece *Fin de Siecle II* (1989). In the spectacular *Megatron/Matrix*, a layered display of national flags alternates with animated sequences drawn from different national icons. With a nude woman at its center, *Megatron/Matrix* plays off of the voyeuristic gaze with a dramatic display of multichannel images. The conceptual *TV Clock* (1977) and the sublime *Zen for TV* (1963) attest to Paik's constant remixing of ideas from the past. This was not a cavalier expediency but a deliberate decision to reuse ideas and to investigate how an image, sequence, or idea can inform new work. The large-scale pieces develop most clearly from his masterpiece *TV Garden* (1974), in which *Global Groove* lights up a garden of spreading plants and television networks; the *V-yramid* (1982), one of the first freestanding sculptures composed of large television consoles and miniature sets, creating a kaleidoscope of multiple arrays of synthesized moving images; and *Fish Flies on Sky* (1974), in which monitors are suspended from the ceiling, face down, creating clouds of moving images fed by multiple channels of image-processed video. *The More the Better* (1988), in the National Gallery of Contemporary Art in Seoul, indicates Paik's ambition to remake the

television experience in a physical space, to draw on multiple points of view. Sound accompanies much of Paik's work; he understood that music invites the viewer into the work's unexpected visual experiences.

Looking back at his life and the legacy of his art, I often contemplate the power and the intense mystery of this man who could write like a poet, open doors to all kinds of institutions and opportunities, and realize so much in his artwork. He embraced a multifaceted view of media, and I would like to suggest some of the ways that his achievements are an example and a challenge to a new generation of artists.

As we look back over the past century and consider the invention of the cinema, television and video, the internet, interactive platforms for video games, and new digital media, it's clear that the moving image has had a fundamental impact on all of the arts. I am convinced that the history of twentieth-century art will be rewritten through the moving image and that online access to a virtual archive of moving images and histories will expand our understanding of diverse media practices.

Paik imagined a future of flat screens, video projections, mobile cameras and sound systems, instant access, and flexible digital media. He was an active part of a large community of international artists. We can be inspired by his example and by what I like to call a thick history made up of many artists, movements, styles, and genres of work in active distribution and exhibition around the country. This history engaged an array of social and political issues, including civil rights, feminism, LGBTQ rights, and protests against the U.S. involvement in Vietnam. Today is a time of enormous change, in which the social networks and mobile forms of distribution and reception can be activated to transform and remake the structures and hierarchies of the art world. The small cellphone screen, for example, can replace the high-end image, providing the user with immediate access to a virtual archive of the moving image. Paik understood this as he constantly reframed the moving image, seeing the possibility of bringing a thoroughly transparent and transformational medium to everyone.

Paik viewed scientific, technological, and cultural change as dynamically connected to a changing political and social world. He believed in art as a transformative practice that gives expression to a humanist and generous world view. The writings collected here give expression to that mix of creative thought and ideas that motivated him over his long and inspiring career.

NOTES

This essay is drawn from writings I have done over the years: John G. Hanhardt, ed., *Nam June Paik*, exh. cat. (New York: Whitney Museum of American Art, 1982); John G. Hanhardt and Caitlin Jones, eds., *Nam June Paik: Global Groove 2004*, exh. cat. (New York: Guggenheim Museum, 2004); John G. Hanhardt, *Nam June Paik: The Late Style (1996–2006)*, exh. cat. (Hong Kong: Gagosian Gallery, 2015); John G. Hanhardt, *The Worlds of Nam June Paik*, exh. cat. (New York: Guggenheim Museum, 2006); and John G. Hanhardt, *Nam June Paik: Global Visionary*, exh. cat. (Washington, DC: Smithsonian American Art Museum, 2012).

1 Hanhardt, *Nam June Paik: The Late Style*.

2 Stockhausen quoted in Edith Decker-Phillips, *Paik Video*, trans. Karin Koppensteiner, Marie-Geneviève Iselin, and George Quasha (Barrytown, NY: Station Hill Arts, 1998), 29.

3 Moorman quoted in Benjamin Piekut, *Experimentalism Otherwise: The New York Avant-Garde and Its Limits* (Berkeley: University of California Press, 2011), 169.

4 Karl-Otto Goetz to Nam June Paik, dated January 20, 1963, Smithsonian American Art Museum, Nam June Paik Archive.

5 Wuppertaler Stadtnachrichten, undated clipping, Smithsonian American Art Museum, Nam June Paik Archive.

6 Undated typewritten and annotated text, Smithsonian American Art Museum, Nam June Paik Archive.

7 Calvin Tomkins, "Video Visionary," *New Yorker*, May 5, 1975, 44–79.

8 E. H. Lockwood, *A Book of Curves* (Cambridge: Cambridge University Press, 1961).

9 Nam June Paik, "How to Make Oil Obsolete," 1980, Smithsonian American Art Museum, Nam June Paik Archive, reprinted in this volume.

10 Nam June Paik, typescript dated November 30, 1966, reproduced in *Flykingen Bulletin*, Stockholm, in 1967; reprinted in *Nam June Paik: Videa 'n' Videology 1959–1973*, ed. Judson Rosebush (Syracuse, NY: Everson Museum of Art, 1974), unpaginated. Reprinted in this volume as "Flykingen Bulletin."

11 Nam June Paik, "Global Groove and Video Common Market," 1970, first published in *The WNET-TV Lab News*, no. 2 (1973); reprinted in *Nam June Paik: Videa 'n' Videology 1959–1973*; in Hanhardt and Jones, *Nam June Paik: Global Groove 2004*; and in this volume.

12 Ibid.

13 Caitlin Jones, "Escape from Videoland," in Hanhardt and Jones, *Nam June Paik: Global Groove 2004*, 32.

14 Ibid., 33.

15 Paik, "Flykingen Bulletin," reprinted in this volume.

Music and the Avant-Garde: Performing Fluxus

Writing, for Nam June Paik, was a means to explore ideas and extract new meanings from a variety of sources. His mind was restless, and he was forever seeking to make connections between different disciplines of knowledge. Writing was a primary form of communication for him, and what he wrote feels — fifty years after many of these pieces were written — still fresh and relevant.

For Paik, paper was a surface to be manipulated, and his typewriter an instrument for taking apart and dynamically reshaping language. Just as he rewired the television to create new moving images, he saw the typewriter as a disruptive yet generative tool, one equally capable of fostering ideas with friends and colleagues, creating manifestos, and developing his thinking on the future of technology and communication. Paik also frequently wrote by hand and voluminously annotated his typescripts, indicating that he rarely considered writing as a fixed output but rather as a living, evolving, and mutable medium for expression.

This section's division between "speculative writing" and "scores" is fairly arbitrary, because they share similar strategies aimed at developing new methods for interpreting music and performance. Paik's writings here provide a context for and theorization of a particular moment in the avant-garde. More specifically, the scores and speculative writings foreground the way chance and change affect our perceptions of everyday life, challenging many of the norms and conventions of interacting with the world. Paik's employment of the Fluxus score — a form explored by many of his contemporaries, including Yoko Ono and George Maciunas — allowed him to create haiku-like observations that were worded as performative instructions. Wildly fanciful and sometimes immediately realizable, the scores were tests of an audience's ability to interpret the pieces and to reimagine how to respond to instruction. In a sense, Paik used the Fluxus score to engage with the world that he had entered in the West. Pushing the boundaries of composition and performance, sound and experience, he recast the rules of

socialization, eradicating the distance between composer and listener, artist and participant, in order to further his agenda of creating a new, responsive art.

In his writings, Paik repeatedly emphasized the role of friendship, extolling the virtues and talents of the likes of Joseph Beuys and John Cage, Charlotte Moorman and Jud Yalkut. His friends and collaborators served as a constant reference and measuring stick for him, and he sought their approval even as he desired to surpass them. Paik was intensely ambitious, and his amiable personality belied a competitive spirit. Driven by a restless intelligence that absorbed everything it came in contact with, from Schoenberg's serial compositions, which he studied in Japan, to Stockhausen's sound lab in Cologne, Paik seized upon ideas and practices and absorbed them all into a new combination of art and technology. Just as the scores freed him to range widely over various experiences and expectations, his speculative writings transformed the parameters of argument and evidence, enabling him to break through the "sound barriers" of musicology and art history. And these texts enact that rethinking, building on each other, so that the scores embedded in *Symphony for 20 Rooms* became an inspiration for his first one-artist exhibition, which featured the prepared televisions and pianos that comprised "Exposition of Music–Electronic Television." This event synthesized his mutually informing love of composition and participation, and it is in the pages of this chapter that we begin to see the linkages between Paik's writing and practice, between his conception and execution, and how his training as a student of music informed the visionary trail he would blaze as an artist who worked across media.

A: SPECULATIVE WRITINGS

Formal Development of the Pre-classical Symphony (1957)

To me it seems to be a peculiar and significant matter of fact, that one asks oneself first what forms exist in music, before asking what form itself is. (Moser begins his Lexicon of Music by immediately explaining what kinds of forms there are, without first establishing what form itself is.)

This approach differs from prevailing practice - in fact, it is just the opposite. And this indicates just how important form is, especially in music. The complexity of the term "form" 2(; Blume) is a further testament to its importance. Of course, one may no longer state: "Music is a sounding [tönende] form." (Hanslick), yet one can also not deny that in no other artistic genre does technique play such an important role as in music, and that music is one of the few artistic disciplines not requiring deep life experience from the musician. It is customary to say that music is better suited to expressing a feeling, rather than representing an object. But I would like to state with near certainty, that neither expression nor representation are the most prominent features in music. It could be said that music is one of the rare cases of an art that corresponds to the original meaning of the word "techne", though not entirely.

Form is so important and so comprehensive. Therefore, if one were to speak only of the development of form, then there might be a danger of losing the "form" itself. Almost all great artists were reformers, but not all reformers were great artists. I would like to view novel and deep

aspects of art in their juxtaposition to each other. "If it is for all, it is not art, if it is art, it is not for all." (

Of course, there are several (or 2) types of forms; in one case the term 'development' can be applied more correctly than in the others, for example in the pre-classical symphony, or in Beethoven's Sonatas; but can one speak of development in Bach's choral preludes or the preludes (from the Well-Tempered Clavier)? Here, typological classification is impossible, let alone identifying aspects of development. Therefore, I would like to not only speak of 'development', but also of the unique invention of form, even though this may appear old-fashioned and also betrays the systematic unity of this presentation.

II. Suite and Sonata

Bach's Prelude (W.T.C Bk. 1, E-flat major, after measure 24), also Beethoven's Sonatas (the 2nd movement of op. 2, no. 2, the Finale of op. 49, No. 1), also Mekern's op. 24 are in Rondo form. But which commonalities could possibly exist between these pieces? This is why the form must be considered in two ways, according to the large formal structure, as well as the smallest individual components [*Zustandsteilen*].

However, the suite "is a simplified version of counterpoint, in which simultaneous polyphony is converted to a homophonic succession", (Sondheimer); it is still more contrapuntal than sonata form, that is: "consistent and unrelenting in the continuation of ideas until the end." On the other hand, the sonata form is built from manifold ideas, and moreover with sudden changes (contrast) (action)". Unexpected incidents must unexpectedly surprise the listener." (Scheube).

Bach's Preludes (in minor) are also comprised of several or diverse motives. But here, new motives appear in this way: A B C D
 A B C D

In spite of this, it is not a canon; the diversity avoids contrast and sudden changes.

A brief motive appeared in the suite in "small-form" that was continued, repeated, or varied, one that was too small and dependent to exist alone, which lived out its existence in his suite." (Sondheimer).

But the theme in the sonata is a "complex of several motives that are synthesized into a unity through cadencing" Sondheimer), and are embedded in dualism or contrast, often in a kind of hierarchical organization in mature sonata form.

Previously unpublished excerpt of a seminar paper written by Paik in 1957 while attending the University of Munich. Translated from the German by Oliver Schneller and Heather O'Donnell.

Postmusic (1963)

Postmusic
The Monthly Review of the University for Avant-garde Hinduism. (1963)
edited by N. J. PAIK
FLUXUS a. publication
- an essay for the new ontology of music -

New ontology of music (PAIK)

I am tired of renewing the form of music.
- serial or aleatoric, graphic or five lines, instrumental or bellcanto, screaming or action, tape or live... -
I ~~hope~~ must renew the ontological form of music.
In the normal concert,
the sounds move, the audience sit down.
In my sosaid action music,
the sounds, etc., move, the audience is attacked by me.
In the "Symphony for 20 rooms",
the sounds, etc., move, the audience moves also.
In my "Omnibus music No.1"(1961),
the sounds sit down, the audience visits them.
In the Music Exposition,
the sounds sit, the audience plays or attacks them.
In the "Moving theatre" in the street,
the sounds move in the street, the audience meets or encounters them "unexpectedly" in the street.
The beauty of moving theatre lies in this "surprise a priori", because almost all of the audience is uninvited,
not knowing what it is, why it is, who is the composer, the player, organizer - or better speaking- organizer,
composer, player.
"Music for the long road" - and without audience,
"Music for the large place" - and without audience
are more platonic.
Alison Knowles notifying no one escaped secretly from the hotel and saying nothing unrolled 1000 meter sound tape
in a street of Copenhagen.
There was not one invited "audience", not one photographer; only the program was due to be printed,
announcing "Time indeterminate, date indeterminate, place somewhere in Copenhagen and Paris."
"The music for high tower and without audience" is more platonic. Alison Knowles "ascended" to the top of the
"Eiffel tower" and cut her beautiful long hair in the winter wind. No one noticed, no programm was printed,
no journalist was there. Sorry, Dick Higgins saw it. It is just the unavoidable evil. He is her husband.
The most platonic music was xxxxx with ooooo , which no one in the world knows about, except us two.
Precisely speaking, only this xxxxx can be called a "happening". "Happening is just one thing in this world,
one thing through which you cannot become "famous". If you make the publicity in advance, invite the critics, sell
tickets to snobs, and buy many copies of newspapers having written about it, - then it is no more a "happening".
It is just a concert. I never use therefore this holy word "happening" for my "concerts", which are equally snobbish
as those of Franz Liszt. I am just more self-conscious or less hypocritical than my anti-artist friends. I am the same
clown as Goethe and Beethoven.
The Post music "The Monthly Review of the University of Avant-garde Hinduism" comes in succession from my search
for the new ontology of music, and simultaneously is
The first "Journalisme pour la Journalisme" in the sense of "l'art pour l'art", or
"La poste pour la poste" in the sense of "l'art pour l'art".

Every revolution of musical form was due to, or had something to do with the new ontological form of music.
for example in the gregorian chant the time when it was to be played was of main importance.
Imagine how matin services in the early mornings sound completely different from vesper services in the evenings,
although melody is almost same for the outsider.
This WHEN (time of day and day of year, a very interesting measure, which shall be intensely developped & exploited
in my post music "The Monthly Review of the University of Avant-garde Hinduism")disappeared in 18th century
when that music escaped from the church.
Pre-classical symphony (mood music a la MANTOVANI) came into life to entertain the half-intellectual nobles
in their dining rooms, grew up to the Ninth Symphony to satisfy the heroism of romantic free-bourgeois and then
fell down to the Schubertlieder to be sung in a Vienna "gasse".
Bach's Goldberg Variations should be so long as to make the "lord" fall asleep.
KARAJAN's show business and
CALLAS' idiotology are
unthinkable without the record industry.
New American style boring music is probably a reaction and resistance against the too thrilling Hollywood movies.
Post music is as calm, as cold, as dry, as non-expressionistic as my television experiments.
You get something in a year.
When you are about to forget the last one you received you get something again.
This has a fixed form, and this is like the large ocean......
calm sunny calm calm
rainy calm windy calm sunny
calm sunny sunny sunny calm
stormy calm stormy stormy
stormy calm stormy rainy calm calm calm etc.

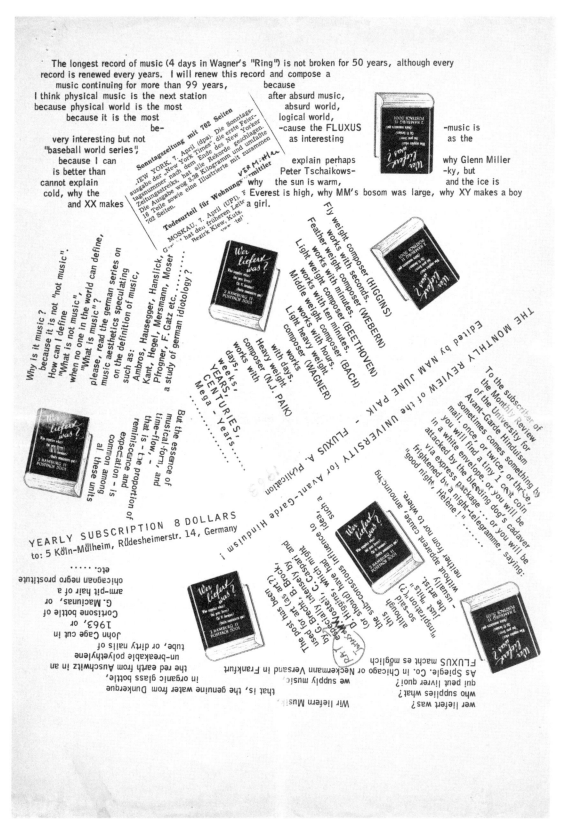

Vintage photocopy on paper; double-sided, 12¼ × 8½ in. Smithsonian American Art Museum, Nam June Paik Archive (NJP.1.PAPERS.1); Gift of the Nam June Paik Estate. Originally published in 1963 as a double-sided offset lithograph by Fluxus.

The Age of Slow-motion (1964)

While preparing his one-man show here,

paik: 'Dear Kosugi! write your biography quickly!!'

Kosugi: "I came to New York, to teach them how to be shy"

 **

P: "Dear, make a press clipping. You need that sort of thing here."

K: "I came to New York, to teach them how to be shy."

P: "Wake up a little earlier!, the shop will close, before you eat breakfast."

K: "I came to New York, to teach them how to be shy."

His friend cried, " H E L P ! he has not uttered even one word, for the last 24 hours.."

Ray Johnson is out of his cave.

 Some one must be in.

John Cage is the man of complexity. Each one took certain moments and developed them in his own way. Roughly speaking, George Brecht,, his simplicity, Fluxus,, his defiance to European 'serious culture', Higgins,, his self-contradiction, Ichiyanagi,, his elegance, Kaprow, his acte gratuite, some pop artists,, his lyrical irony, which decayed soon to the enjoyable fun of average American mass in its second-class followers, Wolf,, his intellectualism,, many otheres,, his musical graphic and contact-microphone, Lamont Young,, his plateau form,, I,, trying to inherit his 'Fetishism of Idea' but maybe ending up simply copying his 'Idiotcracy'.......

 and Takehisa Kosugi,,,his Platonism, almost infantile,,,,,,,

 ,,,,,,,,,,,,,,,,,,,,,,,

 In the hubbub of shopping day for 'Variation NO.5',

I said to John,,

 "You might get that kind of plug at Lafaette, but you will have to wait 20 minutes,,,".

John answered:

" I waited all my life ".

 The versatile art scene of New York is entering the age of slow motion.

 The game betwenn the built-in slow motion of American Artists, which shows the tendency of becoming too materialistic against thier will,

 and,

 the born-in slow motion of Asian artists which

shown the tendency of becoming too spiritual

 against their will,

 will be a suggestive and rather futuristic specta-

 cle,........

Gods wait and see .

God waits and sees ??

Letter from Paik to John Cage, December 1964, Box 10, Folder 4, John Cage Series II, Northwestern University.

Robot Opera Program (1964)

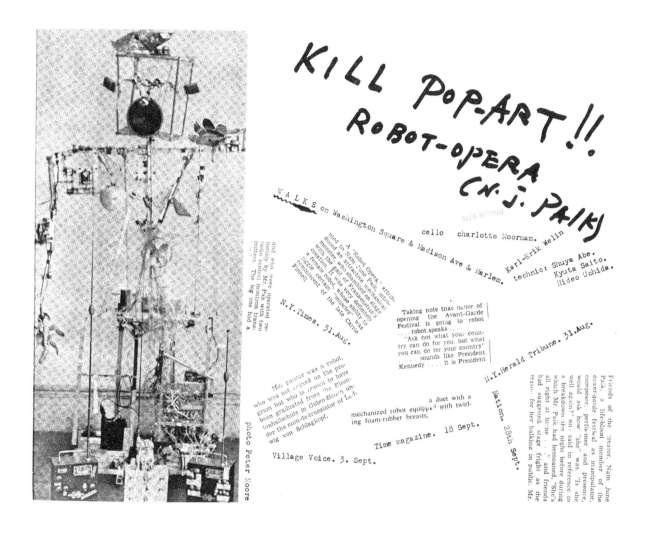

KILL POP-ART!!
ROBOT-OPERA
(N. J. PAIK)

DAVID BEHRMAN

cello charlotte Moorman.

Karl-Erik Welin

WALKS on Washington Square & Madison Ave & Harlem.

technic: Shuya Abe.
Kyuta Saito.
Hideo Uchida.

and who were operated re-
motely by Mr. Paik with two
radio control minitron trans-
mitters. The big one had a
. . . .

photo Peter Moore

A "Robot Opera," attrib-
uted to Nam June Paik, intro-
duced an attractive mechanical
monster who shambled on stage
with the flair of Frankenstein's
creation. It was very definitely
a female robot, whose ability to
jiggle certain "muscles" was
reminiscent of the late Carrie
Finnell.

N.Y.Times. 31.Aug.

Her poster was a robot,
who was not named on the pro-
gram but who is known to have
been graduated from the Eisen-
tonhailschule in Guten-Ba(?)n un-
der the nom-de-translator of Lo.
wig von Schlagkopf.

Village Voice. 3. Sept.

Taking note that numor of
opening the Avant-Garde
Festival is going to robot
robot speaks
"Ask not what your coun-
try can do for you, but what
you can do for your country"
. sounds like President
Kennedy it is President

N.Y.Herald Tribune. 31.Aug.

a duet with a
mechanized robot equipped with twirl-
ing foam-rubber breasts,

Time magazine. 18 Sept.

Nation. 28th Sept.

Friends of the creator, Nam June
Paik, a life-blood member of the
avant-garde festival as manipulator,
composer, performer and presence,
would ask how "she" was. "Is she
well again?" or said in reference to
a breakdown the night before during
which Mr. Paik had bemoaned, "She's
all right at home . . ." and friends
had suggested stage fright as the
reason for her balking in public. Mr.

R O B O T O P E R A

OPERA WITH ARIA	IS	BANAL
OPERA WITHOUT ARIA	IS	BORING
KARAJAN	IS	TOO BUSY
CALLAS	IS	TOO NOISY
WAGNER	IS	TOO LONG
MONEY	IS	TOO SHORT
MET-OPERA	IS	TOO DIRTY
SOAP-OPERA	IS	TOO CHEAP
POLLOCK	IS	TOO SAD
POP-ART	IS	TOO POP'S
ZEN	IS	TOO MUCH
PAIK	IS	TOO FAKE
DRUG	IS	TOO BORING
SEX	IS	TOO BANAL
00000000	IS	TOO XXXXXX
XXXXXXX	IS	TOO 000000

Gluck contra Piccini
Wagner contra Puccini
Robot-opera contra Soap-opera

Awake! C'est deja midi!!!

Meet the people, who do not know the name PabloPiccasso

Robot-Opera every streets & squares in New York.

timeindeterminate
date...........indeterminate
place..........indeterminate
audience.......<u>INDETERMINATE.</u>

If you meet,
 pease, don't watch it more than 3 minutes?!

sorry

Vintage photocopy on paper; double-sided, 8½ × 11 in. Smithsonian American Art Museum,
Nam June Paik Archive (NJP.1.PAPERS.28); Gift of the Nam June Paik Estate.

Untitled/Most of my So-Said "Action Music" Pieces (1967)

Most of my so-said "action music" pieces are not playable
by other performers ,, maybe not even by me now, because the
past ten years changed my physiognomy and psychology.. may be
for bad........ Josef Beuys told me that America corrupted me,
which I agree.....

Anyway this unplayability of un-corrupted pieces induced
me to write several "playable" (therefore a little corrupted)
music pieces around 1962,

 "Cut your left arm very slowly with a razor blade for about
 10 centimeter"
 is one of them.

[Long illegible stretch, covered by masking tape]

I am just reluctant to endorse the superficial headlines of
newspapers...... same thing goes also to my Opera Sextronique...
I would like to call Charlotte Moorman rather a
 "top-FULL Cellist",
although I consider my work necessary , her suffering important.
 - - - - - - - - -
Critic left before the performance
 and
Photographer came after the performance...
 was my pain in vain ?
 ha ha ha
 surely I am corrupted.

Previously unpublished typescript, Nam June Paik Estate.

Charlotte Moorman: Chance and Necessity (c. 1992)

Looking back at the 20th century we can point out quite a few blunders which border on
comedy. One is the Maginot Line which did not extend to the Belgian border. If they trusted
the Nazis so much, why did they build the expensive fortress to start with? While French
intellectuals
were celebrating the Popular Front, Colonel De Gaulle was the only one awake at that time.

The second folly is the British and Singapore. The British fortified Singapore for billions
of pounds but all the guns were fixed toward the sea. The Japanese army practically walked into
the island from the back door unopposed. Even Churchill did not point out this incredible folly.

The third folly is Marxism, and the world's intellectuals who tried to defend Karl Marx
as long as possible.(Many even after the Hungarian Revolution; some even after the Prague Spring,
and quite a few academics even after 1975 up to 1989)... Why did the cream of intellectuals, not
only the smartest but the most conscientious ones, for so long commit such a foolish mistake?
Why could they not say "Yes, you are right" to the many semi-educated hard-hats and the readers
of the tabloids who condemned Marx long ago? And why has there not yet been any significant

auto-criticism or auto-analysis in the liberal magazines? If we cannot trust
our intellectuals in the academy, who should we trust?

There has been a double standard in the application of human rights violations. I will not
defend General Pinochet's cruel rule, but in the seventies, were the same standards applied to
China and Mao Tzetung condemning their state terrorism?

One day I said to John Cage that 95% of the world is stupid, and that this is why this poor
Korean was able to make a living in Manhattan that easily. He laughed and agreed with me.

Charlotte Moorman and the combination of classical music and nudity was the same thing.
It was such a logical and sure-fire idea, that I still wonder why nobody did it before us.
After all in 1965 there were many thousands of artists and performers who were frustrated and
looking for a new breakthrough. I bet there are still many new openings and loopholes in
art history even in 1992 which are being overlooked right now by millions of young people
who complain that everything has already been done, so that they cannot do new breakthroughs.
However, the history of the world says that we don't win the games, but we change the rules of
the games.

We are like a mythical Greek bird who walked on the ground and if she encountered a large
hole she took wing and flew over it.

Actually Charlotte Moorman flew over the hole in Paris during a Festival de libre Expression
organized by Jean-Jaques Lebel in 1965 at the American Center at Montparnasse.

The first evening was done by Ferlinghetti (reading his poems on a car with his mountain full
of spaghetti) composed by J.J. Lebel. The second evening was by Charlotte and me, and the third
evening was to be a one man show by Ben Vauthier. On one of these evenings we watched a
marvelous trio by Earl Brown, Emett Williams and Robert Filiou. American Center was on the
left bank and our hotel was near Pigalle on the right bank. When we finished the rehearsal it
was 6:30 and our show was to start at 7:00 PM. Charlotte suddenly said, "Oh, I have to go back
to the hotel. I have to fetch my black formal." I was at a loss. It takes two hours to cross
the Seine and come back at the rush hour, and how can you get a taxi during rush hour to start
with? But Charlotte, a very demanding woman kept insisting...I could forsee our debut concert
in Paris would be a disaster. It would begin at 9 PM, two hours after the announced time. The
impatient and spoiled crowd of Paris intelligenti will go home. Then my eyes caught something
at the corner of the greenroom. There was a huge roll of clear plastic drop cloth which Ben
Vauthier brought here as the prop for the next evening.

I pointed it out. "How about that?" "What?" She could not guess what I said. I repeated:
"This is your formal." "Oh no." she screamed quite perplexed. I noticed a very quick change
of her expression - in a split second I sensed something was clicking in her mind - feminine
mystique. Shyness, shame, success, success de scandal, again her southern upbringing. Her
mother at Arkansas, again da capo, opening and closing...her vacillation went up and down in
waves in a very short time. Many years later, I analysed Greta Garbo's facial complexion and
found that she can become a virgin, then a whore, then a saint, and back to a virgin many times
in a split second. I sensed that that kind of tension was passing through her mind in this
fateful second - after all it was 1965. Even toplessness was forbidden everywhere in the world
including the Paris strip joints, much less full nudity. It was not easy but she crossed the
Rubicon. In order to hide her shyness she drank straight scotch. When she stepped out there was
a roar of applause and she drank more, , played more, and drank more and got more applause.
She fell backward on the makeshift stage. On that day she got enlightened. She had been a rather

stiff performer, self-conscious with a great amount of stage fright. But this baptism of nudity, uproar and straight scotch opened a new nerve center, which made her a sensitive and inspiring performer.

The Chinese say, when a bird dies, her last singing is beautiful. When a minister dies, his last advice is beneficial and selfless. So was Charlotte's last performance. It happened at the MIT Center of Advanced Visual Study presided over by Otto Piene, Charlotte's longtime patron and faithful sympathizer in the spring of 1990. 25 years passed like a blitz for all of us. For Charlotte it was an entrapment inside the double helix of pain and pleasure, the ecstatic upward spiral of career and a constant agony of her growing tumor. She underwent the uterus operation in 1962 or 63 when she was only 29, and her tumor escaped the first operation. In our first or second meeting in the summer of 1964 she already talked about her terminal illness. As in the case of George Maciunas's asthma and Josef Beuys's war wound the sickness was the motor for their super-manly endeavour. By 1969 her tumor moved to the stomach and kept growing. She looked like she was five months pregnant. But there was neither money for an operation nor or for insurance. Frank Pileggi, not yet married, showed me his wallet...and Blue Shield medical insurance...that could save her. Their beautiful romance started when Frank Pileggi (night manager of the Hotel Paris where Charlotte occupied a room for a long time) opened the lock of her room, when she was locked out of her room due to a delay in payment. That happened rather often, and Frank would sneak into the corridor and quickly used his master key and fade away. After the talk with Frank, my duty was to go upstairs and persuade Charlotte that she should marry immediately for love and life. With Frank's insurance and the additional help of Howard Wise she was able to extend her life for about 20 years, although the last ten years were quite painful. However, Frank's supermanly management kept her alive and well enough to go through many festivals, performances, and trips to the Solomon Islands and to Israel. The last few years were especially painful, wherein Charlotte needed frequent injections of morphine. Frank had to wake up every hour on the hour and inject morphine then go to sleep again only to wake up after 60 minutes. His greatest wish was to sleep for eight hours in a single stretch. But being sick is prohibitively expensive. My efforts were not sufficient. In this long agony Otto Piene has been one of the few who supplied not only words and good will but also money and jobs. And Charlotte enjoyed the aura of mighty MIT. One of her cherished pictures is her photo session with Jerome Wiesner, the president of MIT and the personal science advisor to Kennedy and Johnson.

Her last performance in the spring of 1991 was especially brilliant. Her bow-movement was as fast as an Olympian fencing champion. I almost see blue sparks flying from her cello's body. I thought about two things: A Chinese proverb about the swan song, the beauty of the last cry of a dying bird, and the honesty of the last advice of a knighted gentleman, who has nothing to fear on his deathbed. -- And if I may add, I had had a flash of mind ... before her performance (it was almost 9 PM or so) she must have had her hourly injection lest she doesn't get sudden pain in the midst of her performance. And this dose of morphine must have made her mind fly like a goddess or shaman. In any case, her disfigured body and charismatic performance was a flash back of her first charismatic (throw-everything away) performance at Paris in 1965, which was incited by the combination of nudity, cellophane formal, booze and public jeers, and she had had a beautiful body, a little like Rubens -- full of sensuality -- exactly the opposite of Twiggy, who would become famous two years later.

In 1977 on a Colorado mountain, I asked Allen Ginsberg how long he would like to live (he was about 50 then). He answered: "I want to see the next century." He would be ça 74 or so... Somehow this artificial demarcation line of 100 or 10 defines or even changes people's mood like a knot in a bamboo tree.

About 7 months ago, I delivered to Frank Pileggi 100 sheets of expensive paper, saying "Let Charlotte sign on the bottom of the paper in her better moments. I don't need any of them. But you can print Charlotte's drawing or photograph on them. You can make some money." I know that Henry Miller left many blank papers (signed) and his family sold them as a signed blank sheet. Collectors would print Henry Miller's drawing on them and sell them at $1,000 a piece. Yesterday Barbara Moore called me and said Frank wanted to return this paper (unsigned). Yes, Frank's devotion was purely for love. This soft man did not have the nerve to ask her to sign the addition, as Mrs. Eva Beuys was so to Beuys.

I cannot forget the affectionate scene I witnessed 7 hours before her death. Knowing that the end was coming, Charlotte repeated many times to Frank "Thank you, thank you."

In 1961 I was going to quit my performance career. I was moving from the period of intensity as a genre (on the stage enlightenment, das Aufhebung aufheben of various dualisms in your body and the world) into the new genre of freedom, variety, visual pleasures, and cognitive interest, which includes sound objects, einsatz to the electronics and the world of electronic TV.

I was quite firm about this conversion and I only reluctantly staged the neo Dada event at the Kammerspiele and participated in Fluxus at Wiesbaden. However after having arrived in the U.S. I met Charlotte Moorman. She re-kindled my interest in the performances. (Actually I had sought young women who would play classical music and semi-nude in public. I asked Mieko Shiomi and she refused. Alison Knowles did one performance at Amsterdam (Vostell's opening at Rokin Gallery), yet she did not play any classical instrument. Charlotte was the first woman, who met both qualifications, and had a musical technique, courageousness, beauty and artistic sensitivity.).

Maybe it was not easy, as I indicated at the beginning of this short essay... it was very difficult for her and was very lucky for me to find her...maybe the one and only candidate in the whole world.

Will she have a successor?

Will anybody play my piece written for her?

After all, since J.S. Bach wrote 12 partitas for cello, no composer wrote so many pieces for the cello. It is my claim to music history. The Rieman Dictionary, which we revered so much in my student years in Munich University's Musicology department asked for my biography and printed many of my pieces for Charlotte...It was my revenge on the University of Munich's two assistant lecturers who ignored my epoch-making essays on the prehistory and entstehung of sonata form in the 17th century.

Charlotte did it.

Undated typescript, Nam June Paik Estate. Edith Decker-Phillips identifies the text as being from spring 1992. Originally published in German, in a translation by Decker-Phillips, in *Nam June Paik: Niederschriften eines Kulturnomaden* (Cologne: DuMont, 1992), 194-198. English text reviewed by Alan Marlis.

TV Bra For Living Sculpture (1969)

Nam June Paik - Charlotte Moorman

 In this case, the sound of the cello she plays will change, modulate, regenerate the picture on her TV-BRA.

 "The real issues implied in 'Art and Technology' is not to make another scientific toy, but how to *humanize* the technology and the electronic medium, which is progressing Rapidly— too rapidly. Progress has already outstripped ability to program. I would suggest 'Silent TV Station.' This is TV station for highbrows, which transmits most of time only beautiful 'mood art' in the sense of 'mood music.' What I am aiming at is TV version of Vivaldi . . . or electronic 'Compoz,' to soothe every hysteric woman through air, and to calm down the nervous tension of every businessman through air. In that way 'Light Art' will become a permanent asset or even collection of Million people. SILENT TV Station will simply be 'there,' not intruding on other activities . . . and being looked at exactly like a landscape . . . or beautiful bathing nude of Renoir, and in that case, everybody enjoys the 'original'. . . and not a reproduction . . .

 "TV Brassiere for Living Sculpture (Charlotte Moorman) is also one sharp example to humanize electronics . . . and technology. By using TV as bra . . . the most intimate belonging of human being, we will demonstrate the human use of technology, and also stimulate viewers NOT for something mean but stimulate their phantasy to look for the new, imaginative and humanistic ways of using our technology."

Originally published in *TV as Creative Medium*, exhibition brochure (New York: Howard Wise Gallery, 1969), n.p.

My Jubilee ist Unverhemmet [My Jubilee is Unmetered] (1977)

In 2 weeks I will be 45. It is time for *Archeology of Avantgarde*. I lived in Korea in the 40's, where only available informations were from Japanese books printed before World War II. Therefore it was a great luck that I heard the name of Arnold Schoenberg available in Korea in 1947 or so. He immediately interested me, because he was written as a devil or the most extreme avant- garde. However there were no record or scores of Schoenberg available in Korea in 1947, except for a pirate edition of his op 33 a piano piece. It took 2 or 3 years of desperate struggle to find only available record, which was released in the pre-war Japan, Verklärte Nacht. I will not forget forever the excitement of holding this fragile 78 RPM record in my hand like a jewel from Egyptian tomb. And I cannot forget the disappointment of this record, which was purely a Wagnerian Quatsch.

Korean war came soon after.

25 years after this experience I found the same record of Schoenberg in a flea market in New York. I played this record 4 times slower (on 16 RPM) in a Merce Cunningham dance event. Merce smiled and said: "You improved Schoenberg."

 Hamburg 2/7/1977 Nam June Paik

P.S.

I question myself now, why was I interested in Schoenberg? Only because he was described as the most extreme advantgarde. I question again myself why was I interested in "most extreme"? It is because of my Mongolian DNA. - Mongolian-Ural-Altair horse back hunting people moved around the world in prehistoric age from Siberia to Peru to Korea to Nepal to Lappland. They were not center-oriented like Chinese agrarian society. They saw *far* and when they *see* a new horizon *far* away, they had to go and *see far* more-

Tele-vision means in Greek to
see *far*. See far=fernsehen=
Tele-vision

Liner notes for Paik's 1977 LP *My Jubilee ist Unverhemmet* (Edition Leeber-Hossmann).

George Maciunas And Fluxus (1978)

Marx gave much thought about the dialectics of the production and the production medium. He had thought rather simply that if workers (producers) OWNED the production's medium, everything would be fine. He did not give creative room to the *DISTRIBUTION* system. The problem of the art world in the '60s and '70s, is that although the artist owns the production's medium, such as paint or brush, even sometimes a printing press, they are excluded from the highly centralized DISTRIBUTION system of the art world.

George Maciunas' Genius is the early detection of this post-Marxistic situation and he tried to seize *not only* the production's medium *but also* the DISTRIBUTION SYSTEM of the art world. Thus he exposed the new dialectic tension in the '60s and '70s, that often the most politically radical artist is supported by the most conservative money.

Is he the last cowboy in the art world? Even a permanent pessimist like me disagrees... I was moved, when I was asked at a small party in Adelaide, Australia all about FLUXUS. I thought if Fluxus survived so long without any support from the official art world, we MUST HAVE DONE something right... and also I thought that the name Fluxus didn't have to continue... any fresh individual spirit like Maciunas will challenge the power-structure... and this new man will enjoy success, as much as failure, which has been the most remarkable trait of George. I wrote to Mrs. Brown that George will come back, as the Red Army came back to Stalingrad. George said in the hospital to Mrs. Brown, "The Red Army never left Stalingrad".

The coming postindustrial age will be the strange hybrid society of the decentralized do-it-yourself kind of distribution and the material necessity of a more centralized, decision-making process in a highly technological area.
As long as we can say "Small is beautiful"... somebody will remember Fluxus... and our GM, who is not General Motors, but its inverse case.

Nam June Paik, Feb. 23, 1978

Wiesbaden 62

George Maciunas was driving a Volkswagen bus. He made a sharp left turn. A Mercedes Benz behind almost hit George's VW bus. He instantly shouted to the Mercedes, "Watch out, you bastard...you have a better car".

Both of the above were published in *Flash Art* no. 84-85 (October-November 1978): 48.

On Cagean interpretation Of Cage

Semantically speaking, John Cage means "the absence of a definition"

(Heintz-Klaus Metzger)

Therefore every recording of John Cage is the ash of John Cage.

Therefore the cannonization of Cage commits a double-sin, like

ex-anarchist Fascists.

"Loyal" Cageans have condemned Moorman-Paik's realization of 26'1"1499

as "not faithful" to Cage...we are proud of not being Toscanini.

The essence of Cagean message is "Nature"...and if "sex" is not nature, what

else is "Nature".?...That negligeance was conspicuous also in SUZUKI.

"Zen Against Suzuki"..... a best seller in 1970's.

Zen has been dead for the last 300 years. Only salesman was alive.

Two Americans has revived it...through "democratisation". nobody has time to

meditate 30 years in the mountain.----acceleration.

Instant Zen No. 1...... John Cage---through electro-mechanical device.

Instant Zen No.2....... Timothy Leary...through chemical device.....

No.2 is dangerous...but being dangerous is better than being dead.

A great Monk asked to a greater Monk. "What is Buddah?"

 Greater Monk gave the greatest answer " toilet paper---used, dirtied,,dried".

next stage is to abolish the adjective "great" and its comparative

cases.

Revolution succeeded....apparatchiks took over...we old guards are on way to

exile.

Dear Gregogry.. Don't correct my English...

'60's is over..it is time to disrupt English grammar

after having disrupted FCC TV scanning lines.

this essay is by Charlotte Moorman and

Nam June Paik

or

"Apology of Charllote Moorman" by Nam june paik...

am I too "classical" ???

Undated typescript, The Gregory Battcock Archive, courtesy of the Nam June Paik Estate. Originally published in *Oceans of Love : The Uncontainable Gregory Battcock*, edited with an introduction by Joseph Grigely (London: Koenig Books, 2016), ill. 35, n.p.

B.C./A.D. John Cage (1993)

1960: (Cage was 48) Cage was talking continually about Nothing-ness. I asked him: "What about... when you die, you burn all the tapes and scores and leave to music history only one line: "there lived a man called John Cage'?" Cage answered: "It would be too dramatic."

1982: At the Westkunst (Cologne) he was with Klaus Schöning. His arthritis had greatly improved after the acupressure and diet recommended by Ms. Yamamoto in New York. Cage said (he was 70): "I will be healthy when I die." He premiered a play in which many famous deceased artists come up and talk... (James Joyce, Mcluhan etc.). The play was macabre yet fresh. I thought his spring of ideas did not dry up. While you have this spring, you are still in spring.

1990: I had had a small show with Robert Kushner at the Holly Solomon Gallery. Unexpectedly, Cage showed up at the opening. He could not bend his back, so he had to take a bus, as he couldn't

get into a taxi. I was surprised and rather embarrassed for his effort. Shigeko said maybe he came to say good-bye.

1992: I visited Cage to hand him a modest royalty check for his work. He chuckled at my misspelling "Loyalty" - instead of Royalty. While I was there, there was the constant ringing of telephones. They were all good telephones... but the combination of many goods can be bad. I asked him why he didn't hire a secretary or buy a mechanical screening device? He said "No..." Like Joseph Beuys, he made a quasi-religion out of answering those phones. Before going to Korea (for my sixtieth birthday), I told Margarete Roeder: "Don't send him to so many birthday concerts... The celebration will kill him." Roeder said: "Of course, but John gets mad when I say do not go."

After his death, Roeder said: "John died on the full moon day. A Zen monk dies on the full moon day." I said "But the Zen monk knows in advance when he dies."

Did he leave a will? I will write down mine here so that I cannot retract it later.
1. I will choose may way of death. Euthanasia is legal in Holland possibly in Mexico also, I will die in Holland, because it is cleaner and they bought my first TV Buddha.
2. When I cannot communicate my will, somebody must ship me on the next plane to Amsterdam.
3. I have not yet decided whose music I should hear on the threshold. I wonder... it can be Palestrina or Josquin Desprez or John Cage's Winter Music played by David Tudor, or Beethoven's Spring Sonata the second movement or Saint Saëns' "Swan" played by Charlotte Moorman... I can only die once, but so many possibilities!!
4. Financially—10% of my money, if any, must go to Amnesty International. 50% must go to Shigeko Kubota. 40 % should be spent for a modest Video computer arts museum. It should open in 2010 (I may or may not be alive) and close in 2032 (I will be 100 years old.) Even Duchamp needed 100 years to convey his ideas. I may need more. The museum will last only 22 years (2010-2032 A. D.). This number of years, 22, forms a symmetry with my debut gallery whose number was also 22 (Gallerie 22 at Kaiserstrasse 22 at Düsseldorf, Germany). In the year 2032, people will love my sloppy, messy aesthetics. Well before that year, people will understand the beauty of the REAL John Cage music.

There is one phrase which I hoped to explain to John, but never had the chance to. I once said (even on TV), that listening to John Cage's music was "like chewing the sand". It was meant to be the highest compliment, but people thought it was derogatory.. I would re-phrase it....
Good John Cage is Bad John Cage.
Bad John Cage is Real John Cage.
Real John Cage is Good John Cage.
Good John Cage is Not a Good John Cage—da capo.
People often say that Cage was a good music philosopher who influenced many good people, but he was not a good composer. In my case, this was radically un-true. I was attracted by his music and not by his theory. At Darmstadt, Germany, 1958, I first attended his lectures but I was not impressed. He looked to me like a superficial American Zen Modernist, of which there were many then, and even now. What converted me into a fervent Cagian was his concert with David Tudor... specifically Variations I and III and "boring" Feldman's music, in which they played only 3 notes for more than 5 minutes. The next day his "Music of Changes" came which was really "boring". I used the phrase "Music of Unchange" in my review in the Ongaku geijutsu (Tokyo) that year. At

that time Cage played two or three kinds of music. One is "good" and pleasant music, which many could enjoy (such as Sonatas and Interludes or Variations I or III in Tudor's interpretation). The second category is messy and unkempt like Winter Music (also often done with Tudor, one of the greatest geniuses in music history). In this second case he really becomes a devil and throws away sounds to people, like you throw away sand to the garden... without any consideration of decorativeness or kurzweil-ness (to make the passing of the time short) or perfection. This truly INSCRUTABLE side of Cage is what I admire. Many of his disciples and younger friends became once again CHOOSY and aesthetical... after having passed through the Cagian Baptism. I became so, too. But Cage alone had the guts and the confidence to spit out the shit...

I remember his chess concert at the Electric Circus around 1968. He and his chess partner were playing chess. The chess board was wired and manipulated by Tudor. Certainly NOBODY could make "good" music for 3 hours without spending 3 years on composition and rehearsal. But here everything was improvisation. The result was something beyond good and bad, beautiful or ugly, partially good or partially bad. The result was the carpet of sound for 4 hours, which you either must accept or not accept. It was like the Universe. Fuller said: "I accept the Universe". I said: "I accept Cage"... because it was nature or universe. Its vast quantity disarmed our little measurement scale called "quality". As we know, we use the word "Quality" in two different meanings:
1. Better... or worse... a comparative case of adjective.
2. Different... e.g. Munster cheese may be better or worse than Camembert cheese but certainly A is different from B.

In Cage's music, the vast quantity made this distinction inoperative. It was like chewing the sand... No artist before or after managed to go so completely beyond the decorativism or careerism or betterism. Cage could compose while talking with friends, because he did not care about "quality".

In 1962 I said to Allison Knowles: "My life started one evening in 1958 at Darmstadt. 1957 was B.C. (Before Cage). 1947 was B.C. 10---Plato lived in B. C. 2500, not in B.C. 500.
What does A. D. means? "
She said "A. D. is the abbreviation of After Death".
World history started with the free deaths of three men.
Socrates, Bo-i of China and Jesus.
In any case, for me, 1993 is 1 A.D.

John Cage asked George Brecht "I hear you now live in Cologne". Brecht answered: "No, I live in Sülz", it is like saying "I don't live in New York, I live on 103rd street." George Brecht told me, "I think, John Cage is an ambitious man", as if it were a great discovery...

Asked about his opinion on Karlheinz Stockhausen, Cage answered: "World is large enough for two composers". I asked John: "When have you thought, you are a genius... which year?" He said with a smile: "It is nice to talk to you".

Asked by Italian TV, which town in Italy he likes most, John answered: "I prefer Venice, because it has already abolished automobiles"... It was 1958, well before the ecology movement. (Information: Heinz Klaus Metzger)

Originally published in *World New Music Magazine* 3 (1993): 95-97.

B: SCORES

Seven Fluxus Scores (all c. 1962)

Fluxus Champion Contest

Performers gather around a large tub or bucket on stage. All piss into the bucket. As each pisses, he sings his national anthem. When any contestant stops pissing, he stops singing. The last performer left singing is the champion.

1962

Prelude

Audience seat are tied up to backs before performance.

Fluxus Hero Or Heroine

(For Frank Trowbridge)

Piss on the subway tracks and thus stop the train.

Zen For Street

Adult in lotus posture & eyes half shut positions himself in a baby carriage (perambulator) and is pushed by another adult or several children through a shopping center or calm street.

Dragging Suite

Drag by a string along streets, stairs, floors: large or small dolls, naked or clothed dolls, broken, bloody or new dolls, real man or woman, musical instruments, etc.

Atom Bomb Victim

Two uniformed men wearing gas masks carry on a stretcher an "atom bomb victim," a woman, half of the body prepared in a manner of cruel wounds and deformations, the other half in a sex-feast.

Moving Theater

Fluxus fleet of cars and trucks drives into crowded city during rush hour. At the appointed time, all drivers stop cars, turn off engines, get out of cars, lock doors, take keys and walk away.

Previously published in *The Fluxus Performance Workbook*, ed. Ken Friedman (Trondheim, Norway: Guttorm Nordø, special edition of *El Djarida* magazine, 1990), 44.

Omnibus-Music No. 1 (1961)

a sketch to

OMNIBUS-MUSIC NO. 1 (16 1961 . spring)
 dedicated to earl Brown
 because the first "geographical music"is
 composed by him in 1955.

1 Oclock.
 all the audience get on to the O-bus.
O-bus drives around the largest rotary of the town
 seven times in clock-wise direction,

 three times in counter-clock wise direction,

 two times clockwise direction very rapidly,

 all the audience get out of the O-bus , where it started
 , and shake the dice six times.

 if - f. i. - the number 2. 4. 3. 5 . 6 . 1. come out,
this audience
 get on the second tram, or routine) O-bus,

 pass 4 stations and get out there, and wait,

 get on the third tram,

 pass the 5 stations, and get out there and wait there,

 get the first tram,

get the sixth tram,

pass one station, and get out.

 all the audience are scattered, and they walk,

alone,n till they find a cat or a baby, sleeping in
a perambulater, or a an grandmother, who is looking down,
from a window in third floor, or a police or
a grass, which xxx has sprung out where the asphalt-pavemen
t is broken, or a mr smith or b herr schmid,
and then ring or ask xxx him, whether
 he prefers goethe to shakspeare,

 or

 anton Webern to arnold Schoenberg,

 and find out 30 and combinations
 such as

Typed text on paper (1 page) / paper with ink additions (12 pages), 8¼ × 11¾ in.
Smithsonian American Art Museum, Nam June Paik Archive (NJP.1.PAPERS.18A-F);
Gift of the Nam June Paik Estate.

half - time

or

a piece for the peace.

play on the first July

12 o'clock ^noon^ (Greenwitch mean time)

the tonika - accord of C. Major

for

10 minutes.

thinking that.

Some one, some where

in the world

is

play ing

exactly same time

exactly same sounds

— PAIK —

Manuscript (c. 1962), D-197.4, John Cage Series, Northwestern University.

Symphonie No. 5 (c. 1965)

Die Ewigkeit-kult ist die längste krankheit der Menschheit.

The Eternity-cult is the longest disease of mankind.

WHEN to be played, is equally important as
WHAT to be played.

The First Year

ON THE FIRST OF JANUARY.

I O'clock midnight
play PP SOSTENUTO

2 o'clock midnight
play

PP o

espressivo el
cantabile

3 o'clock midnight

play

dolce

5 o'clock and 3 minutes early morning

PP

delicatissimo

12 o'clock noon

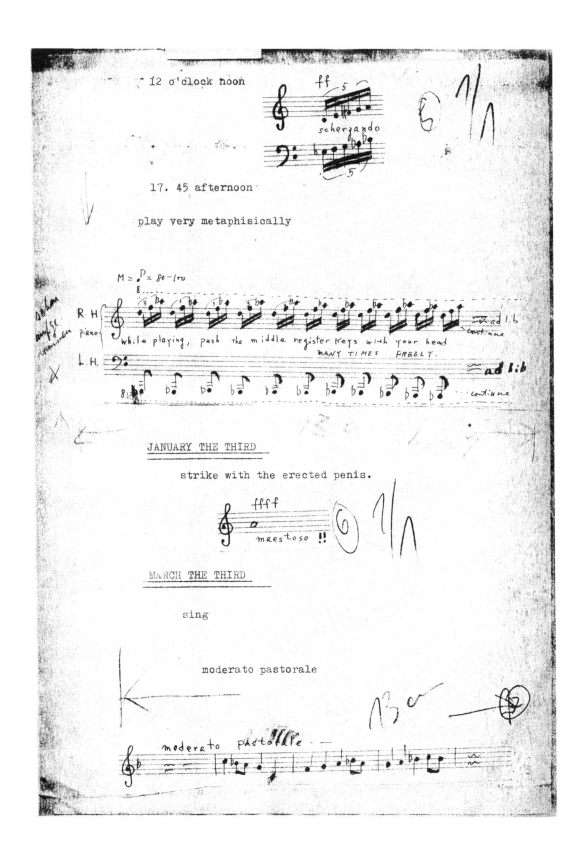

17. 45 afternoon

play very metaphisically

JANUARY THE THIRD

strike with the erected penis.

MARCH THE THIRD

sing

moderato pastorale

MARCH. THE 28TH 15; 15 P M .

 hop with one leg.

APRIL THE 15 TH

 only think to play.

OCTOBER ON THE THIRD SUNDAY AFTERNOON ABOUT 16.45.

 burn withered leaves in the garden,
 and while burning,

 read your old diary.

THE Second YEAR

 think, for, all, the, year,

 whether,

 you, are, a, man,,

 or,
 a, woman,....

THE THIRD YEAR

 MAY THE FIRST 18. 43 o'clock.

 ride in a taxi

 and see

 ONLY the Taxi-meter.

On a beautiful spring morning,

 count the railings on the longest bridge in your town
 1)

 in the foreign language, which you know the least.

1) railing==
 = das Pfeiler
 = la grille
 = 欄干

JULY THE 13TH
 23. 34. o'clock

On a **very hot** and sunny summerday

 count the railings on the longest bridge in your town,

 in the foreign langauge, which you know the least.

THE FIFTH YEAR

On a very cold and windy and snowy midnight,

 count the railings on the longest bridge in your town

 in the foreign language, which you know the least.

 and
 break open the " PORTILLON AUTOMATIQUE" of the Paris-subway

or, kneel down in a christian church

and feel the pain in your knee,

OR,

play the record of the funeral march of the EROICA sinfonie
(Beethven) at half speed, disconnect the amplifier and
speaker completely and hear

directly at the needle

....... stroaking a colander with both hands.
7)

(& 7) colander =

das Sieb =
la passoire.

DECEMBER THE 31 TH 23. 35 o'clock

hold till the next year..........

THE 10TH YEAR.

JANUARY THE FIRST

hear Beethoven's first sinfony

and immediately make love!

(in standard position)

and immediately
hear Beethoven's second Sinfony

and immediately make love !

(in upside-down position)

and immediately

hear Beethven's third sinfonie
and immediately make love!

(in social democrat x democratic socialist
position)

and immediately

hear Beethoven's fourth sinfonie

and immediately make love !

(in dog's position) (??)

and immediately

hear Beethven's fifth sinfonie (the Fate)

and immediately make love!

(both standing , face à face)

and immediately
hear Beethoven's sixth sinfonie(pastoral)

and immediately make love
(in avangarde HINDUs position, that is.....
man stands like a tree,

and woman perches on him like a woodpecker
1)
and.........)

1) le Pivert

and immediately

 hear Beethoven's seventh sinfonie

 and immediately make love

 (hip à hip)... it is possible, try !

and immediately

 hear Beethoven's eighth sinfonie

 and immediately make love

 (triole) (stereo)

 the first lies down
 the second sits on the face
 the third sits on the waist.

and immediately

 hear Beethoven's nineth sinfonie

 and immediately make love

 (with ..,............)

 you may change the partner every times
 according to certain rule ,
 f.i.
 every times 5 years older..
 or
 every times with different race,
 whose skin is darker and darker....

 if you fear to be K. O.ed or T.K.Oed
 before 9 rounds are over, as 1,
 please, interrupt ... before......comes,
 (clinch)
 and hear the next sinfonie.. and go....

 N.B. ref: RAINER:
 "Sexual pleasure in marriage"
 "Liebe in der Ehe"

Marina Oswald, 22, Marina's Kods. Lee continued to visit Marina only on weekends, but mostly to sleep and to watch television; she once confided to a friend that he had intercourse with her only about once every two months. Also during this time he

(13)

from JANUARY THE SECOND 12. 01'. 30."

 till JANUARY THE THIRD 12 o'clock 1 minute 30 seconds
 055 micro second.

 play all day long the fortessimo music(BACH! BACH! BACH!)
 without interruption, without eating, sleeping, drinking!!!

JANUARY THE THIRD 14. 68--- 21. oo'08"o'clock

 read Baudelaire's complete work for seven hours
 sitting on the " prepared " W.C. like this genius.

or,
 begin to read inW.C.
 "Karamazov's brother"
 (Dostojewskij)
 and don't come out
 till you read it out!!

Herr
 Peter BROTZMAN
 (Bundesrepublik
 deutschland)

KUNST KOMMT von Können, nicht
vom Müssen, selbst wenn man sie
auf die Toilette verlegt. Meditieren
nennen es die einen, eine Geschmack-
losigkeit die anderen.

7777days . complete pause. forget that you are playing
 the sinfonie No.5 of N. J.Paik.

 (the eternity-cult is the longest disease of mankind

 what is the longest disease of womankind ?
 love??

 what is the longest profession of womankind??

 prostitution ???

 ??
 what is the longest profession of mankind????

 ?
 torture?????????????????????????
 ??????????? ????????

Sing gregorian chant in the following sequence.

 7778th day 72th page of LIBER USUALIS

 496th day 18th page of LIBERUSUALIS

 596th day 81th page of LIBER USUALIS
 - 3891th day -45th page of LIBER USUALIS

 45th day 54th page of LIBER USUALIS

 -10 x9th day 90th page of LIBER USUALIS

 522th year 487th page of LIBER USUALIS

 + 9999th year $\sqrt{99}$th page of LIBER USUALIS

 $\frac{1}{2\pi\sqrt{LC}}$ th year $2\pi\sqrt{LC}$ th page of LIBER USUALIS

 $$L = \sum_{x=1}^{\infty} \frac{5.4}{4.5}x \quad , \quad C = \sum_{y=1}^{\infty} \frac{4.5}{5.4y}$$

 $\pm \frac{1}{2\pi\sqrt{LC}}$ th year $2\pi\sqrt{LC}$ th page of LIBER
 USUALIS

 $$L = \sum_{x=1}^{\infty} \frac{5.3}{45}x \qquad C = \sum_{x=1}^{\infty} \frac{5.3}{4.5}x$$

 $\pm \frac{1}{2\pi\sqrt{LC}}$ th year $\sum_{x=1}^{\infty} \frac{5.4}{4.5}x$ th page of LIBER USUALIS

 $$L = \sum_{x=1}^{\infty} \frac{5.3}{4.5}x$$

 $$C = \sum_{x=1}^{\infty} \frac{5.3}{4.5}x$$

100TH YEAR ANNIVERSARY !

Make honey moon trip to the SPACE, AND
Try to make love in the weightless situation,
and investigate, which position of all 48 positions
of sexuel intercourse is the most suitable one in the

" NO-GRAVITY- COITUS".

(Imagine, how it is difficult).

133 th YEAR.

Play the Grosse-Fuga (OP 133) of L.V. BEETHOVEN

first violin part on the globe
second violin part on the moon.

the viola part on the Venus..

the Cello part on the Mars...

commencing exactely on the first of July
12' o'clock 10 minutes high noon..
(Grreenwich mean time of the globe)
(S F Music No 1)

202 th YEAR

in the year of 2111 A.D. (or 149 A K
after Kennedy)

all the palnets celebrate the 200th birthday of uncle John.

" Who was Mr. arnold Schoenberg ? "
" He is the teacher of John Cage la grand.

Schoenberg taught John Cage,
as Clementi taught L.V. BEETHOVEN."

(excerpt from the Venus Times 2111 A.D.)

The kosmos museum of Venus star bought "three piano integral"
of N.J.Paik for 3 Million dollars.

(tranport cost from Bensberg Refrath .
Bundesrepublik Deuthland to the Venus
301 Mio dollars.

(excerpt from the Mars times 2111 A.D)

230 TH YEAR

THE FIRST OF SEPTEMBER !!!

Ask to Chinese (if there is still any Chinese in the world)
whether the Atom-War killed,

__ONLY__ 400 million chinese or 600 million chinese.

and Ask to the " Deuthche Soldaten Zeitung",

whether Hitler killed,

__ONLY__ 4 million Jews or 6 million Jews.

DECEMBER THE 7 TH (Honolulu time)

December the 8th (Japan time)

LARGO

count the waves of the Rhine

365 TH YEAR

Repeat all what you have played from the beginning till now
in one year in the same succession and time proportion.

one year is abridged to one day.

one month is one hour.

one dayone minute.

one minute.................one second.

one second.................. one microsecond

one micro second.............one piccosecond.

one picco second.............one nano second.

400TH YEAR

AT LAST

Wolf Vostell became more famous than Pablo Piccaaso.

George Maciunas became more famous than J.S. Bach.

Christine Keeler became more famous than
J.R. VALENTINA TERESHKOWA!!!

He said Miss Keeler did not regard herself a street prostitute or a call girl. He quoted Ward as telling her:
"You are not a call girl or prostitute because you have not got the prostitute mentality."

401th YEAR

FRIDAY OF THE 13th on a month..

play

and don't move for three days and
nights.

singing

P andante Sostenuto

(from my early songs, composed in 1948. Seoul)

125 mm
breit

444th year april the 4th . 4 o'clock. 4 minute. 44 seconds. 444444 microseco

do something very calm.

555th year may. the 5th. 5 o'clock. 5 minutes. 55 seconds, 555555 microsecon

do something very calm'.

666th year .june. the 6th. 6 o'clock . 6 minute. 66 seconds. 666666 microsec

do something very calm..

1000th YEAR winter

At a Sunday Service in a christian church,

(if there is still christian church)

Wait till the service is over.

The congregation(Gemeinde) gets to its feet, walks sideways to the aisle , go slowly out

........ coughing............

Listen cArefully to all the noises around.,,

.... footsteps, coughs, whisper,

bustle of clothes, bell.....

etc. ,.,.,.,.,

LARGO

① ‖: Count the waves of the Rhine :‖

(if there is still the Rhine.)

② $$\sum_{x=-\infty}^{\infty} = \left[\,\hat{\ominus}\,\right]^{\frown}$$

2357 th Year 13th MONTH 35th day 25.5 o'clock

Write a funeral march for your
 grand grand grandgrand son.

9999, 99 th year on a bright October Sunday,

 look up at the gothic tower,
 and See the white clouds, --- -- - drifting behind.....

SLEEP FOR 30 YEARS !!!

10003 th year

 pick up your old inpotent penis with your finger,
 and . play the first piece of Czerny-etude (30)
 with this penis, on keyboard (alone , or in
 a public concert)

mP non legato

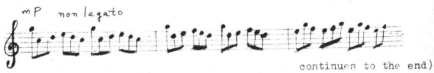

 continues to the end)

@ on a midsummernight in a promenade concert.

To a very beautiful girl,
 please, hold the bow (der Bögen, le archet)
 of the violincello
 in your beautiful vagina,

 and play an attractive music
 on the violincello
 with this beautiful bow in a public
 concert.

 (preferably Saint Saens'
 death of swan)

4289 th year
 A
 on the krystal NACHT (November. the 9th).
 and/or on the Spiegel Nacht (November the 23th),

522.1 th year

Eat every morning (even number date)
one black key of piano,

Eat every morning (odd number date)
one white key of piano.

99997999 th year

???????

$10^9 \times 10^{10} \times 30^{31}$ th year

???????

$1000^{10} \times 10^{99} \times 11^{161}$ th year

?????????

(22)
$$\pm\infty < \pm\infty < \pm\infty$$

play this sounds for the duration of ✗ 1964 years without pause.

long

(23)

elle est retrouvée!

Quoi?....... l'Eternité.

C'est la mer

allée avec le soleil.

(A . Rimbaud)

121212121212121212121212................12th YEAR

 on a bright Sunday morning,

 hear a Mozart in the bed..

 . .
 . .
 . .
 . .
 . .
 . .
 . o
 . .
 . o
 . .
 . .

 See how a tiny pebble

 grows up

 to a mountainous ROCK !!

 continue......

125 mm
breit

continue

Vintage photocopy (22 pages), 11¾ × 8¾ in. Smithsonian American Art Museum, Nam June Paik Archive (Box, Folder 16); Gift of the Nam June Paik Estate. Published in a different form in *Happenings. Fluxus. Pop Art, Nouveau Réalismé. Eine Dokumentation.* (Reinbek bei Hamburg: Rowohlt Verlag, 1965).

Etude platonique No. 3

Ives Klein, memoriam

play Kreuzer Sonate (Beethoven op) with the violin without strings and with the piano without hammers

NB.

(1) it should be played very sincerely

(2) to avoid any missunderstanding, it is recommendable to write on a blackboard the famous maxim of the great composer "From Heart to Heart

(3) perhaps it is also recommendable that players rehearse with the normal Instruments and play without string and hammer only in the concert

(4) The score should be used to get the synchronisation of both players. They should end together.

(5) Applause can be the real one (or tape-recording of Jazz-festival

(6) for the especially snobistic audience, the synchro-interpretation system is to be lent, so that they can hear through ear-phon the real Beethoven Kreuzer-Sonata performance.

Undated manuscript, Smithsonian American Art Museum, Nam June Paik Archive (Box 13, Folder 19).

Suite for transistor radio (1963)

allemande.

The first movement of beethoven' fifth sinfonia

is over.

the conductor wipes the sweat on his fore-head

the hornist shakes the spittle out of horn

the deeply inopressed audience whispers and

rustles.

then

now

the conducter takes the stock and all the

orchester is about to play the more serios

next movement.

just in this moment,

play a transistor radio---not very

loudly---

in your seat and stop after a while.

if you are not enough bold,

please , use wireless remote control

to start the radio playing.

courante

on a bright full moon night in autumn,

take a walk with a transistor phono

player, playing j.s. bach

sarabande.

I love quite much the distorted twist

coming loudly from the cheap

transistor radio of a teen-ager.

in amsterdam channel, or in middle small river,
burn a violin, and throw it to the river
connect a threat it a transistor radio singing.
put it into the water very slowly.
lay a transistor radio in a plastic basin
playing
let it float in the middle of channel
for many days and nights.

Originally published in *Happening & Fluxus*, Hans Sohm (Cologne: Kölnischer Kunstverein, 1970), n.p.

Sinfonie for 20 Rooms (1961)

Collection of Peter Wenzel. 1973 recreation of a lost original, originally published in *Source: Music of the Avant Garde*, no. 11 (1974).

To The "Symphony For 20 Rooms" (c. 1963)

One evening in the summer of 1960 I visited Karlheinz Stockhausen with the intention of explaining to him that fixed form has to be maintained because it is based on the form of sex, one-direction-crescendo (can you imagine a many-direction crescendo? We have but one heart), climax, catharsis - human nature - Ying Yang - Nature of Nature - proton and electron.

As if he had expected me to say something like this (and I never got around to really say it to him), he began to explain that we must get rid of fixed musical form because it is like sex. It has no freedom. It is as old as the theory of tragedy of Aristotle, of Faust, etc. Then Stockhausen explained the possibility of a free and calm love.

> In his yet unfinished piece "Paare" (pairs) there is neither a fixed beginning nor ending. The audience may come into the concert hall and leave freely. And come back. All the while the music continues, for 5-6 hours or more until the last listener has left.

This idea impressed me but did not convince me because at that time I had been seeking for "the last consummate second". In vain I had been working for half a year in order to "fix" on tape this last consummation of 30 seconds.

Next spring, on my way to take a cure at Titisee, while looking out of the window of the moving train, I realized for the first time the old Zen-Cage thesis:

> "It is beautiful, not because it changes beautifully but - simply - because it changes."

If nature is more beautiful than art is, it is not so because of its intensity or complexity but because of its variability, abundant abundancy, endless quantity.

The word "quality" has two different meanings although in everyday usage the meanings are rather mixed-up.
1-"good, better, best"-it permits the possibility of comparison.
2-Character, individuality, 'Eigenschaft',-it excludes the possibility of comparison.

We can put an end to (aufheben) quality (in its first meaning) by means of the formidable quantity, endless variability, abundance of the mediocres. Then only the second meaning of quality (character, individuality, etc) remains. One can arrive at a consciousness of quality (second meaning) through some religious experience or by another extreme situation. Then each single moment becomes independent. One forgets as quickly as children do. Stockhausen's new term "Moment" seems to me to be of strong importance in this connection.

But how can one arrive at variability without losing intensity? Unifying variability and intensity has been one of the most important problems. Is intensity (tension, high voltage) essential to life? Perhaps one has to substitute this physical dimension rather by a spiritual or ideological dimension, f.i. ambiguity, depth, etc., if there is such a dimension.

Everyone can experience this consciousness through love for a while. The Zen priest also aims at a kind of calmness or calm ecstasy, but an eternal extended one, without crescendo, climax, catharsis, - the causes for delusion, illusion, error and deception and self-deception. Therefore they say that love is as bad as hatred.

They train themselves to diminish, level and balance the amplitudes and frequencies of the waves of their love, hatred and life. - Zen requires hard training. Many neglect or try to neglect this under the disguise of "natural nature" or "good taste". Who is trained, can endure better the tediousness. I admire the "Music of Changes" most of all because it is Cage's most tedious composition.

In my last compositions - "Homage a John Cage", "Etude for Piano", "Simple", "Variation on Themes of George Brecht and La Monte Young", "Etude platonique no.1", - I have tried to demonstrate that there _Is_ the absolute, and that (=the absolute) _IS_ the absolute.

In the next series of my compositions - "Symphony for 20 Rooms", "Etude Platonique no.2 for 10 Rooms and a Beautiful Girl (as tedious as possible)", "Read Music - Do It Yourself (Answers to La Monte Young)", "Bagatelle americaine", "Half-time"- I will try to demonstrate that the relative _IS_ the absolute. Do I need to also demonstrate that the absolute _IS_ the relative? This latter thesis you will encounter on each single day of your life and love - from Joseph Stalin till Anton Webern,.......

As I mentioned before: it was Stockhausen's idea to let the listeners leave and come into the concert hall freely. John Cage wanted to compose his "Music Walk" for two rooms of the "Galerie 22" in Düsseldorf where the listeners were supposed to move freely from one room to the other. When the piece was first performed there, this was not realizable. With respect and appreciation I note Cage's and Stockhausen's priority in this respect; although art is often a bastard the parents of which we do not know.

Originally published in _An Anthology_, ed. La Monte Young and Jackson Mac Low (New York: 1963), n.p.

Bagatelles americaine (1962)

Saw a piano	into three	parts.
Hang the first	part like	Mussolini.
burn the second	part like	Hitler
decide the fate	of the third	part in a
people's court	with prosecuter	without attorney.

Fluxus Chemical Co. Announces.

 Dye Your Sperma.
 when you take a pink pill,
 your sperma will be pink-colored.
 when you take a violette pill,
 your sperma will be violet-colored.
 when you take a Pill X,

 your sperma will do spiral dance
 inside her womb for 48 minutes.

Fish in the grand canal of Venice or Amsterdam
for whole night,,, singing a LaMonte Young's piece.

I learnt by heart 1000 names of unusual, & unnecessary
Medicine for no reason , when I was minus 17 yrs old.

Swim at Zee-Duik Canal in Amsterdam, watching
girls de plaisir sitting in windows, waiting customers

The cry of dog, run over by car,,,,,
 Moving Theater No.t

See Your eye with your eye

Originally published in Hans Sohm, ed., *Happening & Fluxus* (Cologne: Kölnischer Kunstverein, 1970), n.p.

Metro-Music and *Bagatelles Americaine* (1962)

Bagatelles Americaine

Metro-Music (ça 1962)

walk the paris subway tunnel from
Franklin D Roosevelt to Stalingrad,
thinking about ~~xxxx~~ Sewage tunnel :. Warsaw.

Bagatelles Americain (ça 1962)
if you are a bad composer, and if you want to write a
good music —endlich—, put up a stone-chair
in your favorite spot in Berner Oberland.

If you are a good Composer, and if you want
to write a very good music,

put up a stone chair in your favorite spot
in Berner Oberland.

If you are a very good Composer, and
if you want to write even a better piece,
put up a stone chair in your favorite
spot in Berner Oberland.

Xerox of Paik's handwritten script, bpk/Staatsgalerie Stuttgart, the Sohm Archive.

Sonatine foe Radio (1963)

 Sonatine foe Radio

 Radio M.C. read and broad cast following commands to
 radio lisrtner . (one instr ction each 10-20 seconds)

 1) Put out the light o f your room.

 slap the left cheeek of your wife,.
 hear this radio very loudly
 hera this radio very softly
 put on the the light of your room and wake up your chirderen.
 find a commercials just now on the air and dont buty this product foerver.
 puy on and off ths radio 5 times.
 turn the radio to DRadio Moscow, hear 5 minutes and come baeck to this
 radio satatiob
 Sing youer national Anthem very loudly ,,, weeping.
 destroy this radio set and continue to hear with xax anoter set.

 radio station transjmit following things,.

 the xxd radio program of 1931 A D same date/
 radio program of ;92; same date.
 racording of War news in 1941. Dec 7th
 pull.out a vacume tube fromthis rdradio set and put it bacik aftre

 after one minute.
 saying Electronicxs ueber alles

 thsi s radio satations transmit the call sign and cycle announcement
 of radio peiking, radio hanoi, radio cologne, radio congo, radio
 madagascar.

 narrator say 5 times
 "please, say 5 times : Fluxus for G O P

 telephine to your telephone number.
 cut of f three pieces of your armpit ahairs and
 burn the first piece, tasye the second one, donnte the third t
 to Fluxus.
 Go to th e W C , splush the water theree times, aspitting
 and come again. fill a cup with th e water from toilet basin

 Hang your self jst fo 30 seconds, or hang a doll, which youh had for
 long time.
 dont breath fo 53 seconds,
 read today's newspaper and find out.
 3 errors, 5 mistakes 7 injustice, 12 mean9ngless things, 14 trvial
 things, 16 fakes, 21 banal things, and2 evils, 2 sins, commited by this
 paper in one day.
 bow to this radio set, which is bringing my voice to you.
 telephine immediately to your mayor.
 telephone to this radio statin saying thtat it was tethe sebest program you heard
 in your life.
 Kiss your left neighboutre, kick your right neighbour and change the
 your right sock to your left sock.
 Puatt the light of your room.

Unpublished typescript, Museum of Modern Art Archives, Series VII, Folder C.133.

Moving Theater No. 2 (1963)

Monthly Review
of
University for
Avangarde Hinduism
N. J. Paik
Fluxus-A

MOVING THEATER No. 2
(N.J (PAIK)

DECORAE A TRUCK, or a Dump-car (Kippwagen) aa, auto mobile a CAR

WITH MANY JUNKS, and BUDDAHS being hung like late Moussolini, and Mothers or motors and Films and naked or bleeding DOLLS and real HUMAN BODIES and

DRIVE @ THE DOWN TOWN and poor and rich districts and small villages ----- all over the world and in short

MEET THE PEOPLE, WHO DOES NOT KNOW THE NAME PABLO PICASSO.

MOTTO!

MOVING THEATER !!
LIVING MUSIC !!!
PEACE WITH Fluxus !!!!
WAE UP! c'est déjà MIDI !!!

Handwritten script, Box 10, Folder 6, John Cage Series II, Northwestern University.

My Symphonies (1973)

Anton Webern wrote sinfonie but neither Cage nor Stockhausen wrote any . . .

I wrote already 5 sinfonies.

No. 1 is Young Penis Sinfonie . . . which was published in the Decollage No 2 in Cologne and later re-printed in the *New Bohemian* by John Gruen (Shorecrest).

No. 2 is Sinfonie for 20 rooms. It was written in 1961 spring. Introduction was printed in Anthology (edited by MacLow and Young) (1963). The finished score was lost in complicated transaction between Cologne-New York-Tokyo-Cologne involving Lamonte Young-Gergoe Maciunas-Toshi*-Yoko-Akiyama-Paik. Present version is the english translation of the one-before the last version, which is written in German and somehow survived for 12 years in my permanent exile.

No. 4 is the instruction to be printed in the Decollage No. 4, which tells "Please, look for the Symphony No. 4, which is printed somewhere in this magazine:". but somehow Vostell did not print it. (1963)

No. 5 was printed in the Vostell-Becker Happening book from Rohwolt Verkag.

What about symphony No. 3?

I forgot to write . . . simple, like that---therefore recently, I commissioned Ken Friedman to write my Symphony No. 3.

nam june paik

1973

Feb. New York

Originally published in *Source: Music of the Avant-Garde* 11 (1974): 75.

"This Script is Not Final, and is Subject to Changes": Nam June Paik between Page and Screen

by Gregory Zinman

In 1988, Nam June Paik drafted a proposal for a satellite television special, *Space Rainbow*, that would link together nations around the world. In the proposal, Paik described *Space Rainbow* as opening with a shot of a kinetic sculpture by Greek artist Takis and a computerized image of the Acropolis, which would then morph into the figure of a bird soaring over the island of Crete. The accompanying voiceover would say: "Thousands of years ago Icarus plunged to his death when the sun melted the wax on his wings . . . we wait to see if this time he will make it with computer chips and a bit of luck, in this greatest adventure story in the history of video."[1] The resulting art event, eventually funded through the collective efforts of television stations from a dozen countries, was retitled *Wrap Around the World*, and it differed significantly from Paik's original plan. Combining the pop music of David Bowie with the avant-garde piano work of Ryuichi Sakamoto, traditional Japanese Buhto dancers with Merce Cunningham's choreography, and Brazilian carnival with a car race from Ireland — all filtered through Paik's real-time video image processing — *Wrap Around the World*'s transmission mixed together cultures, artistic practices, and national identities in an effort to find a way to unite the world through media. The unpublished proposal nevertheless gives us additional insight into Paik's career-long insistence on developing new ways to think across media — in the moment, over centuries, and into the future — as well as into the ways he continually refined and repurposed his ideas as he brought them to fruition.

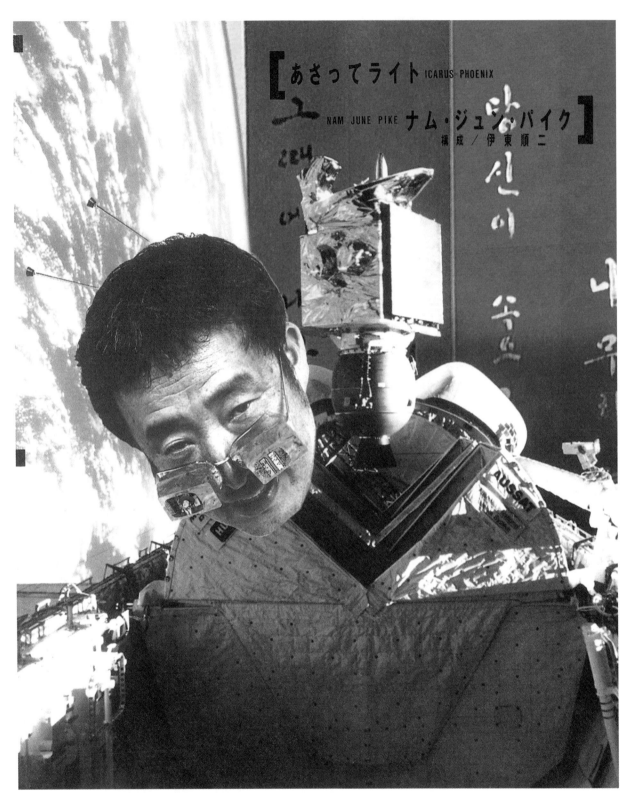

Front cover to *Icarus=Phoenix* (Tokyo: Parco, 1988). Collection of Peter Wenzel.

Paik has been variously characterized as "mischievous," a "jester," a "prankster." Collaborators and critics alike pronounced his methods and aesthetic "chaotic." Chance and indeterminacy were indeed crucial elements of both his practice and his conception of his art. But reading Paik's writings alongside his three satellite projects from the 1980s, *Good Morning, Mr. Orwell* (1984), *Bye Bye Kipling* (1986), and *Wrap Around the World* (1988), we begin to see that, actually, Paik was a planner – and a painstaking one at that. The proposals for his single-channel works and satellite broadcasts included in this volume illustrate the ways in which he thought through media in a nearly compulsive manner, as enumerated lists.[2] What emerges from reading these proposals is not a sense of chaos but rather of programmatic rigor, something rarely associated with this artist. The editors hope that the publication of these works will aid in a critical reassessment of Paik's process in relation to his output.

Both in his art and in his writing, Paik was a messy Hegelian – he adored the dialectic of binaries and oppositions, but he was less interested in cleanly synthesizing those elements into a coherent whole. Rather than articulate tidy resolutions, he favored presenting juxtapositions and letting viewers wrestle with the resulting cognitive variances and convergences. This volume offers an opportunity to explore the myriad dichotomies and convergences within Paik's oeuvre.

The concept of participation – by his readers, viewers, and collaborators – is central to understanding Paik's aesthetics and methods. Paik had a longstanding interest in satellite technology as a means for expanding the possibilities of both communication and televisual art. In 1977, he took part in the Documenta 6 satellite telecast from Kassel, Germany. The art festival broadcast a transmission orchestrated by artist and critic Douglas Davis and beamed performances by Paik and Charlotte Moorman, Josef Beuys and Davis to twenty-five different countries. In one section of *Bye Bye Kipling*, Davis pounds on a layered, mise-en-abyme image of himself knocking his fist against the television, exhorting viewers at home to "come on over to the television screen. This is collaborative television. Knock on the screen . . . the whole world can hear you."[3] Together/alone: the domestic television viewer was now reaching out and grasping the idea of a networked communication community. Though relatively new in art world practice, the utopian promise of satellite technology linking up the world's nations had already entered the wider culture, and on the largest possible stage. The first international satellite broadcast, *Our World*, had aired on June 25, 1967, featuring segments on Picasso, Marshall McLuhan, the construction of the Tokyo subway, and the Beatles premiering their new song "All You Need Is Love." The show was watched by an estimated 500 million people. Paik's innovation was to filter *Our World*'s universally minded sensibility and didacticism into a work that both self-identified as and was received as art. Populist, sporadically entertaining, and spectacular art, yes, but art just the same. In other words: Paik wanted to produce art as television, rather than make television about art.

That he often changed his mind about how best to do so is not surprising. As the June 3, 1988, proposal for *Space Rainbow* concludes, "This Script is Not Final, and is Subject to Changes."[4] Indeed, few elements of Paik's work were ever "final" – he often reused,

recycled, and remixed existing pieces in the creation of a self-aware media ecology, cultivating a kind of self-referential bricolage of that type that now dominates our contemporary media environment of message-board GIFs, selfies, and remixed audio and video online. One need only notice how the typewritten passages pertaining to *Space Rainbow* are crossed out and rewritten by hand in order to realize how Paik understood his work as being in perpetually in flux. In Part 4 of the program, for example, Icarus was to find a perch in the center of London. Paik scribbles a line through "London" and replaces it with "Korea." He notes that his proposed "Trans-Atlantic Picture Phone Drama" should "be written by a talented writer," who will provide the details for a story culminating in a "tele-kiss" between New York and London (or Hamburg); he proceeds to sketch out the camera compositions for the play, rotating the final shot ninety degrees. Still other parts are reordered, scratched out, and rewritten.

What strikes the reader of these documents is the tension between the linear and programmatic nature of Paik's plans and the ways that he used the myriad affordances of video technologies in the programs. Compositing, keying, editing, and superimposing images both on the fly and in the editing suite after the programs aired, Paik undid his careful designs, finding new pictures and new formal and thematic relationships in the process. That he did so in the context of a global milieu in which, for instance, "London" could be replaced with "Korea" in the blink of an eye underscores how utility and flexibility shaped Paik's outlook on his art. The idea that countries, not individuals, would be conjoined in affection further accentuates Paik's holistically utopian world view.

At first glance, *Kipling* appears to be a messy farrago of hasty ideas and shoehorned acts, though it achieves moments of astonishing synchronicity, such as in what is billed as the "first live satellite jam session" between percussionist David Van Teighem playing in New York and Samul Nori bleating free jazz trumpet in Tokyo. Such revelations were balanced by hoary sight gags, such as host Dick Cavett and Sakamoto clinking beer steins across space-time on a split screen. Technical glitches and failures occurred throughout. At one point, Cavett accidentally hot mic'ed his way out of a gaffe-filled interview, saying "Walk off? Go to hell, I can't find where I'm going . . . they tell me the voiceover's cut" as he wandered off camera. Many segments were linked together with prerecorded flashes of Paik's kinetic video synthesis – bursts of shifting color patterns and video matting. The resulting program represents an attempt to lay out an overarching consideration of the human condition, from the local to the global, from the intimate to the universal, from slapstick to the sublime, and from the physical to the spectral.

And yet many things changed between Paik's proposals for his broadcasts, which were written not only as part of his artistic process but also as a means of soliciting participants and funding, and their realization. Take, for example, item number ten on one of his several proposals for *Kipling*: "Satellite twin performance by Richard Kriesche."[5] It is unclear whether Paik indicates a recording or a new iteration of the artist's 1977 video piece in which twin girls, sitting in identical rooms, read passages from Walter Benjamin's "The Work of Art in the Age of Mechanical Reproduction." (In the original work, each room also had a live TV image of the other sister reading at the same time.) Though Paik

may have been eager to incorporate the work of his fellow video innovator Kriesche, the piece doesn't appear in the final version of *Kipling* – just as it did not appear in *Orwell*, though Paik proposed something similar in his initial script for that broadcast. The *Kipling* broadcast did feature another "twin performance," as artists (and identical twins) Ellen and Lynda Kahn, dressed in matching outfits as Tokyo Rose – the sobriquet of a World War II-era Japanese propagandist – deliver, yes, a rose, between New York and Tokyo in a manner that makes it seem as if a single woman had teleported between the two cities. The brief sequence is far more electronic vaudeville than Kriesche's Frankfurt School-derived critique, but it demonstrates the ways Paik manages to fold a literal image of what he expressed as a "vision of twoness" into a live moment that simultaneously references the history of animosity between the United States and Japan while visualizing their rapprochement.[6]

However off-the-cuff the rose pass might seem, we see in this exchange a glimmer of how Paik imagined telecommunications might be capable of circumventing the rules of space and time. Satellites, Paik argued, would allow us to roam the earth from our couches and easy chairs, "learning how to shorten distances by shrinking the earth, that is, how to transcend the law of gravity."[7] Born from his life and work, this globetrotting sensibility shapes his writings as well, in which Paik hopscotches between far-flung locations from paragraph to paragraph or even within the span of a single sentence, as when he writes in a tentative script for *Kipling*: "Japanese host throws ball across the ocean to New York."[8]

Paik's satellite work did not aim at a facile universality, but rather meant to mediate a robust plurality, opening cultural windows through which different faces, customs, and art could be seen. If the messy, glitchier aspects of the satellite productions illustrate how his reach at times exceeded his grasp, his attempts to introduce people to one another, whether those people were artists on opposite sides of the globe, viewers in their homes, or (in the case of *Kipling*) the live audiences packed into New York's 4D nightclub and a Tokyo shopping plaza, stem in part from his own complicated relationship with his Korean heritage and his cultural standing as an international figure.

Paik faced criticism from the Korean press for *Bye Bye Kipling* and was accused of having unduly favored the program's contributions from the United States and Japan. Paik's writing grants insight into his negotiation of his status as a "cultural nomad" (to use the title of Edith Decker-Phillips's German-language anthology that helped inspire this volume) and of his Korean identity. That negotiation apparently began at an early age. Paik recalled having been raised "under the domination of Japanese media," while he was also under the sway of American popular culture "such that Shirley Temple's name was the first name registered and detained in my child-brain, even before the names of my father, or Syngman Rhee or Prince Konoye."[9] These were not benign observations. Paik's remarks here emanate from his essay on the American oil crisis of the 1970s, in which he proposes information itself as an alternative form of energy. His prescient take on an "information economy" that would eventually swell the coffers of Silicon Valley startups developed from a cultural pivot he observed as a kindergartener

in Seoul. "In 1940," he writes, "the sweet picture of Miss Temple was replaced by a symbolic slogan, which soon ceased to by [sic] symbolic - 'One Drop of Gasoline is One Drop of Blood'" – thereby marking the start of what he dubbed "The First Oil War," which took place between Korea and Japan.[10] Pop culture yielding to politics: Paik's writings demonstrate that his study of long histories – musical, dynastic, political – informed his thoughts on entertainment as a conduit for ideology, and his vacillations between an aesthetics of boredom designed to counteract culture industry spectacle and a whole-sale engagement in the same.

Paik had a complex relationship with his birthplace and often mentioned that Korea lagged behind more technologically savvy nations, referring to himself as "a simple boy from a backward country."[11] Similarly, when he included sights and sounds of Korean culture in his work, they were often redolent of the past, whether it was a traditional dancer in *Global Groove* (1973) or Skip Blumberg's reportage on contemporary Korea incorporated into the mix of *Bye Bye Kipling*, work not even undertaken by Paik himself. Studying music in Germany, Paik seemed resigned to the impossibility of Korean genius, writing, "As a student from 'under-developed' Korea, I did not have any hope or illusion of making a career (?), positive or negative, in Germany. I had thought that a few geniuses were fallen from the heaven by some unseen Creator, and they should be either German or French, not even English or Swedish."[12] Even as he was hailed as a hero in his homeland – Carol Brandenberg, who produced the satellite pieces, recalls Paik being received as a "huge celebrity," in Korea, and mentions that she and Paik dined with the mayor of Seoul when they were planning *Kipling*[13] – the artist seemed to revel in positioning his work between East and West, so that "Cage and Korean pottery," for example, could become a subset of a late-1960s proposal regarding "Comparative Aesthetics,"[14] or Joseph Beuys's numinous practice could be linked to Mongolian and Korean shamanism.[15] What we now call Paik's "aesthetics of boredom," itself an appropriation of Zen Buddhism and a reaction to mass media entertainment, typified by such iconic works as *TV Buddha* (1974), *Zen for TV* (1963), and *Zen for Film* (1962–1964), has roots in court music in Japan and Korea, as he wrote in "Binghamton Letter" (1972).[16]

Similarly, we see in Paik's writings an intense appreciation for philosophy, as well as a predilection for mixing concepts and aesthetics from Eastern and Western schools of thought. His written texts engaged, in equal measure, the intellectual contributions of Plato, St. Augustine, and Spinoza and the wisdom of ancient Chinese philosophers such as Han Fei (see this volume's section of "China Texts").[17] In a long, wide-ranging treatise on cybernetics, politics, and comics, Paik wrote, "As is well-known, Indeterminism is the atomic core of the 20th Century, cutting through Physics (Heisenberg), Philosophy (Sartre), Aesthetics (Cage), Mathematics (Cantor), Warfare (Guerrilla tactics), and politics (Nehru), and needless to say playing a dominant role in the information theory."[18] *Bye Bye Kipling* sought to instantiate this bridging of practices and cultures by bidding its titular figure adieu, as well as his famous poetic summary of cultural diametric opposition: "Oh, East is East and West is West and never the twain shall meet." Nothing could be further from the truth for Paik, who expressly contextualized *Good*

Morning, Mr. Orwell in terms of the ideas of French mathematician and theoretical physicist Henri Poincaré regarding the discovery of "new RELATIONSHIPS between things already existing," as well as with regard to the popular fictional Japanese figure Sarutobi Sasuke, a ninja with the ability to conquer space and time.[19]

His associative thinking and appreciation for deep historical exegeses extended from national narratives to art world ones. In the essay "DNA is not racism," he muses on the value of speculative fiction as a means of rethinking both the past and the present. His idea of "negative science fiction" is deployed in order to rethink historical relationships between East and West, as when he imagines an encounter between the Scythians, a group of Eurasian nomads, and Koreans that results in the production of mutually informing art—a thought experiment that provides him a jumping-off point to muse on the nature of video within the art market.[20] "I enjoy the speculating business into the deep past, before the invention of private property system . . . yes, our video art is a communal communistic property, easy to share but hard to monopolize . . . therefore hard to live within the art world system, which thrive on the-one-of-the-kind exclusiveness."[21] The satellite pieces, more than any single-channel works, further challenged the economic vagaries of the art world; their one-off nature, coupled with their free transmission via public television, ensured they would have neither scarcity nor exclusivity. The satellite broadcasts were also the primary site of Paik's valorization of "onceness," the unique, one-off quality that gave the broadcasts their performative frisson and coincided with the idea of "twoness" mentioned above, a summation of his goals for recasting television from a unidirectional broadcast into a technology of two-way communication that fostered a back-and-forth dialogue between cultures and nations. Paik utilizes the distinctive material characteristics of his chosen media even as he rethinks their purpose and function, so that the liveness of television differentiates it from film's playback, but the satellite hookup's capacity to encourage participants to talk back to one another differentiates the satellite pieces from most television outside of news—satellite's immediacy functions best as a two-way encounter, where life is shared instead of merely observed.

When Paik wrote about regarding the "mystery of being once only," it was not merely an example of attention-seeking hucksterism designed to boost a program's audience share, nor was it simply a rebuke of the emergent time-shifting viewing habits informing videotape culture. Rather, in his seeking an aesthetic experience that cannot be replicated, we see the outgrowth and extension of Paik's Fluxus "action music" pieces of the early 1960s transposed to the realm of the satellite broadcast. As he famously stated, "There is no rewind button on the BETAMAX of life. An important event takes place only once."[22] Paik is here attempting to imbue video art—which, like a sitcom or soap opera, carries the potential to be rerun countless times—with the immediacy and vibrancy (or tedium) of everyday life.

Indeed, the idea of ephemeral video, for Paik, carried well-nigh spiritual connotations. The singular broadcast event, he wrote in 1985, was the "HIGHEST art-form humankind has invented. As the *miracle* is the cornerstone of every major religion in

the world, *onceness* constitutes the very motor of human history. . . . Through LIVE video art, we are finally able to deal very concretely with the central problems of human existence (chance, hazard, bet, venture). Pascal and Sartre would be very jealous of video artists!!!"[23] Endeavoring to capture – and subsequently release – the caprices of human indeterminacy on video became a loftier goal than any possible outcome as art or entertainment.

The singular event, as embodied by the satellite broadcast, also contained an idea central to Paik's understanding of the technology of video, that of two-way communication. Well before the advent of Skype or Facebook Messenger, Paik saw simultaneity and response as potential hallmarks of repurposed television. In the proposal for *Chip Olympics* (yet another working title for what became *Wrap Around the World*), he wrote, "We will transcend the traditional contradiction of LIVE and CANNED, and instead introduce the new concept of IN SYNC," thereby expanding tropes found in the 1920s "city symphony" films of Walter Ruttmann and Dziga Vertov, which attempted to tie together the rhythm of urban life as a cause and uniting effect in the lives of its citizens.[24] Paik wanted to push this notion of mediated togetherness, in which media technology such as the satellite both facilitates and eradicates the mediated act of communication between two or more people. These linkages provide a means of ensuring that artworks such as the satellite broadcast remain outside the economic orbits of either broadcast television or the art market. As Paik wrote, "two-way communication does not easily interface itself to the capitalistic system, which must always pinpoint a buyer and a seller."[25] That the guiding principles of media transmission could be empathy and expression rather than control or profit is a guiding principle of Paik's exploration of technical communication.[26]

Paik thought that bringing people together through video might produce new ways of creating art, as when Sakamoto and Merce Cunningham performed their "Transpacific Duet" in *Wrap Around the World*. Implicit in this extensive telecollaboration is the idea of people working together to create something beautifully polyvalent, an artwork that can be understood as a dialogue between thinkers pursuing a similar goal of reciprocal representation and exchange. Paik, who expressed a repeated desire to set up two-way television displays in Times Square and Red Square in order to thaw Cold War tensions, wanted to extend this partnership to his audience. In "With the U.S.S.R (LIVE),"

CHIP OLYMPICS

My first show for WNET/TV Lab was called GLOBAL GROOVE (1972-1974). Since then I systematically explored the path for global tv......Germany-New York Live TV (1977 with Joseph Beuys), Rockefeller Foundation's Visa Series (eight shows), Paris-New York Satellite TV (1984) and New York-Tokyo-Seoul link-up (1986). I feel now it's time to wrap around the world by synthesizing the valuable experience which was gained in the past fifteen years of experiment.

Saturday 10am (N.Y.) is a magic time. It is the only time which can be shared by the whole world in sync.
 Los Angeles 7am London 3pm Paris/Bonn 4pm
 Athens/Jerusalem/Cairo 5pm Moscow 6pm India 8pm
 Peking 10pm Seoul 11pm Tokyo midnight

We will transcend the traditional contradiction of LIVE vs. CANNED, and instead introduce the new concept of IN SYNC, in which a number of nations are telecasting a show with the same theme - in this case art,sports and global networking - and, having exchanged videotaped materials in advance and edited them according to their needs and preferences, they will still make a live interconnection frequently so that they can keep the two-way -ness of High Tech TV and an anti-parachute kind of information flow. In this way, since we are not billed as a LIVE show, we don't have the pressure of doing everything live...sufficiently relying on the well-edited material, we can switch on to the live TV whenever it becomes necessary. It is a technically and financially much more sensible way than the purely LIVE shows that I did in the past.

The upcoming Seoul Olympics to which the Soviet Union and China have officially announced their participation is an excellent opportunity to advance in this direction. So far all preliminary talks I held with VIP's in other countries - Japan, France, Greece, Spain, Bolivia, Yugoslavia, needless to say Korea, are very positive because the spirit of Olympiad is still alive and this spirit is stronger the smaller their country is. Therefore we can get the collaboration from many countries more easily on the occasion of Olympics, overcoming this century-old enmity or scepticism among different peoples.

Show date is Saturday the 10th of September or Saturday the 3rd of September. New York time: 10am. 90-120' show. (one or two weeks before the start of the Seoul Olympics.

--
Each station around the world will have complete freedom in gestalting its own show from the three time flows as below. Symbolically speaking, the key station and I are just a supermarket with a lot of ingredients. Each station is like a

Nam June Paik, *Chip Olympics* script, 1988, first page. Vintage photocopy of typescript with additions in ink (5 pages), 11 × 8½ in. Smithsonian American Art Museum, Nam June Paik Archive (Box 9, Folder 1); Gift of the Nam June Paik Estate.

enumerated as item number nine in the script for *Space Rainbow*, children, teenagers, babies, and dogs from the Soviet Union and the United States were intended to mirror and respond to one another through the satellite link. Paik also proposed showcasing a wedding in Moscow that would be simulcast with a wedding taking place in New York, and combining footage of Soviet athletes arriving in Seoul with interviews with "their families and teachers in Moscow."[27] These examples would eschew celebrity and experimentation in favor of the quotidian and familiar, providing down-to-earth footage that was nevertheless transmitted from space. For Paik, representing the contextualized other as normal — or even mundane — could do significant work toward erasing global fear and suspicion.

A (somewhat poor) speaker of five languages, Paik wanted to use television as a kind of "electronic Esperanto" that would be able to transmit meaning universally, a dream of the original avant-garde brought to bear on the electronic age. "Better communication among peoples is so much more important than putting men on the moon," he said in 1968. "The space effort is self-deceptive, like heroin. It changes nothing for us."[28] Paik believed that the artist played a primary role in fostering communication by humanizing technology, transforming it to allow for easier use and applicability.[29] Two-or-more-way televisual communication, he argued, would spur unexpected meetings of people and connections, which, taken together, "will enrich the synapse between the brain cells of mankind."[30] Paik even mused that it might foster geopolitical change. Writing in the context of rising Cold War tensions during the first Reagan administration, Paik offered home-grown pop culture as a powerful means of capturing the hearts and minds of the so-called Evil Empire: "I think that when we get satellite dishes that are so small that they can be hidden and we can watch American TV worldwide, then the Soviet Union will collapse in ten years."[31] Ironically, Paik's interest in rethinking broadcasting was partially inspired by, and a pithy response to, a foundational tenant of communism: "Marx: Seize the production-medium! Fluxus: Seize the distribution-medium!" — an information-age realization that what is made is less important than how it is received.[32] This medium-is-the-message sensibility is mirrored in his 1993 essay "Venice — Turtleship — a Trial Of Mr. Picasso . . ." in which he imagines leaving, in his will, the money to fund a weekly satellite video art program that will run for 40 years, "until everybody on Earth is conditioned to tune in to the video art program offered on their local cable channel every week Friday at 8pm."[33] Over decades, the continuous satellite broadcasting of video art will help transform the pop culture viewer into an art lover, and vice versa.

Though his work has been criticized as purveying an unreflective techno-utopianism, Paik's writings point to a considered idea about the reorienting of broadcast media into a communication platform, one that would recast the purpose of satellite television altogether. Paik thought that video and television could simultaneously provide entertainment and serve as a booster of democratic process. Such thought, rooted in his favored concept of participation, was evident in earlier interactive works such as *TV Crown* (1965/1999), *Tango Electronique* (1965), and *Participation TV* (1963/1998), which invited art viewers to become art producers as they took control of the televisual

controls provided by Paik, helping establish a model for participatory engagement with and through media. For Paik, this televisual exchange of information – what he called "the main nonmaterial product of post-industrial society"[34] – held the potential not only to change the nature of communication, but to help develop new pathways toward participatory democracy. In the Museum of Modern Art's 1968 catalogue *The Machine as Seen at the End of the Mechanical Age*, he wrote that "'electronic democracy through instant referendum' (John Cage). . . . is by far ignored or delicately suppressed."[35] Elsewhere he averred, "if we could assemble a weekly television festival comprised of music and dance from every nation and disseminate it freely via the proposed Video Common Market to the world, its effects on education and entertainment would be phenomenal. Peace can be as exciting as a John Wayne war movie. The tired slogan of 'world peace' will again become fresh and marketable."[36] Learning from other cultures, he thought, would be an infectious source for understanding, and subsequently for fostering peace.

Paik's satellite proposals reinforce this idea of not only exhibiting cultures to one another, but combining them in dramatic fashion in order to produce new modes of electronic empathy, as when he planned a "WHOLE EARTH SYMPhony" in the *Space Rainbow* proposal, envisioning taped performances from the Japanese countryside blending with live feeds of pop music in Tokyo, while a rock show is transmitted from Freud's home in Vienna.[37] Or take the example of his imagined "wedding of the Statue of Liberty with the Statue of Columbus in Barcelona, 500th anniversary of discovery," which Paik immediately pairs with the sentiment: "How can you 'discover' a land which is inhabited by 5 million Indians," a quote from African-American comedian and social critic Dick Gregory, which deflates the colonist grandeur implied by this meeting of memorials.[38]

And yet Paik was also aware of the power dynamics that result from digital divides, and he warned of potential imbalances, writing, "The satellite's amplification of the freedom of the strong must be accompanied by the protection of the culture of the weak or by the creation of a diverse software skillfully bringing to life the qualitative differences in various cultures."[39] He added: "As long as the absorption of a different culture makes up the greater part of the pleasure of tourism, the satellite may be able to make every day a sight-seeing trip. So, Sarutobi Sasuke not only embodies the origins of cosmic aesthetics but also the ethnic romanticism that must always be the companion of satellite art."[40] The power to send people traveling between spaces – a phenomenon described by Sasuke as supernatural and by Walter Benjamin as a psychological response to the moving image – is touristic in nature and informed by power dynamics, however consciously or unconsciously.

Paik was also keenly aware of his foibles and misfires, as when he wrote in the proposal for *Chip Olympics* that he would try for another "Trans-atlantic duet: Amsterdam-New Amsterdam (half-success 'Bye Bye Kipling . . . this time better prepared')."[41] Certainly, later in his career, his vision of the satellite experiments was limpidly self-deprecating, even going so far as to say that *Kipling* was the "first car accident in the E-highway."[42] Nor did he think it would be the last. In "Rendez-vous Celeste" (1988), he

wrote, "Needless to say, High Tech is not a panacea. It is just a local anesthetic. There well be many unforeseen problems ahead."[43] Paik made use of happy accidents and turned glitches into aesthetic "choices" (e.g., *Zen for TV*), and his writings help broaden our understanding of how he anticipated and designed for imperfection in the satellite works. A tentative script for *Bye Bye Kipling* bears a notable postscript – one surely open to interpretation and variable in its implementation: "Add FAKE MISTAKE (control room confusion) somewhere."[44]

NOTES

1 Nam June Paik, "*Space Rainbow*," June 3, 1988, Smithsonian American Art Museum, Nam June Paik Archive (Box 9, Folder 6).

2 See John Hanhardt's introduction to this volume for more on Paik's writing style.

3 Nam June Paik, *Bye Bye Kipling* (single-channel video, edited version), Electronic Arts Intermix, 1986.

4 Nam June Paik, "*Chip Olympics*," June 3, 1988, Smithsonian American Art Museum, Nam June Paik Archive (Box 9, Folder 6).

5 Nam June Paik, "Proposal for *Bye Bye Kipling*," January 5, 1986, Smithsonian American Art Museum, Nam June Paik Archive (Box 8, Folder 14); reprinted in this volume.

6 See Robert Barr, "Two Tries at Linking the World on PBS," Associated Press, October 3, 1986.

7 Nam June Paik, "Art & Satellite," in *The Luminous Image*, ed. Dorine Mignot (Amsterdam: Stedelijk Museum, 1984), 67; reprinted in this volume. The passage also appears in *Nam June Paik—Mostly Video*, exhibition catalogue, trans. Yumiko Yamazaki (Tokyo: Tokyo Metropolitan Art Museum, 1984); and in Nam June Paik, "La Vie, Satellites, One meeting – One life," in *Video Culture*, ed. John Hanhardt (Rochester, NY: Visual Studies Workshop Press, 1986).

8 Nam June Paik, "Tentative Script," May 11, 1986, 3, Smithsonian American Art Museum, Nam June Paik Archive (Box 8, Folder 13).

9 Nam June Paik, "The First Oil War (1941-45)," first draft, unpublished typescript, 1979, Box 944, Folder 6350, Record Group 1.7, Series 200R, Paik, Nam June 1977–1981, Rockefeller Archive Center, SUNY Stony Brook; reprinted in this volume.

10 Ibid.

11 Nam June Paik, "DNA is not racism," in *Jos Decock: dessins et aquarelles* (Paris: Château de Nemours, 1988); reprinted in this volume.

12 Nam June Paik, "I Lived only one year in Munich," in Josef Anton Riedl, ed., *Neue Musik, Sondernummer zum Kunstprogramm der Olympischen Spiele* (Munich: Druckerei Holzinger, 1972), 58; reprinted in this volume.

13 Carol Brandenburg, "Nam June Paik and Me," April 2014, available at https://americanart.si.edu/research/paik/resources/brandenburg

14 Nam June Paik, "Comparative Aesthetics – cybernetics of arts," n.d., box 423, folder 3648, Record Group 1-2, series 200R, Paik, Nam June 1967–68, Rockefeller Archive Center, SUNY Stony Brook; reprinted in this volume.

15 Nam June Paik, "Spirit-Media-Kut," in *A Pas de Loup de Seoul a Budapest* (Seoul: Galerie Hyundai/Galerie-Seoul, 1991), 46; reprinted in this volume.

16 Nam June Paik, "Binghamton Letter," January 8, 1972, Smithsonian American Art Museum, Nam June Paik Archive (Box 7, Folder 9); reprinted in this volume.

17 "Nam June Paik," in *Vision and Television*, ed. Russell Connor (Waltham, MA: Rose Art Museum, Brandeis University, 1970), n.p.

18 Nam June Paik, from an untitled essay, n.d., page 24, Smithsonian American Art Museum, Nam June Paik Archive (Box 14, Folder 27).

19 Paik, "Art & Satellite," 67; reprinted in this volume.

20 "In any case, in order not to become again the pseudo-scientific racism, we must find a new genre of litterature called the negative science fiction which deals with distant past as the science fiction deals with the distant future . . . and with the same techniques, that is: the free combination of proven knowledge, speculated wisdom, pure fantasia . . . and rich mixture of inventiveness without responsibility." Nam June Paik, "DNA is not racism," reprinted in this volume.

21 Ibid.

22 Paik, "Art & Satellite," 68; reprinted in this volume.

23 Nam June Paik, "Context Is Content . . . Content Is Context," *Send*, no. 10 (Spring 1985): 27; reprinted in this volume.

24 Nam June Paik, "*Chip Olympics*," n.d., Smithsonian American Art Museum, Nam June Paik Archive (Box 9, Folder 1); reprinted in this volume.

25 Paik, "Proposal for *Bye Bye Kipling*," reprinted in this volume.

26 Paik was hardly alone in this challenging of broadcasting norms, and he insisted on recognizing the contributions of his collaborators and predecessors. In the first script for *Good Morning Mr. Orwell*, Paik discusses adapting a two-way communication piece by Kit Galloway and Sherrie Rabinowitz, and notes that the artists who conceived and realized this work (Galloway and Rabinowitz along with Shirley Clarke, Wendy Clarke, and Richard Kriesche) "should be credited through the character-generator DURING the performance not as a part of end-credit." Nam June Paik, undated typescript, c. 1983, Smithsonian American Art Museum, Nam June Paik Archive (Box 8, Folder 7); reprinted in this volume. Originally published in *Art for More than 25 Million People . . .* (Berlin: DAADgalerie, 1984), n.p.

27 Paik, "*Space Rainbow*," 5.

28 Grace Glueck, "Art Notes: The World Is So Boring," *New York Times*, May 5, 1968, D31.

29 Calvin Tomkins, "Profiles: Video Visionary," *New Yorker*, May 5, 1975, 76–77.

30 Paik, "Art & Satellite," 67; reprinted in this volume.

31 Willoughby Sharp, "'Artificial Metabolism': An Exclusive Interview with Nam June Paik," *Video 80*, no. 4 (Spring 1982): 17.

32 Nam June Paik, unititled and undated manuscript, Series VII, Folder A.602, Fluxus Collection, The Museum of Modern Art.

33 Nam June Paik, "Venice – Turtleship – a Trial Of Mr. Picasso . . . ," in *Feed back and Feedforth* (Tokyo: Watari Museum of Contemporary Art, 1993); reprinted in this volume.

34 Paik, "Art & Satellite," 69; reprinted in this volume.

35 Nam June Paik, 1968–1970 essay written for the exhibition "The Machine as Seen at the End of the Mechanical Age" at the Museum of Modern Art, expanded for *Nam June Paik: Videa 'n' Videology 1959–1973*, ed. Judson Rosebush (Syracuse, NY: Everson Museum of Art, 1974); reprinted in this volume.

36 Nam June Paik, "Global Groove and Video Common Market," 1970, published in Rosebush, *Nam June Paik 1959–1973*; reprinted in this volume.

37 Paik, "*Space Rainbow*."

38 Ibid.

39 Paik, "Art & Satellite," 71; reprinted in this volume.

40 Ibid.

41 Nam June Paik, "*Chip Olympics*," June 3, 1988, Smithsonian American Art Museum, Nam June Paik Archive (Box 9, Folder 6).

42 Nam June Paik, "Rendez-vous Celeste," 1988, Smithsonian American Art Museum, Nam June Paik Archive (Box 14, Folder 22); reprinted in this volume.

43 Ibid.

44 Paik, "Tentative Script," 5.

Transforming Video and Television: Media Art Practices

This section, like the first, is divided into two mutually informing parts: "speculative writings" and "scripts and plans." This dialectical organization is in keeping with Paik's general approach to media art – one shaped by his study of Hegel at the University of Munich. This chapter shows him at his creative peak as his ideas gathered momentum, focusing on video and television art after he moved to the United States in 1964 and settled in Manhattan. Emboldened by his experiences in Europe as a member of Fluxus, Paik embraced his now home, which provided a platform for his emergence as an international artist. He expanded his practice to include broadcast television as well as video, utilizing television networks, satellite transmissions, installation art, single-channel video, and performance art practices, as well as the development of an image processor. His writings in this section articulate a host of theoretical considerations regarding the way these investigations into media would impact the worlds of art, education, business, diplomacy, and politics.

Paik worked tirelessly to advance video as a contemporary artist's medium. A utopian thinker grounded in the classics and versed in the avant-garde, he explored new media while remaining tied to aesthetic and conceptual strategies – chance, improvisation, the absorption of the found object, indeterminacy, and participation – that emerged from the radical art movements of the 1960s. Paik loved the moment of change and valued shifting perspectives. From his SoHo neighborhood to the stage of a satellite transmission, Paik's intensely humanistic inquiry into art could inform, entertain, and lift the human spirit. His efforts to do so were supported by institutions such as the Rockefeller Foundation and the Television Lab at WNET, and sustained by collaborations with Shuya Abe, Allan Kaprow, and Allen Ginsberg, among others. Reading these texts further cements Paik's historical importance and his role as a visionary thinker. It is our hope that by looking back at his prescient forecasting of our present, readers will be inspired to pursue new avenues for engaging and transforming the continually changing media ecology of the twenty-first century.

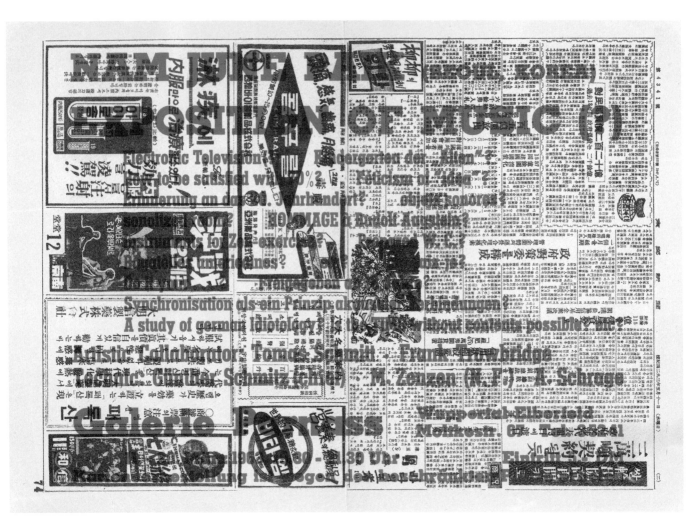

Poster for "Exposition of Music–Electronic Television," Paik's first solo exhibition, at Galerie Parnass, Wuppertal, March 11–20, 1963. From the collection of Peter Wenzel.

A: SPECULATIVE WRITINGS

Exposition of Music (1963)

It is known that Prof. K.O. Goetz is publishing on kinetic painting and programming of electronic television. My interest in television has substantially been prompted by him. I thank him for that with great respect. As well, I would like to mention Vostell's idea (Décollage-Television) and the efforts of Knud Wiggen (my "competitor" regarding the "music-machine") to build an electronic studio in Stockholm.

K.O. Goetz once said: I have done many experiments with [Braun's vacuum tubes] in Norway (17 years ago). It created marvelous images. But unfortunately one can neither control nor determine it. DETERMINE!... this word hit me like lighting. Yes—then it must be the most suitable means to tackle with indeterminism (the central problem in ethics and aesthetics of today, perhaps in physics and economy too (see the recent polemics between Erhard and Hallstein)). The basic concept of my television experiments lies in this. Similar to K.O. Goetz, who already in 1959 came to the conclusion that an electronic image which is to be created productively (not reproductively) has to be defined in a way as non-deterministic. Although Goetz thinks inductively and I together with Vostell think deductively, one can say that electronic television is not a mere application and expansion of electronic music to the field of optics but it remains in contrast to electronic music (at least in its first stage), which shows a fixed, determined tendency in its serial method of composition as well as in its ontological form (recorded audio tape destined for repetition). Naturally such stylistic quality has to do neither with a high or low valuation of single pieces (if there is anything like that outside of art auctions), nor does it concern the still young future of electronic music (as was demonstrated again at the last "Music of this Time" concert in Cologne).

I have not only expanded the material to be treated from 20 kilocycle to 4 megacycle but have rather used the physical quality of the electron (indeterminism, its double character as particle and wave). The smallest unit human intelligence can think and prove at present is a nice slap in the face of the classic dualism in philosophy since Plato... essence AND appearance, essentia AND existentia. But with the electron... existence IS essence. (Interesting parallel to Sartre's speculations about human freedom.)

To determine electronic movement is a contradiction in itself. You can for instance build a sine-tone generator for only 10 DM—if you want to put a precise scale to it, that is, to determine its frequencies (there is no absolute "precise" in technology and hardly in physics), you need more than 10,000 DM. Apart from this natural instability we have another dimension of indeterminism of the electron; it is live broadcast of television, radio, police radio, amateur radio, coffee machines, electric drill, pirate radio station, propaganda radio station, taxi radio, SOS radio, spy radio and so on, up to the transmissions of satellites. The electron is everywhere. The passing of a car already causes a new movement and constellation.

*

There are—roughly speaking—two or two and a half types of NOTHINGNESS:
1. a) the absurd being cast into this world of human existence (factuality).
"Why are you killing me?"
"Because you live on the bank across the river."
(Pascal on judiciary; law and justice.)

Any justice in international law and any boundary dispute refer to this "fragility."

b) "Nothingness" as dialectic element in the leap to freedom, to the belief in god, to the act of revolution and/or to rape and execution... favorite motive of Sartre—Camus... etc.

The nothingness a) b) is humanistic, dynamic, appassionato, often cruel. (My activity so far (Action music etc.) belongs rather (perhaps) in this category.)

2. Other kinds of nothingness are static, cosmological, trans-humanistic, ontological... etc.

Nothingness as completeness = prehistoric chaos (Lao-Tse, Chen Chu)—trans-humanistic mystery ("thing as such" with Kant)—

Nothingness as primary subject in metaphysics as question of being (Heidegger)—

out of sight of the Palomar telescope—optimistic nature worship of Montaigne—Cage (it is strange that nobody has written about the stunning similarity between Cage and Montaigne)

e.g.

"A philosopher plays with the cat.

Does the philosopher play with the cat?

or

Does the cat play with the philosopher?"

 (Montaigne)

"I dreamt/dreamed that I became a butterfly. Am I the dreaming butterfly that thinks it is a human?

or

Am I the dreaming human who thinks he is a butterfly?

 (Cage—Chen-Chu)

Cosmic boredom—

Harmony quasi chaos—

Chaos quasi harmony—

My new Work (Exposition of Music—Electronic Television) is closer to the latter kind of NOTHING-NESS. Perhaps one can deduce the dimension of depth by it which can be felt but hardly proven.

try it

In the beginning it will (probably) be interesting—later it becomes boring—

continue!

it becomes (probably) interesting again—

then it becomes boring again—

continue!

it becomes (probably) interesting again—

then it becomes boring again—

continue!

... ...

... ...

... ...

If this wave (one of the most common phenomena in the physical, biological, human world) accumulates, then you reach maybe beyond the beautiful and the not beautiful.

Whether I can convince you or not—

If one is allowed to convince others in these things at all or not (there is no borderline between convincing and forcing) is a different question. Anyway, together with Dick Higgins I like to tell the music critic or more precisely the music reporter (in the sense of sports reporter): one can take a horse to the river but one can't force it to drink.

 NAM JUNE PAIK

PS. Further, I learned from Mary Bauermeister the intensive use of technical elements, from Alison Knowles "cooking party," from John Cage "prepared piano" etc. etc. etc.... [Moebius loop], from Kiender the use of mirror foil, from Klein "monochromity," from Koepke "shutting event," from Maciunas "Parachute," from Patterson "Tereminschaltung und Ansatz zur Elektronik," from Vostell the use of barbed wire and from Tomas Schmit and Frank Trowbridge many different things while working together.

Text from back of poster for "Exposition of Music-Electronic Television," Paik's first solo exhibition, at Galerie Parnass, Wuppertal, March 11-20, 1963; translated from the German by Edith Decker-Phillips.

About the Exposition of the music (1963)

In most indeterminate music, the composer gives the possibility for the indeterminacy or the freedom to the interpreter, but not to the audience. The audience has only one freedom; that is, to hear or not to hear the music going on—a quite old freedom which they had, or were compelled to have, by listening to boring classical music such as Brahm's Symphonies or "Tristan et Mélisande". The end result of "indetermined music becomes (at least for the audience) usually nothing but a "normal strip of time—good or bad or mediocre, or very good—strip" of time—a time flow of only direction, as in traditional music, or in our life, destined later or sooner to the certain death with one-way time. (The freedom must have more than two ways, directions, vectors, possibilities, of time.)

The audience cannot distinguish the indetermined time or sounds of the interpreter from the determined time of the interpreter. The audience cannot fully co-feel the waiting, surprising, disappointment, hesitation, stuttering, expecting, jumping, flee, deviation, jetting, betting, choosing, pushing, being pushed back, determining, deciding, plunging into, vacant space, bothered space, common space, filled space, fully vacant space and/or/=/vacuntly filled space—consummation, purge, ejection, stop, crashing, etc. ... of the interpreter, which all usually constitute the main substance, (or a-substance) of the conception, (or a-conception) of so-called freedom.

The problem becomes more confused if the interpreter has a "rehearsal" ("répétition" in French), or if the interpreter plays it many times as his favorite "repertoire"—often even by heart. This is the prostitution of freedom; although, it can be great art, as Tudor's, Welin's, or Caskel's performances. Precisely spoken, if the interpreter rehearses even only once, the degree and the character of the indeterminacy become the same as in classical, if not baroque, if not renaissance, if not medieval music. This is why I have not composed any indetermined music, or graphic music, despite my high respect for Cage and Cage-friends.

The not sonorized music-graphic is, as a new genre of art, very hopeful; it can inaugurate the new art of pure intellect, imagination, and reasoning as chess, detective stories, and puzzles.

A step to get rid of this self-deception (among many, too many, self-deceptions—mauvaise foi—of modern artists ... there is no "ism" without self-deception) is Stockhausen's idea of 1960, in which he tried to give the audience the freedom to leave and return to the concert hall. (das paar)

In 1961, I have written a sketch to the "Symphony for 20 rooms", where the audience has a choice of at least 20 different sound sources, between which they can freely circulate. The free time leads the music necessarily to the space-music (room-music) because the free time requires

more than two vectors (directions), and two vectors constitute necessarily the space (room). In this case, the room (space) is no longer merely the enrichment of the sound, but the indispensable "better-half" of the sound. (without pedantry, such as demanding the ears to do what they cannot do)

As the next step toward more indeterminacy, I wanted to let the audience (or congregation, in this case) act and play by itself. So I have resigned the performance of music. I expose the music. I made various kinds of musical instruments, object sonores, to expose them in a room so that the congregation may play them as they please. I am no longer a cook (composer), but only a feinkosthandler (delicatessen proprietor). This self-degradation gives me also some other unexpected joys, as every self-degradation usually does. For instance:

(1) they give me possibilities of combining many senses; touching, blowing, caressing, seeing, treading, walking, running, hearing, striking, etc.

(2) they make music more calm than any former calm music, and they make the room more mobile than any former mobile room; therefore, they can exploit a new category between music and architecture;

(3) perhaps I can sell them. "What you really posses in this world is only what you can sell." A. Miller?!?!?!?!

(4) the wise play the wise music, and the stupid play the stupid music; this curious fraternité is perhaps a necessary evil of democracy; even the wisest has no right to compell the idiot to happiness; the freedom is the good, but the compelled good is no longer the freedom, and no-freedom is no more the good. (Berdjaiev)

music for the people
by the people
of the people

Originally published in *Décollage* no. 3, ed. Wolf Vostell (Cologne, December 1962): n.p.

Electronic TV & Color TV Experiment (1964)

In my two previous essays on this subject (*Decollage* N. 4 and *Fluxus Newspaper* No. 3), I treated the aesthetical aspects of the electronic Tv experiments and its relation to electronic music. This essay will mainly be a technical report.

I COLOR TV EXPERIMENT

A Three taperecorders are added to the convergence-circuit, so that convergence-circuit is modulated over the waves from the taperecorders...Any black & white image gets random picture. (Point A.B.C. at circuit diagram)

B Three TV cameras fed to each Kathode of red, green, blue, electro-guns of the color picture tube, so that one shadow mask picture tube shows three different images of three colors at one time. The brightness of the three images I controlled by the amplitude of three taperecorders at the reversed phase. (Point E.F.G.)

II BLACK & WHITE TV EXPERIMENTS

A The picture is changeable in three ways with hand switches. Upside-Down; Right-Left; Positive-Negative.

B The screen can become larger and smaller in vertical and horizontal dimensions separately according to the amplitude of the tape-recorder.

C. Horizontal & vertical deflection of normal TV is changed into the spiral-deflection. Any normal square image is varied into a fan-form. (Special Yoke-ossilator-amplifier is made for it.)

D A TV screen (negative) in match-box size.

E TV Picture is "disturbed" by strong demagnetizer, whose place and rhythm give rich variety.

These experiments were made in Tokyo in 1903-04 with technical help of Mr. SHUYA ABE & Mr. HIDEO UCHIDA, whose ability and creativity I cannot emphasize too much. My cooperation with these top engineers broadened and changed my Lebensanschauung.

III The following is a recapitulation of my first show in Galerie Parnass in March, 1963 Wuppertal, Germany.

A A relay is intercepted at the A/C 110 volt input and fed by a 25 watt amplifier without rectifier. Unsymmetrical sparks are seen on the screen.

C 10 meg ohm resistor is intercepted at the grid of the vertical output tube and then the waves from the generator are fed here, so that both waves interfere and modulate with each other. (Point I)

D The waves from the taperecorder are fed to the horizontal output tube's grid, so that horizontal lines are warped according to the taperecorder's frequency and amplitude. (Point J)

E The vertical output tube is cut out; you see only one straight line.

Professor K.O. Goetz of the Kunstakademie in Duseldorf, Germany has published since 1960 on the idea of feeding the Kathode of the TV picture with a computer. This idea has not been realized, because he could not get a computer and our largest computer is still too slow to send 4 million points in each one 50th second. Although this idea and my method is completely different, I want to pay due respect. Also, TV-decollage of W. Vostell (Smolin Gallery, N.Y.C. 1963) shows rich possibilities of combinations of TV and hetero-TV elements. ("Shoot the TV," "Bury the TV," "TV behind canvass," "TV blur" etc.) Knud Wiggen is—hopefully—working to establish an electronic TV studio in Stockholm. I hope for financial help from foundations for us all.

Originally written for Paik's show at the New School for Social Research, January 1965. Reprinted in *Nam June Paik: Videa 'n' Videology 1959-1973*, ed. Judson Rosebush (Syracuse, NY: Everson Museum of Art, 1974), n.p.

Printed in George Brecht and George Maciunas, *FLUXUS cc fiVe ThReE* (Fluxus newspaper # 4), 1964, offset lithograph on paper, 23 × 36 3/16 in. open; 23 × 18 1/8 in. closed, Collection Walker Art Center, Minneapolis, Walker Special Purchase Fund, 1989. © 2018 Artists Rights Society (ARS), New York/VG Bild-Kunst, Bonn. © 2018 George Maciunas Foundation/Artists Rights Society (ARS), New York.

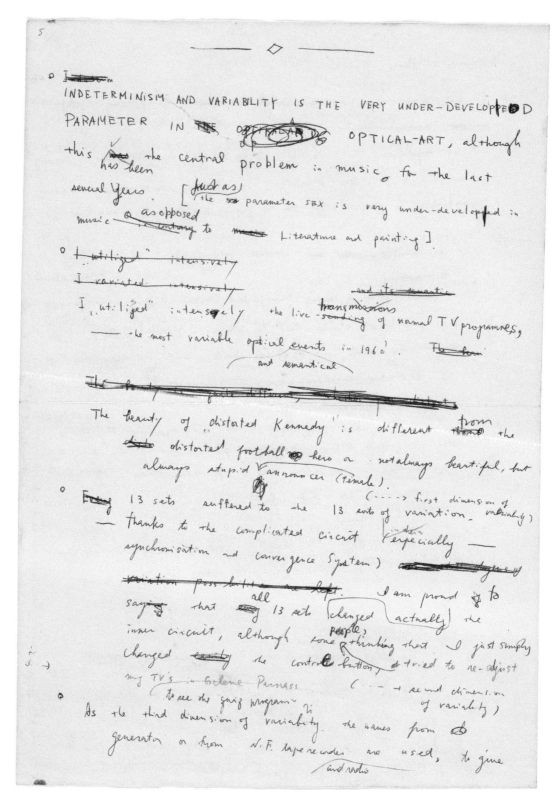

A page from Paik's handwritten first draft of "Afterlude to the Exposition of Experimental Television," 1963. Museum of Modern Art Archives, Fluxus collection, Series I, Folder 980.

(5)

INDETERMINISM and VARIABLITY is the very UNDERDEVELOPPED

parameter in the optical art, although this has been

the centralproblem in music for the last 10 years, (just

as paramrter SEX is very under developped in music,

as opposed to literature and p optical art.

I a) I utilized intensely the live-transmission

 of normal programm, which is the most variable

 optical and semantical evets, in Nineteen-sixties.

 The beauty of distorted Kennedy is different

 from the beauty of football hero, or

 not always pretty but always stupid female announder.

 b) As
 Second dimension of variablity.

 13 sets suffered to 13 XXXXXXXXXXXXXXXXXXX sorts

 of variation intheir VIDEO-HORIZONTAL-VERTIAAL units.

 Imam not not proud to be able to say that all 13 sets

 actually changed their inner circuits. No Two

 sets had the same kind of technical operation.

 No one is the simple blur, which occurs, h when

 you turn the vertical and horizontal control-button

 at home. I enjoyed very much, the study of electronics,

 which I began in 1961, and some life-danger, I met

 while working with 15 Kilo-Volts. I had the

 c luck to meet nice collaborator, especially like

 Mr.Shuya Abe (TBS nettwork).

 c) As the third dimension of variablity , the waves from
 various generators , tape-recorders and radios are
 fed to vearios points to differnt rhythms each other.
 This rather old-typed beauty, which is not essentially
 combined with High Frequency Technik , was easier to
 understand to the normal audience.

A xerox of a page from Paik's typescript for "Afterlude to the Exposition of Experimental Television." bpk/Staatsgalerie Stuttgart, the Sohm Archive.

Electronic Video Recorder (1965)

NAM JUNE PAIK

ELECTRONIC VIDEO RECORDER

Cafe Au Go Go ∘ 152 Bleecker • October 4 & 11 1965 • World Theater ∘ 9PM

(a trial preview to main November show at Gallery Bonnino)

Through the grant of J D R 3rd fund (1965 spring term), 5 years old dream of me

the combination of Electronic Television & Video Tape Recorder

is realized. It was the long long way, since I got this idea in Cologne Radio Station

in 1961, when its price was as high as a half million dollars. I look back with a bitter

grin of having paid 25 dollars for a fraud instruction "Build the Video Recorder Yourself"

and of the desperate struggle to make it with Shuya Abe last year in Japan. In my

video-taped electro vision, not only you see your picture instantaneously and find out

what kind of bad habits you have, but see yourself deformed in 12 ways, which only

electronic ways can do.

> *It is the historical necessity, if there is a historical necessity in history,
> that a new decade of electronic television should follow to the past decade
> of electronic music

> **Variablity & Indeterminism is underdeveloped in optical art as parameter
> Sex is underdeveloped in music.

> ***As collage technic replaced oil-paint, the cathode ray tube will replace
> the canvass.

> ****Someday artists will work with capacitors, resistors & semi-conductors as
> they work today with brushes, violins & junk.

> Laser idea No 3
> Because of VVHF of LASER, we will have enough radio stations to afford
> Mozart-only stations, Cage-only stations, Bogart-only TV stations, Under-
> ground Movie-only TV stations etc. etc. etc.

Projects for Electronic Television (1965)

I hope to open a studio for electronic color television
in New York City so that I can begin more complicated
technical experiments such as maximum exploitation of
shadow-mask color TV picture tube, self-programming
of whole video signal through TV cameras, tape-recorders
(visual and audio), the combination of electronic music
and electronic TV, and if possible, combining the TV
with computers and self-invented 50 channel data recorders.
As an adjunct to these experiments I plan to construct
a compact version of electronic TV for concerts so that
it can easily be transported and demonstrated in colleges.
It will have unprecedented education effects since it
bridges two cultures, appealing both to artistically and
scientifically minded people. These two projects of
experimentation and education are aimed at a third stage--
the development of an adapter with dozens of possibilities
which anyone could use in his own home, using his increased
leisure to transform his TV set from a passive pastime
to active creation.

Originally published as a reproduction of Paik's typescript in *Nam June Paik: Videa 'n' Videology 1959–1973*, ed. Judson Rosebush (Syracuse, NY: Everson Museum of Art, 1974), n.p. Paik added a note that read, "This essay was written to the New School for Social Research, New York, in collaboration with Bill Wilson while I was living at his house in spring, The last line anticipates the video synthesizer."

Untitled/"Cybernated art is very important..." (1965)

* Cybernated art is very important, but the art for cybernated
 s
 life is more important, and it need not be cybernated.

 May-be George Brecht's pianissimo is the most adequate one.

* But if Pasteur & Robespierre is true, that we can resist to
 certain built-in
 the poison , only through the poison, then specific frustration

 caused by cybernated life requires certain cybernated catharsis.

 My everyday work with video tape & cathode ray tube convinces

 me of it.

* 'Cybernetics', as the science of pure relations, or 'relation-

 ship it self' has its origin in 'Karma' in Budhism.

 McLuhan's famous phrase ' Media is message' is formulated by
 (1947)
 Norbert Wiener as ' Signal, where message is modulated(sent),
 is signal
 xixxa as important as the message, where the message is not

 modulated.' inx

* As happening is the fusion of various arts, so the Cybernetics

 is the exploitation of boundary regions between various existing

 sciences.

* Newton's physic is the mechanic of power, and unconciliatory

 two-party system, where the strong win necessarily over the weak.
 a tighny an indeterministic (grid)
 But in 1920's, a German genius put the'THIRD pp party' between
 in vacuum tube
 mighty two poles, (plus & minus), thus enabling the weak
 making the
 control the strong first time in the human history.& later blossm
 of cybernetics possible.
 It might be the Budhistic'third way' , but anyway Cybernetics is

 born in last year to shoot more German plane on the English sky.

 with German invented vacuum tube.

 Buddhist says also

 Karma is Samsara (
 Relationship is metempsychosis.

 we are in open circuits

Typescript, Staatsgalerie Stuttgart, the Sohm Archive. © Photo: Staatsgalerie Stuttgart. Originally published in a different form in *Manifestos*, a Great Bear Pamphlet (New York: Something Else Press, 1966), 24; reprinted in *Nam June Paik: Videa 'n' Videology 1959-1973*, ed. Judson Rosebush (Syracuse, NY: Everson Museum of Art, 1974), n.p.

Sonata quasi una fantasia .

for Billie Kluver

nam june paik

Some utopian or less utopian ideas and phantasies

for Billie Kluver.

nam june paik

1) Can the laser, so-said breakthrough in electronic, become

also the breakthrough in art??

Some day every high-brows will have Laser©phone number,

as they have today telephóne or telex nuḿber, which

enables to communivate everywhere wirelessly and simultaneously.
evryone

Someday more élaborated scanning system and ~~xxkxixx~~

and something similiar to matrix cirkcuit and rectangle
in color T V
modulationsystem will enables to send much more informations

at single carrier band, f.i. audio, video, pulse, temperature,
combined
moisture, pressure of your body. If combined with robot

made ofrubber form expandable-shrinkable cathode ray tube,

and if it is ~~txxxi~~ ' une petite robotine',,,,,,,,,,

please, tele-fuck!

with your lover in ~~R©~~ RIO.

2.5) Can we have a 'coherent' smell , like a 'coherent' light?

 When we xxx can oscillate, modulate, amplify, scan,

 deflect, mix smells ? Smell-Laser........

 (Amplify the smell ! Dick Higgins, from 100 plays
 plays, 1961)

3)Smell Music . a Million Dollar Idea.

 A small container with fan and various condensed incenses

 is attached to car,. Driver chooses , changes smells, like

 they do today with Radio. Smell can be also regulated by

music or tape-recorded signal.

 f.i.
 50-200 C/S,,,;,,,,,,,, coffee flavour
 200- 400C/S ,,,,,,,,,, curry.......
 400-800 c/s , ,,,,, perfume Channel No.5.
 800- 1600x David Tudor's favorite Indian incense
 1600- 3200........... menthol-wake-up smell
 3200- 3800 candy
 3800- 8000........... woman, 38 years, very frustrated,,
 8000-15000,, ,,,,,,,,,alcholxxx scoth wisky.

 I hope to patent it and sell to G M .

What comes after No-Bra-Bra ?

" Sex & Stripes "

The dress is cut from neck to bottom

vertically in many lines and stripes.

The girls walk. These stripes swing.

Bodies & underwears are

seen, hidden, seen

,, ,,, in soft wind.

* * * * *

What comes after "King Size Bed" ? ?

" KINETIC BED" !

Bed is devided into 8-10 parts.
Its form is quickly adjustable to fit better
for each 48 positions of love.

8-10 electronic controlled motors are
equipped to give enriching movements &
vibrations to bed & love.

Imagine the romantic vibra tion in the closed 'wagon lits'
of honey moon in "Trans European Express" running
the Swiss Alps.
 o r
Imagine the thrilling sex at the rolling yacht
on the Floridan Billow.

Imagine the 'weightless love' in space ship
and its enormous difficulty !

THANKS TO UNIVERSAL GRAVITATION

Chen-Chu's Taoistic maxim " the use of uselessness" became

very useful to keep the the boom of western free economy going.

Electric tooth brush, color T V , Topless, F M stereo,

red line in white tooth paste, neckless beer bottle, Pop art,

third annual avantgared fesyival, including myself,,, ,,

all junks & jewels serve for this single purpose.

In 21th century, you can choose not only life or death, but

w h i c h c o l o r of death.

you can choose yellow , or blue, or green, death or even

transparent death , by shooting yourself with th laser-gun of

ecuivalent clor. Color in death will become as important as

color in life in 20th century.

what a leaping augumentation of freedom in free society.

* * * *

If you want to stage the Laser Happening No.1 <u>N O W</u>

, simply catch a rat at a lower Manhattan loft , and

kill it with laser-gun in upper manhattan galerie before ladies &

gentlemen. (I dont do , because I am Pacifist).

dye

Cage said ,'red dye is better than red die'.

Therefore I made a more humanistic version.

Hundreds of lasers are oscillating in a dark room in different

colors. Colors are invisible , until someting intercept it.

You or he or she, walks around , clad or unclad, and various spots of

body arsdgxsdx dyed in many colors and they changes according to

your moving.

" If it is good , credit goes to John Cage,

if bad, blame comes to me" (paik).

un-seeable,,, unhearable,,,, untouchable,,,, ~~of~~ *art*

This is the best idea of all these series and hope to realize it
as soon as possible. (~~me~~ with billie kluver)

Very Very strong magnets , electromagnets are hidden behind~~x~~
walls , fllors, ceiling, which have adequete rift to pass through
magnet power like the cleft in TV yoke or human vagina.

clothes, shoes, hats (are of magnetized metal sheets.

 (of audience (one only!))/// In accordance with electro-
magnets, which are turned on & off with certain sequenses and rythms,
he is pulled, pushed, stuck, shaken, from wall to wall, even flown
to ceiling. ,,, ~~inxasxxxdxmxxxxixxxsxtxinxsxquxxsxxandxxxhyxhx~~.
F,i, HE walks on the floor , suddenly stuck at one point and released
mystiously after a while ,,, etd etc,etc, ,
It might even influence brainwaves. (Hideo Uchida , an eccentric
 electronic inventor, who disvovered the transistor-principle earlier
than American, observed that tone and topic of passenger's conversation
changes, when tram passes under ~~kexxyx~~ hifgh votage overhead cable)
~~Hempi~~ (Dema Gizutsu 1964 Tokyo)

Maybe we can send certain waves directly to brain , which modulates
brainwaves, and entertain, enlighten, expend the brain,, a kind of
 electronic LSD.
 (See picture , measuring the brain waves of zen enlighten ment
 by University of ~~Xyxbx~~ Kyushu , psychological seminar)

Maybe we can put various weak electronic signals directly to human
body using various human body as plus minus poles.

Syngman Rhenn's police used wrists as poles. After the initial inhumane
 shock-pain, they lower the voltage, as much as the tortured can unders-
and the and interrogate , menacing to level up the voltage anytime
 , if the tortured will not confessed. It let man verbally swing,
like a kid on the swing.,,, of pleasure. of pain.

 Trench in Algerie ~~inxenyadxhxnddrixxn~~ used the ~~genitil~~ *Penis* as a pole,
and invented a hand-driven electric generator ~~zzasxxxxinx~~
 for INSTANT torture at the field.

 Maybe south -vietnamese police discovered a new pole.

)(My interst to medical electronic is incited by Jim Tenney,
 who has excellent ideats in this domain.

6)

secret

xy using
various part of human body as plus-minus poles.

F.i Syngman Rhee's police used wrixsts as poles ;xxxx

After having given initial inhumane shock-pain, they

lower the voltage , as much a s the tortured can understand
— but not stop and
the question , and ~~keep interrogating~~a, interrogate,

menacing
~~scaring~~ to level up the votage anytime , if the tortured

will not confess..... It let the man verbally swing

like childen on the swing. French xxxx in Algerie

used the genitial as a pole and invented hand driven electric

generator for the 'In INSTANT torture at the field.

May be south vietnamese police invented discovered a new pole.

(My interest to medical electronic is aroused by JIM

TENNEY, who has excellent ideas in this domain .)

8) Time Capusale music

,,,,, well, all music is a kind of time capusale,,,,

but........

xxpxx A pille of xx many layers of various tastes are made.

The audience chews. taste changes in accordance of time.-capuse
capu_sale-design.

It can be combined with 'ear- music', sothat

appassionata-part is accompanied,by hot taste,

dolce part ixxx with sweet tadte, terrible part with

kikker xkixine. quinine.

xxx- Time -capusale combination of various narcotic might be

more interesting but

Kill POT--art

because it is the double escape from reality.
Total capitulation through total mastuarbation.

POT-art will be very useful and necessary, when utopia is

realized on the earth, but not before as the compensation of

A candy , containing a miniature miniature motor inside,
shouldbe made to give an artistic feeling to mouth or vagina.

think it is an brilliant idea.

5) "Mr. Paik's effort lacked any spark of originality , sensitivity,
or talent"....... Maybe festival will improve. I t couldn't
get worse" (Howard Klein. N.Y.times)

But the architecture cannot have its 'Cage' or 'Webern', [world]
because even the far-out genius needs the money ,that is ,
the approval of community , in order to try and prove his idea. [contemporary]
Not very excellent interior design of Lincoln Center makes me
think to constitute interior design, which is so indeterminate ,
that later world needs ks not suffer for 1000 years, as they do
at St Peters in Rome, and they can exxily change better,,,,,
that means,bitter for contemporary society, easily. without hurting
 originals.
If Cathode Ray tube becomes flatter and cheaper, we can construct
whole wall with it. Unlimitted possibilities of colour and
patterns , its sequential change(from very slow to very quick),
and 3-dimensional illusion are obtainable and controlable.
Each four nights of 'Ring' can have different interior design,
and each 'entr-actes of Fidelio, also fit to its content.
 matching to developping plot.

 Waste of money ? ?

 " Send rice to India " (Arthur Koepke)

8)

10)

 As T V has replaced radio,

 so TELE-PET will replace T V .

 (~~Buy NOW the glamour-stock of 22 century.~~)

 Each family has certain numbers of TELE-PET ~~%~~x , (

 robots, made of rubber-form, expandable-shrinkable

 cathode ray tube, which can take any form, and is

 capable of doing every functions of human beings.)

 today

 As you turn on the T V or drug/ ~~TELE-PET station~~

 you turn on TELE-PET,. switch.

 They will play every entertaining progam , transmitted by

 N B C telepet station.

 IN a naughty late-late show,

 you can even caress her.

 in a horror show,

 Frankenstein might really kill you.

 think ~~is lying~~

 If you ~~dont like~~ your president ~~at~~ News Conference,

 ~~hi~~ hit him!

 Buy NOW the glamour/stock of 22th century !

p u r e s w i t c h .

A composer in Gide's "Counterfieter " is dreaming to
compose a music . which is consisted of

only a single ~~consummate~~ accord of
consummate beauty.

I have been dreaming to compose a pure switch,
a time series of ~~consummate beauty,~~
~~poliphonic~~ such a perfect proportions , that,

~~they become to the consummate beauty,~~
and whatever signals are triggered by it

, they should become to a consummate beauty.

Some more practical plans

TV I | TV II

1	2	3	4
5	6	7	8
9	10	11	12
13	14	15	16

1	2	3	4
5	6	7	8
9	10	11	12
13	14	15	16

TV screen can be devided into 16 parts, and each parts are interchangable.

Even number parts of one T V picture and odd number parts of
the other T V picture can be ∅ put together
 T V
It will be interesting to put picture of normal scanning to
various abnormal scanning, f.i. radar scanning , etc etc.

WE can wind vxryx many , very complicated xxxx coil
to all over picture tube and give various electricity to i .

many
strong
electro-magnet
is attached to picture tube. coil is wound around
 TV picture tube

The nipple of

My robot no.3 (a female mannequin) waxxsupposed tox
is made of photo-electric telemin , s o that if people's hand
approaches, it begins to weep,.

 to breast

My robot no.4 was supposed to be a standing statue , which vomit,
~~{with electro magnetis~~ or collaps, spectator stand in front of him.
 when

~~Myxchiefxtechnicalxcooperatorx~~

Variation on the Variation No. 5 of Cage.

12) ~~Radar Dance~~ for Cunningham.

Cage's Variation No.5.(with its photo-electric
triggers of Kluver and Telemin-oscillations of Mog)
incited me to think of ~~RADAR-DANee.~~ *RADAR-DANCE for Cunningham.*
Cunnungham and ~~Halex~~ Caroline Brown wear aluminium
folie costume. It looks very nice.
2-3 radars waves are transmitted , and signals ~~now~~
reflected from Aluminium - folie can be made audible or
visible on screen.

" If it is good~~xyxd~~ , credit goes to Cage,
if bad, blame comes to me " (paik)

13) I have not composed any orchestra music and never thought
that I would. But following Clipping (N.Y.Times .
14th Sep ,965) urged me to compose a orchestra music
, possibly a super-sonic simphny played by
" completely novel living matter undreamed of today"

intelligently than
uncoordinated attempts that
are currently being made.
Dr. Price said that the fruits
of such a program could have
"political, social, biological and
economic consequences (which)
would dwarf those of either
atomic energy or the space pro-
gram."
Among the things that could
come from the ability to make
life he said, were the synthesis
of foods, fibers, drugs and com-
pletely novel living matter un-
dreamed of today. Ways might
be found in the course of such
a program to improve the breed
of man, himself, and to create
whole new organisms, he de-
clared.
Asked if the program might
extend to the creation of new or-
ganisms as complicated as hu-
man beings, Dr. Price said:
"I couldn't imagine this
would not happen in a century
or so."
He emphasized, however, that
such feats were not f
for or to fore

$92
voted
millio
ident
The
Mans
presse
be ca
later
'Mem
the c
a nar
effort
the cu
"abou
Th
of an
India
granti
ment
provis
last
said
to res
Sec
had
would be t
making
ticular
one cou
of the

The Synthesis of Living Matter
Is Proposed as National Aim

Can the laser, so-said break-through in electronic, become

also the break-through in art ?

someday every high-brows will have laser-phone, number,
as they have today telephone or telex number, which
enables to communicate everyone everywhere wirelessly
and simutaneously.

Someday more elaborated scanning system and something
similiar to matrix circuit and rectangle modulation
of color T V will enable to send much more information
on a single carrier band , f.i. audio, video, pulse,
temperature, moisture, pressure , movements of your body
combined. .,,,,, whole parameter of personality and
situation.

If connected with a robot , made of rubber form
expandable-shrinkable cathode ray tube,,etc,,,

and if it is 'une peteite robotine',,,,,

please, TELE-FUCK

with your lover in RIO.

Undated typescript, Nam June Paik Estate.

Utopian Laser-TV Station (1966)

McLuhan is surely great, but his biggest inconsistency is that
he S T I L L writes books and he became well-known mainly through books & he doesnot care
about the situation, that he is excluded from the media for which
he evangelizes.(=T V).
Very Very Very hifg frequebcy osscilation of Laser will enable us to
afford thousands of big & small T V stations and this will free us from
 the monopoly of few commercial T V channels. I am video-taping the following
 T V programms , which will be broadcasted after 50 years, .

 I M A G I N A R Y P R O G R A M (not yet approved by
 mentioned artists)

First of March. 1996. A.D.

Morning 7 A M . Chess lesson by Marcel Duchamps

 8 A M . Meet the Press. Guest. John Cage

 9 A M . Morning gymnastic. (Merce Cunningham,, Carolyn Brown)

 10 A M . Something Else University. on Indian incense , chinese
 cockroach,,etc (collection of unimportant & unnecessa-
 ry knowledge. by David Tudor)

 11 A M . For the more meaningful Boredom.(Tree Movie(1961 January)
 of Jackson MacLow (to film a tree or anything with a standing
 camera for many hours.)

 12 noon News by charlotte moorman
 Nobel Prize for 1996 ; peace prize : Cage.
 Chemistry prize. Inventer of paper plate
 physics prize: De Gaulle. Medicine Prize. the inventor
 of painless safty abortion pills. Literature prize:
 Richard C, Higgins (? ? ?) or Tomas Schmit (???)
 what prize for charlotte moorman ????

 1 P M . Commercials ,from the Fluxus Department at 34th st & Broadway.
 Alison Brand Atom Shoes for car-less society (this shoes is
 equipped with small wheels , fed with strong , tiny atom
 engines, & can travel from Harlem to Wall street in 15 minuts
 without parking problem.

2 P M .

 How to use my 'Stereo-eyes' & Buddha- head ? by Emmett Wil
 liams

3 P M : Travel guide to Kurdistan, Turkistan, Kasackstan,,
 by Dick Higgins.

 4 P M : The confession of top-less cellist. (Charlotte Moorman)

 5 P M : Cantata :'Image Sacree de Mary Bauermeister' by n j paik.

6 P M : Stock-market report ' How to lose your money quickly ?
 by George Maciunas.

7 P M : Avantgarde Cooking Recipe by Alison Knowls
 (for endless sex,, for temporary death, ,for controllable
 dream,,for endless unsex,, for endless youth)

8 P M : Symposium on modern Platonism. (G. Brecht. R. Filiou.
 A. Hansen. J. Jones, R. Johnson.)
(9 P M : Happening and and in Old Testament (A.Kaprow))
10. P M ..Baby Care by Grand baby (Diter Rot).
11 P M ARS NOVA Quartet by Corner, Godstein, Lucier, Tenney,
Late show ,, Movie of 60's (R) (Brakhage, Breer, Mekas, Vanderbeck)
12 Midnight.
 EDITORIAL : ART & POLITIC : by Vostell
1 A M suggestion for tonight bed technic from the ancient
 Greek material (a source reading in Greek)
 by Christian Wolf.
2 A M Goodnight poem: (rude chants by Carol Berge).
3 A M dream music by Lamonte Young
 &
 Mahjong Contest by
 AYO Takehisa Kosugi, Toshi Icjiyanagi, Yoko Ono

 Continued to morning 6 A M.
 6 A M Alcohl-contest by all star member.

Typescript, Staatsgalerie Stuttgart, the Sohm Archive. Originally published in a slightly different form in
Manifestos, a Great Bear Pamphlet (New York: Something Else Press, 1966), 24; reprinted in *Nam June Paik: Videa
'n' Videology 1959-1973*, ed. Judson Rosebush (Syracuse, NY: Everson Museum of Art, 1974), n.p.

Computer Programming for Visual Arts and Electronic Opera (1967)

The current problem in the application of computer to Humanities
is that every one is saying,this <u>can</u> be done, or that <u>can</u> be done,
but very few things were REALLY done. But in case of visual arts, even
such a paper project is lacking. The big technology-gap existing between
visual arts and other sister arts, especially music, is shown vividly in the
fact that 1o,ooo reviews in the "Computing Reviews" (1960-66), the stan-
dard magazine in this field, do not contain even one contribution
on visual arts.
 In the first stage of '<u>Art and Technology</u>', which is
currently going on in the New York art world, the co-operation of artists
without technological knowledge and technicians without artistic
phantasy, proved not to be always fertile. In the second stage of
'<u>Art and Technology', </u> in which computers have to be necessarily
brought in, the artists, who do not possess the intellect <u>and</u> patience
of mastering computer programming techniques will have even more
difficulty.
 It is a very rare opportunity
that an artist is allowed to use various expensive equipment at

Bell Labs under the guidance of prominent scientists such as
Messrs. M.V.Mathews, P.Denes, M.Noll. I have been studing computer
programming for the last year for this prestigeous chance, and I
am confident of positive results both in short range and long range
projects, as written in other longer essay, presented before.
My work will have a great meaning to music also, because it will expand
the conventional electronic to 3-D electronic Opera, thus
giving new possibilitis for composition and distribution
through educational Television, college showings and other media.

Typescript dated March 30, 1967, Smithsonian American Art Museum, Nam June Paik Archive (NJP.2.EPH.65A-D); Gift
to the Nam June Paik Archive from Timothy Anglin Burgard in memory of Ralph Burgard. Attached to a letter from
Paik to Ralph Burgard (see page 353), in which Paik describes the essay as his "application" to Bell Labs.

Flykingen Bulletin (1967)

In almost 10,000 essays reviewed in the
Computing Review (1960 - 1966), there are very few
contributions to visual art, as compared to a dozen
or more to music, literature and to history. In
spite of interesting work done bt Peter Denes,
Michael Noll, Bella Julesz, K.O.Goetz, and Stuttgarter
Group, many new possibilities are left open for
further development, especially if the extreme
importance of the cathode ray tube and video tape
recorder to the arts is considered. On the other
hand, computerized video experiments derived from
the unorthodox instinct of the artist will surely
bring forth some unusual results in the research of
pure science and applied technology.

1) The systematic study of SCANNING in symmet
ric and asymmetric, geometric and ageometric, deter-
ministic-probalistic-indeterministic, periodic and
aperiodic ways.
The main reason for the quick success of my elec-
tronic art was that I gave up very early the product-
ion of video-signals (information quantity: 4 million
bits per second), in order to concentrate my efforts
on the creation of unusual scanning patterns (very
manageable information quantity: 15,000 and 50 bits
per second). Especially the addition of third
deflection yoke and triple modulation was a break-
through. The quick switching of various deflection
patterns (eg. spiral, oval, triangle, etc.) with
adequate gate circuits as in chromatron color TV
will enrich the variability by far. I am confident

that the introduction of the computer to this
already well proven area will bring immediate
success.

a) Artistic use

Whole movie, TV technique will be revolutionized,
the scope of electronic music will be widened to
the new horizon of electronic opera, painting and
sculpture will be shaken up, intermedia art will be
further strengthened, bookless lieterature, paper-
less poem will be born.

b) Pure scientific research

The new possibility of drawing every kind of form
from abstract pattern to realistic image via grade
of mixture of both, will be helpful in the research
of Gestalt psychology in its whole sphere, namely
sensory organization, characteristic of
entity, behaviour, association, recall, insight,
learning, etc... It might contribute also to "hot"
subject of visual electronics today such as optical
recognition, optical character recognition, optical
scanning of a customer's account, video telephone,
sparkchamber photograph, etc., needless to say, radar
and anti radar.

c) For artistic eyes

Someday mediacal electronics will progress so much
that vidicon artificial eyes will help the blind.
In that case the vidicon scanning must be <u>exactly</u>
the same as the retinal structure of patient's eyes.
Beyond the fact that the standard retinal structure
would be much more complicated than today's
regular scanning techniques, there will be a large
and delicate range of individual differences among
patients, which might vibrate even daily. In
that case we must have very fine tuning system of
scanning with manual and electronic controls,
comparable to but far surpassing today's ophthal-
moscopy, in order that vidicon signals should be
translated into adequate synaps to optical nerve
without distortion. My scanning experiments will be
of some use for this ultimate goal.

d) For video telephone

Confidential pictures can be scanned with very
complicated secret "coded" frequencies, and sent
to reciever. This will be useful, just as simple
scrambling is useful, (eg. a Ford car designer

showing his new car model to an executive in the
coded picture via video telephone in complete con-
fidence.)

e) Synthetic Face

For the police identification, anthropological
study of various face types, beauty surgery, and
manicure industry, etc...

The above technic will enable us to construct any
kind of face, eg. a suspect who has the long contour
of John Wayne, melancholy eyes of James Mason plus
Chou En-Lai, half bald as Yul Brynner, oriental flat
nose, but with sensual mouth of,,,,,,,say,,,,,,,,
Oscar Wilde, but wearing glasses rather like James
Joyce's,,,,,and with sex appeal of Henri Vidal.....

2) I suggest to build a 7 channel video signal
mixer,in which each camera shoots the separate parts
of various faces, enabling to compose one face out of
7 men's characteristics. Beyond the above mentioned
police use for pattern perception, beauty surgery,
anthropological use, etc., it will enrich the TV and
film technic tremendously.

a) Eyes weep, while mouth smiles.

b) Only eyes come out of face and fly away.
(negatice feedback of eyes will erase out original
eyes electronically.)

c) A face with slowly shrinking mouth

d) A face with two mouths and three eyes.

e) Whole face shakes, but only nose stays
unmoved.

f) Put dog's eyes and cat's mouth to
Adenaur's face.

3) Video signal input

The painfil gap existing between TV video signal
(4 meg c/s) and the output speed of computer (eg.
IBM 7090: 400,000 bits per second) requires an
unusual solution. One way would be to record the
program in slow speed and speed it up in play-back.
But still astronomical quantity of information bit in
single frame and its sequence requires enormously time
consuming program work, and just this shortcoming
demands an original programming system, with many
short cut ways and artistic phantasies, for which I
may say myself, I have often been credited. As the

first step I will establish many machine independent subroutines, which may be used by other programmers like twelve tone rows or raga in Indi an music. Eg:

a) Subroutines of various basic forms, ranging from geometric to irregular form like bacteria.

b) Subroutine of place inside a frame

c) Subroutine of size.

d) Division of raster to many fields and its interchanebility.

e) Stretch and shrink each field in various directions.

f) Subroutine of combination of all 5 subroutine and the superimposition with realistic images. As human laughter and dog's bark is superimposed in Vocoder, so Picasso's face is scanned into the face of gnawing cat.

Among vast application of this method in art, science and technology, one interesting example would be the imitation of the statistical movements of virus, bacteria, fishes, and mass people.

4) Another important usage of computer in visual art is a concordance of movie and TV shows, as Cornell University did with Shakespeare concordance. Cataloging and indexing of all main actor's and director's scene by its contents (f.i. walking, waiting, anxiety, love, fight, jealousy,eating,joy,crying, including length of scene and emotional pitches) on videotape will be very valuable for cine-library, a good study material for student and a great fun for ordinary viewer and historian, sociologist, psychologist will profit out of it.

5) Cathode-ray wall

Mood art in the sense of mood music can be invented and installed in the home. Big theater or opera house could change their lobby designs everyday, matching to their repertory and this lobby design could progress in accordance with the developing plot. Big cathode-ray wall with color cidophole or controlable electroluminiscence can be programmed for this purpose.

6) Medical electronics and art is still widely
apart, but these two fields can also change each other's
fruits eg. various signals can be fed to many parts
of head, brain, and bodies, aiming to establish s
completely new genre of DIRECT-CONTACT-ART, and this
artistic experiment can bring some scientific by-
product for this young science in electro-anes-
thesia, electro-visual tranquilizer, electronic
hallucination through the film for closed eyes,
electro-sleep and other electro-therapy.

Electro-magnetic vibration of the head
might lead the way to electronic zen.

I am beginning to video-tape the programs of
 future 'Utopian-Laser-TV station', which will
be broadcasted in 1999. I will video-tape
 full-length of lecture-series, without cut,
 and Merce's Concert at 23, 4 . , I think,
 they will allow me, since it makes neither
 any noise, nor it needs additional lighting.
 Since I dont require any commercial picture
 quality, I can tape at any corner of hall
 very obscurely.
 As the gala-opening of this Utopian T V station

Published as a reproduction of Paik's typescript in *Fylkingen Bulletin* (Stockholm, 1967), and reprinted in *Nam June Paik: Videa 'n' Videology 1959-1973*, ed. Judson Rosebush (Syracuse, NY: Everson Museum of Art, 1974), n.p. In the latter publication, Paik included a note that read: "1966. The following essay was written in winter and copies were sent to Max Mathews, Mike Noll, James Tenney and Lejaren Hiller, Jr. It was printed in the Flykin-gen [sic] Bulletin (Stockholm) in 1967."

World First

VIDEO-TAPE

MONTHLY MAGAZINE

by Nam June Paik

SOMEDAY LONDON TIMES
will become "VIDEO-TAPE..

YOU CAN HAVE

"INTIMATE TV SHOW FOR ADULT ONLY.

or
$\oint_{n=0} 3-D$ THESIS. —as difficult as —

KANT + WITTGENSTEIN + Norbert WIENER

$\log_a ($ $)$

```
1967  January issue :   Bookless literature.
      Feburuary issue:   Paperless poem.
      March   issue :   potless poet.(Eddie Schlossberg)
      April   issue :   Topless Cellist.(Charlotte Moorman)
      May     issue :   Backboneless composer (Nam June Paik)
      June    issue :   Ego-less artist (Tomas Shmit)
      July    issue :   Moneyless society (all star cast)
      August  issue :   Chez Vous,madame (edition privee).

                   ,,,,continued,,,,,,,,

              each issue 100 dollar

         order to:
```

Vintage photocopy on paper; single-sided, 11 × 8½ in. Smithsonian American Art Museum, Nam June Paik Archive (NJP.1.PAPERS.9); Gift of the Nam June Paik Estate.

Norbert Wiener and Marshall McLuhan (1967)

(1, Twenty years ago Norbert Wiener, whose hobby was to read the
Encyclopedia Britannica from A to Z, anticipated the Intermedia.
"For many years Dr. Rosenblueth and I had shared the conviction that
the most fruitful area for the growth of the science were those which
had been neglected as a no-man's land between the various established
fields. Since Leibniz there has perhaps no man who had had a full
command of all the intellectual activities of his days. A century ago
there may have been no Leibniz, but there was a Gauss, a Faraday,
a Darwin. Today there are a few scholars, who can call themselves
mathematicians, physiologists, or biologists without restriction.
A man may be a topologist, or an acoustician, or a coleologist......
......it is these boundary regions of science, which offer the richest
opportunities to the qualified investigators.." Eg."the physiologist
need not be able to prove a certain mathematical theorem, but he must
be able to grasp its physiological significance and to tell the
mathematician to what he should look".(Norbert Wiener: Cybernetics. p.2)
The above conception of intermedia brought forth an inter-science called
cybernetics, and the latter pushed the electric age (engineering with
the technique of strong current) into the electronic age (control and
communication using the technique of weak current), which exploded
as the escalated "Mix Media" in Marshall McLuhan's "global village".

(2) McLuhan's famous phrase "the medium is the message" also existed
implicitly in the science of communication since the 1940's.
Norbert Wiener wrote that the information, in which a message
was sent, plays the same role as the information, in which a
message is not sent. It sounds almost Cagean..... Cage might
say," a notation, with which music is playable, plays the same
role as the notation, with which music is not playable".
I titled several of my pieces as "playable music", since most
of my musical compositions are not playable.

(3) Another parallel between the two thinkers are the simulation
or the comparison of electronics and physiology. Wiener's main
theme was "control and communication in animal AND machine" (note:
animal comes first), which he put as the subtitle of his main
work, "Cybernetics". He reached to the automatic control of the
anti-aircraft gun, an earliest model of today's huge computer, through
the study of feed-backs in animal's nerve system. Also the binary co-
de of today's computer has its origin in the "all or nothing"
character of our Neuron synapses, which are either simply "ON",
or simply"OFF".
 McLuhan expresses his view in the following way: "We wear all
mankind as our skin......Man extended, or set outside himself,

a live model of the central nervous system itself".(Understanding
Media: P53, P56)

(4) Indeterminism, a core in the thought of the twentieth century
from Heisenberg via Sartre to Cage, reflected also in Wiener and
McLuhan. For Wiener indeterminism was entropy, a classical terminology
of statistics, and for McLuhan indeterminism was the "cool media
with low definition".

Wiener::: "Messages are themselves a form of pattern and organization.
Indeed, it is possible to treat sets of messages as having an entropy
like sets of states of the external world. Just as entropy is a
measure of disorganisation, the information carried by a set of
message is a measure of organisation. In fact, it is possible to
interpret the information carried by a message as essentially
the negative og its entropy and the negative logarithm of its
probability. That is, the more probable the message, the less
information it gives. Cliches, for examples, are less illuminating
than the great poems."(Norbert Wiener: The human use of human beings.
p 21) White noise has the maximum quantity of information.

McLuhan :: "A cartoon is a "low definition" simply because very
little visual information is provided. The telephone is a cool
mediem, or one of low definition, because the ear is given a meager
amount of information. And speech is a cool medium of low definition,
because so little is given and so much has to be filled in by the
listner. Hot media are low in participation, and cool media are
high in participation or completion by the audience." (ibid: p36).
This (audience participation) might have been the first bait,
taken up by Cage.

It is illuminating to seek the common denominator running through
these parallels. (Mix-media.. the study of media per se.. simulation
of electronics and human nerve system.. indeterminism..)..
Wiener used these charactrestics as the micro-form to construct
the technical interior of the electronic age, whereas McLuhan used
them as the macro-form to interpret the psychological and sociologi-
cal exterior of the electronic age. The unity of micro-form and
macro-form almost hints the harmony of Leibnitzian monadology.
These are at the same time the original contributions of two thinkers
, and one doesnot discount the other's sognificance.(In a way
McLuhan put Wiener inside-out, as Marx put Hegel upside-down.)
 Of Course, M.I.T's professor of mathematics and McLuhan,
the hippie Joycian, could not agree in all the points. The resemblan-

ce of the African oral village and American T V culture missed the
attention of the square professor, whereas the passionate preaching
about the delicate but horrible difference of Machine Time and
Human Time by Wiener didnot bother the elegantly cool essayist.
Wiener ended with CIO-Riesman like pessimism of this age, which
he created largely by himself; but McLuhan, a convinced catholic,
is glaring wirh Fuller-Cagean optimism.

 (stop)

Art history and musicology suffered too long from the separation of
the unseparable. Technological division of work, Darwinian (?)
conception of development (no historian started with Piccasso and
ended with Greece), Woelfflinesque obsession with style, endless
peeling of the onion, to find out who influenced whom,,,,,, all
these toils killed the subject of the study before studying.
But if all arts merge into one, as recent movement of Mix Media shows,
then the study of various arts should merge too into one by the
qualified investigator, who, if I may simulate Wiener, is " a
specialist in his own field but possesses a thoroughly sound and
trained acquaintance with the fields of his neighbours". The method
of Wiener and McLuhan is instructive for this expanded art study.

 (5)
Both McLuhan and Wiener jump around and float over many
demarcated zones, that have been off-limits for a single scholar.
McLuhan spits out James Reston, Al Kapp, African Village, Finnegan's
Wake, Korean alphabet in one breath. The almighty genius of
Wiener can fly over Bergson, Newton, Gibbs, Heisenberg, Cantor,
von Neuman, Hilbert, Gestalt, Maxwell, Leibniz, with jet speed.
In McLuhan sometimes the quotations is more *collage* than
logical demonstration. Pindar's "Kunst und Künste", Marlaux's
"Musee imaginaire", Yoshio Nomura and Blyth's work can be valued
from this point of view as tentative classic. But the radical
thrust in this direction will be as fruitful as cybernetics
it-self.

"Il n'est pas de mot qui vienne plus aisement ni plus souvent sous la plume de la critique que
la mot d'influence. Il n'est point de notion plus vague parmi des notion vagues qui composent
l'armement illustoire d'esthetique (:P. Valerie)
"American TV age is not "influenced by the African tribal age, but both have certain communica-
tions and a rather *correspondance symbolistique*" (end)

Typescript, Staatsgalerie Stuttgart, the Sohm Archive. Published in a slightly different form in *Institute of
Contemporary Arts Bulletin* (London, 1967); reprinted in *Nam June Paik: Videa 'n' Videology 1959-1973*, ed. Jud-
son Rosebush (Syracuse, NY: Everson Museum of Art, 1974), n.p.

Comparative Aesthetics—cybernetics of arts (1967)

Introduction (Norbert Wiener and Marshall McLuhan)

1) Cage and classics

 Cage and Hegel. Cage and Montaigne. Case and Heisenberg.

 Cage and Stirner. Cage and Korean pottery.

2) Zen and electronics.

3) Aesthetics of boredom.

 a) Oriental tradition. Indian cosmology-passive philosophy of
 china-space in Sung painting.-static court music in Japan
 and Korea(Gagaku-shijo)---to the progression of boring art
 to ritual art(Noh) and to ritual itself(tea) and the diffusion
 into the stylized everyday etiquette (Ogasawara-riu)-Kosugi

 b) European tradition.(Ennui). Baudelaire-Chekhov-Proust-
 Wagner-Satie-Ives Klein.

 c) American tradition. Gertrude Stein-Hemingway-Cage--Morris-
 Young-Dick Higgins-Fluxus-Jackson MacLow-Warhol-Primary Structu-
 re. (including base ball, life insurance , stock market & drug)

4) Mini Art and Japan

 George Brecht and Basho

 Ray Johnson and Issa

 Event as Hiaku theater (George Maciunas)

5) Art and technology

 from electronic music to electronic painting (difference & simila-
 rity)

 Seurat and color T V

 Possibility of medical electronic as an art medium(Lucier-Tenney-
 Titlebaum-Lienau-Paik)

 possibility of video taperecorder

 various techniques, used in 9 evenings festival

 various techniques, used in my own electronic art work.

6) Computer and Audio-visual arts

 Max Mathews-Jim Tenney-Peter Denes-Micro Noll-(Bell Labs)

 L.J. Hiller (Illinois)

 K.O.Goetz-Max Bense-Xenakis (Europe)

 my own idea and experiements (See attached paper)

7) conceptions of TIME

 India-Greece-Bible-Newton-Bergson-Gibbs-Hussearl-Heideggar-Sartre-
 Cage-Wiener-Stockhausen-(time series)

8) Conceptions of NATURE

 Jean-Jacque Rousseau-Theodore Rousseau-Henri Rousseau -Montaigne-
 Hindemith-Suzuki

9) <u>Theory of Confusion</u> in the oldest Chinese historian (Ssu-Ma-Chen) and
 the newest American historian (Arthur Scheisinger, jr)

10) Is pot an instant Zen ?

11) Communistic interpretation of Laotze.(from North Korean Source book)

12) Word composition in Finnegan's Wake and chinese characters.

13) Feldman's notation and Korean medieval notation.

14) Theater of symbolism.

 Sophocles-Allan Kaprow-Noh-Korean Mudang play.

15) non-professionalism in Bunjinga and Dada

Typescript, Staatsgalerie Stuttgart, the Sohm Archive.

Machine Show essay (1968)

1968-70. "The following essay was originally written for the catalogue of "Machine Show" at the Museum of Modern Art in New York, and was later broadened."

From Marx to Spengler, from Tolstoy to Tockeville, not a single prophet of the recent past predicted the greatest problem of todayparking.

 * * *

Vietnam war is the first war fought by computer

 and

 the first war lost by American.

 * * *

Niechtsze said hundred years ago....."God is dead."
I say now "Paper is dead.....except for toilet paper "
If Joyce lived today, surely he would have written his Finnegan's Wake on video tape, because of the vast possibility for manipulation in magnetic information storage.

 * * *

TV is as mass media as Sex.
Before Kinsey beautiful lady used to whisper to her neighbour, "My husband plays only one piece on piano...and always with one finger..." Kinsey wiped out this frustration and made the heresy to the authdoxy. TV-culture is in the pre-Kinsey stage at this moment. As wife was just a sex-machine for her husband (before), public is just the Pavlovan dog for the network (presently). The infinite potentials of TV, such as: two-way communication, audience participation, "electronic democracy though instant referendum" (John Cage)....is by far ignored or delicately suppressed.

 * * *

Radio Free Europe is interesting and informative, but the noise, which jams that station is also interesting and informative.enjoy both.
Jam your TV station and make it "Radio Free America."

 * * *

$$\frac{ABC + BBC - NBC \times PBC = \pm \text{ sorry}}{\sqrt{Cage}}$$

 * * *

Marshall McBird says....."Wind is moving the flag."
Marshall McButterfly says..."Flag is moving the wind."
Marshall McLuhan says...."Your mind is moving."

* * *

Plato thought the word, or the conceptual, expresses the
deepest thing.
St. Augustine thought the sound, or the audible, expresses
the deepest thing.
Spinoza thought the vision, or the visible, expresses the
deepest thing.
This argument is settled for good.
TV commercials have all three.

 * * *

How to de-educate the educational TV ???

 * * *

Someday there will be a TV commercial of a pill, which
does nothing. (The Atlantic Monthly)

 * * *

At least one silent TV station!!
 TV sound annoys me more than TV picture.

 * * *

Are we living at 459 West 25th Street, or 33 Avenue C, or
 69 East 69th Street ???
 or
are we living in Channel 2 & 4 & 7 and sometimes 13 ????
I would rather live in Channel Paris, Channel Moscow,
Channel Hong Kong and Channel Tel Aviv...constantly....

 * * *

Huntley-Brinklewitch ;;;................(Russel Connor)

 * * *

Every great idea started in the mimeograph machine.
Every great poet started in the little magazine.
But if the TV production costs stay as prohibitively high as
today, TV will be the most repressive medium ever in-
vented by mankind since Hierograph and parchment.

 * * *

Choice is........not a commercial TV or public TV.
 but
 relevant information in bad technique
 or
 irrelevant information in good technique...
"If movie is done technically bad......I know, it is true.

If movie is done technically good......I know, it is a lie."

<div style="text-align: right">--Norman Bauman (1968)</div>

Nobel Prize in literature (2002 A.D.)

 A video roman, which was directly recorded
 and multiplied on a video display unit and
 written by a novelist, who has not published
 a single book....hard cover or soft cover.

...if there is still something called Nobel Prize in 2002.

 * * *

There is about 100:1 price difference between seven color
offset printing and simple typesetting. But this 100:1 ratio
will be reduced to 1:1 in the video book device.

 * * *

Tolstoy spent 20 pages for the description of Anna Karenina
and Flaubert 30 pages for Madame Bovary....

 What they needed was simply a Polaroid camera.

 * * *

Who will benifit most in the coming picture phone age?

 Defense Industry?

 Call girl system??

 Video Baby Sitter, Inc.?

Anyway there will be many topless answering services.

 * * *

If you cannot stop the development of electronics (1929 Now)
 you cannot stop the development of nudity (Paradise Now).
One follows the other, as moon follows the sun.

 * * *

Seven billion dollar beauty business......what comes after
 body-painting??????.....body hair dyeing.
Guys will wonder more about girls standing in the subway
 in front of him......."Does she? Does not she?"

 * * *

Don't go honey noon to moon.

 * * *

Wall to wall carpet1940.

Wall to wall TV 1970.

 It is a reality through laser-TV and solid-
 state thin picture "tube." TV without a box
 is no longer TV, but a "video environment."

 * * *

"Venice is the most advanced city of the world...it has al-
ready abolished the automobiles." (John Cage, in 1958
Italian TV interview.)

 * * *

Everyn Wood Rapid Reading Institute:

47 times faster reading speed (Money back guarantee).
Can you watch 30 minutes Huntley Brinkley

 in 6 minutes 22.8 seconds??

 * * *

Socrates bemoaned before death: "I wish I had seen
"I Am Curious (Yellow)."
"I Am Furious (Green)." (Nam June Paik)

P.S. This essay is dedicated to the inventor of the paper
plate. English correction is Carlene Lindgren. Someday
Walter Cronkite will come on the screen and say only one
word and leave: "There is nothing new under the sun. Good
night, Chet!!"....20 minutes of blank and silence........

Essay written for the "The Machine as Seen at the End of the Mechanical Age" exhibition at the Museum of Modern
Art, expanded in *Nam June Paik: Videa 'n' Videology 1959-1973*, ed. Judson Rosebush (Syracuse, NY: Everson Museum
of Art, 1974), n.p.

Expanded Education For The Paper-less Society (1968)

This report is written during the first three months of
my tenure at Stony Brook, on a Rockefeller grant. The second
report will follow in May, 1968.

1. Instant "Global University" (see Note 1)

Suppose a girl in Kentucky wants to study the Japanese Koto
instrument and a graduate at U.C.L.A. wants to experiment with
certain Persian or Afghanistan musical instruments. How would
they do this?

The mailable television (i.e. video tape) would enable the
individual lessons for many subjects to be givenfrom anywhere to
anywhere. For instance, twenty different music students of an
American university could study twenty instruments of a Gagaku
orchestra, which exists only in the Japanese emperor's court,
using video tape, and then go on a concert tour to Japan dressed
in authentic costumes. This would be a major cultural shock
to the Japanese, comparable to that of Admiral Perry. This
technique applies in less spectacular, but more substantial fields.

There could be an Oxford-Stony Brook lecture change, a Yale
and Stanislawsky School (Moscow) drama lesson change, a Tulane-
Nairobi dance lesson change, a Yeshiva- Tel Aviv liturgy study
change, Berkeley-Stony Brook lecture links, a star-lecture cooperative
amongst eighty-six New York State university campuses, etc. In
order to evade a complicated foreign exchange problem, a barter
system of service should be created.

2. 97% of all music written is not printed, or printed early
enough for contemporary evaluation, performance and study. 97%
of all electronic music composed is not recorded, or not recorded
early enough for contemporary feed-back. A vastly unfavorable
gap exists for the composer, compared to the booming pop-op-Kinetic
art boom. Even experienced concert managers and performers have
difficulties getting materials from composers, who are often
 unreachable, whereas composers on their part complain of the
too rare performing chances. (See Note 2 - a desperate letter
from Sidney, Australia). A simple, inexpensive measure would
solve the whole problem. An information center for unpublished
scores and unpublished electronic music should be created, which
would provide a xerox copy, and a tape copy of musical pieces,
at the request of performers, students and organisers from all
over the world. The average time lapse of ten to thirty years
now existing between the completion of a piece and the publication
of its score or record could be shortened to only two or three
days, with a 95% cost reduction and an extension of the convenience
of "being published" to every composer in the world. Only one
librarian with a xerox machine would be needed for this improvement.

3. It is a blunder, bordering on a miracle, that we have no, or
very few, images and voices of the great thinkers of the recent past
on record, especially as the 16mm talkie was readily available.
For instance we have hardly a record of Hussearl, Freud, Proust,
Joyce, Kandinsky, Berdjaiev, Merlau-Ponti, Suzuki, Gide, Thomas Mann,
Schoenberg, Varese, Bartok, Mondrian, Dilthey, Witgenstein, Shaw,
Valery, Jung, Keynes, Buber - even Nietchze and Tolstoy lived well
into the film age, as did Thomas Edison himself. This negative
wonder is the biggest waste of instructional resources, if we
recall how much footage of late-late show movie and Hitler news
reel was filmed. Therefore, nothing is more urgent and success-
proof than to film the images and voices of aging great thinkers
of today, and yesterday, in sufficient and surplus quantity, who
might pass away any day, such as Marcel Duchamp, Jaspars, Heideggar,
Gabriel Marcel, Ortega Y Gasset, Lucasc, Toynbee, Radaklishnan,
Ernst Bloch, Niebuhr, Puller, Sartre and Russell. The interviewer
should be a qualified philosopher himself and the camera crew as
minimal as possible, so that Jaspars or Heideggar can talk as
naturally as "Chelsea Girls". An NBC or NET-style expensive
film technique is not only unnecessary, but may be harmful for
this subject.
b) America has 5,000 colleges, which require 20,000 philosophy
teachers. The shortage of qualified teachers of philosophy is
acute, especially at the junior community college level. This

discipline cannot profit much from automatic devices or computerized
quiz machines. The supreme act of "philosophieren" requires
a total involvement of the whole personality. Therefore new
information techniques such as video tape, film, audio devices,
loop techniques, non-linear printing techniques, light art,
stroboscope, medical electronics, brain wave transmission should be
used for the total conveyance of great philosophers' messages,
and for the stimulation of students' own "philosophieren" and maybe
for the preparation of post-McLuhan, non-linear, possibly more
iconographic and totally involved 22nd century philosophy. If
philosophy wants to recover the hegemony which it held for centuries,
the students of philosophy proper should also be exposed to today's
electronic situation, instead of to parchment philology.

Needless to say, Jaspars and Heideggar's own explanations
about themselves, which we have described above, would be a strong
means for qualitative and quantitative improvement of philosophy
education. This technique applies also to other humanities and
social sciences, in which personality and scholarship are
essentially combined.

c) Video tape reading aids can also be useful for major
philosophy classics in original language and English. IBM is
making a computer index of painting related to music. The same
thing could be done, if it is not already underway, about the
pictorial material on philosophy, although my idea of video tape
guides to philosophy is far from the mere accumulation of portraits
or birth places etc. In my next report I will go deeper into this
point.

4. The western music as a whole can be grasped as a many faceted
dialectic struggle between TIME (sound) and SPACE (notation and other
various visual elements). Therefore the impact of the video
tape recorder cannot be overestimated in composition (electronic
opera), musicology (the whole Eitner Lexikon on video tape for the
instant access to all the sources in Montpellier or Manheim) and music
education. Synchronized visual accompaniment to the sound track
on video tape (notation, written explanation and, ocassionally,
the performer himself) will enrich the study and appreciation
without disturbing the musical flow,while saving the teacher's time.
While the sound of the video tape proceeds, the following information
can be visible on the accompanying video part:

a) Medieval music
 source and modern transcription and musicological problems
 parallel with sounds (stylistic and development =
 e.g. plain chant --Tropus -- Sequenze -- Motettus) and
 Neumen problems ("The most authentic performance of

Gregorian chant is no more authentic than the Neo-gothic
church built in the 19th century" - Besseler)

b) Poyphonic music (13th - 17th century)
esoteric polyphonic techniques, indicated with arrows, etc.
Ockeghem's 32 parts fuge will be properly appreciated
for the first time in history in this way - also Bach's
Choral Vorspielen, Kunst der Fuga etc.

c) Classical music
thematic development, macro-form analysis, interpretational
problems, such as controversial dynamic, phrasing, different
sources, finger, batton, breathing, various stresses on inner
parts Marquanto, which often escapes untrained ears, etc.

d) Music of romantic era.
By following the proceedings of Leitmotiv on video tape,
program music can be restored from oblivion. Also text-
melody correlation (recent semi-sensation in musicology,
Professor Georgiades' "Schubert Lieder") and the deterioration
of functional harmony.

e) Seriel and electronic music.
Intellectual information concerning the total organisation
of whole parameter, frequency analysis, and technical
information of electronic sounds. In some Stotkhausen,
Boulez' music, the complexity of score makes the simple
following of sound with score very hard, and this "paper music"
(in a good sense) requires the paper understanding, since the
accurate performance is impossible.

f) Music Graphic
In this other kind of "paper music", sound and notation
are far apart so that the imaginary double play becomes
an integral part of understanding. The listener should
know that - e.g. Tudor pushes the middle C key for an
apple figure on Cage's piano concerto, whereas K-E Welin
go under the piano and eat a nut for the same symbol.
This feticism of ideas is piercing through Pop art, Mini
skirt and the Fortran block diagram and is a stylistic
criterion of 20th century culture. Following the score
in the indeterministic music is indispensable in the opposite
meaning from the deterministic music.

g) Event and Action music.
Often there is no way to make the notation of music except
by recording the whole performance. Stockhausen and Ligeti
suggested a film of my action music pieces (1959-61) to
be used as a score, which I rejected for a philosophical reason.
However, for many events music (which exists now in every
country in the world) such as Brecht, Chiari, Christiansen,

Hidalgo, Kosugi, Patterson, Schnebel, Shiomi, Tone, Welin, Young, video tape will be a useful supplement for their sketchy instructions.

h) Mix Media Music.

All opera, and all non European music are mix-media pieces. Video tape is the only legitimate way of study, except for the actual performance. For ethnological music, which broke the barrier of academy since the success of Ravi Shanker and Folkways Record, video tape exerts maximum power. E.g. the acoustical analysis of pitch and timbre (obertone, formant) should replace the outmoded, often insulting pentatonic transcription. Pentatonic is the invention of 19th century Europe.

i) The younger generation is increasingly visually inclined with more desire for the total and instant perception. How would the classic music, including the new serious music, fare in the age of ELECTRONIC VIDEO RECORDING?

The above experiments, plus more Utopian research, are preparatory experiments for this big question.

5. Most singing students finish their full college course without playing even once in the opera which they studied so painstakingly. This kind of half study turns them into half teachers. Acting in the opera should not be reserved only for the most talented. Following video Ersatz will enable singing students to taste the operatic situation with more than now, and to shorten the rehearsal time by ten to one, which results in the increased frequency of actual performances.

e.g. Traviata

1st film (or video tape) should be made of everything but Soprano part, and used for the soprano part rehearsal.

2nd film is made likewise without tenor part and used for the tenor part rehearsal.

3rd film - likewise without baritone

4th film - likewise without base.

Film can be projected onto four walls simultaneous to ease the acting lesson.

This method, which has already proven workable in the field of pop music, applies even more to drama.

e.g. Macbeth without Lady Macbeth

Hamlet without Hamlet

Romeo without Juliet.

A teenage Ophelia in Nevada can be a co-star to Lawrence Olivier's Hamlet via the screen.

This whole scheme will be much more effective, if 3-D Horography is once realised on the stage.

A simple chorus piece without one part would help the sight singing exercises and a string quartet without one instrument would cut out the rehearsal time and ease the traffic jam - slightly.

6. If revolution meant for Russians of 1920
 electrification
 then the revolution in 1960 means
 electronification ... mind to mind ... planet to planet.

But even McLuhan misuses and mixes up the words "electric" and "electronic", which have as much difference as tonal and atonal, much less the average academician. In order to focus the attention of the whole academic community drastically to this electronic situation, the following events are suggested.

a) There are more than dozens of TV stations in operation in campuses here and also, most likely, abroad. A contest of student TV stations should be held, which would attract wide attention from journalism etc.

b) In addition to the student house organ paper, the student body should use their TV station for news, commentary, etc.

c) In addition to the Year Book and graduation photographs, every student can make a short self introductory speech or act on video tape, which would run on TV in student restaurant or main corridor incessantly. The graduation book can be an Electronic Video Disc, if it gets popular. If we allot half a minute for each student, still we can show 1000 students for one day. It means every student (5,000) of Stony Brook can be on screen once a week, which makes the big public university as intimate as a New England prep school.

d) It is often said that in the big university the faculty and student body lack interrelation. This old song is again repeated in the recent Stony Brook incident. I urge a simple but effective solution. Important faculty members, especially the President and Deans, should make regular TV speeches or hold discussions with the student body and this video recording should be going on day and night at gathering points of students. A video recording system would also be allotted to students, so that they can also convey their answer to the higher administrative body. Many universities have a $1m. TV system, and currently it is no more than a 'sleeping beauty'.

e) French, German, Italian, Spanish, Russian TV should be shown constantly in the student gathering places. It helps language study (without strain), deepens global consciousness, (again the instant global university), and helps the study of journalism, political science, arts, economics etc. TBS (Japan) station had

a bi-lingual broadcasting system and we are making an enquiry about the present state of this experiment. This makes English speaking people understand one of the major TV stations of Japan. Another idea is to intercept Chinese Television

 in Macao or Hong Kong if possible, and show programs in the campus if possible. The copyright problem could be undercut if we concentrate on commercials etc.

f) I asked for the catalogue of educational film about music at Stony Brook, Lincoln Center Library, Columbia Teachers' College. The result was very poor. I was in several TV programs here and abroad, which are all unretraceable now, in labyrinth. I recall seeing several good music programs, which have high instructional content, which are all lost in the deep sea of TV stations. An international catalogue of educational film and video tape at least, on music, art and philosophy, should be made, or accellerated if in progress. Also a salvage action should be conducted on the remaining news reel of film including 8mm amateur film fragments of recently passed great thinkers, such as Schweitzer, Buber, Shaw, Camus, Suzuki etc., before it gets too late.

Internal and international exchange promotes efficiency, through the division of work, and the elemination of double work, which constitutes a main point of McNamara's new operational philosophy. (See Note 3). McNamara's method promises a successful application in the coordination of all Instructional Resources Centers in the New York State University, because surely they have many duplications. As businessman's capital should turn over as fast as possible, so academic resources should turn over as fast as possible.

An academic currency system (say, one NEWTON equals 5 skilled manpower hours) can be created in order to undercut the barrier of foreign currency control and differences of purchasing power, and the ox=cart tempo of budgetary offices.

"There were 61 global services in 1965 fall" (John Cage), and we will have one more now.

g) Last, but not least, I was happy with Richard Hartzell's opinion, that my electronic color TV experiments have instructional resource value.

Dozens of playabilities can be assembled to a console and can be distributed to Kindergarten or elementary school. Its educational effects:

1) Children are exposed to electronic situation very early.

2) My electronic TV shows various basic facts of physics and electronics concretely, such as amplitude modulation, radar, various scanning, cathode ray, shadow mask tube, ossiro scope, ohm's law, obertone, magnetic character, etc. and it is a very pleasant way to learn these important facts.

3) It gives the possibilities of electronic drawing. It is better
 than the light pen because my way is multi-colored and it
 provides much interaction with the air program.

4) Since my color TV is the unusual, unorthodox application of
 an every day commodity, this stimulates the kids for more
 original, less prejudiced thinking.

An attachment for 10 possibilities can be manufactured for form $200 -
$300. The cheapest 18' color TV set costs $244 retail, which
would sell wholesale for about $180. The total cost would be in
the range of $500.

7. Elementary music education is a fertile domain for the computer
assisted instruction, since it employs simple numbers, simple rules
with few exceptions, and little controversy on the basic facts.
The universities of Connecticut and Stanford have done considerable
research in this field (see Note 4) and I assume Illinois, Princeton etc.
have also made contributions to music education. Stony Brook should
adapt this programming and experiment to actual education, which
would often lead to the discovery of better solutions - but
o sometimes, the best use of the computer is no use of the
computer, since computer time will remain expensive, and a computer
is not portable, and standardization of computers and programming
is of the remote future. Therefore, purely electronic solutions
would be viable for certain simple purposes, although research
and experiment in computers should have priority, for many higher
reasons.

a) For automatic pitch detector for solfeggio, or absolute
 pitch training, combination of bandpass filters and or R-C
 resonance circuit will be sufficient. Automatic frequency
 controls can chow the deviation of intervals and pitches on
 magic eye. (Jim Tenney and J-C Risset's technical advice
 should be noted on this point, as well as general advice of
 Jim Tenney in all fields concerning computer-aided music and art).

b) A combination of punch card and specially wired key board can
 become a teaching machine of general bass exercise, score
 sight play exercises, etc.
 a) and b) can be massproduced and sold to every high school.

c) Jim Tenney suggested that whole harmony and counterpoint courses
 can be put on video tape with computerized answers. He is
 also trying to introduce electronics and computer programming
 to music and art schools as part of the regular curriculum.

d) Mr. Mathew's (Bell Labs) music console program.
 Everyone writes a poem or draws a picture, but few dare to
 compose music. This mysterious psychological barrier can be
 broken down by Mr. Mathew's epoch-making programming - that is,

a real time sound generation from the light pen on the cathode
ray tube score. It can be applied into Kindergarten to promote
their creative thinking and to detect their talent earlier. A
free composition class, like a free drawing class, can be
tried from a very early age, since this machine lets the
kids record their composition before every studying the
notation. It should also be tried at mentally retarded
children's schools and asylums for the insane.

1) composition means a new way for self expression, which
results in a relief of tension and favorable psycho-therapy.

2) it provides valuable data for many sciences (biology,
psychology, medical electronics, and brain research)

3) maybe we would find a man, who is as crazy as Gogh, but
as genial as Gogh. (A mentally retarded kid in Japan is
educated and promoted to a prominent painter .. Yamashita
Kioyshi).

e) Mike Noll (Bell Labs) last month completed a 3-D drawing
program (world first?) by which we can draw ACTUALLY a 3-D
figuration using the light pen, cathode ray tube, and
medium size computer. It can be useful for experimental
art classes, maybe for sculpture class, and drawing course
for engineering student and the teaching of solid geometry.
Both Mathew's and Noll's programs are adaptable to the present
facility of Stony Brook IRC. I personally feel that high
level applications like Noll's or Mathew's programming would be
more valuable, since it means the augmentation of new knowledge,
and creation of new art, whereas low level application, such
as sight-singing, or ear-training is just a money saving in
teaching yesterday's music. From a national point of view,
the former would draw much more favorable attraction to Stony Brook.

8. There is often a complaint made that a big microphone class
kills the personality of the teacher, but this technique can be
used in such a way that it not only amplifies the voice of the
teacher but also amplifies his whole personality. John
Brockman Associates Inc. and USCO used mix media techniques in the
promotion of Scott Paper company, with great success. It should
also be tried in education. (See Note 5).

9. How to prevent a slum kid, who would knock down even a teacher,
from breaking an expensive teaching console?

A live teacher is the combination of scholar (that is: data storage
and data processing unit) and personality (that is: a highly
versatile input-output unit). Presently the main job of Computer
Assisted Instruction is concentrating on the programming of central
processing units. But if Computer Assisted Instruction proves
to be economical and if it were to spread to mass education,
(which actually is the main goal of all endeavor), then how would

the console replace the stimulation, attraction, reproach and praise
of teacher's personality, especially to small children and unmotivated
and less privileged kids from bad neighborhoods? In the practical
application stage of CAI, this so called peripheral unit (input-
output unit, equivalent to teacher's personality) will become
actually as important as the so called central processing unit.
Who wakes up a drowsy girl, and who protects the frustrated kid
from breaking the high vacuum cathode ray tube, and who soothes
the intellectual scepticism which does not agree with the computer's
answer? Just at this point the high flying imagination of the
avant guarde artist should be mobilized and put to work, as Allan
Kaprow is preaching, and has been for the last five years, to
stone ears. Significantly enough, the President of Xerox announced
a parallel opinion (See Note 6). According to Mr. McColough,
70% of computer business and profit was made in the hardware
section, (that is the Central Processing Unit) in the past decade.
But in the coming decade this proportion will be reversed, and 70%
of the profit will be made in the so called peripheral unit (input-
output unit), in which Xerox will be more competitive with IBM.
The artist is the professional manipulator of mind, and we should
add our surplus imagination for this project. Medical electronic
devices to wake up, stroboslight, direct cinfluence of brain wave
wind-light-tactile (see Note 7) devices, certain noise-refrigerator
devices etc. can be added, plus an electro sleep generator, to
put a hopelessly sleeping girl to sound sleep. Serge Boutourline,
of Inter-Action Inc., is experimenting with several interesting
devices in this Input-Output problem. Even a robot should be
considered for first and second grade children.
10. In the age of information, the library of the university will
become, if this rude parallel is allowed, as active as the Central
Intelligence Agency in America. Therefore, besides the above
mentioned Jaspers-Heideggar films etc., the following archive
is suggested.
a) I found that used computer tape (half inch) is useable on a
Sony video tape recorder. Despite considerable loss in video and
audio, it is still functionable as a documentary and studying
aid, although it is far below the level of artistic and entertainment
use. Anyway, this enables one to record a one hour TV show for
$1, (a saving of 50:1 compared to new tape) - 10,000 hours tape of
1960's TV programs will be very valuable for the future. The
supply of used computer tape in Canal Street has dried up, but
an arrangement could be made between a big corporation and a
university, since every month much surplus and used tape is put out
of service from the computer. This cheap video recording
possibility will also make the recording of on and off campus
scenes easily executable.

b) Audio tape library.

I assume some institution is recording important radio stations,
such as WBAI, Pacific Radio, WNYC etc. If not, Stony Brook should
record these important documents of this century. In fact, Stony
Brook can record ALL the panel discussions in radio TV station etc.
It can be done cheaply.

c) Allan Bryant is a Princeton educated musician, who calls
himself a full time music collector and part time composer. This
ex-patriot has been recording on tape many broadcasts of New Music
on German and Italian radio stations since 1959. He has some
valuable world premieres and rare performances but I do not know
the present state of his collction. Although it has defects,
it is still valuable already and certainly will be valuable in the
future. Perhaps Stony Brook could buy this collection and
encourage him further, financially, to record more new music in
a more professional way. I reserve my final opinion until I see
Bryant's collection in Rome this summer. It is amateurish, since
he did it for his own fun.

d) Heinz Sohm, a dentist in Stuttgart, has a most comprehensive and
highly professional European Avant guarde Archive, from 1960 to date.
It is valued very highly among professionals.

11. New Use of Slide or Video Tape.

The feeling of environment and inner space is not conveyable
through books or movies, but many medium to small sized monuments
(smaller gothic church, Egyptian cave in Luxor, Stone garden of
Ryo-anji Kyoto, even Sistine Chapel) are smaller than a big pool or
a gym. Through the multi-projection of color slides on four walls
and ceiling the authentic feeling of these monuments is much better
reproduced than by other traditional means. For instance, in the
case of, say, Chartres, or the Stony Garden of Kyoto, the gradually
but constantly changing hues of colored windows or stone according
to the time of day and the weather might give more information about
the artistic content than a hasty trip with a noisy guide, especially
when the sound of the original church chorus etc., is played.
Perhaps we could even reproduce the whole Acropolis in the soccer
field. This project has considerable technical difficulties but
a company like the Disney Corporation could construct it with tents
and travel around various college campuses.

b) Slide-audio combination (or video tape).

A famous art work with various comments by many classical art
historians, such as Vassari-Stendhal, Goethe, Winkelman, Ruskin,
Pater, Woelflin, Dvorsak, Worringer, Berenson, Weidle, Sedlmayr.

c) Some literary works which are concretely related to certain
places or scenery can be recorded on video tape. In that way
students can experience a literary stroll with the guide of genial

description, learning a foreign language, e.g. Goethe's Italianische
Reise, Gide's Congo, Thomas Mann's magic mountain, Sartre's Bourge
as a model city of nausee, and Proust's French scenes, Basho's
Okuno Hosomichi etc.

12. As a citizen of Korea, a minority nation in the minority continent,
therefore necessarily a cynical observer, who picked up three Western
and three Eastern languages during eighteen years of wandering from
Hong Kong via Cairo to Reykjavek, I am particularly sensitive
about the East-West problem. Reischauer (former Ambassador for
America to Japan) called for the sweeping renewal of curricula on
this project, from elementary schools on, and surely East-West
communication is the biggest task of communications research.
A professor in Kyoto University wrote "If West knows about East
only one-tenth of what East knows about West, there will be no war"
(see Note 8).

a) The ambiguity of a Chinese poem and philosophy is better
explained on video tape than by any other means. Reflex pondering
and rich association of mental process, and calligraphical content
and style, original mandarine sound on soundtrack, etc. convey
the many parameters of a Chinese poem much better than the current
way of printing. This technique also applies to ambiguous French
poems of Mallarme, Valery etc. including original French reading.

b) 80% of the family planning job in India is the publicity job,
for which artists are best talented. The only way to reach an
Indian villager is through mix-media language, which is the avant
guarde artist's own language. Meanwhile a first class Ad-man would
never go to India to live and probably third class talents are
getting paid in India at first class rates and are doing third rate
jobs. Bizarro vision, unorthodox approach, rich imagination, and,
most important, a genuine love of India and a will to study and
admire Indian culture - all these make the artist a qualified
publicity worker for family planning, and probably more talent for
this work will be gathered among artists than among any other group.
A small experiment could be initiated in this direction. (See Note 10).

13. Research and Development, Operations Research, Cost Efficiency.
All these managerial propellers of post war industry are virtually
unknown in art and the interrelation of art and education. Allan
Kaprow has been preaching since 1964 that pure research should be
propelled in art and art education like it is in any other academic
field, and avant guarde-think-tank should be mobilized to vitalize
the often too cautious academic community.

Typescript dated February 1968, Smithsonian American Art Museum, Nam June Paik Archive (Box 14, Folder 6).
Published in different versions in *Radical Software* 1, no. 1 (1970): 7–8 and in *Nam June Paik: Videa 'n'*
Videology 1959-1973, ed. Judson Rosebush (Syracuse, NY: Everson Museum of Art, 1974), n.p.

Versatile Color TV Synthesizer (1969)

This will enable us to shape the TV screen canvas

as precisely	as Leonardo
as freely	as Picasso
as colorfully	as Renoire
as profoundly	as Mondrian
as violently	as Pollock and
as lyrically	as Jasper Johns.

In the long-ranged future, such as versatile color synthesizer will become a standard equiptment like today's Hammond organ, or Moog synthesizer in the musical field, but even in the immediate future it will find wide applification.

1) TV-tranquilizer, which is at the same time an avant garde artwork in its own right. As Time magazine quoted me with emphasis, the tranquilizing "groovy" TV will be an important function of future TV, like today's mood music at WPAT or WOR-FM.

2) Enormous enrichment of background scenery of music programs or talkshows, combined with sharp reduction in the production cost is especially effective for young generation's rock programs. Traditional psychedelic light show cannot compete with electronic color synthesizer as much as Ferrari racing car cannot catch even a good old DC-4.

3) This will provide valuable experiments for EVR, which would be aimed for more sophisticated or educational layer of consumer. Eg., what kind of visual material will accompany the vast repertoire of classical and pop music? People will be quickly tired of von Karajan's turtle neck or Beatle's long hair. The study of this problem cannot be started too soon, and it might end up by producing a new furtile genre, called "electronic opera."

Originally published in *Nam June Paik: Videa 'n' Videology 1959–1973*, ed. Judson Rosebush (Syracuse, NY: Everson Museum of Art, 1974), n.p.

Global Groove and Video Common Market (1970)

The Treaty of Rome (1957) was preceded by a decade of vocal
exhortions by prophetic statesmen like Robert Schuman, Jean Monnet
or Hallstein and tedious,tiresome, painstaking and prolonged negotia-
tions by the economists from six European countries. Many times
it was termed as hopeless, utopian or academic. But its result,
European Common Market, long dreamed trade free zone, surpassed
even the wiledst dream in growth and prosperity. England's trouble
is a well known fact.

Videoland on this spaceship earth resembles the
devided state of European countries before 1957. Many TV stations
around the world are hoarding [the deadstocks of] video-tapes totaling
a hundred thousands of hours and asking impossibly high price or
complicated procedure for some commodity , for which they have
almost no prospectus of selling at all. Or, this videoland, so-called
communications media, is so dis-communicativ each other that practically
nobody knows , what to buy , to import or export. Should video-culture
stay as devided, nationalistic or protectionistic as the block
economy of the Thirties, which amplified the depression,

instigated Faschism, and incended the World War II ?

World Peace and Survival of Earth is the public interest
Number I, and needless to say, public interest number I must be
the Interest number I of Public Television. What we need now is
a champion of free trade like J.F. Kennedy, who will form a
video common market modelled after the Eurupean Common Market
in its spirit and procedure which would strip the hieratic
monism of TV culture, and promote the free flow of
video information through inexpensive bartar system, or convenient
free market.

McLuhan's premature high hope for the Global Village via TV is
based on an obscure book, "The Bias of Communication," by H.A. Innis (1951),
which traced the origin of nationalism to the invention of movable type.
But ironically today's video culture is far more nationalistic than
print media. Eg : you simply cannot escape Camus or Sartre in a
book store. But when do you remember of seeing a production of
French TV recently ? Is it thinkable that a wonderful folks, who
delivered us a line of genius from Moliere to Goddard became suddenly
petrified in front of silver flick ? David Atwood (a director in WGBH)
reports a a contrary thing. or , TV cameras are following so
busily the latest spots of violence that kids, who take most education
from TV, would think that such noble countries as Switzeland or Norway
is a chunk of real estate lying somewhere in Milk Way or at best
beyond Madagascar. How can we teach about peace blocking out one of few
exsiting examples from screen ?..or, most Asian faces, we encounter
in the American TV screen, are either miserable refugees, wretched
prisoners or hated dictators. But most middle class Asians are seeing
essentially the same kind of clean-cut entertainment shows on their
home screens, as most American Nielsen families do. Did this vast
information-gap contributed to the recent tragedies in Vietnam ?
Were'n't those simple minded GI 's in Song My prejudiced even in the
slightest degree from All-American TV screen at Mid West before
landing to Saigon, which necessarily have all miseries of war-torn country.?
If yes, those accused G Is are also the victim of monistic TV networks
to certain extent. Don Luce (former director of the International
Voluntary Service in Vietnam with a ten years service record) notes :
Jazz was the first tie between blacks and whites.
Mozart was the first tie between Europeans and Asians.
Beethoven was the last tie between Germans and Americans during W W II.
Currently Rock music is the only channel between youngs and olds.
But the power of music as the non-verbal communication medium
has been wasted as much as the vast resources under ocean.were.
Therefore if we could assemble a weekly television festival,
which comprises all kinds of music and dance from every nations,
and disseminate it freely via proposed Video Common Market to the world, its

effect in education and entertainment will be phenomenal. Peace
can be as exciting as John Wayne's war movie. The tired slogan
of "world peace" will become again fresh and marketable.

Belive it or not, back in 1938 (!) Buckminster Fuller
defined the word "ECOLOGY", as follows :
"very word 'economics' springs etymologically from 'Ecology' meaning
: the body of knowledge developed out of the HOUSE. We stress not
housing but essentiality of comprehensive research and design".
..."The question is survival , and the answer, which is unit, lies
in the progressive sum-totaling of man's evolving knowledge. Ind-
ividual survival is identifiable with the whole as extension or
extinction" ("Nine Chains to Moon", 1938)

On the last Earth Day Ecology was treated as a temporary
face lifting or local anesthesia. But Ecology is not a "politics",
but a devoutful Weltanschuung, which believes in world design,
global recyclisation, the shift of our attitude from "you OR me",
to " you AND me", as Mr. Fuller, the guru of whole movement, never
ceases to emphasize. Global Groove and Video Common Market
 treats the root of pollution much more than one more conventional
 documentary on a lake or so.,
Let me finish this essay in a digital way :
The New York Times spends about 70 % of her important
pages to international coverage.
The New York Daily News spends about 7 % for the equivalent.
NET's average is near to the Daily News than to the Times.

Typescript dated July 10, 1970, Smithsonian American Art Museum, Nam June Paik Archive (Box 8, Folder 14).
Originally published in *The WNET-TV Lab News*, no. 2 (1973); reprinted in *Nam June Paik: Videa 'n' Videology
1959–1973*, ed. Judson Rosebush (Syracuse, NY: Everson Museum of Art, 1974), n.p.

Simulation of Human Eyes by 4-Channel Stereo Video Taping (1970)

dedicated to Shuya Abe (my great mentor)

The reason why the so-said "documentary" movie is often a tendentious interpretation of
reality is partially due to its techno-existential form. Its output is confined to one stripe
of film or video tape, one-way time, one vector-direction — therefore no space for space that is
randomness and freedom (which is one spectrum of randomness).

I always admired Emmett Williams, especially his stereo eyes (commonly called "cross
eyes") because cross eyes gives us more freedom. I suggest the construction of a four-channel
stereo camera-VTR (video tape recording) which would more objectively stimulate our eyes.

Our eyes are a very efficient combination of two different functions: (1) Freedom, wide view,
and (2) focussing, concentration.

In usual film-making process, the former case is the long shot; the latter case is the
closeup or zoom-up. But, alas, in most documentary film, the relationship of these two attitudes
is far from being ideal. Often the director of documentary film is so persuasive that, in fact,
he is imposing his view with skillful editing and powerful zoom-up.

If film or video tape is really becoming an extension of eyes, it should cease to be so imposing but should imitate as much as possible the function of **eyes** — that is, a very versatile combination of freedom and focussing, or closeup or long shot. I think the four-channel camera-tape complex will overcome the shortcomings of traditional camera or film-making style. One camera is confined to the front shot. The second camera scans the left side — the third camera scans the right side. The fourth camera scans the rear view and is occasionally used for focussing on one point. This camera group's angles have to be kept intact also in playback.

In talking with Steve Gillmore this afternoon, it came to our attention that the multi channel video taping might solve or shelve the difficulty in editing, which is a severe structural defect of video tape in comparison to film.

Nam June Paik
California Institute of the Arts
September 21, 1970

Originally published in E.A.T./L.A, *Survey* no. 6 (October 1970); reprinted in *Nam June Paik: Videa 'n' Videology 1959-1973*, ed. Judson Rosebush (Syracuse, NY: Everson Museum of Art, 1974), n.p.

Video Synthesizer Plus (1970)

Shuya Abe and I am stranded in Los Angeles without car...We miss New York's dirty subway... John Lindsay is a great man, who charges on 30 c for a refrigerated ride...Abe-san said "We are Darma-Monk"...Darma was so diligent for 9 years in sitting and meditation that he did not even go to men's room...the accumulated shit eventually melted away his limbs and Darma became to be loved as a Buddha without legs... this leg-less man's wireless transmission is all what TV is about today...and in coming carless society.

Video synthesizer is the accumulation of my nine year's TV-shit (if this holy allusion is allowed), turned into a real-time video piano by the Golden Finger of Shuya Abe, my great mentor. Big TV studio always scares me. Many layers of "Machine Time" parallel running, engulfs my identity. It always brings me the anxiety of Norbert Wiener, seeing the delicate yet formidable Dichotomy of Human Time and Machine Time, a particular contingency of so-called Cybernated Age. (I used technology in order to hate it more properly.)...In the heated atmosphere of TV-control room, I yearn for the solitude of a Franz Schubert, humming a new song in the unheated attics in Vienna...Ironically a huge *Machine* (WGBH Boston) helped me to create my anti-machine machine... this is a place to thank beautiful people there...Michael Rice, Fred Barzyk, John Folsom, David Atwood, Olivia Tappan, etc...you just never know.

Let us look back to the mid 19th century...most people were deprived of the way for self expression in the visual art. Only the selected few had the access to tools, such as oil paints or canvas and know-how. But the invention of camera changed the scene and made everybody into an active visual artist. The size of camera industry and art business illustrates the massive desire to create an artwork, instead of watching a masterpiece on the wall. Will this process repeat itself in the TV world? Will the network program become a wall painting in the museum and we active video creators and creating machine, such as video-synthesizer etc., become as big as Kodak, Nikon, Zeiss Ikon combined? If yet, will we be able to subsidize the ailing NBC or CBS from our tax-deductible portion of income...Dear Phyllis: don't smoke cigarette, and live longer to see our D-Day.

Paik-Abe video-synthesizer is a humble effort for this day, putting 1001 ways of instant TV making. We gave up High Fidelity but we won the Super Infidelity...adultery is always more interesting than marriage.

The "attraction" of drug experience to young people lies in the peculiar "ontology" of this unfortunate medium.

Generally speaking *art* consists of three different parties: (1) Creator (active-transmitter); (2) Audience (passive receiver); (3) Critics (judge or carrier-band).

Through this discrepancy, all the complicated contingencies in the art world, or art-pollution, such as vanity, school, style, intrigue, manipulation etc., come up to the scene. The dubious distinction of so-said First Class artist or second rate musician or minor poet etc., is also a result of this discrepancy.

But in the drug experience, all three parties are united into one. A kid who smokes a joint or so is at the same time creator, audience, and critic. There is no room for comparison and grading, such as "first class drug taker" or "second rated pot smoker" etc...This ontological analysis demonstrates to us once again that drug is a short cut effort to recover the sense of participation...and basic cause lies in our passive state of mind, such as TV watching, etc.

Can we transplant this strange "ontology" of drug experience to "safer" and more "authentic" art medium, without transplanting the inherent danger of drug overdose???

Participation TV (the one-ness of creator, audience, and critic) is surely one probably way for this goal...and it is not a small virtue...Not at all...

Originally published in *Radical Software* 1, no. 2 (1970): 25; reprinted in *Nam June Paik: Videa 'n' Videology 1959-1973*, ed. Judson Rosebush (Syracuse, NY: Everson Museum of Art, 1974), n.p.

Sonsbeek catalogue essay (1971)

'TV tortured the intellectuals for long time ...
it is about the time that the intellectuals torture TV ...' John
Canaday said something like that a few years ago ... it is
happening all over ... now artists are striking back TV both in
hardware and software.

Communication means the two-way communications. One-way
communication is simply a notification ... like a draft call.
TV has been a typical case of this non communication and mass
audience had only one freedom, that is, to turn on or off the TV ...
comparable to the freedom in concentration camp where inmates
had only one kind of freedom, that is, to touch or not to touch
the electric barb wire. My obsession with TV for the past 10
years has been, if I look back and think clearly, a steady
progression towards more differentiated participation by viewers.
In my first 'Electronic TV' show (Galerie Parnass, Wuppertal,
1963 March) I mainly manipulated the TV scan-line, which is the
prime mode of control in the technological society. I remember
of having spent a long evening with Joseph Beuys and Günther Uecker
watching 'Zen for TV', which consists of just one vertical
scan-line.

At the Bonino Gallery (1965) in New York City, I did two more
kinds of participation ... a rather physical one using a powerful
magnet and a delicate time manipulation using a Video Tape
recorder. In 'TV as a Creative Medium' (Howard Wise Gallery,
New York) and 'Vision and Television' (Rose Art Museum, organized
by Russel Connor) the video-transformation of self-portrait and
self-feedback taught me about the mystics of electronic media
and possibility of changing the interior space of future
architecture through wall to wall TV. From 1969 to 1970, I have
collaborated with Shuya Abe (a great engineer-artist) to make a
video-synthesizer, which would accumulate all my past experiments
into one playable console. It was generously supported by WGBH
Boston, a leading public television station in U.S.
This can grow to a video-piano at every household in the post-video
cassette age. People can create their own art and send it to
their friends through video-telephone lines and elevate their mood
by watching or attaching certain medical electronic gadgets and
control their own brainwaves in order to achieve an instant
Nirvana.
It is nog without sentiment that I show my TV at Sonsbeek, which
lies so near to Wuppertal and meet old friends ... Cybernetics
and Karma is <u>one</u> thing ... a network of Hetu-pratayaya.

Typescript of an untitled essay published in *Sonsbeek 71*, exhibition catalogue, ed. Geert van Beijeren and
Coosje Kapteyn (Arnhem: Sonsbeek, 1971), and reprinted in *Nam June Paik: Videa 'n' Videology 1959 1973*, ed.
Judson Rosebush (Syracuse, NY: Everson Museum of Art, 1974), n.p.

Binghamton Letter (1972)

<div align="right">nam june paik, 1972 Jan, 8</div>

Dear friends at Radical Software ·
Westerners pretend to be younger than their age...we Asians often pretend to look
older...My mother used to say, "I cannot wear such thing.. it would look too young".
People compliment to Bucky Fuller ..he is only 70 years young... Korean express
"I have <u>eaten</u> 40 years , or so .. John Cage, who has out-asianized himself
more than any Asians... certainly more than power-conscious Indian politicians,
prestige-conscious Chinese cadres, G N P conscious Japanese businessmen and super-
chauvinistic Koreans...(is it not about the time for Hippies to quit their Pseudo-
Hindu cult ?)... has managed to pretend to be older than his
age.

Commercial Break, No. 1
Nam June Paik is making a tribute to John Cage (a non-documentary)
for WGBH (with David Atwood) for John Cage's 60th birthday.

Now video makes our Time consciousness radically different. Between the 20's
and the 30's there is a gulf, a huge demarcation line more striking than
the turn of century line. It is more like A.D. and B.C. in the christian calendar.
the 1930's is alive everyday in our home screen as late late shows, and it will be
so for centuries to come,,,, where as 1920's is gone and gone...with wind but without
video. While watching many mediocre paintings of the 17th century at
Reijs Museum at Amsterdam, I suddenly realized that minor master's still-life and landscape
were not an artwork but merely a visual environment of that day...and so is our daytime
shows and latenight talk shows.... We don't watch them... they are just there
 TV to live with...

 (Commercial Break No. 2)
Some cable or public TV should air "TV to sleep with". . .
What comes after waterbed ??? Video-bed.
 Ralph Hocking and I are making a video-bed to sleep on.

The word "history" came into being, because our events were told and written
 down thereafter. Now history is being recorded in image or video. Therefore
 from now on there is no more "History", but only "Imagery" or "Videory".
 Eg : University should change their course name from "Contemporary American
History" to "Contemporary American Videory".

White snow at Binghamton made me nostalgic about cold cold night snow at
 Rose Art Museum (1970), when Phyllis Gershuny, very tall and pregnant, first
 told me about "videonewsletter", which she started with you...few people
took it seriously.. many even didnot bother to answer your questionnaries... but,
 Lo. behold... it is now a world-famous-Radical- Software... Last June Phyllis
Gershuny , with her baby, crawling and crying, came up to Cal Arts (L.A.)
to give a lecture with full of authority. Students admired her as a revolutionary,
who MADE it. it was a unforgettably beautiful scene... sorry, we could pay her
 only 30 $ from Disney Emperioum.. I felt like a pig... a small one.
It is about time that somebody writes a decent review on "Vision and Television"
(organized by Russel Connor at Rose Art)... the most important fact.. it is the
first art show, which attracted many dogs. Everyday quite a few dogs were waiting at
the door to get into the museum... and it was not a meat-Happening à la 1960's
Happening era,...but a cold, cool video show in 1970 January.... The reason was
clear later... About 100 TV sets were humming and zumming their 15.000 cycles
 horizontal Oscillation frequencies... and it is, though hardly audible to human ears,
the most attractive frequency range for dog's ear. Therefore 100 TV sets at Rose
art Museum must have sounded like Beatles at Shea Stadium and Mohhamed Ali at
 Madison Square Garden combined...to all unsophisticated country-dogs of Waltham, Mass.
 There must be a channel for dog on Cable... to soothe down the irritated dog's
 nerve living in a small Manhattan apartment... I will compose many "ultrasonic

lullabies" for dogs. and we will see many commercials for video cassettes
for dogs, as we see of cat-food commercials.

When communication satellite enables global TV in full swing, will CBS
carry cat-food commercials to hungry Bengali people ?

Commercial Break No. 3
John Cage comes up on the screen. and says
 "This is the newest Pill from FLUXUS Chemical Company...
 you swallow it.
 it tastes nothing...smells nothing...
 and does nothing".
 Joh n refused to do it on his program.

We are hearing so much about "Broadcast standard" in video.
 But the more important the content is, the technical standard tends to be
 less perfect ... Eg, CBS report on the dissenters in Soviet,..
 and many satellite relays, which tends to loose color sync often...

and finally MÓÓN LANDING
Moon landing's picture was way way below the F C C broadcasht standard.
Why did F C C not forbid the broadcasting of Moon landing?... it was a
 double standard. Moon landing killed so-said F C C standard in
 video-technology for good..... this fact is as important as
 moon landing itself. I heard it from Dan Sullivan,
a very competent chief engineer at Cal Arts video studio.

 Commercial Break No.4.
 skip

 Difference of the 50's liberal and the 60's radical is that the former was serious
and pessimistic , the latter was optimistic and loved fun. Who changed the society
more ??? I think, the latter. John Cage's refusal to accept "Serious" continental
 aesthetics and the rise of Happening, popart, Fluxusmovement signaled the
beginning of the Sixties. .. What will signal the Seventies ???
 needless to say.... "video".
 Video-Videa-Vidiot-Videology.
 Currently there is a danger that video becomes like "poetry", ..one guy writes,
 and only his immediate firends appreciate. ...I dont know, how many un-edited dull
 tapes I had to sit through politely.... We should be more conscious of the .situation
 that we are in the era of information overload and it means information-retrieval
 is more tricky than information recording..... Therefore one of Binghamton

experiment of Ralph Hocking, Ken Dominick, Bob Diamond, Shierry Miller is
how to compete with Walter Cronkite with half inch tape ??? Here I think,
my endeavour with video synthesizer becomes also important in seemingly
pure information exchange.

———————————————

Geisha s is the oldest Time-sharing device of male chauvinism.
Marriage is an instant Sex-access system.
Telephone is point to point communication system.
Radio-TV is a point to space communication system...like fish egg.
Ultimate goal of video revolution is the establishment of
space to space, or plain to plain communication
without confusion and inteference each other.

How to achieve this goal ?
it will need decades of experiments.
Douglas Davis' Hokkaidim event at Corcoran Gallery (last June) was so
far the most ambitious endeavour to touch this home base at one shot.
Nobody expected a hole-in-one, but it showed vividly that our direction
was right, workable... and many more experiments
should be done toward this very end.
What is art ?
is it the moon ?
or
the finger-tip, which points to this moon ?
Avantgarde art is the finger-tip and Hokkadim was a sharp
finger-tip.

———————————————

I am a Korean... I tend to pretend to look old... I am almost 39 and half
years old , still I am sloppy like hell...I hate perfectionist. Yukio
Mishima was a "perfectionist"... his death was a "perfect" mistake.

———————————————

(Commercial Break No. 5)
I am selling my loft at Canal Street.
2000 $ fixture. 145 $ rent.

———————————————

Paul Valery wrote in the thirties that a middle class French young man can
enjoy more material pleasure than Louis the fourteenth.
On the same logic, our brother in disadvantaged neighbourhood
can enjoy more visual pleasure than a middle class young man
in the thirties...Nowadays anybody can see 20 movies a week, which
nobody did in the thirties... The poorer people are, the richer
is their visual life....

```
                          Is is progress ?
                          Am I a pig ?

          _____

     Dear Radical Software :
                    It is only two and half year, since we all met at
          Howard Wise Gallery... and in video calendar, it looks like a last century.
             it means that we covered a huge terrain... Not any other art
                discipline did so well, as we did.... it is a time for
                   congratulation...   For myself,   I re-lived the excitement of
               early Sixties, when we made various Fluxus events and publication.
     I am deeply grateful for that... and I am lucky to have had the youth twice.
        and it is just a beginning... when we get "wall to wall TV," video cassettes,
       cable TV, 3-D color TV all lined up.... where will we be ?

                    Let's us live long.....
                                          as Marcel Duchamp did.

                                          [signature]
```

Typescript dated January 8, 1972, Smithsonian American Art Museum, Nam June Paik Archive (Box 7, Folder 9); reprinted in *Nam June Paik: Videa 'n' Videology 1959–1973*, ed. Judson Rosebush (Syracuse, NY: Everson Museum of Art, 1974), n.p.

COMMUNICATION-ART

Geisha is the oldest Time-sharing device of male chauvinism.
Marriage is an instant Sex-access system.
Telephone is point to point communication system.
Radio-TV is a point to space communication system...like fish eggs.
a lot die. a lot survive.

Ultimate goal of video revolution is the establishment of
space to space, or plain to plain communication
without confusion and inteference each other.
(From multiple points to multiple points (two ways)
How to achieve this goal?
it will need decades of experiments.
Douglas Davis' Hokkadim event at Corcoran Gallery (1971 June) was so
far the most ambitious endeavour to try to touch his home base at one shot.
Nobody expected a hole-in-one, but it showed vividly that our direction was
right, workable ... and many more experiments should be done toward this
very end.

What is art?
is it the moon?
or
the finger-tip, which points to this moon?

Avantgarde art is the finger-tip and Hokkadim was a sharp
one.

Norman Bauman, my longtime Lin-Piao, said to me flatly,
"Doug Davis' segment in Boston Symphony Video
Variation is BETTER than yours." I was as furious as MAO,
but Norman's plane did not crash at Mongolian desert.
Doug based the aesthetics of his
"better-than-mine-variation" on a complicated German
Formula, which reads:

$$\frac{-8^2}{8\pi^2 M}\left(\frac{a^2\Psi}{ax^2} + \frac{a^2\Psi}{ay^2} + \frac{a^2\Psi}{az}\right) + V(x, y, z)\,\Psi = E\Psi$$

But seemingly uncomplicated equation of Mr. Davis
*(published in **Arts Magazine**) impressed me as much as*
Schroedinger's. It reads:

Man=Media=Selection

STUDIES IN COLOR VIDEOTAPE II

Our chick sister in North Hampton would say, "Why artist bothers with communication, information, and media?" Discovery of art-forgery is 100 times bigger news than the discovery of new art well, listen to the hidden voice of our good old Baudelaire. Evis is nothing but a research on art and communication.

Correspondences

All nature is a temple whose living pillars seem

At times to babble confused words, half understood;

Man journeys there through an obscure symbolic wood,

Aware of eyes that peep with a familiar gleam.

This equation symbolizes our input-overload-situation and a guy with Madison Avenue office with 50 incoming telephones a day would have found this equation, and not me, a Canal Street hermit with two incoming telephone signals a day, of which one is from N.Y. Telephone company, which scares me of an impending suspension of telephone service due to backlog of unpaid bills.

We have the negative Logarithm of Malthusian Law in the ratio of Input signals and human perception or in the ratio of machine time and human time. In Malthusian England food supply did not increase as fast as the population growth. In Doug Davisian Amerika our life-space or sum-total of wake-up-time does not grow as fast as out exponential leap in the input signals to digest or process. A few adventurers in TIME, like Columbus was an adventurer in SPACE, tried to cope with it by simply taking UP-pills for having fun and not going to sleep for many years. A well-known fashion designer hardly slept for the whole decade of the sixties. Finally she took her life on her 40th birthday.

Ultimate and bloody irony of media is that the N.Y. Times, which hardly mentioned her in her life, suddenly came up with many thousand words obituary complete with prettiest picture instantaneously after her death. Where were all these ignored information sleeping? Electronic truth is that if you amplify certain signals, you ended up amplifying the noise component of the target-signal more than the useful information. Therefore the bigger the circulation (of a magazine), the worse is the quality.

Man=Media=Selection=Elimination.

If you replace Baudelaire's pre-Marconian "nature" to our pan-cyber-nated "video sphere", all words and insinuation of the symbolistic poem becomes a "clear-cut definition" of what artist should be doing today as the aerial antena of this society. We have million bits of UFO daily and Radar is nothing but a two-way Television. The second stanza of the "Correspondence" is even more profoundly 70-ish. and it almost predicted what Doug Davis would do in that unforgettable evening at the Corcoran Gallery and Channel 9 TV in Washington D.C. on the wedding night of Trish Nixon. Hundreds of Cadillac assembled and black-tie-chic went into wedding. Hundreds of hippies came on foot, bicycle, and on battered school bus to Corcoran, which is annexed to the wedding hall. For next 30 minutes whole Washington youth community were magnetized with plane to plane information flows---Baudelaire wrote the review in advance as follows:

Like endless echoes that from somewhere far beyond,

Mingling, in one profound and cryptic whole unite,

Vast as the twin immensities of night and light,

So do all colours, sounds and perfumes correspond.

As stated before, the malaise of our time is the balance between input and output ratio. 40,000 commercials are hitting us yearly, according to the statistics, but we can afford to buy only 40 of them. Consequently we create an artificial output unit, eg lying on the bench of Psychiatrist and TALK...like a goldfish. Since I cannot afford that hobby either, I spend two hours daily in toilet,---pants down---and read 8 weekly magazines, 4 monthly magazines and 3 daily papers. I enlarge my output unit, or electronically speaking, I lowered the impedance of output. In a recent FLUXUS event, organized by Maciunas for Ben Vautier, he handed out Ex-Lax chocolate

(plain-wrapped) without warning to participants. Ben spent his last 24 hours of U.S. stay in toilet. It is my interpretation of Doug Davis' another brilliant piece, in which viewers are encouraged to look at only the backside of TV set. Voila, look at the beautiful asses of French Can-Can dance at Moulin Rouge....

But here a super-natural transfiguration has happened.

What you see, is the mystical glow of 60 cycle pulsation only...Norbert Wiener's enigmatic aphorism, "Information with content is as important as the information without content" is finally artistically proven. It is a mystique of communication-art on the level of Charles Baudelaire and Ray Johnson. Sigmund Freud, who started also with an us-psychology, reached to the "sublimisation of impetus" in his later years, a problem unsolved by his death.

Perfumes there are as fresh as children's bodies, springs
Of fragrance sweet as oboes, green and full of peace
As prairies. And there are others, proud, corrupt, intense,

Having the all-pervasiveness of infinite things,
Like burning spice or resin, musk or ambergris,
That sing the raptures of the spirit and the sense.

Orginally published in *Douglas Davis: An Exhibition Inside and Outside the Museum* (Syracuse, NY: Everson Museum of Art, 1972), n.p.; reprinted in *Nam June Paik: Videa 'n' Videology 1959-1973*, ed. Judson Rosebush (Syracuse, NY: Everson Museum of Art, 1974), n.p. Collection of Everson Museum of Art.

Media Planning For The Post Industrial Age (1974)
Only 26 years left until the 21st century

Telephone has been around over 100 years and has influenced almost every aspect of our life. However, according to Kas Kalba of Harvard University, only two essays have been written about this important subject during this time while countless studies have been conducted about some dead language in Maya or Babylonia. Television's influence in our life is equally prevalent, and the average American is spending 6.5 hours daily in front of this small box. However, it is still a chic thing to say "I don't watch TV," of "I don't own a set."

Is this attitude a harmless snobbery, which we all relish discreetly, or an alibi for cynical defeatism? What price did we pay for this intellectual hautesse?

1) Many New Yorkers take it for granted that Public Television comes on channel 13, but this is not so in other parts of the country. In more than half of the American cities and villages, including such important Metropolitan area as Los Angeles, Washington D.C., Philadelphia, Pittsburg, San Diego, etc. Public/educational TV stations are operating on the inferior UHF frequency band, such as Channel 26, 56, 44, 86, etc, which are very difficult to tune in, and if somehow tuned in by tinkering with the circular knob, reception is so bad that proper appreciation

of the TV programs is quite difficult. Subsequently, in those UHF
areas, high quality programs on Public TV channels, including day-
time childrens programs, televisions are largely wasted, resulting in
the loss of millions of dollars every year. How was such a grave
handicap imposed on the important public/educational TV, while up
to seven strong channels are allocated to commercial TV, often showing
nothing but 10-year-old reruns of "I Love Lucy?"

Who is to be blamed? No one but the liberal establishment and
their traditional indifference toward communication media other than
prints and books.

In the late 40's the FCC announced that any qualified company
could be awarded up to five channels on the strong VHF band, such as
Channel 2 or 13. However, hardly any intellectual community paid at-
tention to this small magic box. They could have occupied one strong
channel in every community almost free of charge. How much would it
cost now for us to buy VHF TV licenses (such as channel 13, 9, or 7)
in the 120 areas in which public TV is now operating on the weaker UHF
educational stations? Easily $30 billion or more - the price we are now
paying for this intellectual alofness toward TV.

Lord Thompson, newspaper king in Britain, once remarked that a
television license was a license to print money. Recently the Washington
Post paid $34 million to acquire a TV station on the VHF band in Hart-
ford, Connecticut which, by the way, has its public/educational TV on
the inferior UHF band. If it costs that much in Hartford, how much
would it cost in the more populous cities of Los Angeles or Washington
D.C? Valuable VHF bands are occupied by commercial interests just as
valuable park land has been asphalted by the mindless real estate de-
velopers for the "suburban-exurban sprawls." It is by far not enough
to care about physical environment such as air, water, and greenery.
Mental environment is equally important. Mind pollution is as bad as
air pollution.

History will repeat itself if we don't plan the future carefully.
two people bought the franchise right of a cable TV station in the same
town - Hartford, Connecticut - for $50 in 1967 and sold it to a cable
company for three hundred thousand dollars recently.

2) 1974 is the world population year. Finally a communication
satellite will beam educational TV into 5,000 villages in India. How-
ever, one sixth of the Indian population is living in the big cities,
which need not be covered by expensive networking via microwaves. A
few populous Indian mega-cities could have had inexpensive educational
TV with a heavy accent on population control as early as the 1950's,
and community TV sets in the street corners or in mobile vans could
have absorbed the minds of entertainment-hungry masses like a sponge.
There is no reason why media waited 20 years for this, because South
Korea, quite poor and war ravaged, entered into the TV age back in the

50's. How much difference would it have made to the 100 million people in urban India for the past 20 years - the critical period of the population explosion?

Research has shown that population control is a complex socio-economical communication problem, which can neither be cured by purely medical solutions nor simplistic slogans on billboards and Madison Avenue-style commercials. Deep and long-term persuasion need a medium as complex and versatile as television.

3) A peculiar sense of history is happening in our consciousness of TIME. The 30's are alive every night at home on the late, late shows. Whereas the 20's are gone forever. Since this unbalance is bound to continue and accumulate indefinitely, someday a demarcation line between the 20's and 30's could become as distinct as Gothic and Renaissance. However, what kind of visual resources have we inherited from the 30's? again the complete neglect of audio-visual language by the academic people in the past made us lament the loss of enormous educational resources. We spent countless feet of films on Class B Hollywood movies and the Fuehrer's newsreel; however, we somehow managed to miss the film recording of almost all of our great humanists, thinkers, and artists, such as Husserl, Freud, Proust, Debussy, Ravel, Joyce, Kandinsky, Berdaiev, Merlau Ponti, Gide, Mann, Schoenberg, Dilthey, Wittgenstein, Shaw, Jung, Keynse, Schumpeter, Einstein, etc. Future generations might think that the 30's was the age of only W.C. Fields and the Marx brothers.

4) Major problems of today, such as energy, ecology, balance of payment, population, and multi-national business practices are essential global problems which require global thinking and treatment. So is our century-old prayer for peace on Earth. Even before the age of the communication satellite, TV has been a potentially important tool for international understanding. It is a super-Esperanto, which can skip language barriers through meta-verbal expressions. How much have we used this medium for the workd peace during the past 30 years?

TV cameras are following so busily the latest spots
of violence that kids, who receive most of their education
from TV, think that such noble countries as Switzerland
and Norway are chunks of real estate lying somewhere in the
Milky Way or at best beyond Madagascar. How can we teach
about peace while blocking out one of the few existing ex-
amples from the screen? Most Asian faces we encounter on
the American TV screen are either miserable refugees,
wretched prisoners, or hated dictators. But most middle-
class Asians are seeing essentially the same kind of clean-
cut entertainment shows on their home screens as most
American Nielsen families. Did this vast information gap

contribute to the recent tragedies in Vietnam? Weren't
those simple-minded GI's in Song My prejudiced, even in
the slightest degree, by the All-American TV screen of the
Mid-West before landing in Saigon, which necessarily has
all of the miseries of a war-torn country? If yes, those
accused GI's are also victims of monistic TV networks to a
certain extent. Don Luce, a former director of the Inter-
national Voluntary Service in Vietnam with a ten year ser-
vice record, notes: "American failures in Vietnam have
been essentially failures in communication and understanding"
(Introduction: Senator Edward Kennedy, from <u>Vietnam: Un-
heard Voice</u>, 1967 Cornell University Press).

5) Certainly TV has contributed to much of the stupidity and
evil of our decade, but its hidden benefit should not be forgotten
either. Since 1946 the number of movie-goers weekly has been decimated from
78 million to 17.9 million in 1972.* If we had not invented TV, movie-goers would
still be storming to the Time Square area and parking and causing con-
gestion, which, unbearable as it is today, would have multiplied
manifold. Luckily, TV has decentralized our entertainment pattern to
the home screens so that various evils connected with congestion, such
as parking, pollution, juvenile delinquency, violence, sexual offences,
*statistics from the Motion Picture Association of America.
and even group-racial flare-ups have been contained. The benefit of
TV is so omni-present and at the same time so invisible that even the
most adept ecologist forgets to be thankful for it.

6) Due to poverty and high illiteracy, many children in dis-
advantaged areas had hardly any access to information before the TV
age. The advent of television broadened the horizons and aspirations
of poorppeople beyond the confines of the plantation and ghetto walls.
Maybe this is why South Africa bans any TV, even today.

An authoritative study conducted in 1970 by Robert Power, director
of the Bureau of Social Science Study for CBS, revealed the extreme
importance which black people attach to TV culture. As reprinted here
(printed in detail at the end of the article), 65% of the black people
questioned found television <u>important</u>, whereas only 26% of the while
people said so. TV is informative for 61% of the blacks (32% of the
whites), and <u>relaxing</u> to 62% of the blacks (29% of the whites).

This study allows the interpretation that TV is a major source
of education, information and entertainment for black people, and it
is even more significant because there had been hardly any such oppor-
tunities for black people before the advent of the TV age. Anything
TV gives them is a pure plus, whereas TV is often a replacement for
something already existing for white people.

It was not until the mis-sixties, however, that the liberal establishment started to employ this new tool for the improvement of the racial situation, and in this neglected time lapse of 15 years, there has been much tragedy.

Now we are standing at another point in history, when bussing has failed and the effort for integration is being questioned. Television power, an integration and understanding on the air, can be even more useful, because it can skip the dirty, complicated earth. I wonder what would happen if a two-way cable television link connected two pre-school day care centers in white and black neighborhoods, and children from the two cultures would start to play with each other through cable TV without the strain of bussing and its negative effect. Is this an escapism, a hypocrisy, or a first remedy for the long-term cure of the racial problem? In any case, technology is here waiting to be used with much less expense than bussing.

TV as a mass entertainment medium is slowly but steadily approaching a complex juncture.

The double jolt of ecology and energy crises questioned the validity of an economic system based on cheap energy and high growth. Still, however, very few people realize that these two revolutions meet on a profound plateau.

The mass entertainment TV as we see it now will be divided into, or rather gain many branches and tails of, differentiated video cultures. Picture phone, tele-facsimile, two way inter-active TV for shopping, library research, opinion polling, health consultation, bio-cum-munication, inter-office data transmission and many other variants will turn the TV set into the expanded mixed media telephone system for 1001 new applications, not only for daily convenience but also for the enrichment of life itslef. This is the so-called MINI TV, an information flow for and among limited numbers of special interest groups via video-cassettes - video discs, pay TV and cable TV - equivalent in printed form to Xerox copying machines, academic hard-cover publications, mimeographs, and posters.

This mini and midi TV will merge with many other paperless informa-tion forms - audio cassetts, telex, data transmission, domestic sattelite, micro-fiche, private microwave - and eventually the laser-optic carrier band. They all will form a new nuclear energy in information and ociety-building, which I would call tentatively "BROADBAND COMMUNICATION NETWORK." Setbacks in urban cable companies retarded considerably the coming of this new nuclear energy. A recent article in the New York Times, however, says as follows:

Whether cable will become a medium unto itself, instead of an aid to television reception, has never been a question; the question has always been when. Optimists still predict it

will happen in the nineteen eighties; pessimists give it longer,
some not until the 21st century. (March 10, 1974)

Even if we take the most pessimistic view, the 21st century is
only 26 years away. The fact that the plight of the VHF frequency
band and public/educational TV is the direct result of misplanning
exactly 26 years ago, demonstrates beyond any doubt that planning
for the BROADBAND COMMUNICATION REVOLUTION must start NOW.

Investment by U.S. industry in communication is already $13.9
billion, which is 7.5 times bigger than its $2.58 billion investment
in automobiles, trucks, and parts put together. (1974 est.: source:
New York Times, November 25, 1973.)

If the liberal establishment continues to ignore media and communi-
cation and leave it to the mercy of purely commercial capital, govern-
ment agencies, or computer-analysts, all hardware will be again monopolized
by some mysterious power complex and the result might be a super-watergate.

It may not be purely coincidental that watergate is a "communica-
tion game" from start to finish; two ececutives from an ad agency, bugging,
walkie-talkie, Sam Ervin topping soap operas in Nielsen ratings, an 18-
minute erasure, secretary's long telephone call, acoustic analyst, in-
stant analysis, super spy as a best seller writer, and so on. Contrarily,
well managed revolution will become a backbone for the post-industrial
society while reducing pollution and energy consumption as follows:

1) Transportation and communication are considered generally as
two separate issues, however, we have to ask first WHY people travel.
People travel to communicate something, either for profit or pleasure.
In the case of pleasure driving, they are, in fact, subconsciously
communicating with themselves via machine, since few have the courage
to scrutinize into their deep selves. The frequency of travel will
reduce if the need to travel reduces. What we need is an Ersatz (sub-
stitute) technology to travel, and broadband communication is the
strongest candidate for it. The Economist of London (January 1974),
a publication not known for an easy enthusiasm, states as follows:

Above all, the greatest of the three main transport re-
volutions since the 1770's is now speeding towards us. It will
clearly replace the internal combustion engine revolution as
dramatically as that revolution replaced steam, and it happens
to be extraordinarily energy-saving. This great new transport
revolution is telecommunications. Because the businessman's
future essential tool, the computer, talks to other computers
by telecommunication, instead of by taking a walk, much of
present business travel and then personal travel to work are
going to become unnecessary in the main growth jobs in post-
industrial societies. Even in the 1970's some of this travel

willbe replaced by a great growth in telex transmission, fac-
simile transmission, by telecommunication, picturephone, etc.
As there is no logical reason why the cost of telecommunica-
tion should vary with distance, quite a lot of people by the
late 1980's will telecommute daily to their London offices while
living on a Pacific island if they want to; and temporary
price rises for oil-driven travel in the early 1970's will-
now bring a few of these habits forward.

The University of Southern California at Los Angeles, supported by the
National Science Foundation, is investigating the possibility of
tele-COMMUTING and its implications in urban life. Jack M. Nilles,
its director, estimates that

> . . . the monetary costs of telecommuting, using technology now
> available, are about the same as those for commuting by private
> automobile and will decrease relative to private auto commuting
> as gas prices go up and computer associated technology gets less
> expensive. An initial finding, he said, is that the average Los
> Angeles commuter uses the equivalent of about 50 kilowatt hours
> per day driving to and from work in his private car. This com-
> pares with a cost of two kilowatt hours per day used by a modern
> computer terminal and telephone line. For more information on
> this study, contact Mr. Nilles at 213/746-7464. (ETV Newsletter,
> March 4, 1974)

Peter Goldmark, retired director of CBS Lab, and Douglas Davis,
editor of art and architecture for _Newsweek_, are also advocates of
tele-commuting. (_New York Times_, November 11, 1973 NW)

2) WGBH, Boston's public TV station, has fundraising auctions
twice a year, and it is not only their most popular program, but reaches
to the proportion of a city-wide festivity. This demonstrated that TV
can function as a department store. A large mail-order concern is using
rural cable TV as a supplement to their catalogue output, and someday
benefits in ecology and energy will be noticeable.

3) Recently, there has been a steep rise in apaer prices, which
would cast a negative effect on press, education and culture. Even
without the paper shortage, it is an ecological sin to chop up so many
trees to print junk mail, when we have alternative ways of informa-
tion storage and dissemination. The whole Encyclopedia Britannica
can be printed on a tape of 30 minutes or less, and every day news-
papers can be fully recycled by printing on magnetic paper via cable
TV, and underground video artists can make a living making the com-
mercials for the corner supermarkets. Reduction of junk mail and
direct ads alond will seriously take the burden off of the beleaguered

postal system. Fuel saving in trucking the heavy papers in newspaper distribution and postal service will also be significant. Tele-communication has a peculiar advantage. It takes the same amount of money and energy to send a message to four families or to four million families.

4) Daniel Bell, noted sociologist at Harvard, published an interesting chart on the "General Schema of Social Change" in his recent book, The Coming of Post Industrial Society (1973). This entire chart deserves careful scrutiny and contemplation.

chant to be inserted here

According to Professor Bell, "manufacturing goods," the dominant economics of the Industrial society, will be replaced by "SERVICE" in the post industrial society. "ENERGY," the main technology of the Industrial age, will yield to "INFORMATION" in the post industrial age. Moreover, "GAMES BETWEEN PERSONS" will be the chief design of the post industrial society and our "AXIAL principle" will no longer be "ECONOMIC GROWTH", but "CENTRALITY AND CODIFICATION OF THEORETICAL KNOWLEDGE." Professor Bell cites the following criteria as further features of the post industrial age: health, education, research, government, abstract theory, simulation, models, system analysis, future orientation, and forecasting, etc.

What is the largest common denominator running through all these criteria? It is again nothing but a cerebral amalgam of media, communication, knowledge and information, which will function as substance, lubricator, impressario and cybernetic interface in the future society

5) The prognosis on the ecological doomsday and the proposal for the zero growth economy (eg. by Club of Rome, etc.) has met stiff resistance from business and some economists (eq. Milton Friedman, etc.). Many ordinary citizens also prefer later ecc0-crisis to immediate recession. The two positions, however, are not unreconcilable. Not all economic activities are EQUALLY energy consuming or polluting. For example, a $10,000 expenditure on two big cars, plus maintenance costs, is incomparably more energy consuming than a $10,000 expenditure on a painting. A $400 vacation to Miami (jet, car rental, heated pool) for a week's vacation is far more taxing to energy and ecology than buying a $400 stereo system, which can be enjoyed for many years.

A $100,000 production of a PBS drama (enjoyed by millions of people) is not more energy consuming that a $100,000 private airplane, enjoyed by one man for sport. Yet both sets of activities contribute to the GNP in the same way. Instead of blind worship of the GNP, we must subdivide the GNP into two categories, one with a high energy-ecology facotr, and the other with a low energy-ecology factor. If we promote the latter case in economical activities, we can combine high growth economy, energy independence of America, and preservation of

the environment harmoniously. In addition to the blind sum-total of the GNP or the Per Capita Income, we have to also measure this same index divided by the energy-ecology factor, which reflects the long-term welfare of the individual and the nation.

Will low-energy GNP be big enough to support the whole economy? Daniel Bell's prophecy (a high information-low energy sector as the dominant force in our post industrial society) is butressed by a comprehensive study of art and artist by New York State Senator William T. Conklin. According to this report, artist and art institution contributed $1 billion to the New York State economy. This is no baloney. One billion dollars is as much as the revenue of a whole state the size of Maryland, Virginia, or Tennessee.

If we also add up the ripple effect of this $1 billion to adjacent economic fields such as real estate, restaurants, hotels, fashion, and advertisement, the following excerpt from a recent editorial of the New York Times (March 4, 1974) becomes fully justifiable:

> New York's cultural activities are the cornerstone of a vast range of businesses that reach to the very heart and reason for the city's existence. Its arts and entertainments are one of the bases of its identity, supremacy and attraction, not only for individuals, but for the corporations that are its financial lifeline. The improvement of cultural operations and funding is essential.

This is not a local New York phenomenon. John Kenneth Galbraith echoes the same opinion and even amplifies it for future forecasting:

> Over a longer period of time the arts and products that reflect artistic accomplishment will, for the foregoing reasons, be increasingle central to economic development. There is no reason, a priori, to suppose that scientific and engineering achievements serve the ultimate frontiers in human enjoyment. At some point, as consumption expands, a transcending interest in beaury may be expected. This transition will vastly alter both the character and structure of the economic system.
> They (arts) will also be an expanding part of economic life. The opportunities for enjoyment from artistic development have no visible limit; they are almost certainly greater than those from technical development.
> But this expansion would be much greater were the sources of our present attitudes on art, science, and technology better understood. The arts now have an infinitely smaller claim than science and engineering on both private and public resources. This, we have seen, is the result not of public preference,

but of conditioned belief. People - including artists them-
selves - are persuaded to accord importance and priority to
what is within the competence and serves the needs of the tech-
nostructure and the planning system. (pp. 68-70, Economics &
The Public Purpose).

Conclusion

The Depression of the 30's was fought back by bold public works
and capital expenditures such as the TVA, Rockefeller Center, and high-
way building. Especially massive interstate highways have become the
backbone of economic growth for the last 40 years. New economic dis-
locations caused by the double shocks of energy and ecology and the historical
necessity for the transition into post industrial society require
equally radical remedies. This social investment must also be economi-
cally viable. These remedies should modernize the economical infra-struc-
ture, make American economy internationally more competitive and con-
tribute to the long-lasting post industrial prosperity.

A vast new industrial comple surrounding the broadband com-
munication network will be one of those much needed stimuli; also,

almost limitless new video programs will be required to fill empty
channels on cable TV; empty cans of video discs and cassettes will
keep new incoming generations busy for a long time. Since video
video programs have little room for automation, employment will stay
on a high level for an indefinite period, especially for the educated
worker.

For the same reason, boredom with conveyor-belt jobs, the symbol
of the past automotive age, will be minimal, and many people will
find renewed and continued pleasure in their work. The present import
of foreign video equipment would not affect the balance of payment for
too long, because America is destined to be a huge exporter of video
programs, as it has been in film and music for the past half century.
Its impact is not only economical but social and political. As a
Korean growing up in Seoul in the 30's, Shirley Temple was the first
name I heard and retained in my memory - before any Korean or Asian
name, including my father's. Repackaging and translating tens of
thousands of old Hollywood movies for the whole world will be a new
industry in itself.

The building of new ELECTRONIC SUPER HIGHWAYS will be an even
bigger enterprise. Suppose we connect New York and Los Angeles with
a multi-layer of broadband communication networks, such as domestic
sattelites, bundles of co-ax cables, and later, the fiber-optics
lazer beam. The expenses would be as high as a moon landing, but
the spinoffs would be more numerous. Long distance telephone will
become practically free. Multi-point color TV conference calls with

sophisticated input-output units will become economically feasible.
While not energy consuming in maintenance, (except for the initial cop-
per), it will cut down air travel and snarling airport-downtown limou-
sine service forever. Efficient communication reduces social waste
and malfunction in every corner, resulting in exponential savings in
energy and ecology. They will cease to| be just an Ersatz or Lubricator
but will become the springboard of unexpected new human activities.
One hundred years ago Thoreau wondered: Even if the telephone company
succeeded in connecting people in Maine and with people in Tennessee,
what would they have to say to each other? The rest is history.

 Before indulging in this Utopian script, however, we have to de-
fine a concrete program which The Rockefeller Foundation can immediately
embark on with its limited resources. I suggest that we choose a
professional sub-group as a prototype model and study their com-
munication needs carefully and experiment with them in depth to-
ward the application of the new broadband technology in all facets
of their social activities and measure their contributions to
energy, ecology, and efficiency factors.

 This prototype model will be applied to other professional sub-
groups later. Toy salesmen, golf teachers, insurance men, cancer re-
searchers, food distributors, the HEW Department - anyone can be in
this prototype group. I, however, would choose artists, not only be-
cause I have some professional stake in this, but also for the following
reasons:

 1) In recent history the artist's instinct has often functioned
(sometimes better than the computer) as an early warning system for
forthcoming social change.

 2) The artist is by definition a specialist in trans-media
manipulation and meta-verbal languages.

 3) Artists have already invented a brand new art genre: "Video
Art."

 4) John Kenneth Galbraith predicted over-average growth in the
art-related market.

 5) Artists don't work on a union scale - overtime and doubletime -
yet they are as a group more creative than, say, a shoe salesman's
association.

 The French anthropologist, Claude Levi-Strauss, said, "Culture
is (a) network of communication." American anthropologist Bateson and
psychoanalyst Ruesch go even further:

 "Values are . . . simply preferred channels of communication
 . . . as soon as interpretation of message is concerned, no
 clear distinction can be made between communication theory,
 value theory and anthropological statements about culture.

This combination of features is the medium in which we all
have to operate: therefore we call it social matrix."

The history of the 60's has shown us what the interrupted com-
munication, the so-called credibility gap, can bring to the social matrix
and value system.

So far the Ford Foundation has spent about $250 million Public
television for the past 23 years and will spend $50 million more in
phasing out its commitment to public TV. The Rockefeller Foundation's
expenditure to TV has been $2.8 million for the past 12 years, and
their grants are distinguished for their future-oriented investment.
It has funded three experimental centers at the three best TV sta-
tions in the country (KQED in San Francisco, WGBH in Boston, WNET in
New York) while giving high art education to millions of viewers. It
has also succeeded in expanding the outer limits of this medium. The
invention of Paik-A be and the Steve Beck video synthesizers show that
artists can compete with big corporations in hardware design, with
very minimal capital. It is the first step toward the humanization
of technology - the utmost necessity for our survival.

Another big goal is how to cut the prohibitive TV production
cost ($2,000 a minute) without sacrificing the quality. Experimentation
is still going on, and with positive prospects.

Further funding included the following ventures: Two conferences
have been held concerning video art at the Museum of Modern Art, New
York, and at the Everson Museum at Syracuse. Global Village people
went to Bangladesh and experimented with villagers about the efficacy
of video as an intra-village communication tool. The Alternate Media
Center at N.Y.U. is experimenting with new applications of video to
medicine, and the Aspen Institute of Cable TV held an important con-
ference on this theme last summer.

How are other countries doing? NHK (the Japanese public TV/radio)'s
budget is only 10 times bigger than American public TV, but the real
difference is much bigger, because the NHK has been getting this sort
of money for the past 40 years - since the radio days. The accumula-
tion of resources in many forms is formidable. Herman Kahn was quite
right when he ascribed Japan's excellent educational TV as a main
reason for her quick post-war ascendancy.

Undated typescript, Nam June Paik Estate. Published as "Media Planning for the Post-Industrial Society,"
report prepared for the Rockefeller Foundation, 1974, reprinted in Klaus BuBmann and Florian Matzner, eds.,
Eine DATA base/Nam June Paik (catalogue for the Paik exhibition in the Venice Biennale, 1993) (Germany:
Edition Cantz, 1993).

Input-time and Output-time (1976)

The more I work with Video, the more I think about Lessing's distinction of Space art and Time art in the eighteenth century. Video is preemptive. If you are watching NBC, you cannot watch CBS...or if you are watching Ira Schneider, you are not watching Frank Gillette (or vice versa). Napoleon said, "You can always recover the space lost, but you can never recover the time lost." Time is a very limited commodity. (Oil is also a limited commodity because you need geological time to produce it, unlike corn or rice.) A rich collector can buy up big space and fill it with many paintings. However, he cannot add even one single second to his lifespan. The poor and the rich are equal before death. Time is money, according to folk saying, but time is actually the inverse of money. Modern consumer society found out that the more money you have, the less time you have. (Compare a farmer in Mexico and a swinging couple who shuttle between Fire Island and the East Side.) Likewise art lovers do not mind strolling the vast space in the Hirschhorn Museum or Norton Simon's Pasadena Museum, viewing hundreds of mediocre paintings, but they refuse to sit through even a single stretch of a mediocre film or play...they get up and leave...and even tell their neighbors to avoid that film or play....

Much confusion about today's video art comes from the lack of categories to distinguish

"good *and* boring art"

from

"bad *and* boring art."

Boredom itself is far from being a negative quality. It is rather a sign of aristocracy in Asia. And again this confusion stems from the confusion about INPUT-time and OUTPUT-time. In the overzealousness to counter the CBS-type entertainment, or in order to preserve the purity of information or experience, some video artists refuse to edit or to change the time-structure of performances or happenstance. In other words, they insist that INPUT-time and OUTPUT-time be equal. However in our real life—say, live life—the relationship of input-time and output-time is much more complex-- e.g. in some extreme situations or in dreams our whole life can be experienced as a flashback compressed into a split second (the survivors from air crashes or ski accidents tell it often)...or, as in the example of Proust, one can brood over a brief childhood experience practically all of one's life in the isolation of a cork-lined room. That means, certain input-time can be extended or compressed in output-time at will...and this metamorphosis (not only in quantity, but also in quality) is the very function of our brain, which is, in computer terms, the *central processing unit* itself. The painstaking process of editing is nothing but the simulation of this brain function. Once on videotape, you are not allowed to die...in a sense. Three artists, Paul Ryan, Shigeko Kubota, and Maxi Cohen, videotaped their fathers before death. Videotaped death changed their relationship to death. Video art imitates nature, not in its appearance or mass, but in its intimate "time-structure"...which is the process of AGING (a certain kind of *irreversibility*). Norbert Wiener, in his design of the Radar system (a micro two-way enveloping-time analysis), did the most profound thinking about Newtonian Time (reversible) and Bergsonian Time (irreversible). Edmund Husserl, in his lecture on "The Phenomenology of the Inner-Time-consciousness (1928), quotes St. Augustine (the best aesthetician of music in the Medieval Age), who said "What is TIME?? If no one asks me, I know...if some one asks me, I know not." This paradox in a twentieth-century modulation connects us to the Sartrian paradox "I am always not what I am and, I am always what I am not." On my recent trip to Tokyo I bought dozens of books about TIME by Oriental and Occidental thinkers. On my return to New York, I found out that I have NO TIME to read them.

Originally published in *Video Art: An Anthology*, ed. Ira Schneider and Beryl Korot (New York: Harcourt Brace Jovanovich, 1976), 98.

Interfacing two different media

[handwritten annotations: relationship of boundry regions / The Research into the problem of between boundard. / or as described by N. wien / complex problem of the between many diverse elements such / there]

Interfacing two different media , eg music ad visual arts, or
hardware and software, Eastern aesthetics and Western Avantgardism
[handwritten: electronia and human perception,]
[handwritten: for]
...these multiple interfacing concern and ability system-interfacin.
has been my major task , since I started working in the electronic
music Stdio of West German Radio Station in Cologne (birth place
of electronic music) with Karheinz Stockhausen in 1958.

For the past one year as an Artist in Residence at TV lab, WNET,
I have continued the research and devlopment in this familier
and furtile terrain .

1)Introduction of Digital Computer into video-synthesizer.
 (In collaboraton with Bob Diamond) *[handwritten: digital]*
 GeneYoungblood said in the Expanded Cinema that Computer
and Video is the two most powerful tool of today, yet the full-f
fledged digital computer has not been used in any video synthesizer
today. (includeing the machine existing at "computer Image Cor-p
poration). Therefore certain form of marriage of computer and
video can bring forth mare marvel and at the same it will
provide the vast future *[handwritten: for]*
[handwritten: will] open up the vast new terrain to be explored by many dozens of
artists and engineers, as my past achievement in the video synthe
sizer design.

 Acually
 Actually I have done some research on this
line back in 1967 and 68 under the guidance of Max Mathews and
Michael Noll at Bell Labs on the capacity as "Residential Visitor".
However I didnot incorporated digital computer into the design
of Paik-Abe Video Synthesizer at WGBH in 1969, because at hat
that time most computers were not movable , therefore impossible
to move into TV studio. Time sharing basis was also m impossible
because usage of telephone line makes the output speed inadequate
for the xix on line (istant) pictre generatioN.

However the rapidly advancing computer technology made the intro-duction
of digital computer into the video art quite plausible and economically
viable. Beauty per Dollar ratio will be much more favorable than
traditional color video production. This is not the automation in
traditional sense, which is aimed to cut personals in doing the same
job. Our goal is the adverse of it. Since computer-video will open up
a vast terrain of new beauty and new demand in market for the untapped
beauty in the wide open channels in CATV and video cassettes, which
is experiencing the lack of materials in order to fullfil new
technically open field, The success of digital computer-video will
create much me many new jobs for artists, engineers and marketting
en businessmen. This will certainly create a new chain reaction
for more diverse computer-video synthsizer, and as in the case oof
video synthesizers, more competition will create simply more good will
and more beauty, because new possibility in this terrain is wide wide
open like in the case of Wilde West. Even though we might stagnate
in the short periode(which is high unlikely), our experiment will
greatly benefit the late comers, because the merit of any computter
research is that it is so "systematized" that every work done by
th predecessor, whether t it is successful or not, will give benefit to
the successor. As a mater matter of fact Boolean Algebra, the
starting poitnt of today's binary computing system was found by
George Boole, who died over hundred years ago. My initiative in
this field will certainly spur other video-art researcher into this
new field and will start a healthy competetion. Due to its immense
possibility, there will be little duplicaion each other. As you see,
since I published my first video synthesizer on May 22 1970, we
see half dozens of different video synthesizer and all are quite
different and our friendship is quite beautiful, inlike otar fielld
other field, because road is wide open, and theere is room of
one more dozen of different video aynthesizer. I was very proud

in Washington's media conference on December 2, because Ron Hays
played my machine...if machine were to survive, it has to be niv

has to be universally applicable... like automobile, which
anyone can drive føɪx to anywhere. Paik-Abe videosynthesizer
ia the only video synthesizer which has been used cross country
(Boston, New York, Binghamton, Chicage, Los Angeles) by more
than 100 artists.

Bb Diamond was born in New York City 26 years ago and went to
Bronx C Science High School, Brookline Poly-tech. and had worked
ih the New York University Computer Center and at Control Data
Corporation. He worked at Binghamton Experimetal TV Center
for the past two years and helped building the Video synthesizer
eing installed at WNET TV Lab. He has favorably impressed
V David Loxton and John Godfrey. His job at Control Date was
in the lntorfacing of Interfa Harware and Software.

He is quite qualified to pull it through and he is a creative
tinker. *Increasing the study*

There is another spin-off of this research. Inorder not to be
(Computer) dominated by computers in the future society, everybody should
master somewhat of basic computer basics and eg. InDartmouth
College , computer is taught as a part of liberal art at
undergraduate level. Cohination of minu computer and
very beautiful color TV screen, which can be programmed by student
, will make a most effective teaching machine for computer, *student to learn*
art, and fundamental man-machine relationships. I spent two
days in 1970 at Man-Machine Lab in M.I.T. who was experimenting
with video delayline, which avantgard artist did in 1966.

*Increasing more and more students are learing computer
programing as a part of liberal art study at undegrad level.*

Typed text with additions in pencil (6 pages), 11 × 8½ in. Smithsonian American Art Museum, Nam June Paik
Archive (Box 15, Folder 9); Gift of the Nam June Paik Estate.

Feedback Americana

Edwin H. Armstrong, an undergraduate at Columbia University
invented Feedback circuit back in 1913. It took 50 years for society
to findout what it means. Feedback circuit is a special device,
which recycles and amplifies the incoming signals (or, past)
through a few micro second delaylike and give out a clearer
output signal (or present). Therefore its phenomenological structure
has certain affinity to the consciousness of history,
"Nostalgia"... a pendulum between past and present. Electro-
nically speaking, Nostalgia is nothing but a sweet-sour homeopathic
feedback circuit of extended delayline.

There is a mythe, that TV is an "instant" medium, where as metal
sculpture is a "permanent" medium. The ironical fact is that many
of huge metal sculpture is being destroyed due to
lack of storage space , and fragile electronic information has been
kept for the eternity due to convenience in storage and retrieval. Eg the ,1920's is gone forever
but the 1930's
is alive everyday in the late-late show TV screen. This phenomenon
is bound to continue for a few more decade, and one day the demarcation
line between the 20's and the 30's will be as distinct as B.C. and A.D.

Feeback is not only the favorite technique of video artist
but it expresses the essence of ART ingeneric term. The cult of
eternity , long levity, preservation of cultural heritage
have been a primary function of art and museums from the time of
Pharoach's Pyramid to the age of Polaroid and Port-a-Pak
of school, because we are all fragile and
mortal.

> "Elle est retrouvee
> Quoi ?... l'eternite.
> C'est la mer
> Allee avec le soleil. (Rimbaud)

In consultation with friends at a foundation, which is preparing
projects on American heritage for the Bicenteniel celebration
I am undertaking following program projects, which
will utilize the peculiar medium of video, which can jump back
and forth the TIME, as well as Space.

1) Recycling the hidden visuel resources through advanced video-tecni
 que. (in Collaboration with Jud Yalkut, New York based independent film maker.)
 Tens of thousands of beautiful prints and graphics often in
 color have been kept in major libraries and museums. They are
 all copyright free. Using new video technique, such as matting
 keying, an animating through two live cameras and
 video synthesizing and computer switching, we can make

attractive video arts presentations of these historical American

heritage, it will be better in quality cheaper in p. cost

It will not have them appearance of traditional educational film

but rather of a many faceted feedback, because the color print, which is beautiful

in itself will be counterpointed with the status of same location

at present time. Result will be parceled out for 5 minutes

segments, which can be telecast at midnight, just before the

sign-off of PBS stations. Jud Yalkut and I are undertaking

the New York part only for the telecast as

midsummer night's dream in August through channel 13,

and Mr. Norman Lloyd suggested that it can be extended to

old prints from various other Eastern Cities.

2) Audio Visuel heritage

When General Eisenhower was coming back from Europe after

V-E Day, his portable radio on the transatlantic airplane caught an radio commerical , while

approaching on the Canadian Coast. This radio commercial

made him feel that he was back home finally. This episode drasti-

cally demonstrate the importance of our audio-environment in influen-

cing our subconsciousness. However university's academic circle is

so dominated by print-journalism that proper attention has not

been paid to the audio environment of the past 50 years. Likewise

in any celebration of American Heritage for the bi centinel celebration

the rediscovery of forgotten cultural good in the golden era of

radio, especially many serious radio dramas written by

talented playright is an essential thing, because one feature of

American culture is the emergence of mass culture through new technology, which draws a

fascinating locus in complicated con-and-pro- relationship with

so-said serious high culture.

WGBH and Boston Symphony demonstrated in the "Video Variation",

an interesting video accompanyment can be put together along the

classical repertoire of music. Can we do it on the sound track of

classical radio drama pieces? "videonisation of 50 years quintessence

of our verbal audio environment"? On19th January 73, I made the

live video accompanyment to the famous radio drama

of Orson Welles' "War of the World". There were about 130

sophoisctated audience and responce was quite encouraging.

Radio drama can be re taped inexpensively using young director

and actors, or old vintage tapes can be cleared for the re-broadcasting.

In any case, it is a huge cultural resources, not to be left in

oblivion. Video part can be varied from abstract

to real and sur real, in counterpoint way

Undated manuscript fragment, Smithsonian American Art Museum, Nam June Paik Archive (Box 15, Folder 9).

Why is Television Dumb? (1976)

Why is television dumb? There is only one reason, because television does not have random access.

For example: Encyclopedia Brittanica. It is very big, very long, but nobody says it is boring. Whereas television that length is (considered) boring. In Encyclopedia Brittanica you can go to 'A' or 'M' or 'P' or anything with equal facility, evenness. Whereas with television you are the prisoner of time. You must go in order from 'P' or 'M', you have to read all the letters (to get to the one you want). That is only one reason why television is dumb. There is no other way. And when television becomes a major technology, an information input/output system, then we are getting more and more dumb...

I think the best technology, information, has to do with education—our thinking. Especially in the next century when gasoline becomes three time higher than now, all non-energy consuming activities will become major activities, like video game. In that way, in the post industrial society, the cerebral activity will become the major thing and information centers will become the core. Not only (do) I say that but economists say that too. All art is the same thing. For instance, I got a chance to write a paper for a foundation and the foundation was talking about limited growth. The problem is how to combine economic growth with non-growth in the energy consumption. And they can combine (the two) because not all economic activities need to consumer energy. For instance, for $100,000 you can by an airplane which one man can ride n and pollute the air. Or for $100,000 you can buy a Jasper Johns painting and benefit the economy just the same. It hardly pollutes anything, just a small corner. It is better for society to reach men by a $100,000 Jasper Johns painting than by airplanes and still it is one man's consumption. With $100,000, when we produce a PBS drama, we can serve many more people with the same amount of energy consumption. So in this information dissemination (of television), the energy consumption is the same whether you send it to four people or four million people...

We grew up in the number technologies. Harmony and the 12 tone. Everything is numbered. However, when I go to an art school and try to reach artists the tone, the beauty in numbers, it's very hard. No artist wants to deal with that. They think numbers are impure. However with musicians, you know, it's all numbers. Now, one video disc can contain 54,000 pages. That one video disc can contain 54,000 pages means about 20 volumes of Encyclopedia Brittanica. Its pages don't have to be written. It could be a full color slide...(This) is a very big benefit for photographers. This is the first time photographs can have mass communications. (Do you know) who bought the first disc, the first customer? The CIA. With 200 machines they can take pictures of everybody living in the world. It's better to know about that...

We can live because we can forget. If we can not forget the past then we end up in the insane asylum, the mental hospital...Because, however, of videotape, we are not allowed to forget. The past is always there. Once on videotape, you are not allowed to die. It is there all the time. What this has done to our history of consciousness and is very interesting. For instance, now the old television stations (are saving may of) their old videotapes. The French television (stations) have about ½ million videotapes in their archives. (This is true) even with the artists. In the last seven years, if all the tapes that were made were put together they would last longer than 100 years maybe. So, if one wanted to have a PHD in video art, he would have to spend his

entire life just watching the artists' tapes. So the artists who are to survive, say in the 22nd century, would be the buys who knew how to make short tapes. So when we make videotapes, we must keep in mind that other people must be allowed to eat and go out and take a walk...It's not a joke, but historical consciousness is now a very different thing.

...Video makes new relationships. In New York couples split all the time, but the video couple never splits because they can not afford to split because they have only on machines between them. I don't want to be pedantic, but the mathematician Poincare (he was) a turn of the century French guy. At the turn of the century they were inventing new things. Then Poincare said we were not discovering anything new, we were just discovering new relationships between that which was already existing in the world. Working in video, consider it working in relationships. I consider it (the creation of) relationships because you can stop and retrieve it...

*Jules Henri Poincare. French Mathematician, 1854-1912.

Originally published in *Hindsight II: A Record of Events* (1978), accompanied by a note reading "Excerpted and edited from a talk given in conjunction with the showing of videotapes by Nam June Paik, on November 11 & 12, 1977."

Random Access Information (1980)

We have a thing called art and we have a thing called communication and sometimes their curves overlap. (A lot of art does not have much to do with communication and a lot of communication has no artistic content.) In the middle there is something like an appleseed, and that is our theme—maybe our dream, too. When we look back on the history of communication, the problem until recently has been how to record information At first people recorded on clay plates or in stone Before that "plus" information was memory, "minus" information was forgetting, and if we do not forget ... we cannot record. There is a Chinese anecdote which says that there are these things called dreams. In the "plus" reality we have lots of frustrations. In dreams we have the same thing but in negative pictures, where the "minus" is discharged, and becomes zero a balance of plus and minus. Now there are two problems. First with electronic memories. We are not allowed to forget if we remember everything, or much too much. We get an *idée fixe* and become paranoid. Then we have to go to an analyst (or artist) and be discharged. The thing with videotape is that we now have too many recordings. But the biggest problem is for video curators When you are a curator of painting or sculpture, you can look at thousands of works a day. But in video everybody makes 30-minute videotapes, because Sony makes 30-minute video cassettes. So the video curator has to look at thousands and thousands of hours of videotapes.

This problem with video is not in the recording, but in the retrieval. Richard Leakey had several ideas that impressed me. One is that, for the past 50 million years, human beings have had color perception but before that, monkeys used to be like owls. They were night people. Monkeys used to sleep during the day and walk around the forest at night. Then about 50 million years ago, monkeys came out of the forest to the edge of the woods and became daytime animals. As soon as monkeys became daytime animals they perceived color pictures which leads to an interesting conclusion. The reason artists stay up late is because artists are more like monkeys— closer to roots. (It makes sense that artists are closer to the monkey than to the businessman.) Another extension of Leakey's ideas is about the honeybee having color perception. The reason flowers have color is to attract the honeybee If the honeybee did not have color perception, by a

chance of God or by mutations, then all the flowers would be black and white. (It is very nice to imagine black-and-white flowers throughout the world, for the shape of flowers would be much more exquisite than now.) The flowers would have to attract the honeybee by shape alone, not color.

Video is a very crude model of life. It is like doing your own anthropology, because through video you learn about life. For instance, before I worked in video, I never thought color was a function of time. People think that when you make a painting, you draw upon random access to color. You paint red here, or yellow or blue, choosing this or that. But when you look at nature, every season has its own colors, like light green. It starts out with light green, then April and May have lots of different flower colors, and summer is very blue. Autumn goes from yellow to red, and then winter is gray. Video colors were made on exactly the same principle. I think it was a genius, an artist, who designed the video color system. In television there are no pictures, just lines. It is like weaving. The difference between weaving and television is that television is constantly weaving and that image can always be rewoven and woven again according to new patterns—that is how I designed a video synthesizer. Television also goes faster. In the '50s a group of RCA engineers produced television with only one line. Because television space does not exist, all spatial information had to be translated into lines and dots with no width, so that the signal could be transmitted, without wires, on a single channel. They also had to put all colors into that line, so they devised a kind of social contract. There is one wave that is called the color sub-carrier wave, which is one second divided by three and a half millions. Although they are already very short, they are again subdivided by many phases: e.g. seven phases represented by rainbow color bars. The first one-seventh of this short distance is called blue: the next one-seventh of this wave is called yellow: the next one orange: then magneta etc This circuit opens and closes very fast (21 million times a second), passing the colors in sequence. As in nature, in television the succession is very, very fast time makes color. It is a social contract. When you make films, you dye the chemicals with nature, through the lens. But in television there is no direct relationship between reality and the pictures, just code systems. So we got into time.

According to Plato, the visual arts are said to imitate nature. Music supposedly imitates the song of a bird or according to Ambrose the rhythm of working. What video imitates is the time component and the actual process of aging. For instance, when you work with video or audiotape, at the beginning it decreases very slowly, and by the end of the tape it decreases very, very quickly. Everybody has that experience. When you look back on your own life, you see that when you were a child, the days were very, very long. At around the age of 30 or 35 the days get faster, and after 40 the days get faster still. Our time consciousness, how we experience the passing of time, is exactly like a tape. It is not new or unnatural that time consciousness imitates tape reels because tape has the same structure as trees. So tape imitates trees, and we imitate tape reels.

It was Shigeko who invented death for video.

When you look back to music at the turn of the century, before the invention of the record as a multiplication system, only classical musicians like Beethoven and Schubert, were known beyond their own villages. The vast industry of popular music did not exist. However in different villages popular music existed as folk songs, which were never heard outside the village boundaries. Today classical music makes up only a small part of the music world, and to most people music means pop music The quantitative relationship of classical music and popular music got turned upside down by the invention of the "record." Earlier there were a few geniuses like

Scott Joplin, who invented a musical style suitable to multiplication. Joplin and other musicians thought about multiplication from the beginning, during the process of composition. (It is rather strange because no painter thinks while painting, about what his painting would look like in a color slide, even though the NEA panels often choose their grantees from color slides.) Scott Joplin was much more influential than Schoenberg, and even Mantovani was more important than Schoenberg in terms of social structures. You cannot put Schoenberg's music into an elevator. Who will be the Scott Joplin of the visual arts when the visual arts are made for television in the next century? This will happen because art is the oldest form of communication.

Many people make big painting, but only a few get transported, because artists and dealers do not make very much money. The people who make the money are all of the transporters and insurance people. It has been like this since the '50s. Now, with the onset of the energy crisis, sculptors and big color field painters have to be very well known to have their work shipped around the world, and even for them it is getting harder and harder. There was a joke going around that the organizers of Documenta were going to drop all Americans, and show only West Europeans in Kassel, in 1982, to save money on freight. It is a concrete problem. Someone like Scott Joplin surpassed Schoenberg because he systematically made the music to be shipped out.

The artist who will make it big in the next century will be the one who is capable of programming big paintings into transportable shapes, because the energy crisis will go on and on until the year 2050. If we succeed in fusion in the year 2050, we can again paint big old paintings and make big sculpture like Rodin. But nobody is sure about it, because we still have not reached the break-even point in fusion research.

The artist's job is to think about the future. Now, future projection is very difficult. Herman Kahn, the best-known futurist, failed in two major areas. In 1967 he published his study of the year 2000. A lot of foundation money was spent to make this book, but when the book came out in 1967, Kahn had not even mentioned ecology or environmental pollution. In 1967 the hippies were making a big thing about ecology. Kahn, the best-known futurist, was not even as good as the hippies in the street. Then in 1971 the same Mr. Kahn published a study of the '70s and again he did not mention anything about the energy crisis. He is still making a living as a futurist.

When we think about the future, we have to make several different projections, one being whether we succeed in fusion or not. Of course if we succeed in fusion we are back to 1962 with cheap energy (the only problem being pollution). If we fail at fusion, there is no future really. Solar power will not take care of our kind of life style. Fusion is the only area where the Americans and Russians are working together, because nobody knows if it will succeed or not. Fusion is basically imitating God. With videotape we imitate God only half-way, in that we record everything. We can rewind videotape but we cannot rewind our lives. The video playback machine has "fast forward," "rewind," "go" and "stop" buttons while our lives have only one button—go. Today there is Betamax, a God-defying device, because you can see the nine p.m. Public Television drama before the seven p.m. news. That sort of thing never happens in life. If I had known when I was 25 how I would feel as a poor artist in New York City at 47, I would have planned my life differently. There is no way to know in advance, because life has no "fast-forward" or "rewind" buttons. So, you go step by step, and if you make a mistake you try to correct it with another mistake. We hire teachers and pay them because a teacher, like a Betamax, can go "fast-forward."

Back to random access. Time-based information and random access information are differentiated by the retrieval process. The "book" is the oldest form of random access information. The only reason why videotape is so boring and television so bad is that they are time-based information.

Human beings have not really learned how to structure time-based information in recording and retrieval very well, because it is new. No one says that the *Encyclopedia Britannica* is boring, although it has lots of information, because you can go to any page of the encyclopedia, to A or B or C or M or X, whereas when you watch videotape or television, you have to go A, B, C, D, E, F, G. While the comparison is simple, the difference is very big. That is why the book is alive and will be alive until electronic information conquers the random access problem.

Music and dance, which are time-based, are more successful, because both have, maybe, a half-million years of history (which makes them much older than painting). As Leakey also said, the reason painting suddenly appeared about 20,000 years was not because people suddenly became smart, but because, before there were agricultural communities everybody moved 2,000 miles every year. So even if you had the best paintings in the Museum of Modern Art, you could not carry them. The only art forms people could carry were music, verbal poetry, and dance, art forms without gravity, that could be stored in the brain. So the oil and the energy crises are problems of gravity. The reason we have the oil problem today is that for millions of years, when we moved a 60-kilogram body, we only moved a 60-kilogram body. But over the last 50 years, we move a 60-kilogram body by moving a 300-kilogram car. It is the most stupid system ever invented. The only way to conquer the situation and make oil obsolete, is to move our ideas without moving our bodies at all. I coined the phrase "stationary nomad" which we are not yet. You dig up ruin after ruin to understand the past, as if you understood the present. I call it a new phrase, "the archaeology of NOW," which is what the Marpets' video documentary is all about.

John Cage had an amazing idea in the '50s. The first electronic art was electronic music, which also was strictly a time-based art until 1958. That year Cage performed at the Darmstadt new music summer course, after which he said, "It's as dead as a doornail." He said he wanted to make electronic music that is playable either three seconds or 30 hours without a definite retrieval time (similar to the encyclopedia). Cage is an incredible genius to have seen this problem, this audio- and videotape problem that there are particular lengths that cannot be changed. There are video junkies who watch whole videotapes but most people refuse to watch whole videotapes any more. Combining random access with video is a major problem that needs to be solved. Of course MCA and other video disc manufacturers are trying to solve it and it seems likely that in video the tape format will be gotten rid of completely. Now that people are talking about recording everything digitally on a sheet of magnetic paper without tape random access becomes immediately more plausible.

Paintings in the next century will most likely be electronic wallpapers, which can be programmed to be very complicated or very simple. There will be standardized electronic canvasses so that if you wanted to show your paintings in Iceland or the Republic of the Congo, you would just mail your program card. The card would be inserted and the canvas would light up from behind. This kind of system has to come, otherwise there will be no communication among artists at all. There would also be electronic still pictures (which are related to the same energy simulation). As film becomes more and more expensive, there is no reason why photographs need exist. When you record a situation electronically, you can make a direct, high-quality paper print, thus skipping the chemical stage completely. The next stage will be electronic still cameras. It will be a low-light camera so no one will have any secrets at all. Pocket-size video cameras are already really taking off. Combining a videotape recorder and a camera in one, similar to Super-8, these small cameras will record onto one-hour cassettes of quite good quality.

Since 1961, Joseph Beuys and I have had a wonderful kind of contact. I found out at one point that he was saved by the Tartars in Russia during World War II, when his plane was shot down.

The Tartars and Koreans are very close, even though the Tartar lives in the Russian Crimea, almost half-way around the world from Korea. We compared the customs of the Tartar and the Korean shaman, and found that they are close, which is amazing. This supports Leakey's theory that music and dance are much older, because they were only systems that could economically be transported. In the future, the only artwork that will survive will have no gravity at all.

There are so many interesting things that are not known. What I am thinking of is a kind of negative case of science fiction. Science fiction is where you figure out, from very little knowledge, the future and outer space. But what happened 20,000 years ago before records of any kind were made? It will be very interesting when we research and figure all of this out.

POSTSCRIPT

There are Yang people and Yin people. Yang people create mass art (like Rock music), and Yin people create aristocratic, elitist and snobbish art. These differences will continue even if the visual arts establish a multiplication system equivalent to today's music industry. The best part of Cage's creation is his LIVE electronic music, which is a whole TIME-SPACE art, which can never be made into either audio or video disc. Higher video art will take the form of video installations and a kind of notation form will develop to "convey" certain kinds of artwork: the conductor Eugene Ormandy "interprets" Beethoven's *Third Symphony* from the score. A young video curator in the 21st century will "interpret" a video installation by Peter Campus from notations and photographs.

Originally published in *Artforum*, no. 19 (September 1980): 46-49. © Artforum.

Video déjà vu? (1982)

The marriage of art world and video world in the early seventies was a marriage at gun point. The love-making has not yet started. Who will be the match-maker for the second marriage???
I bet it will be the thin video screen, which can be made to any size...made out of the liquid chrystal or some kind of semi-conductor...

Am I a hardware junky? Yes...if I am so...so was Karl Marx. Although it is getting increasingly hard to justify Karl Marx after Hungary, Chekoslovakia and Poland, and his position in our historical perspective will slip down, still we cannot change the historical fact that he was the almost ONLY ONE philosopher, who did dig into the changing pattern of hardware development in the mid-nineteenth century and tried to get the most humane, if not-realizable, solution out of art and technology at that time. His feat looks more brilliant, if you compare him with the idealistic, almost psychic pedantry of post-Kant, post-Hegelian philosophers, who ruled the academic world at that time. If you exchange the world of steam engine to the world of satellite, and if you exchange the world of industrial revolution to the post-industrial revolution, you can still guess the genius of Karl Marx. The tragedy of Herbert Marcuse people was that they tried to strip the 'science' from a mystic who was drunken by the 'science'. The tragedy of today's official art world is that they are still heeding this regressive interpretation of Marx by Marcuse and trying to suppress the honest research, which is trying to get the most human solution out of today's post-industrial revolution.
We have had a number of great prophets at the turn of the century...Arnold Schoenberg to Einstein, Tocquville to Tolstoi, Freud to Marx...but ALL these brilliant geniuses failed in one point in prophesy...They forgot to mention the biggest problem of today...which is 'parking...'

Yes...for them...for those profound minds, the 'parking' problem was too trivial...So too was the TV problem too trivial for the great minds of this century that if Harold Rosenberg and Clement Greenberg failed to notice it in the fifties as the most potential art medium, it was not their fault...

TV set was too trivial for those great fighters of the modern art. And of course, still there are too many profound minds in these art world, who like to close their eyes to the cloud of upcoming revolution.

For artist and art world the impact of the large scale thin TV screen will dwarf the runaway success of home videotape recorder by manyfolds, since videorecorder is by essence a TIME machine, whereas large screen (thin) TV is by essence a SPACE machine, for which visual artists excel...and please, listen...our friendly, nasty art dealers!...It is much easier to sell or buy 'SPACE'...than 'TIME'...It is very hard to sell or buy TIME...We cannot sell our *dream*... for this reason.

It is much harder to become a pimp for the prostitutes than becoming the real estate brokers... Composers starve, whereas visual artists are buying up the real estate in Soho and Florida... Yes, prostitutes are TIME-artists.

WHY??? Because time is harder to become the commodity of speculation than SPACE, because TIME goes away, but SPACE stays...As a musician, I found out that the main difference of musicians and prostitutes is that musicians get 'paid' after the performance...If you imagine the difference of service they do, you will understand this business practice...What would happen if musicians run away with money...before the performance?

What would happen if client runs away without paying after the 'service' by ladies? Money-back guarantee does not work here onthologically.

One forgets the fact that in 1968, the year Herbert Marcuse did hit the bestseller list around the world, the oil price was historically lowest (in real term). The Shah of Iran did lead the revolution for the third world and demanded the 'objective' price for their one-way street resource...(oil is one way street, as any time-thing is...) with this exploitation of the third world resource young people of the industrialized world had a short 'utopian' time, during which they can move up to commune and play hippie and revolutionary games...Dreams collapsed, when the oil price was adjusted to other merchandise's level (compared to 1948).

Art world managers, who are still dreaming this anti-technological, counter-revolutionary dream, will wake up some day.

Art world consists of three factors:

1) Vanity
2) Exclusivity
3) Beauty

Of course, video world can supply you only the third thing...*beauty*, but not vanity or exclusivity, since video is essentially a multipolitical, therefore 'democratic' medium. *New York Jan 21,82*

Originally published in *'60'80 Attitudes Concepts Images* (Amsterdam: Stedelijk Museum, 1982), n.p.

Art & Satellite (1984)

I have just returned to New York from Tokyo/Seoul after having set up a large Video art show at Tokyo Metropolitan Museum, using more than the twice of space of my Whitney Show. In order to fill up the space, I more or less re-constructed almost all of my past works. However the most popular one was neither the Japan premiere of my *TV Garden* nor *Tokyo Matrix*, but *Good Morning Mr. Orwell* (live satellite New York-Paris 1984, January 1).

It is all the more amazing because both *Garden* and *Matrix* use 60 TV sets each, whereas *Good Morning Mr. Orwell* used only two TV sets. At *The Kitchen* in New York in the last winter I experienced the same thing. Day after day New Yorkers came to *The Kitchen* and sat through a one hour presentation. It continued for one month in the midst of cold winter and I was awe-struck when I heard from my nephew Ken that an official at the World Bank read about it in Nepal in a newspaper published in Singapore. Finally I felt I did something right...but I don't know yet the WHY's.

Certainly I am not the first artist to have used the satellite. Douglas Davis did the pioneering work both on the theoretical and artistic level. He intensively tried to develop the two-way-ness of this medium. Due to lack of funds, he had to simulate this two way situation during Documenta 1977. He knocked the TV-tube, and it was knocked back from Caracas (simulated). In the cablecasting experiment in Manhattan, he pressed his finger to a corner of the TV set and viewers at Manhattan Cable were asked to press their fingers on the same spot. Imaginarily the picture tube became hot on that spot. Equally tenaciously working for this medium is the West Coast pair of Kit Galloway and Shierrie Rabinowitz. The record of their three day experiment between Los Angeles and New York let me cry three times (*Hole in Space* videotape).

Especially moving is the sequence in which an old lady in New York sees her grandson for the first time (through satellite). I took their idea of trans-continental feedback to construct Merce Cunningham's trans-atlantic feedbacks which was the highlight of the show, both visually and semantically.

So far we have reached 10 million people in Korea, 5 million people in the U.S. and Canada and 2-3 million people in Europe. However this impressive number is not everything. One test case we made showed that it is more interesting to accumulate...say...5 million people from 5 different countries than to reach the same number in one country. We can interconnect the same kind of people from different countries, so that certain highbrow shows can make an economically viable entity.

At the turn of our century, the French mathematician Henri Poincaré said the following thing... (Yes it was in the midst of so-called material progress and the discovery of new Things...) Poincare pointed out that what was being discovered was not new THINGS but merely the new RELATIONSHIPS between things already existing.

We are again the fin de siècle...this time we are discovering much new software...which are not new things but new thinks...and again we are discovering and even weaving new relationships between many thinks and minds...we are already knee-deep in the post industrial age. The satellite, especially the live two-way satellite is a very powerful tool for this human Videosphere.

I thank four producers, who made this bold experiment possible. Carol Brandenburg (WNET TV New York). Christine Van Asche (Pompidou Center, Paris). Jose Montes-Baquer (WDR, Cologne) and Lee Won Hong (KBS TV, Seoul).

Let me continue this article with a translation of the introduction to my show at TOKYO Metropolitan Museum, which was initiated by Mr. Yurugi, a young curator here.

It is said that all the sciences can trace their roots to Aristotle: but the science of cosmic aesthetics started with Sarutobi Sasuke, a famous *ninja* (a samurai who mastered many fantastic arts, including that of making himself invisible, chiefly to spy upon an enemy). The first step for a *ninja* is learning how to shorten distances by shrinking the earth, that is, how to transcend the law of gravity. For the satellite, this is a piece of cake. So, just as Mozart mastered the newly-invented clarinet, the satellite artist must compose his art from the beginning suitable to physical conditions and grammar. Satellite art in the superior sense does not merely transmit existing symphonies and operas to other lands. It must consider how to achieve a two-way connection between opposites of the earth; how to give a conversational structure to the art; how to master differences in time; how to play with improvisation, in-determinism, echos, feedbacks, and empty spaces in the cagean sense; and how to instantaneously manage the differences in culture, preconceptions and common sense that exist between various nations. Satellite art must make the most of these elements (for they can become strengths or weaknesses) creating a multitemporal, multispatial symphony.

These factors complicated matters immensly for the broadcast of 'Good Morning, Mr. Orwell', which was transmitted simultaneously on two channels from New York, San Francisco, and Paris, and received simultaneously in the U.S.A, France, West Germany, parts of Canada and Korea.

First of all, there was the difference in time. There is a six hour time difference between New York and Paris. It was impossible for it to be prime time in both countries, so I chose a cold winter Sunday. Noon in New York (Sunday, January 1, 1984) would be freezing cold, so most people would still be at home (with a hangover). Twelve noon in New York is 6:00 p.m. in Paris. I figured that even the worst philanderer would take his dinner at home on New Year's Day. In Korea, this unfortunately turned out to be 2:00 a.m. on January 2.

A second difficulty was the difference in general knowledge and language. Orwell's *1984* has become so well-known in English-speaking countries as to be almost stale. Obviously, it needs no explanation. In French-speaking countries, however, it has been out of print since the 50's, and, what is more, there is only one critical work dealing with it. Therefore French TV required a long, long, fifteen-minute commentary both prior to and in the middle of the broadcast. These differences made this difficult avante-garde art even more difficult.

There is no rewind button on the BETAMAX of life. An important event takes place only once. The free deaths (of Socrates, Christ, Bo Yi and Shu Qi) that became the foundations for the morality of three civilizations occurred only once. The meetings of person and person, of person and specific era are often said to take place 'one meeting-one life', but the *bundle of segments* of this existence (if *segments* can come in *bundles*) has grown much thicker because of the satellite. The thinking process is the jumping of electrical sparks across the synapses between brain cells arranged in multilayered matrices. Inspiration is a spark shooting off in an unexpected direction and landing on a point in some corner of the matrix. The satellite will accidentally and inevitably produce unexpected meetings of person and will enrich the synapses between the brain cells of mankind. Thoreau, the author of *Walden, Life in the Woods,* and a nineteenth century forerunner of the hippies, wrote, 'The telephone company is trying to connect Maine and Tennessee by telephone. Even if it were to succeed, though, what would the people say to each other? What could they possibly find to talk about? Of course, history eventually answered Thoreau's questions (silly ones, at that). There developed a feedback (or to use an older term, dialectic) of new contacts breeding new contents and new contents breeding new contacts.

'Good Morning, Mr. Orwell' of New Year's Day, 1984, produced all kinds of feedback. Cage and Beuys are friends, but they have never performed together. Beuys and Ginsberg are two artists who have many things in common (active political involvement, heated performance, complete anti-nuclear naturalism, similar age, romanticism), but have never met. The heavenly stars (Mars, Saturn, Altair, Vega, etc.) meet periodically, but the earthly ones do so very rarely. When I ponder what mysteries the encounter with other people holds for our insubstantial lives, I feel it is a terrible shame that great geniuses may pass their prime without ever meeting. And even when such encounters have actually taken place (for example, Cage and McLuhan; Cage and Buckminster Fuller), no camera has recorded the event. What a loss for the history of human civilization! In 1963, French television recorded a meeting between Edgar Varèse and Marcel Duchamp. Now that both of these giants have passed away, I find it a stirring moment no matter how many times I watch it. The satellite will no doubt amplify these mysteries of encounters by geometric progression. If I may relate a personal experience I was surprised to find a photograph of myself and my respected friend Beuys at our first encounter (at the 'Zero' exhibition held at the Galerie Schmela, Dusseldorf, 1961) in the catalogue *Zero International Antwerpen*. Indeed, I had not even known that such a picture existed.

Thanks to the satellite, the mysteries of encounters with others (chance meetings) will accumulate in geometric progression and should become the main nonmaterial product of post-industrial society. God created love to propagate the human race, but unawares, man began to love simply to love. By the same logic, although man talks to accomplish something, unawares, he soon begins to talk simply to talk. It is a small step from *love* to *freedom*. To predefine freedom is a paradox in itself. Therefore, we must retrace the development of freedom historically in order to understand it. The progressive American journalist Theodore White once wrote how impossible it was to explain the difference between *liberty* and *greed* to the leaders of the Chinese Communist Party at Yanan during the Second World War. There are 2,500,000,000 two-character permutations and combinations of the 50,000 Chinese characters. *Ziyou*, the two-character word for *freedom*, however, did not come into being until the nineteenth century. Just as it is harder to translate *ren* (benevolence, humanity) and *li* (ceremony, etiquette) into English than *dao* (the way [of life, etc.]) it is extremely difficult to translate *liberty* and *freedom* into Chinese. It seems that *gòngchan*, the word *communist* as the Chinese Communist Party, is a loanword from Japan; perhaps *ziyou* originated in a similar fashion. Even in bright and free ancient Greece, there was the term *free man*, referring to a social class, but there was no philosophical concept for freedom. The passionate idea of freedom is said to have been born under the most unfree, dark domination of medieval Christianity. Moreover, it was amidst the rise of fascism and the decadence of the Russian Revolution and after the loss of bourgeois freedom before and after the Second World War that man was most strongly and keenly aware of this passionate idea. The existentialism of Camus, Sartre, and Berdyaev was once again forgotten by West European society from the 1960s on, when it experienced a return of freedom and prosperity. In any case, freedom is not a concept inherent in man (it is found neither in *the Koran* nor in the *Analects* of Confucius) but is an artificial creation like chocolate or chewing gum.

The 'increase in freedom' brought about by the satellite (from a purely existentialist point of view, an 'increase in freedom' is paradoxical; freedom is a qualitative idea not a quantitative one) may, contrary to expectation, lead to the 'winning of the strong'. (Although the imported concepts of freedom and equality may appear to be close brothers, they are in fact antagonistic strangers.)

Recently, an Eskimo village in the Arctic region of Canada started establishing contact with civilization. So far they have only four stores. The first is a general store. The second is a candy shop. (They had not even tasted sugar until quite recently.) The third is, of all things, a video cassette rental shop!!!!

Video must have immeasurable magical powers. This means that the Eskimos' ancient traditional culture is in danger of being rapidly crushed by the bulldozers of Hollywood. The satellite's amplification of the freedom of the strong must be accompanied by the protection of the culture of the weak or by the creation of a diverse software skillfully bringing to life the qualitative differences in various cultures. As the poets of the Beat generation learned from Zen, Philip Glass obtained hints from the music of India, and Steve Reich looked to the music of Ghana in their creation of original forms of late twentieth century high art, it is not an impossible task.

As long as the absorption of a different culture makes up the greater part of the pleasure of tourism, the satellite may be able to make every day a sight-seeing trip. So, Sarutobi Sasuke not only embodies the origins of cosmic aesthetics but also the ethnic romanticism that must always be the companion of satellite art.

Originally published in *The Luminous Image*, ed. Dorine Mignot (Amsterdam: Stedelijk Museum, 1984), 66–71. An earlier version of this essay was published in *Nam June Paik—Mostly Video*, exhibition catalogue, trans. Yumiko Yamazaki (Tokyo: Tokyo Metropolitan Art Museum, 1984), 12–14; reprinted in *Video Culture*, ed. John Hanhardt (Rochester, NY: Visual Studies Workshop Press, 1986), 219–222.

Rendez-vous Celeste (1984/1986/1988)

How often do stars on the earth meet?

How often or seldom do stars in the heavens meet each other?

Is it possible for a star on the earth and a star in the heavens to meet?

That will be the ultimate challenge for the electronic super highway.

The difference between the old highway and the new highway is that in the old highway, we knew what was the car, and what was the cargo before the highway was built, whereas in the new highway we don't know what kind of car we will have or what kind of cargo/passenger we will have on the road. And will the highway be attractive enough to make the whole effort worthwhile? The electronic super highway is still a very expensive gamble.

I did attempt an equally expensive gamble in broadcasting a satellite event in the 'eighties which almost ruined me financially, and nearly killed the careers of a couple of venturesome producers.

China has its own tale of "A Midsummer Night's Dream". They detected that a certain two stars meet every year at the same time; the seventh day of the seventh month in the lunar calendar. The date being in the middle of the hot summer, they injected a lot of Romanticism in it. They named one of the two stars involved "The star of a young bachelor pulling an ox (a role model in their agricultural society). The other star was was named "weaving girl-star" (The western name of these two stars are Altar (male star) and Vega (female star) respectively.)

When these two stars meet in the midsummer night, clouds would wrap them from the intruder's eyes and honeydew rain would bless the couple inside who must depart next morning. Even now in Asia, 7/7 night is a midsummer's night celebrated by outgoing young men and women.

I tried to stage a High-Tech version of this legend on January 1, 1984. It was part of "Good Morning, Mr. Orwell" between Paris' Pompidou Center and New York's WNET studio.

Born in the same decade, Joseph Beuys and Allen Ginsberg share important common traits. Both were heavily engaged in politics, especially in the anti-Nuke and Green Movements. Their works are an amalgam of folk artsy charisma and high artsy sophistications, a Yang power in the Yin attitude. However, as far as I know, they never had any contact with each other. It was the not so different between Cage and Beuys besides a couple of casual meetings at parties.

I wanted them to hug each other and play each other and dispense their genius-vibration to millions of common folks through the electronic air waves. After all they are the chosen few who would represent our age to the future generations.

I also conjured up the idea that if Merce Cunningham and Jean Louis Barrault (Paris) danced with each other, improvising and interactively looking at each other via a satellite monitor it would be the dance event of the century. What naivite!

I contacted Jean Louis Barrault via Judith Pisar, my patron-saint of many years, but Barrault said that it was his year long tradition that he spent new Year's Eve with Parisian orphans in his theatre.

I did not forsee that despite their huge success they are still professional competitors who developed their personal styles during long years of struggle/occasional failure, and enormous luck.

In any case, Cage, Beuys and Ginsberg agreed that although they had no time to compose new interactive pieces (which was not their personal style anyway) they agreed to do a parallel performance, which would be mixed in the synched-up electronic space and their echo of vibes would be transmitted live to ca. 20 million viewers in the major air waves of six countries (U.S., France, Germany, Korea, Spain and Switzerland, maybe also Belgium). In every country we had respectable ratings.

Poor Merce had to be content with a street dancer dressed like Chaplin who frequents the courtyard of the Pompidou Center. Now both Beuys and Cage are gone. This became the only occasion of the collaboration of these three geniuses.

John Cage performed an amplified cactus piece, accompanied by Kosugi and Tone. Beuys came with two Turkish pianists and they just crouched under three grand pianos, they dressed in blue jeans with the knee parts sheared out. At some point, they came out to lean on the piano key board with their back to the camera. This Ying - performance was juxtaposed with Cage's Zen-like cactus performance. Their 2 in 1 superimposed picture looks like a Sung brush painting frozen in ultra high frequency.

In the second half, Allen Ginsberg chanted merrily about re-conciliation between the 2 X super powers, while Joseph Beuys let a Dutch artist shave his beard - - as simple as that. Merce Cunningham danced with his own ghost; electronic feedback of his own image shuttling between Paris and New York, and he later found his partner in the Chaplin beggar. He danced also.

The Entertainment part was provided by the live mix of the San Francisco based Rock group, Oingo Boingo (a song about Mr. George Orwell) and super models of Studio Barcot's fashion show in Paris.

In 1986 we tried a 3-way Satellite game: Seoul, Tokyo, New York "Bye Bye Kipling"-PBS (N.Y.), KBS (Seoul), Asahi TV (Tokyo). It was conceived as an artistic accompaniment to the Marathon race going on in Seoul. The climax/goal of the Marathon should coincide with climax/goal of Philip Glass playing at Disco Club 4D in N.Y. The lengthy,

sometimes tedious Marathon process would be interlaced with Avant garde of Folk Music from Korea, Japan and the U.S. However, at that time Korea had only two Satellite transmitters which were occupied for the Marathon event only. We hurriedly moved the Korean musicians to Tokyo and New York. Without knowing of our technical restrictions, some Korean newspapers criticized my pro-Japanese bias. In Tokyo, the owner of a world famous piano manufacturing company tuned in and saw the video tape insert of Stan VanDerbeek's piano destruction and felt his whole life's work was insulted on the TV program, which his venerable company sponsored. In New York, some viewers complained asking why WNET is broadcasting a Marathon race for such a long time when there were no Americans participating in it. In any case, these complaints were just the first car - accident in the E - Highway.

In any case in Tokyo there was the Korean farmers percussion group, Samulnori and in New York the Avant garde composer and performer David Van Tieghem. Both agreed that they would look and listen carefully to the other side and would make a collective improvisation. A similar experiment was also attempted in 1988 between Merce Cunningham (N.Y.) and Ryuich Sakamoto with 3 Okinawa lady singers. David Tudor supplied a harsh but exquisite sound tape.

Also there were live conversations between Isse Miyake/Arata Isozaki on the Tokyo side and Arman/Keith Haring and Dick Cavett on the New York side.

Towards the end video art twin sisters Eileen and Lynda paraphrased a Satellite idea by Shirley Clark. Eileen came up at the right side of the TV screen and received a Rose from the New York host Dick Cavett. Dick Cavett told her to give it to our Tokyo host R. Sakamoto. Eileen disappeared from the picture. After a short while the other twin Lynda appears on the Tokyo side to give a similar Rose to Sakamoto. In return, Sakamoto gives a big apple to Lynda, who would quickly fly to New York and ask her twin counterpart Eileen to give that apple to Dick Cavett. This is a nice trick involving split screen and identical twins via Satellite technology: Cavett-Rose-T1,T2-Rose-S. S-Apple-T2, T1-Apple to Cavett.

In looking back, these were quite ground-breaking experiments because it was done in front of many millions of eyes. However, the newspapers did not like it too much and Christine Van Assche of the Pompidou Centre was almost fired. At the News Event of the changing of A.D. 1,999 to 2,000 we will do the 30 in-out put, live event, and the theme might be the Dialogue between the poor south and the semi-rich north via music... in musical terms the rich north owes very much to the poor south. They hardly pay for the African rhythms...these are unpatentable

Needless to say, High Tech is not a panacea. It is just a local anesthetic. There well be many unforseen problems ahead.

Typescript, Smithsonian American Art Museum, Nam June Paik Archive (Box 14, Folder 22). Originally published in *The Electronic Super Highway: Travels with Nam June Paik* (Cincinnati: Carl Solway Gallery, in conjunction with Fort Lauderdale Museum of Art, 1995), 141-143.

Context Is Content...Content Is Context (1985)

Good Morning/Bonjour M. Orwell was a collective effort by many artists and managers. Sometimes they risked their careers for this business. I cannot be more grateful for their co-venture. And for their sake, I feel obliged to set the balance sheet right.

AESTHETIC PRINCIPLE

The distance between live satellite TV and 'established Video art' is as far apart as the distance between 'established Video art' and film art. In established Video art, we are able to employ many powerful new techniques which are not available to the traditional filmmaker: instant video-synthesis, repetition at no cost, CMX editing (which allows us to go down ten generations, yet recover the original quality in no time), and a thousand possibilities in exact keying, matting superimposition, wiping, ADO, Quantel Mirage, etc. Of course, these virtues do exist in similar film technique, but at prohibitive cost both in dollars and time. When we compare film art to video installation, our technical ease is beyond comparison. We have liberated ourselves from narrative structure. At long last, John Cage's dream (...to make music without beginning or end...) has become common sense. Simply, it IS (by definition) ontologically impossible to make boring video installations. Audiences can leave at any time...and they do leave to live.

What do we gain by sacrificing the above virtues with live satellite TV? The answer is found in the same reason why people shop at Korean vegetable stands, avoiding canned food...because vegetables are fresh with VITAmins...

VITA...life itself.

Quite a few video critics who are friendly to me, deplored the lack of certain kinds of aesthetic quality which they expect from 'conscientious' film/video art, such as good editing, social meaning, in-depth study of performance art, metaphor, profundity, etc. I agree with them, too. Certainly the show was full of loopholes, both avoidable and unavoidable mistakes... however, these defects do not explain why at least five million people around the world sat through the 60 minute program. (I base this figure on the 45 minute rating in New York and Germany, which was a share of 2. Sometimes PBS shows are below one; that is, unmeasurable.) If you sit through sixty minutes of a show which has neither plot nor sex/violence, that is a sign of strong approval or interest. Not only did the audience have 20 alternative channels, but, at the same time, both the CBS and NBC networks were showing NFL football. Besides, January One is a busy time for families, friends and long distance telephone calls! Also, the show's defects do not explain why the closed-circuit showing at the Kitchen was filled six times a day for 30 days in an unusually cold winter. The Kitchen management was flabbergasted by this SUSTAINED popularity, which was made possible ONLY through word of mouth communication, not by mass communication.

We must have done something right, which we haven't discerned yet. The Newness comes in 1000 disguises...Many little sweetnesses lurk in unexpected corners at decent intervals...like on a honeymoon trip.

UNION PROBLEM

Generations of intellectuals fought for the unionization of workers. Sometimes their heads got cracked. If they were lucky, only their promising careers as lawyers, doctors or administrators were truncated. However, when workers gained power, intellectuals got paid in reverse... from Trotsky to the hippies (who were beaten up by the construction union in the Seventies). I understand that de-unionization is a trend in the Silicon Valley. Must we wait until the

de-unionization of the American airwaves...say...in 30 years? I will be 82 years old. John Cage will be 102. Beuys 93 years old...

At least we will be in the same generation...here or there.

DOUGLAS DAVIS AND GEORGE PLIMPTON

Douglas Davis and the Kit Galloway/Sherry Rabinowitz team are artists who work almost EXCLU-SIVELY with satellites. Doug Davis initiated the Documenta satellite and in 1977 achieved one-way broadcasting from Kassel to New York and Venezuela. He also tried a two-way satellite transmission, Kassel to Venezuela, which failed due to a 500,000 DM shortfall. Naturally, I wanted to honor his pioneering achievement in my program. However, Centre Pompidou had realized an hour-long two-way satellite piece with the Whitney Museum a couple of years ago (*in memoriam* to Roland Barthes), and therefore the Pompidou side did not want to repeat themselves after so short a time At the WNET side, we pondered the nature of Douglas Davis, which is of a profound sort. I agree with noted critics Pierre Restany and Jim Harithas that the Documenta satellite/Doug Davis performance was far superior to my own. However, in this show, Beuys was also going to do a profound performance, and we could not afford two profound performances in one show. In this hit or miss kind of situation (live show), we have to spread out the risk factors and make a smorgasbord of possibilities. Therefore, I did not fight too much for the inclusion of Davis, yet I emphasized his role in the newspaper interviews so that he received the proper credit. As for Kit Galloway and Sherry Rabinowitz, we adapted their cross-country feedback into Merce Cunningham's trans-Atlantic feedback and did credit them at the end. (Sorry the credits were so small.) They were magnificent at the rehearsal but somebody pushed the wrong button during the real thing...*c'est la vie*...or...we will soon have a new expression "*c'est la satellite*".

Our satellite show *Good Morning Mr. Orwell* was lopsidedly male oriented...we had only three women stars compared to 10 male stars. Therefore I had thought of a woman host...yet even if Nastassia Kinsky had come to us, we most likely would not have accepted her, since being a host is not easy...one must be an expert in literature (Orwell being a writer), and speak well on TV. In this sense, Plimpton did fit the requirements and he did his job well...especially his impromptu encounter with Charlotte Moorman, which was mellow and juicy. P.S. (an excerpt from my report to Centre Pompidou on Jan 30 84) Is LIVE TV An Indispensable Part of High Art?

If video art remains an inexpensive copy of FILM art, we don't need a LIVE show. If we want only to deliver only cost-efficient entertainment on TV, we don't need LIVE TV. However, we want to develop video art not only as a high art, but as the HIGHEST art-form humankind has invented. As the *miracle* is the cornerstone of every major religion in the world, *onceness* constitutes the very motor of human history. Important things happen only once in our lives and they are neither repeatable nor reversible—death, defloration, birth (where, when, in which social milieu). Through LIVE video art, we are finally able to deal very concretely with the central problems of human existence (chance, hazard, bet, venture). Pascal and Sartre would be very jealous of video artists!!! We can even encode their metaphysics in popular entertainment as we did on January First. In the very particular time-frame and mind-frame of January One at high noon, the wavelengths of two million Americans, one million Europeans (in France, both East and West Germany, Belgium, Denmark and Holland) and one million Koreans were united in sync. The immortals of our time (Beuys, Cage, Cunningham, Allen Ginsberg, Laurie Anderson, Tinguely-Saint Phalle's garden, etc.) met in ELECTRONIC SPACE! Their souls were superimposed and etched into four million brains and eternalized in the videotape. (The show gained 1-2 million more through telecasts in Spain,

Yugoslavia and repeats at PBS in the USA.) If the immortalization of the immortals is the prime function of a museum, the Centre Pompidou could not better fulfil its function than through *Good Morning Mr. Orwell*, because the fragile nature of performing artists requires a special kind of curatorship. This Essentia is, historically speaking, much more important than a few points in the Nielsen Ratings.

(Editor's note: Nam June Paik has assembled the best parts of the original French and American transmissions into a new, 37-minute edit. *Orwell, Revised* has been exhibited at the World's Fair in New Orleans and at the 1984 San Francisco International Video Festival.)

Originally published in *Send*, no. 10 (Spring 1985): 26-27.

A Satellite—The light of the future Asatte—literally, the day after tomorrow (1987)

This title is not just a play on words. Just as it took 20 years for electronic music and video art to be popularized, we won't know how to use or appreciate satellite art until we reach that time in the future. (asatte).

At the moment, there are three artists specializing in using satellites, Kit Galloway and Sheirie Rabinowitz are both from the US West Coast. They both firmly believe in the conscientious participation in the movement towards social evolution, an idea which has its origin in the sixties. They have been working hard and between them have been the supporting base of satellite art.

In "Good Morning, Mr.Orwell" (1984), I successfully used a technique of theirs to create a 'feedback' image of Merce Cunningham. 'Feedback' is an amplified image caused by time delay when, for example, a signal sent from NY to Paris is then replayed back to NY. They also made a two-way video link-up between L.A. and NY, for three days which involved public participation. The video was live and just connected two points in much the same way as a telephone does. Although it was not broadcast on TV, many people learned of it, when on the second day ABC reported the event on the news. People who were separated on the East and West Coast all gathered for this experimental event to get a glimpse of each other's faces. There was an especially impressive moment when a grandmother in LA got to see, for the first time, her grandson who was born in NY. But I feel the effect of communicating via satellite is greater on those who have been separated for a long time than those who are seeing each other for the first time or have no relation. The tape of this work, entitled "Hole in Space" still stands as a 'textbook' for the satellite studies. (1)

I was pulled into the world of Satellite Art, when they showed a satellite broadcast at the opening of "Documenta" in 1977. Prior to that, I was absorbed with TV Garden's first European performance and hadn't got onto satellites. But Douglas Davis (present architectural and photography critic for News Week) and Dr. Herzogenrath talked me into doing a performance with Charlotte Moorman. This 30 minutes program was divided into three 10 minutes sections: 10 minutes Beuys, 10 minutes Davis and 10 minutes myself and Moorman. Although it was only a one-way communication, it will remain historically as the first satellite art work. (it was simulcasted in Germany, New York, Boston and Venezuela.)

What was also interesting was that it was received by the Moscow Broadcasting Station. They did't show the program to the public but someone from Moscow had made the effort of contacting the Broadcasting Station in West Germany and paid a receiving-fee in dollars! So at least we

know that someone quite influential in the Moscow Broadcasting Station is interested in our work, although we don't know who.......Now that Beuys has passed away, I remember well the lecture he gave back in 1977.

Personally I've really learned a lot through having to give lectures I was once asked by Mitsu Kataoka. This was to give 3 experimental lectures actually using video telephones between the East and the West Coast. Mitsu Kataoka, a second generation Japanese, is a really interesting man. He's the prof. of Design at UCLA, and designs everything from Cable TVs to the latest Kawai piano model.

During these lectures, Shirley Clark who lives on the West Coast and her daughter Wendy who lives on the East did something really interesting. Wendy had just returned from her winter vacation in the Bahamas, and as a souvenir she sent a large shell as a temporal image on a splitscreen, to her mother in the West. Shirley, in return sent a flower, also via the splitscreen, to wintry New York. Since this was such an original idea, I adapted it and used it twice in "Bye Bye Kipling". Once when Ryuichi Sakamoto and Dick Cavett threw their hats to each other and also when flowers were presented. Also during video-phone lectures, Bill Wegman came with his famous dog and brought it face to face with another dog from the West Coast. But we don't know if either dog really reacted to the dog on TV, which has no smell. For a dog, his nose is more important than his eyes.

But what impressed most from the lecture was when Al Robbins, a very good video artist from the East Coast met and talked with his mother, in L.A., whom he hadn't seen for a long time. Similarly, a student in L.A. met her old teacher in Washington again, after a long time, and talked together very happily......It was this moment that all the 10 participating people became quiet and felt the coming of a new two-way art. It often happens that your affection for somebody becomes stronger when you are separated through space and time, even on an international telephone. (This experimental video was shown by Nancy Drew at the Long Beach Museum.)

Kit Galloway and Shierie Rabinowitz were unfortunately unsuccessful when they applied to NFAC (an American art board) for a grant to come to Japan to make a satellite communication. If these two artists, fanatic believers in the use of satellites come to Japan, sparks will certainly fly.

In Autumn 1986, Douglas Davis connected NY, Amsterdam and Venice via a live, simultaneously broadcast TV thriller. Diane Keaton, well known for having played opposite Woody Allen appeared in America, and the art critic Pierre Restany appeared in Venice. The event was broadcast through PBS.

I wonder about the result of a proposal somebody made to IBM which was to install a Sony Jumbotrone in public squares in seven different countries and have children play with it. Mr.Peter Park, a Korean Social Studies Scholar, present professor at the Massachussetts State University, told me about the idea of installing huge TV screens in Time Square and in Red Square and allowing communication between the citizens. At last, after 20 Years, the hardware has reached the point of experimenting with this idea. I should think we need another 20 years to really make use of the hardware.

Since "Documenta77", "Bye Bye Kipling" is the third satellite work from New York and a work in which I feel I finally reached my goal. I owe a lot of this to the real time marathon race in Korea and to Teru Satoh's precise directorship in Japan, Lee Dong-Shikn (KBS), Carol Brandenburg, Alan Weiss, Bob Lanning and to many others. In Korea, there was a lot of dissatisfaction with the reception of the program but as an initial trial I think we ought to be basically content. The free use of such complicated hardware and software on a huge scale, and the fact that in this

trial, we could feel the weight of the different histories of the three countries make me think that even if Mozart comes alive today, he wouldn't be able to hit a homerun with his first hit.

Wiesbaden 12/15/86

"Why a live broadcast?"

"There would be much less risk in a prerecorded broadcast and everyone would understand the content. What's more, there would be no rough gaps or pauses and you could present a completed product without any seams showing."

Not only the general public come up with this kind of question, but also the directors' of post-production departments of TV companies quite often ask me the same type of things. To this, I normally respond, "Well then, Why do some people climb Mt.Everest?" That is to say, even in the 1950's when Hilary and Tenjin were successful in reaching the summit for the first time, there were other various means, including the predecessor of the helicopter called an Auto Gyro to make an "attack" from the sky.

If you think of the organized mobility used for the Normandy landing operation, a frontal attack on Everest where there is no actual enemy should be much simpler action to make. For example, rather than dying at the Eiger summit, it would be far easier to arrive on a tunnel train at Junghrau, close to the destination, and from there climb to the top taking video 8. These days you might not find it so hard to pick up a Japanese girl student on the way. Needless to say, the reason to take on the challenge of Everest or the Eiger summit derives from the instinctive passion of a human being for adventure or the risk in its self. Ever since Prometheus, ever since Columbus, this has been one motivating power in history.

So, in "Bye Bye Kipling", there were double risks, the aspect of newness and Virginity—the fact that this two way communication between the East and the West took place for the first time—was operating simultaneously with the aspect of risk, and what's more "Virginity" is heightened when risk is at its peek (Pascal? Sartre?)

Even so, "progressive" producers from England and Germany asked me, "Why a live broadcast?" The answer concerns the number of channels in each country. In England and Germany, there are only 3 to 4 channels on TV which is small compared with American TV which is a buyer's market handling 20 channels. English and German TV is a seller's market which is far more evolved (?) and so the good is not spoilt by the bad. Yet, the fact remains that any employment increase must depend on the post-industrial service industry. No matter how the labor unions of the two countries may protest, they now have come to a stage where they must make up their mind about setting out in cable TV and direct satellite broadcast. Sooner or later, they will have to follow the American example of having 20 or even a hundred channels.

Then why is live broadcasting inevitable for 20-channels TV? Because the more risk there is on a program, it becomes more talked about, and the success of a broadcast depends on word of mouth publicity.......Then what will happen when the live broadcast between countries becomes the usual thing and no longer be talked about? At least, that will take another 5, 6 years, and by then, we must seek for a new adventure both inside and out of the TV media.

"Bye Bye Kipling" was a great success as American Home TV entertainment (though I don't know if a TV program can be anything but entertainment. Entertainment is a pastime, and a pastime on a mass level makes time pass quickly which is not quite the same as the ideology of spending time practiced by the Eastern Mediavel aristocrats) but this live quality in time (as in the Broadway saying, "The show must go on") caused several technical mistakes which even effected editing.

According to the scenario, at the 22nd minute when Japan joined the broadcast, Ryuichi Sakamoto was supposed to have introduced three plastic artists from Japan, Aiko Miyawaki, Toshimitsu Imai and Tadanori Yokoo in English. This was going to be followed by a short but precise segment where the camera created an artistic space. The piano wire sculpture that runs across the sky like an anti-gravity gun bullet (Miyawaki), one hundred voluptuous Japanese Art Deco Kimonos (Imai), and the mixed colored oil painting formed by the three basic colors of the Edo era which are reformed into bravery of the Kamakura era (Yokoo). But, one of the technical staff forgot to provide Ryuichi Sakamoto with an earphone set! Ryuichi was waiting for the signal but of course the "GO" signal never reached him. Although we were calling, "Sakamoto! Sakamoto!", from the mixing room, the "Professor" standing outside in the square could not hear our voices from the second floor basement. After 43 seconds of waiting, America decided to set off with Lou Reed who was coming up next. Of course, Sakamoto can't be blamed for either of the two mistakes.

When the Japan-United States live correspondence was over, we rushed on to record Miyawaki, Imai, and Yokoo to make it in time for the broadcast in Japan (two hours after the live correspondence). I felt even worse for David Tudor's Living Theater and Toshi Ichiyanagi and Yuji Takahashi from Japan whose great ensemble was supposed to represent the finale of the broadcast but the satellite was cut a few minutes before the expected time and no communication was possible.

Due to the time difference, the Japanese stars were obliged to leave home at seven in the morning to attend the rehearsal from eight. I would like to take this opportunity to apologise for the mistakes that happened in spite of these people's efforts.

At the Korean broadcast, there were even bigger problems happening. Since in Korea, the 4 circuits for satellite transmissions were all taken by sports programs, the main event in Korean TV. I thought of changing the schedule, but lasting a 90 minute live broadcast I wanted to show the stamina of the marathon runner. And also to overwrap the live music of Phillip Glass with the live struggle of the marathon runner both making a simultaneous finish which would create a double climax. An electric orgasm was one intention of the broadcast. My idea was by achieving this, I could go beyond what Leni Riefanstahl has done, whose sports art has been defined as the best. That is to say, no matter how well the Berlin Olympic film by Leni Riefanstahl was made, it is only a record of a past phenomenon "that is a recomposition". If we succeed in putting together sports and art, both happening in a present progressive form making the two finish at the same time, then by doing so, the sympathy from the world-wide audience would be aroused in the same present progressive form. No matter how good the technical level is, or how much it costs, havn't we gone beyond what Leni Riefenstahl did? This is what I believe and is the theory behind the aesthetics. So when the time comes, people would understand the essential and developmental advances in "Bye Bye Kipling". This is what I thought and finally didn't change the broadcast schedule of "Bye Bye Kipling" although there were not enough circuits to make the live broadcast with live hosts and live art.

But the Korean home audience didn't know anything about the backstage dramas. It gave them the impression that the two-way communication was made only between Japan and the United States (Sakamoto vs. Dick Cavett for example) and that Korea's participation was second class in spite of the fact that Korea was paying a larger percentage of the production costs ($ 170,000) than Japan ($ 130,000). A fact which brought back the memory of the old wound of discrimination. To make things worse, the Korean broadcast was 4 days after the live broadcast and people had already seen the marathon which Japan had won. After all, the intellectuals were tired of the sports program which had gone on for one month, covering both before and after the Asian

Tournament and could not understand why Nakayama, the marathon runner from Japan had to appear on the screen over and over again (as it no longer had the thrill of a live broadcast......). Since the old wound might open up again, I had planned to mix the high-light of the Asian Tournament (Skip Blumberg) with the News Clip of 1936 in the actual tele-casting, which however got cancelled in the excitement of the live TV. In the Berlin Olympic Games two Koreans, Sun Ki-Geon and Nam Sung-Nyong had to wear the Japanese flags, because Korea was occupied by the Japanese at that time. However, two Korean News papers, Dong-ah Ilbo and Cho sun Illbo erased the Japanese flag from two runners shirts by photoretouching and published their picture without any national flags. Because of this "alteration" both papers had their publication suspended for more than 8 months. This is passed on today as one of the most famous folklore story of Korean resistances against Japanese Imperialism.

In-en. These Chinese characters, according to the Kenkyusha's Japanese-English dictionary are translated into a Sanskrit word "KARMA", whereas "KARMA" stands for the origin of "METEM-PSYCHOSIS" among us. In the Meriam-Webster Pocket Dictionary (1964 edition) KARMA is defined as follows:

"The force generated by a person's actions held in Hinduism and Buddism to perpetuate trans-migration and to determine his destiny in the next existence".

My view is that In-en is a vague yet contradictory idea where a necessary cause and an accidental peripheral are combined. The word itself is a type of "restless noun" which one would use when they are at a loss for words trying to get out of a situation shifting from one foot from the other. However, in Indo-Germanic languages, KA or CA seems to have a significant meaning. As well as KARMA which I just mentioned, KAMA (love) as in KAMA SUTRA, CASA (house), CASE, CAUSE, CASUAL are some examples. Take the latter two examples, CAUSE and CASUAL look alike yet mean something quite the contrary. We realise that when they are put together, we come back the exact contradictory idea of the oriental word "In-en". In our everyday life, there are many "CASES" that are neither "CAUSE" nor "CASUAL" and as we become older, we become more aware of the saying that everything will follow KARMA.

According to Taisetsu Suzuki, the spiritual awakening in Zen can only be gained through learning the two characters IN and EN but I was surprised when in Japan, Tony Cocks, the ex-husband of Yoko Ono gave me some LSD to take, and I experienced the sequencing of time freezing solid as in the simultaneous relation of space.

Perhaps the greatest effect of the Satellite is that it enables one to work out a mutual relation (In-en) artificially and in an accelerated way, and also the sensitive network made between the two new consciousnesses may well be beneficial to economical and cultural growth.

Therefore, it shouldn't be unnatural to introduce below, all those unsung heroes and king makers that made up "Bye Bye Kipling".

Politics makes strange bed fellows.

The adverbial words for In-En is "by chance". Suppose the "by chance" chanced its luck continuously for ten times and we say that each probability of "by chance" was 10%. The result would be ten to the power of ten.......which is 1/10 (to the 10th power-RL) an astronomical figure. Until the spring of 1986, six months before the broadcast, ASATTE-LIGHT was in the dark.

Just by chance, the art critic, Junji Ito and Susumu Miyoshi from Dentsu visited Hiroe Ishii from Sony Video. Ishii who was making the Adelic Penguin (Kit Fitzgerald and Ryuichi Sakamoto) talked about the "Bye Bye Kipling" project just by chance, and this moved the two people from the two companies (Wakao Fujioka from Dentsu and Haruo Kuroki from Sony). On the other hand just by

chance FBC TV in Fukui (Mr.Kato) invited me to Japan through Gallery Watari and Shizuko Watari handed me the whole sum. My old friend Issey Miyake knew Alvin Ailey and Sankaijuku by chance. And by chance Mr.Kobayashi from TV Asahi came back from the position of ABC correspondent in New York and decided to do this project in 5 days. Just by chance, there was an allumuni association of the Tokyo University Cultural Department 8D held for the first time after 30 years, and by chance I was in Tokyo and went and met Hohgan who had become the president of a six-billion yen company, Telecom Japan. Also by chance Minoru Morimura of Recruit published a book on "Bye Bye Kipling". What was the most impressive "by chance"?

Late at night in Akasaka, I was having a drink at a bar with a couple, Arata Isozaki and Aiko Miyawaki, and there, by chance, in came Mr.Kinokuni of the Seibu Museum. I went ahead and said, "Please give me twenty million yen". Then he replied, "I wouldn't know about two hundred million yen but for you, Mr.Paik, I would think we can manage twenty million yen." And discussed the matter in a meeting at Seibu the following day. At this stage, for the first time the balance shifted to the PLUS and marked a definite GO. This meant that even the late Joseph Beuys contributed to the by chance. Pierre Restany who is fit and healthy introduced me to Junji Ito and Toshimitsu Imai and Imai's son, Alexander (at the time 25) assured me that if Dentsu should abandon the project, he would prepare the sixty million yen. There were another set of thrills in the just "by chances" process and these were the just "in times" which happened in Korea.

A satellite is a rippling wave across the sky. Like the lovers, Kengyu and Shukujo (two lovers from the old Japanese folktale who became stars, so they could meet once a year in the Milky Way), this meeting is old but new.

<div align="right">N.Y. 4/8/87</div>

P.S. The logo for "Bye Bye Kipling" was made by Dan Sandin and Marylin Wulff in Chicago.

Dick Cavett adlibed Kurodabushi, a folklore song when the sound from the 4D was cut several times which shows the experience of his 20-year career.

The unsung heroes from the Japanese side were Teru Satoh and the person who made the artificial blue wave.

Originally published in Japanese and English in *Icarus=Phoenix* (Tokyo: Parco, 1988), 15-19.

Nostalgia Is The Extended Feedback ('30-'60-'90) (1992)

Before 1950
> Artists discovered the abstract space.

After 1960
> Video artists discovered the abstract time.

<div align="right">time *without* contents.</div>

Allen Ginsberg said: "Time is a big lie"... the video art can show you how many different and colorful lies we can create and experience in our life and art. Certainly lies and lying is more interesting than telling the truth. The discovery of new artistic truths rarely makes the news. Yet the discovery of art forgery always does.

Video can accelerate or slow down, reverse and inverse, warp and distort the straight arrow of time. The French say "le temps se passe"... I wonder what the "se" means.

Let's think about the time span of 30 years.

When we look back 30 years from 1990, the 'Sixties seems very close. Most of the main stars are still here and active. The King-makers of the 'Sixties are still the King-makers of the '90s. Even the artistic taste may not have changed that much, as the press pretends.

However, if we look back 30 years from the standpoint of 1960, the distance almost looks like a grand canyon time-trip. It started with Hitler and ended with the Kennedy campaign. Stalin, collective farms, the Holocaust, Hiroshima, Korea, Berlin and Eisenhowerian complacency are in-between.

There is another grand canyon in the perception of the thirties between the print media and the electronic media. The print media reports more or less accurately what had happened, but electronic media's only heritage is the Hollywood version of that time... Greta Garbo and Ginger Rogers. Needless to say, young people are growing up thinking the 'Thirties is not the age of the Depression and Dictatorship but the age of Busby Berkely. Therefore some revision of the 'Sixties may be necessary now.

The first, which comes to my mind is the Nine Evenings of the E.A.T (Experiment in Art and Technology) organized ambitiously by Billy Klüver. In hindsight, the case of Bob Rauchenberg's great DARK performance forces upon us a new interpretation.

In the huge dark room of the 69th Regiment Armory there was not a single dancer or actor. Performers are exclusively made up of hundreds of young people, who strolled the space at a leisurely pace. One by one they say their name... and name only. At that moment we see his face projected in grey rough-grained on a large screen. The freshly invented Tibicon camera, which can pick up the image in the dark (and was possibly used in Vietnam to screen the Vietcong infil-trators) was used for the first time in art. It was an eerie, "unheimliche" scene. Rauschenberg created a large negative space in front of the paying audience of middle-class background who drove two hours from New Jersey to get an evening of live science fiction "entertainment". Cer-tainly in 1966 this bitter minimalism was in full swing in the LOFT style performance for maybe 20 of the in-crowd. Very soon in the 'Seventies, the grand style minimalism would invade Lincoln Center and the Avignon Festival. Yet Rauchenberg suffered the situation of Catch-22. He had to advertise in order to pay for the expenses... then he was courting the fire—the wrath of enter-tainment critics of the daily papers.

We suffered exactly the same fate in 1970. After 6 years of TV labs, which televised its product in the New York Metropolitan market of WNET Channel 13 TV Station (we used to get the share of 1 or 2 which means over 100,000 viewers) we ventured out to the Public TV cross country, which will guarantee 4 million viwers. The Rockefeller Foundation (Howard Klein) and Russell Connor and I organized the national TV shows of video artists, which unveiled Bill Viola, John Samborn, Kit Fitzgerald, and John Alpert/Keido Tsuno. We did well for the meagre budget, but we made one mistake. We hired a professional Madison Avenue press agent, who generally promotes Hollywood or BBC productions with 20 times more budget. The result was a wrong match... and our show was scuttled after the first season.

With a certain chagrin, I looked back at the great dark performance of Bob Rauschenberg. In 1968, I shared the dinner table with Henry Geldzahler, our conversation drifted into art and technology, for which he was known to have little interest. He said something like this:

"An artist can use various technologies, yet technology per se does not yet define any aes-thetics. Technology is not a panacea".

Yet when he took over the National Endowment on the Arts in the '70s, the team of Henry Geldzahler and Chloe Aaron made the far-sighted grants to the nascent art of video, which in

combination with the Rockefeller Foundation and New York Councils on the arts, laid the foundation of today's video art.

Originally published in *Paik: Du cheval à Christo et autres écrits*, ed. Edith Decker and Irmeline Lebeer (Brussels: Editions Lebeer Hossmann, 1993), 19–21.

For a Deer (1992)

some artists get discovered after 100 years or so... But matematicians
who get discovered after 100 years or so, seems to me even more mysterious,
because I dont understand even the contemporary matematics or geometry
of ancient Greeks. Therefore the feats of say..Evariste Galois
(1811-1832 , who lived shorter than Schubert or Mozart),
or George Boole (1815, whose father was a shoe repair man), or
Cantor (group theory), who doubted is his death bed, maybe he was wrong,
because everybody said he was wrong) fascinated me all along, and it was
my secret desire to understand these three guys formulas some time before
my death. However my so called success killed many my secret desires including this one. One must finish and package one's own shit first.

———————————

George Boole's binary theory was a USELESS discovery for long time ,
untill Shannon or Von Neuman finally made use of it. But I want to
quickly add that I-Ching of China also made use of binary code.
and I must also quickly add that Iching was fist used by the Ying Dynasty of the
ShanTung Province, whose tribe has close ethnic links with the
roaming Koreans before the Big Biblical Flood, of which there are many
discription in the ancient Chinese script.

I made two early decisions , instinctively or from
practical reasons). In 1962 I made the decision NO? to use the Video Input
but to use the Vertical and Horizontal inputs of TV Tube. The reason
was a practical one, because the video circuit deals with 4 mega cycle,
for which I had had no machines, but Horizotal and Vertical inputs
deal with 60 or 14.000 cycles, for which I had had already 15 machines,
left over from my electronic music days.

 - - - -

The other decision was that I gave up the digital road in 1967.
John Cage inrtroduced me to Max Mathews at Bell Labs, and I was
a resident visitor at Bell Labs at Murray Hills for half year.
I got their Limousine Service ever y morning and got the return trip
4 PM. From this upper middle class half day I retrun to the
jobless artist life at Canal street with 25 Cents Pizza and 15 cents Coke
I associated with such eminent scientists as Ken Knowleon, Michael (?)
Koll and a Hungarian (fresh from Bude pest). a Denes.
They were all very nice to me. Sometimes I had to endure the Violin Solo of
Max Mathews (MIT PHD), whose interval deviates considerably from

well temperd pianos. In any case I thought the digital technology
, at its enfance , was too slow for me. It took three months to run
my first computer generated movie BUG FREE. I thought, what if I work
for a year for a program and if the result doesnot please me ???
Then I must work another year to run the second program ?? and
what if that doesnot satisfy me after all those travail ?
However the good old analogue way was real time thing I could quickly
modify, hijack and crash...and rise again... it was more human.

_____Around 1982 the first realtime digital machine (Squeeze Zoom) was introduced
at the NEXUS production made by Quantel, the company who makes a lot of
Missile guidance system... I had a tickle in my back..
since on that year in Europe a lot of my friends were picketing the SS 20
missile deployment. In any cse the first realtime digital machine
gave me the sensation, as if TV was re-born. It was like when I played
my first Debussy after those years of Beethoven or Chopin..
I felt like I bought a New Piano.

In 10 years from 1982, those realtime digital machine (Squeeze
Zoom, Adio, Mirage, Harry, K-scope) has reached to the stage of
di minished return. Shuya Abe, John Godfrey, Paul Garrin, and
many engineers at Nexus , Broadway Video, Matrix, Postperfect
gave me many CREATIVE ideas of their own, which I stole with or
without credit. Since 1983 Paul Garrin's help has been crucial.
Since 1987 I had to go the digital way more intensly.
The first was a Freiburg company called 3 F technik, which did my
Dokementa 87 projekt. Then in 1989 Sin Sung Electronics Korea (Oh, Seh Hern
, and Lee Jong Sung) did marvellou software-hardware combination
in the multi plex system. 1989 Whiney Museum (fin de Siecle)
was not no possible without Rebecca Allen's and Hans Donner's Computer
Graphics.

More generously Dean Winkler and Judson Rosebush opened their
software chest to me, which was accumulation of thier 20 years of
hardwork.... Condition was that I print their name every 30 seconds
for about three seconds on the screen plus some cash and my art works...
very very generous....
I cannot thank enough for all the help I got from the great artist-
engineers from all over the world, including Brazil.

 Paik N J
 5/10/92

Typescript, originally published in *Het Binaire Tijdperk: Nieuwe Interacties*, ed. Charles Hirsch (Ghent:
Ludion, 1992), n.p. The essay's title is a friendly address from Paik to Hirsch, whose name is the German
word for "deer."

Mediatique Memory (1992)

Any media study should start with the languages, and I have a very checkered memory of language. In my grade school years 1939-45 in Japanese-occupied Korea, we grade school children talked to each other in Korean at home, but no sooner did we go out from our house gate than it turns into Japanese (otherwise a policeman can stop us & pick us up). We would spend the whole day in school speaking Japanese, and when we came back with the same friends into our homes, our language very naturally turned back in Korean... so naturally that we did not even notice it. It had its advantages. My mother, who was unschooled and did not know a shred of Japanese, was unable to check my homework, so I could always cheat my mother with the homework.

However our tragi-comedy was played out after school. Before we went home we had a regular meeting of "repentance" in which our teacher (he can be a Korean) questions us as to "Who spoke Korean today?" We grade schoolers put the finger on each other, we became informers... "He spoke such and such word in Korean"... and this boy must retort, "the accuser did it also at lunch time". Those Korean words could be a single verb or noun, which comes up unconsciously. Punishment can be classroom cleaning afterwards or denial of a recommendation to the better high school, or the taking away of our prestige BADGE which says "I speak only Japanese everyday". This badge was given only to the upper third of the class.

It took the English 1000 years to stamp out the Celtic tongue from the Irish, but the Japanese had to do it in 30 years in Korea. The Japanese blend of perfectionism did have its own "aesthetics". Certainly I would not deny its virtue. Lukács and Kafka wrote their main works in German and not in Hungarian or Czech (voluntarily). I am writing this essay in English, not in Korean (voluntarily). Certainly world culture would have suffered if Joyce, John Lennon, Shaw, Wilde, or Beckett wrote their works in Celtic. Most likely these geniuses worked harder because they knew they were addressing the whole world through German or English instead of local tongues. They are all humans with frailties.

In 1948 Korea there was a bubbling avant-gardism, quite a few composers knew the stylistic differences of Bartok, Hindemith, Stravinsky and Schoenberg. There was a yearning for everything new... Marx included. Yet the particular book I picked up in Seoul about Modern Music with a chapter on Schoenberg was printed in the pre-war Japan... Culture is a two way street.

By 1940 ALL Korean language daily newspapers were forbidden except for one, which was the organ of the Japanese colonial government. Monthly magazines in Korean died one after another commercially because so few Koreans were able to read Korean and there were hardly any Korean Companies who could advertise in them. By 1941 or '42 even Japanese magazines were getting thinner and thinner due to the lack of paper caused by the world war II situation. 1941 was the third year of my schooling, and my reading appetite was growing day by day. I was experiencing an acute withdrawal syndrome in printed matter.

One day I was following my mother in cleaning up our attic. Among the heavy dust I found a great treasure. It was the accumulation of monthlies and Movie magazines of 1937 or before. It was my sister Hiduk's library before she was married. There were a bundle of photo magazines, of American/European movie stars. I still remember the movie "Morocco" by the director "Von Sternberg", the photo story on "Invitation To The Ball" by the French director Julien Duvivier, something called "Orchestra girl" starring Stokowski and Deanna Durbin, the German movie "Unfinished Symphony" and Leni Riefenstahl's "Triumph of the Will". They were thick and large... my only window to the West. I still smell the dust... the sweet smell of dust. I read them many, many times, they were an oasis inside the cultural desert of war time which young people of today can

never imagine. I always laugh at the words "Information Overload". Actually I dare say that even now Information Overload may not exist in many important metropolises of today. Unlike food and sport, you don't notice your own undernourishment where culture is concerned. Cultural desire is often a latent, dormant desire.

In 1942 or '43, I read in a popular monthly published in Tokyo that American will lose World War II. His argument was that Americans were very spoiled by material luxury and their society was not made for depravation. We (Tokyo people) could live with the power blackouts, since most of the houses were two stories. But what could happen in the Emipre State Building when all the elevators were stopped? Can you walk up and down 130 stories?

What about heat? American homes are so overheated that Manhattan's fashion models don't wear underwear, even panties, lest the underwear disturbs their heavenly curves. They were only one layer of silk dress and fur coat... they slip in and out of limousines for door-to-door travel... Wow... these beautiful women without underwear. This anti-American propaganda kindled my desire for New York.

Originally published in *Paik: Du cheval à Christo et autres écrits*, ed. Edith Decker and Irmeline Lebeer (Brussels: Editions Lebeer Hossmann), 9-11.

B: SCRIPTS AND PLANS

Scenario (1962-1963)

1) While playing any other film,
 put on and off, on and of--many times--
 the "NO SMOKING" sign of the hall.

P

2) Project a very colorful color-film, such as striptease
 etc----, to a pool , waterfall, or to the jet of the water
 on a midsummernight ,
 &/or
 to the snow of wintergarden in a very cold midnyght.
 One may lounge there.
 (originally concepted for the beautiful garden
 of the Galerie Parmass . Wuppertal, W. germany.)

3)Project the projector without film on the screen,
 so that we can enjoy the dust, dots, the movement
 of the dust of the screen, lense, air, ETHEL.

[Handwritten on side of page:]
1) You may play or print this scenario or a part of this scenario.
2) The TITLE of Toshi's piece is decided. "LIFE MUSIC.. The Score will be sent soon.
3) In my article on experimental TV. There was such a phrase. I have the luck to have nice col-
laborator. Mr. SHUYA. ABE (TBS network)
please change it
 To.
 Mr. S. ABE.
 (TBS Network should be ommitted.)
 because he is prohibited to take side job by TBS. Thanks
 MAY I send all my thing to. the adress of Canal St 359?

4) a composition anonyme-
 poly- dimensional study of the film.....
 More than five interpreters stand in corners and
 center of the hall, with their ownn projecter.
 Each interpreter has same or different strip of
 of film. All the interpreters play their part
 , , through moving the projecter itself with
 characteristic directions, directions, forms,
 directions, speeds such as

 They can also a change the film motor speed

and the brightness of the film-projector with
variable resistance,
They can even-also put on- off the main lamp
 of the hall and the lamp of projecter &
They can even-also shoot the eye of the audience with the
 projector and 2000 W spotlight.
........ANYway
 they can combine all technic, described
 in this scenario (No. 1 - No. lo).
Very loud acccompaning sounds can be used or not.
If good played, this piece can surpass almost all films,
filmed, from C.Chaplin till Liz Taylor.
But 80 % of the success is to be ascribed to
the interpreters. It is , why L I call it
 " composition anonyme". I hope to compose
my own (determined)version in 5 years.

5) project a very excited agitating scene of Hitler's
 speech(from Fühler's Wochen Schau) in very slow speed.

6) VERY SUBLIME FILM CONTEST
 The interpreter is cameraman.
 HE should film very famous building , such as
 U.N. building (new york) , Notre dame de Paris
 or Cathedral de colonge.
 He begins to film with full exposure and
 continue closing the lense VERY VERY SLOWLY
 , that finally the film ends with no exposure.
 The developed film should show the delicate
 scale, ranging from the darkness up to the bright
 white, which expresses the curve and pulsation of
the interpreter,. Therefore he should take
 very much time (minutes and hours)
for one round. Some thinkable curves are

[drawings of curves]

It can be filmed many times by same or
different interpreters,,, also in COLOUR.
 in suny, rainy and snowy days.
You may still polish the film after the development
, when the result is not satisfactory.
Cut off the motor and lamp of projecter.
Put the variable resistances between them and A.C. current.
 Regulate the speed of of motor

and the brightness of the lamp SEPARATELY.
This technic is very fertile and can be used universally
 in combination with other kind of film. Through it
the film ceases to be the REPEAT-art and attains the high quality
of unrepeatable "einmalige live performance" like music and drama.

7) FILM- unedited-
 The mental training to accept fully, some natural
 movements is a good exercise for zen.
 F.i. you may follow a heavily burdened truck
 for about 30 minutes , filming it uncessantely,
 and show the film , without editing.

or F . I .
 you may film and record the schoolboys,
 playing in the recess time from the roof of
 primary school in preferably Brooklin or Monmartre,
 without interruption
 and show it and play back it to the audience,
 without editing from the beginning up to the end.
 please, lock the door of the hall, so that
 no one can escape , before the film ends.

8) One should develop an unfilmed film and project it
 in the screen. The interpreter is supposed to play it
 many many times , before the public performance
 to get more " snow" on the transparent film.
9) Project a scotch tape and see!
10) Project the projecter without film.
 and...... you may sit in the middle of white
 screen just without comment, or you may cut the hair
little by little very slowly, or you may perform
 a real (unfilmed) scene , which you meet very often
in commercial film such as bettiquette scene , fight and kill
scene detective scene in the middle of white screen.
This piece is a little no good, but has some raison d'etre,
if played between many commercial or avant-garde films.
11) A pretty actress in Theater am Dom (Köln) , whose
name I forgot , suggested me to operate the
projector with hand. It is a genial Idee.
12) You can make any boring Hollywood film interesting,
if you cut the film several times and
splice it again or put tlı e lamp on and play
cheap transistor radio in your seat in

Unpublished typescript/manuscript, Nam June Paik Estate.

Electronic Opera (1967)

April 18 1967

 E L E C T R O N I C O P E R A

The request for the reformation of opera comes from many sides.

1) From the standpoint of 'opera proper'.

The opera dramaturgy has not essentially changed since Wagner.
All famous opera, including 'Wozzek' and 'Moses and Aron', are
the careful melange of existing dramaturgical styles. Electronic
sounds are occasionally used for superficial effects but not
essentially enough to change or influence the opera itself.

2) From the standpoint of 'electronic music proper'.

The short history of electronic music has experienced many turning
points,,, namely, from concrete sounds to the electronic sounds, and
then to combinations of instrumentalists and the introduction of
live electronic elements, such as contact microphone etc. But the
rapid progress of video electronics provides us with means to compose
 a "T O T A L E L E C T R O N I C O P E R A",
which uses only electronic sound and image as composition material,
and employes only computer technology as the material form, and
uses only generators and video taperecorder as the performing charac-
ters and instruments, and finally uses only T V as the distribution
media. As the use of sine wave generators is inadequate to compose
the pentatonic folk song, so the use of video electronics to
reproduce a pretty face mainly is anachronistic. Essentially
deflection patterns (eg. spiral,oval,triangle,etc.) with adequate
gate circuit as in chromatron color T V will enrich the variability
by far. I am confident that the introduction of computer to this
already well proven area will bring immediate success.

a) artistic use.

Whole movie, T V technique will be revolutionized, the scope of
electronic music will be widened to the new horizon of electronic
opera, painting and sculpture will be shaken up, intermedia art
will be further strengthed, bookless literature, paperless poem
will be born.

b) pure scientific research.

The new possibility of drawing every kind of form from abstract
pattern to realistic image via every grade of mixture of both,
will be helpful in the research of Gestalt psychology in its
whole sphere, namely sensory organization, characteristic of
organized entity, behaviour, association, recall, insight, learning
etc.. It might contribute also to 'hot' subject of visual electron-
ics today,such as optical recognition, optical character recognit-

ion, optical scanning of customer's account,video telephone,
sparkchamber photograph etc., needless to say,radar and anti radar.
c) for artistic eyes.
Someday medical electronics will progress so much that vidicon
artificial eyes will help the blind. In that case the vidicon
scanning must be EXACTLY the same as the retinal structure of
patient's eyes. Beyond the fact that the standard retinal
structure would be much more complicated than today's regular
scanning technique, there will be a large and delicate range of
individual difference among patients, which might vary even
daily. In that case we must have very fine tuning system of scan-
ning with manual and electronic controls, comparable to but
by far surpassing today's ophthalmoscopy, in order that vidicon
signals should be translated into the adequate synaps to op-
tical nerve without distortion. My scanning experiments will be
of some use for this ultimate goal.
d) for video telephone.
Confidential pictures can be scanned with very complicated
secret 'coded' frequencies, and sent to receiver. This will
be useful, just as simple scrambling is useful,(eg. a Ford
car designer showing his new car model to an executive in the
coded picture via video telephone in complete confidence.)
e) 'SYNTHETIC FACE' for the police identification, anthro-
pological study of various face types, beauty surgery, and
manicure industry etc..
The above technic will enable us to construct any kind of face,
eg. a suspect, who has the long contour of John Wayne, melan-
choly eyes of James Mason plus Chu En-Lai, half bald as Yul
Brynner, oriental flat nose, but with the sensual mouth of,,,,,,,
,,say,,,,,Oscar Wilde, but wearing glasses rather like James
Joyce's,,,,and with sex appeal of Henri Vidal........

 2) I suggest to build a 7 channel video signal mixer,
in which each camera shoots the separate parts of various faces,
enabling to compose one face out of 7 men's characteristics.
Beyond the above mentioned police use and possible use for pattern
perception, beauty surgery,anthropology etc., it will enrich the
TV & film technic tremendously.
a) eyes weep, while mouth smiles.
b) only eyes come out of face and fly away. (negative feed-back
of eyes will erase out original eyes electronically.)
c) a face with slowly shrinking mouth.
d) a face with two mouths and three eyes.
e) whole face shakes, but only nose stays unmoved.
f) put dog's eyes and cat's mouth to Adenauer's face.

3) Video signal input.

The painful gap existing between TV video signal (4 meg c/s) and the output speed of computer (eg. IBM 7090:400,000 bits per second) requires an unusual solution. One way would be to record the program in slow speed and speed it up in play-back. But still astronomical quantity of information bit in single frame and its sequence requires enormously time con-suming program work, and just this shortcoming demands an origi-nal programing system, with many short cut ways and artistic phantasies, for which,if I may say myself, I have been often credited. As the first step I will establish many machine independent subroutines, which may be used by other programmers like twelve tone rows or raga in Indian music.

eg. a) subroutines of various basic forms ,ranging from geometric to irregular form like bacteria.

b) subroutine of place inside a frame.

c) subroutine of size.

d) division of raster to many fields and its interchange-blity.

e) stretch and shrink each field in various directions.

f) subroutine of combination of all 5 subroutines and the superposition with realistic images. As human laughter and dog's bark is superimposed in Vocoder, so Picasso's face is scanned into the face of a gnawing cat.

Among vast application of this methode in art, science, and technology, one interesting example would be the imitation of the statistical movements of virus, bacteria, fishes, and mass people etc..

4) Another important usage of computer in visual art is a concordance of movie and T V shows, as Cornell University did with a Shakspeare concordance. Cataloguing and indexing of all main actor's and director's scene by its contents (f.i. walking, waiting, anxiety, love, fight, jealousy, eating, joy, crying, including length of scene and emotional pitches) on videotape will be very valuable for cine-library,a good study material for student and a great fun for ordinary viewer, and historian, sociologist, psychologist will profit out of it.

5) Cathode-ray wall

Mood art in the sense of mood music can be invented and install-ed in the home. Big theater or opera house could change their lobby designs everyday, matching to their repertory and this lobby design could progress in accordance with the developing plot. Big cathode ray wall with color eidophole or controlable electroluminescence can be programmed for this purpose.

Unpublished typescript, Smithsonian American Art Museum, Nam June Paik Archive (Box 14, Folder 4).

A Day Project (1972-1973)

1972/73. "The following two pieces are written for specific purposes... which are easily detectable by reading them."

A-Day Project (excerpt)

Art and Artist is not the marginal appendix of New York City, but the core of its existence, because New York's future depends on its function as software-media-nerve center of the world in the increasingly ephemeral post-industrial society. Artist symbolizes the information-knowledge-biocybernetical sensitivity. The following program will have a maximum impact on this fact. Media attention is conditional to "dyne", or ration of acceleration of speed and not to the speed per se, and even less to "mass", or static weights.

A-Day
(Art Day on channel 13 from morning 9AM through midnight until 2 AM)

On this one full day WNET cancell ALL programs and broadcast nothing but art-related programs. In order to combine quality, variety, and cost-efficiency, and no-risk production, I propose five-dimensional production.

New Projects

Twenty six years ago Norbert Wiener published a prophetic message, which signaled the coming of the cybernetic age:

> For many years Dr Rosenblueth and I had shared the conviction that the most fruitful areas for the growth of the sciences were those which had been neglected as a no-man's land between the various established fields. Since Leibniz there has perhaps been no man who has had a full command of all the intellectual activities of his day. A century ago there may have been no Leibniz, but there was a Gauss, a Faraday, a Darwin. Today there are few scholars, who can call themselves mathematicians, physiologists, or biologists without restriction. A man may be a topologist, or an acoustician, or a coleologist....It is these boundary regions of science which offer the richest opportunities to the qualified investigators....The physiologist need not be able to prove a certain mathematical theorem, but he must be able to grasp its physiological significance and to tell the mathematician to what he should look. —Norbert Wiener, Cybernetics, 1947, p. 2.

Research into the boundary regions between various fields, and complex problems of interfacing these different media and elements, such as music and visual art, hardware and software, electronics and humanities in the classical sense,,, this had been my major task since 1958, when I joined the electronic music studio at West German Radio in Cologne, headed by K. Stockhausen.

For the past one year, as an artist-in-residence at WNET-TV Lab in New York City, I have pursued this familiar and furtile terrain. Again and again Norbert Wiener's prophesy has proven to be valid even today.

I. Introduction of digital computer into video synthesizer (in collaboration with Bob Diamond).

Computers and video are the two most powerful tools of today, said Gene Youngblood. Yet the full-fledged digital computer has not been used in any of the video synthesizers existing today (even the one at Computer Image Corporation). Therefore if we succeed in the fruitful interfacing of a digital computer and video synthesizer, its effect will be phenomenal.

Actually, I have done some computer research at Bell Labs as a Residential Visitor in 1967/68 under the guidance of Michael Noll. However I did not incorporate a digital computer into the design of the Paik-Abe Video Synthesizer at WGBH in 1969, because at that time most computers were not movable, and time-sharing (through telephone lines) made the output speed inadequate for on-line operation. However the rapidly advancing computer technology made the introduction of a digital computer into video art quite plausible and economically and artistically viable. Beauty Per Dollar Ratio will be much more favorable than the traditional ways of color video production.

Specialized computer equiptment dedicated to one application, usually a minicomputer and a specialized terminal, is an area of the market that is growing at about a 50% pace now compared with 12 to 15% for the entire industry, and this growth is not expected to slacken in the immediate future. —New York Times, January 7, 1973.

This is not automation in the traditional sense, which is aimed at cutting the cost of personnel, while doing the same job. Our goal is rather the opposite. Digital computer video will open up a fresh new terrain with powerful programs which will awaken the latent desire for video art into the concrete and conscious level, and eventually increase the jobs for video artists, engineers and businessmen. Our research will fire a chain reaction, which will let many other video artist-engineers move into this field, as the successful launching of the Paik-Abe video synthesizer did in May 1970 in the field of video synthesizers.

The beauty of any computer research is that one's effort will not and cannot be wasted. Computer science is so systematized that every effort of the predecessor, whether success or failure, will be compiled and used by the next comers. As a matter of fact, Boolean Algebra, the essentials of binary system, was invented more than 100 years ago, and it slept for 80 years before getting into service. The vast amount of rules and vocabuary of Machine Language is a 20th century Pyramid, which is created by the millions of stones, the toil of thousands or researchers. Since computerized video synthesizers have a vast virgin land before them, there will be little room for duplication with other artist-engineers. Eventually the form will mature and can be set up in many other video centers, now sprouting out like mushrooms.

I was very proud at the Media-Art Conference in Washington D.C. on December 2, 1972, because the Paik-Abe video synthesizer was played not by Mr. Paik but by Mr. Ron Hays. If a machine is to survive as hardware, it should be universally applicable.. like an automobile, which anyone can drive anywhere. So far the Paik-Abe video synthesizer is the only video synthesizer being used cross-country (WGBH, WNET, Binghamton TV Center, Chicago Institute of Arts, California Institute of Arts at Los Angeles) by more than 100 artists and it has bene aired locally and nationally quite a few times.

Bob Diamond was born in New York City 26 years ago and went to Bronx Science High School and Brookline Poly Tech, and worked at N.Y.U. Computer Center, Control Data, and Binghamton TV Center. His work at the WNET-TV Lab impressed David Loxton and John Godfrey favorably. Bob's youth and experience in computers at Control Data (which has developed so-said third generation ((super)) computer even before IBM) will make all my seemingly far-fetched prophecy into solid reality in 12-18 months.

There is another important spin-off of this research and development, which cannot be ignored from the educational and national point of view. Increasingly more undergraduate students at liberal arts colleges are taking the computer course as a part of a basic college curriculum. It has been very successful at Dartmouth College. Combinations of computers and beautiful color TV synthesizers will be an effective teaching maching for computers, media, TV, art, and man-machine

relationships in general. In 1970 I visited the Man-Machine Laboratory of M.I.T. and was surprised to see that they were experimenting with the video delay line, which Ken Dewey did many years ago.

II. <u>Software Projects</u> (in collaboration with Jud Yalkut).

Edwin H. Armstrong, an undergraduate at Columbia University invented the feedback circuit back in 1913. It took 50 years for society to find out its deeper meaning. Feedback is a special device, which recycles and amplifies the input (or past tense) through a few micro seconds delay line and strengthens the outgoing signals (or present tense). Therefore its phenomenological structure has certain affinities with our consciousness of history or nostalgi, a pendulum between past and present. Electronically speaking, Nostalgia is nothing but a sweet-sour, homeopathic feedback circuit using a delay line of decades.

There is a myth that TV is an "instant" medium, where as a metal sculpture is a "permanent" medium. The irony is that big metal sculptures have been often destroyed due to the lack of storage space and that instant and fragile electronic information often gets kept for years, due to the convenience in storage and retrieval. Eg., the 1920's are gone, but the '30's are alive everyday as late late TV shows. This strange phenomenan is bound to continue forever, and someday, for some new generation, the demarcation line between the '20's and '30's will be as unreconciable as B.C. and A.D.

Feedback is not the only favorite technique of the video artist, but it expresses the essence of ART per se in generic terms. Cult of Eternity, long-levity, immortal preservation of our cultural heritage, has been a major function of art from the time of the Pharoach's Pyramid to the age of Polaroid and Port-apack, because we are all fragile and mortal.

Elle est retrouvee
 Quoi ? l'eternite.
 C'est la mer
 allee eavec le soliel
 —Arthur Rimbaud

I am undertaking the following programs, which will utilize the peculiar medium of video, which can jump back and forth the TIME, as well as SPACE.
1) <u>Recycling the hidden visual heritage</u> (in collaboration with Jud Yalkut, New York based film maker, and pioneer at Video films.)

Tens of thousands of beautiful prints (eg., Currier and Ives, Eno Collection, Stoke Collection, etc.) are semi-sleeping in many libraries and museums. They are all copyright free. Using new video techniques, such as matting, keying, video synthesizing, etc., we can animate them and make them into fresh video beauty at moderate cost. Cost-efficiency will be better than double the traditional 16mm animation stand. It will not have the traditional educational film's stale look, but fast-paced, many-faceted feedbacks, both in electronics and semantics. The beautiful color prints will be juxtaposed with the present scenes, filmed and synthesized. The result will be parceled into five minute segments and will be aired during summer from Channel 13 locally. We are concentrating on the New York scenes, but Mr. Norman Lloyd suggested that it could be extended into other old Eastern cities.
2) <u>Recycling the hidden audio heritage.</u>

When General Eisenhower was coming back from Europe after V-E Day, his portable radio on the plane caught a radio commercial approaching the Atlantic coast. This radio commercial made him feel that he was back home—finally. This episode drastically demonstrates the power of our audio-environment in Freudian level. However, our academic circle is so occupied by print media that proper attention has not bene paid to the audio environment or heritage. The feature of American culture is the emergence of mass culture through the use of electronic audio-visual media, which draws a faschinating locus in a complicated firtationship with Europe-imported High Art. Eg., Mr. Walt Disney built the California Institute of Arts but did not want to put a "film department" in it, because Walt Disney did not consider film as a serious or high art form.

It is a pity that great radio dramas, which were written by great authors and which reflect the TIME and atmosphere of history very well, can be forgotten in the advanced stage of video technology. We can revitalize some of them be creating an autonomous video accompanyment to them. I tried it at Kitchen and the Mercer Art Center using Orson Well's The War of the Worlds. The result was encouraging. The video part can be a combination of abstract, sur-real and realistic images, and it can be more counterpointal than harmonic. There are a great deal of old radio shows recorded and kept by nostalgia buffs. It will make a good late late show for PBS channels.

3) Video archive of senior American musicians.

The Rockefeller Foundation is interested in a half inch tape video archive of senior American composers of serious music. A counterpart of this project, a video archive of senior pop and folk musicians in Kentucky, Tennessee, New Orleans, and the American Indian Reservations will make this archive complete in the music field.

Actually America has an intellectual climate suitable for radical experimentation. We are, as Gertrude Stein said, the oldest country of the twentieth century. And I like to add: in our air of knowing nowness. Buckminster Fuller, the dymaxion architect, in his three-hour lecture on the history of civilization, explains that men leaving Asia to go to Europe went against the wind and developed machines, ideas, and Occidental philosophies in accord with a struggle against nature; that, on the other hand, men leaving Asia to go to America went with the wind, put up a sail, and developed ideas and Oriental philosophies in accord with the acceptance of nature. These two tendencies met in America, producing a movement into the air, not bound to the past, traditions, or whatever. —John Cage, Silence, 1958

Originally published in *Nam June Paik: Videa 'n' Videology 1959-1973*, ed. Judson Rosebush (Syracuse, NY: Everson Museum of Art, 1974), n.p.

Selling of New York
verbal text will be written by Russel Connor. 4 minutes-6 minutes.
about 4 minutes of commercials from France, Italy, Germany, etc will be
added. This should be acquired by David Loxton through the help of
a N E T ma n, who has most contacts with European TV stations.
I would like to have at least 15 minutes of commercials, so that we can choose
from them. (Also I want to use something for John Cage show at WGBH)
It ca n be the rerun of NET show, which shows the best commercials of the world
(competition)

This 4 minutes text (R.C. :host) will be filmed by 16 mm and half inch in normal
position.

on March 9 or 10, in Binghamton, Same text will be synthesized with R.C.
and videotaped directly 4-5 times .
On March 14,15,17 (Tuesday-Thursday) , about 16 scenes (5-15 seconds each)
will be filmed on 16 mm Auricon TV shutter (rental 40 $ a day).
It can be done at 359 Canal street. except for a few other locations.
We dont need more than 8 or so.

There are also following material from my other works.
 Lindsay feed back.
 McLuhan talking and distorted.
 TV cross
 Ed Schlossberg's excerpt.
 Charlotte TV bra in Jackie-Paik tape of NET.
 A llen Ginsberg video synthesized. (AV 5000)
Time proportion of three different R C.
 Video synthesizer... 2 minutes.
 TV set retake..... 1 minutes 45 seconds.
 RC normal 15 seconds.

 In this proportion, program can be extended into 5 or 6 minutes.

Send L.A -N.Y. excursion ticket to SHuya Abe
 3531 East Telegraph Roadd
 Fillmore, Ca lifornia 93015
 telephone 805-521 1860
 805-521-1687

shooting script. (final order not yet decided)

 scene 1 : bathroom and girl and TV.
 inside bubble soaked bathtube
 girl reads book...maybe a youth oriented title, such as
 Mao or Abbie etc.. she may throw the book to the TV set (?), she
 can utter a comment like "bull-shit, or such thing... TV is as always Russ
 Connor.
 At some point girl smears TV set screen with shaving cream, which is
 put on her foot.
 at 359 Canal Street.
 and at one very fancy bathroom.
 scene two
 toilet basin . russel connor's talking comes from inside.
 after a while a hand lift the toilet lid and there is a
 TV set keep talking.
 talk is interrupted by the water splushing noise.

 ma ybe we ca n rea lly flood the basin with water. (cost 100 $)
scene three
 TV set looking upward, is surrounded with many candles.
scene four.
 TV cross (from BBC)
scene five
 Russ ta lking from Charlotte's TV bra. and TV glasses.
scene six
 TV set lookingupward on the grass... flower-petals dropping on TV
 screen one by one and covers the TV set. (good)

scene seven
 book shlve . Camera panns book shelf slowing.. we can arrange
 various funny book titles ...and pass a TV set , which is put on
 among books.

scene eight.
 camera slowly closing up to a pair of long beautiful legs...
 legs slightly and smoothly open and see Russ Connor talking on
 TV. leg ca n open and close a few times.
scene nine
 on water bed, a young couple caress each other watching TV.
 and this TV can be situated behind fish tank.
scene ten
 a TV set with two pairs of legs.. one pair is distinctively girl's
 with red manicure on foot-na ils... legs fondle each other in various
 position
scene eleven.
 camera shoot the letters "invisible TV", while Russ Connor's
 talk keep coming
scene twelve.
 round-shape TV set on the ba ck bottom of a girl (tall)
 sit on a blue matress, blue ba ckground. Girl moves
 her hands... a kind of dance...it can be later superimposed with
 chroma key ble plus synthesized material.
scene thirteen
 jud's bed room at 7 Saint Marks Place.
 camera moves back and forth from TV set and various
 posters and other typically hippiesque items...and great disorder.
scene fourteen
 TV bed at Binghamton.
 camera shows first a bed covered with blanket, or country style
 and pillow... a small girl (daughter of Hocking) comes up and
 un cover the blanket, and you see that bed is made out of 6 or 8 TV
 (screen to the ceiling)... girl lies on bed with a doll.
 TV sets a re talking same Connor-message.

scene fifteen
 Horse-driven carriage for tourist at central park. TV set on the seat
 and go a while

scene sixteen.
 visit of the N.Y. Times computer-TV screen based national and international
 information center. maybe also consumer-information center at
 an Ad Agency.
scene seventeen
 Russel Connor or Allen Ginsberg or his type sleep on a pillow made out
 of TV, in which R.C. talks.
 scene eighteen
 Russel Connor makes face, or strike back with fist and his own head to
 the TV set, in which he his talking himslef.
 or he can kiss this TV set, or kiss with a girl in front of this TV set
 first with full light. nrxt with candle light, and third candle alone.
scene 19.
 we see reflected TV image (RC) on the dark glasses of a girl ...
 after a while she stands up and walk up to the TV and shut off...
 camera shows that she has nothing on.
scene 20.
 a naked lady walks on a country road with TV set (circle one)
 on the back.
scene twenty one
 2-3 small TV sets in side TV screen ..
these TV sets clashe each other.

Undated typescript, Nam June Paik Estate.

march 10... will develop more...

<u>SUITE 212</u> Paik/Yalkut

1) N.Y, as the art center

 rape of statue-Liberty (Videosynthesize)

 Duchamp talking about NEW York (1964, NET production) *check library*

 Duchamp's house and Edgar Varese's house (super 8 or 16mm)

 Varese of

 videonization of Varese's "Desert". (VS and M is M)

 possibly John and Yoko's imagine (scene at Battery Park
 overlooking statue of Liberty)
 (I minute : 100 $ to Yoko ?)

 Connor's voice on video6synthesized (fo from Binghamtontape)
 braggig N.Y. as 1 billion $ art industry.

Meanwhhile in Paris.. American music is flourishing....
 VSing from shigeko's Paris striptease half inch tape.

announcing the upcoming Duchamp retrospective at MOMA

2)

 <u>N.Y, as global city</u>

 Stan Vanderbeek's computer commercial "Man and His World" (50 ")
 Italian Festival 1'.
 and Joe Colombo (Tambelini... VSing. ()
 Russian Tea Room- Caril Berge (film) 16mm.

 Khurschev (WGBH)
 Korean dance (halfinch- VS)

Armenia Restaurant of Bleeckerstr

2.3 74½. pure abstract Video at Radio 23, a Frank O'Hare s

3)

Allen Ginsberg and Literary New York.

 a) Ginsberg chanting with an Australian stick (native's)
 1'
 VS colorized from half inch (shigeko's)

 b) filming 2 minutes or less.
 Poe's house,- Poe's hospotal- White Horse Bar(Dylan Thomas)
 - Meat Market (Mellville worked here for 19 years)-
 MarkTwaine's house,- Dickens' hotel- Tomas Paine--
 Cooper's house-Hotel Chelsea (William Bourough's etc)
 - Auden's and 9th street poet's corner and Thomkins park

 c) Ginsberg chanting (Kinescope from half inch()(Rombex)
 (150 $ approved at initial
 budgetting)

 d) visiting UPS (?)

4) Uptown scene

 a) Rolls Royce piece by John Godfreyl. (2' 30)
 b) Fifth Avenue.. past and present (12 1'30") (film and print)
 c) antique car parade (Tavern on Green and Fifth avenue)
 1'30")

 b) can be on the chroma key bra as stated later.

5) Chroma-key bra

 left bra (n.y's old scenes

 right bra (N.Y.'s new scene... same location)

 chromakeyed lady talked.... who ? it should be
 an experienced tax narrator.

6) Selling of New York.. (rerun)

7) SOHO
blue hand strokes the back of a nude body.

various SOHO scene is keyed into to this blue .

to be filmed.by jud.

Lette Eisenhower taking bath and unveil her Venetian blind.

8) China Townshow (Marshall Aphman)

a) roll... Noodle making show (WGBH)

b) roll... 51st state Acupuncture show

mix a and b.. and later punctuate with

Seventeen mott street
Wah Kee.

Honghing.
brakfast
buddhist temple

Hong fat
c) How to read chinese neon signs
d) promo of a chinese movie 1minute.

9⁻) Japan show

a) Mainichi TV's beautiful song (girl)(not yet used)

b) Nescafe commercial and Pepsi commercial (not yet used)

c)George Ohsawa's historical Macro biotic lectures.
d) how to order at Japanese restaurants.

10) Communication show

Ken Dewey- McLuhan-Currier and Ives- Telephone(antiques) shops-
old radio commercials and commedies...Cable stations- Kitchen.

TV bra

11) Francis Lee's Encounter group (3 minutes)- Jud's Herman Nitsch. (16mm)

(12) chinatown Belly dance
Blue Belly to chinatown

12) Indian and Dutch

> Inglewood park- Indian dance and fashion show and museums
> and Amsterdmam tape (shigeko's) (3 channels)

13) Jewlish in Lower Eastside. etc.
 Heritage

> Jud's footage (Lower Easy Side, new and old)
> 9:23 CHINEXEERE (not gt aired.. excellent from WGBH)
> candle scene
> East Broadway Synagogue... Hassidic Jews in Brooklyne.

14) Irish New York

> St Patriks (super 8 andcolorized)
> Irish bars.. and trade center at 57th street.
> JohnReilly's half inch tape.

15) Broadway

> tap dance with Fred Astire 's colorized picture(still)
> on U.S.I.S. DAY.

> chroma key on palm and mouth with the B'way neon signs.
> interview with S N Behman or some other personality.
> old newsreel.

16) N.Y. Painters (realism)

> Raphael Soyer, Edward Hopper, Rginald Marsh (Conny Island by
> Bob Parent)

17) All about Village

> lady, who slept with Washington and Napoleon
> Washington Sqaure, Bleeker and McDougal street.
> Alternative Media Center etc etce etc.

18) Black experience and international Avantgardism.

> Interview with Carman Moore
> Carman Moore plays with Charlotte Moorman (cello duett)
> Small Paradise and Apollo Theatre and Schomburg Collection.
> Black despair (?) or wisdom (?) excerpt from Ken Dewey
> (Don Harper)

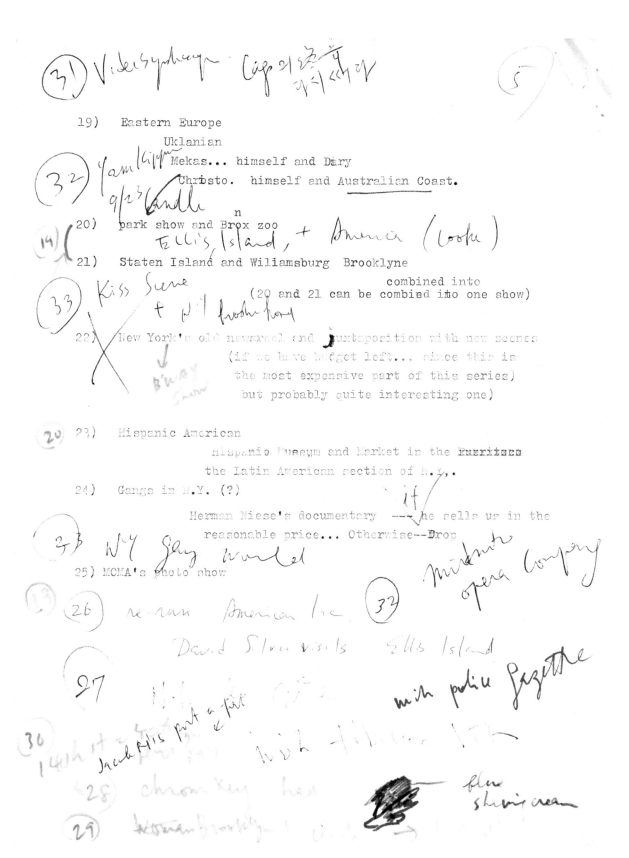

19) Eastern Europe
 Uklanian
 Mekas... himself and Dary
 Christo. himself and Australian Coast.

20) park show and Brox zoo

21) Staten Island and Wiliamsburg Brooklyne

 combined into
 (20 and 21 can be combied ito one show)

22) New York's old newsreel and juxtaposition with new scenes
 (if we have budget left... since this is
 the most expensive part of this series)
 but probably quite interesting one)

23) Hispanic American
 Hispanic Museum and Market in the Puerticos
 the Latin American section of N.Y..

24) Gangs in N.Y. (?)
 Herman Niese's documentary ----he sells us in the
 reasonable price... Otherwise--Drop

25) MOMA's photo show

26) re-run American Inc.

Don't Lick Stamps in China

One reason for going to China: Professor Gregory Battcock feels
it is too cold in New York. At the same time a girl is ice scating,
obviously enjoying the cold and thus telling us, Mr. Battcock's
opinion is not true for everyone.

Next scene: Mr. Battcock on board of S.S. Rotterdam as one of
5oo passengers of which 4oo are women, a fact which he apparently
does not appreciate. Life on board: King Neptune ceremony for
crossing of the equator, Buffet, Cabaret, dressed up people.
A speaker makes us believe at first sight that this is a publicity
film for SS Rotterdam.

After getting out of this trap we realize,this is a film about
the problems of tourism, of communication, about seeing and not
seeing, trying to make us aware of the fact that, when we regard
the world it is only our own eyes we are looking through.

Elderly women appear as stills (dead?). In between this collection
a young Asian port worker, young,lively, human. East and West stand
for future and past. The same idea some time later, a young American
women who appears cold, decadent and without illusions is confronted
with Chinese youngsters who seem to know that it is worth living
for the revolution.

The island Tristan da Cuna appears. 2oo people live here depending on
sheep and potatoes. A mail boat stops here once a year. The Rotterdam
passes by. One cannot decide which feeling is stronger: typical,
places like this are not interesting for tourists of that sort, or:
thank god, they pass by, and tourism does not spoil the place.

A Russian freighter, a Moslem pilgrim ship to Mecca do not affect
people on board of the Rotterdam. They play ping-pong while the ship
moves from Kape Town to India and they will remember Kape Town
as a show of negro folk dances and Hong Kong as a parade of military
musicians in the harbour.

Undated typescript, Smithsonian American Art Museum, Nam June Paik Archive (Box 7, Folder 16).

Media Shuttle: New York-Moscow/You Cannot Lick Stamps in China (1978)

by Nam June Paik in collaboration with

Dmitri Deveyatkin and Gregory Battcock.

Two international shows for P.B.S.

In this show I am aiming two or three innovations in content and
technique.

1) Comparative Videotology or video as a medium for cultural
 criticism.

 The function of the human brain (cogito) is uncovering the constant of the relation-
ships hidden from the conventional cognitions. Videotape-making
is nothing but the extension of this human activities using the
electronic medium. Therefore I chose NOT the theme of U,S.S.R or
China per se, but the show about U,S,A AND Russia or show about
 American in CHina. Therefore this AND or IN , conjunction or
proposition is the KEY element in this show, therefore it must not
be confused with the conventional docementalry travelogue.
INTER-relationship IS the substance.

2) In order to faciliate this points I have chosen to subdevide the
TV screen into 2 or 3 pieces so that more efficient use of screen's
ambiguities could be achieved.

3) from this reason I utilized the 3/4 inch format more efficiently.

 I am making a new breakthrough by making the air master tape
directly on 3/4 inch tape, which will reduce the future production
cost substancially.

4) Collaborating artist in te Media Shuttle New York Moscow is
 Dmitri Deveyatkin and "You cant lick stamps in China" is
 being done in collaboration with Gregory Battcock. The former shot
 many hours of videotape in Russia, while he was the student at
 Moscow's film school, and the latter shot super 8 film in
 a cruise to China. As I wrote before the interrelationship during
 the cruise is as important as what is seen in China per se.

Undated typescript, Smithsonian American Art Museum, Nam June Paik Archive (Box 7, Folder 14).

Sattelite Piano Duette Beuys-Paik (1981)

Berlin, Feb, 1981

It is hardly known, but Josef Beuys' Debut in the art world
was through piano and Hase (hare) in Feb 1963 at the Fluxus
Festival at Kunst Akademie, which Beuys himself organized.
It was well before his solo performance at Rene Block Gallery in
Berlin (1964,December) or his solo exhibition at Schmela Gellery
(1965 December).

 Our nostaligia to this piano performance did lead
to the piano duette at Kunst Akademie in Düsseldorf in 1978
and again the success of this concert let us look for a
major stage for our pianism, which transcends the professional
perfection or technical virtuosity.
 In May 1982 I will have the access to the

Whitney Museum court yard and New York and Boston's VHF airwave, which, unlike Cable TV or UHP, will reach virtually million people. I mean Channel 13 WNET TV, New York and Channel 2, Boston, WGBH TV.

It coincides with my retrospective exhibition at Whitney's fourth floor and a part of the second floor , which is scheduled from April 26 to June 2o, 1982.

Because of the difference it must be in Berlin 11PM and New York 5 PM, on Saturday or Sunday. New York will repeat the the recording of the live show around 11 PM or later.
Show will consist of three separate components, which will be mixed freely during the 30 minutes live trans-atlantic piano duette, which is needless to say the first trial on this planet.

1) Beuys piano and other performance (10 minutes)

2) Paiks piano or other performance (1o minutes)

3) trans-atlantic dialogue or discussions of
Beuys and Paik with the friends or public via sattelite.
Beuys is free to do whatever he wants to do, but in my part
I envision following elements.
1)A sattelite insert from Paris with Pierre Restany and
catherine Ikan and a fire eater.
2)An adaptation of video pieces by other artists, which
is especially suited to this sattelite Duo.
(eg : Shirley and Wendy Clark, (Los Angeles),
Kit Galloway (L.A.) and Kriesche (Graz) etc)

Typescript, Joseph Beuys Archiv/Stiftung Museum Schloss Moyland, JBA-B 007708.

Notes by Nam June Paik: *Brandenburg Concerto No. 7* (1981)

9/22/81

Notes by Nam June Paik: Brandenberg Concerto No. 7

Josef Beuys-Nam June Paik duetto with Piano etc. via
satellite

Place: Berlin Brandenburg Gate (Beuys)

Whitney Museum Courtyard, New York (Paik)

Time: the first or second Saturday in May, 1982 (during Paik Whitney show).

New York time: 5:00 pm

Berlin time: 11:00 pm

Macro-structure

A) 10 minutes, free for Beuys...

10 minutes, free for Paik...

8 minutes, introduction and ad-lib dialogue between Beuys-Paik,
public in Berlin and New York (concert audience must be invited
beforehand to avoid hoodlums)

B) New York sends the video-audio signal which Paik chooses to send to
Berlin, and Berlin sends the signal which Beuys chooses to send to
New York. TV director in Berlin and New York is free to make the
broadcasting signal out of these two sources (plus their pretaped
information) on their discretion, in consultation with their artists
(Beuys in Berlin, Paik in New York). In short, I want make sure
that both Beuys and Paik keep their autonomies and artistic integrity
and make the TV product which is harmonious with the style of their
TV stations, that is, WDR third program in Germany and WNET Channel
13 in New York.

I briefed this idea informally with David Othmer (WNET local
programming director), Carol Brandenburg (NET TV LAB Associate
Director) in April 1981 and Wibke von Bonin (Visual Art director
in WDR third program in Cologne) in June 1981 and did receive very
favorable response.

Josef Beuys, Whitney Museum (John Hanhardt and some trustees) and
especially Deutsche Akademische Austausch Dienst in Berlin (Dr.
Willan Schmied) (a semi-governmental organization) are supporting
this project.

Dr. Willan Schmied gave me grant for a half year residence in Berlin
for this project, which includes also some travel and catalogue
expenses, but also he promised that he would TRY to get satellite
cost free (or in the most favorable rate). In any case, Saturday
afternoon seems to be fairly un-busy time, and according to Kit
Galloway (our consultant) there is one satellite jointly owned by
German and French government, named Symphony, which is not yet
heavily used, therefore, maybe obtainable by Dr. Schmied free of charge.

There is also interest from Australia to join into this project.

Microstructure

Paik's part (10 minutes)

1) Brandenburg Concerto No. 6 (the last movement only) will be played
 as the opening in Berlin, New York, possibly also in Australia.
 Paik and Beuys conduct first their own orchestra but in the middle
 they switch; they conduct the other orchestra VIA satellite (that is -
 Paik in New York conducts the Berlin Orch estra via satellite,
 Beuys likewise the orchestra in New York via satellite). Time
 delay through satellite (3 seconds?) will make a nice distortion...
 During this Brandenburg Concerto the announcer say that Brandenburg
 Concerto No. 7 is being composed 200 years after No. 6.

2) Paik performs a satellite piece by Shirley Clarke and Wendy Clarke.

 Using split screen trick, Paik pours beer from New York and through
 a trick the bottle neck appears in Berlinside and beer comes up to
 fill the glass in Beuys' hand... Beuys returns the trick with
 Berliner Weiss beer, to Paik through the same trick.

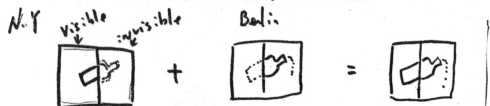

3) Paik performs a twin piece by Richard Kriesche.

 Using the same trick of the split screen... A twin girl A
 (about 8-10 years old) brings a rose to Paik. Paik says to
 the girl, "give it to Oncle Beuys in Berlin..." She disappears,
 and the other twin (B) appears in Berlin and gives the rose
 to Beuys. Beuys gives a kiss and says to give this kiss to Oncle
 Paik in New York... Twin A appears and gives the kiss to Paik...

 Paik says, "you are fast... you can run in the light speed... "
 She says she is space-girl. Both girls appear and dance a short
 routine. (Or do other short drama: maybe TWINART sisters,
 although there are too grown up.)

4) Paik and Beuys play Hayden's Clock Sinfonie, alternating the
 notes as follows...

5) Paik and Beuys make an oil painting drawing together through
electronic superimposition. (using a translucent paper...).
We auction them via satellite (possible including Australia)
and donate the proceed to the Amnesty International or Free
International University or somewhere else. (I have to
consult with Beuys on this point.)

Beuys' Part

10 minutes is free for Beuys...
Most likely Beuys wants an intensive piano duette improvisation
as we did in the Kunst Akademie, Dusseldorf, in 1978...
In New York we can run the past performance film of Beuys
as the background... German side is free. Again Beuys
must OK this part.

8 minutes can be a really ad lib trans-Atlantic conversation by
new friends and old friends and 8 minutes can go very quickly,
especially because Beuys have a lot of fans in New York due to his
phenomenal success in Guggenheim.

As the coda I introduce on the air, "this program is produced in
the New York side, believe or not, by a lady named Miss Brandenburg..."

Beuys says, "we have also a Mister Brandenburg..." and he introduces
one. Miss and Mr. Brandenburg make a tele-kiss using the split
screen, and they talk each other their family stories or anything
which comes on their mind.

Program can end with the Brandenburg Concert No. 1, the first movement.
(Charlotte Moorman can play it in solo with orchestra accompaniment;
the other half (Berlin) can play the cello piece, which Beuys dedicated
to Charlotte.)

Typescript, Joseph Beuys Archiv/Stiftung Museum Schloss Moyland, JBA-B 023467-1 to -3.

First script for *Good Morning, Mr. Orwell* (1983)

Nam June Paik

N.Y. N.Y. 10012

Although satellite has been available for cultural use for a
long time, within an affordable price range ($10,000), not many two
way broadcasts with cultural content have been tried. Imagine, for
example, Merce Cunningham and Jean-Louis Barrault making a sky duet
on live TV. Imagine a discussion on the existential problems of today
between Simone de Beauvoire and Norman Mailer. . . or a performance
duet with Josef Beuys and John Cage. "Sky is the limit!!" is not a
symbolic word anymore in this case. With less than the cost of a
one night broadway production, which reaches only a few hundred
people, our trans-Atlantic satellite production will reach millions of
people on two continents, and many million more behind the iron curtain;
as it is well known, many Eastern European countries can receive
broadcasts from western TV networks.

Due to international timezone differences, the ONLY possibly time
for the broadcast is a WINTER, SUNDAY, noon N.Y. time (West coast time
is 9 a.m.West Europe 6 p.m.) In any other season, people will be
outdoors. An even better day is January First, in thesame time slot.
However, by far the best date is 1984 January First, when we will
FINALLY reach this ORWELLIAN year. However, I doubt whether we can
raise money to meet the deadline. Even if we miss this fantastic
opportunity, 1985 January first will be interesting enough, as
Barbara Mayfield suggested, it can become an annual or biannual event.

Both Carol Brandenburg (WNET TV Lab) and Wibke von Bonin (WDR,
Cologne) urged me to write a well structured script, hiring a pro-
fessionalwriter and a host (eg. Dick Cavett). The following is my
sketch for this "Professional and conventional"script. In this pro-
posal I reflected the current multitudes and parallel existance of
pop and serious culture, because they exist, and also multi-dimen-
sional happenings make the structuralization of TV shows much easier.
(eg.: for Merce Cunningham, City Center stage is about 100,000 times
larger than a 17 inch TV set).
Any successful TV show must reflect this basic fact and we cannot
enough emphasize this difference.

Sunday noon, N.Y. time: Paris/Cologne, 6p.m. : San Francisco, 9a.m.

0.00	(audio, video) A rock Superstar starts his/her hit song.
WNET	In case of 1984, a new song should be written, "Good Morning, Mr. Orwell". (event 1)

0.02 A French rock star or pop singer starts "her" hit song,
Paris (in case of 1984 she sings new song, "Bon jour Mr. Orwell".
Pompidou (event 2)
Center
Channel 2

0.04 A German rock or pop star sings his or her hit song.
Cologne (in case of 1984, "Guten Morgen, Heir Orwell").
WDR (event 3)
Studio

Events one, two, three will go on parallel in both audio and video.
In video, the squeeze zoom will keep all three transmissions on the
same screen. In audio, a VERY GOOD audio man will make an improvised
harmony or polyphony out of these three songs. Of course, in every
new entry (French and German) the new singer must have a certain
hegemony over the other two singers, yet in one minute hegemony in
solo, three voices can melt, in various proportions, in a musically
viable way. In whole one hour long telecast (live), the audio man's
mixing role will be 100 times harder than the video man's, due to the
heavy use of the squeeze zoom, which makes video work easy and rich.
 (in the same vain, the professional TV writer, whom Carol
Brandenburg will choose, must be one who has an INTIMATE knowledge
of the possibilities offered by the squeeze zoom, as well as keying,
soft keying, soft wipe of many patterns, as well as straight mixing.
I must help this "Writer X" with those technical details.)

0.08 All three singers and their supporting groups talk to
 each other. The host or hostess' presence can be mixed
 into conversations.(most rock people in Europe speak
 excellent english; Simultaneous translators may be
 too monotonous.)

0.09 All three singers will sing sing a British and/or Italian
0.09 song such as the Beatles' "Come Together". (Mrs.
 Orwell still lives in Italy. During the Italian song,
 her taped interview can be blended in, if she agrees.)
 (Interview can be done by a WDR or RAI crew, or by a
 freelance group in Italy. Each station will have this
 tape ready).

0.10 Jean Tinguely's machine and Nicky de Saint Phalle's doll
 (with French children playing in the Tinguely park in
 Paris) starts.
 In New York, Allen Ginsberg appears, and starts the

audience participation chanting OM and AH. N.Y. and
Paris and Cologne audiences join. Maybe also simul-
taneous hand clapping, which can make a strange satellite
effect due to time delay. We can do a cross ocean candle
feedback experiment.

0.11 While Allen Ginsberg and audience's chant is slowly
 fading out, Merce Cunningham (N.Y.) Jean Louis Barrault
 or Marcel Marceau (or his class of performer) and
 Josef Beuys appear simultaneously on the screen and start
 the sky trio. (Here Video Director has the best chance to
 show his/her squeeze zoom virtuosity. The electronic
 positioning, squeezing, expanding, wiping, mixing, keying
 possibilities are limitless. While keeping the originality
 of these three geniuses, we can show dazzling high tech
 innovations.).
 Music will slowly melt from Allen Ginsberg to John Cage
 and his supporting groups: video: closeup of John Cage.
 Music in Paris and Cologne will be decided by the per-
 forming stars and will be mixed in N.Y. (likewise, vice
 versa).
 for 10 minutes we should pay homage to these great men by
 giving them full freedom, and tinker with their doings as
 little as possible. Jean Tunguely and Nicky de Saint Phalle
 must also be included in this time slot. In Paris, there
 exists the technical possibility of switching between the
 Tinguely Park and Centre Pompidou (where Jean Louis
 Barrault and Marcel Kind will be situated). In case this
 switching becomes cumbersome, we should put back Tinguely's
 Machine and N. de Saint Phalle's doll, while Beuys, Cage, and
 Cunningham are still on TV and slowly blend into the
 literary section which will begin about 23 minutes in.

0.23 In Paris, Tinguely Machine, de Saint Phalle's Dolls,etc.
 In New York, Allen Ginsberg and Peter Orlovsky sing rock
 and country songs of their creation, forming a musical
 background to introduce guest literary figures, such as
 Susan Sontag or Norman Mailer. In Paris, Simone de Beauvoire
 joins in to the discussion. In Cologne, literary figures
 such as Heinrich Boell, Guenther Grass, and John Cage and
 Josef Beuys (who also publish literary or philosophical
 tracts) will participate in the discussion. (we may have
 to limit the personalities here to get the really big names
 such as Simone de Beauvoire, etc.).
 During the literary talkshow of about 10 minutes or so, we can

enliven the visual background with silent films of Sartre, Marleaux,
Hemingway, or early films of Beuys, Cage, or Cunningham, etc., or use
the architectural beauty of Cologne's cathedral and Pompidou Center,
in a segment of well edited, possibly processed (digital/feedback, etc.)
images. With this visual boost, we can prolong the high quality dis-
cussion without losing the total impact.

0.34 Public TV station in Columbus South Carolina (and/or in
 Virginia) will cut in. New York will lost the air wave
 for about 8 to 10 minutes. This section will consist of
 Native American music and dances (not commercialized...
 Folkways Record style) and should include various ethnic
 groups such as Bluegrass, Country/Western, Early style Jazz,
 American Indian dances, etc. In this time frame, Paris and
 Cologne should match with their versions of folk music from
 various regions of central and west Europe, including
 possibly Swiss, Austrian, Dutch, Belgian and Scandanavian
 countries, Italian, Spanish...We will choose only those
 countries who will broadcast this live show.

0.44 Younger artists in music, dance and performance, from
to New York, will appear. (to be arranged by Artsservice).
0.54 Also, in Cologne (arranged by Wibke von Bonin)
 Paris (arranged either by Pompidou Ctr. Or Anthenne ?)

0.55 Grand Finale...reappearance by all stars.
to (sequence should be written by the writer).
0.58

–––––––– –––––––––––––––––––––––––––––––––––––––

 This script basically outlines only the events to occur in
the U.S. side of the production (New York, Virginia, South Carolina).
Paris and Cologne will make their own shows in accordance with this
timetable, including live radio show on WDR. Depending on funding
situations, the possibly exists to increase the time and role of the
Southern U.S. Public TV in this broadcast.
 Nam June Paik will be in Paris as Coordinator and minor performer.
Although This Show looks now more like an "international All Star Game"
than a media art event, as originally conceived, we can still insert
a few mini-happenings, which will enhance the feeling to the
ordinary viewers that indeed it is happening LIVE trans-atlantically.
It can even add the entertainability of this show.

(1) Long beer bottle neck by Shirley and Wendy Clark.(1)
 Using the split screen technique, I pour an Amstel Beer to a cup held
 by John Cage (or somebody else)...trans-atlantically. Needless to say

a hidden man must be ready in New York (Cage) side to simulate my

action behind the scene.

(2) <u>Twin piece by Richard Kriesche (Austria) adapted by N.J.P. for the sattelite</u>

(2) .

an Austrian little girl with national costume (alps white hat) comes
up from the left side of the screen and hand me (Paris) a Dutch tulip, I I give a kiss and say
to her

to give the tulip to John Cage in New Amsterdam. She disappears to the right side

and after a while her twin sister appears from the right side of

the screen (split , or full screen) and hand the tulip to Cage,

Cage kisses her and say "you are very fast" and show her N.Y.'s a model of trade
center tower; say "We have a twin, too and split half and give one tower
to her and she returns to the right side.... After a while (2 seconds)

the first girl appears from the right side of the screen and give

one tower to Paik (Paris). Then both girls appear on the screen

and make a small dance or singing or both. (This piece will be

rather expensive to produce and must be paid by Richard Kriesche)

(or Austrian TV-cultural council)

(3) <u>Transattlantic candle feedback by Kit Galloway and sherrie Rabinowitz</u>

adapted for this show by N J P.

I put a candle in front of TV monitor in Paris and shot by a camera and sent to N.Y. and the
New York

camera man (he must be the best cameraman in the crew) shoot it

and return the picture to Paris,... according to my move

we can make a fantastic time delayed feed back which only satellite

can make . Kit and Shierrie team made a convincing case of this feedback
through tranns-american microwave feedback using a dancer. I will start
with candle, then try the hand clapping (thus experimenting and proving
the difference of time delay in picture and sound) and later do whole
face and mody movement. Although I dont look as good as a young lady
dancer, (as it was the in the original performance in San Francisco) , I can do better
in utilizing the unforseen effect, which will be Spectacular even for the
ordinary folks. Host of commentater should explain to the layman exactly
this <u>live science fiction movie.</u> eg the half inch distance between
 two images means the many thousand miles space electronically compressed
and we see twenty of them that means million miles of electronic trip
in one picture

five artists who cinceived and realized this important media works (Shriley
clark, wendy clark, richard kriesche, kit galloway , shierrie rabinowitz
should be credited through the character-generator DURING the performance not
as a part of end-credit.

Dr. Wieland Schmied of Deutsche Akademische Aus tauchdienst
in West Berlin agreed formally that DAAD will put out a sizable catalogue
with many pictures for the permanents record on paper. At the same time
DAAD Galerie will organize an art show, which show not only picture
but also three pallel videotape shows and one WDR radio show at the
same time, because all three TV stations will make different mixes
in audio and video during the show. I hope that Pompidou may do the same
thing and with the resource from Pompidou and DAAD we can expect to have
a sizable catalogue with three languages.

Twenty First Century will begin on January First 1984 noon by us.

 Paik telephone.
 Germany 21o1-1792o (call me at 9 am or midnight)
 untill July 2
 (very often travelling)
 , therefore try
 every 3-4 days in same time
 zone)
 New York 212 226 5oo7 (try the same time zone)
 (July to August 15)

Typescript, c. 1983, Smithsonian American Art Museum, Nam June Paik Archive (Box 8, Folder 7). Originally
published in *Art for More than 25 Million People* . . . (Berlin: DAADgalerie, 1984), n.p.

Although This Show looks now more like an "international All Star Game"
than a media art event, as originally conceived, we can still insert
a few mini-happenings, which will enhance the feeling to the
ordinary viewer that indeed it is happening LIVE trans-atlantically.
It can even add the entertainability of this show.

AMSTEL BEER

(1) <u>Long beer bottle neck by Shirley and Wendy Clark.</u>........(1)

Using the split screen technique, I pour a beer to a *cup* held
by John Cage (or somebody else)...trans-atlantically. Needless to say
a hidden man must be ready in New York (Cage) side to simulate my
action behind the scene. Ⓐ [] Ⓑ [] A+B []

(2) <u>Twin piece by Richard Kriesche (Austria) adapted by N.J.P. for the sattelite</u>

(2).

an Austrian little girl with national costuume (alps white hat) comes
from the left side of the screen
up and hand me (Paris) a tulip, I I give a kiss and say to her
DUTCH
to give the tulip to John Cage ~~New York~~. She disappears to the right side
in New Amsterdam
and after a while her twin sister appears from the right side of
the screen (split , or full screen) and hand the tulip to Cage
Cage kisses her and say " you are very fast " and show her N.Y.'s trade
the *a model of*
center t... say "We have a twin, too and split half and give one tower
tower
to her and she returns to the right side.... After a while (2 seconds)
the first girl appears from the right side of the screen ., and give
one tower to Paik (Paris). Then both girls appear on the screen
and make a small dance or singing or both. (This piece will be
rather expensive to produce and must be paid by Richard Kriesche)
(or ~~ORF~~ Austrian TV - cultural council)

(3) <u>Transattlantic candle feedback ba by Kit Galloway and Sherrie Rabinowitz</u>

adapted for this show by N J P.
and shot by a camera and sent to N.Y.
I put a candle in front of TV monitor in Paris and New York
the
camera man (he must be the best cameraman in the crew) shoot it

and return the picture to Paris,... according to my move
me can make a fantastic time delayed feed back which only sattelite
can make .. Kit and hierrie team made a convincing cared of this feedback
through trans-american microwave feedback using a' dance. I will start
with candle, then try the hand clapping(thus experimenting and proving
the difference of time delay in picture and sound) and later do whole
face and mody movement. Althogugh I dont look as good as a young lady
dancer, (as it was the in the original performance), I can do better
in utilizing the unforseen effect, which will be spectacular even for the
ordinary floks. Host or commentater should explain to the layman eactly
this live science fiction movie. eg a half inch distance between
two images means the many thousand miles space electronically compressed
and we see twenty of them that means million miles of electronic trip
in one picture

five artists who cinceived and realized this important media works (shriley
clark, wendy clark, richard kriesche, kit galloway , shierrie rabinowitz
should be credited through character-generator DURING the performance not
as a part of end-credit.

Two pages from Paik's script for *Good Morning, Mr. Orwell*, ca. 1983. Typescript, 11 × 8½ in. Smithsonian American Art Museum, Nam June Paik Archive (Box 8, Folder 7); Gift of the Nam June Paik Estate.

Proposal for *Bye Bye Kipling* (1986)

Nam June Paik
January 5, 1986

To:
NHK Department of International Relations
Mr. Toshio Iwasaki

Bye Bye Kipling

A. Its meaning:

1) Two-way communication is the most intriguing and the least developed part
of the so-called new media technology. Perhaps because two-way communication
does not easily interface itself to the capitalistic system, which must always
pinpoint a buyer and a seller.
Point to point two-way or multilateral communication has recently become
commercially viable for multinational corporations or between heads of state
and businessmen as "tele-conferences". However two-way communication for
people vs. people has hardly been developed or even tried. The only existing
examples are the French-American experiment "Good Morning Mr. Orwell" by
me or the teleconversations between the citizens of Leningrad and Seattle
(on January 4, Channel 4 WNBC N.Y.). Even the LIVE AID concert last summer
(which was conceived on a larger scale and successful in almost every aspect)
failed to utilize two-way experiments, due to the time delay which is inherent
to the physics of the satellite.

2) It is of great importance to attempt an interactive and multilateral communication
among the peoples of Japan, Korea, China, the United States, etc. Of course
such a project would avoid any mention of political events of the recent past
among these four nations, which have had quite a few ups and downs.
This will be a purely cultural and media experiment. It is a very challenging
project, due in part to the gigantic problems in East and West communication,
such as the difference between the Judeo-Christian culture and the Buddhist-
Confucian, etc. Yet this project is one that PBS-WNET, the largest
non-profit TV system in the U.S., and NHK, the largest and oldest TV system
in Asia, are destined to initiate.

3) The previous points address the international importance of the project. Equally
important is its influence on the development of video art within Japan. It
might sound impolite, but it is often said that video art from Japan trails
 behind that of Europe or the United States. Recently we have seen
the commercial success of music video (MTV), observing at the same time
the emergence of excellent music video tapes from Japan. However, behind
the success of American music video is a accumulation of twenty years of
video art experiments. The foundation of this basic and non-commercial research

has brought forth the facade of success in music video and/or computer graphics. More specifically, Andy Setos, who is the vice-president of MTV, and Tom de Fanti, Dan Sandin and Louise Etra, who are the founders of the world's largest computer graphics conference SIGGRAPH, have been my younger friends since the early 1970's. You might even say that some of them were a kind of 'students' of mine in that early period.

Therefore, if NHK agrees to join in the endeavor for Bye Bye Kipling for a joint production and simulcast in Japan, it will greatly spur the development of video art in Japan.

B. Bye Bye Kipling, its concrete plan:

Needless to say, Kipling is an English poet who lived at the turn of the century, when the British Empire was in its apogee. His "East is East, West is West, and never the twain shall meet" has become everyday jargon in the U.S. Now, when every point in the globe has become equidistant through the use of the satellite, not only is Kipling dead, but his premise is dead also. We are now seeing the emergence of the Pacific Basin (or rim or ring) as a new regional concept, in place of the traditional "East and West" concept. In April 1986, the University of California in San Diego will host a Pacific Rim conference attended by Nobel Prize-class scholars, and it may inaugurate a new school devoted to the study of the Pacific Ring area. Therefore, we will put a secondary title of "Pacific Basin Festival" under the main title of Bye Bye Kipling, which will enable us to introduce various video film clips on the culture and mores of the Pacific Basin islands and nations. Bye Bye Kipling will be 'sold' as a live show, but we will mix the live and taped segments in a 70:30 ratio, mitigating stage fright of the participants and other risk factors.

Regarding video clips, I am sure that there must be a number of interesting video films in the NHK film library which would interest American intellectuals. We also are considering the following materials for insert:

Naura Island reportage..."If money rains"

Elephant races in Thailand

Eskimo Olympics (which emphasizes the Eskimos' own identity consciousness through its sport)

Ryuchi Sakamoto's new music video (video by Kit Fitzgerald and Paul Garrin)

Video art piece by John Sanborn and Dean Winkler

These tapes will stimulate a wide range of interest - artistic, ethnologic and media-tique.

C. The content of the program:

Japan, Korea, America, and China will each select their own programs of art and culture. Receiving countries will respect these selections, and the motive of

self-determination. The ultimate contents will be decided in an editorial conference
by Japan, Korea and the United States, considering the needs of each country,
but for the moment, the candidates for inclusion are as follows:

American side:

1) Interior space and mobile multiple TV monitors designed by Arata Isozaki,
 which are enjoying a runaway success in the New York disco PALLADIUM.

2) Phillip Glass, who kicked back Kipling's idea by his profound relationship
 to the music of India.

3) Robert Rauschenberg becomes the electronic partner of Issei Miyake,
 the designer, and his longtime friend.

4) Double-speed dialogue between two New York critics
 (Calvin Tompkins, art, and Roger Angell, sport)

5) Sky art, laser movies, toy computer animation made by the artists in
 residence at the Center for Advanced Visual Studies, MIT.

6) Important video art works and the best of music video by the top bands.

7) Satellite contact art by Douglas Davis. (He is also the architectural
 critic at Newsweek, but he will appear in the private capacity as an
 independent artist).

8) Cross-ocean satellite feedback by Sherry Rabinowitz and Kit Galloway.

9) Satellite Illusion happening by Shirley and Wendy Clarke.

10) Satellite twin performance by Richard Kriesche.

11) Two or three big name performers, who can be easily recognized in
 Japan and Korea.

12) Excerpts from the MTV classics (six pieces of 30-seconds each).

From Korea:

The following classic arts will be video art-ized by me (NJP):

1) Samul Nore (folk art centered around percussionists)

2) Kaya gum

3) Priest dance and sword dance

These three, 1), 2), and 3), will be mixed live on the air with American percussionists
and harpists in Western style from New York City (a kind of interactive TV).
The time delay caused by the satellite will be ignored.

4) Thousand Islands boat race (by the Dartmouth crew team and the Korean
 team) in the southern tip of the Korean peninsula.

5) Diving fisherwomen off Cheju Island

6) Traditional sports of Korea

From Japan:

The Japanese contribution must be decided by NHK. We feel that Isozaki's
architecture, Issei Miyake (the designer and friend of Bob Rauschenberg's) and
Ryuichi Sakamoto might be of interest to the American public. But it is up to
NHK to choose the Japanese stars (with the exception of Isozaki, who should
be represented as the architect of the Palladium). Of course, Japanese classical
art is also welcome.

A Japan-Korea-U.S. three-way conference will decide how to combine the above
 mentioned attractive yet diverse elements into sequential order, and where to
put the video clips from the Pacific and other Asian countries (besides Japan,
Korea, and China). A 30% deviation of output will be allowed in advance.

D. Broadcasting time:

U.S. - American Standard Time on Saturday, September 27th, 9pm-10:30pm
Japan and Korea - Sunday, September 28th, 1986, 10am-11:30am

E. Bye Bye Kipling, Ideas for the script:

The worst problem that we faced in the scripting of "Good Morning Mr. Orwell"
(between FR 3, France and WNET, New York) was the difference in preconceptions
concerning Mr. George Orwell. Whereas "Nineteen Eighty Four" has been etched
in the minds of every average American for a long time, the book has been out
of print in France since the 1950's. Not even intellectuals in France were familiar
with the cliché of "1984". Therefore, the broadcast over FR 3 in France had to
explain about Orwell and the meaning of the magic number 1984 during the program
itself, taking up as long as fifteen minutes, making the total program rather 'boring'.
Therefore we allow also in Bye Bye Kipling that the three receiving countries
- Japan, Korea, and the U.S. - can change the program content up to one-third
of the total running length (90 minutes). They can do on-air editing according
to the intellectual needs of their countries. If needed, even the title of Bye
Bye Kipling can be dropped in Japan and Korea. Consequently, whether or not
Japan relays the Asian Games from Seoul will not make a great difference. During
the time-frame in which the United States is showing the Asian Games from Seoul,
the Japanese side can replace them with certain video clips of their choice.
In other words, the very core of the telecast is the inter-communication of four
countries (Japan, Korea, China, U.S.A.) and their contents in each country can
be widely divergent. In particular, we expect China to join us as the transmitter,
but not as the receiver.

The ninety minutes will be divided as follows (in the event that NHK does not
send the sporting events from the Asian Games in Seoul):

Japan	20 minutes
USA	20 minutes
Korea	20 minutes
China	15 minutes
Other countries	15 minutes
	90 minutes total (art and cultural programs only)

In the event that NHK does decide to send the sports from Korea, NHK will subtract
the length of each country's contribution in art and culture proportionally, according
to the above table.

The United States will carry about 20 minutes of sports from the Asian Games
in Korea, and its proportions for art and cultural programming will be as follows:

Japan	17 minutes
USA	17 minutes
Korea	14 minutes
China	14 minutes
Other countries	8 minutes

This gives a subtotal of 70 minutes for art and cultural programs, plus 20 minutes
for sports.

The three minutes devoted to Isozaki's architecture has been counted as a part
of the U.S. section. As he is Japanese, in actuality the Japanese contingent
ends up with 20 minutes still. In other cases, the interactive program segments
can be allocated to either country participating. Therefore the whole program
cannot be so neatly separated as in the above tables. For example, if we manage
to realize the tele-meeting of Sumo wrestler Konishiki and his family from Hawaii
on the New York side, this scene could be counted in both countries. In any
case, the ultimate meaning of Bye Bye Kipling lies not in the competition but
in the collaboration among the nations involved, and we don't really have to count
the beans for proportional transmission.

TIME TABLE

Until March 4th, NJP is mainly in New York (212) 226-5007

March 6	NJP New York - San Diego
March 10	NJP arrives in Seoul
March 15	NJP arrives in Tokyo
March 20	Carol Brandenburg arrives in Tokyo (for this project)
March 29-	WNET president Jay Iselin arrives in Tokyo (for other matters)
April 12	
March 20-27	NHK-KBS-WNET three-way conference in Tokyo or Seoul

NJP can stay in Asia until April 15th.

"Good Morning Mr. Orwell", which was West-West communication, was overwhelmingly
supported by the major American media and press, and its sequel of East-West
communication Bye Bye Kipling has been eagerly expected.

This telecast will become a milestone in the history of world broadcasting, or
art history. We are eagerly hoping for the participation of NHK.

By the way, as for the $130,000 that WNET is asking from NHK ... the simplest
way to think about it is as follows:

WNET is giving 70 minutes of programming to NHK and receiving 20 minutes of programming. Therefore the difference is 50 minutes, so the $130,000 can be considered as a production fee for 50 minutes.

Moreover, it can be received as a tax-deductible contribution from U.S.-based Japanese concerns. I sincerely hope that you can find an imaginative and convenient way to solve this question.

 Happy New Year 1986

 Nam June Paik

Typescript, Smithsonian American Art Museum, Nam June Paik Archive (Box 8, Folder 14). (Translation of the original proposal written in Japanese.)

Chip Olympics [*Wrap Around the World*] (c. 1988)

My first show for WNET/TV Lab was called GLOBAL GROOVE (1972-1974). Since then I systematically explored the path for global tv......Germany-New York Live TV (1977 with Joseph Beuys), Rockefeller Foundation's Visa Series (eight shows), Paris-New York Satellite TV (1984) and New York-Tokyo-Seoul link-up (1986). I feel now it's time to wrap around the world by synthesizing the valuable experience which was gained in the past fifteen years of experiment.

Saturday 10am (N.Y.) is a magic time It is the only time which can be shared by the whole world in sync.

 Los Angeles 7 am London 3pm Paris/Bonn 4 pm

 Athens/Jerusalem/Cairo 5 pm Moscow 6 pm India 8 pm

 Peking 10 pm Seoul 11 pm Tokyo midnight

We will transcend the traditional contradiction of LIVE vs. CANNED, and instead introduce the new concept of IN SYNC, in which a number of nations are telecasting a show with the same theme - in this case art,sports and global networking - and, having exchanged videotaped materials in advance and edited them according to their needs and preferences, they will still make a live interconnection frequently so that they can keep the two-way -ness of High Tech TV and an anti-parachute kind of information flow. In this way, since we are not billed as a LIVE show, we don't have the pressure of doing everything live...sufficiently relying on the well-edited material, we can switch on to the live TV whenever it becomes necessary. It is a technically and financially much more sensible way than the purely LIVE shows that I did in the past.

The upcoming Seoul Olympics to which the Soviet Union and China have officially announced their participation is an excellent

opportunity to advance in this direction. So far all preliminary
talks I held with VIP's in other countries - Japan, France,
Greece, Spain, Bolivia, Yugoslavia, needless to say Korea, are
very positive because the spirit of Olympiad is still alive and
this spirit is stronger the smaller their country is. Therefore
we can get the collaboration from many countries more easily on
the occasion of Olympics, overcoming this century-old enmity or
scepticism among different peoples.

Show date is Saturday the 10th of September or Saturday the 3rd of
September. New York time: 10 am. 90-120' show. (one or two weeks
before the start of the Seoul Olympics.

Each station around the world will have complete freedom in
gestalting its own show from the three time flows as below.
Symbolically speaking, the key station and I are just a
supermarket with a lot of ingredients. Each station is like a
cook, who will make its own smorgasbord from the following
materials. The show will be as GOOD as its own
director/host/writer team can be. The show can be truncated
or shifted to another time zone according to its broadcasting
schedule.

 1) <u>TIME FLOW AA</u>
 On August 1, we will have a NON broadcast satellite event,
 in which each participating station will transmit 15 minutes
 of video material, of which they are most proud (excluding
 political propaganda).

 2) <u>TIME FLOW BB</u>
 Is from LIVE TV signals coming from the air on the broadcast
 date. Each station can take them either directly from the
 air, fresh from 10-15 sources..or take it from the New York
 mix.

 3) <u>TIME FLOW CC</u>
 LIVE stage shows at each station with host/performance group/
 and director No.1.

The Director No.2 at the master switch makes an instant composite
signal (audio/video) out of these three video sources. The
switchboard and director himself can become an important source of
information, since global networking is what the show is all
about.

PART I: Celebration

1) Acropolis, Athens, Greece. LIVE 5pm

 a) Takis (the internationally renowned kinetic sculptor)'s gong

 b) the parallel performance of:

 1) Greek chorus with solo by Melina Mercouri (for instance:
 "Never on Sunday?"

 2) Greek sportsman - throwing the discus

 c) computer graphics of the Acropolis and Greek discus thrower
 a la Praxiteles (a very high tech feeling) (from New York)

 d) New York host chatters in a small corner box, or off-camera

2) Paris LIVE 4pm

 Hommage a Baron Coubertain, the father of the modern Olympic
 movement. The content will be decided by the French TV
 station.

3) Seoul LIVE & tape. 11pm

 At an old palace and/or the Olympic Stadium.

 a) Korea's funny native sports and sexy diving girls

 b) Olympic sports, such as diving (especially suited for
 dazzling digital effect)

 c) swinging folk dances and mysterious shaman rituals

 e) slapstick dialogue between the New York host and the Korean
 host (in traditional costume)

4) LIVE from Bonn - Beethoven's birth house

 Rock & Roll based on Beethoven's 9th Symphony "Freude schoener
 Goetterfunken" hosted and conducted possibly by Dr. Biolek.
 And/or from other German towns with other narrative motifs.

PART II: NEW ROCKS or music sport cocktail
(ALL LIVE with certain visual accompaniment (tape), which can be
the profile of Olympic athletes past and present)

 London, a very famous rock singer (Peter Gabriel?)

 Tokyo, a very famous musician, such as Ryuichi Sakamoto
 (co-star with David Bowie in "Merry Christmas, Mr.
 Lawrence" and more recently in "The Last Emperor"
 directed by Bertolucci).

 Moscow, combination of new rock and Olympic stars.

 Canada, (Toronto and/or Montreal)

 Hungary, (Budapest)

 Sydney, (visual background of Ayer's Rock, the aboriginal's
 sanctuary)

PART III: NOSTALGIA (Media feedback)

Casablanca

LIVE show from the modern day Ricks Bar, Hyatt Regency Hotel in
Casablanca..if possible with the daughter or son or stepson
or Bergman-Bacall.

Jerusalem

Live from the cave, where the Dead Sea scroll was discovered...
the dawn of the information age.

Salzburg or Vienna

from the birth house of Mozart. LIVE music or
Freud house in Vienna.

Warsaw

Chopin house direct...the Revolution Etude.

Peking

Acrobat...the symbol of this show, a new combination of art
and sport.

Boston

Walden Pond, or the Boston Common.

Liverpool

From the clubhouse, where the Beatles started..for example,
a singer, Julian, the son of John Lennon, if possible.

PART IV: VIVE LA DIFFERENCE

Another leitmotif of this show is the harmony between different
people. We show here a vignette, sweet & sour, from multi-ethnic
countries/cities, who are making it somehow. (maybe short
sitcoms)

Switzerland. Zurich and Locarno.

Brussels and Liege

Yugoslavia

INDIA

French-speaking Africa

Los Angeles (Latin population group)

PART V: Hello Columbus

1992 is the 500th anniversary of Columbus' discovery? of America
...and the year of the Barcelona Olympics.

All related cities are preparing frentically for this occasion.
...a preview...

　　　　Barcelona

　　　　Genoa

　　　　Sao Paolo (computer graphic) by Hans Donner with Live Music.

　　　　Bolivia

PART VI: Trans-atlantic Duet

　　　　Amsterdam - New Amsterdam

　　　　Media tricks using split screen (half-success "Bye Bye
　　　　Kipling" ..this time, better prepared)

PART VII: White Night

Special tribute to the Nordic countries, democracy, peace, and
outstanding achievement in sports, such as Nurmi, or Sonja Henie

PART VIII: FINALE

WHOLE world people sing together Auld Lang Syne conducted from the
water tower of James Joyce fame in Dublin, Ireland.

　　　　The following multi national event can be inserted in the
　　　　middle of show

6) Kiss in Sync LIVE

　　a) Live, real wedding ceremony in traditional costume & style
　　　　from many cultures, eg. China, India, Mali or Senegal,
　　　　Switzerland/Sweden, etc. We can take 3-4 countries.
　　　　International toast, giving and receiving indigenous
　　　　presents via split screen.

　　　　　　(Wedding/dance music from some countries..)

　　b) New York host announces that we are waiting for the live
　　　　birth of a baby. When the first baby comes, we must cut
　　　　it into the live show at any time it occurs. The second
　　　　and third babies as well...but the 3 must come from
　　　　different continents. TV cameras must wait in delivery
　　　　rooms of hospitals around the world.

6') International Comedian Contest (Live, or taped and condensed)
　　Every tongue has a different way of mimicking the rooster.
　　Well-known comedians from several countries, wearing their
　　traditional robes, will mimic the call of the rooster...
　　"cock-a-doodle-doo" (English), "Kokodekko" (Korean) and
　　"Kokkek Koko" (Japanese). They will also use the body language
　　to express gestures meaning money, crazy, stupid, flirt, rich,
　　etc.

They will continue, taking up such common themes as: (gesture contest in cultural differences):
> mother-in-law visits, husband and wife fights, dog-cat fights, etc.
> (such primitive and simple themes work better in an international context and will be quite funny)

16) Whole Earth Sports (tape)

Many important locations and cultures which have not been included so far will be mixed here, including Thailand's elephant football (Skip Blumberg) and Naura Island's car races - Naura Island in the Pacific, where 6,000 people are served by 9,000 imported workers. Profits from bauxite mines are converted into real estate in Melbourne, Australia, and the islanders live without working in perpetuity and beyond. They are reported to amuse themselves with a game where they drive a new Datsun into the sea over a cliff and swim back. The one with the car that last lands the furthest out from the shore wins -- a game not yet accepted by the Olympic committee.

12') World-wide Clapping Event (Live)

Rhythms - tango, fox trot, waltz, mazurka, samba, etc.

13) Global Quiz (videotaped a month before and condensed)

The old and tired quiz formats such as "What's My Line" and "charades" games can become fresh again, when tried on an international scale with guests such as: a venture capitalist from Budapest; a camel caravan leader from Cairo; an inscrutable Chinese mahjong player; a kiwi farmer from Haifa; a cobbler in Tibet; Alpine yoddlers.

Also we can do a quiz show on the Olympic games (records, historical anecdotes).

Eurovision has set up a whole quiz show network. We can borrow it and let European TV manage these quiz shows. It can be just a European event due to the cost factor.

18) Bells from the world LIVE

Church bells, temple bells, street bells from all over the world.

Xerox of undated typescript, Smithsonian American Art Museum, Nam June Paik Archive (Box 9, Folder 1).

PART 3
Culture and Politics: Local and Global

Nam June Paik was an intensely political person. He understood how organizations work, which people held power, and how to effectively collaborate and bring different forces together to support his goals. His ability to draw attention to himself through his appearance, his Fluxus performances, his global connections, and his humor all played well with his modest and unassuming manner. It was a remarkable and genuine performance, out of which he established friendships with artists, powerful individuals across the art world, and patrons from the realms of educational outreach and mass media. People were attracted to his brilliance. Paik was a truly charismatic genius and made an impression on people with his original ideas, idiomatic command of multiple languages, and willingness to collaborate and share credit. These qualities afforded him multiple opportunities to marshal resources and bring people together to realize massive projects, such as his global satellite pieces. He also enjoyed intense loyalty. He was loved for his indefatigable optimism, and his seemingly unrelenting work schedule did not keep him from maintaining his "downtown" appearance, friendships, and credibility. His friendship and collaboration with Charlotte Moorman was one of the most extraordinary artistic partnerships in twentieth-century art. He created performance and sculptural works specifically for Moorman, and she, in turn, performed his works tirelessly. They were both energized by their collaboration, and her arrest on changes of indecency following their performance of *Opera Sextronique* greatly troubled Paik and pushed him to reflect on the artist's position and role within — and on the margins of — culture.

The selection of texts in this section attests to how Paik saw events on both a global and a local level. A local cable station or composer was as important to him as an international art celebrity or popular entertainer. Paik lived and worked in lower Manhattan, a center for both the creation and exhibition of innovative art ideas. But from this starting point, Paik traveled the world over, and he was heralded in Germany, France, Brazil, Mexico, Korea, Japan, and Italy as a local artist — many countries and cultures claimed him as one of their own. He was constantly on the move, exploring other ways of life, and these experiences informed his thinking and his artmaking.

Paik's politics were simultaneously utopian and pragmatic. He often wrote about how the cultural, political, and economic success of the United States stemmed from its openness to immigrants. He offered ideas about how two-way communication technologies could help alleviate poverty, resolve the oil crisis of the 1970s, heal racial divides, and end the Cold War. Representation of the other via media was a crucial component of Paik's writing and practice. More hopeful than naive, Paik believed that art should aspire to affect social change, a deeply held conviction that plays out across the pages of this chapter.

Untitled/"Why philosophy is (has) not changed, as much as art"

* Why philosophy is (has) not changed , as much as arts and science
 has changed in the last 50 years???---(leitmotiv 1).

 * If I solve this problem, surely get I a Nobel Prize.
* *

 * From extreme idealism (Plato) to extreme existentialism(Sartre),
 from extreme objectivism (Descarte) to extrem subjectivism(Berkeley),
 from extreme spiritualism(St.Augustine) to extreme Materialism (Marx),
from extreme rationalism (Spinoza) to extreme mysticism(Eckhardt),
 all the halftones between them,,, with every shade of it,,,,
 every combinations of 2,3,4,,,, ISMS are said already.

 * The map of philosophy and philosopher is completed, in late 19
 century, at the x same time, when the map of the world
 is completed.
*# Malarmesaid,
 at the last 'fin de siecle', already,
 " I have read all the books, already,
 but my flesh is sad"
 and or but we are nearing to the new 'fin de siecle'
 already.

#$* an d or but or because or although, or öł,
 Goethe, a german poet, said already in 18 century,
 "every-thing is said before,
 but we must say it again."
 Why repeat?
 Repetition is the character of biological existence.
 more or less

 Should we'philosphy' again , although
 as we should fuck again, already we know that our parents fucked
 already, and otherwise our or my existence is impssible?
*%$#
 HOW MANY millions of books are published , after Bible said,
 4000 years ago, "There is nothing new under tb sun."

 What a paradoks ?
 The conformism has progressed so much that the criticism to
 the conformism became also conform.

%&

 Therefore the purpose of this book is the possibility of
 of the suicide of book.

Undated typescript, Staatsgalerie Stuttgart, the Sohm Archive. Originally published as a reproduction of
Paik's typescript in *Happening & Fluxus*, ed. Hans Sohm (Cologne: Kölnischer Kunstverein, 1970), 26.

1) After the necessary-nonsence of moon race, I suggest
 as the next "national goal", the creation of

 ELECTRONIC ESPERANTO, or the universal language using

 all electronic media, such as ~~computer~~, video tape, *etc*

 cumpuer drawing- and computer translation. The surplus

 brain from NASA should be mobilized for the much more

 useful project. It requires a big scale, multi-channel
 effort.

2) Sex Education for the space colony.

 Each planets has different gravitation, (eg: moon has

 only one quater gravitation of the earth).

 this difference disturbs human motion, especially 'love scenes',

 which requires a delicate, and complicated motion under

 the psychological stress. A small mistake would let

 bridegroom fall out of bed. In order to have the harmonios

 life on the space colony, ~~specialxtrainingxofxvarious~~

 ~~muscles~~ special program for the physical training should

 be conceived. *on the earth before immigration.*

3) American contribution to the Zen tradition is an

 ~~accereratedxenlightenmentxorxparketime~~ time

 instant enlightenment, or part-time enlightenment

 through mechanical aide (Cage's chance operation) or

 chemical aide (Dr. Leary's drug use).

 But ~~Prof.xSatox(psych~~ several psychologist succeeded

 in recording the brain wave of the high Zen priest in the

 mental state of enlightenment.... next thing would be

 to feed this wave back to Hawks or hoodlums.....
 the brain of

 This and ~~such~~ new medical electronic equipment as electro-
 other *such*

etc

sleep generator is a new resource for the art. (Brain wave is first

uxxxxxxxxxxxxxxxxxxxxxxxxxxxxxxxxx usec in music as a sound source

by Albin Lucier).

4) Xiagt sytejwhgdhghokenppofwaityabyirdpodoqeonelyoyhibiibakol

As information storage device, magnetic recording has vast advantage

over paper and printing.

but

as information-retrieval device, paper is more convenient than

magnetic storage,...

A careful compromise would make the best use of both media,

and artist's talent shou∅ld be used for this solution, _which_

~~Whose~~ consequence cannot be overestimated in the whole area of

belle-lettres and jour~~lenl~~ism. _journalism ~~and etc.~~_

think about electronic ~~book~~ !!

 small container with fan nd various cond nsed incences

is attached to car. Driver chooses, chan∅ges smell,

like they do with car radio. Sm∅ll can also be regul∅ted

by music or tape-recorded signals. _especially WAKE-up
Menhol flavour_

f.i.

50-200 c/∎s ¹/s	coffee flavour
00-400	curry flavour
400-8 0	david tudor's favorite indian incense.
8 0-160	Channel no.5
1600-32oo	menthol wake-up
32 0-380	candy
380 -8000	tibetian incense
700∅∎∎∎∎∎ 5000	woman, 38years, very frust rated.
8000-15000	scotch wisky flavour.

Undated typescript with additions in red ink (2 pages), 11 × 8½ in. Smithsonian American Art Museum, Nam June Paik Archive (Box 15, Folder 2). Gift of the Nam June Paik Estate.

The First Oil War (1941-45) (first draft) (1979)

If the ever deepening oil crisis erupts into a hot war,
historians will name it "The Second Oil War", since we had had
on already, which is conventionally called World War Two.
The slowly unfolding oil drama since '74 looks like a late late
show re-run of the '40's movie - at least for me, who grew up
in Korea under the domination of Japanese media.

Generally speaking, Japanese writers on WWII emphasize
the oil factor much more than their American counterparts.
Whereas the recent Time essay "World War II: Present and Much
Accounted For" failed to mention the oil problem even once in
the 300 lines long essay (August 29, 1979), Minoru Toyoda
remarked in his biography of Yosuke Matsuoka ('79) : "Roosevelt
knew that the Japanese would counterattack in desperation, if
oil and scrapmetal were embargoed" (underlined by this writer).

For Mr. Toyoda, American embargo to Japan was a convenient
and even convincing alibi for the first shot at Pearl Harbor.
Americans would, of course, retort that the oil weapon, which
was used for the first time effectively in 1940-41, was nothing
but a counter-measure to the Japanese invasion of China.
Whichever logic may hold today, it is not uninteresting to re-
remember that oil indeed triggered, if not caused, a very hot
war out of a long smoldering international dispute over the
decades. It turned an aggressive, yet confused nation into a
reckless adventurer. The Japanese have an old proverb for it:
KYU SO NEKKO O KAMU (A desparate mouse bites a cat).

As far back as the '20's Admiral Isoroku Yamamoto, the
leading dove in 1940 and the "brilliant" architect of the Pearl
Harbor attack in 1941, wrote back home from Washington, D.C. that
if one saw the oil fields in Houston, Texas, and the assembly-
lines in Detroit, one would not attack this country. His admira-
tion for the abundant energy in the U.S. was also implied in his
letter to a Geisha friend saying that in New York even the
subways had a heating system - a line which would amuse today's
subway sufferers.

The trade picture was quite different then. America was
the major supplier of oil, cars, metal and metal products, and
cotton. Tokyo's taxi fleet was mainly American cars burning
American oil. Even some of Japan's bombers, which raided China,
were U.S. made. Toyota and Datsun passenger cars were generally
mocked at as "Wasei", although their trucks had already scored
a major market share. To America, Japan was a one product export
country, like today's Latin American countries. Her item was
silk, a raw material which was destined to be wiped out by
Dupont nylons. Trade balance was heavily in favor of the U.S. -

in some years as much as one to three. The founders of Sony and
Canon were still idling in the military service. American
confidence was well expressed in Roosevelt's address vis a vis
the developing gasoline shortage in the Eastern Seaboard;

"If we cut the oil off, they (Japan) probably would have gone
down to the Dutch East Indies a year ago, and you would have had
war...Therefore there was...a method in letting oil go to Japan,
with the hope - and it has worked for two years - of keeping war
out of the South Pacific for our own good..." (7/25/41 NYT).

Apocalypse for Japan started also in Vietnam, held by Vichy-
France. "Camb Ranh Bay: We are certain to hear a great deal more
about this place on the coast of Indo-China..." this haunting
line appeared in a New York Times editorial on July 26, 1941,
a quarter century before American build-up there. America
"escalated" the oil squeeze in ratio to Japan's advance on the
oil-rich south.

1940 July 25: Licensing requirement for the export of oil and
 scrapmetal (...including the Sixth Avenue El).
 July 31: Embargo on aviation gasoline.
1941 July 31: Total embargo of oil and freezing of Japanese
 assets.

Only six days afterward, the privy of Emperor Hirohito
wrote in his diary, "...from another angle, the problem has
become extremely simple, i.e. the question is oil".

Just one month afterward, the Supreme Council of the Emperor
decided for war.

"Time was running short. Japan's petroleum reserves,
enough for about a year, were dwindling; she must eat crow or
strike south for the oil wells of the Dutch East Indies" (Hanson
Baldwin). Admiral Yamamoto, who as the vice minister of the navy,
had brought down the whole cabinet to stop the axis pact with
Hitler just one year before, gave in and proposed a limited
warfare: to occupy only the oil fields of Indonesia, raise hell
in Hawaii and the west coast, and negotiate peace with the
U.S.

The European Theatre was not an exception in this global oil
game. In the spring of 1942, the German general staff poised
for the occupation of Moscow, an attainable goal for the still
undefeated German Army. But Hitler, an amateur strategist, over-
ruled this professional assessment, dismissed his chief commander,
and embarked on the fateful encounter in Stalingrad. General
Reinhold Gehlen attributes this 'blunder' to Hitler's concern for
oil; although the German Army had had enough oil for the time

being, Hitler wanted to secure Caucasian oilfields through
Stalingrad. General Gehlen, as is well known, was the master spy,
who served Hitler well in the Russian front and later served the
CIA well in the same affair: his contribution to America is
reputed to be comparable to the feat of Werner Von Braun.

The fall of Moscow and further operations of the German Sixth
Army, must have delayed the counter-offensive of the Red Army,
resulting perhaps in incalculable chain reactions, from D-Day,
to Yalta, and maybe even in the use of the A-Bomb.

If the Germans had shared the atomic experience with the Japanese
it would have complicated post-war German problems, yet relieved
some Japanese from the nagging complex that only they got it
because they were 'colored'.

Indeed, the Second World War was the first Oil War in many
aspects. At the end of the war Kamikaze pilots were given gasoline
for only a one-way trip - from the base to the American targets.
Even if they failed in suicide, there was no gasoline to return.
And today's syn-fuel technology is another bastard born in that
conflict.

I went to a Korean kindergarten in Seoul in 1939, thinking that
Shirley Temple was my best friend. The magic of American Media
Power was such that Shirley Temple's name was the first name
registered and detained in my child-brain, even before the names
of my father, or Syngman Rhee or Prince Konoye. But in 1940 the
sweet picture of Miss Temple was replaced by a symbolic slogan,
which soon ceased to by symbolic -
"One Drop of Gasoline is One Drop of Blood".

Cars, even omnibuses, were rapidly disappearing. People were
cheered by a hit song: "Aruke-Aruke...walk walk to the edge of the
world". Walking fever gripped the whole of Japan, like jogging
has seized America (by the way, brown rice, au courant here now,
was also pushed by the Japanese authorities to offset the deficiency
in animal protein). My childhood memory is inseparably intertwined
with the tragi-comedy of running a car without gasoline. There
were two kinds of 'synfuels', none of them in liquid form. The
first kind, a still quite civilized one, used acetylene, a grey
fist-sized solid lump, which generates vast amounts of heat,
bubbles and the smell of a thousand rotten fish, but in this
process also moves the car (I wonder if the much publicized fuel
cell battery of NASA's space car is related to this monster: NASA's
car uses hydrogen only, but acetylene is the compound of hydrogen
and carbon). Our '37 Hudson lost her trunk and air-flow styled
lid. An ugly gas oven was placed there, which would mix acetylene
with water. The amount of acetylene-gas going to the engine was

controlled by a new bulb which required constant fumbling of the
driver's hand. Without this fine tuning the car would cough or
boggle or sigh, or simply die down. Starting was no problem,
but putting the car away was. Every evening our chauffeur had to
clean out a whole day's residue - a grey, thick, muddy compound...
this stinking car-dung found its way to our Perrier quality
fountain, which was shared by the whole neighborhood. We did get
the first taste of 'pollution'.

However, acetylene was heavenly compared to the new generation
of synfuel...a good old charcoal, which you use for barbecues.
History will record that this was the first solar powered car
of mankind, which uses 100% organic and renewable natural resources,
the predecessor of the much talked about gasohol or emanol oil.
Even this third grader was astounded to see that the simple
charcoal does not only make a good hibachi steak, but also moves
the gas-guzzler (by then my father moved up to a Buick limosine
with 7 seats. The wonder of this car was an intercom system,
which connected the back seats and the chauffeur without opening
the glass partition in between). As always, the lower technology
requires higher participation of human beings, and is therefor
good for employment. A country lad was hired to get the charcoal
car started every morning, a daily ritual lasting 2-3 hours.
This boy, named Kiwa, came at 6:00 AM, to preheat the motor oil.
Then he emptied a sack-full of charcoal into the oven in the trunk,
kindled it, and stirred it with a large metal stick. Every 30
minutes he repeated this process until many sacks of coal were
reduced to the compressed heat pellet...while he inhaled enormous
amounts of dust and poisonous gas. At 7:00 AM our chauffeur
showed up. The push-button ignition system, which we are all
familiar with, did not work in the charcoal driven car. At
this point Kiwa screwed a huge crankshaft into the belly of the
engine and turned the whole engine manually until the car got
started. The moment the first piston fired, he had to jump
back, lest this manual crank shaft hit his arm in reaction.
Many assistants broke their arms this way, but something worse
was waiting for our man Kiwa. He had had tuberculosis, which
radically progressed due to charcoal gas, and killed him before
his nineteenth birthday. I clearly remember his last visit
to our family. Ash-pale and constantly coughing, he bowed to
my mother from the courtyard, as if it was he who did something
wrong. According to Korean custom a male servant was not allowed
to come up to the family room, where the mother and sisters
reside. Going to our weekend house was an adventure in itself.
When the car climbed up the Arirang hill outside Seoul, my father
and we three little sons had to jump out of the car. My father

walked, we sons pushed the car uphill and only my mother stayed
in. The charcoal-powered car may be an ecological wonder, but
it was a tree-guzzler. It was stripping the already bare Korean
mountains of trees. I have heard that North Koreans used this
car even into the Fifties.

The rapid technological regression continued - 'back to nature'
was not always fun. When our refrigerator broke down without
spare parts, we called back our old ice man, a hunchback. Every
morning he delivered a huge piece of natural ice from the Han
River, which was preserved for the whole summer in his deep cellar.
We three brothers even succeeded once in making hand-made ice
cream from this 'natural ice'. We devised a double-drum bucket.
The inner perimeter held cream while the outer perimeter held
the mixture of salt and ice. We three boys took turns and
rotated the inner drum very fast for a long time, until the
cream inside became sticky. We quickly learned the law of negative
feedback...the input energy was far greater than the output energy..
like today's nuclear fusion. Exhausted, we never made ice
cream again. When the electric record player conked out too,
it brought back the hand-wound gramophone from the antique store.
Even the metal needle was replaced by a bamboo splinter, which
reduced the howling Beethoven to a mosquito's hummings. Still
the arts lived on.

Luckily, Japan celebrated their major defeats as great
victories. After the Solomon campaign ('42), we Korean boys
got a candy bar, the first candy in 3 years. I ate only half
and kept the other half for Christmas. at Christmas I found that
worms had already eaten it up. After Leyte ('44) we all got
one rubber ball, the only rubber ball in five years. A second
grade class from another school went out for an excursion.
While waiting for a suburban train, this virtually irreplaceable
rubber ball slipped from a boy's hand and bounced onto the
tracks. The boy followed the ball without seeing the approaching
train. His teacher, a young woman, jumped onto the tracks, pushed
the boy to safety, and was killed.

Japanese propaganda skillfully extrapolated Paul Valery's
thesis that (technological) civilization is "fragile". I
remember strange rhetoric that ran something like this: "In
a black out, it is easier to walk around in flat Japanese
houses than to walk up 100 floors in the Empire State Building.
American homes are so overheated that the fashion model wears
only one layer of dress, and nothing under it, to show her
curves. She picks up her fur coat and drives to her appointment
dressed only in a summer dress, even in the severe New York
winter...Japan's austere and spiritual lifestyle is more

resilient in an emergency".

However, this copy backfired on my adolescent sensitivity.
An imaginary landscape of American ladies walking around Fifth
Avenue without underpants - this absurd picture was super-imposed
on the khaki-colored Seoul-scape in my soul.

I saw my last chewing gum in 1939. My mother did not permit
me to try it, lest I swallow it. I continuously dreamed of this
chewing gum...its rosy skin covered by white powder like a
beautiful virgin Geisha...until 1945. Liberation came with
Wrigley's and Jeeps. My first chewing gum was as sweet and as
anti-climactic as my first sex, which would come a few years
later.

The age of Ersatz-rubber ended.

The age of Ersatz-democracy dawned.

Unpublished typescript, 1979, Box 944, Folder 6350, Record Group 1.7, Series 200R,
Paik, Nam June 1977-1981, Rockefeller Archive Center, SUNY Stony Brook.

How to Make Oil Obsolete

My twenty years of video research in art and life
have convinced me that Information must be recognized
as an energy alternative. Information not only enhances
energy efficiency in such daily essentials as transportation,
shelter, and industrial production, but more importantly,
it is creating new patterns of entertainment and life-
style, which will help the American economy expand without
increasing its energy use. Under "information" I include
also such non-electronic softwares as art, education, books,
exercise, etc.

Generally speaking, the more spiritual or intellectual
an activity, the less energy it requires. Dancers and yogis
can experience ecstasy using 200 calories, but to the same
end a racecar driver must burn up 200,000 calories of gas/
asphalt/metal. A rich man can spend his $100,000 for a
Rothko painting or a Cessna plane. Both cases register
equally in the GNP, but their energy consumption differs
greatly. Similar analogies apply to many sets of patterns
of consumption: eg. A $50,000 TV drama for a million viewers
versus a $50,000 yacht for a family; or a $600 video
recorder with a ten-year life span vis-a-vis ten days'
car rental; or $15 (a book and a soyburger) vs $15 (a
steak dinner). In each pair the former contributes to the
GNP as much as the latter, yet with much less energy use,
per dollar and per hour. The problem lies in the consumer's
choice.

Millions of young men and women who left their suburban
homes to live in the inner-city have already chosen.
They gave up the big room, the big car, the green backyard of
suburbia, and bought instead the cultural and post-industrial
services of the city, despite the discomfort of congested
living. Physical space and electronic/imaginary space have
become increasingly interchangeable. Japanese cram their
already tiny apartments with various electronic gadgets to
create this imaginary space. For better or worse, we have
become stationary nomads. The information-transportation
trade-off has not only reduced the need for business trips
but will also deprogram our addiction to pleasure driving,
a sub-conscious communication with ourselves via machine as
surrogate shrink. Advanced feedback systems will make this
psychological dependence "ersatz". By the way, "ersatz"
was an invention of World War One. So was Clemenceau's
haunting slogan: "One Drop of Gasoline is One Drop of
Blood."

Will this new post-industrial activity be intensive
enough to stimulate the whole economy? Since 1950, the
real per-capita income of Americans has grown by about
75%, but most of the increment has gone towards the purchase
of two softwares: college education and health care.
"Over a longer period of time, the arts and products that
reflect artistic accomplishment will...be increasingly
central to economic development." (J.K. Galbraith)

Unlike our capacity for food, sex, and alcohol,
our information-need knows no limits because the brain
knows no limits. We went to college without Xerox machines,
and were not much inconvenienced. Today's students cannot
imagine college life without the copying machine. Intellectual
Parisians hardly miss a fat Sunday paper, yet Americans line
up at Le Drugstore to pay $5 for a copy of the Sunday New
York Times. Soon many homes will own a hundred years'
worth of the Times on videodisc and we will discover the
true joy of browsing through the classifieds, e.g."brand new
'37 Nash, $675". A vast array of computer games and quizzes
will be generated from this information morgue.

Information is no longer a means to get something live
and concrete, but has become an end in itself. The age of
"Information for Information's Sake" is dawning after a
hundred years of "Art for Art's sake." Communications flow
is the new metabolism of homo sapiens. Constant change in
taste and fashion is an organic input/output process
equivalent to the transformation of food into protoplasm;

as natural as breathing in our body, waves in the sea, or the waning of the moon. Someday brain-power must prevail over oil-power and petrol will become as obsolete as the dinosaur. America, "the oldest country in the Twentieth Century" (Gertrude Stein) is destined to lead this post-industrial revolution. Progress should no longer be measured in terms of per-capita GNP, but by the per-capita GNP divided by the energy consumption, (which would also indicate ecological well-being.)

Not least important is the role of information in the national defence. American power is based as much on software as on hardware. It may be a mixed blessing, but America movies, TV, records, and fashion penetrate into the hearts and minds of Second and Third World peoples. For example, Polish television shows six-and-a-half hours of American TV a week, whereas Americans may not watch that much Polish TV in a lifetime. When I was growing up in the Japanese occupied Korea of the 30's, Shirley Temple was the first name to register on my pre-kindergarten brain... long before the name of any Asian, or even that of my father.

NOTES

1. Do not hesitate to edit for purposes of brevity or to correct my Korean English.

2. My mailing address in May and June is

 %KUNSTAKADEMIE June 23-July 15

 Eiskeller Strasse 1 110 Mercer St.

 D-4000 Düsseldorf N.Y. N.Y. 10012

 West Germany

3. Telephone Contact: Leave message at Mr. Bloch
 Tel. 011-49-30-2113145

4. My contact person WNET TV Lab is Carol Brandenburg.
 Tel. 212-560-3190

5. Statistic of real income growth appear in Washington Post editorial titled "Questions on Economic Growth." Reprinted in November 7, 1975 International Herald Tribune.

6. Galbraith quoted from his "Economics and the Public Purpose" pages 68-70.

Undated typescript, Nam June Paik Estate.

Untitled/"As Kandinsky and Mondrian etc discovered abstract SPACE..."

As Kandinsky and Mondrian etc discovered the <u>abstract SPACE</u> in the
30's, we, video artists, are discovering <u>the abstract TIME</u> .
The abstract TIME could be sub-categorized into

<div align="center">

TEMPI A priori

and

TEMPI A posteriori

</div>

Tempi apriori is an immanent time structure in Kantian sense.
Tempi a posteriori is the composite of the real happentance in the
so-said real world and various facets of electronic time structures,
which could be said as the "IMMEDIATE GIVENS" in Bergsonian sense.

It is often over-sighted but Norbert Wiener studied Logics and Math with
Bertrand Russell before designing RADAR system. Norbert Wiener then
developed the most fashinating concept of so-said "TIME SERIES", which
also exists in the nerve system of animal (and human beings). From
this theoretical base Stockhausen and Boulez created their best pieces
in the early 50's... which are from TIME-serial point of view the first
positive step since the 32 parts FUGUE of Ockeghem (14th century Dutch
Polyphonist).

In video, space is the function of time, as Kant wrote so in his
"critique of pure reason". Even COLORING is done in the phase of
3.58 mega cycles. We are familiar now with the concept of "TIME BASE
correctors". In the later part of the 19th century and the first half of
this century the academic philosophers tried to construct their metaphyi-
sical system without SEX (Freud) and material condistions (Marx). Nowadays
some academic art critics try to construct video system without studying their
the material conditions of video : that is electronic reality.
and they claim to be a Marxist. Their effort is doomed as much as
the effort of Cohen, Rickert, Windelband etc etc.

Martin Heideggar quotes Pascal in the first question...
"What is being?"... or "What is <u>is</u>" ?
We cannot ask this question since it is a paradox. Before defining

the second "is", we must define the first "is"... and both are identical.

Husserl quotes St. Augustine...

"What is TIME" ?

I know, if nobody asks... I dont know, if you ask"...

and we know at least the essence of TIME is being and the essence of
being is TIME...

I need TIME to study TIME... the first paradox.

 Video may give us a new key in human beings classical onthological
questions.

 I need time OFF from the hectic production schedules at NET TV.

Undated typescript, Nam June Paik Estate.

Proposal two/Walt Disney a radical interpretation/Some other proposals (1971)

Proposal two:

What distinguishes American Culture from Europe is that
 the pop-culture seriously challenged sosaid serious high art,
 and maybe partially overrun the 'high art'. (parallel?:
 interplay of sacred and secular music in 14-16th century ?)
Maybe because the U.S. ran into the mass-consumer society earlier
 than other countries, also the lack of tradition and open space can be
 of a considerable factor for it.

A parallel history of pop and serious music in the U.S (1919-1970) can be incorporated
 into single program according to decade, which will critically
illuminate this singular phonomene and at the same time
 expose to the broad public the obscure but important figures,
such as Henry Cowell, Harry Partch, Alan Hovanas, Carl Ruggles,
 etc. Too many Americans think that Copland and Thompson
 are only American composers on the earth. Maybe Nadja Boulanger
 can be also filmed. Collage of pop music and serious music
 is also easier for the big public to digest
 as entertainment, which is not negligeable
 in Network TV. But at least in this case , we have
 an excellent ground to do so-collage also for the academic
 point of view. Pop-music can be accompanied by the
 contemporary industrial design and serious music by the high art.
 of that time. Maybe we find that Louis Armstrong's
 voice is also a tone-cluster, in the same sense that Henry Cowell's
piano piece was so. Jaspar Johns owns a collage by Kurt Schwitters

, which Schwitters specifically dedicated to Henry cowell.

Maybe MOOG synthesizer is one corner, like in the career of
Monteverdi..., in which Secular and Sacred music meet.

——————————————— ———————————————

WALT DISNEY

a radical interpretation

California Institute of Arts is an embaressing example, (maybe
symbolic) that the serious artist are fed by Pop-artisan's
money. It seems that Walt Disney himself was not too comfortable
as a film maker. He schemed that the major body of Cal Arts
 should have Painting, Sculpture and serious music and a little
of design. He didnot put Film into the original plan of Cal Arts.
Therefore the case of Disney and CIA is one fascinating example
of the complicated relationship of pop and serious art in
American culture. Besides this, Walt Disney is , or ought to be
the subject of very serious study.

1) The core of today's upheaval is the communication revolution,
 and the core of communication revolution is nothing but the
 search for the grammar for the synthetic visual language,
 which runs from posters, cartoons, TV news, to optical
 pattern recognition of computers and videosynthesizer.
 Micky Mouse and Donald Duck is one of the earliest and the
 most succesful model of this "SYNTHETIC VISUAL LANGUAGE".
 The animation process is a kind of non-electronic video synthes-
 izer..... Marshall McLuhan supplied also enough justification

 for the study of cartoon. He ranked the cartoon, telephone,
 and TV as cool media with low definition and high participation,
 a media for the youth. He wrote that both Piccasso and
Joyce was great fans of American cartoons.
2)
 Allan Kaprow, the master of Environment-art, said that
 Disneyland is a great Environmental art work, and Disney's
 influence on early Sixty's artwork, especially Claes Olden-
 burg is serious.
3) The most important..... a young computer system analyst from UCLA
 said that the most important innovation of Disney is just "to play"...
 an increasingly vital work in the coming post-industrial
 age...4 days week is a reality now.

Therefore it seems that there is enough reason to
make a critical assessment of Disney heritage by avantgarde
and serious artist and critics, covering all four points,
1) complicated interaction of pop and serious culture in U.S.
2) as the explorer of synthetic visual language.
3) for-runner of Environmental artwork
4) forrunner of PLAY philosophy.

Talent pool of Cal Art would be of great help and Bob Corrigan
promised me to get a full collaboration of Disney family.
Eg., free use of Disney's old films alone would guarantte
the success of this program for the mass audience,

Some other proposals

Re-vitalisation and colorisation of old movie showing
great performers...

1) TOSCANINI 's own work (30 minutes documentary).
2) "Carnegie Hall" (Walter, Rubinstein, Heiffetz, Piatigols
ky.. etc... made in 1947)
3) Toscanini revisited (Bell Telephone Hour)
(obstacle : copyright arrangement)

Black Mountain College (Rauschenberg, Cage, Cunningham, Franz Kline
Ray Johnson, Jackson MacLow, Living Theater... part of)
Fuller (?), Suzuki (?)
or as a part of 1950's culture.

LIFE magazine (1937-1967)
World War II Cartoons
or Cartoons from the New Yorker, Colliers etc (1910-1960)

Spring Sonata (Beethoven)
BSO Two channels
and tomorrows Video Art, which is
as absolute and pure as
Beethoven's late string quartet,
Mondrian's painting
and
Malarme's poems.
Global Music Festival .

Unpublished typescript, 1971, Box 353, Folder 2192, Record Group 1.5, Series 200R, WGBH-Educational Foundation,
1971, Rockefeller Archive Center, SUNY Stony Brook.

I Lived only one year in Munich (1972)

Erinnerung an Muenchen

nam june paik.

I lived only one year in Munich out of my total residency of 7 years in Germany,
 but Munich, especially Stachus Platz (Kaufehof) is the scene, which still
haunts me most... say... as often as the salon of Mary Bauermeister or Fluxus
 Bull sessions, which would shape much of my later life.

 It was 1956---I smuggled myself to India without visa, found it more
interesting than moonlanding (it was before Sputnik days) and drove from Cairo to Alexa
Alexandria and the mere sight of Mediterrenean sea and its association with
 Renaissance culture overwhelmed me with a primitive and holy joy. I was a
 typical "Rice Christian" in the cultural sense.

 I arrived in Munich November 23 1956...after a month of sunshine in
Egypt. It was a dark cloudy day after a dark cloudy day. I had to wait my
 strassen bahn, which is to be unstiegen am Stachus platz...often shivering
 at dusk. I repeated in my lips "Dunkle Sehnsucht----dunkle sehnsucht", which was
 a popular phrase as a by-line to Andres Maurois' "George Sande", just published.
 "Quick" was selling "Mein Tochter :Romy Schneider" . At Landshutter Alee 25,
 near Nymphenburg Schloss I was carrying up the coal from the cellar to the
fifth floor every Saturday afternoon. my rent was 75 DM.

What saved me from total depression was the snowfall at Englische Garten, to
which I could stroll easily from the StudentenWerk and New Music concert series at
Lehmbach Galerie.

There was a small personal story before goingto Munich.

In Tokyo I was studying two things parallely. While the study of liberal arts
was going excellently, my composition had been stagnating for years. Becoming
frustrated 24, I made the decision. When I fail in Mainichi competition
, I would give up my composition. My work was the first to fall. I sold a few books
--- Sartre's "une chemin de liberte", Bible, etc... and spent a night
 at Yoshiwara (Tokyo's 300 years old pleasure house)... Next morning I was
 no more a composer, but a music historian.

 Therefore I was enjoying at Bayerische Staat Bibliothek some new discoveries (?)
 of unpublished manuscripts by Michael Hayden, or Anton Filz or thinking about
 some affinities between Webern and a short piece of Emanuel Bach. This
 philological study greatly calmed my betrayed ego. (When the Manchus invaded
 China in 17th century, they initiated many mammoth philological projects
 for the same reason. It consumes the wasted intellectual energy fairly well.)

While covering the huge collection of DTO or DTD, I was tasting
 a cozy corner of petit bougeosie...I was accumulating the security, not in terms
of bank interest but in terms of out-of-print books covered. Professor
 Georgiades and Hans Sedlmayr treated me well, I spent whole christmas season at
 Beuron's famous monastery, whose chief singer-father (Pater Maurus Pfaff)
was my teacher of the Gregorian.

As a student from "under-developed" Korea, I did not have any hope or illusion of
making a career (?), positive or negative, in Germany. I had thought that a few
 geniuses were fallen from the heaven by some unseen Creator, and they should be
 either German or French, not even English or Swedish. Even Bartok or Mussolgsky
was not the first rate composer so I thought, because he didnot participate in the dialectic
 development of the great middle European Tradition. I believed naively
 Paul Hindesmith's assertion that only one composer can be born from every
50 million people, and even then Hindesmith didnot count --most likely-- non
Westerners under this 50 million people. But the encounter with real and living
 music at Lehmbach Gallery in Munich changed my whole concept. It was unbelievable
 and stunning that I had to sit through mediocre piece after mediocre piece of
 contemporary European composers, even including the work of Hindesmith. In Tokyo
 university, with strict academism soaked with admiration of Western culture,
 our job was not to judge but to learn the Western music. Therefore if we would
 encounter a piece, which would not impress us, both teacher and students
 would rather say " I don't understand this one", than to say "This is a bad piece"
...Therefore the accumulation of mediocricy at Lehmbach Galerie finally killed my
 heavy minority complex of Asian composers, and it lead me to think that "I can
 compose at least as bad as they do".

 To be fair to Herrn Buechtiger, there were a few good pieces.
Stokhausen's Klavierstueck II was well performed and well received. I remember
 well a piece by Anton Riedle, in which a single percussionist struggled heroically
with two full rooms of various percussions-instruments---it was a few years before
the debut of brilliant Caskel .

Spring came. Young comple were lining along the Isar river.
 I moved from Nymphenburg Schloss to Schwabin, near Ursula Kirche. I needed not
 climb 5 floors every Saturday carrying coal. Guenther Schuller, who was writing a dissertation
on a Southern German composer of 17th century called Herr Paix, told me that his
 next job would be to write about Herr Paik. I started to re-work about
 my String Quartet, which failed miserably in Mainichi competition. A policeman
 appeared with 10 signatures from my neighbours that I played piano too loud.
 I cannot compose without piano like Igor Stravinsky. Breeze at
 Starnberger See dissipated my "dunkle Sehnsucht".

 ────────────────────

 1972 June, New York's Anthology Cinema. With a prominent Wahl-Muenchener Herman Nitsch
 ---, master of O M Theater. He works with blood and bones and meat of cow and

goat, but he cannot love enough Anton Bruckner. We spent a few precious minutes
talking about unforgettable interpretation of Bruckner's No.7 at Herakules Saal.
(Fritz Riegler conducting Muenchener Philharmoniker). Equally unforgetable was
my new year's eve (Silvester Nacht) in Munich. Richter played all Bach
organ program at Augustiner Kirche. This was my first New Year in Europe.
When I came out of church---fully dowsed with the magnificient performance---
there was a quiet snowfall and ringing chruch bells.

Munich's rich cultural heritage amplified and finally cleaned my "dunkle Sehnsucht"
nach European culture and minority complex toward Western composer. It could have
happened ONLY in Munich. Umsteigung at Stachus Platz
became the Umsteigung of a lot of things.

<div align="right">(Binghamton, N.Y. 1972 July 15)</div>

p.s.
Seven years after my Munich days, the Nymphenburg Schloss appeared again
unexpected into my eyes, this time as the location site of "Last Year
at Marienbad", which deals deeply with the complicacy of time-space relationships.
...
and this time I was watching this auto-biographical scenery in Tokyo, while
developpong my first color TV work with Abe....and again this
color TV work led the way to make a John Cage film, in which John is
walking around New York City, just guided by I-ching.

By a strange Karma, I have never been to Munich since
1957, although I visited almost all German cities many times since then...
instead of myself, my film, a strange mixture of information-retrieval system in
the antiquated plastic form,is going back to Munich...after 15 years.

Rarely do I send just a film with so much sentimentality.

Originally published as a reproduction of Paik's typescript in *Neue Musik*, Sondernummer zum Kunstprogramm
der Olympischen Spiele, ed. Josef Anton Riedl (Munich: Druckerei Holzinger, 1972), 57–61.

Beuys weeds—Beuys creeds (1984)

"Fine steeds beware the horseman's eye," it is sometimes said. But if the superb steed is not
discovered by a distinguished owner, its youth will be extinguished plowing barren fields. It is
not a question of competition between the first-rate artist and the second-rate artist. It is the
"battle of luck-fate" between first-rate artists of like talent. In Beuys' case, the discoverer
of the socially inept, withdrawn, meditative rustic that he was, was not the proprietor of famed
Gallery S or Gallery B. And of course, Museum director Dr. So-and-so had nothing whatsoever to
do with it. Rather it was two young farmhand brothers in the house neighboring Beuys' in the
backwoods of Holland.

After the war, when Beuys was demobilized from service and recuperating from war wounds, the
half uneducated brothers, who were much younger than he, lived next to him. Through some kind
of intuition, these brothers came to think, "We dun got the world's greatest genius liv'n right

side by us." They used what little resources they had to buy the whole output of this eccentric young artist, who had sustained an injury in the head, and stashed it away in their storehouse; one of them had studied art history for only a half year.

One day, one of the brothers had an idea: "We ain't seen Paris yet. I hearn tell it's but a half day's way." So they set off for Paris in their barn truck. Having no place to brush their teeth, they climbed up on one of the historic fountains typical of Paris and washed their face and brushed their teeth.

X X

How much of this legend, which I heard from René Block, is true I do not know. However, Beuys' authenticity is in the origin from which legends such as this begin. It is of course certain that these brothers are actual people and that they have a mountain of early Beuys works piled in their warehouse. Of course they never appear in the social setting of the gallery *vernisage*. One story has it that, based on his merit as a Beuys collector, one of the brothers became a lecturer at a college.

O O O

This story oozes with the weird laughter of the Dutch rural peasantry of Bruegel, who painted the scene of a pig running away with a kitchen knife stuck in its side. Bosch's weirdness also comes out here. And Van Gogh's God-touched half-madness. And Ensor's romanticism. Then suddenly appears the perplexing figure of the great master of contemporary Flanders--Beuys--laughing at an apex of the indigenousness of these four earlier artists.

X X X

In a previous article (in the Beuys special issue of the *Bijutsu Techo*) I quoted *Time* critic Robert Hughes as follows: "Joseph Beuys was the first post-war German artist to wander freely among the more *volkische* fragments of Teutonic romanticism—some of them still hot enough to make the needle jump--and assemble them into an art of obstinate personal idiosyncrasy." Here I hasten to add the following.

The Germanic people, defined broadly, trace back to the Neolithic era when they were cave dwellers living throughout the large region from Iceland to Austria. The roughly one thousand years since this race came in contact with Christianity and entered the historical era, represent not even one fiftieth of its history. Vienna is a city which is deeply permeated with the coloring of Eastern Europe; Christian and German legends were relied upon and sustained only with great difficulty here during the occupation of the outer reaches of the greater Germanic region by Genghis Khan and the Turks. Woody Vasulka, a Czechoslovakian who is a good friend in computer video, related the following: For one million years since before recorded history, Vienna and Prague had been a three day's walk apart. After World War I this distance became three months because of the Versailles Settlement. And after World War II it became three years because of the Yalta Settlement.

Thus, within the same Germanic Sphere, the cultural spheres of Vienna and Prussian Berlin are at thirty degrees variance.

Furthermore, Holland of the lower Rhine, and Belgium and the adjoining German areas of the so-called French Flanders are off another sixty degrees. Living in the West for nearly thirty years, it is finally very clear to me that current political boundaries are vastly different from cultural spheres. To really understand the diversity of the arts in the West, it is necessary to become familiar with the natural landscape and economic spheres going all the way back to the Stone Age. And therefore, to understand Beuys, it is essential to keep strongly in mind

that he is not an artist representative of Germany proper so much as an artist from Flanders in the *Nieder Rhein* by the Netherlands border.

This very small very unique region, Flanders, has produced individuals of remarkable genius ever since medieval times. Painters such as Jan Steen of a practically surrealistic high-focus realism, Rembrant, Rubens, Bosch, Bruegel, Van Gogh, Ensor, Mondrian......having travelled to Holland and Belgium quite a few times I've come to think that these farm folk are crazy. However I cannot yet point to exactly what it is about them that is so singular. Ask them directly, and they evade the question with a characteristic chuckle, a cryptic "heh heh heh."

(1) They possess abandon-resignation.

(2) They possess a knotty laughter.

kusho, nakiwarai, kosho, takawarai......bikusho, waraisute...jicho...

(bitter smile, tearful smile, raucous laughter, uproarious laughter......wry smile, forsaking laugh...self-scorn...)

While "to smile" and "to laugh" are the only English verbs, over ten laughter verbs can be expressed in *kanji*-characters; Flemings understand all these shades. When Beuys names a certain bourgeois and amidst uproarious laughter says, "I got half a million bucks off that chap," he stands 180 degrees away from Mammonism; his uproarious laughter is that of Robin Hood--to kill money with money.

(3) They are country rustics. The smell of soil...or even more, feeling the smell of manure... or feeling the smell of dirty socks or the fondness for the unsightly indecent, an anti-snobbish snobbism that looks down on the shiny finished merchandise of the parvenu. Call it an anti-urban sophistication.....

(4) Superstitious, mysterious, weird...it leads through a collusion with death.

<p style="text-align:center">O O O O</p>

Thinking about Beuys' regionalism, one unexpectedly confronts "death"; and from this "rumination on death" emerges Beuys' universality, and a source of his fascination that appeals so broadly to the people of the world.

Looking at a Beuys catalogue is like looking at a catalogue of "Various Design Ideas of Death". Together with Shizue Watari, I saw his recent work *Schmerz RAUM* (Agony Room) at the Konrad Fischer Gallery in Dusseldorf: it is an empty lead room with just one naked light bulb lit, a chamber that is "darker than pitch black." Throughout Japan, the war generation rose above the rational debate over whether World War II was a war of aggression or defense and came to sympathize with the nihilistic novel about killing by Yasuhiro Gomi who fought as a foot soldier licking the soil of mainland China for quite a few years. Likewise, it is undeniable that the German war generation that forfeited its youth in a lie to death and coldness in Stalingrad overcame their assertion of principles and came to sympathize with the Yin world of Beuys, who gave greatest expression to the Russian Steppe. And of course death is not the private property of the Germans. It is the monster all mankind seeks with trepidation to gain a glimpse of. In his *Discourse on Human Existance* (1938?) Kiyoshi Miki (a pre-war Japanese pacifist) remarked that "Death is an idea." Confucius put it this way: "I do not even understand life. Much less, do I understand about death." One cannot help but wonder what Miki thought about death in September 1945 when he saw his forecast come true. Moments before being liberated with high promise of becoming the highest leader of new Japan, he died in his solitary confinement cell besmeared with his own vomit and excretement.

Or what could Webern's state of mind have been when he died at about the same time due to an inadvertent discharge from an American sergeant's weapon while seeking refuge in the Austrian countryside. Like Miki, it was after a long period of impoverishment and being prohibited from writing, that Webern was nominated Chairman of the Austrian Association of Contemporary Music and was just about to return to Vienna to become a world leader of contemporary music. But just then, he died from an American army misfire, the misfire of his emancipator. Given a cigar from his daughter, he smiled a bitter smile (*kusho*) and took his last breath in a cloud of smoke.

<center>O O</center>

John Cage, who was cured of rheumatism by a macrobiotic diet and *shiatsu* treatment by a Japanese woman, joked "When I die, I ought to have a perfectly health body."

<center>O O</center>

Beuys' wife said
"He's like an old oak".......pretty stalwart,
really.....
and smiled complacently.

Originally published in *Joseph Beuys* (Tokyo: Seibu Museum of Art, 1984), 168–169.

From Horse to Christo (1981)

A thorough study of video has to start with the horse since up to the invention of the telephone in 1863, also the year Monet invented impressionism, the horse was the fastest means of communication. The coincidence of these two events is significant as both inventions have torn apart a world so solidly put together by Newton.

Approximately 30 million years ago monkeys left their forests, became active through the day and started traveling. From then on to the year 1863 the fastest means of communication has never been faster than the fastest means of transportation. In other words: Telex and Concorde were equally fast and the horse combined the functions of Telex and Concorde. This fact cannot be stressed enough since about 90 percent of our decisions today have to be made without direct contact. The separation of transport and communication has enabled a dramatically increasing number of decisions which speeded up the pace of changes, if not 'progress', in geometrical progression. One example: The transatlantic cable cut down the transmission time of a message between Europe and America from 6 months to 2 seconds. When Napoleon sold Louisiana to the USA Mr. Monroe was the American ambassador to France. As a decision would have taken 6 months Mr. Monroe decided to buy Louisiana from France without asking his headquarter in Washington. The current economic difficulties Moscow faces resulted from the fact that Karl Marx in Paris wasn't able to phone Friedrich Engels in Wuppertal ... and he called himself a 'scientific socialist'. The whole tragedy of the left in the nineteen-sixties has its source in the hopeless battle of justifying the 'scientific socialist' which is based on an outdated understanding of science. Adorno hasn't realized the importance of the telephone.

The telephone exists for about 100 years. It has influenced our life in almost every aspect. In spite of this (after Kas Kalba of Harvard University) only 4 essays have been written about this important subject in this time whereas numerous studies on some dead languages like the Maya or of Babylon were carried out.

The one-million-dollar-horse

In 700 BC a Chinese emperor entrusted one of his ministers with one million dollars in order to find a horse that could run a thousand miles per day. The minister traveled all China for three months—but in vain. When he finally found it, it was too late: the horse had died the day before. The minister cried ... then he paused for a moment. He paid half a million dollars for the dead horse and dragged the carcass to the palace.

The emperor was—understandably—outraged. For such wrong acting the 'silken string' was waiting for a Chinese minister. The minister replied calmly:

"Your majesty ... people will talk, rumors will spread in no time... if you pay half a million for a dead horse, how many millions will be paid for a horse that is alive?"

And see: Soon it was possible for the emperor to purchase a one-thousand-mile-horse—and not only one but three (after Dyang Kuo Tsu, 290 BC).

When information technology improves, misinformation technology improves at the same time. A lie is always more interesting than the truth, news of a murder is always more interesting than a virtuous story. The revealing of a fraud in the art business creates bigger headlines than the discovery of brilliant new artistic achievements. The reason is that the reader is continuously the positive ion which asks for bad news in order to neutralize the instinctively positive ego.

The most successful misinformation campaign took place during World War II when Hitler was to believe the landing of the allied troops would be prepared for Calais (instead of Normandy where they actually landed). A number of innocent, even noble people were sacrificed in passing this wrong information to Hitler. This technique is not new at all. Already Sun-Tze (700 BC) distinguished two kinds of spies. First: the 'living spy' whose task was getting behind the frontline of the enemy and returning with the desired information alive. Second: the 'dying spy' who carried wrong information into the area of the enemy. There he was voluntarily betrayed. Tortured, he would tell his lies to the enemy and was killed after.

Mornings three--evenings four

Two thousand years ago there lived a man in China who possessed a monkey farm with hundreds of monkeys ... he loved them. Anyway, he got poorer. Perhaps he spent too much money on the monkeys, perhaps it was stagnation.... One day their owner came to the monkeys and said: "My dear friends ... I am bankrupt ... I must reduce your daily ration. I can only give you three peanuts in the morning and four peanuts in the evening!" Every single monkey cried: "With such a meager ration we can't live ... soon we will be too hungry."

The owner of the monkeys thought for a while and then said to the monkeys: "I will give you four peanuts in the morning and three peanuts in the evening...." Each monkey's face lit up again and they were pretty happy.

The two-million-dollar posts

Emperor Shang of China erected a simple post at the southern gate and offered a million dollars to the person who would take the post to the northern gate. "One million dollars for half a day's work? Emperor Shang is joking."

Then Emperor Sheng doubled the bounty. A guy moved the post, just for fun and the last thing he expected was two million dollars. But he was rewarded immediately in the way the order was defined.—Now everyone talked about it.

At this moment the emperor passed a number of new, very strict laws accompanied by harsh penalties. These laws were obeyed at once.

The rumor, a strange bird from the human mind, was the first radio Homo sapiens invented. There is no law for why some rumors travel faster than other rumors—like there is no law in the world of advertising. It is just a second cycle of metabolism in which it is more important being new than being true. What matters is simply a little surprise.

Recently Michael Hart, an American historian, proposed a daring thesis. Western civilization was more developed than Chinese civilization until the second century (AC). At this point the relation of progress reversed; the Chinese civilization not only caught up with Western civilization but took the leading position until the 15th century. From the 15th century till today the west became the leader again. Michael Hart thinks that the inventions in the field of communication, the paper in second century China and the printing press in Germany in the 15th century, were of decisive importance. (Of course, Koreans and Chinese had invented movable printing types, but the outcome of automation is completely different in a phonetic culture with 26 letters compared to a pictographic culture with its 50000 symbols.) According to Mr. Iwamura, a Japanese specialist on Mongolian history, the horse was domesticated only around the year 1000 (BC) (old fossils show a horse that is not bigger than a dog).

The immediate progress of humans around the year 1000 (BC) may have its reason in the 'invention' of the horse which not only changed the basics of warfare and transportation but of *communication* too!! I am convinced that the developments of the Bronze Age are connected to the domestication of the horse.

Today one talks about 4K-memory, 64K-memory or even 256K-random-access-memory-chips which enable us to put some thousand color slides on a plastic chip of the size of a credit card. The invention of paper by a Chinese eunuch in the second century equals the sudden introduction of a 64-K-memory chip in the age of the good old Trioden vacuum tube. Astonishingly the quality of writing has decreased since the introduction of paper in China, like it does comparably today. The invention of photography deteriorated the quality of the static image compared to the time of etching and oil painting.

The invasion of television impaired the average quality of the moving image in comparison to the time of film. The same is valid for recorded pop music in comparison to Bach.

In any case, we are now in the 'glorious' time of video-vida-videology and vidiots.

What comes next? The highest communication power is PSI—the psychic power. If a country can make use of PSI power and can control it, it will be the most powerful country on earth. (England was the first country using coal and dominated, the USA was the first country using nuclear power and dominated.)

Which one will be the next superpower in the 22nd century? Of course ... Bulgaria, which has the highest percentage of gypsies in its population. Because of their extraordinary gift for PSI they will have an effect like uranium for this century or the coal of the Ruhr area in the last century. The scientific research on PSI has accordingly advanced the most in Bulgaria ...

Then our friend Christo, the only world famous Bulgarian, will be admired like Leonardo and Washington together.

The text was written in English in 1981 and published in German in *Kunst und Video*, ed. Bettina Gruber and Maria Vedder (Cologne: DuMont, 1983), 66-69. Bettina Gruber and Maria Vedder were asked, but the original English text wasn't found. It was later published in French in *Paik: Du cheval à Christo et autres écrits*, ed. Edith Decker and Irmeline Lebeer (Brussels: Editions Lebeer Hossmann, 1993), 105-108. The above version was translated back to English by Edith Decker-Phillips.

DNA is not racism (1988)
Les acides aminés ne sont pas racistes

-Dung-jan-mit-ti o-dubta- (Korean)
-To-dai-moto-kurashi- (Japanese)
Both proverbs say the same thing.
-Under the bright light source, there is always a shadow... of course, there proverbs were invented before the discovery of the laser light, which is a coherent light, which stays as thin as Jos Decock's body and therefore does not cast a shadow.

However her artistic life has been shadowed under the bright light of Pierre Restany. Many art lovers and snobs who flock to Rue Payenne... often overlooked a strange eradiation which the other half of the household transmit... or... the nature of this lightening is such a nature that it contradicts the standard snobs's taste.

As a simple boy from a backward country, Korea, I have always been fascinated by the rustic beauty... (Richard Goldstein, now a jet-set artist at the Metro Picture Gallery in Soho, once my driving teacher at Cal Arts, asked me "what is the secret of Beuys art" and I answered "well... his mother once made me a very good country soup...".
Is asked Jos Beuys whether he agrees... and he agreed.
In the Seibu Catalogue (1985) I wrote on Beuys not as a German artist but as a flemish artist... natural prehistorical border being far more important than the political border, which was set either after the napoleonic war or after the wilsonian good will conference.
Beuys again agreed to be a flemish artist.
After the daily galloping progress in the DNA research, one is allowed once again to ask the genealogy question, which has been tabooed after the WWII.

In my 30 years life in the Western world, and if I may be also snobbish, shuttling between one foreign continent and the other foreign continent, I cannot but change... or deepen the history and geography lesson I had in Korea.

For me the headache in the history test in Korean school was Alsace-Lorraine question... not necessarily Alsace changed the side... so many times... but also it was just the borderline case in the importance for Koreans... Well, you cannot memorize everything in the history data before the test... you must "speculate" in advance, what will be the question to be posed, and what will be skipped over by the teacher... and in my struggle in skip or not skip... 1848... 1870... 1917... 1940... headache was always the Alsace-Lorraine... for a Korean high school history it was not so important... however.. .it did seem not that unimportant either... I was always per-plexed before the test... "again... god-damn Alsace... which side this time... shall I memorize? or skip it or forget it... and what if it comes up to the test???"

It made my sleepless night even more sleeplessly...
I said this episode to Pierre Restany and he did burst into big laughter...
"What??? Small question for the history?????"
No... it was THE TOP question for us for long time.

Well... very few French know that Koreans used the movable metal types two hundred years before Gutenberg... and the only surviving book printed with this original type exists in the French National Library and that this book was brought back to Paris by the French Navy, who won a small Korean-French War "erupted" in the Kwang hwa island off Seoul, in the late 19th century.

I said to Christine Van Assche... In my experience... Arthur Koepcke... Josef Beuys etc... flemish and danish are quite different from other germanic tribes in the broader sense, such as Swede or Hochdeutsche... even from Colognians... their tragic-comic sense is unique... and their diligence and divine lunacy...!!!

95% of flemish or danish work like worms in the field and they support the 5%, who are lazy... drunk... crazy... some of them ending up... Van Gogh's... Peter Breugel's... Hieronymus Bosch's... Josef Beuyses... Jan Steen's... Arthur Koepcke's... et Jos Decock's.

Christine Van Assche... with the perfect art historical knowledge... said: "Oui... it is because of spanish invasion...!!"
But I said... "Well... that is too recent... maybe those Vikings... who went around the world and picked up various germs and viruses and they got dispersed among wide population and made those wild fews...".

Or maybe 7 mystical Celtic springs, which Beuys found in his native Kleve, as Caroline Tischdall said to me...

In any case, in order not to become again the pseudo-scientific racism, we must find a new genre of litterature called the negative science fiction which deals with distant past as the science fiction deals with the distant future... and with the same techniques, that is: the free

combination of proven knowledge, speculated wisdom, pure fantasia... and rich mixture of inventiveness without responsibility.

E.G.: Scythians reached the southern tip of Korea... near Pusan... and the King of Silla (stationed near Pusan) had a crown which has the shape of male deer horn and made of pure gold... both figures are also the characteristics of Scythian art, although the shapes of male deer horns are very different in the two cultures. However this types of crowns were not found so far in China or Japan... (maybe somewhere buried in Mandchuria, Gobi or Siberia?).

Beuys said... there was not the desert of Gobi... it was green... and his obsession was "eurasian continent"... I bet not only he was physically rescued by the Tartars... (who are ethnically very close to the Koreans), but also he may have felt sympathy to their craziness... that is: shamanism... obsession with the living ghost.

The more I work with T.V., the more I think about Neolithic the new stone age... because both have one big thing in common... that... is the audio-visual memory structure with the time-based information recording system...

One is chanting/dancing... the other video recording... and I enjoy the speculating business into the deep past, before the invention of private property system... yes, our video art is a communal communistic property, easy to share but hard to monopolize... therefore hard to live within the art world system, which thrive on the-one-of-the-kind exclusiveness... cash and carry object, not any other usefulness, this thing will just show off... sheer competitiveness.

The successful art market item must have two characteristics:
1 - It must be perfect, or near perfect. New, or near new, and *decorative*!!
2 - It must titillate the vanity of the buyers, that is:
I own something which you don't own, and which cannot own. Therefore I am superior to you.

Therefore our art world is the translated world of animal kingdom, where only one cock has the chance to screw a hen... and a hundred of them, where 99 other cocks go hungry.

Only in art world and heavy weight boxing only top 5 can pay rent, and 99.999 other artists/boxers go hungry, where as in the world of lawyers and physicians, you can make a living, if you are *reasonably* good (problem is that you can fix both art game and heavy weight boxing game, but the former is much easier than the latter).

However in this softness of software ruleless rule, there is also the endless attraction of art game...

Money alone is not interesting.
Art alone is not interesting.
But the combination of the two makes a strange chemistry, which attracts so many young people and ruin them at 30 years old... like the Lorelei rock.

Around 1977 after a long dinner with Pierre Restany and his friends Jos Decock modestly opened her graphic cabinet... I felt homesick... obsession... mistery... transcendental power... rustic depth, which goes beyond the drilling holes of Walter de Maria, beyond the distinction of being good taste and bad taste... (Duchamp: I have no taste!!! I always say... I have bad taste...). Without thinking twice, I said to Jos... "Wow, I like it... let me write in your catalogue"... She was modest enough not to have asked me to write for 10 years. I repeatedly said to her, "I like your handwriting which bore the trait of drunken god a la Bosch..." I said maybe three times... "I am serious let me write... I am not saying it to flatter Pierre Restany...".

Jos is the only person with whom I speak in French... Of course, I don't understand French and I don't speak French... She knows it... Yet she speaks in French may be for 5 minutes... I smile during these 5 minutes... then I answer in English for 3 minutes... whatever comes up in mind... needless to say, my answer has nothing to do with her question. I know perfectly well that she did not understand my English... yet she starts again to speak in French which I don't understand and she does not stop for next 5 minutes... with great laughter. I continue to talk back in English for the next 4 minutes or so... this goes for two or three more rounds and then says good bye and gives me a big hug.

In the concret term there were not a scintilla of communication... not more than e.g.: Pierre is in Milan or... he will be back on next Tuesday... you want to drink a Perrier or white wine?...

But in the advanced state of information theory, this is a profound form of communication...

The more ambiguity there is, the more rich is the conversation...

Read Lao-Tze.

By the way I categorized Koepcke as danish although is a german.

His mother was the sister of the famous german communist Thaelcman, enshrined in the history of german resistance. Koepcke's mother was tortured to death by Gestapo. Koepcke's father unknown. Koepcke grew up in the Nazi Germany in which even a "good" Nazi went hungry, as a bastard orphan... the nephew of a communist leader actively working in Moscow, after the war he went to Danemark, instead of having a privileged life as the son of martyrs in Eastern Germany... Koepcke lived only to suffer... suffered from many mental and physical illness... he died barely 50 in Danemark...

He always sounded and acted like a Danish Viking...

Am I a racist? Or a traditionalist? Or a DNA art historian?

NAM JUNE PAIK, New York, Janvier 1988

Originally published in French and English in *Jos Decock: dessins et aquarelles* (Paris: Château de Nemours, 1988), 3-15.

Sohm decided to collect ONLY information on art and not ART itself (1991)

Sohm decided to collect ONLY information on art and not ART itself, in the mid 60's well before Daniel Bell coined the word "post industrial age" based on information.

Bell defined the world history into three epochs.

1. agri-age based on *land*
2. industrial age... based on *energy* (coal and oil)
3. post industrial age... based on *information*.

At the post industrial age, people telephone to telephone but not to convey the wish to do, or purchase something. Daniel Bell, ex-marxist, formulated this thesis at the late sixties published in 1972, while whole intellectuals were hooked into Adorno (that is, the combination of Marx and Freud). Certainly I admire Adorno, although I don't understand him too well. But I can read at least his Werk-verzeichnis... Among his works done in the U.S. exile and post U.S. stay in Germany, the ONLY work he did on mass communication is one or two studies on Radio.

From the Communication theory point of view General Gehlen did better. He is the ONLY German, who won World War II. At the waning days of WWII, he persuaded Hitler to move *all* intelligence files of German spy networks and bury them inside the Bavarian Alps. Then he surrendered to the U.S. army, but insisted that he would talk only to an U.S. general... amused he was brought to a general... General Gehlen said that he had 3,000 spy networks still operating, some with wireless transmitter, behind the Soviet line... within a week he was in Washington D.C. with the U.S. colonel uniform...

Some day I will write a philosophy of information. It will be very different from semiotic people or Habermas people, whom I respect very much, although again so far I did not penetrate into his forbidding German language barrier. Habermas is popular even in Korea (south).

My book should contain at least three sections:

1. art
2. fashion
3. espionage

eg; most historians think that the Polish army contributed very little to World War II... people laugh at the Polish cavalier charging into German tanks to be slaughtered... even the 13 week series on Polish history on the U.S. public TV (co-produced with Thames TV London and NDR, Hamburg. The U.S. side producer was Carol Brandenburg of my satellite fame) failed to mention that Polish contribution to allied victory was in rank with the U.S., Soviet and English. The Polish was the key to the allied victory. Why? Not even the Polish army knows about it.

Before the start of WWII, British and Polish spies made a fake accident on the highway between Berlin and Danzig... so-called corridor, which ignited WWII. They did get an advanced information that German secret coding machine Ultra will be shipped through this corridor... and they intercepted and faked a high way accident and replaced the German coding machine with the burned out replica. Stupidly enough German intelligence people did not suspect and since then, the allies were reading all German and Japanese mail like in a fake Las Vegas pool table... The game was settled on that day and 30 million deaths on both sides was just a ritual to make sure that what is bound to happen, should happen so that all the stupid people are convinced that war is over. The coding power is the expression of basic mathematic power of a nation, which cannot be duped

or replicated or short cut. It was as fundamental as say... steel production power at 1940 or so, which cannot be quickly increased or decreased... The U.S. has a lot of mathematicians now... and 10% of all American mathematicians are involved in the spy decoding business... now Russia is gone... they became jobless... of course, some of them will be diverted to antiterrorism or economic competition... but in the economic, what can they do?? all generals are fighting the war with the last war's technology.

Therefore Mr. Sohm's decision not to collect art but *art information only* is comparable to the world historical evolution in peace and war... in art history he is as important as Daniel Bell, Herman Kahn in the social thought history or British-Polish team who stole Hitler's coding machine and did not admit it until *1975*!! I gave a book about it to Ingo Gunther in 1982, and it changed his life, too.

You could argue that Mr. Sohm collected only drucksachen because he did not have money to acquire art objects or paintings. But that is only half the of the pie... he could have easily collected smaller objects or drawings, but what I see the principle and decision... and non-commercial decision... to exclude everything but those little drucksachen... and he spent countless hours in a small village to index and cross index and complement and care... he memorized a most of my concert dates, places and even programs... Why did he do that?... personal malaise was often the motor to drive a hard bargain...

In case of George Maciunas, it was his asthma... he foresaw the limited life span... early in his life... he hated everything. He hated Hitler's Germany because Germans started the war, which drove him from Lithuania. He hated America, because society in America is full of contradiction. He probably hated his father, because he worked with Germans. He hated Mayor Mr. Beam, because he tried to stop his Soho co-op business (Maciunas had no license in architecture or real estate dealing). He hated many artists, because those artists, who bought cheap lofts did not pay their bills. He said that America needed only 5 artists, that all the other artists were lazy loafers who went to college, because their parents asked them to go, but they chose art department, because it was the easiest.

Now Charlotte Moorman... beautiful and great cellist, who ended another of tragic yet glorious life the day before yesterday. She had the first tumor operation at the age of 29 in 1962 (uterus), and the tumor escaped the first surgery and from 1962 to 1991 she saw the slow degradation of her body for 29 years...

From the first day we met, she said that she was terminal, although at that point the tumor was considered benign. I once asked Sohm why he did what he did. Why did he spend countless nights to file and index and copy and cross index and refile the documents instead of going to the kneipe and have fun... or come to N.Y. with dentist good earning and go to glitzy openings...

He gave that cynical and diabolic laughter that is typical for him. He matches Arthur Kopcke in that particular laughter. "When I was born it was Hitler and war time... and I had a very strict, diabolical father... I had to suffer from both. Then defeat and hunger... then came the communists... again I had to flee to the west... to this small village... a friend died prematurely..."

He hinted a series of problem after problem... and these countless nights at fluxus information desk were his response. He had to escape and revenge as Maciunas did.

... one day in the mid sixties he wrote to the all time sage Jean Pierre Wilhelm, who after all arraged Wiesbaden museum to Maciunas: "What should I do with the money I got from the sales of the DADA book collection?"

Jean Pierre Wilhelm referred him to Wolf Vostell.

The rest is history.

...................in the fluxus movement, Henry Flynt, drop out mathematicians, also noticed the power of information... he coined the word "concept art" also quite early in the art historical terms... (coined in 1961, published in 1963).

[handwritten in the German edition:]
British
 M.I.6 produced
 Kim Phylby ____
 who is Fluxu's
 Kim Phylby?

 Paik
 N.Y. Nov. 10.91

Originally published in *liber maister s* (Stuttgart: Staatsgalerie Stuttgart, 1991), 55–59.

Fluxus ≥ Picasso (c. 1992)

New York liberals, love not so much anti-communists as anti-anti communists. This double standard has existed since the 1920's, through the Stalinist purge days, even after the fall of the Berlin Wall and the opening of the KGB-Stasi file.

Fluxus has had an anti-anti communist wing (Henry Flynt, George Maciunas), an anti-communist wing (Vytatus Landsbergis, Milan Knizak), May '68 Paris wing (Jean Jaques Lebel) and the lofty figure of Jackson MacLow.

MacLow, Phillip Corner and Malcolm Goldstein were among the famous arrestees at the St. Peter's demonstration, a watershed event in the early Vietnam movement in the mid 60's.

We know many cases of artists' engagement in politics, but the Fluxus may be the first and only art organization , which ACTUALLY changed the course of one important country (Lithuania, which slew its giant

neighbor) and contributed prominently to the revolution of
Czechoslovakia.

In 1966 or so, Dick Higgins wrote in the *Something Press Newsletter* , "<u>please,</u>
<u>Send scotch tape to Milan Knizak in Prague because they are very short</u>
<u>of it.</u>" By then Milan Knizak was a loyal friend of George Maciunas and a
long-standing Fluxus member with an excellent art output. he came out
from Prague during the 1968 revolution, we had very lively encounters.
We tried to meet and discuss more often, but me, a poor artist with big
video expenses and a weak body in Manhattan had a severe natural limit
to my daily schedule. However, as a refugee from both communist and
anti-communist dictatorships, we had a more intense friendship with
each other than with New York's cafe revolutionaries, at least I thought so.

The finest moment came to Milan Knizak when the Soviet tanks rolled in. He
declared, "I cannot live anymore in New York's asphalt jungle, I will return to
Prague and resume fighting!" Later in Berlin (1980) he told me that he was
arrested over one hundred times, but never tortured. I told this to Mr. Yu, a
South Korean cultural attaché in New York, "Mr. Yu, the communist country is
better than South Korea." At that time, in 1984, torture was rampant in South
Korea, needless to say, this is true even today in North Korea. Even the
president of the People's Republic of Czechoslovakia singled out Milan Knizak in a
radio speech as, "the worst of his kind." After many arrests and ten years
without a passport, with no travel status, he was allowed to come to Berlin for
DAAD scholarship (1980). He smuggled out a sadly beautiful 10 minute 16 mm movie.
He told me it involved 7 illegal acts:

1) The gathering of people was illegal
2) Acting without a license was illegal
3) Purchasing the film was illegal
4) Processing the film was illegal
5) Duplicating the film was illegal
6) Showing the film was, of course, illegal
7) Smuggling the film out to the West was illegal

Finally the Velvet Revolution succeeded. We met in New York in 1992. We
embrace each other. New York's cafe revolutionaries would never understand
this feeling. He told me, as the new director of a powerful art academy, " I fired
every professor." He thought Havel was too slow. He is a celebrity who
appears on national television almost every week.

I wonder whether a Fluxus artist <u>can</u> succeed as a realpolitik politician. He
suffered enough as the number one dissident artist and his art work (split-level
disc-collage) did look as superb as ever in the 1994 mega-exhibition "Europa-
Europa" stage in Bonn's kunsthalle, created by Pontus Hulten and Jakob
Wenzel.

I wrote about Vytatus Ladsbergis' relationship with Fluxus and the world
renowned act of defying the Soviet tank in 1991 **NB 1**. When I finally met this ex-
president in New York in 1994 I was struck by certain common traits which he
shared with two other Lithuanian giants: George Maciunas and Jonas Mekas.
It is a paradoxical combination of two opposite characteristics:

1. a combination of defiance and humor, like a frog
2. a combination of extreme fatalism and extreme optimism
3. a combination of a smile and resignation

According to Jon Hendrix, Landsbergis' name appeared in Fluxus publications
about seven times during the sixties. Mieko Shiomi (Osaka, Japan) reached out
to Langsbergis through a mail out act, back in 1974-75 -- twenty years before
the Inter-net -- at that time even Xerox was forbidden in Lithuania.

DEFIANCE AND HUMOR. GEORGE MACIUNAS WANTED TO BE
REINCARNATED AS A FROG -- THE MOST ECOLOGICALLY SANE OF ALL
CREATURES.

English Editing: David Kalal

Undated typescript, Nam June Paik Estate. Paik included a handwritten note at the top of the text that read
"catalogue NJP art as witness," indicating that it was written for the second volume of the 1995 Kwangju
Biennale catalogue, *Art as Witness: The Spirit of Kwangju Resistance in May* (Seoul: Life and Dream Publishing,
1995).

Venice—Turtleship—a Trial Of Mr. Picasso... (1993)

The highlight of the 1993 Venice Biennalle was outside the Giardini (the Biennale compound).
There were 45 works of art, measuring exactly 1 meter by 1 meter, and sponsored partially by
the Turkish government. These 45 boxes were made by 45 artists from 45 countries, and they will
be sold in October to raise money to defend Turkish immigrants from the neo-Nazi violence in
Germany. I decided to dedicate my gold prize of the German Pavillion (shared with Hans Haacke)
to the Turkish immigrants...

At the opening of the Hungarian Pavillion (Josef Kosuth) I met an old friend from the former
Yugoslavia, an attractive woman director of a Belgrade museum. I asked her, "Which side are you
on?" "I am on the peace side. Pray for peace now. I am Serbian, my husband is Croatian (a pro-
fessor of art history). My daughter belongs nowhere." She started crying amid the clinking of
the champagne glasses.

Later I visited the Korean section of the Italian Pavillion, and met again another pair of
enemies...a Greek artist from Cyprus and a Turkish artist from Turkey, two countries that were
at war just a few years ago.

Mr. Achille Bonito Oliva, the Director of this 45th Biennale, compressed many unsolvable prob-
lems of today into a small pellet with the finesse of a "Goldfinger" and through the prism of
ART rather than any cheap idealism.

It was in 1985 that Miss Ishii of Sony arranged a chauffeur-driven car for me to go out to the
Tsukuba Expo and make a quick tour of the popular pavilions and do some experimenting with their

Jumbotron. While I was entering the Korean Pavillion I noticed that the Koreans were offering a resting place, where visitors were invited to sit down and eat a takeout lunch box (obento) without charge. I thought what a generous gesture in this expensive fairground, where even an ice cream can cost a fortune. Then it hit me...oh yes, this is the place that was intended for the "Turtleship" of Admiral Yee Sun-shin. I had the chance to see the blueprints for the pavilion before its construction, and this was the place where the Koreans would show their famous combat vessel. The Turtleship was the world's first armored ship, invented by Yee-Sun-shin in the 16th century, and used time and time again to defeat the Japanese navy. It was one of a few inventions that Korea can claim in the World's Halls of Science. And therefore it was quite natural that it would be shown in its reconstructed form in a science exposition like Tsukuba '85. But obviously it had been shelved for some political reasons. I told myself that if 'they' are so scared of 'somebody', I will make it someday by myself.

This someday came sooner than expected. Taejon (Korea) decided to hold a science expo in 1993, and my proposal of the High-Tech Turtleship was accepted.

But in the course of my research on the Japanese invasion of Korea (1592-98), I was more impressed by the stupidity of the Shogun Hideyoshi than the valor of the Admiral Yee Sun-shin. Hideyoshi honestly believes that he could reach Peking, and occupy this metropolis long enough to relocate the Japanese Emperor there. He did win almost all the land battles, and even managed to defeat the numerically much superior Chinese army, but his Japanese army then collapsed from exhaustion. Despite winning most of the battles, the outcome of the war was predetermined before the outset. Even if Hideyoshi's army could have reached the Yalu River on the Manchurian border with Korea, old General Winter would be waiting there, just as he would defeat the much superior army of Douglas MacArthur in 1950/51. Certainly the team of Tojo and Yamamoto in 1941 had a much better chance to force the Americans to accept a Hanoi-type of peace settlement at some point in the course of that war. In the forties, isolationism was quite strong in the U.S.--including E.J. Muste on the left, Patrick Buchanan's father on the right, and Joseph Kennedy in the center. And if radar has been invented a few years later, there might have been a Vietnam style of ceasefire--for which some mediator might have even gotten a Nobel Prize for Peace.

Why then, is Shogun Hideyoshi so much more popular than Shogun Tokugawa Iyeyasu, who ushered in 300 years of peace in Japan, and made the Meiji Restoration/Revolution possible? Because the tales of battles are much more exciting than a tale of peace. Hollywood doesn't make movies that don't make money. However, whether violence in media contributed toward real violence in the real world, or whether violence on the screen gives ersatz satisfaction of our basic instinct in the real world is still under debate. Although we have been exposed to daily dosages of carnage in local conflicts in the media since 1945, the world has been spared a World War II style disaster. Certainly media is of secondary nature compared to the real racial or economic conflict which did lead to world wars. It is not only Mr. Henry Kissinger who might compare the peace of the second half of the twentieth century to the peace in Europe between the Vienna Congress and the Franco-Prussian War. This 20th century peace has been "buttressed" by the constant blood on the TV screen.

Certainly Tokugawa Iyeyasu deserves a place in world history as a very original thinker in the realm of political science. He was as successful as, say, Metternich. And this is the role that the artist can play in the coming century. With all the new gadgets of high tech industry, we can make peace as exciting as war. Certainly it won't be by avoiding violence in the software, and serving up lipservice in the style of the traditional old liberals. If Virtual Reality blood can avoid or postpone real blood in real life, then let it be...

I remember a pleasant dinner with Mr. Takeyoshi Miyazawa at Christmas time in 1969. We were celebrating and brooding over the coming decade of the 1970's, and the achievement of the Sixties. Our conversation drifted to the Woodstock music festival and Daniel Bell's book "The End of Ideology." We agreed that campus Marxism, which was then raging in the world, was approaching an end; and the revolution in lifestyle in the high tech society would replace social revolutions of the past. Mr. Miyazawa said it would be his editorial policy in his new executive position. History has proven that we were right. Then a new question arises...accountability.

How do we treat Picasso's mistake? He did not renounce his belief in communism, even after the bloody affairs in Budapest or Prague. Should we forgive him because he was senile??? Then why did we applaud Bertrand Russell's anti-American Vietnam trials, as he was also senile. If we recognize the legitimacy of Bertrand Russell's activities when he was 80 or ninety years old, we should also demand political accountability from Picasso in his 80's and 90's. Because this double standard, or bias, in the liberal press covered up a lot of serious crime in this century. For example, in Paris, George Orwell's "1984" was never reprinted after its initial success, or was it due to the subtle influence of the Communist Party in the publishing world? Even today we don't question the balance sheet of the leftist government in France in the Thirties. Did their false expectation of Stalin, the Lincoln Brigade in Spain, and a distaste of rearmament contribute to the downfall of France? During the "phony war," did they believe that Josephine Baker's singing on the Maginot Line could stop Hitler? Why did they condemn Pinochet yet not Mao in the 1970's? Did a former Maoist French film director ever recant his guilt publically?

The accumulation of all such double standards in both journalism and historical writing is symbolized by the muzzling of any criticism of Picasso's communism. Because of his standing in the art world, many young and innocent souls were converted into communism and lost their lives under torture in unlucky areas such as Africa and Latin America. In prosperous areas like western Europe many middle-class intellectuals saw their life dreams crushed for believing in the wrong God.

It was disheartening to see in 1922 that the majestic experiment for socialism by the intelligentsia failed. That is the biggest disappointment of this century for many intellectuals, myself included. That means, the evolution of human beings did stop somewhere. Individual interest still prevails over the communal interest. Trotsky's naive idealism was usurped by Stalin's peasant realism. Will the 21st century see the renaissance of eco-socialism, where the communal interest of the human being prevails over the individual egotism of the rich countries? Shall we deny the pleasure of driving, airconditioning and mass-tourism to two billion people of China, India and Pakistan? And if genetic engineering brings a 90-year lifespan to the ever increasing population of the world, what should we do?

We video artists must fill up those empty hours of life. We have a lot of work to do...but so far nobody will pay for the video art.

The first clause of my "will" is that my money will buy satellite time (one hour a week), (eg, Friday at 8pm), and telecast video art to each time zone of the globe. And that a modest art program should continue at least from the year 2010 to 2050, until everybody on Earth is conditioned to tune in to the video art program offered on their local cable channel every week Friday at 8pm.

The question remains...what is video art?

Another question...

Maybe old style social revolution will come back due to mass unemployment, as the result of the collapse of the defense industry.

Picasso may have been right after all. I may be tried then.

THE TRIAL OF

 PAIK-ASSO

 PAIK-ASS

 PAIK-ASSHOLE!!

(English correction by B. Mayfield)

Originally published in *Feedback and Feedforth* (Tokyo: Watari Museum of Contemporary Art, 1993), n.p.

Untitled (Politics and Comics) (c. 1969)

"American failures in Vietnam have been, essentially,

failures in communication and understanding."

Don Luce

(former director of the
International Voluntary
Service in Vietnam, with
a 10-year service record)

from "Vietnam : unheard voice"
(Cornell)

(1)

J. Grew, a U.S. ambassador to Japan, wrote in the
1940's as follows: "Now I ask you to give special thought
to the Chinese--our leading Allies in the Pacific...no reverse
on the field of battle could quench their indomitable spirit,
no seas of disaster were too deep for them to pass through
unbroken, no destruction by fire and bomb could subdue or
weaken their determination to survive...such nations, such
people, and such leaders cannot be defeated.... Once militant
Japan is out of picture, their should remain no threat of
further war in the Pacific area. Japan is the one enemy
and only enemy, of the peaceful peoples whose shores overlook
the Pacific ocean...(once the war is over) the share of the
Chinese in the new Pacific is bound to be a great one.
(Report from Tokyo, pp.68-9)

E.O. Reischauer, another U.S. ambassador to Japan, said
in the 1960's:

> Speaking to the Tokyo press, Reischauer described Mao's mainland as "fundamentally a weak and backward country," contended that Peking's real power is too often exaggerated.
>
> "Natural Partners."
>
> In the long run, Reischauer suggested, relations between the U.S. and Japan, despite "cultural differences," may some day be as intimate as those between the U.S. and Britain. As "the only two great industrial nations facing the Pacific side of the world" the U.S. and Japan are "natural and essential partners."
>
> TIME, AUGUST 26, 1966

This reminds me of a famous Koan from Bi-yan-lu. Two monks
are quarreling by a flying mast. The first says, "The wind
is moving the flag; the second says, "The flag is moving the
wind". A third monk passing by yells, "Your mind is moving".
Who is the third fellow, who would yell to these old men,

"Your mind is moving"?

By now even high school drop-outs mumble about communication theory and St. Marshall's evangelism. They are keenly aware that:

1) The communication revolution is THE revolution.

2) The core of this revolution is the diversified parameters of non-verbal, visual language, which range from Mickey Mouse to the optical pattern recognition of computer via Huntley-Brinkley.

3) These fancy techniques have served for wars and preventive wars long enough. It is high time to redirect these sophisticated techniques into peace problems and let them work for Preventive Peace, which prevents even preventive wars.

4) The core of this Peaceology, which is in turn the core of all communication research, is the information gap existing between the East and West. Not only did the Asian continent replace the Balkan Peninsula of the '40s, but also the information gap is exponentially multiplied here by the conglomerated fusions of ethno-linguistic, geo-political, socio-economical, and ideo-cultural gapologies and their endless permutations.

As one of the few Asian intellectuals who are recognized by the progressive minority in the New York scene and who are tuned into its needs, I feel destined to pronounce energetically my positions on this matter.

(3)

War is not fiction.

Casualty is not fiction.

But all these irrevocable realities do happen through a mere
fiction: a "phenomenologie der Geist". The real, concrete,
substantial, justifiable grounds, such as economical conflict,
border dispute and ideological animosity generate international
tension and cold war. But the catalyst, which transforms the
cold war to hot war, is a fictional avoidable phantom, like
abstract fear, inflated anxiety, or vibration and reverberation
of paranoia and maladie imaginaire, all of which are nothing
but mental diseases, generated by a gamut of

COMMUNICATION PROBLEMS.

Harold Laski hinted this in the Forties.

The Pacific War was unnecessary. It was fought in vain.
Today the situation in Asia is exactly the same as before 1941.
The concrete reason for the U.S.-Japanese war was to protect
the Western interests in China and to deny South Eastern Asia
to the emerging Japanese. Today the U.S. has lost the Chinese
market anyway. The Japanese are dominating South East Asia
anyway. Or, was it a war of liberation to democratize Japan?
The Japanese had been enjoying a fair amount of democracy in
the Thirties, and it was the rising U.S.-Japanese tension and
the resulting military regimes which killed the indigenous
democracy. As far as the Zaibatsu, the Japanese defense-
industrial complex, is concerned, they are today stronger than
ever. Let two cartoons from 1945 tell the story. Our
communication research will also shed new light on possible
"Civil War II" in the U.S. cities.

Yun Gee

INDO-CHINA: *guerrillas received weapons in paper packages.*

CONTAINER CORPORATION OF AMERICA
SAVE WASTE PAPER

Fortunately or unfortunately further amplification of this
book project exists in the coming year.

1970 is the year of Karma. The fifth anniversary of
Vietnam escalation coincides with the 25th anniversary of
V-J day.

Well-planned mammoth riots in Japan to stop the renewal of
the controversial U.S.-Japanese security pact will coincide
with an equally well-planned mammoth festival at Osaka's
Expo '70, and the former wants to shut down the latter.
(N B I)
Moreover the Okinawa and Vietnam problems are far from over.
Recently Premiere Sato told Der Spiegel (Germany): "There
are two giants in the world; but the world is big enough
for the third". In 1970, Japan will return as a major focal
point in the international scene, beyond Zen and Sony. 1970
is the year to be used as shrewdly as William Shirer used the
Berlin Crisis for his "Rise and Fall".

(NB.1)
The U.S. will be inundated by
extravagant PR for the Expo '70.

The World War II provides us with irresplaceable, eye-opening material for communication research. Although innumerable studies have been conducted on this war ("Mother of Inventions"), Cagean or McLuhanesque approaches have not yet been attempted.

War is surely not 'groovy,' but its chronicler need not be 'square.' Before Pop Art, there was TV, before TV, there were comics and cartoons. Cartoons are more "real" than photographs, as Freud is more "real" than Marx. In a way, they are a major icon of today, especially in the pre-TV age, that is, the time of World War II.

> "In fact, the war of the icons, or the eroding
> of the collective countenance of one's rivals
> has long been underway...." (McLuhan)

As the Vietnam war is fought on living room TV sets, so was World War II fought in the cartoons of the grand illustrated magazines of the time, such as Colliers and the Saturday Evening Post. Significantly enough, McLuhan put cartoons, TV, and the telephone into the same category, that is, "cool media," which are distinguished by "low definition, high participation" and strong appeal to today's youth.

> "...and as for the cold war and hot bomb scare,
> the cultural strategy, what is desperately needed
> is humor and play....It is play (humor) that 'cools'
> off the hot situation." (McLuhan)

John Cage's great contribution to this century is that he liberated art from the pressure of dead-serious European culture, through humor and picturesque actions.

> "Fuller spoke of Semantography, universal picture
> language devised by C.K. Bliss, said it was rich
> in nouns, while what we need's verbs. Servant
> problem, What is What? Russia, U.S.A. Which is
> Which?" (John Cage)

Mixed Media techniques revolutionalized music (Cage), painting (Rauschenberg), theater (Living Theater), TV (Laugh-in? or Paik?), printing (McLuhan-Fiore) and maybe economy (Rostow). It is high time to apply it to communication research. It will turn W W II vintage cartoons into a bundle of fresh Morning Glories, as Duchamp's magic hand turned the toilet basin into a 20th Century monument. Hereby we exploit the strange onthology of book-binding (two side-ness) in order to incite a permanent confrontation.

Each left page shows the U.S. war cartoons, which affect young and old for different reasons -- cynical kicks and nostalgia. Every corresponding right page shows Japanese war cartoons., which will throw today's Americans into convulsions of laughter. Moreover these Japanese cartoons will be supported by excerpts from a hundred previously untranslated Japanese essays and comments which will have a many faceted pertinence to the post Vietnam dilemma. Needless to say, these facing materials will be matched with the virtuosity of an experienced marriage broker...blow by blow, smile by smile, absurdity by absurdity. It is a political Kama Sutra. 1001 positions of the erotic couples in Hindu temples exhaust pleasure and transcend it into the religion. Likewise 1001 positions of U.S.-Japanese comic couples will transform themselves into something completely new and profound, perhaps into the height of the classical epic in post-Joycean style.

1) FEEDBACKS

a) spatial feedback

The word feedback has become a cliche, but it is a cliche
with which you have to live -- like bread and butter. In
fact, it is the bread and butter of electronic culture, as
typesetting and linearity is the bread and butter of print
culture. Well-publicized virtues of electronic culture --
such as a-linear methods and processes, decentralized networks,
the delicate equilibrium of multi-directional checks and
balances, the reasonable hope for post-industrial Pantheism,
in which everything affects everything, putting an end to
linear dictatorship -- all these virtues are the direct
consequences of the feedback technique, which lurks in every
corner of circuiteries. E.g., in home TV sets, a compensatory
feedback guards your TV tuner from drifting...in the hi fi
set, a negative feedback makes up for the lost frequencies.
Predictory feedbacks made automatic anti-aircraft gun and
radar possible. Flip-flop and the multivibrator are the
basis of "square" computer and "hip" electronic rock. Both
the vast Esso refineries and home oil burner will explode in
minutes without an adequate feedback system. But among this
para-existence, there is a clear-cut common denominator:
feedback never occurs in an open circuit. CLOSED CYCLE is
the unconditional pre-requisite for this happening -- and what

is a more tightly closed cycle than W W II, which hardly
saved the neutral countries? It is a classical "kill or
be killed" situation. Subsequently W W II produced violent
feedbacks, which saw no parallel in history for its ugliness,
bigotry and prejudice. Goebbels was the Marilyn Monroe of
that age. Teeth by teeth, tits by tits, feedbacks of the
ugliest cartoons will wake up even the densest rednecks.
Here are some American examples (S. Group one). Japanese
cartoons will be added later to have wonderful lays with
strange bedfellows.

Feedback technique runs in many layers of symbolism.
The next page depicts the admiral of "brilliant treachery."

TIME

THE WEEKLY NEWSMAGAZINE

JAPAN'S AGGRESSOR: ADMIRAL YAMAMOTO

His was the daring execution of a brilliant treachery.

This sinister cartoon will not only accompany equally
biased Japanese cartoons, e.g., the blind glorification
of this admiral or the blind insult to General MacArthur, etc.,
but also a rather embarrassing feedback.

A recent biography reports the following items:

 * This admiral of treachery admired the president of fair
 play, Abraham Lincoln. He recommended Lincoln's biography
 to many fellow Japanese naval officers, commenting that
 Lincoln belongs to all humanity, not just to the U.S. alone.

 ** Yamamoto was in today's jargon a dove. He expressed the
 opinion that only the insane would fight the U.S., if
 they had once seen Detroit and Texas. The U.S. is not
 a paper tiger, she has fighting spirit and adventurism,
 backed by scientific research. He objected to the Japanese
 spiritualism, which ended up as the Kamikase suicide bombers.

 *** He was keenly aware of U.S. materialism.
 "In America, even the subway and cars have heaters," he
 wrote to his Geisha friends back home in 1920; he also
 had great fun watching a rich heiress working at an office
 job, where she was overjoyed by a pay raise of a few dollars.

Do I need a fourth layer of feedback a la Naom Chomsky, that
Pearl Harbour was actually not a treacherous sneak attack, but
a near-entrapment? No, my aim is not to find out the "truth,"
what actually happened, but just to find out what was fed to
people as the "truth," which was to form the consensus and
influence the history. There lies the difference between
the historian and information specialist.

This graceful cartoon evokes a poetic feedback from
the Japanese side.

Takami Jun: Diary of Defeat (a free excerpt and translation)

1945, February 17

 I copied a drawing of Renoir's all day long listening
to the bombing sound....I don't understand my mind.

March 13

 A lot of guesses on the possible landing place of the
U.S. army. I may have to take up arms too...."Let us
thank, at least, the Fates that 'I live in a century
which is neither lazy nor boring'" (Montaigne)

March 23

 Cigarette ration becomes three smokes a day from seven
a day.

March 26

 We got our sardine ration. Five sardines for each...
a big surprise...only three days ago we got three sardines.
This sudden luxury might have happened because of the
bombing. Since they could not transport sardines to
Tokyo, they had to dump them in suburbia.

August 14

 Instead of rice, we ate the potatoes from our garden.
When the Americans come we won't even get potatoes,
since Americans like potatoes....What will be left for
us to eat?

(13)

April 7

Magnificent formation flight of enemy bombers...
they were so placid and serene that my mother mistook
them for Japanese. My wife sighed, "They are
beautiful, even though they are enemy"....One tiny
Japanese fighter went up and made a suicide attack...
our heart ached.

April 24

Current Tokyo talks...and they are the serious ones:
Eat only scallions (green onions) for breakfast...
then your house will not be burned down in tonight's
bombing.
Pray and bow with folded hands to the goldfish...then
they will protect you from bombs. (Since live goldfish
are very scarce now, even porcelain goldfish are sold
expensively....)

(after Japanese capitulation and end of war)

August 29

A government official placed a help-wanted ad for
1,000 "special consolling ladies" for the American
soldiers and got 4,000 applications...this "success"
outraged him.

September 2

Rumours of U.S. raping...here are some Japanese
reactions:

A. "We lost the war, we have to give thanks that
we (or she) were at least not killed...."

B. "When we recall what we have done in China...."

September 6

At last girls' high schools are closed in order to
protect the girls from the soldiers.

September 30

General McArthur ordered press freedom, which is the
first freedom in Japan and in my life. It is more
conceivable that a country looses freedom after defeat
and occupation, but, on the contrary, freedom was given
by the victor to the defeated. What a shame for the
Japanese government and people for not doing this
themselves.

October 3

The Tokyo-Ginza is flooded with U.S. sailors...the
dazzling white of their uniforms shot my eyes with pain....
"They've got plenty of soap..." was my lonesome comment.
Mr. Y. said, "They do machine-washing...quickly and
easily...not like us, who struggle by hand...."

October 18

> Near the Emperor's palace, many Japanese office girls
> were flocking around U.S. soldiers...less courageous
> girls were walking nearby as if wanting to be jeered
> at or teased...jealousy???anyway not nice to see....
> I shuddered at the thought that these girls have gotten
> voting rights through U.S. decree.

November 6

> In a train a black soldier said to a Japanese, that
> the Japanese orange is not so sweet....In the other
> end of the train two Japanese youths traded some
> prejudicial remarks about this black soldier, then one
> of them went up to him....I was a little anxious about
> what would happen...then he bowed to this soldier and
> servilely begged cigarettes....
> (This is one of the many interesting incidents regarding
> U.S. cigarettes in this diary).

November 6

> Three months have passed since the occupation, but I
> have not yet seen any Americans beating a Japanese
> citizen. I recalled a native of a South Pacific island,
> who said that Euro-Americans are good people as individuals,
> although their national (colonial) policy is cruel....

December 1

> A Japanese is reading LIFE magazine (ostentatiously) in
> a train. I hated to see it...why doesn't he read at home?

This is a tiny sample from Takami's 600-page diary, which
is rich with documentary and literary value. The subtle
psychology of Radiguet and the resignation of Thoreau's
diary are curiously mixed in rapidly changing abysmal
conditions.

Ex-Marxist liberal Mr. Takami saved harsh words for the
American bombs, which menaced his life day and night, but
remarkably his temper exploded when GIs and "native girls"
began to fraternize. How would the following innocent U.S.
cartoons praising "exotic love" resonate to the painful pen
of Mr. Takami? Still many Americans believe that the economic
benefit of the R & R program would outweigh the emotional
repercussion in dealing with underdeveloped countries. For
them I have been thinking of translating a Japanese bestseller
of the 1950's, a collection of candid confessions of Japanese
B-girls, and even the pitiable one who was in the last stage
of syphyllis. These gloomy, partially Sado-Masochistic
accounts shocked all Japan, and will do so also in this country.

But of course there are a number of cheerful records of U.S.
Sex Power which was as superior as U.S. Air Power. A B-girl
noted that in the first days of the U.S. occupation, she was
so occupied that she had to chew down Onigiri (rice cake made
for picnics), "looking up at the ceiling" while 4-lettering,
being unable to get up even for a short lunch break...she was
a chain-smoker at the wrong end.

If "bombing is as American as cherry-pie" (H. Rap Brown), then
so are Geishas as Japanese as cherry blossom???

 a famous Geisha joke....

"One guest talks about the stockmarket, another gentleman preaches about democracy, and a third one tries to convince me of the beauty of Claude Debussy, but in the end, what they want is always the same." If you want to be more successful in your next Geisha party in Tokyo, listen to her rating of U.S. etiquette and U.S. bediquette.

"Why, Sarge—you can't drink tea <u>any</u> old way in Tokyo!"

Japan produced numerous volumes of "occupation literature" in belles lettres and non fiction. They will be condensed and strewn in this book like "fleurs de mal." Soul-searching post-Vietnam souls cannot overlook these testimonies, which are largely transferable to the other occupied countries. These are especially valuable since Japan is one of the few countries which have both U.S. bases and press freedom.

"How do you spell that word 'ennui'?"

This student-soldier will soon be meeting a Japanese student-soldier in the South Pacific, and will kill him, if lucky enough, or will be killed, if unlucky. Then what was that Japanese student-soldier thinking in the same situation?

He was reading Montaigne, also a lonesome skeptic.
Letters sent home by the fallen student-soldiers were published after the war and became the first best-seller in the post war era and has stayed as the student classic No. 1 ever since.
This is one book which I cannot read without literally crying.
Student Power with a capital S is here to stay as the consolidated "fifth class." If they are to have their own "das Kapital," it will be on their list.

b) <u>time feedback</u>

Nostalgia is an old homeopathic feedback and a sweet and pungent
privilege of mature men. Our cartoon anthology is a double-edged
sword. It titilates the Vietnam-twisted libido of the Hippie
and at the same stroke sends their parents on a trip in a time
machine. W W II constitutes, however hard it may have been,
the broadest and most emotional common denominator of all mature
Americans. Its Freudian essence, old cartoons, cannot help from
moving them to tears, smiles and soothing memory lanes, as
"Casablanca" of Ingrid Bergman and Humphrey Bogart never fails to do.
The Buddhist says, "Love is the source of hate, hate is the source
of love." Actually, our electronic environment is a burgeoning
nostalgia market. TV's late late show, FM stereo station a la
Mantovani, Reader's Digest's big business on the old songs and
bands -- all are exploiting the peculiar ability of the electronic
medium to jump past and future, East and West at will. Our
collected cartoons do an equivalent function in the printed
environment.

Perhaps the tragicomedy involving the car-gas-tire shortage is the
funniest one of all, because it shook the bottom of everyday life.
It has also an excellent counterpart on the Japanese side, that
used to say, "a drop of gas is a drop of blood." From the following
cartoons the old get their pie, the young get their kick. In a
perverted way it casts strange shadows on the Marcusian utopia (anti-
consumer society) and McLuhanesque utopia (carless society). John
Cage was once asked on Italian TV which town of Italy he preferred.
He answered, "I prefer Venice, because it is the most advanced town
in the world. It has already abolished automobiles." Militant

(21)

Zen boys and brown rice girls were exhilarated by these carless
cartoons and said they might support the Vietnam war if it gave
such fun.

"Well, it looks like a buttercup to me."

"How's business?"

c) <u>space-time feedback</u>

China has turned suddenly from No. 1 friend in Asia to No. 1
enemy in the world. The information flowchart was scraped
to the very bottom. Input became output. Plus became minus.
The new block diagram looked like a circus of jigsaw puzzle and
go game.

At one end of this triple feedback there is a superb Steinberg
cartoon which should be discovered, if nothing else just for the
sake of art. On the second corner, there will be an arsenal
of Japanese cartoons against the Chan Kai Shek-FDR alliance.
But the third corner for this multiple feedback will surpass
them in the nowness and provocation. In 1967, K. Hayashi
published an unsettling book, called:

<u>If the U.S. and China Fight</u>

Mr. Hayashi is a veteran staff officer of the last Japan-China
war and his prognosis is backed by his frustrating first-hand
experience on the vast Chinese soil. The digest of this book
might affect the outcome of the next election.

2. ENTITY through ENTHROPY

After demonstrating an effective application of the feedback technique to our quasi-comic book, we step further into the simulation of "enthropy"..another feature of cybernectics.

As is well-known, Indeterminism is the atonic core of the 20th Century, cutting through Physics, (Heisenberg), Philosophy (Sartre), Aesthetics (Cage), Mathematics (Cantor), Warfare (Geurrila tactics), and politics (Nehru), and needless to say playing a dominant role in the information theory.

Humor comes from Unexpectedness. If man beats dog, there is outrage. But if dog beats man, there is laughter.

But If man walks, it is normal
 If man tumbles on a stone, there is an enthropy
 and therefore it is funny.

This Bergosonian observation received powerful backup from McLuhan.

Noting that both Picasso and Joyce were great fans of comic books, Mr. McLuhan discovered a serious onthological meaning of this medium, and has reached a paradoxical conclusion that this "seemingly superficial," shallow entertainment is in reality a profound manifestation of our time.

The first comic books appeared in 1935. Not having anything connected or literary about them, and being as difficult to decipher as the *Book of Kells,* they caught on with the young. The elders of the tribe, who had never noticed that the ordinary newspaper was as frantic as a surrealist art exhibition, could hardly be expected to notice that the comic books were as exotic as eighth-century illuminations. So, having noticed nothing about the *form,* they could discern nothing of the *contents,* either. The mayhem and violence were all they noted. Therefore, with naïve literary logic, they waited for violence to flood the world. Or, alternatively, they attributed existing crime to the comics. The dimmest-witted convict learned to moan, "It wuz comic books done this to me."

It is relevant to consider that the old prints and woodcuts, like the modern comic strip and comic book, provide very little data about any particular moment in time, or aspect in space, of an object. The viewer, or reader, is compelled to participate in completing and interpreting the few hints provided by the bounding lines. Not unlike the character of the woodcut and the cartoon is the TV image, with its very low degree of data about objects, and the resulting high degree of participation by the viewer in order to complete what is only hinted at in the mosaic mesh of dots. Since the advent of TV, the comic book has gone into a decline.

It is, perhaps, obvious enough that if a cool medium involves the viewer a great deal, a hot medium will not. It may contradict popular ideas to say that typography as a hot medium involves the reader much less than did manuscript, or to point out that the comic book and TV as cool media involve the user, as maker and participant, a great deal.

the cartoon is a do-it-yourself form of experience that has developed an ever more vigorous life as the electric age advanced. Thus, all electric appliances, far from being labor-saving devices, are new forms of work, decentralized and made available to everybody. Such is, also, the world of the telephone and the TV image that

The "information with low definition" means for Marshall McLuhan
the pleasant Sunday cartoons or TV shows. Even "Dick Tracy"
or "Mission Impossible" cannot scare him physically more than
a mosquito. But the similar signal patterns had meant for
Norbert Wiener and six million Londoners a matter of life or
death. The horrifying Luft Waffe crossing the Dover Channel
during the Blitz was in fact quite a scary "information with
low definition and high participation." Their numbers, types,
courses, and targets were the mystery for British ground gunners
that had to be somehow quickly decifered, calculated. It
required "high participation" of ground gunners. Thus the
struggle with the chance and random number chart began in order
to shoot down German planes. It was also the beginning of
Cybernetics.

Wiener: "Messages are themselves a form of pattern
and organization. Indeed, it is possible to treat sets
of messages as having an entropy like sets of states
of the external world. Just as entropy is a measure
of disorganisation, the information carried by a set
of messages is a measure of organisation. In fact,
it is possible to interpret the information carried
by a message as essentially the negative of its
entropy and the negative logarithm of its probability.
That is, the more probable the message, the less
information it gives. Cliches, for example, are less
illuminating than the great poems."(Norbert Wiener:
The human use of human beings. p21). White noise
has the maximum quantity of information.

Wiener's heavy academic explanation becomes empirically true if we look back in history. Many outstanding thinkers have combined vagueness and profoundness, brevity and insight, relavation and paradox, such as Malarmee, Pascal, Lao Tze, and Nietzsche. Malarmee's one line is Valerie's one page -- and it is in this point that our cartoon anthology draws a second parallel with communication theory's "positive randomness." In this book, dozens of cartoons and comments on the same theme are mosaic-ed together in such a way that they form an organic entity, a many-faceted information complex. Sometimes it resembles a TV picture or wire photo, in which numerous halftone dots make one picture and sometimes it resembles a creative chaos of John Cage, in which rash judgement is sacrificed for an honest cognition. Recently the N.Y. Times used a 1941 cartoon to describe the Defense Industrial Complex. One cartoon was powerful enough to flash back the history, but in our case dozens of related and contradictory cartoons make an "entity with enthropy," which, thanks to its built-in confusion and a-linear process, can reflect the confused state of reality.

Carton Group D involves you in the peculiar environment of the Great War, and supplies you with a new insight, earned the hard way through Vietnam. The profitable patriotism of big concerns exhorting the average citizen to work harder, the inflation in taxes and men, the increasing interference of the government, the desperate effort of the peace industry not to miss the bus...all the complex image of war economy is visualized in the totality and culminate in the famous phrase of Dr. Johnson, "Patriotism is the last refuge of the scoundrel."

There is a profound reason why John Cage's now famous "chance operation" once jolted the musical establishment and swept the international avantgarde world like an avalanche and ended up with the "I-Ching jingle of teeny boppers." Affinity of the Rand Corporation and random numbers is not a phonetic randomness.

McLuhan put it this way: "The new electric structuring and configuration of life more and more encounters the old linear and fragmentary procedures and tools of analysis from the mechanical age. More and more we turn from the content of messages to study total effect....Concern with effect rather than meaning is a basic change of electric time, for effect involves the total situation, and not a single level of the information moment."

In the game of chance

 Wiener is a grocer
 Cage is a chef
 McLuhan is a gourmet

 or vice versa

3. CONTROL

Norbert Wiener subtitled his main work as "the study of
communication and control in animal and machine."
How were these naked apes controlled in the course of the big
machine called war? In case of the Axis, control was clear,
therefore in a way "innocent." In "free" countries, mechanism is
far more intriguing. Control is aimed at the self-censureship of
the subconscious. Freud remarked that wit belongs to the realm
of the subconscious and has the structural resemblance to dream.
Therefore the cartoon is an effective tool to manipulate the
subconscious, or collective ego. Tremendous amounts of romantic
cartoons about the South Pacific Islands and girls wiped out the
hell of Guadalcanal. The celebrated German philosopher, Ernst
Bloch, told a Western journalist while he was still living in East
Germany: "In East Germany we know at least that we have no freedom."

Today the foremost medium for this invisible control is the
synchronization pulse (50 c/s) of TV scanning and F.C.C. By virtue
of this medium-bath we tune our screen to the big stations, and
thanks to this 50 c/s permanence, when Johnny Carson laughs, 50
million Americans laugh. When Lucy cries, 30 million Americans cry.
Kids get the withdrawal symptoms from 50 c/s pulse when they reach
school age. In W W II it was pin-up girls who replaced Johnny and
fed soap dreams to GIs. An overwhelming quantity of Sex cartoons
in front and home-front was the repressive tolerance No. 1 of the
Forties.

Other latent control is commercial consideration. Since all
news media is by nature a mass media, it has to presuppose a
sort of public consensus before reporting. On the holy day of
moon landing, we could credit Werner von Braun, but even the
National Enquirer could not credit the former employer of Werner
von Braun. The narcissistic instinct of the consumer is much
stronger than the First Amendment. Francis Bacon's allegories
about the idols of cave and marketplace are still alive in the
free press under democracy. A hundred Japanese essays, which
will be scattered in this book, will give the glimpse of this
transparent curtain. Here are some examples:

* In 1961, (before Dallas) Professor Óuchi, a noted expert on Marx,
pointed out that everything was academically wrong in JFK's
inauguration speech, as far as facts and details on Marx were
concerned.

** The Bungeishunju, a very popular monthly review, has run a
regular column to criticize the international review on Japan.
They did not spare even the best American newspapers. The selection
from these columns will be of vital importance for concerned
Americans who want to know the extent of news manipulation.

*** Colonel Cannon, quite a celebrity in Japan, might be also a
victim of this transparent curtain. He was reportedly an opium-
addicted U.S. agent who kidnapped a well-known leftist writer from
the street and confined him in a private house without any legal
procedure for forty days, supposedly with the intention of planting
him as his agent. This sensational expose has a high entertaining
value -- at least -- and need not be saved from mystery fans here.

4. S/N RATIO

One important function of cybernetics is the electronic sensor,
the detection of information. In 1940 Dr. Y.L. Lee of Bell
Telephone succeeded in digging out very feeble information
buried in the noise at -20 db, using an ingenious combination
of filter and predictor invented by N. Wiener. With the same
approach we try to dig out the meaning of signal patterns
involving "Hippie" culture.

"Oh, you'd like Thoreau."

To the disheartenment of young campus hippies, and in odd
contrast to this beautiful cartoon, Japanese Zen monks played
a leading role in war propaganda. Macrobiotic food, the darling
of the "turned on generation," was officially promoted by the
militarist to camouflage the food shortage produced by reckless
and agressive warfare. Haiku poems, for many hippies the ultimate
form of peace and simplicity, were often used as an anti-democratic
dagger. Exposure of this singularity, which was hardly revealed
by any Japanese or Western Orientalist, might disillusion some teeny
boppers or enrage some politicians, but it is healthy. The
translation of anti-FDR Haiku will be as pop arty as Roy Lichtenstein's
blow up comics. Kamikaze suicide bomber's farewell poems, written

before the death flight are so wierd that Dr. Timothy Leary
could have dreamed them on a "trip."

Nowadays no book is complete without mentioning the "war of
liberation." Here are two wierd examples: In 1942 Mr.
Matsushita, a U.S. educated liberal theologian, asserted that
the aim of W W II was to liberate Americans from their material
"More-ism," and indulgence in decadant luxury. He would like
to see Americans go back to the platonic zeal of the Mayflower,
inspired by Japanese spiritualism. Luckily Matsushita failed
to liberate Americans from America, but was liberated by Americans
from his own dictatorship. But, strangely, after the war young
Americans voluntarily liberated themselves from the material
"More-ism" and indulgence to decadant luxury by help of Japanese
spiritualism and they are filling the Filmore East every weekend.
Matsushita's presumptuous war aim is partially fulfilled by way
of complicated detour.

Another dubious thesis of the "war of liberation" was launched
by the ex-Marxist, ex-militarist writer named Fusao Hayashi.
In 1967, at the height of the Vietnam escalation, he ignited
a big controversy by insisting that the Pacific War was the
war of liberation of all Asian people from white supremacy.

My proposed book will contribute toward
 the liberation from the war of liberation.

5. INDEXING

Nowadays we are so flooded with data and information that even
the combination of the inductive genius of Hegel and the
deductive genius of Darwin would flounder. Lily-white Descartes
would throw himself in the Seine in order to preserve his
virginity of cognition -- "claire et distincte." As in modern
economy optimum consumption becomes more critical than optimum
production, so in modern society does the efficiency for
information retrieval become more of a factor than the capacity
for information recording. The Biblical saying, "there is
nothing new under the sun," implies that everything in this world
is in fact a problem of new indexing. Henri Poincaré refined
this formulation at the turn of the century by saying that the
discovery of a new knowledge was nothing but the discovery of a
new relationship -- that is in my definition a new indexing
possibility. But with the arrival of the computer age and
digital tape, the science of indexing per se has gained the
momentum of death or survival.

Therefore it is not a small feat of this book that it introduces
a radically different INDEX system which is not attached at the
end of the book as an Appendix, but which is spread all over the
main body of the book, as an integral part of the book, like the
Basso Continuo of Baroque music. As I have often said, each
single cartoon is a highly eloquent information unit, a typical
model of an operative non-linear module. These operative non-
linear modules will be printed and bound in the linear order in

the book rather conventionally, but within it there will be
many keys, numbers, and clues for the criss-crossed index
system, which would permit the reader to jump and stop upon
his own interest.

Its existential form is rather like a World Fair site, where
the public can move freely in a non-linear operational manner
according to their own interests, following the easy but
effective guidance system, or like a Mandhala, in which time
and space are united and complex liaisons are scanned at light-
speed. In the high art of Cybernetics, the Push-Pull of love
and hate is reduced to the abstract combination of Ohm's law
and Kirchhorz' law. Information with a message plays as
important a role as information without a message.

 Cybernetics is Karma.
 Karma is Samsara.

6. CONCLUSION

Seven billion dollars is spent annually in America for the
beauty business. Mirrors follow us from morning to midnight,
from bedroom to bedroom, even at the subway vending machine.
But where is the mirror for our soul?
How can we see our mental, intellectual and moral makeups?
It is a blunder bordering on a miracle that a 900-billion-dollar
GNP failed to produce even a single mirror for five dollars.
Sartre's paradox, "I am always what I am not, I am always not
what I am," becomes sadly accurate in a new context.

We are living in an image-oriented age inside a package-oriented
society. "The Russians had only to adapt their tradition of
Eastern Icon and image building to the new electric media in
order to be agressively effective in the modern world of
information." (Marshall McLuhan). The War of Icons is being
waged on a global scale. America, who is destined to be the
world policeman of this century, has to polish her image mentally
and physically. She should even sleep in front of the mirror,
removing carefully the lunch hour's ketchup, erasing the kiss
mark of the neighbor's wife, putting on a big Lindsay-smile,
brooding over the necessary evil of carrots and sticks, pigs
and cops.

> "The meaning of a message is the change which is
> produces in the image." (Kenneth Boulding)

The greater the calling for restraint and responsibility by the
super-powers, the greater the need for self-view and self-analysis.

It is not a pure chance that de Tocqueville, a French traveller
to America, and Ruth Benedict, an American traveller to Japan,
have had more penetrating insights into both host lands than
the hosts had of themselves. Both used the principle of radar
scanning, two-way communication. Needless to say, communication
always means two-way communication. One-way communication is
a dictate, Bekanntmachung and Vertoten. And what would make
a sharper mirror, or a better radar for Americans than a
comprehensive anthology of Japanese writings on this country --
from Prime Minister to prostitute, from the time of Admiral Perry
to Neil Armstrong, but especially centered on the time of fateful
confrontation, W W II and the U.S. occupation? The U.S. has
shocked and soothed, scared and educated, allied and ambushed,
helped and snubbed, flattered and flattened, cho-cho-loved and
atom-bombed, contempted and competed, admired and assimilated,
pacified, hippified and pop-arted her strangest bed-fellow, Japan.
Accordingly Japanese responses have reached the outer-limit of
extensive and intensive stresses, which has made the complex
image of the U.S. bare and stripped, through making Japan's
own self bare and stripped...like Yoko and Lennon.... On a
global scale Socrates' dialectic is endorsed by electronic
technology.

Computer ahd moonlanding are not panaceas.

The Vietnam War is the first war fought by computer
and the first war lost by America.

Ian Fleming wrote in Goldfinger,

"Koreans eat cat!"

What a slander-----

we eat only dog.

Undated typescript, Nam June Paik Estate. Published in a different, shorter form in *Nam June Paik: Videa 'n'*
Videology 1959-1973, ed. Judson Rosebush (Syracuse, NY: Everson Museum of Art, 1974), n.p. Paik's note in that
version read: "I tried to apply communications theory to the East-West communications problems. I wrote this at
the height of the Vietnam War, and as an Asian, I thought, I could supply some insight which would escape the
attention of American Journalists. Here are excerpts from that unfinished work." NB: Page 28 of the typescript
is lost or does not exist.

Avant Garde on Trial (c. 1967)

(1)

From November 17th 1966, until January 28th 1967, many girls
of 'Les Ballet Africaines' danced with 'bare bosom',,, jumped
intermingled with equally semi-nude male dancers at the 47th st
theater in N Y C . (Ethel Barrymore theater),,,, and made
money.
Just 12 days later, and only 6 blocks apart, Charlotte Moorman,
an internationally well known cellist and avantgardemusic promoter,
played with same costume ('bare bosom'), played quietely (that is,
not jumping , not not approaching any male dancer,,, only one
male on the stage was 7 feet apart, fully dressed in business
suit playing equally quietly piano) two famous classic music..

> Massenet's Elegy
> &
> Brahms's Lullaby.,,,,, for the privately
>> invited audience ONLY
>> without charging money.

> While the former African girls were hailed as 'art'
>> by City Hall,
>> the latter (more famous) American Girl was arrested
>> in the most disgraceful way and internationally
>> bad reputation was imposed to her and her bourgeouis
>> family and concert was interruped.

FROM WHERE this UNFAIR and BIASED application of law ??

> If Piccasso's masque is as artistic, as African primitive masque,
> then legitime Avantgarde music should be , as artistic as
> native African Dancer.

One charge aginst Charlotte Moorman is that she 'outraged public

decency'. (1143)

But it was the police, who outraged the public, but not

Charlotte Moorman as the World Journal Tribue reported. (Feb.10th,67)

They all smiled when Charlotte Moorman
sat down to play the cello.

But the smiles quickly turned to chants
and the chants swelled to a demonstration
and the demonstration led to eight carloads
of cops being called last night to cope with
the capacity audience at the W. 41st Street
Theater, one block from Times Square.

By WILLIAM HIGLEY
World Journal Tribune Staff

Another Charge is"the wilful and lewd exposure".

The supreme Court gave the definition of 'obscenity' in the ROTH

case in 1957.

1)"to the average person, applying contemporary community
standards, the dominant theme taken as a whole appeal to
puririent interest"

2) it must go "substantially beyond the customary limit of candor

to the point of patent offensiveness".

3) it must be "utterly without redeeming social importance".

and all three elementsSHOULD "COAISCE".

* * * * * * * * * * *

1) a) various examples of community standards are described i nthe

page 2.

b) Dominant theme was not the appealing to prurient interest.

The concert began with the solemn morning chime of

Japanese Zen temple in Northern Japan and the recording

of morning Buddhism-servicc. and then Charlotte Moorman

played in complete darkness a noble classic music

'massenet's Elegy, while her electric light Bikini

was on and off. Not single popular or vulgar music was

played. Not single sound from Jazz, Rock, Folk,Beatles

were played. In the second piece, even electronic

music , composed by the computer at Bell Telephone Laboratory,

was played with Brahmes' Lullaby. Please, think,,,,,,

All the world is filled with vulgar sounds, and songs.

If we wanted to appeal we to the prurient interest of

average person, why have not chosen one of that piece , which was

at handy any time at any place? Can you imagine music pieces,

which is more inconvenient, inadequate, unproper to stress

the prurient interest than above mentioned four piece

(two classic, one electronic , one Zen music) ???????

Especially Zen music, which opened the whole concert was supposed

to come back many times during the concert, like Ritornello in

Monteverdi or Leitmotivs in Wagner's MUSIKDRAMA.

c) One more important element of whole composition is the 14 kinds

of masks and 4 kinds of bow.

 masks-- classic, modern art plastic kind, sunglass,
 funny German carnaval mask, gas mask, G.I.cap
 etc.

 bows-- normal Cello bow, fresh flower, yardstick,
 normal violin, used as cello bow.

 Of all these props, which I used, NO THING had any obscene
 association. If prurient interest were a main motiv,
 there were wide range of possibilities.

d) Bare bosom was an integral part of composition, but only one
 part of this total structure,, and it was as naturally,
 as nobly exposed as Miro's Venus,,, far from being lewd.

3) A s far as 'redeeming social importance is concerned, nothing

will more eloquently testify about her social importance, than

her two recent appearance in 'cellophane'.(underneath nude).

in Marshall McLuhan's (needless to say THE most important philosopher

living today) two recent publication. One in 'Media is Massage'(

McLuhan and Fiore) (Bantham Paperbacks) and the other in on NBC'S

McLuhan documentary program on Sunday 4 PM (March 19th).

Her performance of Paik's 'Variation on the theme by Saint Saens'

(nude-cellophane inevitable) on N B C is another example of

'community standard .

If mere semi-nudity does not constitute the violation of law, as

in the case of Ballet Africaines(N.Y.Times didnot written that

it was an exceptional only onetime permission)(17th of November,

N.Y.Times),,, then will Charlotte moorman prosecuted,

because she played Brahms ????

or will she prosecuted, because of 'collage' of

Brahms and bare-bosom ?

If 'collage' is the ground to be prosecuted, then

police should ban all the collage works from Art Galleries in New York,

(that means 90% of current art works), and fill the vacunt walls with

the healthy 'Arian'art , kept in the Nazi archiev in Munich , or

import from Russia the 'healthy' artworks, preferably produced under

Stalin, for the 'Social Realism'. Then it will match to the situation,

that a policeman, who could not distinguish Massenet from Bach, could

interrupt a serious concert by reputed musicians, and drag a lady

cellist, in such a disgraceful way that she was not even allowed to put

on blouse in snowing cold winter night, and she was not allowed to

pick up her grand mother's family ring, which was lost in the

hubhub of the arrest.

Typescript (4 pages), 11 × 8½ in. Smithsonian American Art Museum, Nam June Paik Archive (Box 14, Folder 1); Gift of the Nam June Paik Estate.

The Confession of "topless" (?) Cellist

No sooner Andy Warhol noticed me, than asked

> "How you managed to get arrested ?",,,, looking 'cooly ' into the
> other side,,,his favorite, may-be a-bit-self-mystifying pose.

Village Voice headlined afterwards " Getting Arrested Is Not As Easy
As It Seems",,,,in the case of Abortion Demonstration.

Legend says that I called Newsweek " Come & See How I will be arrested".

The rumour of 'conspiracy' or Alone is spreading in this era of
'Credibility-gap'. D A rushed to judgement, accusing me for
'publicity stunt'. Why is publicity necessarily bad ? F D R confided
to S.N. Behrman that if he one young, he would become a
Mad-Ave-Ad-Man. ,,,,,,, and

> Dali is a great artist despite of his publicity,
> Mathieu is not a very great artist , depite of his publicity.
> Webern is a great artist, despite of his non-publicity.
> And many many artists are mediocre, despite of his non publicity.

———

1966 Summer, West Berlin, Cafe Frolence, overlooking K-damm, where
the dream of fabulous 'twenties' are still wandering through the
 tawdry post-cold-war prosperity, I and Nam June were masterminding
the Music Marathon ,,, the European Premiere a Erik Satie's prophting
work 'Vexations'.

This is a sensational discovery, like Bach's now NO.I masterpiece
=Mathews Passion=, which slept hundred years in Lipzig's library
until Mendelssohn gave a rebirth in 1850.
 and Vexation slept also 50 years ,
 until John Cage fell upon a harmlessly looking
manuscript at Erik Satie's Parisian apartment (he nearly
shubbed aside until he noticed,,,,&)was electrified by the instruction
'repeat 840 times'!!.
 and would be still sleeping , if John has not noticed the electrifying instruction.
[score of *Vexations* by Erik Satie, pasted into the typescript]

Who can dare to let people hear the same tune over and over again
for full 18 hours ??? Chelsea Girl's 4 hours is like a innocent
short story compared to the nightmare 18 hours of Vexations. Although the esthe-
tics of 'boredom' goes back to Alfred Musset 'I will count
1.2.3.4.5.6.,,,,,, until my death', and Baudelaire, " The unresistible

<u>indifference</u> caught me and crashed me ,as.....) 'la soleil
ne frise qu'obliquement la terre, et les lentes alternatives
de la lumiere at de la nuit suppriment la verite at augmentent
<u>la monotonie, cette moitie du neant</u>"., and also Lois Aragon
wrote a monotonous poem in 1919,

 1,2,3,4,5,6,7,8,9, la mort.

and if as the contemporary sociologists are true, that the landmark
of youth is apathy and indifference , then boredom and monotony
must be the dominating aesthetics of today. For the World premiere
of Vexations at Pocket Theater, N.Y. Times, who generally dont come
under 14 streets , sent 9 reporters to cover this longest music,
round by round,, blow by blow.

 (n y times excerpt).

Now back to Cafe Florence, Kurfuerstendam, Berlin, 1966.

I was deadly worried about the performance by six pianist from
5 countries,,(Germany, Austria, England, U.S.A.
and Korea). I havenot touched piano after I graduated Juliard
with C- with the mercy of my poor teacher. I can match to other
runners , especially attractive blond from Berlin ?

Paik looked at me : " your brunette is nice, but so is Ilse's
blonde. Your lips is volutous, but some feels, Ilse's thinner lips
more sexy. Ilse's style is not so grand, but so is your figure
a la Rubens. Your piano technic contra professional concert
pianist 'Ilse',,,,, is saylike I am boxing against Mohammed Ali.
,,,,,,,, but turning to windo but ,,,, Your bosom is a granite like the
heavy weight champion's,,,,,,,,,, play topless !!!!".

I was petrified with schock, thrill, bashfulness, Arkansas' mother's
tele-reproach, but never thought of sharing N.Y.'s finest prison
with a fresh murderess. Anyway Vexation went well like a midnight be-in.
There were no bar between performers and listners. they chatted,
stayed, slept, caressed, yawned together. This marathon knew no
gold or silver medal. Paul Moore wrote in Spiegelthat
my bare-bosom matched to the style of Erik Satie, who opposed
Wagner's thick make up and over gesture, and asked simple and
naked sounds to French music,,,,, the sounds 'without Sauerkraft'.

This demand went so far that in 1924, one year before Satie's
death,he composed a ballet 'Relache', in which Marcel Duchamp
danced totally nude ,,(only a ivy-leaf decoration), before the
banner, written 'Erik Satie is the greatest musician of the world'.

according to
the libretto of Francois Picabia. Rene Clair's film for this
ballet 'Entre-act' is now one of the top-classic of avantgarde
film. I discovered this score in Paris Natiotal Library and gave
possible the first performance after the war. I was arrested in
New York (1967) only semi-nude, but Parisian police in 1923, didnot
bother Marcel Duchamp's total nude.

Passing through East Germany's grey buildings and quiet 'car-less'
streets., Paik pondered,, " if there is the progress in society and
progression in mathematics, then why not the progressive progression
in music ????". ,, thus the Opera sextronique was born.

 Lightless- topless- bottomless, sideless-backless-all-less-
 no-less (with fur coat).

Undated typescript, Smithsonian American Art Museum, Nam June Paik Archive (Box 14, Folder 1).

Aesthetics of Bibim-bab [a rice hash]—The Art of Post Industry Era (1995)

In the past, the art-the fine arts was considered as nothing but a derivative, a decoration from the tip of the economic life.

If, for instance, your dignified son made up his mind to major in art, you would throw him out of the house treating him as a dissipated person. However, the art-the fine arts nowadays play a leading part in economic success as the driving force of the economic society. Why this Copernicus-like change?

It is due to the transition from the 'Hardware Capitalism' to 'Software Capitalism'. Now, it has become a simple fact that only the person who beats the competitors in the field of computers wins in the worldwide competition and especially in the competition of softwares in order to survive the 21st century.

If this is so, where does Korea stand in the international standings right now and what are the visions of the future?

This year being the 'Year of Arts', I think this is the most important question that we have to ask ourselves. It's because the task that has to be accomplished in the era of 'Software Capitalism' is of great importance. What do we have to leave behind us in the 'Year of Arts'? In conclusion we have hope. Yet, there are corrections to be made as well.

If someone asks which is more important, 'seller' or 'buyer' in art, I would reply without hesitation that 'buyer' is by far more important. Also, Im confident that there are many exemplary 'buyers' in Korea.

'Buyer' of fine arts is an adventurer with a venturesome spirit who buys the least necessary product at the most expensive price. The people buying art that are recognized as classics such as Picasso, Chagal, or Lausenberg are different but, buying the pieces of contemporary artists aged between 30-50 requires much nerve. That is to say, there are quite a number of elites combining wealth, creativity and intelligence in Korea.

However, we can't blame the conglomerate's wife for putting up bare front because vanity and speculation can find their subject somewhere else besides modern arts.

Nevertheless, it is true that Korea in the 90's has much bigger and active art market than that of Japan in the 70's. Then, why are the buyers, namely the capitalist or their offsprings more important than the noble, hungry and endeavoring creator?

The reason is simple. Creating art is an experience which makes the continuous pleasure possible. Especially to an artist with a qualification of more than a middle or high school teacher, it is much more ideal. Also, since it is not easy for the buyers of contemporary art to invest in an art market that is low in the probability than that of the stock market.

In this sense, businessmen in Korea may as well have the pride that they are the creators of the 21st century and that they are different from the millionaires in Hong Kong buying antiques and jewellery and different from the Japanese millionaires who spend their wealth on French Impressionism.

I know very well the examples of France and Netherlands, the past supreme countries of arts, losing the dominance despite the government's support due to the decrease in the number of individual collectors whereas the United States of America, Germany and Italy holding supremacy due to the rise in the number of individual collectors.

In the case of Japan, the people live in a small apartments far away. So they don't have the time and place to purchase the pieces even when they have enough money. The state of things with arts in Japan in the 60's were equivalent to that of the situation in Korea in the 90's as far as the informational strength is concerned. The young in Japan understand more clearly the actual state of international arts than the young in United States or Germany. Then why did it not interlink with the development of the contemporary arts? I think that is due to the frequent occurrence of innate earthquakes, the failure of postnatal real estate policy and the over-obeyance toward the nation's authority. Also, the art market is dead. The Japanese collectors are willing to pay for the paintings of impressionists such as Manet, Monet, Van Gogh, Gauguin, and Renoir but not for the paintings of their contemporary artists.

Up to 1960, the world history were divided into four stages.

1. Primitive Communistic Age 2. Feudal Age 3. Capitalistic Age 4. Socialistic Age

However, in 1972 the world was in chaos from the oil-shock and when the socialist states were still in one peace, Daniel Bell, a sociologist from Harvard University under-evaluated the importance of oil. Instead, he believed that the driving forces of our society are information and intelligence and predicted the arrival of Post-Industrial Society. He segmented the World History into four stages.

1. Hunting-Gathering Age 2. Agricultural Age 3. Industrial Age 4. Post-Industrial Age.

The principal element of Industrial Age is the manufacturing industry and the substance of that age is oil, labor and hardware machineries. The principal element of Industrial Age is service and the ultimate substances are information, intelligence, computer software and investment.

When we look around our surroundings, we find ourselves in a world where all the goods(hardware) from washing machines to T.V's and cars, are consumed by people(even the Chinese citizens) that we can't buy them anymore even when we have the money. The Hardware Age has finished. The Software-Service Age has arrived.

Nevertheless, Where do we stand in the age of Software-Service?

A conglomerate chief predicts that although in Industrial Age our labor did not reach the standards of Japanese labor in intricacy and equality, but since individual mobility and creativity is required in Post-industrial Age we might be in a better position than the Japanese labor. Yet,

at present Japan is monopolizing the world market with Nintendos and Sega TV games while we can't even make a Soon-shin Lee TV game. Nothing can be accomplished without putting effort into it.

Then, where can we find the breach?

We have a big advantage called the 'aesthetics of Bibim-bab. We also have the humor which is rich and which has the audacity of tolerance. Our folk music and the syncopated triple beat rhythmic movement are connected directly with Kazakstan and are cut of from Japan and China. The rainbow-striped pattern of a Korean bride is a scientific analysis of the spectrum of a rainbow and it gazes at a open space via Mongolia and Tibet.

If we develop the latent possibility of our culture through the eyes of art, we can gain endless opportunities to cultivate the competitiveness in the Post-industrial Age.

For us, now is a good time in many ways. The problem is how are we going to ride the tides of new civilization and information in the globalized world. Since the recordings of history, the new civilization always came to Peninsula from south-west to north-west. We don't know what changes the globalized world in the 21st century is going to bring. What changes would the equidistant worlds of the 21st century present us with?

The civilization of the past 20 years brought us the development of fine arts as we know today and therefore it may be possible to make the Tong Gu culture of the post-ancient burial mound period of Corea (an ancient Korean state) if the 200 year peace continues.

Then, is the software culture of the 21st century all European and American? or is multipolarization possible? May be, maybe not. Nowadays, India's computer software industry centered in Bombay beats China, Japan and Germany both in quality and in quantity and stands firmly behind the United States and France.

It is because English is spoken in India and in recent times, talented mathematicians have come forth in great numbers.

France is historically strong in maths and naturally the United States is full of top stars from around the world. From these facts, we must learn something.

As I stated above, then why has the fine arts risen from the bottom to the center of the economic structures of our time?

The demands for home appliances (e.g. electric washing machine) or cars has reached the state where the demand exceeds the supplies and as a result new products are produced more on the ideals of aesthetics and prevalence. In the case with clothes, the primary purpose, to protect our bodies from cold weather has diminished and the functions of self-beautification has taken over. Also the function of automobiles has been shifted towards ostentation rather than mobility. Fine arts and information (namely fashion) have become the center of domestic consumption power or international competitiveness so to speak.

If this is the case, what about the new product, the core product of the post-industrial society and software capitalism, which is heading the United States and Europe's economy?

It is a plaything which contains experience—where art and information plays the leading role—, feelings, ecstasy and which makes us lose track of time. Multimedia, Virtual Reality, International telephone call, 500 channel Cable T.V., PC GAME, Internet...All of these are non-manufactured goods. We have been using telephone as means of communication. However, these days we phone to telephone. That is, the telephone has been raised in status from means to purpose. Just as the fine arts has been raised in status from means of religion to art for art and pure abstract art, the telecommunication has been changed to 'Something' of it's own purpose.

In this sense, multimedia(including movies, art and music) artists who are within the range of international trade have raised their status from a 'clown' to a 'Social Planner'

Korea is exceptional in aesthetic consciousness but is far behind Japan in international information power. The term 'Virtual Reality' has become familiar in Korean society but no less than 3 years after Japanese society. A 3 year term difference in Hi-Tech industry is fatal. This is the reason why the 'Year of the Arts' has to be the 'Year of Information' in a way.

This article is taken from 'Cho Sun Ilbo'(1st Jan '95)

Published in *Nam June Paik* (Seoul: Over the Century, Galerie BHAK, 2001), 2-3. Originally published in Korean (with some Chinese and English) in the *Chosun Ilbo*, January 1, 1995.

Annotations to a Life: Commentaries and Letters

Paik was an active letter and postcard writer. He mailed countless messages to his friends and to people with whom he wanted to keep in touch around the world. They are personal records of aesthetic and conceptual debates and illustrations of the immense pleasure he experienced as he pursued myriad projects. He loved to travel and enjoyed the company and conversation of people he met, along with good food. He was intensely social and readily absorbed information and perspectives from the people he met, from cab drivers to museum curators. In this chapter, readers will learn of his friends from when he first arrived in West Germany, including Mary Bauermeister and Wolf Vostell, and will discover the epistolary relationship he initiated with John J. O'Connor, the *New York Times* television critic with whom he corresponded after settling in New York City. The works reprinted here demonstrate how Paik used writing to exchange ideas with friends and colleagues, cajole collaborators, and charm those he admired. By turns aphoristic, nonlinear, and open-hearted, these letters and reflections are among the most intimate writings by the artist.

A: COMMENTARIES

My projects in 1966-67

 Instead of becoming just another "successful" artist in
commercial galleries and concert halls, I want to devote the
next year to academic and fundamental research, which could change
art and the status of art in society radically for coming decades,
for which support from the current art business is not to be expected.
1) After the full blossom of the electronic age the most part of to-
day's arts(music, painting,sculpture,literature, film, T V)will
become just the certain magnetic constellations on tape. But the
application of computers to visual art is almost nothing at present
except for very few weak examples, although computer music is
already widely discussed and realized among various groups throughout
the world, e.g. Prof. Hiller at the University of Illinois, Mr.
M.Marthews at Bell. Labs, N.J., M.Koenig at Phillips Studio in
Eindoven, Holland, James Tenney at Yale, the Princeton-Columbia
Studio for electronic music, Knut Wiggen in Radio Stokholm, and
Prof. Max Bense's computer poem in Technische Hochschule in Stuttgart
, Germany, etc. The ration of information-bits between visual art
and music is 4,000,000 : 20,000 or 200:1. This means that the computer
is 200 times more effective in visual art than in music and the pro-
gramming job is accordingly 200 times more complicated. The computer
programming is the combination of diligence and creative imagination--
-- due to its vast capacity. First class art work will be produced
verylikely, when a talented artist become a professional programmer

[page(s) missing]

8000 dollars brand new. It will be brought here to use possibly
in Cage's Variation No.5 (as originally planned in 1965) and later
for other uses. A huge cathode ray wall, consisting of 25 T V sets
will be built in the Bonino Gallery in the autumn of 1966.
 It serves for art, as well as architecture. It present trend
toward more sensible indeterminism continues, the architect will want
more variable room than now. E.g., the interior designer of an
opera house would want to have different decors of lobby each night
according to repertoire. It could be achieved through either cathode
ray projection , or construction of a cathode ray wall , or programmed
electro-luminescence wall. Also in private hours, the "mood-art" in
the meaning of "mood music" can be introduced by cathode ray.
My big screen experiments are aimed at these futuristic functions.
5) Various concerts, happening, films, and literary activities
will continue as before,and if still some time is left, which is
doubtful, I want to begin the laser and radar experiments.

Undated typescript, Smithsonian American Art Museum, Nam June Paik Archive (Box 13, Folder 20).

Mary Bauermeister or "I accept the universe" (B. Fuller)

Can a tadpole garble about a frog, or an egg criticize about a
full-fledged peacock ? Although Mary is younger than me by birth,
her artistic career in New York is longer, more established and
sophiscated than mine. Her works are already the treasured gems of
many major museums, private and public collections in America. This
jet-set artist is at east in the most secluded and exclusive art-salon
on this and the other side of the Atlantic Ocean. Therefore my role in
this page is nothing but the humble chronicle of a graduate of
the "Court of Mary" (once called the "Lorelei of the Avantgarde")
, which includes many of today's celebrities and semi-celebrities.

 I blushed to read an innocent critic describe me
as "one of precursors of a new breed of artists who are scientists,
philosophers and engineers." If I have any trace of such an extra-
vagant virtue, I owe it to Mary Bauermeister's brilliant experiment in
art and technology way back in 1959-61. The reason why people think
of her as a consummate painter rather than a rampant avantgardist is
because her experiment is too good, too successful. She manages
to erase the trace of long toil and trials from her finished
canvas, a rare virtue, which Josef von Sternberg ("Morocco," "Blue
Angel") once described as the prestige of true genius. Mary's brush
sings like a Mozart symphony, which sounds just like a nice melody
for casual observers, but reveals many profound innovations for
scrutinizing connoisseurs.

 Trapped in a gigantic traffic jam on the Los Angeles Freeway,
Allan Kaprow grinned, "I like L.A. very much, because it is
a very decentralized city..." His remark flashed me back to 1960,
when I received an unforgettable letter from John Cage, commenting
on a New York art-event, "It was very beautiful, but it had a common
European failure...it had ONLY ONE center..." Decentralization,
non-linear feedback system is an eminent category of today's electronic
existence, affecting profoundly the thinking of enlightened artists,
economist, urban strategists and think-tankers. Decentralized
communication-flow is what today's emerging sub-culture and video-
movement is all about. Picasso sensed it in his late cubistic epoch,
maybe even Rothko on his foggy plateau. But did they reach even
into the vicinity of Mary's lense boxes, which , if seen
as closely as at one-inch distance, turn you on like speeding on
the L.A. Freeway, passing multi-junctions every minute? The viewer
becomes just an on-off synapse of a communication sattelite itself,
receiving and reflecting multiple networks of millions of signals,
incoming-outgoing, wightless information pulses. ("Information with
content plays an equally important role as information without

content"...says Norbert Wiener.) Pure energy, pure information
without gravity (it <u>does</u> exist, but cannot be seen, like God in the
Old Testament) must resemble a bundle of pure rays,---white,
smell-less, static, statistic and anti-septic like Mary's lense boxes.

But of course, Mary is not a naive science-freak, à la Rand
Corporation, who equates G N P with happiness. Eight years
before artists went under deep sea, or dug a ditch on the desert,
she manifested keen rapport with Nature. Nobody ever heard of
"ecology" in 1960, when Mary was trying hard to make a "painting to
grow", a canvas made out of various living plants with different
speeds to grow, to yellow, to die. (Chinese Buddists describe the
death as "returned to live"). Her concept included a fish-tank
and a plant, which never grow but don't die for one century.
This valiant effort was to be crystalized later into exquisite
collage of Sicilian marbles and stones---a U.S. Custom office
tried to crack one of her stones to check dope... what nonsense...
you get stoned in a natural high just touching them....

Norbert Wiener wrote an oracle in the 40's, which signaled
the coming of the information-video-computer age and molded the
environment in which artist's allergy would be shaped. "In fact
it is possible to interpret the information carried by a message as
essentially the negative of its entropy and the negative logarithm
of its probability. That is; the more probably the message, the less
information it gives. Cliches, for example, are less illuminating
than the great poems." Mr. Wiener proceeds to tell an intriguing
paradox that white noise, or complete random patterns, contain
maximum quantity of information. Mary's oil-painting around 1959
curiously resembled this very "white noise", multi-colored snow
flakes. This is a typical information with low definition, which
automatically requires higher participation by the viewer. In
existential form it approaches to telephone and radar screen,
in which you have to <u>talk back</u> ,,, otherwise communication is not
only lost, but not even begun. For this purpose this precocious
girl, who had two Chinese style pigtails hanging around her bosom
down to the waist, employed the mystical force of magnetism.
A few white noise squares were loosely attached via magnet to the
metal canvas, which animates us to indulge in a rule-less game,
ego-less art, money-less investment, plot-less "Twilight zone",and this
all happened in 1960 or before. Sometimes she combined in this game
changable black-lite with light sensitive paint. In short Mary has
, as one of very few painters, succeeded in injecting a new
onthology of "indeterminacy" to the essentially heavy and immovable

art of painting. Is it a rape of "genre" ? Certainly not.

 John Cage introduced indeterminacy into music.
 Sartre introduced indeterminism into philosophy.
 Heisenberg introduced indeterminism into physics.
 See, where they are now...and imagine the niche carved for Mary
 in art history.

 Yes, Mary's entourage has been as colorful as George Sand's....
Yet her dignity dictates her to be detached...and apparently she didnot
try to collect her due in this great year of Kate&Gloria&Germaine&
Jill& Shirley& Bella, as she somehow succeeded in not attaching herself
to any of the changing fashions of the Manhattan art world, although
she can lay claim to quite a few of them.
 Through her pure artistic quality and conscience, she gained
an evergreen permanence in this ephemeral century.

Undated typescript, courtesy Mary Bauermeister. Originally published in *Nam June Paik: Niederschriften eines
Kulturnomaden*, ed. Edith Decker-Phillips (Cologne: DuMont, 1992), 165–168.

George Maciunas (1990)

We commonly refer to "the three Baltic countries", but these small countries differ very much
from one another. There is Andy Mannik of Estonian stock, twice taller and strong than I am,
of his casualness. (I am a very disorderly person.) I was pleasantly surprised to know that the
Estonian grammar is almost identical with that of Finland, thus the two languages belong to the
Ural-Altaic family, to which the Korean language also belongs. Of course, thse linguistic close-
ness does not necessarily mean ethnic relationship. Syntax was said to have been invented during
the latter half of the New Stone Age, so there is a difference of tens of thousands of years
from ethnic origins which are said to have been differentiated during the Old Stone Age or long
before that. Seen from the evolution of the universe during hundreds of thousands of years, it
is a matter of a short time frame that such inventions of civilization as vocal harmony, con-
jugation of verbs, and the use of honorific terms which are all characteristics of Ural-Altaic
grammar transmitted between the Tungusic and the Estonian people.
 Compared to the Estonian people of Andy Mannik, the Lithuanians of George Maciunas are quite
different. They use the Indo-European language. Unlike the German and English which use a "cor-
rupted" form of Indo-European grammar, the Lithuanian uses an orthodox Indo-European language
very close to the classical form of Sanskrit. It is quite remarkable, because both classical
Chinese and classical Greek have died out as colloquial forms. In Israel, Hebrew was resusci-
tated from a dead language artificially, whereas Lithuanians must be a stubborn people to use
the 4,000-year-old language of Indian high priests. The 40-year rule of communism doesn't matter
to the long history of Lithuanians, whose state stretched well into the Russian continent in the
Middle Ages. Included among the famous Lithuanians I've met are, beside George Maciunas and Jonas
Mekas, is Jean-Marie Drot, a great producer of French TV, who helped me a great deal in my video-
tape *Merce and Marcel* (1977). Altogether, there are about 5 million Lithuanians living in their

country and scattered in Europe and America, and they have a 30-volume national encyclopedia published in the Lithuanian language, a feat maybe only possible in a socialist economy, which does not take commercial accountability into their consideration. The encyclopedia contains a long article on Maciunas' father, and it hoped that Maciunas' son will also be so honored.

A primary school classmate of Maciunas is the head of Lithuania's liberal opposition party. Maciunas senior studied in Berlin after World War I, during the brief golden period when the three Baltic countries enjoyed independence, and became an architect specializing in the construction of electric power stations. His wife, a blonde Russian, was a ballet dancer at the Lithuanian National Opera, and in her old age she was active in the United States as a Russian language specialist. She was also a good friend of the granddaughter of Tolstoy and Stalin's daughter, Svetlana, during her brief stay in the United States, and more importantly she helped complete Kerensky's memoirs as his secretary. After George Maciunas died young at 47, she dictated a memoir of Maciunas fils in Russian. Maciunas senior worked during the independent Lithuania and under the German occupation to maintain the electric power station, and came to Berlin with the retreating German army and finally went to American in '47, where he immediately obtained a professorship at CCNY. He must have been a very able specialist to land such a fancy job so quickly. They say, he died an unnatural death (or killed himself) c. 1952 at the youthful age of about 50. How ironic: A prominent professor in this prosperous country kills himself after having survived the Nazi invasion, the Russian invasion, and the confusion after World War II, leaving a talented son (architect), daughter (interior decorator), and a beautiful round-faced wife.

Maciunas' son suddenly fell ill of severe asthma and was reputed to have been uncomfortable with his father's career during the Nazi time. It is said that asthma has something to do with a mother complex. He was a good friend of Claes Oldenburg and Stan Vanderbeck in Cooper Union. Maciunas was recruited in the early Sixties to design the book *Anthology* (the first title was *Beatitude*) published by La Monte Young and Jackson MacLow in 1963. The late Paul Williams (a wealthy anarchist-architect and the kingpin of the artist commune at Stony Point, New York) was a major funder of this publication.

Maciunas founded the Fluxus movement in 1961. I bet he was partially inspired by Jonas Mekas, who resolutely organized the Underground Filmmakers, and by Yoko Ono, whose Chambers Street loft had had a series of performance events organized by La Monte Young. His Marxist background originating from a small country, I bet, helped him to conceive the Fluxus as a truly international movement stretching from Asia to Eastern Europe. His only financial source was his salary of $400. In 1962 he told me that you can live in New York on a $5-a-week food budget.

He bought from the discount shelves in the supermarket all the canned foods without labels. At that time labels were printed on paper and wrapped around the items. When those papers got ripped off, those cans came up on the bargain counter, and people, poor people, used to buy them as a kind of blind date.

Maciunas first wrote in the middle of 1961 to three persons in Europe: Poet Hans G. Helms composer Sylvano Bussotti, and myself. Helms and Bussotti ignored this mysterious American, and I was the only person who responded to him. His letter was typed on expensive red rice paper with the IBM Executive. The rest is history.

Anyway, Beuys loved and respected Maciunas. In 1965, after the famous 24-hours Happening, Joseph Beuys said in a moving speech in honor of George Maciunas, "he should have been here..." However, this eccentric and volatile man abandoned the Fluxus in 1965 and plunged himself into the Soho urban renewal plan and thus paved the way for the success of the Soho Art Community.

Maciunas' achievement is not only the Fluxus, but also Soho, one of the most original and successful cases of urban redevelopment in the world, which made many people rich and which was widely imitated around the world. He purchased 27 buildings and remodeled and sold them to artists with very little profit. For this feat he was prosecuted by the Beame Administration of New York City, an arrest warrant was up for more than half a year, and he was finally severely beaten by a Mafia electrician.

The history of Maciunas' eccentricity has never ceased, as in his life as after his death. He was diagnosed in February 1977 as suffering from liver cancer. Money was needed to treat this incurable disease. I managed to collect U.S. $9,000, including $2,000 from Beuys. But refusing to receive the money for nothing, Maciunas produced and sent to Beuys his works worth U.S. $2,000. I brought the object, boxes wrapped in newspaper, to Beuys, and explained each of them. I said to Beuys, "You're very good at piano, as I listened to you at the 1963 concert. Was it a piece by Mahler?" "No", Beuys said smiling, "it was an Eric Satie." Beuys was at that time at the pinnacle of his fame as a visual artist and didn't care for praise, but he was flattered by my praise of his piano playing, as I would be when someone praised by poor French. It is said that Cézanne was greatly annoyed at the flattering of his painting, but he was very pleased whenever someone praised his gardening.

Anyway, it was during our reminiscences of the 1963 concert that we agreed to raise money for Maciunas. But due to the 1972 student affair, Beuys was officially banned from the Düsseldorf Kunst Akademie. Security officers would arrest him if he tried to enter. The director, Norbert Kricke, officially invited him back to the Akademie so that René Block was able to organize the concert. In no time the auditorium had a full audience. The concert lasted 74 minutes, the reverse number of Maciunas' age of 47. The two worst pianists under heaven pounded the piano keys without practice and previous arrangement. But the audience was as quiet as if they were listening to the piano duet by Toscanini and Horowitz. Among the audience were the high-ranking ministry of education who six years ago were eager to expel Beuys from the Akademie. After the concert was over, the audience applauded thunderously. When I looked over the audience, I noticed that almost everybody was looking at Beuys' side only. Half the audience leapt over to Beuys, requesting his autograph. Finally a few came up to me (out of pity?) and asked for autographs. I was dumbfounded by the popularity of Beuys. . . It was beyond a small envy or jealousy.

Quite a bit of memorabilia followed this event, including a large silkscreen print with Maciunas' gorilla mask (ridiculing Mayor Beame's Administration of the City of New York, who was unable to attest George Maciunas after six months of trying: design: René Block, a photo book by H. Theil and card by Watari, and 9 blackboards written by Beuys in Tokyo (Watari Gallery). Also, a record (33 rpm) which is a underground bestseller at the "Gelbe Musik" in West Berlin.

In the meantime two more years elapsed. Johannes Stussgen, the secretary of the International Free University, planned to issue a festschrift for the 60th birthday of Beuys. At this time Beuys and the Düsseldorf Kunst Akademie reached an out-of-court settlement on their dispute and Beuys was given the right to use the Akademie Atelier for his lifetime as well as the title of professor. But he was "forbidden" to teach the students. Beuys promptly made his old atelier into the world headquarters of the Free University and many students and homeless and drifters (including myself) dropped in.

I midwifed the exchange of artworks by Beuys and John Cage, and thus John Cage's work became a part of Beuys' festschrift and Beuys' work became the benefit print for the Anthology Film Archive (headed by Jonas Mekas).

Another event was when Jean Pierre Wilhelm came to Beuys' house to say his goodbye to the art world. This scene is preserved in the album of Dr. Leve. Jean Pierre Wilhelm and Alfred Schmela were the kingmakers of the German art world in the late Fifties. Their galleries were rivals and the in-places of the German Progressive movements. When I had my debut concert at the Gallery 22 with "Homage to John Cage", many young and established German artists visited the gallery because of its own reputation. Beuys was one of them. It was also Jean Pierre Wilhelm who organized "Kammer Spiele, Neo-dada in der Music", at which I had the second encounter with Beuys. It was also Wilhelm who introduced the Municipal Museum of Wiesbaden to George Maciunas for the group concert of Fluxus. Fluxus could not exist without Wilhelm. He provided me with three big turning points in my career and was at the time suffering from severe heart disease. He was of Jewish origin with a hereditary heart disease who participated in the French Resistance movement during the war, and even though he was not subjected to police torture, he had to live four years underground, which certainly would have aggravated his heart disease. In 1966, when he was in his 50s, he already knew the approach of his end, and one day he visited Beuys' house where Charlotte and I were staying, accompanied by Manfred Leve, the photographer. During our conversation he produced a piece of paper from his pocket and read his "Declaration of withdrawal from the art world", which was faithfully recorded by Dr. Leve in his pictures. After he left us, Beuys, Charlotte and I chuckled among ourselves, "Why the hell did this old man make such a show?" He died the following year.

The reticent Wilhelm never said anything about his Resistance days in Paris. And then ca. 1980 when Jean Moulin was buried in the supreme French National Cemetery, the Panthéon and French media highlighted his achievements, fragments of Wilhelm's activities became known. Jean Moulin was the commander-in-chief of the entire French Resistance, who was captured by the Gestapo, never confessed the facts, and died from indescribable torture. He was a great democratic patriot whom André Malraux once praised by saying that "in a historic moment, the entire destiny of France was laid on the lips of one man."

During the ceremony commemorating Jean Moulin about 35 years after the liberation of Paris, it was Daniel Cordier who was brought into the limelight. Cordier was the chief secretary to Moulin and his right hand man during the difficult times of the Resistance, and continued in the leadership of the Resistance after the martyrdom of Jean Moulin. Daniel Cordier was a dealer of avant-garde arts widely known among the artists during the Fifties and Sixties. In the Age of the Informal Movement, Daniel Cordier was the chief protagonist. Fautrier was also one of his stars in the Sixties and in New York Cordier represented Marcel Duchamp. Wilhelm was such an intimate friend of Cordier that very often his exhibitions were subtitled "in collaboration with Daniel Cordier, Paris". Having been a Resistance leader (like Yo Un-Hyong or Song Chin-U in the occupied Seoul of the Thirties), Daniel Cordier could have made it as the premier in the liberated France. Yet he threw away worldly ambition like an old shoe. He contented himself by becoming an art dealer... a beautiful story.

Originally published in *Ubi Fluxus ibi motus 1990-1962* (Milan: Mazzotta/Fondazione Mudima, 1990), 246-248.

Spirit-Media-Kut (1991)

Medium (Media) as a medieval theological concept denotes an instrumentality or means of communicating with God. The origin of Kut (shaman's exorcism rite) is ol (the spirit itself) in Mongolian which is almost a synonym with media. Therefore, it is natural that a French TV crew came as far as to Korea to shoot the shaman exorcism rite in Korea.

Joseph Beuys was one of very few who came back from death and spoke. We hate death so much that we look at it askance and step back.

Confucius said how we who do not know life could know death? But how could we know life without knowing death?

It has become a cliche since Sartre and et al that nothing defines being and being defines nothing.

Does Yemaek (an ancient Korean tribe) mean a group of old wolves? In the History of Yuan, the rulers called themselves as blue wolves. An American who is well-versed in Korean affairs teased me once by saying that the ties of friendship among the alumni are stronger than among brothers. Is it because of the passion of a small group of wolves? Why the ancient habit of eating dog meat still persist? Any one who looks straight at his own negative parts can overcome his negativity.

Beuys' two great performances were on the theme of wolves. He was fascinated by a stuffed wolf at the Anchorage International Airport. There are in Taos, New Mexico, a center of American Indians, many many kinds of souvenirs made out of coyote; T-shirts, necklaces, pottery. American Indians in Taos live with coyote as a friend, and Americans still kill them with passion. Still the number of coyote is on the increase. So tenacious is life. Koreans fled to Manchuria chased by Japanese today number more than 2,000,000 prospered so much that they built and run a Korean university in Yenchi.

The plaintive howling of wolves sound like the first movement of Tchaikowsky's No. 5 Symphony. What Beuys learned at a Tartar village might have been the shaman exorcism rite of Mongols and the plaintive howling of wolves.

Sentiment of Northern land

Sushimga

The five characteristics of media industry (Art) of today are 1) Sex, 2) violence, 3) greed, 4) vanity, and 5) deception.

There is no such thing as progress in the world of wolves.

Therefore, I think it was quite natural the four-man crew of Canal Plus Ex Nihilo, including Fargier, Gautereaux, Nahon, and Audio man (whose name I cannot recall at this moment) made such wonderful film of my shaman exorcism rite in commemoration of Beuys.

It so happened that I had lunch with a Canadian friend of mine. I asked him, "If I were born as an American Indian, to which tribe would you think I might have belonged?" Without any hesitation, he said, "An Eskimo." An excellent answer! Always as stubborn as an Eskimo, I who liked their habit of stealing a woman for a wife was very glad that a specialist proved anthropologically the nature of my Northernness.

When I was a student at Kyonggi High School in Seoul, I was notorious throughout the school for keeping dirty note books. My Korean language teacher rebuked me for my bad hand writing. He was the believer of Confucius and Mencius. This complex was the most important reason why I who have made a success in making happenings and video arts have shunned until the age of 45 to enter the world of visual art. The best chance has at long last arrived for me to make a revenge to Kyonggi High School!

Mary Bauermeister (who before Cahrlotte Moorman and more than Moorman helped me) has long been absorved in mysticism and psychics. She invited a famous psychic from Scottland. She was reputed to have communicated with gods and for her mysterious predictions. This middle aged woman was in Korean style a shaman.

I displayed on the table a dozen different handwritings by different persons and asked Mary which was the medium capable of communicating with gods. This middle aged Scottish lady picked up one without any hesitation. It was mine, the worst among 2,000 students of my alma mater! I think it was 1977 when I heard this. I was then 45 years old.

"Things are as they are, why shouldn't I make clumsy drawings with my dog's paw-like and crab's paw-like hand, and if I sell them for a couple of hundred dollars, heaven would not mete out punishment to me!"

There occurred a vacancy for a visiting professorship at Hamburg Academy of Arts in 1978. I thought to my self, "If I were to apply for an admission to this school, I surely have failed, but they are offering me a professorship." Miss No Un-nim was an excellent student at this school.

During the physical examination, it was discovered that I was suffering from adult diabetes. Light and darkness are the enternal companions of life!

Shaman's exorcism rite is an art of accommodating the darkness and Hollywood media are the art of accommodating the light.

Originally published in English and Korean in *Nam June Paik. A Pas de Loup. De Seoul a Budapest* (Seoul: Galerie Hyundai, 1991), 46-48. Translated by Paik Syeunggil.

2x Mini Giants (1991)

The East European revolution produced a playwright-president, Vaclav Havel in Czechoslovakia, but few people know that it also produced a Fluxus-president: Vytautas Landsbergis, the president of Lithuania. During the Spring of 1990, the image of this bespectacled and stoop-shouldered "music professor" paraded across the TV news every day. He successfully defied the blockade of Soviet power and the "benevolent" advice of the Western press to go slow lest he destroy the superpower summit. When Gorbachev received the Nobel Prize, Landsbergis sent him a congratulatory telegram: "Your Majesty"

This audacious style of David-and-Goliath situation strongly reminded me of Landsbergis' best friend, George Maciunas, founder of the "small" Fluxus Movement and the "enormous" SoHo glitz.

Landsbergis and Maciunas were both the sons of well-to-do architects, and were best friends at a grade school in Kaunas, Lithuania, in the last peaceful days of prewar Europe. The Soviet-German occupation / war / retreat with the German army / hunger / the displaced person's camp / his father's enigmatic death (suicide?) / the vanity of New York / capitalism's "contradictions"— all these horrendous things made George Maciunas a heavy asthmatic, a fanatical do-goodist, an ego-centric, and a part-time paranoiac. In 1965, as a native Marxist, Maciunas contacted the old friend he had left in Lithuania, who was alas a burning anti-Marxist. In response, in a letter of December 5, 1963, Landsbergis sent Macuinas some subversive performance ideas:

A SEWER'S HYMN

"The performer walks on stage, pulls out from a bag a dozen licey rats and throws tham at the public! / this would be work for people, animals and the public. / Do not take this as a joke, these are chance ideas whih could, in thousands, come to a head, in Fluxus spirit."

Landsbergis, although still confined in Soviet Lithuania, participated three times in the Fluxus mail-art event organized by Mieko Shiomi from Osaka, Japan. Two examples from 1966 are:

SPATIAL POEM NO. 3

"Falling Event. Various things were let fall: Vytautas Landsbergis caught a pike at the lake of Aisetas, cleaned its entrails and threw them into a pit towards the center of the earth. Then he cut the pike into pieces and let them fall onto a frying pan."
 —Lithuania, July 31, 1966

SPATIAL POEM NO. 5

"Open Event. People opened ... Vytautas Landsbergis. A day after my return from the country to my flat in Vilnius, I opened the lid of my piano and hit the keyboard of F sharp. When the sound died down completely, I went to my study to continue on some unfinished work."
 —Vilnius, 1 pm, July 23, 1972

In 1964 Maciunas picketed Karlheinz Stockhausen's music-play *Originale*, played by myself and other Fluxus members on 57th Street. He accused us (or me in particular?) of being "social climbers" and Stockhausen of being a "racist" and a "cultural imperialist" because the latter did not have a high regard for jazz: the Black people's invention. (Maciunas even let the French Fluxus member Ben Vautier picket John Cage and Merce Cunningham in Nice for a similar reason in 1965.)

However, we (Allan Kaprow, Dick Higgins, Jackson MacLow, Charlotte Moorman, Ay-O, and myself) continued the *Originale* performance inside the Judson Hall at 57th Street.

Feeling betrayed by his comrades, Maciunas, the chairman of Fluxus, declared Fluxus dead and plunged into the SoHo housing project. He won a landmark decision to convert a light-manufacturing loft building into an artist studio residence. He endowed the venerable Fluxus name on the first artist co-op in SoHo, at 80 Wooster Street. The similar conversion of twenty-seven buildings followed at no profit to him, igniting the SoHo real estate boom. In 1978, Maciunas finished his life at forty-seven in poverty, betrayed by his tenants, co-op members, and real estate interests.

That same year, Joseph Beuys and I performed a farewell sonata for him at the Düsseldorf Kunstakademie. Soon a quiet renaissance of fluxus began, and behind the Iron Curtain, the slow renaissance of Lithuania was growing, led by the stubborn ex-Fluxus man Vytautas Landsbergis.

Recently the correspondence of these two giants from a minimation was printed in the Lithuanian music magazine *The Young Music*. When he was dying, in 1978, Maciunas entrusted his part of the correspondence to Jonas Mekas, and President Landsbergis kept his half for the past quarter century in the long winters of resistance.

Offprint, Smithsonian American Art Museum, Nam June Paik Archive (Box 9, Folder 11). Originally published in *Artforum* 29, no. 6 (March 1991): 90–91. © Artforum.

Two Rails Make One Single Track (1996)
In 1959 Autumn, I strolled into the old gallery of Alfred Schmela in the Altstadt of Düsseldorf. The size of this gallery is such that it falls somewhere between the navel of a gorilla and a whale... Mr. Schmela, who looked like somebody out of George Grosz' caricature, talked to me. It was still an idyllic time of Düssel-village, when Mr. Schmela put a Sam Francis canvas in a station wagon and sold it to a new Wirtschaftswunder-master like a carpet. Therefore, maybe on

that day I may have been the only visitor to his famous gallery. We got into conversation and I said to him: "I will have a concert in "Zwei und Zwanzig." "Zwei und Zwanzig" is sharing a small crumb of Düsselmarket with Schmela and this Franco-Jewish gallerist is quite international (Fautrier and Cage) and a strong competition to distinctly Niderrheinisch... volkstümlich... and always comical Schmela. Alfred immediately introduced me to his wife [Monika]: "This young Korean will have a one man concert at "Zwei und Zwanzig" and asked me immediately: "What do you think about this our young man?" It was a yellow canvas of a guy called Piene. I said: "Very fresh;" then he took out another canvas from closet, it was an aluminum canvas of Mack. When I went back to Schmela in 1961, he had a roomful of ARMAN. He said: "Nothing sold, too expensive... 700 DM." The cheapeset ones were 30 DM and 50 DM. I reserved the 50 DM one and went back later with cash. He said he shipped it back already.

But in this tiny space, Beuys will soon have the historic exhibit, in which no audience was allowed in this space and he alone explained his art works to a dead hare. Visitors were watching him from a show window at the pavement.

1960 Spring, it was the opening night of the atelier Mary Bauermeister, Cologne, which would change life many times. The main event was a light ballet of Zero Group, it was dazzling. Since space was relatively small and it had the triangle attic roof, this space was ideally suited for the sophisticated light show, which would grow up to degrade into the Electric Circus. I was so "begeistert" that I wanted to meet that artist... it was Otto Piene. Finally I met the guy who painted the yellow canvas at Schmela. Later, I did have another chance to be well acquainted with him at the Schloss Morsbroich (1961?), in which he did show a floating b/w light flakes, which were floating a weightless aesthetics!! before the moon landing or famous pillow of Warhol. Luckily (?) nobody understood. I was a lone audience... maybe everybody went to an Adorno lecture or so... Adorno was the star event in the Bayer-sponsored symposium.

Finally, I did have the substantial conversation with Piene because there was nobody. Artist can be often lonely when it is his best. This weightless rotation somehow did hit me as a pre-cursor of space-age aesthetics... non gravitation existence, which will grip the world

A fluke acquaintance of this day was Hans Haacke. He came as a young student and took my snap shot, which made the cover of a Danish art magazine. Later, he gave to me a TV set, which became a part of my second "CROSS".

1965, The stage turns to New York.

Mary Bauermeister, who introduced me to Piene, got me a gallery, Bonin, north side of 57th Street, I had a show... then the next season, Piene moved into the South side of the same street. Howard Wise Gallery. Soon Piene moved to the MIT in Cambridge. I moved to WGBH TV station Boston. We did the video classic "Medium is Medium" together. Also, we were the resident star of Black Gate Theater in the Lower East side, which was run with iron fist by Elsa Tambellini, born in Leningrad.

Schmela vs. Gallery 22 (Düsseldorf)

Bonin vs. Howard Wise (New York)

MIT vs. WGBH TV (Boston)

Certainly, we were always the parallel rails of one single track. What a Karma-coincidence...

In 1979, Uecker left a Zero catalogue... I was thunder struck... there was a picture of Beuys and me at a Zero event at Schmela... our first meeting... and somebody took the picture and somebody kept it for 20 years...

Art and technology is... in the word of late Stan VanDerBeek... a marriage at gun point. I just read the obituary of Jean Tinguely - another victim-genius of this hard struggle. We have still many miles of journey to go... I am sure Otto will slug on.

Last but not least important, I mention the fond memory of his master pieces... "Flower of Evil?" at the entrance of MIT main hall. Steam collective work at documenta 77... and mile high vinyl column which went up at Soldier's Field... and God waited until then... gave beautiful raindrops... just enough to wet the bridge's first night. Otto dared to work with the very fragile, gigantic, anti-capitalistic art modes. He could have heaped millions of deutsche mark staying in Germany from the glory of ZERO success... yet he did forsake this easy money and plunged himself into the morass of industry-academy-technology-art-nightmare and he got the best out it... and increasingly retro-capitalistic world with dwindling public resource... we must bite the teeth, bite the nails... and give our heritage to the next generation.

(1991 September, hearing the death of Jean Tinguely, who has been always very kind to me, whenever we met... since 1960, Copenhagen.)

Originally published in English and German in *Otto Piene Retrospektive 1952-1996*, ed. Stephan von Wiese and Susanne Rennert, exhibiton catalogue (Düsseldorf: Kunstmuseum Düsseldorf im Ehrenhof, 1996), 46.

B: LETTERS

Letter to Wolfgang Steinecke (1959)

<div align="center">
(Braunsfeld)

Cologne, 5/2/59

(Aachener Str. 687)
</div>

Dear Doctor Steinecke!

Thank you for your brochure for Darmstadt 1959. I have the pleasure of letting you know that my anti-music "Hommâge à J. Cage" is going very well (in spite of the poor mechanical conditions). And that it will be finished until Darmstadt 1959.

First movement is:

"Marcel Duchamp + Dostoevsky = K. Schwitters

<div align="center">
Varieté ≠ Variation
</div>

It is the proof of the fact that the sublime is substantially not separated from the ugly and comedic. Therefore each listener of the performance has to behave as if he had just heard the *St. Matthew Passion* to the end. Of course a not so smart journalist like Mr. Stuckenschmidt cannot bear this demanding intellectual approach. The material is radio collage and speech. The speech is reduced to a primitive level in which phonetic and intonation appear quite differentiated/ distinct but semantic isn't formed yet.

The rhythms are conceived as one unit of breathing, action and dynamic. This is contrary to the procedure of young European composers where rhythm and dynamic are treated separately. I stopped composing this movement 50 days ago since I haven't got the possibility of synchronizing it yet. I will continue writing as soon as my third tape recorder arrives (that means ca. 5.10.59).

Second movement is:

"As boring as possible: like Proust, Palestrina, Zen, Gregorian choral, Missa, Parisian café, life, sex and a dog that looks into the distance."

I have started from an everyday order, that means musicians' world of music, through/by ongoing surprise and disappointment (in the first movement) and through/by the extreme boredom (in the second movement).

The second movement is criticizing the "Wirtschaftswunder" of the Germans where diligence and stupidity are one. Here comes the prepared piano which I will have taken to Darmstadt at my own expense and a second piano. It doesn't damage the second piano as only the strings of 10 keys are loosened. The preparation of the piano is completely different from J. Cage. Except for pianos, some toys will be used (car, tuning whistle, tank, and so on).

Third movement is more like a musical philosophy than a philosophical music. From the speakers are sounding quotations from Arnaud/Artaud and Rimbaud. I am paraphrasing with this action. Through a functional action that has got rid of its function the "acte gratuite" becomes visible on the podium. This symbolizes a way out of the suffocation of the music theater of today.

Here my piano (for 50 DM) is tipped over, glass destroyed, eggs thrown, paper torn, chicken let go and motor scooter comes.

But this doesn't contain humor. Of the Dada artists only those have survived who haven't treated humor as an objective but as a result. E.g. M. Duchamp, M. Ernst, Arp, Schwitters. (Now a small collage by Schwitters costs 50 thousand marks). I want to add music to Dadaism although Dada today still is a taboo for educational philistines/highbrow society.

Today Henze and Buffet wear the crown like once Haendel, Rubens, Liszt, Hindemith, Stravinsky and Picasso did. I am convinced that I have finally found a completely new style. It has nothing to do with the previous new music with arias.

I want to withdraw from my last work "Sirlahyangga" (1958) and instead I send you this new composition. You can well believe in the quality of this piece since I myself have canceled the performance/staging of my composition and have written repeatedly that I don't want to show a "study"—the average level of a "studio concert"—as my "debut".

The performance is easy since Mr. Walther (best piano player at the music academy in Freiburg) and Mrs. Kagel have taken the part without honorarium/payment. Besides that I expect that the technician at your library would participate briefly with his motor bike. I had the honor of being taken for a ride in his company in March 1958. The total duration is ca. 10 minutes.

For the performance I prefer a possibly late date (to have enough rehearsals) and the small auditorium (as prepared piano doesn't sound loud). And this piece must be played at the beginning of the concert because the listener must not see the direction and the preparations on the stage. I hope or believe (if you allow), that you would give this serious (and not restorative) antithesis to the "twelve-tone-mannerism" a chance. (I still love Schoenberg and Stockhausen very much though).

I will realize the spatial design of my composition in the studio in Cologne. I ask you kindly to let me know whether there is the possibility for 2-4 sound channels this year too. As well I would like to write a short introduction for the program. Until when do I have to send it?

I am looking forward to your positive answer.

 Respectfully yours

 Nam June Paik

P.S. Excuse my bad grammar.

Manuscript in Archiv des Internationalen Musikinstituts Darmstadt (IMD). Originally published in *Nam June Paik. Werke 1946-1976*, ed. Wulf Herzogenrath (Cologne: Kölnischer Kunstverein, 1976), 39-41; republished in *Nam June Paik*: *Niederschriften eines Kulturnomaden*, ed. Edith Decker-Phillips (Cologne: DuMont, 1992), 51-53, and in *Paik: Du cheval à Christo et autres écrits*, ed. Edith Decker and Irmeline Lebeer (Brussels: Editions Lebeer Hossmann, 1993), 238-239. Translated from the German by Edith Decker-Phillips.

Dear Mr. Cage!

Excuse me ~~that~~ I have
not written to you very ~~so~~ long. I am very
idle. I have contacts with Mr. ~~so~~ Young
etc, so that I know very much what is
America going on. I wonder of it very much.

~~[struck out line]~~

I hope to hear again something new, ~~and~~
surprising in the concert of Tudor in
Darmstadt. (of you, Young, Ichiyanagi etc)

I have ~~written~~ a Report of you
in ONGAKU GEI JUTSU in ~~the~~ the last Spring.
(TOKYO)
(not without critic) (I send a copy of it)
Perhaps you could read also my critic to you
in my ~~(preface)~~ "preface to the sinfonie for
20 rooms), if it is printed. ~~I~~ I am curious about
you ~~not~~ reply on it.
Naturally. I think over and over, how much
I owe to you. For example, your comment,
~~so~~ " the european failing is to have ,,one" center..
~~node~~ opend a new way for me
I play in Stockholm (oslo copenhagen) 4 new

compositions of 1961. (5études platoniques, = no materials)

② read music ③ Breath ④ Simple

But it is the last pieces of ~~xxx~~ ~~xxxxxx~~ ~~already~~ my "PAST".

The First Part of "Apology of John Cage" is 2/3 completed!
for the second Part ~~~~~ further 2 years
I think you ~~have~~ are already informed of the visit of

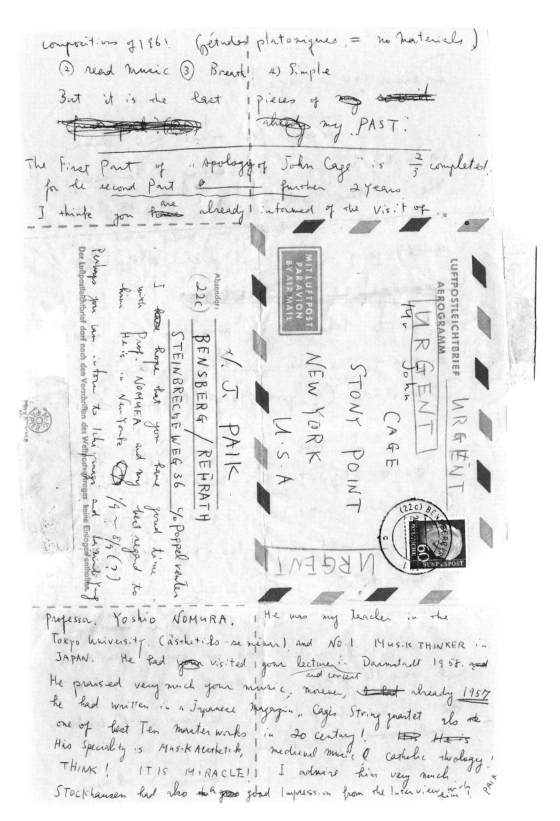

Absender:
(22c)
V. J. PAIK
STEINBRECHEWEG 36 c/o Poppel rechts
BENSBERG / REFRATH

I ~~have~~ hope that you have good time
with Prof. NOMURA and my best regard to
him. He is in New York ② 1/4 ~ 8/5 (?)

Perhaps you can inform to Ichiyanagi and family of

Der Luftpostleichtbrief darf nach den Vorschriften des Weltpostvertrages keine Einlagen enthalten.

MITLUFTPOST PARAVION BY AIR MAIL

LUFTPOSTLEICHTBRIEF AEROGRAMM

URGENT URGENT

Mr. John CAGE STONY POINT NEW YORK U.S.A

URGENT

professor. Yoshio NOMURA. He was my teacher in the
Tokyo University. (ästhetik-seminar) and NO.1. MUSIK THINKER in
JAPAN. He had ~~you~~ visited your lecture and concert in Darmstadt 1958. ~~and~~
He praised very much your music; moreover, ~~I had~~ already 1957
he had written in a Japanese Magazin "Cage's String quartet ~~als~~ is
one of best Ten masterworks in 20 century! ~~He is~~ He is
His Specialty is MusikAesthetik, medieval music & catholic theology!
THINK! IT IS MIRACLE! I admire him very much
STOCKHAUSEN had ~~also~~ good Impression from the Interview with him!

PAIK

Box 10, Folder 4, Correspondence, Paik, Nam June, 1961-1966, John Cage Series II,
Northwestern University.

Letter to Wolf Vostell (1965)

Dear Vostell.

Well

Big is soft. Vostell like Erhardt.

Your friendly and open letter has enjoyed me a lot.

Yes, there is a strong nationalism in America. But as in 19th century in whole Europe. Nationalism is only the façade of real circumstances.,,,,,,,,, Class struggle,,,,,,,,

The fundamental condition in N.Y. is not nationalism but class struggle between uptown and downtown. And big business of uptown MUST promote nationalism in order to earn more profit. Like in 19th century, our real friend is international downtown people,,, Dick, Alison, MacLow,,, etc., and our enemy is international uptown,,, like Darmstadt, or modern art museum in Paris and in New York. So like all international press. Piccard has surely not written about us because we didn't do anything in uptown galleries. Especially therefore we have to unite and fight, but not weaken our existing front line.

Charlotte is a brave woman who is fighting for us artistically as well as administrative. Appearing together with her should strengthen our bond, but not evoke shortsighted nationalism. Like in the working class movement in the 19th century, international cooperation is the strongest means we have, because it is free of business interests and big manipulation of the press.

Our final goal is not surrender but should be occupation of uptown. Destruction is impossible because of economic conditions.

Slowly we have obtained more power. But we shouldn't become the new ruler, become the same as the old ruler. A change of power should bring real change.

I am very, very grateful for publishing me in my absence. But I in my position haven't missed any opportunity in Japan, in radio and press, to mention you. Recently I have dedicated the longest part of my '65-report to you.

Sohm Archive, Staatsgalerie Stuttgart. Translated from the German by Edith Decker-Phillips.

Letter to Howard Klein (1967)

 Nam June Paik
 PO Box 420
 Canal St. Station
 N.Y. 10013

Dear Howard :

 Allan told me that your talk with Mr. Sidney Gelber
proceeded wonderfully. I am very happy and promise you a model case
of "cost-efficiency" in merging art and technology. Actually I beleive
that merging of art and technology should end in the merging of
artist and technician into one person. If you look back, how Chopin's
piano technique helped his piano composition, (although piano had
only 88 keys),,,,, now million keys of electronics and computer
in our disposal,,,, the necessity for the combination of artist and
technician (far beyond collaboration or consultation of the two) into one,
cannot be over-estimated. There is no easy short-cut way to substitute

the long and hard toil to master the strange subjects,,, only what
we can do is to make it more "efficient",,,, and that is, I believe,
the task of Educational Resource Center. Already in Brown University
etc, students can take the computer course in stead of a foreign
language. In music and art school, too,certain selection of electronics
and computer programming , which is especially useful to the arts,
should be carefully picked up and taught to students along with
harmony and counterpoint. Neither pure scientist, nor pure artist
can do this job.

 I shared the studio with Stockhausen, while he was
composing the Kontakte (he selected me as the first person to play
and 'test' his piece), and I am convinced that his artistic imagination
and his profound technological knowledge is inseparable inside his
inspiration, (like in the case of Chopin's etude). As you know,
he studied with Meyer-Eppler, lecturer at University of Bonn, who
introduced Cybernetics into Germany and helped Dr. Eimert and
Dr. Enkel start the Cologne studio. His Zeit-series is, I suspect,
the musical adaptation of 'time-series' of Fourier-analysis. The
subtitle of Die Reihe, "information for the seriel music" came
,of course, from Cybernetics.

 Beleive it, or not, my first aim was to teach Gregorian chant
in the University of Seoul. I studied with Peter Maurus Pfaff (famous
for his Deutsche Grammaphon Records)... Therefore Stony Brook is
like a home-coming for me. You will beleive it, if you read my school
records (enclosed),, no one stays 9 years in four universities,
unless he feels at home in the sweet-sour atmosphere of academy.
Also I have in my drawer ,,,, invention a la Bach,,string quartet
a la Bartok,,, piano piece a la Debussy,,,chamber ensemble a la Boulez,
which was supposed to be played in Darmstadt with Gazzeloni (flute)
and Maderna (conducting) (I withdrew),,,,,,,ha,,,ha,,,,ha,,,, Anyway increasingly
I am feeling that I am misfit to "show biz"(?) and lime-light,,,,,
,,,,,,,,,

 see-you-soon

 with best regards
 [signature]

p.s. My friend in Japan anwered me that second-hand TV projector
 will be ready with only 60 $ more payment. (New: several thousend
 dollars)...but alas, color T V camrera is also in Japan 25.000 $,
 therefore I am thinking to make my with 1200 $,,you will think,
 I am fake but NOT.

Typescript, Box 423, Folder 3648, Record Group 1.2, Series 200R, Paik, Nam June 1967–68,
Rockefeller Archive Center, SUNY Stony Brook.

Letter to Norman Lloyd (1967)

<div style="text-align: right">

Nam June Paik

359 Canal St

N Y C N Y 13

Sept 3, 1967
</div>

Mr. Norman Lloyd

Rockefeller Foundation

Arts Program

Director

111 W 50

N Y C N Y

Dear Mr. Lloyd:

 I deeply appreciate your grant to me. This was virtually the sweet rain on the parched land. Your recognition of my experimental work means a lot to me,,,,,,,,,, not only materially,,,,,.

 I think you read Jack Gould's article in this Sunday Times' TV section,"Soon You'll Collect TV reels, Like LP's", which confirmed in many ways my predictions for the last 6 years. Also I am happy to hear from Dr. Goldmark, the director of C B S lab, and the inventor of LP record and video disc,(in the same article) that " possibly a new art form ultimately emerge to fit playback usage of video disc". In this situation time is more than ripe for the establishment of the world's first electronic TV studio,,,,,,,, if America will not be again 20 years behind to Europe , as it happened in the case of electronic music, despite of her leading position in electronic industry itself. It is waste of fund to build thousand of electronic music studios in campuses, which is mostly the copy of Cologne studio of 1952, while the electronic industry and computer progresses beyond the imagination of imaginative artists. Electronic music changed music but it fell short of changing the life itself. I predict that fully developed electronic video art will change the daily life of high-brows,,,, it will kill "LIFE" magazine, as LIFE killed "Colliers" a decade ago.. The merging of RCA and Random House is the first sign for it.

<div style="text-align: right">

Yours Sincerely

[signature]
</div>

Typescript, Box 423, Folder 3648, Record Group 1.2, Series 200R, Paik, Nam June 1967-68, Rockefeller Archive Center, SUNY Stony Brook.

Letter to Ralph Burgard (1967)

Mr. Ralph Burgard
Associated Councils of Arts
Executive Director
1564 Broadway
N Y C N Y

Mr. Burgard :

Thank you very much for you encouraging letter and
10 dollars. I stacked with it 10 days food from A & P at sheridan Sq.

 2 corned beef can
 6 pounds rice
 5 juice cans
 1 T V guide
 3X3 tuna fish can bargain sale (3 $)
 some of them (tuna) might be left oven
 for your next visit here
 and some others
and with the rest I bought 2 cans of Korean Kimchee at 'South
east Asian food Corp at China town. I will sign on one can,
and bring back in my next visit to your office. Hope , that work
becomes classic in 1984.

 I had a concert and a T V display at Queens College.
Kids liked it. Stan Brakhage told me that my T V work changed
his life (?!), and every college should own one. Actually it is
good for science and art students.

 Please, forgive me some more 'propaganda'.

Henry Geldzahler wrote to me that he thought my work the most
interesting one among entire show at Howard Wise Gallery. Whole
show went to Walker Art Center and will further travel to Milwaukee

Art center until summer. Also Pratt Institute will show
two of my color T V works in their Multiple Art show in May.
Sorry, the ticket of Jewish Musuem concert is already sold out.
But if you will come , I will somehow get,,, or try to get the tickets.
I am observing cynically, my 'Miracle of Economy', that
the more demand I get for my work, the less money I receive.
It is something like American economy, that more it get prosperous,
the more $-outflow , it suffers.

Michael Noll of Bell Labs told me that Mr.
Max Mathews would send their letter directly to you. I think,
you have received by now. I enclosed my application with this
letter. Among the visual artist, only Stan Vanderbeck was allowed
to work at Bell Labs before. All artists in Armory show worked
outside the Bell Labs and with technicians in their free time.
To use Bell Labs equipment and personals in its 'official site and
campus' is a very rare opportunity, which I dont want pass, and I
want to produce my computer picture before christmas, when Swedish
Studio's computer will be set to work. I hope your successful
campaign for my behalf. I emphasized 'electronic Opera' also,
so that the 'foundation for composer only' can also consider my case.
It would be nice, if Educational Television sets up a 'Electronic
T V studio', as French and German Radio set up the studio for
electronic music. Anyway I am very eager to visit you sometime
in near future , may-be I will make an appointment with your
secretary on telephone.

 Yours Sincerely

NB 1. I just got the letter
 of Mr. Mathews, confirming
 his willingness to accept me
 there. I hope, it is sufficient
 for your purpose, otherwise
 I have to beg him again.

Typed text on paper with additions in ballpoint pen and stamped ink, 4 pages, 11 × 8½ in. Smithsonian American Art Museum, Nam June Paik Archive (NJP.2.EPH.65A-D); Gift to the Nam June Paik Archive from Timothy Anglin Burgard in memory of Ralph Burgard.

Letter to Ralph Burgard (1967)

Nam June Paik
359 Canal St.
N Y C N Y 13
226-7187

Dear Mr. Burgard :

There are some good news & some bad news.
I have had several sessions at Bell Labs for my electronic
opera. Although there are tremendous difficulties, owing
partially to my inexperience and partially because of their
GE 600 (it is 10 million $ class computer, which very recently
arrived to Bell Labs. Therefore even the professional
programmer has many problems handling this new enfant terrible.)
I am confident than ever about the artistic merit of this
endeavour.

Yesterday I had a long talk with Mr. Bonino.
He confirmed me about my next one-man show at his gallery (7 West
57th st)and said that he can look forward even commercial
success. But to my dis-heartenment, he categorically rejected
any financial support beforehand, owing to the general business
slump in whole art world. This time I will make some commercial
consideration, it not compromise, to increase the sales-chance.
Eg, ten well-known painters will decorate the outside of my
electronic TV sets,,,,,, etc.

As you see, my main interest is in the field of
computer-opera, which is more challenging and socially more
meaningful. I will send to Mr. Norman LLoyd the enclosed color-
reproduction of my work(hopefull he reminds of my case), but
on the other hand, I don't want to lose my second one-man show
and morever,,,, my financial situation is so desparate
that I have to pursue every lane, which might lead to some
money. Actually there are some signs that my art-objects will
have commercial value in near future according to so-said
in-people in artworld. also I discovered new way to paint,
which is not using any T V tubes but as productive as my
old style. Therefore I wonder, whether Miss Thorn's father
finance my living expences during my work at Bell Labs
to compose electronic O P E R A , but take some present of
me in the form of art work, which become his permanent collection.
In that way, maybe there might be other collectors, to buy in
advance my works before the show. I will have a peculiar
work called *Amitie 7* by 10th of June, in which I make the T V
preparation and Christo of Castelli Gallery wraps whole outside
of T V , making this whole at the same time to his wowrk.

Therefore this is a work by two artists. It would be a life-
saving for me, if Mr. Thorn or other collecter buy this work
before summer, or at least lend me money to me on the security of
this work. Christo's work is very well selling in the market.
This is an unusual proposition and will make may-be more
nuisance to you,,,,, but my situation now is that much destarate
,,,,,,,,

 I am sorry.....

 with best regards
 [signature]

P.s., Russel Baker spent whole his column in defence of
Charlotte Moorman, ridiculing sharply Jude's opinion.(May 14th)
in the editorial page of Sunday Times. Also Clive Barns
wrote in London Times in our defence. These articles in the
most respectable papers by the most respectable critics will
offset any repercussion from the conservative circle. Also
various monthly magazines are preparing *objective* opinion.
American Civil Liberty's Union will write a brief for the
court of appeal, although they will not take over whole defebce.

Typescript, Smithsonian American Art Museum, Nam June Paik Archive (NJP.2.EPH.63AC 001-003).

Postcard to John Cage (1968)

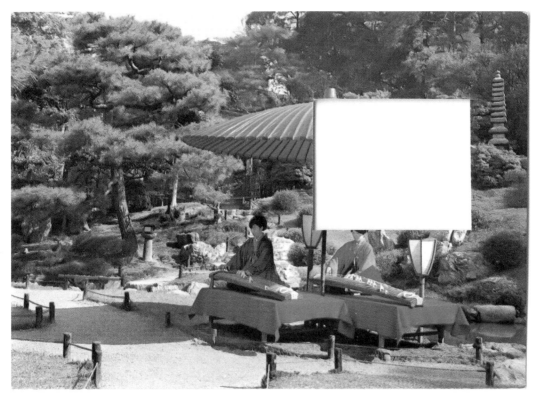

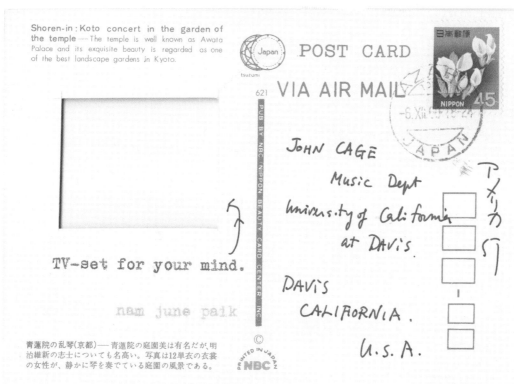

Postcard, Box 10, Folder 5, John Cage Series II, Northwestern University.

Dear John,
I made video synthesizer.
which is

better
thart
I thought.

acceleration of kalender (excerpt)

nam yune paik

dear dietlich, is your kalender still 69?

alison knowles brougt her twins (hanna
and jessie) to stony point.
i asked john cage
 "have you ever thought of generation-
gap existing between hanna and jessie?"

he answered,
 "ask my mother".

hanna was born 15 seconds after jessie ..
and 15 seconds means in electronic time
15.000.000.000 nano seconds.

favorite composer of john cage's mother
was john cage.
she was los angeles times' music reporter
and interviewed arnold schoenberg.

the best thing, charlotte moorman has
done for me, was that she introduced me
bob dunham. he is real tao-ist, therefore
not only timeless, but also nameless.

there are four buddhas in new york.

 john cage makes music

 jonas mekas makes movie

 peter moore makes photos

 bob dunham makes nothing.

your
"live electric
music"s
spiritual influence
is big
in this work.

If you are
in this region
before August 31,

please -----

I hope to make the ⊙
Television premiere of you 4'33" for Piano

exactly 4 o'clock 33 Minutes in early morning
I'll play by myself.

from "Kalender 69.
published by
H. Dietlich

Undated letter, Box 10, Folder 6, John Cage Series II, Northwestern University.

john :

these four letters mean not

'fuck'

but an old anecdote, which
you would remember from
your '50's...

that
in order to explain
what is buddha,
Yima simply silenced.

after having exhausted
all vocabuararies expressing
"thanks", maybe 7 years ago
, what I had to do
was to keep a silence of
one week.

Since you must be fairly
tired of "overzealous" guy,
I will send shigeko with
half inch video tape of WGBH
and sashimi .. in october
choosing a good day.

It rained here xf
 2 hours after your
presence at Harvard
and didnot stop for
two days...

維

摩

一

默

all films came out o.k !
 i'm very happy
I abolished SIGNATURE.

Undated letter, Box 10, Folder 6, John Cage Series II, Northwestern University.

Letter to David C. Stewart (1968)

June 5, 1968

Dear Mr. Stewart:

Please, have my sincere gratitude for your encouragement
for my endeavor. It has been a long and lonely battle
since 1961, desperate days at non-heated "secret
studio" at a village near Cologne and I feel very
relieved to have confirmed that my vision was not
illusion and to see more and more people coming to
this direction. The other day Vincento Minelli
invited me to a dinner to discuss a possible application
of my technique to his film, and Bell Labs is
beginning a computer-controlled scanning experiment,
which smells like a development of my method........
whoever might get fruit and credit, it is a pleasure to
see one's own invention spread, and it makes me
free to leave this terrain in order to seek a new
confrontation.

During last show, I have pondered seriously, whether
I should devote my time to innovation (that is, the
social application), or to a new invention, but I
decided that an extremely poor businessman like me should
avoid the harsh contact with big society and stay
in a laboratory for a basic research. Until now
I have treated the cathode ray tube as a paper, but
from now on, I will treat the cathode ray as pen and
paper. Nietzsche said 100 years ago, "God is dead"...
and I would say now "P[white-out] is dead". Paper has been
as omni-present as God in human civilization for
many thousand years...and shift of chief information
storage from paper to magnetism will bring in a
fundamental shake-up of our art and life. Preparation
for this change, and better utilization of new
resources will require all sorts of talents, ranging
from unorthodox intuition of artist to "square"
researcher at IBM lab. Joyce would have surely
written "Finnegan's Wake" on videotape, because of
latter's vast advantage in manipulation...unscrutable
Chinese letters and arts will become much more
communicative to Westerners...truly usable standardized
electronic Esperanto is within reach of our technology
...video telephone babysitter service will free more

families for theater...there should be a silent TV
station, in which all semantics is written, and not
spoken....highbrows watch it on and off, not interrupting
their thing, while listening to Vivaldi... it will
be MOOD ART in the sense of MOOD MUSIC...an ever-
changing ROTHKO free to every hysteric woman through air
...etc., etc., etc..... Of course, there will be a
lot of set-backs and frustrations before this progress
...e.g., as an information storage device, magnetism
is uncomparably superior, but as an information
retrieval device, paper, with its random access is
still far more convenient... but there will be a
dialectic middle way.... and computer will play a
central role in this complex venture... I don't
trust a romantic artist, talking about computer
miracle, who doesn't sweat out programming himself,
any more than I trust a fashionable "Art and Engineering"
artist who doesn't bother to decipher complicated
circuitry by himself. My first computer movie will
be ready before 20th of July at Bell Labs, but I
don't think microfilm plotter, which is currently
used in usual computer movie, will be a viable artistic
medium, and I consider my work with this device just
as a rehearsal for a more original and powerful
application of computer in the future.

It would be a great pleasure to showyou some of my
new experiments which I will put together by 20th
of June, and your visit at crumbling Canal Street
studio will be most welcome anytime between 20th of
June and 20th of July...but please, give me three
days advance notice to my New York address (box 420
Canal Street Station, N.Y. 10013) or phone 212-226-7187
(I am hardly reachable on phone).

 Sincerely yours,

 Nam June Paik

Typescript, Folder 16, General Correspondence, P-Paik, Charlotte Moorman Archive,
Northwestern University.

Nam June Paik
Box 420, Canal St Station
226-7187
June 1, 1969

Dear Mr. Burgard :

As you would recall, I have been always cautious
in the predictions of my new projects...at Bonino show, PBL program,
and current Howard Wise show, the artistic result and public
responces have surpassed our expectations. Without giving up this
academic prudence, I would still safely prophesy that my new project
will not only increase the potentials of my past work in the exponential
rate, but will affect the pallet of commercial TV in the significant
measure. I am enclosing the block diagram confidentially. It will enable
us to shape the TV screen-canvas

as precisely as	Leonardo,	
as freely as	Picasso,	
as colorfully as	Renoire,	
as profoundly as	Mondrian,	
as violently as	Pollock,	and
as lyrically as	Jaspar Johns.	

In the long ranged future, such a versatile color synthesizer will
become a standard equipment like today's Hammond organ, or Moog Synthe-
sizer in the musical field, but even in the immediate future it will fin
wide applification.

1) TV-tranquilizer, which is at the same time an avantgarde artwork
 in its own right. As Time magazine quoted me with emphasis, the
 tranquilizing "groovy" TV will be an important function of future TV,
 like today's mood music at WPAT or WOR-FM.

2) Enormous enrichment of background scenery of music program or talkshow,
 combined with sharp reduction in the production-cost...especially
 effective for young generation's Rock programs. Traditional
 psychedelic light show cannot compete with electronic color synthesizer
 as much as Ferrari racing car cannot catch even a good old DC-4.

3) This will provide valuable experiments for EVR, which would be aimed

for more sophistcated or educational layer of consumer. Eg., what kind of visual material will accompany the vast reperpoire of classic and pop music ? People will be quickly tired of von Karajan's turtle neck or Beatle's long hair. The study of this problem cannot be started too soon, and it might end up by producing a new furtile genre, called "electronic opera".

Initial investment of 5000 dollars and 4-6 months of time-span will enable the construction of simpler model and production of aesthetical visual sensation of 15 minutes.

Yours Sincerely

Nam J. Paik

Typed text with felt-tipped pen, vintage photocopies of diagrams (5 pages), 8 × 11 in. Smithsonian American Art Museum, Nam June Paik Archive (NJP.2.EPH.48.A-E); Gift to the Nam June Paik Archive from Timothy Anglin Burgard in memory of Ralph Burgard.

Letter to Norman Lloyd and Howard Klein (1971)

Messrs. Norman Lloyd and Howard Klein :

It was a great pleasure to be able to show my video synthesizer to Howard Klein the other day. Howard's penetrating view on the future course of videology impressed all of us. The video synthesizer gained many enthusiastic supporters among V.I.Ps in and out of station.

\# the music director of the Sesame Director saw it and asked my collaboration on the spot. (although it is too early to count on his offer, possibly due to their internal politics...)

\# Boston Symphony's Television producer said it was a "mind blowing experience" and he is very interested to use my synthesizer again in next season in the live telecasting on UHF of their subscription concert.

\# Some officials at University of Massachusetts and Harpur College (S U N Y in Binghampton) expressed interest in purchasing my machine.

\#Intermedia System Inc.,(Some members of Harvard faculty on business and education are working there privately) wants to "market" my machine

\# First time in my life Professor Kepes of M I T liked my work.

\# Mike Rice said that WGBH will hire me again in 1971.

\# Last, but more important...

Mr. Calderwood (new station manager, formerly Vice President of Polarroid in charge of advertisement) was also completely turned on by my machine and urged us to register the patent immediately.

Video-synthesizer is now waiting for the most important guest..
... Norman Lloyd.

On the other hand "Global Groove" is getting groovier.

\# Former director of Municipal Museum of Berne, Switzerland, who has a good relationship with Swiss State Television, said there is a good chance that Swiss TV station supplies their video materials inexpensively on exchange basis.(Since Switzerland is the symbol of World Peace, (the Leitmotive of this show), other European stations might follow this example).

\# An Argentian composer at Columbia Electronic Music Studio, a Turkish Professor at Fairy Dickinson University, a Jugoslavian art critic will work for his country.

\# As for all Asian nations, which include such distinguished musical cultures as India and Bali, we can count on Mr. Porter McCray's unmatched expertise on this area.

\# The Producers of "Black Journal" (NET) have often travelled to the heart of Africa.

We expect various red tapes and unforseen obstacles in the

actual process. But If once the exchange basis and channels are
set up, this program can run for long time with minimum of cost,
since we are 'utilizing'... or 'recycling' (in the ecological jargon)
... the deadstocks of video materials, which is sleeping all over
the world. WGBH alone has presently three thousand different
programms (ca 1500 hours ofvideo or 16 mm in music and non-music)
, which increase day by day, in its archive. Rather tedious
job of copyright settlements could be arranged by a secretary.
I think, this economical factor is a thing to be noted, although
"World Peace" is only one thing, for which we should save neither
money nor toil. I can safely predict that per minute production
cost will be substantially lower than NET Play House. "Global
Groove" is in fact a "Musical Ecology"..."the progressive sum-
totaling of global music resources"...if I may borrow Bucky Fuller's
expression.

As the vast resources of ocean has been untouched for long
time, the superior ability of our musical language to communicate
each other, has been wasted equally long.

The need for the Global Television is unquestioned.
American Public Broadcasting System is...by its own nature...
<u>destined</u> to be the first one.

<div align="center">
Yours Sincerely

[signature]
</div>

CC: Mike Price

Fred Barzyk

Typescript, Box 353, Folder 2192, Record Group 1.5, Series 200R, WGBH-Educational Foundation,
Rockefeller Archive Center, SUNY Stony Brook.

Letter to Mike Rice (1971)

<div align="center">
Nam June Paik

3359 Rowena Ave. L.A. 900 27

May 7, 1971.
</div>

Dear Mike :

I read carefully your Feb/16 memo and realized that there are two
conditions to meet in the WGBH project for New Television financed by the
Rockefeller Foundation.

As for the first one "to <u>devise new</u> approaches using television
as an <u>art</u>istic medium"... with all modesty... I think, I can claim some
credentials. Recently I got letters even from Helsinki and Sao Paolo
asking for the participation in their video art events. In Cal Arts I expanded
and deepened the capacity of video synthesizer, which is a TV machine, solely
designed for artistic use by an artist.

a) to expand... usage of three encoders for richer variation.

b) to deepen... research for the possible use of several medical-electronics

devices as an input signals of video synthesizer.

I am trying to figure out how to change the brainwaves of

a great man into a great picture..

These can be realized without investing any more money for the
hardware part of video synthesizer, as you have indicated in your
letter, because I can borrow the hardwares from Cal Arts.

As for the second condition (the "subject matter") it would be
natural for me to choose some well recognized personalities in American art
and music. Especially the first encounter of electronic music and electronic
art (video synthesizer) would be meaningful. On this matter I did have a long
talk with Messrs. Lloyd and Klein on the March 2. I sought their opinions
rather on their private capacity as an eminent composer and a music critic of
the New York Times, and not as foundation officials. In the middle of conversation
one of these two gentlemen tossed a fresh idea..."why dont you do about
John Cage ? " I was ashamed for that I didnot bring up this idea first.
John Cage's contribution to American history is beyond dispute by now.

I witnessed by myself, how John Cage decisively influenced the
 central figures of European composers almost overnight at Darmstadt
(the Center of New Music at that time) in 1958.
I witnessed also , how suddenly Paris lost the initiative to New York
as the world art center. This big surprise was managed mainly by
Pop Art and Happening. Again John Cage is the man behind these two
movement both ideologically and in personal relationships.
John Cage achieved somthing, which U.S.I.S. failed to do so for decades
with billion dollars budget. He succeeded in making the dialogue
with very influential and imaginative layer of European and Japanese
intellectuals and mitigated their often "indiscriminate" anti-American feeling.
"Cross Talk" concert by Cage's friends attracted 20.000 young people
in one evening in Tokyo's sport palace. His influence to Dance
(through Cunningham) and to literature (through William Burrough's
cut up technique) and to TV (through Paik.. if I may add) is also considerable.
Julien Beck of the Living Theater has been also a long friend of John Cage,
... so was also the community of the Black Mountain College.
John Cage would be a triple crown in base ball.

To trace the genealogy of pop art, one must recreate the atmosphere in which it came into
being. That atmosphere was generated mainly by the composer John Cage, whose essays and lec-
tures have been instrumental in forming the sensibility of some of the most important young
composers, choreographers, painters, and sculptors at work today. Cage's aesthetic, derived
in equal parts from Dada and Zen, in many respects served to open a situation that had closed
down, much in the manner that Surrealism helped open the door to Abstract Expressionism.—
Barbara Rose, *American Art Since 1900* (1968)

There are also other ideas about American theme... eg : a kind of cultural
All Star Game. Marcel Duchamp (art), Cage (music), Cunningham (dance),

Fuller (architecture) is needless to say the towering figure in their
field... and they are related in their ideas and even held close friendship.
I am not sure about Fuller- Duchamp, but Duchamp-Cage-Cunningham and
Fuller-Cage friendship is long and intimate. Using the split screen
technique, super-imposition and multi-input capacity of Video Synthesizer
we can make a visually faschination personality-collage of these four
genies. Semantically we can explore not only each one's idea but also
their inter- disciplinary relationships, which would be of more interest
in order to reflect our hybrid-mixmedia world more accurately. In this way
the tecnical quality of Video Synthesizer (a new concept in mixing) will be
used directly related with the semantic content (inter-disciplinary relation
ships)... therefore the use of Synthesizer will be high dimensional...not just
a gimmick but a semantic necessity.... Last year's video commune demonstrated
Synthesizer's power concerning music,.. New program will demonstrate its
power about more concrete literary expression.

 Anyway this seems to me to be a fool-proof idea, or like hitting
a home-run, which brings four "baggars". Since I have private and priviledged
access to all four genies, I can produce a meaningful 30 minutes program
under the limit of 10.000-15.000 dollars . We should also not ignore the
educational value of this program for future generation via cassette.

Anyway these two ideas are by far not the definitive proposals. I feel tremendoous communication-
gap between Boston and L.A. The best way is to meet again
and start everything from a blank paper. Surely we can find a mutually
acceptable solution on American theme and the use of media. For your reference
I have also enclosed thee original paper on Edgar Varese, which served as the
starting point of my conversation with Messrs. Lloyd and Klein on March 2.
I will be intermittently in New York between May 22 and June 8. May 24, May 25,
June 4, June 7.8.9. and weekends (if you come to work) are preferable dates.

 with bests
 Yours
 [signature]
CC : Lloyd. Klein.Barzyk.

Typescript, Box 10, Folder 5, Correspondence, Paik, Nam June, 1966-1975, John Cage Series II, Northwestern
University. Paik has written at the top of the page, "This is a copy of a proposal to Mike Rice (WGBH).
Understandably, it is written in very conservative and fuckingly political manner. Please forgive."

Letter to Porter McCray (1971)

 Nam June Paik
 3359 Rowena Ave. L.A. 90027
 R
 Feb 17 71
Dear Mr. McCray :

 Cal Arts is finishing the second term. Although we have not
achieved everything, which we intended, still we enjoyed very much working

here. Actually Cal Arts may well be the best art school in the world
at this moment. Experimental Video Projects by Shuya Abe (distinguished
Japanese engineer-artist) and me is quite popular. Students liked our
Video Synthesizer very much. Sony Video Taperecorder (as you remember, you
bought the first import of this kind to me six years ago) is so much in demand
among students and faculty that there is one week waiting line for the machines.
Video is not one more chic fad in Manhattan but it is here to stay... like
pen and paper or canvas... I am beginning to think that our videosynthesizer
will influence not only art and TV world but maybe even beyond.

 As you see, a deep cause of the current ression is that our
industry failed to introduce any radically new consumer good since Color TV
in 1955. So far the laser research and space venture didnot yet prove profitable.
Such small gadets like electric knife and power window in a car were unable
to spur the huge consumer spending. Many in the Wall Street are betting on the
Video Cassette to do this job, but who will spend 50 $ to watch John Wayne
over and over ? Cassette should have the artistic density of at least
Janis Joplin,.. if not Arnold Schoenberg...and I am sure that Video Synthe-
sizer will be of great help for the successful development of video cassette
especially in the music cassette. (there are already ca 200 videocassette
companies in Japan, and many of them are music video cassette specialists)
But I believe that the video-synthesizer would play even bigger role in the
post-pot, post-video cassette age...

 The reason why camera industry (only 50 years old)
has become 1000 times bigger than art market (5000 years old) is that
camera made everybody an artist. Mr. Johns will rather make a bad picture
himself than going to museum to see a Leonardo. The same thing also applies
to the drug problem. Pot is a short-cut reaction of alienated people to regain
the sense of 'participation', which was lost in the organized society and
network TV shows. Therefore the rational solution doesnot lie in the no-
knock law but in the recovery of heightened participation... and here the role
of our video-synthesizer cannot be over-estimated., since it pierces the core
of today's social problem (drug) and economical problem (sluggish consumer
spending). Home-model video synthesizer in the post industrial society (1980-
1990) can become as big as today's camera industry and network TV might
shrink to today's museum size.

 I am spending the first half of March in the
East Coast..and hope to see you in New York.

 Yours

 [signature]

Typescript, Smithsonian American Art Museum, Nam June Paik Archive (Box 2, Folder 18).

Letter to the TV Lab (1973)

The Television Laboratory at wnet|13

304 West 58th Street New York City 10019 581-6000|212

 (copy to David Loxton)

 305 AZABU CO-OP HOUSE

 5-20. 5-CHOME. MINAMI-AZABU

 MINATO-KU, TOKYO

 Nam June Paik

 Tokyo. June 11. 73

To : P. Bradley, H. Klein, D. Loxton.
 (in alphabetical order...)
Everything is expensive in Tokyo, expect for books. I bought 4 books
on mini-computer and read all of them, having confined myself
at home for a week. This study convinced me even more that the
application of mini- computer into video-beauty is quite feasible...
and almost overdue.

 There are a few hidden virtues.
a) It will fire a chain reaction, as my past video-synthesizer did.
 Used mini-computer will become as cheap as 2000 dollars in
 a few years or less.
b) Not only an artist, but also students can benefit from this
 system, since this will become an effective teaching tool for
 computer per se. We have to conquer the "computer" in order not to
 be conquered by the computer.
c) This will be the first case in the application of a full-fledged
 digital computer into video-synthesizer or beauty in video at
 large, therefore a radical renovation of a general system
 and not a betterment of something existing.

 Yours
 [signature]

cc : Russel Connor, Lydia Silman

 p.s. all expences on this Tokyo trip is paid by myself.

Typescript, Box 353, Folder 2194, Record Group 1.5, Series 200R (A78), WGBH-Educational Foundation,
1973-1975, Rockefeller Archive Center, SUNY Stony Brook.

W 200R
GBH Eclec Findtn
1973

from nam june paik, TV lab. wnet April 1.
to : Loxton, Iselin, Klein, Lloyd, Bradley, Connor

Quartly Report 1933 January–March

1) R & D

a) The combination of realtime two-way TV and big screen TV opens
many new possibilities for video as high art. Some of them will be
perfectly applicable even on VHF. Using the videotape made at TV lab
and equipments of TV lab, I conducted six different experiments
involving audience at Kitchen and Cinematheque. . . . TV lab need
not be restricted to the location of 46th street.

the village VOICE, March 29,

movie
JOURNAL
by Jonas Mekas

Later the same Saturday, at 80
Wooster Street, I watched Nam
June Paik performing Fluxonata,
with a prepared piano, video cam-
eras, movie projector, and three
monitors. Paik, who looks more
and more like Harpo Marx, per-
formed with the inexhaustible and
unpredictable inventiveness of
Harpo Marx, for our aesthetic and
humorous enjoyment. His humor
is always very lyrical, again like
that of Harpo Marx. The climax
of the sonata was performed with

the video camera hitting (or
sometimes touching very gently)
the keys of the piano, and pulling
the camera along the keys, side-
ways, and turning it around, to
catch glimpses of the artist him-
self, or the audience, on the ceil-
ing—all the while the camera
recording and transmitting it all
to the three monitors for all of us
to watch and to see what the cam-
era sees—together with the

sounds it makes. A very full, all-
embracing, total experience.

b) Video and computer--- two monsters of today is so complicated
that there are 1001 ways of matchmaking like in the Kama Sutra.
Bob Diamond and I have found at least a few new ways to combine them.
and we are eager to realize it as soon as possible.

2) PRODUCTION

We will have 2 days of video-art production with union-crew soon,
John Godfrey as an independent artist (50-50 collaboration with me).
I hope to acquire more materials later (eg : French TV, Karheinz
Stockhausen, 16 mm film, free of charge) and turn this production
iNto the first Global Groove, for which I have been working since 1969.
We hope to interrupt this music and dance program with pseudo-commerc-
cial breaks by Einstein, Gandhi, Bucky Fuller, McLuhan, B. Russels etc... if budget
allows. Global TV is a legitimate concern of any TV experiment.

Suite 212 (midnight sign off program through video-art touching
some aspect of N.Y.C.) is also going satisfactorily.

3) PROSPECTUS

TV lab has already proven its usefulness for art and video in N.Y.
Russel Connor's CABLEART (on Channel A) will make TV lab even more
useful for artist and viewers. This project is welcome, as far as the
insulation of Cable from Union can be continued, which is as vital
as the insulation of Public TV from the government. It will be also

(2)

the first case of long term collaboration of cable and public TV.
In the long run, WNET might become the front page and editorial page
of the N.Y. Times, and the cable TV the supporting stories inside
the paper. Instead of jumping from Page one to page 35, etc, viewers
will be encouraged to watch the continuation of story on the cable
... or on channel 13 at midnight. In this way some very controversial
stories or profound but slow-paced artworks can be aired without
losing audience and also keeping the tradition of responsible
journalism. The controversy about the "FBI Informer by Paul Jacob"
(American Dream Machine , 1971) could have been mitigated through
this cross-breeding of media. Also some advertising budget of
Channel 13 can be spent on AM, FM radios.(maybe already doing so).

Quite a few well-known artist approached me to work at TV Lab.
This is another sign of the success of TV Lab. In order to pursue
full-time experiment without burdening TV lab and fellow artists, who
are eager to work there, I am putting up a mini-TV lab at home with
special portable video recorder to tape the performing art in very
dark lighting condition...all from my pocketmoney. Video-tape of
avantgarde activities in N.Y. will have artistic and historical value

My own color-editing facility at home saved already quite much money
of WNET and WGBH.

At Champaign-Urbana, I saw plasma screen, currently used for
the computer terminal. It is as flat as a sheet of plastic and
ABSOLUTELY free of flicker... exactly like a sheet of paper.
It will not only save trees, but also save filing cabinet and
trash-can.

The malaise of the New Left leaders and philosophers is that
they dont pay too much attention on the impact of technological
innovation except for the defensive case. According to the Boston
Globe 90 % of new jobs available in 1983 will not require a
college degree.

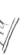

A light valve that holds promise for projection TV has been constructed and oper-
ated by Hughes research scientists. It uses a liquid crystal activated by a
photoconductor to enable a comparatively weak light image to modulate a high in-
tensity light beam for projection onto a large screen. Its advantages over cur-
rent techniques -- longer lifetime, higher brightness, simpler operation, lower
cost -- give the new device a direct potential in theater television systems and
bring projection TV for the home a step closer. (NEWSWEEK. MARCH. 5. '73

Ad — HUGHES ⊶──┤.

Box 353, Folder 2194, Record Group 1.5, Series 200R (A78), WGBH-Educational Foundation, 1973-1975,
Rockefeller Archive Center, SUNY Stony Brook.

Letter to John J. O'Connor (c. 1976)

Dear John O'Connor :

As always... I love your TV-reportages more than TV
itself....

As you know, John Cage's NAME is well known, but
his work is not, because his performances happpenes generally in off-beat
places with little publicity... and his upcoming concerts at Lincoln center (4 evenings
Nov 4-7) have been already sold out. Therefore my "Tribute to John Cage"
at Channel 13 (one night before his Lincoln Center thing) became even more
important. We can un-cage the Cage from the Soho-few.

My role at TV world has been to break the TABUs.
In this show I broke another TABU... that is 'stuttering'. We invited
professor Alvin Lucier from Wesleyan University ,Middletwon, Conn,
who is a heavy stutterer and let him talk au naturelle... it is beyond
funny or sad...or beauty or ugliness... I feel that I am looking into
certain edge of the profound-ness of our existence.

Many friends say that this tape is my best Video work
so far and at the same time one of the best work of John Cage. It is
the culmination of my intellectual flirtation with Cagism for the past 20
years. It is ONLY because of John, that I chose to come to the U.S.
I spurned many chances to come here before I met Cage. This tape will tell
why....

Please, take 30 minutes out and watch the tape at
WNET... Stella will arrange the date.

262-8258 [signature]

262-4248 (TV LAB Carol or Stephanie)

Typescript, Smithsonian American Art Museum, Nam June Paik Archive (NJP.4.EPH.28G);
Gift to the Nam June Paik Archive from Seymour Barofsky for the estate of John J. O'Connor.

Letter to John J. O'Connor (1978)

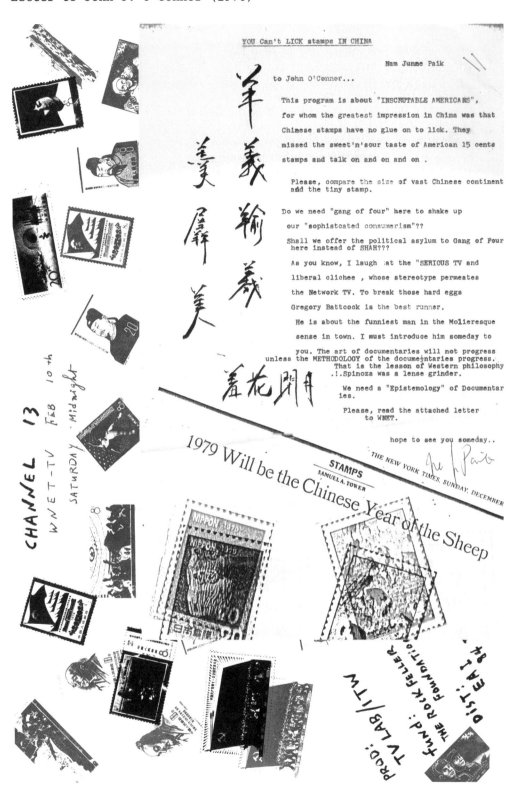

YOU Can't LICK stamps IN CHINA

Nam Junne Paik
to John O'Connor...

This program is about "INSCRUTABLE AMERICANS",
for whom the greatest impression in China was that
Chinese stamps have no glue on to lick. They
missed the sweet'n'sour taste of American 15 cents
stamps and talk on and on and on .

Please, compare the size of vast Chinese continent
and the tiny stamp.

Do we need "gang of four" here to shake up
our "sophistcated consumerism"??

Shall we offer the political asylum to Gang of Four
here instead of SHAH???

As you know, I laugh at the "SERIOUS TV and
liberal clichee , whose stereotype permeates
the Network TV. To break those hard eggs
Gregory Battcock is the best runner.

He is about the funniest man in the Molieresque
sense in town. I must introduce him someday to
you. The art of documentaries will not progress
unless the METHODOLOGY of the documentaries progress.
That is the lesson of Western philosophy
.!.Spinoza was a lense grinder.

We need a "Epistemology" of Documentar
ies.

Please, read the attached letter
to WNET.

hope to see you someday..

THE NEW YORK TIMES, SUNDAY, DECEMBER

CHANNEL 13
WNET-TV FEB 10th
SATURDAY - Midnight

1979 Will be the Chinese Year of the Sheep

STAMPS
SAMUEL A. TOWER

PROD: TV LAB/ITW
fund: THE ROCKEFELLER FOUNDATION
DISTAT. 84

Typed text on printed paper with additions in ink, 14 × 8½ in. Smithsonian American Art
Museum, Nam June Paik Archive (NJP.4.EPH.1); Gift to the Nam June Paik Archive from
Seymour Barofsky for the estate of John J. O'Connor.

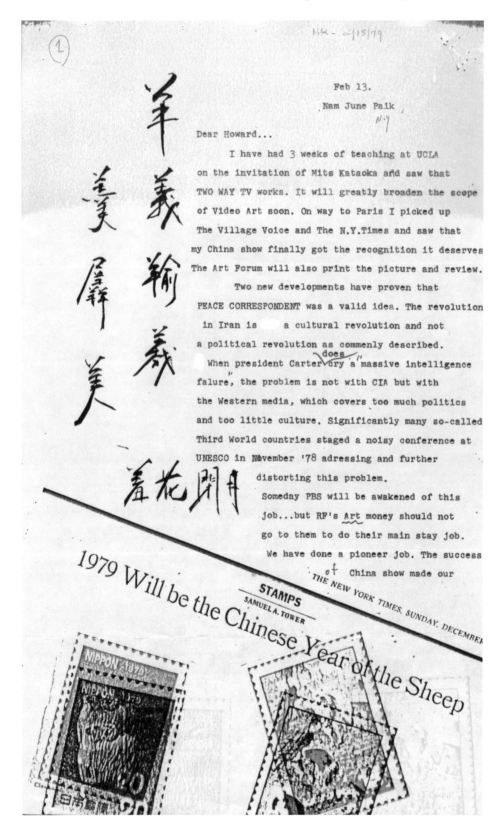

HK - 2/15/79

Feb 13.

Nam June Paik,
N.Y

Dear Howard...

I have had 3 weeks of teaching at UCLA
on the invitation of Mits Kataoka and saw that
TWO WAY TV works. It will greatly broaden the scope
of Video Art soon. On way to Paris I picked up
The Village Voice and The N.Y.Times and saw that
my China show finally got the recognition it deserves
The Art Forum will also print the picture and review.

Two new developments have proven that
PEACE CORRESPONDENT was a valid idea. The revolution
in Iran is a cultural revolution and not
a political revolution as commenly described.
 does
When president Carter cry a "massive intelligence
falure", the problem is not with CIA but with
the Western media, which covers too much politics
and too little culture. Significantly many so-called
Third World countries staged a noisy conference at
UNESCO in November '78 adressing and further
distorting this problem.

Someday PBS will be awakened of this
job...but RF's Art money should not
go to them to do their main stay job.

We have done a pioneer job. The success
of China show made our

1979 Will be the Chinese Year of the Sheep

STAMPS
SAMUEL A. TOWER

THE NEW YORK TIMES, SUNDAY, DECEMBER

NIPPON 1979

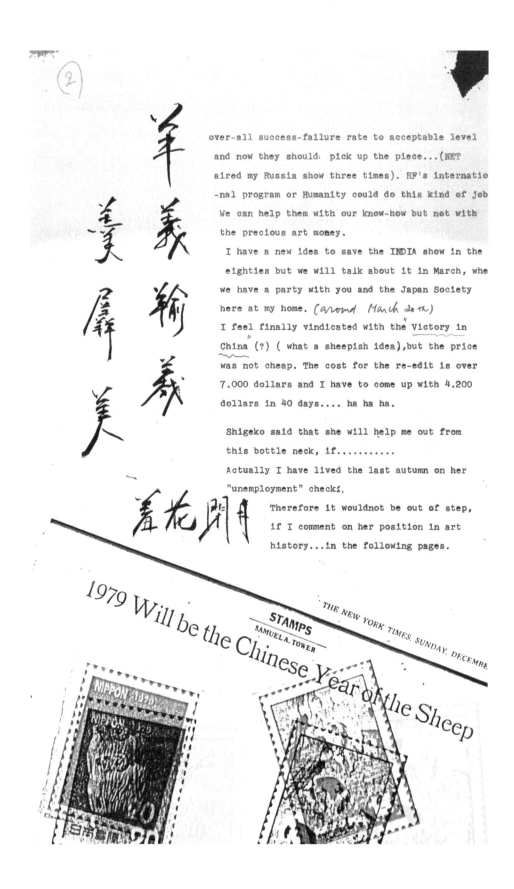

over-all success-failure rate to acceptable level
and now they should pick up the piece...(NET
aired my Russia show three times). RF's internatio
-nal program or Humanity could do this kind of job
We can help them with our know-how but not with
the precious art money.

I have a new idea to save the INDIA show in the
eighties but we will talk about it in March, whe
we have a party with you and the Japan Society
here at my home. (around March 20th)
I feel finally vindicated with the "Victory in
China (?) (what a sheepish idea),but the price
was not cheap. The cost for the re-edit is over
7,000 dollars and I have to come up with 4,200
dollars in 40 days.... ha ha ha.

Shigeko said that she will help me out from
this bottle neck, if..........
Actually I have lived the last autumn on her
"unemployment" checkf.

Therefore it wouldnot be out of step,
if I comment on her position in art
history...in the following pages.

1979 Will be the Chinese Year of the Sheep

STAMPS
SAMUEL A. TOWER

THE NEW YORK TIMES, SUNDAY, DECEMBE

3

Besides, he pointed out, the new developments in technology, such as satellite distribution for public broadcasting, represent a trend away from centralized control.

Carnegie II, therefore, had to devise something entirely different. The commission's report, which is almost twice the length of the Carnegie I document, portrays a process under which programs can be made, on every scale and in every field of journalism and the arts, for the sole reason that, in the judgment of an enlightened advisory panel, they deserve to be made. If it should happen that certain of these programs are unwanted by the television and radio stations of the system, then these works, which would be produced in any case, might find their outlets in

cable television or on video cassettes or on video disks.

In short, Carnegie II's vision extends beyond broadcasting into the realm of the emerging technologies, wherever the programming may take it. Just as Carnegie I coined the term "public broadcasting," Carnegie II, venturing a step into the future, has coined "public telecommunications."

"We have not locked our plan into the existing distribution mechanism. It is not to be a servant of the public broadcasting enterprise but rather an instrument of creativity," explained another member of the commission, Eli N. Evans, president of the Charles H. Revson Foundation.

"We want a system of programmers rather than distributors, a system that wants to bring in writers, artists and communicators in an open-armed way,

king for $1.2 billion a TV, with half of it eral Government.'

and one that sees itself as a bridge to a whole new range of services made possible by the new technologies."

The reorganization plan begins with the elimination of the Corporation for Public Broadcasting. Carnegie II found the organization inadequate to the task of leading the system, vulnerable too often to political influence and given to making "irrational and arbitrary" decisions in allocating funds for programs.

In its place, the commission proposes to establish the Public Telecommunications Trust to guide the course of the system, evaluate performance and serve as the fiduciary agent. Governed by nine Presidentially appointed trustees, the trust would be the system's leader and protector but would have no voice whatever in program decisions.

Those decisions, on the national

The most important part of Carnegie II is that they finally recognized that PBS is not important and CANNOT become important , because PBS can reach only half of America, due to the lack of VHF licences, as I pointed out in 1974 report to you. Already many of PBS watchers in Los Angeles are Cable watchers. Soon Homebox Office netwerks will reach more regions (and people) than PBS.

Therefore Carnegie ... is absolutely right to say that new programming money is not confined to PBS distribution but to every new media. Already *there are* 2 million home casseette recorder owners in the world and the introduction of video disc at Atlanta was a success. Therefore soon there will be NO REASON that museums play a single channel videotape at single monitor, as they do today, because that will be equivalent to to go *to the* library to listen to a Rock'n'Roll record. However, museum will increase its importance in video art. In that time there will be a sharp distinction between Video as High art and video as Low art(mass art).

In that day Shigeko's importance as the forrunner of vdeo sculpture will be fully recognized.

In that day museum will not show ANY single channel video, which anybody can buy in the supermarket. *The* Museum video will be always HYBRID form, Video AND something, which means the control of both TIME component and full space parameters, (that means not 2-D but 3-D including our participatory space.)

(4)

Shigeko recognized this inevitability very early and pursued
stubbornly to the FULL ART VIDEO, giving up any desire for
broadcasting after the initial rebuff. There is no wonder
that quite a few art critics and curoators prefer her work to
my work. I will not print their names, but they include some of
the top names in the established art world, who dosent care
about Video. *generally* Barbara London will tell you that Shigeko's small
one *woman* show (project) at the upstais was the most successful Video
shpw at MOMA in the hitory both in terms of mass attendance and
 the opinion of top level curatorial staffs.

 Another thing, which Shigeko influenced *me* profoundly is
that Shigeko discovered Death for Video. Videotaped death is not
a simple death. Whereas you can term the real life a two-way
communication life, the video taped death is a one way *communication* life.
Instead of asking the Biblical question "Is there Life after
Death??", she formulated a new question "Is there Video After Death
??". As there is Life and Plastic Life, so there will be a Death
and Plastic death. This invention of her will become
 EXTREMELY real and pertinent, when artificial hybernation of
human being becomes practical in a couple of decades. Full
cycle of Videoed life will make the time-shifting device of our
life through the Artificial hybernation really worth while doing.
Since immortality is beyond reach, I will be satisfied *to* devide
my life in the 20th century and *anno* 2020 and 2050. Shigeko's achievement
with Duchamp's tomb and her father's death will be remembered
on that day.

 Although it is awkurd and unethical to praise one's
own wife, but the severity of her work required my interpretation
to you, and hope you forgive my impudance...see you here in March.
 best as always nam ju Paik

p. 5

Dear Howard :

 I am sending you this invoices just as a reference and NOT to seek any additional funding for China show. Most probably 18.000 $ covered neatly the production of both Russia and China, as I predicted. What killed me in fact WAS the Merce Cunningham show, which CPB held it for long time neither rejecting nor approving ... their usual practice...I had to spend at least 7.000 $ from my pocket for Merce show which put me in a bottle neck, almost as bad as in 1966. However, if Shigeko pays my loft rent for a year (6.000 $) , everything will be fine... I may be able to send you a GREAT new news from Paris and Vienna (!!!)

 As a composer I always have thought Video as an extension of electronic music or ELECTRONIC OPERA. Investing into the new electronic opera is much more viable than investing into Opera, a completely dead art form, which managed to produce no more than 2 or 3 good pieces in the past 50 years, despite the millions and millions of dollars put in in many countries.

 Therefore if my triumph in Vienna materializes, it will be my another vindication to the town of Beethoven and Alban Berg... the last great Opera composer in history.

Letter to John J. O'Connor (c. 1986)

from nam june paik

226-5007,
or through
KAY (560-3016)
GiAMASSI

to John O'Connor .

dear Saviour of Video Art !!!

Save us again ...

I met David Bowie in London... told him.

"I canNOT possibly pay you. Come over FREE and do for us".
he simply said YES and will sing and dance for 8 minutes LIVE for my
third satellite show. The first two are already extensively catalogued in
Germany and Japan and the one will be catalogued (or part of my big book)
by Harry Abrams, too. I took the liberty of reproducing your essay on it
in the Japanese catalogue. (3.500 in print). I hope they sent the hnorarium
to you or to the Times. (They are rich).

In TV, which is born to be passive, the transmisssion is more important
than the reception. (TALKING BACK). In this show, I did Kissinger-kind of
Shuttle Diplomacy and 10 LIVE sources.. (about twice as much as LIVE-AID).
About Ten will also broadcast LIVE. LENINGRAD says they will telecast LIVE
LOCALLY un-cut and script unseen (We are creating the broadcasting history,
since we are different from Ted Koppel kind of predictably) and the chairperson
of WHOLE Chinese TV establishment (a lady, who happenes to be in New York on
Sept 10 th) will watch the LIVE show in New York's crummy Channel 13 studio
(with Mr, Baker). Maybe you interview her. H.E.L.P.!!

The Climax , (the last time, it was a double-concerto of Phillip Glass
Live music and Marathon-Goal-In in the Asian Game, Seoul), will be the double
concerto of very serious dance at the hill top of Jerusalem at the EXACT-
Sunset Time (LIVE sun set. hard to get) of deaf and mute dance group around
the LOVE scultore of Bob Indiana (in Hebrew) and the LIVE car race of Ireland.
Miss Ireland will greet us and our host No.1 (an Alien, Tom David) will murder
our host No.2 (Al Franlen) and fly over in 5 minutes and marry her.

I think, we de-throned Lenni Riefenstahl as the Olympic artist No.1),
because Film is written essentially in the Past tense and Video-TV is so in the
present-future tense. Besides Harry Abrams book, SONY will make a memorial
home video edition (LUXUS edition of all 3 past Live art) and there is a talk
that a major Japanese commercial TV chain may establish it as a yearly event
every New Years.... Thanks to you, we are leaving a legacy to the banal TV culture.

JAN/3

(handwritten margin notes, left side: "LIVE !!", "TELECAST", "TO", "DECIDED", "CHINA", "HOT NEWS.")

Typewritten with additions in crayon and ink, 11 × 8½ in. Smithsonian American Art Museum, Nam June
Paik Archive (NJP.4.EPH.28K); Gift to the Nam June Paik Archive from Seymour Barofsky for the estate
of John J. O'Connor.

Letter to John J. O'Connor (1988)

Nam June Paik
December 1988

To: John O'Connor

On "WRAP AROUND THE WORLD"

 -Satellite show around the world, aired on September 10, 1988

It was indeed aired live, not only in Leningrad, but also in
Moscow, also including the area in between these two metropolitan
areas (encompassing a combined population of about 25 million
people). The broadcast time slot was 6:30 pm to 8 pm (prime time).
Since they have only two national channels and one local channel,
we must assume higher ratings than in our much more competetive
national standard of 20 different channels.

In China, it was aired twice.
 1) The first telecast, October 2nd, was in Beijing only on their
 English Service Channel, in the original version.
 2) The second telecast, dubbed into Chinese, aired NATIONWIDE on
 October 19th. Even if we assume only a 50% penetration rate
 of television in the continent, the size of the audience is
 is mind-boggling.

The problem in Korea:

The KBS producer came to New York about ten days before the
telecast, and we agreed to have percussion music conclude the
KOREA section. About one week prior to the telecast, it was
changed to the "Little Angels". Carol Brandenberg asked me who
they are, and I answered that they were kind of a "Las Vegas style
of old Korean dance, quite entertaining...I saw them at Carnegie
Hall". However, one week after the telecast, I was told that
Moon's Unification Church is their main financial supporter. I
was dumbfounded. I protested strongly to KBS - however their
excuse was that the "Little Angels" had also performed at the
White House.

Since a handful of Moonies seems to be tainting <u>ALL</u> Koreans, much
as the Mafia does to ALL Italian-Americans, I have been extremely
sensitive about Moonies, and even dispatched a warning letter to
the Korean General Consulate well before the telecast. I had
checked every financial source, and all were absolutely kosher
(well-known art dealers, participating broadcasters, and myself).

However, it did not occur to me that Moonies could come in as
"talent"...after all, I have been away from Korea for the most
part of 38 years. A tinge of bitter aftertaste is spoiling my
otherwise perfect success, a telecast that should rank equally
with LIVE AIDE (for the Ethiopian famine), both in quantity and
quality.

However, my next show "LIVING THEATER" should re-establish my
radical credentials.
 [signature]

Typewritten with notations in ink, 11 × 8½ in. Smithsonian American Art Museum, Nam June Paik Archive
(NJP.4.EPH.28A); Gift to the Nam June Paik Archive from Seymour Barofsky for the estate of John J. O'Connor.

nam june paik
226 5007, 11o mercer st.

to john o'connor

thank you for your interst for <u>Bye Bye Kipling</u>... you are the
saviour of Video Art itself, when Reagan put $$ to military only and
another saviour Howard Klein retired. In this shopw we secured the
underwriting of 4 majoor Japanese company and one top Korean
company (of course, not Moon)...samsung).. so that we can expand our
artistic and financial base. My show at Holly Solomon... stars are 3 robots
made out of antique TV, which was a local hit in Chicago art fair lat
last may... (N.Y. Debut) will help too, financially.
However my real satisfaction is finally after this show nobody will
talk any more about Leni Riefenstael.... we combined the unfolding drama
of live marathon (for the 70 minutes) and self-crescendoing musical
drama of Phillip Glass (etc) in a dialectic way so that both go up hill
for the same time clix... a kind of electronic orgasm. [simultaneous]
we used "real time"... or many layers and many modi of the real
time in such a way, so thatwe really feel like that space and time
is coordinated.... the name of club 4-D (where is will hapen
in New York side) is by chance... the essence of show itself.
Riefenstael's sports coverage is stuffy _one_dimensional TIME-SPace-shit
stupid journalist tend to think that we d are repeating a MINI-
Live Aide...\ I dont have to mention it to you, sir... but we are doing
very different. [nothing] we are not the rock star a parade.... we are
trying many modi of two way comminatiocation and inteactive
TV....ei : in-ternational striptease, where one side takes off,
throw the part of dress toward space and arrives to New York and
she getting dressed up.... or Two percussionist do improvisation
through earphones corss ocean... and many Twins happening)
My last goal is to set up a gigantic TV screen in Time Square and
Red Square for permanent base and citizen can talk and see each other
365 days and 24 hours... (sponcered aby Ochs Family ????)
it will cast one-millionth of star war and a lot more effective

I am sending you the signed copy of Bye Bye Kipling Japanese pre publication
which sold already over 5.000 (five thousand copies and will sellput
all 7.000 copies before the telecast)
to say the least, it was not easy toarrange 3 countries show, who had had
fights all the times... I am duely proud of it and Carol Brandenburg
will testify it, who went through 2 years of frustration with me..

Typewritten with notations/additions in felt tip pen, marker, and pencil, 11 × 8⅜ in. Smithsonian American Art
Museum, Nam June Paik Archive (NJP.4.EPH.28F); Gift to the Nam June Paik Archive from Seymour Barofsky for the
estate of John J. O'Connor.

Nam June Paik's Chinese Memories

by Edith Decker-Phillips

ORIGINS OF THE CHINA WRITINGS

In this book, Nam June Paik's writings on Chinese history and philosophy have been published for the first time in English, as he originally wrote them. These writings center on quotations and anecdotes drawn mainly from the *Shiji*, the "Records of the Grand Historian" Sima Qian (c. 145–90 B.C.E.), and the writings of Han Feizi (280–233 B.C.E.). Sima Qian was a historian and the Grand Astrologer to the Han emperor Wu after the death of his father, Sima Tan. Han Feizi was Master Fei, a prince of the Han kingdom. Paik's other sources include the writings of Zhuangzi (370–287 B.C.E.), Liezi, and the *Huainanzi* of Liu An. The anecdotes are interspersed with quotations from Laozi's *Daodejing* and Confucius's *Analects*. With the exception of the story "Painted Dragon, Pointed Eyes," which refers to the sixth century C.E., the dates covered in his sources span from the ninth to the third century B.C.E. Paik's writing draws on the content of the stories or sayings but does not quote any of these sources directly. Often he has changed details in order to make the meaning clearer for contemporary readers; he was most certainly not driven by academic interest.[1]

PAIK'S EAST ASIAN HERITAGE

Nam June Paik's connection to Chinese history and literature can be seen in both his person and his work. On the personal side, this connection was shaped by the experience of being a foreigner, which he encountered early on. When the Paik family came to Japan in 1950, he was 18 years old. Outside the house, they were not allowed to speak Korean. He wanted to study European music but was given the impression that an Asian could never become an important composer like Bach or Beethoven. Six years later, he continued his studies in Germany and discovered a different reality. He was well received at the University of Munich, but his goals shifted, and his promising earlier

prospects began to fade. He had been an admirer of John Cage, but was very cynical about Cage's implementation of Zen Buddhism. When he met Cage in 1958, his opinion changed, since Cage embodied Zen in a most convincing way. This seems to have been the point when Paik started not only to incorporate Zen into his work but to reevaluate his own heritage in general.

Moving to the United States in 1964 confirmed for Paik that the West knows much less about the East than the other way round, and that culture and cultural identity are things that can keep people together or pull them apart. When we look at early video-tapes like *Global Groove* (1973), we see his efforts to address the problem: there are Korean dancers, Japanese commercials, American tap dancers, a singing and drum-beating Navajo woman, and African boxers. *Global Groove* was meant to be "a glimpse of a new world, when you will be able to switch on every TV channel in the world, and TV guides will be as thick as the Manhattan telephone book."[2] Television or video for him was a perfect medium to present different cultures to each other, whether high or low culture or some combination. The idea behind it is that the more we know about each other, the less we tend to reject another culture. This approach of presenting different cultures, which developed in the 1970s, became the core of his satellite projects during the 1980s, which utilize the same structure, especially in combining pop and high culture.

Paik's homeland, Korea, came back into his life in the 1980s. While his international reputation grew, South Korea became more prosperous and Korean collectors bought his work. Not insignificantly, his friendship with Joseph Beuys—who had been rescued by Tatars and their shaman following a plane crash during World War II—reminded Paik of the Korean tradition of shamanism. During this decade shamanism, the horse, and nomadic horseback people—all fixtures in Korean history—became frequent motifs in his videos, sculptures, and installations. The invisible backdrop of these motifs has been the China stories that popped up more frequently in his essays and lectures.

The publication of Paik's China stories goes one step further, because he is here presenting his own cultural heritage, in the form of the books he held in high esteem, to Western readers in a slightly adapted way. He did not transform them into artworks but drew from them directly. His selections, with few alterations, don't harm the original texts but add a personal note and offer the opportunity to understand the person and his work in a new and different way. Paik himself developed a deep connection to these books that became a sort of referential subtext to his life. That connection strengthened as he aged. In October 1996, he wrote in a letter: "I became rather religious and faithful after the stroke. I learned to follow the natural path of things (History)."[3] In an interview in 1991 he had said to me: "My relation to Zen is cynical the most if not negative."[4] But never had there been a time when he would have said, Don't read about Zen, or Don't practice Zen. He always acknowledged the value of things independently of his own likes.

THE GERMAN EDITION OF THE CHINA WRITINGS

One might ask why an avant-garde artist who was pushing his work in new directions and who employed the latest electronics would be interested in telling the stories of ancient China. That question first occurred to me 25 years ago when I was working on a German edition of Paik's selected writings titled *Niederschriften eines Kulturnomaden* [Writings of a Cultural Nomad]. It took me many years to fully understand this part of his writing, and I am quite happy to be finally able to pursue that question and try to find an explanation.

Paik had provided a list of texts he recommended for our German book, but the final selection was up to me and the publisher, Dumont, in Cologne. Then, surprisingly, Paik said he wished to have his previously unknown China writings included in the book. This document of his China writings grew still larger over the following months as he added more anecdotes. He even included numerous photocopies of Chinese texts and asked me to extract more stories from those. Of course, the publisher had already set the size of our book, and we had to leave out many stories instead of creating new ones. In the end, 55 of the book's 250 pages were dedicated to the China stories, which turned out to be a valuable addition to the original concept of the book.

For the German selection of China stories, Paik wrote a special preface (see page 193 of the German edition), of which the original English version has since been lost. His preface lists his sources: Sima Qian and Han Feizi translated into English by Burton Watson, Yang Hsien-yi, and Gladys Yang; and Édouard Chavannes's bilingual French-Chinese edition. In the text, Paik describes his special relationship to the *Shiji*, which he had known for a long time. He mentions the translators Fumio and Takeo Kotake, who had each spent 20 years translating the entire *Shiji* into Japanese (*Gendaigo Yaku Shiki*, Tokyo: Kobundo, 1956–1957). Paik probably owned this edition as early as 1964, and he said in his preface to the German edition that this book helped him to survive the "Byzantine idiosyncrasy of the art world in Manhattan." Since then, he said that he had tried to make this book available to Western readers, at least in part.

When I translated his English texts into German, I realized he had often crossed out Japanese names in the texts and written Chinese names in their place. This means that he had used the Japanese edition of *Shiji* when he started retelling and writing down its stories. Another reason for Japanese names in his manuscript is the other source he mentions in his preface, *Kanbun Koji Shôjiten* (Tokyo: Kenkyûsha, 1956) by Mikio Hosoda.

A scholar of Chinese literature, Hosoda collected sayings that have their roots in Chinese history. In his preface, Paik points out that not only are elements of the *Shiji* quoted in newspapers and other media almost daily, but historical facts and anecdotes from Chinese antiquity have been handed down over time and are still part of daily life in Korea and Japan. Hosoda's book provides the original sources for the proverbs that most people use without knowing where they came from.

As mentioned above, while in the process of working on our German publication, Paik added further anecdotes to the first manuscript, which were taken from the Hosoda book. In this case, Yuzo Sakuramoto did the translations from Japanese into English. This group of anecdotes could not be used in the German edition, and we were unfortunately not able to reconstruct the text for the present book (we were not able to obtain the Hosoda publication, and Yuzo Sakuramoto had returned all of the material to the artist). Sakuramoto remembers, though, that he had translated about a dozen short texts. It is interesting that Paik talked to Sakuramoto about his plans to publish a compilation of ancient Chinese stories and anecdotes. In addition to the *Shiji*, he mentioned the *Commentary to the Book of Songs by Master Han* (*Han Shi Wai Zhuan*), which appears to be even more inaccessible and exotic than the *Shiji*.[5]

For the present selection of China anecdotes, we tried to identify the original source for each text. For texts from Laozi and Confucius, we simply referred to currently available translations, which are numerous. No translation was found, however, that matched Paik's version exactly, and it is not clear which source he used or whether he had simply remembered the texts. In regard to Han Feizi's writings, Burton Watson's English translations provide a number of anecdotes but not all of them. I am grateful that the University of Virginia provides a full translation of Han Feizi on its website, *Traditions of Exemplary Women*.[6] Even the *Shiji* translated by Burton Watson didn't contain enough material to trace all of Paik's anecdotes.

THE QUESTION OF BUDDHISM

During the 1980s, Nam June Paik was seen as a member of the international avant-garde. He spoke several languages and was part of a global network. His reputation grew continuously, and he was constantly traveling. While working on the German edition of his writings, he managed to find time for an interview at his Wiesbaden apartment on October 28, 1991, in which I tried to clear up some questions. To me, it was a contradiction that he denied being a Buddhist and at the same time made so many references to Buddhism in his work. Paik said that his family was Buddhist, but that his father had been busy earning money and his mother had been more superstitious than religious. In daily life, religion had played no role. There was a Buddhist temple near the family's summer house outside Seoul, but they secretly laughed at one of the temple's monks, who behaved aggressively toward his brethren. The Paik family was wealthy, modern, and Western-oriented. The religion in which Paik grew up did not interest him, and he associated it with backwardness and a fatalistic approach to life. It was only beginning in 1958, through John Cage, that he became interested in Zen Buddhism. The only Buddhist person he could accept while he was in Japan was scholar and author Reginald Horace Blyth. Blyth was "living Zen," as Paik said, and he went to two of Blyth's lectures. Since Blyth—a friend of Daisetz Teitaro Suzuki, who had brought Zen Buddhism to the United States—died on October 28, 1964, Paik must have met Blyth early that year on his first visit to Japan after moving to Germany, or before he left Japan in

1956. Paik found Suzuki to be a boring writer, and he criticized him for his attitude during World War II, when Suzuki endorsed books like the *Hagakure*, the codex of the Samurai, that influenced Kamikaze pilots. Paik blamed Suzuki for not having taken a critical stand against war (a position that would have been very dangerous for Suzuki to have held).

Paik said that he, like many other intellectuals around him, was a Marxist when he was young because of the economic problems after World War II. He studied Western music and European philosophy and thought the attitude of resignation in Asia at that time was due to the influence of Buddhism and the even more pervasive influence of Confucianism. In our conversation, Paik kept explaining why he wasn't a Buddhist and said that he disliked everything that had to do with Buddhism. It was only his respect for John Cage that had made him change his mind. At one point, I said: "But you are still what you are." His reply was: "Yes, of course, I am 99% Korean."

With this statement, we are finally getting closer to his reasons for compiling the text of his China writings. Korea has been under Confucian influence for a long time, something that is also true for other East Asian countries, and to a certain extent even for Japan. China is the cultural motherland. It had been a highly developed empire since the late third century B.C.E. Being a close neighbor, Korea had not only been part of China's history but had also quickly adopted Confucius's teachings into its system of education and administration. In this way, Chinese history was reflected in proverbs and sayings in Korea's daily language.

It is difficult to determine when Paik started writing down his China stories. There are undated sketchbooks that contain related texts, and there are compiled manuscripts that develop from handwritten texts to almost fully typewritten scripts. The most complete version that existed was the 1991–1992 typescript for *Kulturnomaden*. In the preface mentioned earlier, he wrote that the *Shiji* had helped him to survive the early years in New York City, when he mainly lived on grants, performances, and a little family money. Knowledge of China was a part of his cultural background that secured his identity and was definitely something he wanted to transmit. Given this background, it is obvious that he did communicate small parts of his knowledge of Chinese history from the beginning of his career, specifically in his video work in 1963. Paik's previous period of "Action Music" and his ongoing participation in Fluxus both turned on his hearing John Cage's lecture at the International Summer Course for New Music in Darmstadt in 1958. If Zen was an appropriate vehicle for Cage, it could work for him too, and Paik didn't have to learn about Zen Buddhism. From then on, he poured Zen into his actions, objects, and texts. For example, the composition *Do It Yourself. Answers to La Monte Young*, from 1961–1962, reads, in parts, more like a manual for attentiveness than for Fluxus nonsense. Although the Zen strategy evoked by Cage remained vivid, Paik's video work went in a new direction, one reinforced by his writing. In a flyer for his first exhibition of altered TV sets in Wuppertal in 1963, one can find, next to "John Cage," the name Zhen Zhu. Playing with philosophical ideas, Paik seemingly refers to the philosopher and author of the *Zhuangzi*, Zhuang Zhou, who may have lived in the fourth century B.C.E. in the state of Song. Zhuang Zhou famously wrote that when he

woke up, "he didn't know if he were Zhuang Zhou who had dreamed he was a butterfly or a butterfly dreaming he was Zhuang Zhou."[7] The name Zhuang Zhou can also be transcribed as Chuang Tzu, but with "Zhen Zhu" Paik seems to be confusing the name with Chen Sheh, a rebel and, briefly, king after the death of the first emperor, who plays a role in a few of Paik's omitted China stories. Or it could be *Shen Tzu*, the book by Shen Buhai, a contemporary of Han Feizi. Some years later, in his essay "Norbert Wiener and Marshall McLuhan" (reprinted in this volume), Paik mentions the historian Sima Qian and the philosopher Laozi. There are many more examples of his dropping a name or an idea from a Chinese context into his work. Around 1980, however, the urge to express this context more explicitly became stronger. In September 1981, Paik wrote a short text honoring Ralph Hocking, the founder of the Experimental Television Center. Describing Hocking as a "video hermit," Paik refers to Confucius and adds, "If there is a Laotze in Video, he must be Ralph Hocking." A lot of space in this text is given to Laozi, and Paik sketches out how the *Daodejing* came into being: "the guardman stopped him and begged him to leave a note, which became that short book of Laotze, which, although you Americans can understand only one tenth of it, still turns on so many Americans. . . . One of the great pleasures of being an Asian is that I know enough Chinese symbols to follow the original of Laotze."[8] In 1981, Paik also wrote the essay "From Horse to Christo" (reprinted in this volume), which is equally dominated by anecdotes written down by Han Feizi and Sima Qian.

SCRUTABLE CHINESE

The present selection follows the original manuscript for the German edition, and it keeps the intended overall narrative, but several texts had to be left out for considerations of space. On the other hand, some other texts, omitted from the German edition, have been reinstated. The last three in our selection, "Case Studies and Abstraction," "The Palm of Duchamp," and "The Role of Blacks," were found in a sketchbook with China-related anecdotes. They have been included because they show how Paik developed his ideas and thoughts over decades. To some extent, they provide insight into the way the artist wrote his texts.

Paik must have used this particular sketchbook until the late 1990s, as it includes detailed considerations for the exhibition at the Guggenheim Museum in New York in the year 2000. Glued into the sketchbook are different stories related to China and Japan and even English translations from Hosoda's book. As the cover of the sketchbook

SERIE SUPERIEURE 85 GRS
180 PAGES

JOSEPH GIBERT
LIBRAIRIE _ PAPETERIE _ DISQUES
30 boulevard Saint Michel 26

"Scrutable Chinese" notebook cover, n.d. Cardboard and coated wire with additions in ink, 11¾ × 8¾ in. Smithsonian American Art Museum, Nam June Paik Archive (Box 11, Folder 2); Gift of the Nam June Paik Estate.

shows, it was dedicated to China stories. Three layers of handwriting read: "Chinese capsule – 45Chinesische Kapsulen [correct German: Kapseln]" / "Chinese Clichés Case study" / "Scrutable oriental – case study – dumme Chinesen [stupid Chinese]." The first manuscript Paik sent to me in 1991 had a similar handwritten front page. The title was "Scrutable Chinese (or 'dumme' Chinesen)," a title full of irony, since it is a Western stereotype that Asians are inscrutable, and the word "stupid" in quotes is rather the opposite of his personal conviction. One can find the idea of "Chinese Capsule" on this sheet as well, but not "Case Study." This idea might have occurred to him during the 1990s. The sketchbook includes the short text titled "Case Studies and Abstraction," and in Paik's mind both the *Shiji* and Harvard Business School – both mentioned in the text – mainly deal with "case studies." The second sketchbook story we are presenting, "The Palm of Duchamp," is a collage in which Paik first brings the rebel Chen Sheh together with Marcel Duchamp. "Dancing on the horn of a snail" is a metaphor for Chen Sheh's achievement: within six months, the lowly farmhand became the leader of a rebellion and then king. He was murdered but had so many admirers that his memory survived. For Paik, artists who tried to follow in the footsteps of Marcel Duchamp are so insignificant compared to Duchamp that all of them could fit on his palm. The second part of the story combines the French philosopher Montaigne with Chen Sheh. The quotation of the philosopher who is playing with a cat first appeared on the flyer for the Wuppertal exhibition in 1963, as does the dreaming butterfly. But it cannot be attributed to Chen Sheh, who lived in the second half of the third century B.C.E. This idea is better suited to Zhuangzi, as quoted above. Finally, our third text taken from the sketchbook, "The Role of Blacks," has nothing to do with the China material but takes further what the artist briefly mentioned in his 1970 essay "Global Groove and Video Common Market," where he wrote that "Jazz was the first tie between Black and White." In "The Role of Blacks" he states that jazz and rock were largely created or influenced by black musicians, who even helped to win the Cold War with their music. The text could have been written during the 1980s, maybe even in the 1990s. In his writing, Paik applied the general working principle that good material or a good idea should be recycled again and again.

It was truly Paik's heartfelt desire to have his China stories published, though they are "case studies" of people rather than descriptions of historical events. In Chinese antiquity, these little anecdotes had the function of explaining abstract principles, but they still convey some truth about how people thought or reacted. The Western reader of today could get the impression that human nature hasn't changed very much over more than 2,000 years and that there are certainly a few ideas we have in common. We could say, as Tzu-ch'o does, "Nobody is able to draw a square with the left hand and a circle with the right hand at the same time" (Han Feizi, book 12, chapter XXXIII). And even the Golden Rule was already taught by Confucius: "Tzu-kung asked, 'Is there a single word which can be a guide to conduct throughout one's life?' The Master said, 'It is perhaps the word "shu." Do not impose on others what you yourself do not desire.'" (*Analects*, book 24, 135.)

Nam June Paik, *Chinese Memory* (2005) [detail]. Single-channel video (color, silent) in vintage television cabinet with permanent oil marker, acrylic, record cover, scroll, antennae, and books, 81 × 55 × 44 in. (205.7 × 139.7 × 111.8 cm). Courtesy Nam June Paik Estate.

CHINESE MEMORY, 2005

One work from his late period shows clearly the strong intention of passing on his Chinese literature to the public. *Chinese Memory*, created shortly before his death, makes his favorite books part of a single-channel video installation. Ten books, including the *Shiji* and Han Feizi but also the red "Mao Bible," have been piled up in front of an antique-looking Chinese television cabinet. The cabinet and the TV screen are covered by Paik's typical colorful paintings and drawings of icon-like TV faces, Buddha figures, and text. The silent video contains recycled footage from the tapes *Global Groove, Suite 212* (1977), and *You Can't Lick Stamps in China* (1978). The imagery makes allusions to the theme of the work, only it is more Manhattan's Chinatown than the real China. According to Paik's longtime assistant, Jon Huffman, it is the chanting Beat poet and close friend Allen Ginsberg who is the central figure of the video and even the painting outside. A viewer gets the impression of a living room setting: The antenna on top of the cabinet points to television; the image on the wall reminds one of Mao's Cultural Revolution during the 1960s and is, in fact, the sleeve of the record *Spring Is Eternal in Our Motherland*. It is a record with a clear political message; the third song on the A side is called "We'll Follow the Party with one Heart and Mind." Another part of the installation is the antique scroll that shows a twig with spring blossoms and is, together with the books, a piece of equipment belonging to a sophisticated household. One could understand this work as a statement on China, where the communist era is maybe just a small part of a long history and the classical philosophy is still a determinant factor. But why should Allen Ginsberg be important in such a setting? I think it is not too far-fetched to see this piece as a self-portrait of the artist. Paik makes his personal cultural background the theme of an otherwise typical installation. *Chinese Memories* casts a light on Paik's Buddhist background, touches the Marxist period of his youth, points to his media-oriented life, and even includes a comment on his role in the Western art world. On the front side of the closed TV cabinet one can find, next to his signature "Yellow Peril" (a mock title he had given to himself in the early 1960s), the book stack, which could also function as a library to the text compilation "Scrutable Chinese." The books are placed in the foreground and can't possibly be overlooked. His Chinese literature has finally become a visible part of his art work and part of his legacy.

PAIK'S CALLIGRAPHY

For *Kulturnomaden*, Paik made a number of drawings and examples of calligraphy. Five of them have been included among the following texts. Paik was used to the fact that in European countries and the United States, people enjoyed his drawings and calligraphy – for aesthetic reasons. Hardly anyone was able to read the calligraphy, and he did not make much effort to keep his writing readable. In most cases, he just memorized words or passages from certain texts; in fewer cases, he may have copied something. Furthermore, he mixed Chinese and Korean characters. That could explain why

previous attempts to read and understand his calligraphy have been abandoned too soon. We are extremely grateful for the assistance we received from Sven Osterkamp and Jimi Nam-Osterkamp in Bochum. Although the former specializes in Japanese linguistics, together they were able to identify Paik's illustrations, at least in parts.

In general, his drawings combine technological elements like the TV screen with the moon or flying birds – Paik favored poetic allusions to aspects of nature. The quotation from the Chan Buddhist text *Biyanlu* (page 408) and the citing of Korea's great poet Kim Sowol (page 413) have more impact than the typical drawing or writing Paik provided for *Kulturnomaden*. The *Biyanlu*, or *Blue Cliff Record*, is part of the Buddhist canon and became the "Bible" of the later Rinzai school after Dogen Zenji brought it to Japan on his return from China in the early thirteenth century. In an interview from October 1991, Paik mentioned the importance and beauty of the *Biyanlu*. Osterkamp could clearly identify the 80th anecdote in the *Biyanlu*, "A Newborn Baby." In this case Paik must have had a copy of the *Biyanlu*. Two-thirds of the text quotes "A Newborn Baby"; the last third is written in Korean characters mixed with some Chinese characters and could not be identified. The naming of the titles of poems by Kim Sowol may have been copied from a book as well. Otherwise it would mean he liked the work of this twentieth-century poet so much that he could cite these titles by heart. We can be sure that Paik provided a hidden layer of meaning for us to discover, in which he transmitted East Asian culture to a West that remained ignorant of the East.

NOTES

1 Chinese texts not only have the normal difficulties involved in translation, but since Chinese writing is pictorial, names have to be transcribed into letters that reproduce the spoken word. At present, there are two transcription systems in use for Standard Mandarin Chinese, the Hanyu Pinyin and the Wade-Giles. The latter Romanization was developed by the sinologists Herbert Giles and Thomas Wade in the nineteenth century. The Hanyu Pinyin was developed in China during the 1950s, in an effort to develop a system of syllables parallel to the kana in Japan. Whereas in European countries, the Hanyu Pinyin transcription has been used since the end of the 1970s, in the United States, the Wade-Giles transcription is more common. Paik used sources that were transcribed in Wade-Giles – or Japanese.

2 Quoted from Russell Connor's voiceover at the beginning of *Global Groove*. Cf. Edith Decker-Phillips, *Paik Video*, trans. Karin Koppensteiner, Marie-Geneviève Iselin, and George Quasha (Barrytown, NY: Station Hill Arts, 1998), 156.

3 After his stroke Paik had to cancel a performance in Germany. In this regard he wrote letters to Helge Achenbach, Eva Beuys and Wulf Herzogenrath. The quotation cites the last two sentences from the letter of October 6, 1996. (I have a copy of this letter as Paik asked Stephen Vitiello of Electronic Arts Intermix, New York City, to send me a transcription.)

4 Nam June Paik, interview with Edith Decker-Philips, Wiesbaden, October 28, 1991.

5 Yuzo Sakuramoto kindly shared his memories with us in an e-mail of November 12, 2015.

6 Cf.www2.iath.virginia.edu:8080/exist/cocoon/xwomen/texts/hanfei/page/tocc/bilingual.

7 *The Complete Works of Zhuangzi*, trans. Burton Watson (New York: Columbia University Press, 2013), 18.

8 Nam June Paik, "T-Valley: Ralph Hocking," *Video 81*, vol. 2, no. 1 (Fall 1981): 37.

China Texts: "Scrutable Chinese"

Horse 1

The horse was not only the fastest transportation medium but also the fastest transportation medium for 3000 years; from ca. 1000 b.c. to 1860, the year of the telephone (and Monet). There-fore a good horse, which "sweats the blood", is not only a Rolls Royce but also a Concorde / a radar and a sattelite combined.

700 b.c. a chinese king trusted his minister with one million dollars to find a horse, which runs 1000 miles a day. The minster travelled whole China for three months...in vain. Finally when he found one, it was too late. The horse had died the day before. The minister cried...but paused for a moment. He paid half a million dollars for this dead horse and draged this corps to the palace.

The king was, understandably, mad like "multiple fires". For such wrong doing a chinese minister can get "cooked" or "pickled." The minister answered calmly...
 "His majesty...people will talk...rumor will fly...if you paid half a million dollars for even a dead horse, how many millions a living horse will bring?"

 Lo behold!!!
 The king was able to purchase the thousand miles horse very soon...and not only one but even three.

(from Dyang Kuo Tsu, 290 b.c.)[1]

Art (?)

Han Wei Tze said:

"When you carve a sculpture,

 make eyes small.
 and nose big.

Because you can allways make the eyes larger

 or

 the nose smaller

 (if you make a mistake.)"[2]

A man and his wife went to a temple to pray for fortune.

Husband asked :

 "What did you pray ?"

Wife: "so that you make 10 000 dollars."

Husband: "why not 100 000 dollars?"

Wife: "then you will get a concubine..."

 Ham Wei Tzu (? - 233.B.C)[3]

Horse 2

Chinese border with her northern neighbors (huns, Mongols and now Russians) has been tense for milleneums. In one of those lonesome frontier villages along this endless border there lived an old man called "grand-pa-fortress" who would sometimes devine the I Ging oracle to the villagers.

One day his expensive horse ran away to Mongolia crossing this delicate frontier. His fellow-villagers came in drove to lament but the old man just smiled. "It looks like a misfortune now but

who knows, it may be a good thing later.

After a few months his run-away horse showed up even accompanied
by a geogeous mongolian mare, which is priceless in China. The
villagers came back this time to congratulate...the old man just
shrugged off. "It looks like a good fortune now but who knows...
it may be a bad omen for the future."

Soon a beautiful pony was born from these two horses and the small
son of the old man was happily riding on the pony's back ...
untill this lad fell down from the pony and was severely crippled.
The villagers came back again to lament and console
old man's misfortune, - who now had to raise a crippled son.
The old man smiled again... "This looks like a calemity now, but
who knows? It can be the best thing which happened to me."

A few years later a strong herd of the mongolian army invaded
China through this border-village. All the young men were drafted
and killed in the action. Only this crippled son was able
to conssumate a long and peaceful life...with grand-pa-fortress
and many horses.

<div align="right">

Whai Nan Tsu

by Riu An

(Han Dynasty

100. BC - 400 AD)[4]

</div>

Dream 1

Mr. Yin of Chu, a very rich man exploited his servants harshly.
especially the servant Li, an old man...Although this old man's
muscle power has deterioated to nil, he was forced to work even
more than young servants. At daytime he dragged his body moaning
and groaning and at night he dropped dead on a hard bed and slept
"like mud". But his mind stretched widely in sleep. Every night the
old servant became a king in his dream. He had a large population
to govern and a magnificent palace to enjoy. In frequent parties
and long nights afterwards all of his instincts were satisfied.
His pleasure was incomparable. But next morning he awoke again
to become a servant.
Somebody consolaced his hard lot. The old servant answered:
"Our life is hundred years: half is day, half is night. Daytime
makes me slave. Pain is pain. But night makes me a king above
common folk. Its pleasure is incomparable. What shall I lament for?"

On the other hand Mr. Yin's day is full of nerve-wrecking trivias.
Large and small worries about household accumulates even more

than the accumulation of wealth. Every night he goes to bed exhausted and becomes a servant in his dream. He must attend upon, run around, got screamed and often severely beaten up. In the sleep he groans and moans, screaming out his pains and cannot get rest untill the dawn. Finally the master Yin got ill and consulted a friend, who said: "your position is high enough to honour yourself. Your wealth is in surplus. You excell other people by far. At night your dream makes you a servant. It is the natural order that our pleasure and pain be equally balanced. Even if you want to be consummately happy both at awakend status and at dreaming status, it is beyond the reach of human being."

Mr. Yin reduced the workload of the old servant and worried less about his worldly affairs. He got cured shortly.

(from Rei Tsu)

ca B.C 200. (disputed)

or older[5]

Ecology of Forgetting

Mr. Ho became amnesia in his middle age. In the evening he forgot what he took in the morning, in the morning he forgot what he gave out last night. On the road he forgot about going, at home he forgot about sitting down. His wife got worried and consulted astrologists, witches and sorcerers...in vain. Physicians could not heal him either.

A Confucian in the country of Lu proposed himself to cure the case. Mr. Ho's family offered the half of his property for this service. The Confucian said: "this is not a case for the doctors, witches, sorcerers and astrologists. I will try to change his mind and reform his worry... hopefully it cures him."

He made some test. When the Confucian stripped his patient naked, he wanted cloth. When the Confucian starved him he wanted food. When he was confined to a dark room, he wanted the light. The Confucian became happy and told to the son of the patient: "this case can be cured. But my prescription and treatment can be conveyed to the world only secretly. It cannot be openly told. Therefore let all unnecessary people go away, I will stay with your father alone for seven days."
The son obeyed the order and nobody knows what he did, but the long ailment got cured soon after.

But Mr. Ho, the patient, when he got awakened from amnesia, got enraged like hell. He expelled his wife, punished his sons and

chased away the Confucian with his daggar. Mr. Ho said:

"When I forgot everything, I was in the ecstasy and did not
know the being or non-being of heaven and earth. When I suddenly
notice the things again, all the gains and losses, being and nothing
of the last two decades started to bother me...and the prospect
of the future hapiness and sorrow disturbs my mind...please, bring
back my amnesia...I want to forget at least for a while.

(Rei Tsu)[6]

Here is a survival kit.

An army minister, having failed in a coup, was running away and
was stopped by the frontier guard.
The minister explained:
"King is after me not because of the failed coup d'etat, but
because of my jade. But I threw it into a pond on the way here
already. I don't have any more... If you arrest me and send me
back to the palace, I will tell the king that you have confiscated
the jade and swallowed it. The king must open your stomach..."

The frontier guard let him go.

(Han Wei Tsu)[7]

Death

Someone asked Confucius about death. The master answered :
"I dont know even about live, how can I know about death?"[8]

Teacher

When you walk in three-some, there is allways one teacher.

(Confucius)[9]

Life

Confucious said :

When fifteen I decided to study.

When thirty I stood up.

When forty I did not get confused (vacillate).

When fifty, I knew, what heaven wants from me.

When sixty, my ear was able to follow an advice.

When seventy, I act according to my mind, yet I dont
trespass the norm.[10]

Those who know
don't speak.

Those who speak
don't know.
Laotze[11]

Friends and Rivals

Kuan Chong (died 645 b.c.) and Suo Suo were class mates. They decided
to serve for two rivalling princes of Tchi country so that whoever
wins in the succession game, one of them would get the power and
then help the friend.

While the two princes were sent abroad, their father king,
died with a will that the prince who comes back first
to the palace, will get the crown. Immideatly the two princes started
their race to the capital. Seeing his own prince hopelessly behind
the schedule, Mr. Kuan Chong laid an ambush to the other prince- however
his arrow hit only the buckle of the prince's belt.
This prince continued the trip unharmed
and won the race to the throne.

Needless to say the new king arrested Mr. Kuan Chong, his near-assasin, and
sentenced him to death. But Mr. Suo, now the prime minister,
kept their schooldays promise and pleaded for the life of Mr.
Kuan Chong, (the assassin and friend).

"If his majesties aim is only to govern this country, my assistance
would suffice. But if your desire is to gain the hegemony over all
China - all the earth under the heaven, no talent except Mr. Kuan Chong
can possibly do the job."

Mr. Kuan Chong was not only pardoned. He actually replaced the premier-
ship of Mr. Suo.
Following his superb advices, his boss, the prince of Hwang became
the hegemonistic No. 1 of whole China.
Mr. Kuan Chong said of his friend Suo : "When I was poor, I was co-
venturing a bussiness with Mr. Suo, sometimes I took bigger
share of profit, but Mr. Suo did not blame me for greediness,
or deceit. He knew I was poor. Once I tried a scheme to help Suo but I
failed and made his situation even worse.
Yet he did not blame me. He knew that time has favorable moments and
unfavorable moments. Earlier days I served goverment three times
but was fired three times. However Suo did not say I was dumb,

because he knew that I had not yet met my time.

Also I went to war three times and run away three times. But
Suo did not say I were a coward, since he knew that I had
an old mother to support. In the succession game when his prince
and my former prince were competing for the throne, my prince
lost the game. Other subjects of my former prince comitted suicide
but I said to my comrade "You become the loyalist to die - I will
become the loyalist to live"- thus I chose not self-immolate and
became the shameless person - a would be traitor - yet Suo did
not say I were a shameless coward. Since he knows that it is not a
shame to skip a small loyality. Real shame is not to let one's
potentials be achieved, and one's fame manifested in the world under
the heaven.

Thus it was my parents who bore me to this world, but it was
Suo who really made me."

Thus friendship of Kuan Chong and Suo became the clishee in the
gradeschools text book.

(Yet Han Wei Tsu, a cynical realist, has one more story to tell
about this famous friendship.)

The prime minister Kuan Chong got old and bed-ridden. His King, now the No. 1 hegemonist
under the heaven, personally visited his bed and asked for the
possible successor. The King suggested Suo, his schoolmate, who
made him the premier minister. Kuan Chong said surprisingly No to Suo-Appointment. Citing he
was violent
obstinate, cruel...common people would not follow him with love...

The King asked about Shu Tîao.

Kuan Chong: "No, sir, everybody loves his own body. But Mr. Shu Tîao capi-
talized on your indulgence in women. Since he sensed your jealousy
and suspicion to all men who have contacts to your maids and
concubines inside the palace, he castrated himself voluntarily in
order to penetrate in to your court. (Most eunuches got castrated
very early in their childhood by their greedy parents, before boys
know the meaning of castration.) Therefore Shu Tiao, who does not take
care of his own body, will not take care of his majesties body.

Then the king suggested Kai-Fang from Wei country.

Kuan Chong answered: "His home, Wei country lies in only ten days
distance from our capital. Yet in order to serve you better, he
did not visit his aging parents for 15 Years. It is against human
nature. A man who cannot love his own parents, cannot be expected
to befriend his own majesty.

The king inquired about Yi Ya.

Mr. Kuan Chong: "Yi Ya is your chief cook. When he found out that the

only taste which you have not relished yet is human flesh, he
steamed his own son and offered it to your dinner table, as you
remember. How can he love his majesty, when he does not love his
own son?"
Kuan Chong recommended Shun as his successor, being clean, selfless
and popular.

However upon the death of Kuan Chon, the premier's office fell to the
eunuch Shu Tiao (who had castrated himself to penetrate into court)
In three years, this eunuch premier and Yi Ya (cook, who steamed
his own son) made the putsch, confined the king into palace-guard
room and let him die on thirst and starvation. Corpse was left
rotten for three month untill innumerable worms came out of the
corps, crept through the doorsteps on to the garden.

This grisly story was related by Han Wei Tsu the legalist as a
historical fact in 300 b.c.[12]

The late Kuomoju, chief ideologe of communist china, regarded
Han Wei Tsu higher than Confucious and Laotze.
Then, how did Han Wei Tsu die himself after having dispensed so
many realistic, even cynical observations on human nature?
Han Wei Tse's relationsship with his classmate Li Sǔ is as cele-
brated as Kuan-Chong's friendship.
Li-Sǔ started as a low ranking official in a small province. One
day he went to the toilet and got enlightened there as James Watt got
enlightened from a boiling kettle.
He saw a small mouse coming to the toilet and eating the shit...the
mouse was quite nervous, frightened, so he ate shit a little and
looked around and ate shit a little more and then stopped again to
reconnitor the situation.
Since men were coming often to shit or piss and even hungry dogs were
sniffing to have a share of excrement.

Next day Li Sǔ encountered mices inside a warehouse. The mices here
look and behave quite diffently. They have real grain instead of ex-
crement in the toilet. There are no dogs to scare them off, human
being do not frequent the warehouse as they do to the privy. Mice looks
content, eating slowly on his own pace, as if whole grain house belongs
to them. Ri-Shi got enlightened..."Men is also like mice. His value
depends on where he is...in which corner of this society he places himself.
He quit the small job and knocked on the door of the master Hsien Tsu,
who regarded human nature evil by birth in contrary to Confucius who
regarded human mind naturally endowed with benevolence and compassion.
In this school of Hsien-Tsu Li-Su met Han Wei Tsu, a stuttening Machia-

velian, who (died 233 BC) suggested that the state be governed by strict
law and harsh punishment and not by virtue and rituals. (For Confucius
even music was an important tool to govern the nation.)

The mighty Chin Shi Hwang emperor (the builder of the great wall) read
Han Wei Tsus Essays and sighed: "If I can meet this genius I will be
satiesfied even if I die tomorrow." This episode reminds me allways of the
sudden emergence of Henry Kissinger, in the Nixon administration, the
goverment of "Realpolitik".

Meantime Li-Su (the disciple of Hsien-Tsu and mice) is now serving the
mighty Chin Shi Hwamg emperor to whome he adviced "If his majesty want
to meet Han Wei Tsu, we better invade the Han country. Han Wei Tsu is a
prince of Han Country and he will come certainly as a member of peace
delegation."

Soon Han country was attacked by the mighty Chin Shi Hwang emperor, and
Han Wei Tsu came as diplomat. The Chin emperor treated him well and
got excited by his revolutionairy statecraft theory, yet has not
quite made up his mind in employing this stuttering genius as his minister.
Li-Su, the mice-enlightened, got jealous and worried about the new
superior competition. "His majesty, Han Wei Tse is a smart man but also
he is the prince of our rival Hun country, He may betray us in the
national emergency." And Li-Su approached to the emperor's ear and whis-
pered: "Han Wei Tsu knows already too much about us...dont let him cross
the border in one piece."

Han Wei Tzu was suddenly imprisoned. He pleaded for one more audience
with the emperor but Li Su, his class chum, sent him a bowl of poison.
Ironically Han Tze had allready written a major essay on the danger of
preaching the emperor which is "as dangerous as caressing the scales...
"negative" scales...of an angry dragon."[13]

The prime minister said to his minister : "I just met Mr. Confucius.
After seeing this great man you look like a lice or a flea. I will
introduce him to the king."
The minister worried about his position, if Confucius got hired, said
to the prime minister: "If the king sees Confucius, you may look like
a flea or a lice."
The prime minister cancelled the appointment and let Confucius go.

(Confucius wandered 40 years to get a job or to try out his
goverment theory in the praxis, but nobody hired him).[14]

"Half the Peach"

"If the king loves the woman, the position of the empress is dangerous.
If the king loves the boy, the position of the prime minister is in
danger".
- So goes an ancient Chinese proverb from which we can assume that homo-
or bi-sexuality were not in-frequent in ancient China.

Mitsusia was a beautiful boy whom the prince of Rei-country had been indulging
in. One day they were strolling inside an orchard. Mitsusia plucked a
peach from the tree and started eating. Finding the peach unusually de-
licious he stopped at half and offered the rest to the prince, who was
quite moved by this deed. "your devotion to me is such that you even
forget to eat yourself and give me the fruit."

Later the beauty of Mitsusia-boy deteriorated. Prince suddenly remembered
the orchard incident and scolded: " Oh, that impudant, unmannered young!
He gave me once a left-over peach." There are two sides in the half the
peach.

Once the mother of Mitsusia got suddenly ill. Mitsusia rushed to her side
with prince's charriot without his permission which is punishable by the
amputation of both legs.The prince praised him: "What a filiality -
Mitsusia rushed to the bedside of mother even risking the severe punishment."

When love was over the prince raised the same issue again:"This ungreat-
ful undisciplined kid - he stole my car -"[15]

Nail-Salon-Sting

Prine Chao-Hu of Han cut his nails and did hide one nail inside the palm
and said to the servant "I lost a nail, find quickly, quickly..."
and hasted them to find it.

One servant cut his own nail and offered it to the king: "I Found it."

The king found an dishonest servant who was punished accordingly.[16]

How to edit the videotape.

In the Sun country the fence of a rich man's garden collapsed in
heavy rain. Rich man's son said: "If you don't repair the fence tonight,
a robber might break in." The rich man had a neighbour who came also
and said the same thing.
Sure enough a robber broke in through the collapsed fence on that night
and got away with treasures. The rich man praised his son for far-
sightedness, yet suspected his neighbour for robbery.

Two man said the same thing yet one got praised, the other got blamed.

Gaining the knowledge is not so hard. What to do with this knowledge
is harder - says Chencu.

Wang Pu said:
"It is not hard to become a sage - it is harder to find one."

I told this story to Howard Klein, the director of Arts program at Rockefeller Foundation, when
he appointed me as a consult.

I reminded myself of this paradox many times, when I had to pick up 8 artists and supervise their
production, yet unable to do myself, as a consult for a PBS series in 1978.[17]

Smart Man
Heng Kuang king got drunk and took a nap. The officer in charge of his
hat covered him with an overcoat, so that the king doesnot get cold.

When he woke up, the king was pleased that he was covered by the over-
coat and asked who did it. The servant said: "Officer of hat".
The king punished both the overcoat-officer and the hat-officer,
because one neglected his duty and the other did do his non-duty.[18]

A General
The general Wu Chi was assaulting the middle mountain. One of his
plain soldiers got an infection on his foot. The general knelt down
and sucked the puss out with his own mouth.

The mother of this soldier heard this incident and cried. Her neigh-
bour asked: "Why do you cry, when the general is so kind to your son?"
Mother answered in distress: "Once the same general did the same thing
to my husband, also a plain foot soldier. My husband was so moved by
general's care that he fought like hell and died. I bet, my son will
do the same."

- Soon she got the death-notice of her son.[19]

A Paik illustration commissioned for and originally published in *Nam June Paik:
Niederschriften eines Kulturnomaden*, ed. Edith Decker-Phillips (Cologne: DuMont,
1992), 205; courtesy of Edith Decker-Phillips. The characters here are Korean and
Chinese. The second and third mean "Kimchi," the national dish of Korea.

Communication Theory No. 1

In China the rivalling countries often exchanged their princes as
hostages to show good faith.

The king of Wei assigned his trusted minister H to take care of
his prince during his stay at Hantan, the enemies capital, as a hostage.

The Minister H asked the king: "His majesty, if somebody said that
he saw a wild tiger strolling in the downtown market in the broad day-
light, do you believe him?"

King said no.

The minister again asked: "If two men came up and insist that both of
them saw a wild tiger in the market, do you believe the word?"

King again said no.

The minister H: "If three men came up and say in unisono the same
thing, would you believe them?"

King then answered: "Yes. I would believe then a tiger in downtown."-

The minister emphazised the point :

"You see, his majesty, it is apparent beyond any doubt that there
cannot be any tiger strolling in the downtown. But three man can "make"
a tiger in the broad daylight even in your doorstep. The capital of
rivalling Tsao, Hantan, to where I am accompaniing your son is very far.
In my absence, many more than three men will fabricate misinformation and
disinformations to slander me. I sincerely beg you not to trust any
words about me during my absence and talk to me directly when I come
back.

After the hostage term was over, the minister H returned to Wei, but the
king refused to meet him.[20]

Solo and Orchestra

The malaise of the socialistic economy was described at the Han Wei Tse.

A King of Chi loved a grand orchestra. 300 flutist would join in
the large ensemble. After his death his son got crowned, but this new
king loved only the solo music.

Most of the 300 Flutist ran away - they were just fakers who had been imitating
the performance in silence or in pianissimo.

Yet another story of Han Wei Tse speaks of socialist collaboration.

Three lices were arguing vehemently on the back of a fat pig. The forth
louse, a passer-by asked why...Three lices answered: "We are fighting
for the best spot to suck the blood out of this fat pig."

The forth answered: "Look my friends, in the December feast this pig will be roasted in one piece...then we will be burned together. What are you fighting for without worriing the basics?...The forth lice continued: "Let's work together forgetting the small difference...suck the blood out of this pig so much by December that he looks thin and sick... then man will choose another pig to roast..."

The pig and all four lices survived into the new year.[21]

Hostage Drama

The King of Cheng wanted to occupy the Hu country.

He sent his daughter to the king of Hu as his wife.
In a party the king of Cheng asked his ministers:
"I want to occupy one country, which country do you suggest?"
A minister suggested: "Country of Hu."
The king got enraged: "I just let my daughter marry to the king of that country. How can I dare to kill my daughter's husband?
The minister was executed.

The king of Hu, sleeping anyway with the daughter of the king of Cheng heard this episode and loosened the defense of the border.

Suddenly the Cheng army rushed and occupied/annexed the Hu.

This is from Han Wei Tse.....and Han Wei Tse, writing this story failed to mention the fate of the poor Cheng daughter.[22]

Painted Dragon, Pointed Eyes

Once I visited Tokyo's Ueno Museum to see 48 Buddha from Japan's Sho Soin collection. There was a strange old man, who closed his eyes in front of every Buddha and shaked his second and third finger of his right hand as if he was interrupting an invisible ray between his eyes and Buddha's eyes . A passer-bey who asked him why he would repeat such an eccentric gesture got this answer: "There are two kinds of Buddhas; one created by the priest as an act of pure worship and the other manufactured by the craftsman just for money. The former kind of Buddha gives him, who said he was an antic-dealer a spark of light between his second and third finger and the latter case just darkness.

In China this two traditions of visual arts culminates in the Ching Dynasty (ca. 18th century) in the schoon of Wên Jên Hua which means litteraly "painting by men of letters" the amateurs in the best sense.

A Paik illustration commissioned for and originally published in *Nam June Paik: Niederschriften eines Kulturnomaden*, ed. Edith Decker-Phillips (Cologne: DuMont, 1992), 192; courtesy of Edith Decker-Phillips. About two-thirds of the text is written in Chinese characters only—from column one to the middle of column nine, unusually starting at the left—giving a passage from *Biyanlu*, a Buddhist text composed during the Song Dynasty (960–1276 C.E.). Cf. *The Blue Cliff Record*, trans. Thomas Cleary (Berkeley, CA: Numata Center for Buddhist Translation and Research, 1998), 352.

Personally I jumped around many media (from musicogy to composition,
then to object making, video, drawing, oil painting, piano playing and
finally again back to book-writing in order not to become a craftsman
and to preserve the spirit of Su-Da-Fu class (Chinese equivalent to greco-
roman Freeman.)

A Paik illustration commissioned for and originally published in *Nam June Paik: Niederschriften eines Kulturnomaden*,
ed. Edith Decker-Phillips (Cologne: DuMont, 1992), 173; courtesy of Edith Decker-Phillips. The Chinese character *xin*
means heart. Part of the character is transformed into two birds which form a group with four flying birds.

Mr. Zhang Sêng Yu of the Liang dynasty (502-557 AD) was also one of those
Shi class gentleman, who serves in the court if he is called, and write
poetry in his country home if time is in adverse. He was a right army
general and climbed up to the goverver of the province Wu Hsing. One day he
painted on the wall a scene of the rainforest. Next morning many birds
were found dead in front of his painting. These poor birds mistook his
rainforest for real and crashed their heads.

Later he made an excursion to the temple of peace and pleasure at Chinling now Nanking near Shanghai
and painted four dragons. However he did not complete the painting. The
eyes were missing in every painting. The on-lookers cheered - "Hey the
master, how it comes your dragon has no eyes?---"There aint no dragon
with no eyes"---
Zhang Seng Yu retorted: "dragon will fly away, if I put eyes."
Villagers were not convinced calling this painter-general a faker-
swindler.
Finally the master grabbed a brush...no sooner he put eyes in the
dragon the thunder struck the temple. The villagers could see in the
lightning that the painted wall cracked and the living dragon revealed
herself through it and crawled out.
In the ensuring heavy rainstorm a large carpet of dark cloud wrapped
up the temple and dragon hopped on this cloud and ascended into the
sky.
Immediatly the sunshine returned and villagers could see only 3 dragons
on the wall, for which eyes had not been painted.

Since then Chinese say if a painting is absolutely perfect,
"Painted dragon, painted eyes..."
My favorite Laotze is:

 "To know or to learn how to be satisfied..." is a very important thing.

 How to be satisfied with 75%
 ?
 that is the secret of my life.
 Lower your expectation.
 Yet work 100%.
for better or worse, this Lebensanschauung is shared by Confucian-Buddhist countries of the East
Asia.[23]

Arts / Music

There are two kinds of arts.
Non-gravity arts (music, dance, verbal poetry, folk stories and video) and gravity oriented arts
(monuments, sculpture, painting, architecture and printed literature).

The latter emerged only 20 000 years ago after the transition of nomadic life of hunter-gatherers and tribal economy to the static agrarian economy based on private ownership of land. But history of music and dance must go back many 100 000 years, because only this hypothesis explains such facts as why Korean music is closer to Hungarian music than to the Japanese music. Or certain rituals of Crimean tartar, observed by Joseph Beuys during World War II are much closer to Korean shamanism than Japanese Shinto is to Korean ritual. This explains why the vast volume of Shiji, the Chinese history cum encyclopedia before 60 B.C., gave only the sporadic mention of visual arts whereas it gave no.2 position to music in its general system spending thousands of words. (The order of seven books in Shiji: 1 Ethics; 2 Music; 3 Law; 4 Astrology; 5 Economy etc.)

The medieval Christian theology, which must have retained 10 000 years of Jewish nomadic tradition, gave equally prominent role to music as the Chinese, which have inherited also the vast accumulation of nomadic culture of Northern-Mongolian nomads. The recent research is proving that the famous Yin Dynasty is from northern (Non-Chinese) tribes and they used to wear white clothes as Koreans still do. Confucius said: "When I heard first the music of Chi country, I forgot the taste of meat for three months." (Chi is today's Shan-tung province, very close to Manchuria and Korea).

Musical economy and experience is still more communal or tribal than painting/sculpture. Whereas painting and sculpture became the new commodity of capitalistic speculation, musical economy is maintained by the mass of people who buy mass-produced records.[24]

In 1960 at the palace of Peggy Guggenheim in Venice I asked John Cage
why he is a musician? He said: "Because I promised so to Schönberg."
I asked again: "Why then are you still a musician?", which made him sober.
"In my adolescence I vaccilated between architecture and music. In
architecture you gather things and built them permanently, but in music
you give away yourself...I wanted to give up my ego, myself,
therefore I choose to be a musician.
Yasunao Tone (Fluxus composer since 1962) is also a scholar of Semiotics. He made a successful musical composition based on Shi-Chi for Merce Cunningham, which were choreographed by Merce Cunningham and danced by whole Cunningham Dance Company for many seasons.[25]

Music 2

Poya was a master in harp performance, Tsung Tzǔ Chi a genius in appreciation. One day Poya plucked the tune imaging a mountain-climbing.
Tsung Tzu Chi exclaimed: "I see a rugged ridge before me."
Another day Poya improvised a tune thinking about running water,
Tsung Tzu Chi responded: "What a profound river...."

On an autumn day the two met violent storm at the mountain. Sheltering
themselves under the gigantic rock Poya plucked a sentimental tune
first thinking about the endless rain and then about the collapse of a
huge mountain. In each case Tsung Tze Chi described what was on Poya's mind
who then put aside his harp and sighed: "What a listening ability. My
sound cannot escape from your grasp."

Tsung Tzu Chi died.

Poya broke the harp, cut the string and never touched the instrument
again. There was no more man wothwhile playing for.

It was the story of China in 9th century recorded in Shi Chi.
In 1964 I accompanied Prof. Nomura to a zen musician in Japan who played
a piece with this remark.
"I'll play a flute piece now for you,
it is my best composition,
therefore I've never played for anybody yet."
(Of course in the west, the better a piece is the more it gets played.)

Nietsche said on Wagner:
 "Great history needs great historian."[26]

Study
If you study
and not think

you are
in the dark

if you think
and not study

you are
in peril.
 (Confucious)[27]

I once
did not eat
whole day
and did not sleep
whole night

and

kept thinking

but it did not do
much good to me

pure thinking
is not as good
as reading.

(Confucious)[28]

A Paik illustration commissioned for and originally published in *Nam June Paik: Niederschriften eines Kulturnomaden*, ed. Edith Decker-Phillips (Cologne: DuMont, 1992), 245; courtesy of Edith Decker-Phillips. The calligraphy gives the titles of four poems by the Korean poet Kim Sowol (1902–1934), from right to left "Sanyuhwa" (Flowers in the Mountains), "Chindallae" (The Azaleas), "Wangsimni" (a name), "Yen-niyagi" (An Old Tale). Cf. Sowol Kim, *Fugitive Dreams*, trans. Jaihiun Kim and Ronald B. Hatch (Vancouver, BC: Ronsdale Press, 1998).

Recently Michael Hart, an american historian, proposed a bold hy-
pothesis. Western civilisation had been more advanced than the
chinese culture upto the 2nd century AD but at that point the progress
scale got reversed,...Chinese civilisation not only caught up with the
western civilisation but actually did lead her up to 15th century.
But from the 15th century on, the West became the leader again up to now.
Mr. Michael Hart thinks that the inventions in the communication field,
the paper in second century and the printing press in 15th century,
were the decisive factors in this two reversals. (Of course the
koreans and chinese invented the movable type before Gutenberg but the
impact of automation is vastly different in the phonetic culture of
26 letters (elements) and pictographic culture with 50 000 symbols.)
According to Mr. Iwamura, japanese specialist on mongolian history,
horse was domesticated only 1000 BC (old fossils show the horse not
larges than today's dog) The sudden progress of humanity aruond 1000 BC
may have come from the invention of horse which not only changed the
substance of warfare and transportation but also the communication.!![29]

A Paik illustration commissioned for and originally published in *Nam June Paik: Niederschriften eines Kulturnomaden*, ed. Edith Decker-Phillips (Cologne: DuMont, 1992), 220; courtesy of Edith Decker-Phillips. The characters at right correspond to the drawing at left: *san* (mountain), *su* (water), *in* (human being).

Law and Order

Harrison Salisbury of the New York Times wrote in his "Peking an Beyond":
"I think that it is a great achievement to put man on the moon. But to
put a man on the earth...that is even more."

In order to put a man on the earth, the ancient chinese emphasized the
group-collaboration than the individual freedom.

The symbol of MAN

is made from two sticks. When you take one away, the other must fall
down. "Man" is often written as "between man."

Actually in chinese grammar there is no distinction between singular
and plurals. The most important concept in the Confucian Jin (benevolence)

is made out of four sticks, meaning two men.

This symbol means "benevolence, virtue, generosity" but never a hot
and passionate <u>love</u>, a one to one (Ich-Du) relationship, central to the
Christianity.

It is remarkable and cannot be over-emphaszed that among 5oooo chinese
symbols, and their 5oooo x 5oooo combinations ? 500 000 000 (two and
half billion combinations) there is no symbol meaning freedom. Theodore
White (China correspondent of TIME during WW II) had hard times to
explain this concept of freedom to Mao Tze Tung in Yennan in 1943-44
who tend to equate the freedom to individual greed and egoism.
(See Mao's essay on liberalism)

Martin Luther King Jr. said: "It may be true that law can not make a
man love me, but it can keep him from lynching me."

Around 500 BC , chinese society grow so complicated that the idealistic "benevolence"
of the feudal lord was not enough as a governing normative and there
were no guarantee from the excessive exploitation or cruelty by the upper
class.

A clear, objective law became necessary. But law requires communication, a decree. To enforce some harsh laws to the population without prior notice (if not consent) will breed complain and rebellion.
But how can you notify a new software called "law" to the unalphabetic people without the benefit of TV or printing press?

They used the rumors, the mysterious bird of human mind. Some rumors travel faster than other rumours, as some news stories have more commercial value than others in today's papers.

2 million Dollar trees

Lord Shang of Chin set up a simple pole at the southgate and offered 1 million dollar for anybody who moves the pole to the northgate.
"One million dollar for a half day's work? Lord Shang is kidding."
Nobody took this notice serious.

Then Lord Shang doubled the reward.
One guy moved the tree, just for fun, least expecting 2 million dollars, but he was promptly rewarded as decreed - now whole population realized that the goverment meant business.

At this moment the Lord announced the whole set of new laws, very strict one accompanied by harsh punishment.

Within a year people flocked to the court to complain about the law. They were all severely and equally punished including the crown prince himself.

Thus this harsh and objective law got obeyed well. In a year many people found that the new life under the clear law was actually quite convenient. They again flocked to the court this time to praise the law. But these consenters were equally severely punished as the dissenters...
...since than nobody said
anything anymore.

With the new law the Chin country became rich and strong. But when the king died, the crown prince, who was once punished by Lord Shang, got coronated. Lord Shang, the law maker, escaped in disguise but the city's gate keeper said: "Lord Shang's law said not to let anyone out without the passprt."
He then went to a hotel but the hotelier said: "Lord Shand said not to let anyone sleep without the passport."

Lord Shang sighed: "Did the harm of my law reach to this extent?"

He was trapped by his own decree, as Nixon was trapped by his own tape.
Lord Shang was publicly executed...four ox-carts pulled his four limbs
apart in the market place into 4 directions.

China grew even stronger with the new harsher laws. When two men de-
nounced the king, whole family got wiped out. When three men denounced
the king, whole kinship got wiped out. Famous book burning and the burial
of thousands of scholars took place in this regime. When Han's emperor
liberated China from Chin, he declared:

> "We will have only thress lines of law...
> Dont kill
> dont harm
> dont steal.

HAN lasted 400 years, whereas the united Chin lasted only 16 years,
4 years longer than Hitler.[30]

General

Laotze said: "Big bowl is slower to fill up", meaning a really big
talent is often a slow-bloomer. General Han Shin was also a slow starter,
who who did look a little stupid and timid. When he was a late-teen a
butcher kid tried to get him into a fight in a crowded market.

"You slob, you have a big body, you carry a big sword, but we've never
seen you use it. You coward, hit me, stab my chest with your sword -
is it just a decoration? If you dare not, crawl on all fours between my thighs."

Han Shin surveyed this reckless kid carefully...
He stooped and knelt down and crawled on his knees through the thighs of this hooli-
gan.
Whole market jeered and bantered him as a coward.

Later Han Shin came back as the greates general of that time. He seeked
out this hooligan and gave him the rank of a lieutenant.

Among the 100 heroes in ancient China this general Han Shin is my most favorite personality. I
named 1003 TV Tower in Korea after him. The more, the better is his word: "The more soldiers
there are, I can guide/lead them better."[31]

Case Studies and Abstraction

Harvard business school teaches mainly "case studies, and not so much the theory or principle.
Shi-Chi is also full of such cases studies and not of much theory. Greeks are genius of "abstrac-
tion. They made the architecture, with the set of common denominators, which were abstracted

from far many more layers of common denominators. Finally a few sets of equations and multiple combinations of only 26 phonetic signs expressed their world. The chinese went to the opposite directions. When they enconter the new fact, they invented new symbols. When are faced with new situations, they coined the new combination of symbols. They ended up inventing 50,000 symbols, and permutation of 50,000 symbols are 50,000 x 50,000 x 50,000 = 125,000,000,000,000. In the 19 century, a few guns were enough to destroy this house of card.[32]

The Palm of Duchamp

To fight
 on the horn of a snail
 (Chen Chi
or
to dance on the palm of
 Buddha's hand,
 Thinking it is the big world.
 - - - -

from 1960 to 80,
 most artists danced in
 The palm of Duchamp, who said
art is not art,
art is not not art
art is not not not art
 - - - - - - -

and forgot the number of "not" whether
 it is on a positive case or
 on the negative case
Montaigne and Chen Chin
Montaigne rhymes well with Chen Chin.
a philosopher is playing with a cat—
Is the philosopher playing with the cat?
 or
is the cat playing with a philosopher.

Chen Chin's well known fable—
A man dreamt, he became a butterfly in the dream
 he wonders,
 Am I a man, dreaming to be a butterfly
 or
 am I a butterfly, dreaming to be a man.

Dream is a time tunnel. Dream, as a device to extend or compact the time-distance is
a favorite sports of surrealist, in the west (French)
or in the east.[33]

The Role of Blacks

Ted Koppel is saying that George Orwell was wrong,—TV brought down the wall. I said the same thing back in 1983 and N.Y. Times headlined it (ND: "Artist Challenges Orwell's view" by Grace Glueck). Ironically Polish people, who started the whole process, were out of reach of Western TV.

It was jazz and Rock, largely created or influenced by black musician, which penetrated deep into the iron curtain and touched the hearts and minds of caged souls. In the Heyday of Vietnam protest black musicians and dancers softened the anti-american feelings of French and German intellectuals through their performances and workshops in Paris and Berlin. Alvin Ailey told me personally in 1968 that the high point of his carreer was an evening in Hamburg when normally reticent North European snobs brought down the theater. Both Koreans in Flatbush and Americans in general must acknowledge that Blacks played a major role in winning the cold war as they did so in the Iron triangle and Hamburger Hills in hot wars. And a little money from National Endowment on the arts sustained them in a long march from ghetto to chant d'eElysee, as they did so in my long jump from Seoul to the Whitney Museum.

The NEA and a certain portion of the Welfare budget must be considered as a legitimate part of the Pentagon and CIA budget. Future global competition will move from hardware to software. The Interaction of Hybrid genes in America is a positive asset both in art and science which nobody can copy.[34]

NOTES

1 Cf. Sima Qian, *Records of the Grand Historian of China translated from the Shih chi of Ssu-ma Ch'ien*, trans. Burton Watson (New York: Columbia University Press, 1961), vol. 2, 274. Cf. Zhuangzi, *The Complete Works of Zhuangzi*, trans. Burton Watson (New York: Columbia University Press, 2013), 131.

The quality and condition of horses was of course highly important, especially in warfare and communication in a country as big as China. Therefore numerous passages in the ancient literature deal with the horse in various aspects. The "blood-sweating horses," though, reflects a misunderstanding. Today it is known that in these cases the animals suffered from parasites.

2 Han Feizi, trans. W. K. Liao, online at University of Virginia website *Traditions of Exemplary Women*, www2.iath.Virginia.Edu:800/exist/cocoon/xwomen/texts/list, Han Feizi, Book 8, Chap. XXIII, Collected Persuasions. The Lower Series, 1.

3 Ibid., Book 10, Chap. XXXI, Inner Congeries of Sayings. The Lower Series: Six Minutiae, 4.

4 Liu An, *The Essential Huainanzi*, ed. and trans. John S. Major, Sarah A. Queen, Andrew Seth Meyer, and Harold D. Roth (New York: Cambridge University Press, 2012), 193.

5 Liezi, *Taoist Teachings from the Book of Lieh Tzu*, trans. Lionel Giles (New York: E. P. Dutton, 1912; rpt. London: Forgotten Books, 2012), 65.

6 Ibid., 69.

7 Han Feizi, trans. W. K. Liao, online, Book 7, Chap. XXII, Collected Persuasions. The Upper Series, 1.

8 Confucius, *The Analects*, trans. D. C. Lau (London: Penguin Books, 1979), 107: "Chi-lu asked how the spirits of the dead and the gods should be served. The Master said, 'You are not able even to serve man. How can you serve the spirits?' 'May I ask about death?' 'You do not understand even life. How can you understand death?'"

9 Sima Qian, *Selections from Records of the Historian*, trans. Yang Hsien-yi and Gladys Yang (Beijing: Foreign Languages Press, 1979), 23: "When three walk together, there must be one who can teach me." Cf. Confucius, *The Analects*, 88: "The Master said, 'Even when walking in the company of two other men, I am bound to be able to learn from them. The good points of the one I copy; the bad points of the other I correct in myself.'"

10 Confucius, *The Analects*, 63: "The Master said, 'At fifteen I set my heart on learning; at thirty I took my stand; at forty I came to be free from my doubts; at fifty I understood the Decree of Heaven; at sixty my ear was atuned; at seventy I followed my heart's desire without overstepping the line.'"

11 Laozi, *Daodejing*, trans. Luke Howard Boyd (CreateSpace independent publishing platform, 2012), 127. The first two lines of Chapter 56: "The knowing aren't talkative, The talkative aren't knowing."

12 Han Feizi, trans. W. K. Liao, online, Book 8, Chap. XXIII, Collected Persuasions, The Lower Series, 4. Cf. Han Feizi, *Basic Writings*, trans. Burton Watson (New York: Columbia University Press, 2003), 66.

13 Sima Qian, *The Grand Scribe's Records*, ed. William H. Nienhauser, Jr. (Bloomington: Indiana University Press, 1994–), vol. 7, 335.

The biographies of Han Feizi (Memoir 3, *Shiji* 63) and Li Si (Memoir 27, *Shiji* 87) are part of "The Memoirs of Pre-Han China by Ssu-ma Ch'ien." These books of the *Shiji* — among others — hadn't been translated into English by Burton Watson. The Nienhauser edition started out to fill these gaps and developed into an ongoing project with the goal of making the complete *Shiji* available in English.

The saying "caressing the scales of an angry dragon" appears at the end of the Mi Tzu Hsia / Mi Zixia anecdote in Han Feizi's biography (ibid., 28): "'The dragon is the sort of creature which can be tamed and even ridden. But underneath his chin he has scales that curl outward, each a yard in diameter, and if you tug him by one, he will kill you. The rulers of men also have curling scales; to advise them without tugging on one is close to success.'" Cf. Han Feizi, *Basic Writings*, 79.

14 Han Feizi, trans. W. K. Liao, online, Book 7, Chap. XXII, Collected Persuasions. The Upper Series, 1.

15 Han Feizi, *Basic Writings*, 78. Cf. Sima Qian, *Records of the Grand Historian of China*, vol. 2, 467; Sima Qian, *The Grand Scribe's Records*, vol. 7, 28.

16 Han Feizi, trans. W. K. Liao, online, Book 9, Chap. XXX, Inner Congeries of Sayings. The Upper Series: Seven Tacts, Annotations to Canon VI, 12.

17 Han Feizi, *Basic Writings*, 77. Cf. Sima Qian, *The Grand Scribe's Records*, vol. 7, 28.

18 Han Feizi, *Basic Writings*, 31.

19 Sima Qian, *Selections from Records of the Historian*, 33. Cf. Han Feizi, trans. W. K. Liao, online, Book 11, Chap. XXXII, Outer Congeries of Sayings. The Upper Left Series, Annotations of Canon III, 9.

20 Han Feizi, trans. W. K. Liao, online, Book 9, Chap. XXX, Inner Congeries of Sayings. The Upper Series: Seven Tacts, Annotations to Canon I, 5.

21 Ibid., Book 9, Chap. XXX, Inner Congeries of Sayings, The Upper Series, Seven Tacts, 10; ibid., Book 8, Chap. XXIII, Collected Persuasions, The Lower Series, 3.

22 Han Feizi, *Basic Writings*, 77.

23 Cf. *Zhou Mi's Record of Clouds and Mist Passing Before One's Eyes: An Annotated Translation*, trans. Ankeney Weitz (Leiden: Brill, 2002), 53, annotation 112: "Zhang Sengyu was active at the court of the Liang kingdom during the early sixth century and served the government as a painter and general, as well as the Magistrate of Wuxing. In painting, he specialized in portraits, Buddhist and Daoist figural subjects, and dragons."

Most of Zhang Sengyu's work is lost, but his style was admired in later centuries, as shown in Zhou Mi's (1232–1298) *Yunyan Guoyan Lu*. The legend of the four dragons may not have any historical source but was included in the compilation of Chinese sayings of Mikio Hosoda, *Kanbun Koji Shō-jiten* (Tokyo: Kenkyûsha, 1956), that Paik used as source for his retold anecdotes.

24 Sima Qian, *Selections from Records of the Historian*, 3. Cf. Confucius, *The Analects*, 87: "I never dreamt that the joys of music could reach such heights."

This passage was not included in *Kulturnomaden*.

25 *Music, Genealogy* was composed for Event #201 by Merce Cunningham for the February 3, 1978, performance.

This passage was not included in *Kulturnomaden*.

26 *Shiji* 23, the story of Bo Ya and Zhong Ziji, will be included in volume 4 of the Nienhauser edition of *The Grand Scribe's Records*. *Shiji* 23 is one of Sima Qian's books that were not translated into English by either Burton Watson or Yang Hsien-yi and Gladys Yang. Édouard Chavannes as well left books 23 to 30 out in his historical French translation. This again indicates that Paik relied on the Japanese edition of Fumio and Takeo Otake, which is a complete translation.

27 Confucius, *The Analects*, 65.

28 Ibid., 136.

29 This text was not included in *Kulturnomaden* but had been published before as part of the essay "From Horse to Christo" (1981; reprinted in this volume).

30 Sima Qian, *Selections from Records of the Historian*, 63, 68. These Lord Shang stories are also part of the essay "From Horse to Christo."

31 Sima Qian, *Records of the Grand Historian of China*, vol. 1, 209. The giant video sculpture *The More The Better* with 1003 television sets was conceived for the Olympic Games in Seoul, 1988.

32 The last three pieces are taken from a manuscript in Smithsonian American Art Museum, Nam June Paik Archive (Box OV54, Folder 2).

33 Ibid.

34 Ibid.

Names Cited in Nam June Paik's Writings

Shuya Abe (1932–): Japanese artist and engineer who worked with Nam June Paik to create the Paik-Abe Video Synthesizer and *Robot K-456*.

Edwin H. Armstrong (1890–1954): American electrical engineer known for developing FM radio.

David Atwood: producer at WGBH in Boston where Paik produced the video footage included in *9/23/69: Experiment with David Atwood* in 1969.

Russell Baker (1925–2019): American writer and columnist for the *New York Times*.

Clive Barnes (1927–2008): English writer and critic who was the dance and theater critic for the *New York Times*.

Jean-Louis Barrault (1910–1994): French actor, director, and mime performer.

Gregory Bateson (1904–1980): English anthropologist, linguist, and semiotician who helped apply cybernetics and systems theory to social sciences.

Gregory Battcock (1937–1980): American artist and writer featured in Paik's 1978 video-tape *You Can't Lick Stamps in China*.

Mary Bauermeister (1934–2019): German artist involved in Fluxus; performed in her former husband Karlheinz Stockhausen's theater piece *Originale* in 1961 along with Paik.

Norman Bauman: physicist, wrote about Paik in the *Cybernetic Serendipity* catalogue.

Stephen Beck (1950–): multimedia and video artist who created an early video synthesizer in 1969.

Carol Bergé (1928–2006): American poet and organizer of the art scene on New York's Lower East Side.

Joseph Beuys (1921–1986): a leading postwar German artist, art theorist, and activist who is featured in Paik's 1990 video installation *Beuys Projection*.

Ridolfo Luigi Boccherini (1743–1805): Italian composer and cellist.

René Block (1942–): German art dealer, collector, and publisher.

George Boole (1815–1864): English mathematician and philosopher, known for the development of Boolean algebra.

Pierre Boulez (1925–2016): French composer, conductor, and writer.

George Brecht (1926–2008): American avant-garde composer and conceptual artist and member of Fluxus.

Carolyn Brown (1927–): American dancer, choreographer, and a founding member of the Merce Cunningham Dance Company.

Ralph Burgard (1927–2008): first director of the Arts Councils of America and an advocate for the creation of community arts programs.

John Cage (1912–1992): American composer and music theorist who collaborated frequently with choreographer Merce Cunningham, also his longtime romantic partner.

John Canady (1907–1985): American art critic and author; longtime art critic for the *New York Times*.

Dick Cavett (1936–): American television personality and talk show host.

Christo (1935–): Bulgarian artist who, with his wife **Jeanne-Claude** (1935–2009), created large-scale environmental works of art, including wrapping well-known buildings like the Reichstag in Berlin.

Shirley Clarke (1919–1997): American independent filmmaker.

Wendy Clarke (1944–): American video artist.

Maxi Cohen (1949–): American filmmaker and multimedia artist and the director of the first public access facility in the country, part of the Alternative Media Center.

Russell Connor (1929–2019): American television producer, educator, and contributor to Paik's early television pieces.

Daniel Cordier (1920–): French art dealer and historian involved in the French Resistance.

Merce Cunningham (1919–2009): influential American dancer and choreographer who shaped American modern dance and frequently collaborated with John Cage, who was also his longtime romantic partner. Cunningham is featured in Paik's videotape *Merce by Merce by Paik* (1978).

Douglas Davis (1933–2014): American artist, writer, and critic for *Newsweek*.

Jos Decock (1934–): Belgian painter and sculptor living in France.

Josquin des Prez (ca. 1450–1521): French Renaissance composer.

Dimitri Devyatkin (1949–): American director, producer, and video artist.

Robert Filliou (1926–1987): French artist and "action poet" associated with Fluxus.

Ken Friedman (1949–): Member of Fluxus and former general manager of Dick Higgins's Something Else Press; currently professor of design innovations studies at Tongji University.

R. Buckminster Fuller (1895–1983): influential American architect, systems analyst, designer, and futurist known for designing the geodesic dome.

John Kenneth Galbraith (1908–2006): Canadian-born economist, diplomat, and public intellectual who was a proponent of American liberalism.

Kit Galloway (1948–) and **Sherrie Rabinowitz** (1950–2013): co-founders of the Electronic Café International, a café, performance space, and workshop space in Santa Monica, California.

Henry Geldzahler (1935–1994): American curator of contemporary art, art critic, and art historian who was at one time the New York City Commissioner of Cultural Affairs.

Thrasybulos Georgiades (1907–1977): Greek musicologist, pianist, and civil engineer.

Phyllis Gershuny: artist and co-founder of the *Radical Software* video journal.

Frank Gillette (1941–): American video artist and co-founder of the Raindance Corporation, a media think tank.

Allen Ginsberg (1926–1997): American poet, activist, and influential member of the Beat Generation, featured in Paik's videotape *Allan 'n' Allen's Complaint* (1982).

Philip Glass (1937–): American composer known for creating "minimal music."

Karl Otto Götz (1914–2017): German artist, filmmaker, and professor of art at the Kunstakademie Düsseldorf, often known as K. O. Götz; member of the German Art Informel movement.

John Gruen (1926–2016): American cultural critic who wrote about music, art, dance, and theater.

Hans Haacke (1936–): German-born artist who works in the United States; longtime professor at the Cooper Union in New York City.

Walter Hallstein (1901–1982): German diplomat and politician; one of the founders of the European Union.

Dick Higgins (1938–1998): British composer, poet, printmaker, and Fluxus artist; was married to Alison Knowles.

Ralph Hocking (1931–): leader in the field of electronic media art and founder of the Experimental Television Center; former professor of video and computer art at Binghamton University.

Edmund Husserl (1859–1938): German philosopher who established the theory of phenomenology.

Toshi Ichiyanagi (1933–): Japanese avant-garde composer; studied with John Cage.

Ray Johnson (1927–1995): American artist known for his mail art and collage.

Béla Julesz (1928–2003): Hungarian-born American visual neuroscientist and experimental psychologist who headed the Sensory and Perceptual Processes Department at Bell Labs.

Ellen and Lynda Kahn: co-founders of TWINART, designers, artists, and storytellers.

Herman Kahn (1922–1983): American futurist, military strategist, and systems analyst who was a founder of the Hudson Institute.

Kas Kalba: a member of the Sloan Commission on Cable Communications and professor at Harvard and MIT.

Allan Kaprow (1927–2006): American painter and performance artist; helped develop the Happenings of the 1950s and 1960s. Kaprow is featured in Paik's 1982 videotape *Allan 'n' Allen's Complaint.*

Christine Keeler (1942–2017): English model who became involved with John Profumo, a married government minister and Soviet diplomat at the height of the Cold War.

Alfred Kinsey (1894–1956): American biologist and founder of the Institute for Sex Research at Indiana University.

Howard Klein (1931–): American music critic and pianist; Director of Arts and Humanities at the Rockefeller Foundation from 1973 to 1986.

Yves Klein (1928–1962): French painter and leading member of Nouveau Réalisme, performance art, and pop art.

Billy Klüver (1927–2004): scientist and engineer at Bell Labs who collaborated with Nam June Paik, among other artists, and helped create the multimedia art forms that emerged in the 1960s; one of the founders of Experiments in Art and Technology (E.A.T.).

Milan Knížák (1940–): Czech performance artist, sculptor, musician, art theorist, and dissident.

Alison Knowles (1933–): American artist and founding member of Fluxus known for her installations and performances; was married to Dick Higgins.

Takehisa Kosugi (1938–): Japanese composer and violinist and member of Fluxus.

Shigeko Kubota (1937–2015): Japanese video artist and avant-garde performance artist; member of Fluxus and wife of Nam June Paik.

Robert Kushner (1949–): American painter considered the founder of the Pattern and Decoration movement.

Vytautas Landsbergis (1932–): Lithuanian politician and first head of state after Lithuania declared its independence from the Soviet Union.

Richard Leakey (1944–): Kenyan paleontologist, conservationist, and politician who headed the National Museum of Kenya and the Kenyan Wildlife Service.

Timothy Leary (1920–1996): American writer and psychologist at Harvard University, known for exploring the therapeutic potential of psychedelic drugs.

Jean-Jacques Lebel (1936–): French artist, poet, publisher, and scholar known for developing the Happenings of the 1950s and 1960s.

Claude Lévi-Strauss (1908–2009): French anthropologist and ethnologist who was influential in the theory of structuralism and the development of structural anthropology.

György Ligeti (1923–2006): Hungarian-Austrian composer of avant-garde contemporary classical music.

Norman Lloyd (1909–1980): the Rockefeller Foundation's Director of Arts from 1965 to 1969, and Director for Arts and Humanities from 1970 to 1972.

George Maciunas (1931–1978): Lithuanian-American artist and founder of Fluxus.

Jackson Mac Low (1922–2004): American poet, performance artist, and composer and early member of Fluxus.

Andy Mannik: co-founder of the The Kitchen (originally The Electronic Kitchen), an artist-run art space.

Herbert Marcuse (1898–1979): German-American philosopher and political theorist associated with the Frankfurt School of critical theory.

Max Mathews (1926–2011): American musician and pioneer in electronic music; working at Bell Labs, he wrote MUSIC, a program for sound generation.

Porter McCray (1908–2000): executive director of the JDR 3rd Fund from 1963 to 1975.

Marshall McLuhan (1911–1980): Canadian philosopher, public intellectual, and media theorist known for coining the phrase "the medium is the message" and the term "global village."

Jonas Mekas (1922–2019): Lithuanian-American filmmaker and artist and pioneer of avant-garde cinema; longtime director of Anthology Film Archives.

Henry Miller (1891–1980): American writer who lived in Paris, known for his semiautographical novels.

Yukio Mishima (1925–1970): the pen name of Kimitake Hiraoka, a Japanese author, playwright, actor, and model.

Jean Monnet (1888–1979): French political economist and diplomat; one of the founders of the European Union.

Charlotte Moorman (1933–1991): American cellist and performance artist and frequent collaborator with Paik. Founder of the Annual Avant-Garde Festival of New York.

Jean Moulin (1899–1943): member of the French Resistance who died in Gestapo custody.

A. Michael Noll (1939–): American engineer and professor emeritus at the Annenberg School for Communication and Journalism at the University of Southern California; pioneer in digital computer art who worked for a time at Bell Labs.

Yoko Ono (1933–): multimedia and performance artist, singer, and songwriter who was involved in Fluxus and in the downtown art scene in New York City.

Otto Piene (1928–2014): German artist specializing in technology-based art, and director of MIT's Center for Advanced Visual Studies.

Frank Pileggi: American artist and second husband of Charlotte Moorman.

Henri Poincaré (1854–1912): French mathematician and theoretical physicist who influenced applied mathematics and mathematical physics.

Steve Reich (1936–): American composer, a pioneer of minimal music.

Wilhelm Reich (1897–1957): Austrian psychoanalyst who influenced a generation of psychoanalysts; explored the idea that personality is expressed in the way the body moves.

Pierre Restany (1930–2003): French art critic and philosopher; coined the term Nouveau Réalisme.

Michael Rice (1942–1989): vice president and general manager of WGBH, Boston.

Jean-Claude Risset (1938–2016): French composer who made major contributions to computer music.

Al Robbins (1938–1987): American experimental video artist.

Margarete Roeder: dealer of conceptual and performance art and founder of the Margarete Roeder Gallery in New York City, which represents the estates of John Cage and Merce Cunningham.

Arturo Rosenblueth (1900–1970): Mexican researcher and physician, known as one of the founders of cybernetics.

Dieter Rot (1930–1998): Swiss artist known for his artist books, sculptures, and works made of found materials; worked with many members of Fluxus.

Paul Ryan (1943–2013): American video artist and communications theorist.

Niki de Saint Phalle (1930–2002): French-American sculptor, painter, and filmmaker known for her monumental art and assemblages.

Ryuichi Sakamoto (1952–): Japanese composer, musician, performer, writer, actor, and dancer.

Erik Satie (1866–1925): French avant-garde composer and pianist.

Alfred Schmela (1918–1980): German gallery owner and artist; owner of Schmela Gallery in Düsseldorf.

Tomas Schmit (1943–2006): German artist and author and early member of Fluxus.

Ira Schneider (1939–): American video artist based in Berlin.

Arnold Schoenberg (1874–1951): Austrian-American composer, theorist, and painter associated with the expressionist movement in German art.

Klaus Schønning (1954–): Danish musician known for his work in new age music.

Robert Schuman (1886–1963): French diplomat who was twice the prime minister of France; one of the founders of the European Union.

Albert Schweitzer (1876–1965): French-German theologian, writer, philosopher, and physician; received the Nobel Peace Prize in 1952.

Ravi Shankar (1920–2012): Indian musician; sitar player and composer of Hindustani classical music.

Mieko Shiomi (1938–): Japanese artist and composer who founded the group Ongaku to explore improvisation.

Hanns Sohm (1921–1999): German dentist and collector of artworks and documents of the Fluxus, Neo Dada, and Viennese actionism movements as well as concrete poetry.

Wolfgang Steinecke (1910–1961): German musicologist and founder of the International Summer Courses for New Music (Internationale Ferienkurse für Neue Musik) in Darmstadt.

Karlheinz Stockhausen (1928–2007): German composer known for his electronic music and the introduction of chance into his compositions.

Jim Tenney (1934–2006): American composer and music theorist.

Valentina Tereshkova (1937–): Russian cosmonaut, the first woman to fly in space in 1963.

Jean Tinguely (1925–1991): Swiss painter and sculptor known for his sculptural machines.

Calvin Tomkins (1925–): art critic for the *New Yorker* and author of a profile of Paik for the magazine in 1975.

Frank Trowbridge (1941–): American artist who famously won a literal pissing contest that Nam June Paik called the Fluxus Champion Contest in 1963 in Düsseldorf.

David Tudor (1926–1996): American pianist and composer of experimental music.

Hideo Uchida: engineer, inventor of the transistor.

Günther Uecker (1930–): German sculptor and installation artist; co-founder of the international artists' group ZERO.

Paul Valéry (1871–1945): French poet, essayist, and philosopher.

Christine van Assche (1948–): Belgian art historian specializing in new media art; former chief curator at the Centre Pompidou in Paris.

David Van Tieghem (1955–): American composer, musician, percussionist, and performer known for using any object as a percussion instrument.

Stan VanDerBeek (1927–1984): American experimental filmmaker.

Woody Vasulka (1937–) and his wife, Steina Vasulka (1940–): early pioneers in video art.

Ben Vautier (1935–): French artist active in mail art and Fluxus.

Wolf Vostell (1932–1998): German painter and sculptor, video artist and pioneer in Fluxus who also used television sets in his work.

Anton Webern (1883–1945): Austrian composer and conductor.

William Wegman (1943–): American artist, painter, filmmaker, and photographer known for using his Weimaraners in his work.

Karl-Erik Welin (1934–1992): Swedish pianist, organist, and composer known as an interpreter of avant-garde works and Happenings.

Norbert Wiener (1894–1964): American mathematician and philosopher who was a professor of mathematics at MIT; considered the originator of cybernetics.

Jean-Pierre Wilhelm (1912–1968): German gallery owner, art critic, educator; co-founder of Galerie 22 in Düsseldorf.

Knut Wiggen (1927–2016): Norwegian-Swedish composer, head of the organization Fylkingen in Sweden.

Emmett Williams (1925–2007): American poet and artist.

Howard Wise (1903–1986): art dealer and owner of the New York City-based Howard Wise Gallery. Founder of Electronic Arts Intermix, a distributor of artists' videotapes.

Jud Yalkut (1938–2013): American experimental filmmaker and multimedia artist. Collaborated with Paik on *Video Tape Study No. 3* (1967–1969).

Kiyoshi Yamashita (1922–1971): Japanese artist who suffered from neurological damage; known for wandering throughout Japan and creating works from memory.

La Monte Young (1935–): American avant-garde composer of experimental music.

Gene Youngblood (1942–): film and culture critic, theorist of media arts and film, author of the influential book *Expanded Cinema* (1970).

Index

Aaron, Chloe, 193
ABC (network), 128, 187, 192
Abe, Shuya, 11, 13, 16, 87, 93, 144, 145–147, 195, 198, 205, 208, 260, 368, 423
Abrams, Harry, 379
Adorno, Theodor W., 263, 270, 344
Ailey, Alvin, 192, 419
Ali, Muhammad, 328
Allen, Rebecca, 195
Allen, Woody, 188
Alpert, Jon, 193
Alternative Media Center (NYU), 165, 424
Amnesty International, 36
Amsterdam, 32, 64, 68, 83, 148, 188, 239
Anderson, Laurie, 15, 186
Angell, Roger, 232
Anthology Film Archives, 11, 339
Aragon, Louis, 328
architecture, 92, 147, 232, 234, 334
Aristotle, 66, 180
Armstrong, Edwin H., 170, 206, 423
Armstrong, Louis, 255
Armstrong, Neil, 320
art. *See also* communities; *specific artists*
 as communication, 154, 173–174
 economics of, 34, 166, 175–187, 194–195, 262, 329–330, 344, 365, 411
 experimental, 10, 87, 138–139, 184, 207, 327–328
 history of, 18, 30, 125, 140, 260–262, 267, 271
 revolutions of, 18, 175–176, 204, 360
 technology and, 16–22, 99, 116, 120–121, 126, 193, 195, 345, 350–351, 353, 366
Asia, 7–8, 26, 94, 141, 143, 147, 156, 230, 233–234, 259, 316, 383–384. *See also* Buddhism; China; India; Japan; Korea; Vietnam War; World War II; Zen

Astaire, Fred, 214
Athens, 237
Atwood, David, 143, 145, 147, 423
audiences, 12, 146, 193, 339
 freedom of, 9–10, 66–67, 91–92, 146, 318
 global, 179, 190–191, 222
 participation of, xvii, 8, 18, 21, 38, 75, 82–83, 107, 112, 124, 127, 146, 224, 230, 308
Augustine, Saint, 78, 128, 166, 243, 255
automobiles, 37, 38, 47, 129, 146, 160, 176, 182, 205, 246–251, 300, 329, 330, 331
avant-garde, 4–10, 21, 34, 82, 87, 140–141, 150, 180, 196, 257, 323, 335, 340, 385. *See also* art; communities; Fluxus; *specific artists*
 as community, 2, 5, 12
 festivities, 9, 27
 international, 12, 196, 214, 386
Avignon Festival, 193
Ay-O, 94, 116, 343

Bach, Carl Philipp Emanuel, 258
Bach, Johann Sebastian, 23–25, 32, 52, 56, 63, 260, 265, 327, 351, 383
Bacon, Francis, 313
Baker, Josephine, 276
Baker, Russell, 356, 423
Barnes, Clive, 356, 423
Barrault, Jean-Louis, 183, 222, 224, 423
Barthes, Roland, 186
Bartók, Béla, 131, 196, 259, 351
Barzyk, Fred, 145, 365, 367
Bateson, Gregory, 164, 423
Battcock, Gregory, 35, 216–217, 373, 423
Baudelaire, Charles, 52, 126, 152, 153–154, 327
Bauermeister, Mary, 9, 91, 115, 258, 333, 335–337, 341, 344, 423
Bauman, Norman, 129, 152, 423

Beame, Abraham, 271, 339

Beatles, The, 75, 148, 223, 238, 363. *See also* Lennon, John

beauty, 90, 95–96, 129, 178. *See also* art; music

Beauvoir, Simone de, 222, 224

Beck, Stephen, 165, 423

Beethoven, Ludwig van, 23–25, 36, 49–54, 63, 143, 174, 177, 195, 237, 250, 257, 378, 383

Bell, Daniel, 161–162, 270, 271, 276, 330

Bell Telephone Laboratories, 11, 16, 117, 126, 137, 138, 167, 194, 205, 334, 355, 360–361

Benedict, Ruth, 320

Benjamin, Walter, 76, 83

Berdyaev, Nikolai, 92, 131, 156, 181

Berg, Alban, 378

Bergé, Carol, 116, 423

Bergman, Ingrid, 238, 300

Berkeley, Busby, 193

Berlin, 217, 219–220, 227, 327, 328, 338

Betamax, 79, 175, 180

Beuys, Joseph, 5, 7, 15, 22, 29, 36, 78, 146, 181, 183, 186–188, 225, 344, 384
 biography, 31–32, 176, 183, 188, 260–263, 266–268, 338–341, 411, 423
 collaboration with Paik, 81, 192, 217–221, 235, 343
 performances, 75, 183, 186–187, 217–221, 222, 224, 339, 343

Bible, 126, 243, 258

Bibliothèque nationale de France, 267, 329

Binghamton (New York), 148, 149, 169, 205, 209, 364

Biolek, Alfred, 237

Biyanlu, 393, 408

Black Mountain College, 257, 366

Bloch, Ernst, 131, 312

Block, René, 9, 217, 261, 339, 423

Blumberg, Skip, 78, 191, 240

Blyth, Horace, 386

Bogart, Humphrey, 300

Bo-i, 37

Böll, Heinrich, 224

Bonin, Wibke von, 222, 225

Bonino Gallery, 11, 147, 334, 344, 355, 362

Bonito Oliva, Achille, 274

Boole, George, 194, 205, 423

boredom, 36, 78, 90, 115, 126, 166, 172, 175–176, 233, 327, 328, 346

Boston, 13, 160, 218, 238. *See also* WGBH

Boston Globe, 371

Boston Symphony Orchestra, 364

Boulanger, Nadia, 255

Boulez, Pierre, 133, 254, 351, 424

Boutourline, Serge, 139

Bowie, David, 15, 73, 237, 379

Brahms, Johannes, 91, 323, 325, 326

Brakhage, Stan, 116, 353

Brandenburg, Carol, 78, 179, 188, 222, 223, 234, 253, 270, 380

Brecht, George, 26, 37, 94, 99, 116, 126, 133, 424

"Broadband Communication Network," 158, 163

broadcasts, xvii, 7, 10, 16, 75–82, 85, 87, 115, 121, 149, 182, 186–191, 222–227, 230–240, 380–381. *See also* satellite; television; *specific channels and programs*
 as collaboration, 83, 222, 235–240
 cost of, 182, 190, 225, 235
 live, 75, 79–81, 189–190, 380

Broadway Video, 195

Brötzmann, Peter, 52

Brown, Carolyn, 113, 115, 424

Brown, Earl, 30, 39

Brown University, 351

Bruckner, Anton, 260

Bryant, Allan, 140

Buddha, 17, 36, 71, 78, 145, 359, 392, 407, 418

Buddhism, 65, 78, 99, 191, 230, 300, 324, 336, 384, 386–388, 392, 393, 408, 410. *See also* Cage, John; spirituality; Zen

Bulgaria, 266

Bungeishunju, 313

Burgard, Ralph, 117, 353–356, 362–363, 424

Bussotti, Sylvano, 338

Cage, John, 4, 7, 12, 26, 34–37, 54, 78, 113, 124, 126, 176, 186, 194, 222, 310, 327, 372
 appearances in Paik's works, 115, 149, 183, 224, 225–226, 228, 260
 biography, 35–36, 186, 257, 263, 411, 424
 correspondence, 335, 348–349, 357–359
 4'33", 11
 friendship of, 30, 181, 183, 366
 influence of, 5, 8, 90–91, 102, 109, 284–285, 337, 366
 Music of Changes, 36, 67
 "Music Walk," 67
 sayings of, 37, 66, 123, 127, 129, 176, 207
 and Zen, 66–67, 384, 386–387

California Institute of Art, 12, 145, 148, 149, 205, 207, 256–257, 266, 365–366, 367–368

Callas, Maria, 28

camera (still), 129, 145, 176, 368

Campus, Peter, 177

Camus, Albert, 90, 136, 143, 181

Canada, 179, 182, 237

Canady, John, 146, 424

Canon, 247

Cantor, Georg, 78, 125, 194

capitalism, 80, 230, 329–331, 342, 345, 411. *See also* communism; consumerism; economics; socialism

Carnegie Hall, 257, 380

cars. *See* automobiles
Carson, Johnny, 312
Carter, Jimmy, 374
cartoons, 278–322. *See also* politics;
 propaganda
Caskel, Werner, 91, 259
Castelli Gallery, 355
cathode ray tube, 97, 99, 109, 114, 117, 120, 139,
 203, 334, 360
Cavett, Dick, 184, 188, 190, 192, 222, 424
CBS (network), 145, 149, 157, 160, 166, 185, 352
celebrities, 2, 24, 78, 82, 241, 273, 335
cello, 27–33, 54, 59, 115, 221. *See also*
 Moorman, Charlotte; music
Central Intelligence Agency (CIA), 139, 172,
 248, 374, 419
Centre Georges Pompidou, 179, 182–184, 186–
 187, 223–225, 227
Chagall, Marc, 329
Chao-Hu, 405
Chaplin, Charlie, 183, 199
Chavannes, Édouard, 385, 421
Chen Chin, 102, 405, 418
Chen Sheh, 388, 390
Chiang Kai-shek, 305
children, 38, 66, 82, 136, 139, 154–158, 166, 174,
 188, 223, 248, 401. *See also* twins
China, 7, 216–217, 246–247, 258, 262, 264–265,
 268, 275, 279, 294, 303, 331, 373, 380,
 383–418. *See also* Asia; Confucius, Mao
 Zedong
 art and culture, 126, 141, 182, 194, 231–234,
 336, 387
Chomsky, Noam, 290
Chopin, Frédéric, 195, 238, 350, 351
Christianity, 49, 58, 411, 415. *See also* Bible;
 spirituality
Churchill, Winston, 29
cinema. *See* film; Mekas, Jonas
circuitry, 17, 92, 99, 117, 137, 170, 174, 190, 194,
 201, 206, 286, 361
Clair, René, 329
Clarke, Shirley, 85, 184, 188, 220, 225, 226,
 232, 424
Clarke, Wendy, 85, 220, 225, 226, 232, 424
Clemenceau, Georges, 252
Clementi, Muzio, 54
Cohen, Maxi, 166, 254, 424
Cold War, 7, 80, 82, 242, 281, 390, 419
collage, 13, 97–99, 125, 255, 326, 346, 390
Cologne, 35, 37, 72, 89, 97, 167, 179, 204, 219,
 222–225, 344, 346–347, 351–352
color, 11–13, 76, 92, 98, 109, 120, 129, 140, 149,
 170–175, 190, 198, 201, 203–206, 254, 257,
 260, 336, 355, 392. *See also* painting; tele-
 vision: color; video: color

color synthesizer, 142, 362. *See also* video
 synthesizer
Columbia University, 136, 170, 206, 334, 364
Columbus, Christopher, 153, 189, 238
commercials. *See* television
communication, 143, 155, 157, 159, 164, 218,
 252, 268, 274, 278, 340–342. *See also*
 broadcasts; telephone; transportation
 art and, 173–176
 East-West, 141, 231, 234, 278–322
 future of, 21, 82, 114, 159–160, 163–164, 256
 history of, 173, 256, 263, 265, 414
 technology and, 13, 15, 17, 150, 176, 263, 265,
 414
 two-way, 79–81, 85, 127, 146, 179–180, 186,
 189–190, 230, 242, 320, 336 (*see also* tele-
 vision: two-way)
communism, 82, 127, 181, 269, 271–273, 276,
 335, 337, 392, 402. *See also* capitalism;
 economics; Marx, Karl; Marxism; politics;
 Russia; socialism
communities (of artists), 5, 12, 18, 26, 338, 366.
 See also avant-garde
composers (musical), 22, 32, 36–37, 91–92,
 131, 140, 178, 196, 207, 255, 258–260, 346,
 366, 383
composition (musical), 9–10, 21–22, 37, 68, 123,
 138, 175, 258, 347, 350
computers, 11, 16, 93, 98, 120, 159–160, 164,
 166, 170, 195, 201–205, 331, 355, 360–361
 art and, 116–120, 126, 334, 369
 economics of, 160, 369
 education and, 117, 137–139, 205, 351
 war and, 127, 321
Computing Review, 16, 116, 117
Confucius, 181, 230, 262, 341, 383, 386–387,
 388, 390, 398, 399, 402–403, 410, 411, 412,
 413, 415, 420
Conklin, William T., 162
Connor, Russell, 12, 128, 147, 148, 193, 207–210,
 369, 424
consciousness, 66–67, 135, 148, 156, 166, 170–
 174, 191, 206, 231, 312. *See also* Cage, John;
 philosophy; Zen
consumerism, 142, 166, 172, 251, 255, 319, 363,
 368, 373
Copland, Aaron, 255
Corcoran Gallery, 150, 153
Cordier, Daniel, 340, 424
Cornell University, 120, 203
Corporation for Public Broadcasting (CPB),
 378
Corrigan, Robert, 257
Cowell, Henry, 255–256
Cox, Tony, 191

critics (art), 12, 29, 75–77, 83, 90, 146, 185–188, 191, 217, 232, 254, 257, 261, 333, 335, 356, 364, 366. *See also specific critics*

Cronkite, Walter, 130, 150

Cunningham, Merce, 4, 12, 15, 17, 33, 73, 80, 115, 121, 179, 183–186, 187, 189, 222, 224, 343, 411, 420

cybernetics, 2, 99, 123, 126, 147, 161, 204, 309, 314, 318, 351. *See also* computers; technology

Czerny, Carl, 59

Dada, 32, 127, 272, 338, 346, 366

dance, 12, 73, 83, 130, 143, 176–177, 183, 216, 225–226, 323, 366. *See also* Cunningham, Merce; music

Daodejing (Laozi), 181, 383, 388

Darmstadt, 36–37, 176, 346, 350, 351, 366, 387

Dartmouth College, 169, 205, 232

David, Tom, 379

Davis, Douglas, 75, 150, 153–154, 160, 179, 186–188, 232, 424

death, 31–32, 36–37, 102, 115, 153–154, 166, 174, 180, 194, 262, 336, 338–339, 341, 377. *See also* illness

Debussy, Claude, 156, 195, 297, 351

Decker-Phillips, Edith, 77

Decock, Jos, 266, 267, 269, 424

Décollage (ed. Paik and Vostell), 9, 72, 92

DeFanti, Tom, 231

De Gaulle, Charles, 29, 115

democracy, 82–83, 92, 127, 239, 251. *See also* Europe; freedom; politics; United States

des Prez, Josquin, 36, 424

destruction (in art), 10, 184

Deutsche Guggenheim Berlin, 7

Devyatkin, Dimitri, 217, 424

Dewey, Kenneth, 206, 213

Diamond, Robert, 150, 169, 204–205, 370

Dilthey, Wilhelm, 131, 156

Disney, Walt, 207, 255–257, 280

documentaries, 13, 139, 144, 176, 257, 373

Dominick, Ken, 150

Donner, Hans, 195, 239

Dostoevsky, Fyodor, 52

dreams, 90, 166, 173, 388, 390, 397–398, 418

Drew, Nancy, 188

Drot, Jean-Marie, 337

drugs (recreational), 146, 244, 368

Dublin, 239

Duchamp, Marcel, 36, 115, 131, 151, 181, 211, 269, 328–329, 340, 346, 366–367, 377, 390, 418

Dunham, Bob, 358

Durbin, Deanna, 196

Düsseldorf, 5, 36, 67, 93, 181, 217, 262, 339, 343

Duvivier, Julien, 196

Dvořák, Antonín, 140

ecology, 144, 156–164, 175, 250, 253, 338

economics, 144, 158, 161–164, 172, 246, 252, 263, 271, 310, 319, 329–331, 368, 387. *See also* capitalism; communism; funding; politics

Economist (newspaper), 159

ecstasy, 67, 94, 251, 331, 399

editing (video), 13–16, 76, 144–145, 166, 185, 189, 200, 233

Eimert, Herbert, 351

Einstein, Albert, 156, 177, 370

Eisenhower, Dwight D., 171, 193, 207

Eisenhower, Lottie, 213

Electric Circus, 37

"Electromagnet (or Life Ring)" (exhibition), 11

electronics. *See* computers; technology; television; video

electronic superhighway, 12, 163, 182

energy (resource), 124, 156, 158–164, 172, 175–176, 250–253, 270. *See also* oil

entertainment industry, 2, 78, 143, 155–158, 162, 166, 186, 189, 193, 251, 255, 312–313. *See also* broadcasts; funding; television; video

Erhard, Ludwig, 89

Ervin, Sam, 159

Eskimo, 182, 231, 341

Etra, Louise, 231

Europe, 5, 10, 126, 142–143, 181, 186, 207, 255, 259–260, 275–276, 331, 342–343, 366, 383. *See also* avant-garde; *specific countries*

Evans, Eli N., 376

Everson Museum, 11, 165

Experimental Television Center, 388

Experiments in Art and Technology (E.A.T.), 193

"Exposition of Music–Electronic Television" (exhibition), 4, 10, 22, 90

Fairleigh Dickinson University, 364

family, Paik's, 2, 5, 7, 248–251, 383, 386, 387

fascism, 181. *See also* communism; politics; war

FBC TV (Japan), 192

feedback, v, 170–171, 179–181, 183, 186, 187, 192, 206, 224–226, 232, 238, 252, 286, 288, 300, 303, 335. *See also* broadcasts; circuitry; time

Feldman, Morton, 36, 127

Ferlinghetti, Lawrence, 30

Festival de libre Expression, 30

Fields, W. C., 156

Filliou, Robert, 30, 116, 424

film, 4, 10, 11, 16, 79, 198–199, 225, 256–257, 260, 329, 379. *See also* video

Fils, Anton, 258

Finland, 337

Finnell, Carrie, 28

Fiore, Peter, 285

Fitzgerald, Kit, 191, 193, 231

Flaubert, Gustave, 129

Fleming, Ian, 322

Fluxus, 3, 4–10, 24–25, 26, 34, 67, 79, 87, 115, 126, 149, 272–274, 338–340, 342–343, 387, 411. *See also* communities; Maciunas, George

 events of, 32, 151, 153–154, 217, 241, 258, 339–340

 politics of, 9–10, 70, 94, 272–274

Flynt, Henry, 94, 272

folklore, 191–192, 232

Folkways Records, 134

Folsom, John, 145

Ford Foundation, 165

form (artistic), xvii, 22–24, 66, 308

France, 180, 183, 186, 189, 207, 233, 247, 276, 330–331, 340. *See also* Europe; Paris

Francis, Sam, 343

Franken, Al, 379

Frankfurt School, 77

freedom (political), 89, 102, 181–182, 294, 298, 312–313, 316, 419

Freud, Sigmund, 83, 131, 154, 156, 177, 207, 238, 254, 270, 284, 312

Friedman, Ken, 72, 424

Friedman, Milton, 161

friendships, 4–12, 22, 30, 91, 181, 183, 241, 273, 333, 366–367, 384, 400–401

Fuller, R. Buckminster, 37, 125, 144, 147, 181, 207, 257, 365, 367, 370, 424

funding, 12, 76, 162, 165, 194, 195, 219, 225, 350–356, 360–367, 370–371, 374–377

"Future Program" (exhibition), 10

Fylkingen Bulletin, 117–121

Gabriel, Peter, 237

Gagosian Gallery (Hong Kong), 7

Galbraith, John Kenneth, 162, 164, 252, 253, 424

Galerie Parnass, 4, 9–10, 88, 91, 93, 94, 146, 198

Galerie René Block, 217. *See also* Block, René

Galerie Schmela, 181, 217, 343–344

Gallery 22, 67, 340, 344

Gallery Watari, 192, 339

Galloway, Kit, 85, 179, 186, 187, 188, 218, 226, 232, 424

Galois, Évariste, 194

Gandhi, Mohandas K., 370

Garbo, Greta, 30, 31, 193

Garrin, Paul, 195, 231

Gauguin, Paul, 330

Gazzelloni, Severino, 351

Gehlen, Reinhold, 247–248, 270

Gelber, Sidney, 350

Geldzahler, Henry, 193, 353, 425

Georgiades, Thrasybulos, 133, 259, 425

Germany, 269–271, 274, 309, 312, 334, 346. *See also* Berlin; Cologne; Darmstadt; Düsseldorf; Hamburg; Hitler, Adolf; Kassel; Munich; Stuttgart; World War II; Wuppertal

 art in, 4, 5, 9, 330, 340

 broadcasts in, 180, 183, 185–186, 187, 189, 223, 235

 Paik in, 4–5, 9, 22, 258–260, 329, 383

 radio in, 140, 167, 204, 351, 354

Gershuny, Phyllis, 148, 425

Gide, André, 111, 131, 141, 156

Gillette, Frank, 166, 425

Gillmor, Steve, 145

Ginsberg, Allen, 7, 12, 32, 87, 181, 183, 186, 192, 208, 210, 212, 223–224, 392, 425

Glass, Philip, 182, 183, 190, 232, 379, 382, 425

global village, 15, 123, 143, 165

Gluck, Christoph Willibald, 28

Glueck, Grace, 419

Godfrey, John, 169, 195, 205, 212, 370

Goebbels, Joseph, 287

Goethe, Johann Wolfgang von, 24, 39, 66, 140–141, 243

Goldmark, Peter, 160, 352

Goldstein, Malcolm, 272

Goldstein, Richard, 266

Gomi, Yasuhiro, 262

Gorbachev, Mikhail, 342

Götz, Karl Otto, 10, 89, 93, 117, 126, 425

Gould, Jack, 352

Grass, Günther, 224

Greenberg, Clement, 178

Gregory, Dick, 83

Grosz, George, 343

Gruen, John, 72, 425

Guggenheim, Peggy, 411

Guggenheim Museum (Bilbao), 4

Guggenheim Museum (New York), 4, 7, 388

Günther, Ingo, 271

Gutenberg, Johannes, 267, 414

Haacke, Hans, 274, 344, 425

Hagakure, 387

Hakuta, Ken, 7

Hallstein, Walter, 89, 142, 425

Hamburg, 76, 270, 342, 419

Han Feizi, 78, 383, 385, 386, 388, 390, 392, 420

Han Shin, 417

Han Wei Tsu, 396, 399, 401–403, 406–407

Handel, George Frideric, 344

Hanhardt, John G., 219

Han Shi Wai Zhuan, 386

Haring, Keith, 184

Harithas, Jim, 186

Harper, Don, 212

Hart, Michael, 265, 414

Hartzell, Richard, 136

Harvard University, 154, 161, 263, 330, 364, 390, 417–418

Havel, Václav, 273, 342

Hayden, Michael, 258

Haydn, Joseph, 8, 220

Hays, Ron, 168, 205

Heald, David, 5

health, 7, 31–32. *See also* death; illness

Hegel, Georg Wilhelm Friedrich, 75, 87, 94, 124, 126, 177, 317

Heidegger, Martin, 90, 126, 131, 132, 139, 254

Heisenberg, Werner, 78, 124, 125, 126, 337

Helms, Hans G., 338

Hendricks, Jon, 274

Heng Kuang, 405

Henie, Sonja, 239

Henze, Hans Werner, 347

Herkulessaal (Munich), 260

Hideyoshi, Toyotomi, 275

Higgins, Dick, 24–26, 90, 94, 102, 115, 126, 273, 343, 425, 426

Hindemith, Paul, 126, 196, 259, 347

hippies, 124, 147, 153, 175, 178, 180, 185, 209, 300, 314–315

Hirschhorn Museum, 166

history, 1–2, 5, 7, 11–12, 79, 131, 148, 156, 170, 181, 186, 267, 270, 330, 414

Hitler, Adolf, 55, 67, 131, 193, 199, 247–248, 264, 270–271, 276, 417

Hocking, Ralph, 148, 150, 209, 388, 425

Holly Solomon Gallery, 35

Hollywood, 24, 163, 182, 193, 200, 275, 342

Holocaust, 9, 55, 193

horses, 263–265, 384, 395, 396–397, 414, 420

Hosoda, Mikio, 385–386, 388

Hovhaness, Alan, 255

Howard Wise Gallery, 11, 147, 151, 344, 353, 362

Hsien Tsu, 402–403

Huainanzi, 383

Huffman, Jon, 7, 392

Hughes, Robert, 261

Hultén, Pontus, 273

Hungary, 237

Husserl, Edmund, 156, 166, 255, 425

IBM, 119, 132, 139, 188, 203, 205, 338, 357, 360

I-Ching, 194, 260, 311, 396

Ichiyanagi, Toshi, 26, 116, 190, 425

idealism, 94, 133, 136, 177, 243, 274, 276

Ieyasu, Tokugawa, 275

Ikan, Catherine, 218

illness, 31–32, 36–37, 44, 53, 263, 271, 342, 397–398. *See also* death; health

Imai, Toshimitsu, 72, 190, 192

improvisation, 37, 87, 180, 183, 184, 221, 223, 411

indeterminacy, 75, 78, 80, 87, 89, 91–92, 95–97, 117, 124, 133, 180, 334, 336–337

India, 126, 141, 155–156, 182, 214, 232, 239, 258, 331

Indiana, Robert, 379

information, 77–78, 82–83, 123–124, 152–154, 156–157, 161–162, 172–176, 251–253, 318, 334–336. *See also* communication; cybernetics; feedback; language; technology
gaps, 143, 156, 280
information age, 82, 139, 161, 238, 330, 336
overload, 149, 153, 197, 203
storage, 127, 154, 160, 170, 206, 360–361
technologies of, 7, 132, 264, 314, 334

Innis, H. A., 143

intellectualism, 29–30, 146, 154–155, 185, 190, 207, 233, 270, 276, 366, 387, 419. *See also* knowledge; language; literature; philosophy

Inter-Action Inc., 139

Isozaki, Arata, 184, 192, 232, 234

Italy, 223, 330

Ito, Junji, 191, 192

Iwamura, 265, 414

Jacob, Paul, 371

Jährling, Rolf, 9

Japan, 77, 330–332. *See also* Asia; NHK; Tokyo; World War II
broadcast in, 165, 188–191, 230–235
culture of, 33, 126, 130, 190, 252, 315, 330, 385, 387, 411, 412
occupation of Korea by, 191, 196–197, 246, 248, 250, 253, 275
Paik in, 191–192, 383, 386
and war, 29, 246–248, 250, 279, 281, 283–285, 294–295, 298–299, 303

Jaspers, Karl, 131, 132, 139

jazz, 143, 225, 343, 390, 419

Jesus, 37

John Brockman Associates Inc., 138

Johns, Jasper, 142, 172, 255, 368

Johnson, Lyndon B., 31

Johnson, Ray, 26, 116, 126, 154, 257, 425

Johnson, Samuel, 310

Joplin, Janis, 368

Joplin, Scott, 175

Joyce, James, 35, 94, 119, 127, 131, 156, 196, 202, 239, 256, 360

Judaism, 55, 340, 411. *See also* Holocaust; spirituality

Juilliard School, 328

Julesz, Béla, 16, 117, 425

Jung, Carl Gustav, 131, 156

Kafka, Franz, 196
Kagel, Mauricio, 347
Kahn, Ellen, 77, 184, 425
Kahn, Herman, 165, 175, 271, 425
Kahn, Lynda, 77, 184, 425
Kai-Fang, 401
Kalba, Kas, 154, 263, 425
kamikaze pilots, 248, 315, 387
Kanbun Koji Shôjiten, 385
Kandinsky, Wassily, 131, 156, 254
Kant, Immanuel, 90, 177, 254
Kaprow, Allan, 7, 12, 26, 87, 94, 116, 127, 139, 141, 256, 335, 343, 350, 425
Karajan, Herbert von, 28, 142, 363
Kassel, 75, 175, 186
Kataoka, Mitsu, 188, 374
KBS (Seoul), 179, 183, 188, 234, 380
Keaton, Diane, 188
Keeler, Christine, 56, 425
Kennedy, John F., 15, 28, 31, 95, 96, 143, 193, 313
Kennedy, Joseph P., 275
Kerensky, Alexander, 338
keyboard (musical instrument), 8, 59. *See also* piano
Kind, Marcel, 224
King, Martin Luther, Jr., 415
Kinokuni, Mr., 192
Kinsey, Alfred, 127, 425
Kinsky, Nastassja, 186
Kissinger, Henry, 275, 379, 403
Kitchen, The, 9, 179, 185, 207
Klein, Howard, 12, 91, 109, 193, 350–351, 364–365, 366, 367, 369, 374–378, 405, 426
Klein, Yves, 63, 426
Kline, Franz, 257
Klüver, Billy, 100–101, 105, 113, 193, 426
Knížák, Milan, 272–273, 426
knowledge, 21, 94, 138, 144, 161, 180, 268, 317, 405, 412–413. *See also* intellectualism; philosophy
Knowles, Alison, 24, 32, 37, 91, 94, 115, 425, 426
Knowlton, Ken, 194
Kodak, 145
Koepcke, Arthur, 91, 109, 267, 269
Koll, Michael, 194
Konoye, Fumimaro, 77, 248
Konrad Fischer Galerie, 262
Koppel, Ted, 379, 419
Korea, 155, 259, 266–269, 273, 329–332, 384, 387. *See also* Asia; Seoul
 broadcast in, 76, 179–184, 186, 188–192, 230–235, 380–381, 417
 culture of, 5, 126, 266, 322, 329–330, 337, 385, 387

Japanese occupation, 191, 196–197, 246, 248, 250, 253, 275
 Paik in, 33, 36, 77, 141, 163, 248–251, 253
 shamanism, 78, 177, 237, 340–342, 384, 411
Korean War, 4, 33, 78
Kosugi, Takehisa, 26, 116, 126, 134, 183, 426
Kosuth, Joseph, 274
Kotake, Fumio and Takeo, 385, 421
KQED (San Francisco), 165
Kricke, Norbert, 339
Kriesche, Richard, 76–77, 85, 218, 220, 226, 228, 229, 232
Kuan Chong, 400–402
Kubota, Shigeko, 7, 36, 166, 174, 211, 375, 376–377, 426
Kunstakademie (Düsseldorf), 93, 217, 221, 339, 343
Kushner, Robert, 35, 426
Kyoto University, 141

Landsbergis, Vytautas, 272, 274, 342–343, 426
language, 4, 8, 35, 180, 270, 359, 383
 history of, 154, 191, 337–338, 415, 418
 study of, 1, 135, 141, 196, 241, 386
 translation, 181, 191, 385–386
Laozi, 127, 269, 310, 383, 386, 388, 400, 402, 410, 417
laser, 115, 121, 129, 158, 232, 266, 334, 368
Laski, Harold, 281
Leacroy, Richard, 173, 176–177, 426
Leary, Timothy, 35, 244, 316, 422
Lebel, Jean-Jacques, 30, 272, 426
Lee Won Hong, 179
Lee, Y. L., 314
Lehmbach Galerie, 258, 259
Leibniz, Gottfried Wilhelm, 123, 124, 125, 204
Lennon, John, 196, 211, 238, 320
Lennon, Julian, 238
Lessing, Gotthold Ephraim, 166
Leve, Manfred, 340
Lévi-Strauss, Claude, 164, 426
Li Si, 402–403, 420
libraries, 120, 131, 139–140, 170, 203, 206, 267, 327
Lichtenstein, Roy, 315
Life (magazine), 257, 295, 352
Ligeti, György, 133, 426
Lincoln, Abraham, 290
Lindgren, Charlene, 130
Lindsay, John V., 145, 208
Liszt, Franz, 24, 347
literature, 94, 117, 186, 198, 201, 224–225, 298. *See also* art; intellectualism; language
Lloyd, Norman, 171, 206, 352, 355, 364–365, 366, 367, 426
Lockwood, E. H., 11
London, Barbara, 377

London (England), 76, 237

Long Beach Museum, 188

Los Angeles, 145, 154, 155, 160, 163, 179, 187, 238, 335

love, 66–67, 181, 191, 296, 300, 318, 401–402, 404, 415

Loxton, David, 169, 205, 207, 369, 370

Luce, Don, 143, 157, 278

Lukács, György, 131, 196

MacArthur, Douglas, 272, 290, 294

Maciunas, George, 5, 21, 34, 56, 72, 91, 94, 115, 126, 153, 272–274. *See also* avant-garde; Fluxus

 biography, 31, 271–272, 337–340, 342, 343, 426

Mac Low, Jackson, 72, 115, 126, 257, 272, 338, 343, 350, 426

Maderna, Bruno, 351

magnetism, 336, 360–361. *See also* circuitry; cybernetics; technology

Mahler, Gustav, 339

Mallarmé, Stéphane, 141, 243, 257, 310

Malraux, André, 340

Manet, Édouard, 330

Manhattan. *See* New York City

Mannik, Andy, 337, 426

Mantovani, Annunzio Paolo, 175

Mao Zedong, 30, 276, 392, 415. *See also* China; communism

Marcel, Gabriel, 131

Marcuse, Herbert, 177–178, 300, 426

Marsh, Reginald, 214

Marx, Karl, 3, 29, 34, 82, 124, 127, 177, 196, 243, 254, 263, 268, 270, 284, 313

Marx Brothers, 156, 370

Marxism, 29, 34, 254, 270, 276, 296, 299, 338, 342, 387, 392. *See also* communism

Massachusetts Institute of Technology (MIT), 31, 124, 169, 206, 232, 345, 364

Massenet, Jules, 323, 326

mathematics, 78–79, 123, 173, 179, 194, 204, 254, 270, 272, 317, 329, 331

Mathews, Max, 117, 121, 126, 137–138, 167, 194, 354, 426

Matsuoka, Yosuke, 246

Matsushita, Mr., 316

McCray, Porter, 364, 367–368, 426

McLuhan, Marshall, 15, 35, 75, 115, 123–125, 126, 132, 143, 181, 208, 256, 285, 300, 325–326, 370, 427

 sayings of, 99, 123–124, 128, 135, 256, 284, 309, 311

 media, 18, 99, 143, 152–165, 241–242, 298, 340–342. *See also* broadcasts; communication; entertainment industry

 technology and, 80, 147, 201, 244, 319

 types of, 124, 193, 207, 284

mediums (artistic), 9, 16, 33, 82, 87, 123–128, 146–147, 170, 178, 206, 308, 365. *See also* art; computers; painting; technology; television; video

Mekas, Jonas, 116, 274, 337, 338, 339, 343, 370, 427

memory, 2, 5, 7–8, 173, 268

Mencius, 341

Mendelssohn, Felix, 65, 327

Mercer Art Center, 207

Mercouri, Melina, 237

Merleau-Ponty, Maurice, 131, 156

Metro Picture Gallery, 266

Metzger, Heinz-Klaus, 34, 37

Miki, Kiyoshi, 262–263

Miller, Glenn, 25

Miller, Henry, 32, 427

Miller, Sherry, 150

Milwaukee Art Museum, 353

minimalism, 11, 193

Minnelli, Vincente, 360

Miró, Joan, 325

Mishima, Yukio, 150, 427

MIT. *See* Massachusetts Institute of Technology

Miyake, Issey, 184, 192, 232

Miyawaki, Aiko, 190, 192

Miyazawa, Takeyoshi, 276

Miyoshi, Susumu, 191

Monet, Claude, 263, 330, 395

Mongolia, 33, 78

Monnet, Jean, 142, 427

Monroe, Marilyn, 287

Montaigne, Michel de, 90, 126, 292, 299, 390, 418

Montes-Baquer, José, 179

Monteverdi, Claudio, 256, 325

Monthly Review of the University for Avant-Garde Hinduism, 24–26

mood art, 33, 120, 147, 203, 334, 361

mood music, 33, 120, 142, 203, 334, 361

Moog synthesizer, 142, 256

Moore, Barbara, 32

Moore, Carmen, 214

Moore, Paul, 328

Moore, Peter, 11, 27

Moorman, Charlotte, 5, 9, 29–32, 340, 350, 356, 358, 427

 collaboration with Paik, 5, 7, 8, 9, 22, 29–31, 33, 35, 186, 187, 208, 241, 343, 350

 illness of, 31–32, 271

 nudity, 9, 29–31, 241, 323–329, 356

 performances, 33, 36, 75, 115, 187, 221, 343

Morimura, Minoru, 192

Moscow, 80, 82, 128, 130, 187–188, 216–217, 235, 237, 247–248, 269, 380

Moser, Hans Joachim, 22

Moulin, Jean, 340, 427

Mozart, Wolfgang Amadeus, 60, 97, 143, 180, 189, 194, 238, 335

MTV, 230–232

Munich, 258–260. *See also* University of Munich

Municipal Museum of Wiesbaden, 340

Museum of Modern Art, New York (MoMA), 83, 127, 165, 176, 378

music, 22–24, 91, 92, 94, 123, 130–140, 173–177, 323–326, 364–367, 406. *See also* cello; dance; opera; piano; violin; *specific composers*

 American, 255–256

 composition of, 131, 258, 346–347, 350–351

 electronic, 89, 98, 116–117, 118, 126, 131, 138, 167, 176, 201, 334, 351–352, 354, 364, 366

 indeterminacy in, 91, 95–97, 337

 study of, 8, 21, 23, 25, 137–138, 256

 types of, 23, 113, 132–135, 174–175, 324, 410–411, 419

 video and, 134, 136, 222–227, 230–231

"Music of this Time" (concert), 89

musicology, 22, 32, 125, 132

Musset, Alfred de, 327

Mussolini, Benito, 07, 71

Muste, E. J., 275

mysticism, 243, 341. *See also* shamanism; spirituality

Nam Sung-Nyong, 191

"Nam June Paik" (exhibition), 9

"Nam June Paik: Global Groove" (exhibition), 7

Nam-Osterkamp, Jimi, 393

NASA (US National Aeronautics and Space Administration), 244, 248. *See also* space

National Endowment for the Arts, 193, 419

National Gallery of Contemporary Art (Seoul), 17

nationalism, 15, 142–143, 350. *See also* patriotism; *specific countries*

National Science Foundation, 160

nature, 35, 66–67, 126, 153, 166, 174, 207, 250, 336, 393

NBC (network), 128, 131, 145, 166, 185, 230

NDR (Hamburg), 270

Nehru, Jawaharlal, 78

New Design for TV Chair, A, 14

Newsweek, 160, 187, 232, 327

Newton, Isaac, 99, 125, 126, 166, 263

New York City. *See also* communities; entertainment industry; SoHo; WNET; *specific galleries*

as art hub, 12, 116, 162, 179, 204, 211–215, 335, 366, 371

broadcasts in, 76, 183–188, 193, 217–221, 222–228, 232–240

Paik in, 4–5, 12, 147, 175, 197, 241, 387

New York Daily News, 144

New Yorker, 11, 257

New York Public Library, 11

New York State Council on the Arts, 194

New York Times, 12–13, 109, 144, 153, 158, 159, 160, 162, 205, 210, 247, 252, 310, 326, 328, 333, 352, 356, 366, 415, 419

NHK (Japan), 165, 230–235

Niebuhr, Reinhold, 131

Nielsen ratings, 143, 156, 159, 187

Nietzsche, Friedrich, 131, 310, 360, 412

Nikon, 145

Nilles, Jack M., 160

Nixon, Patricia, 153

Nixon, Richard M., 403, 417

Nobel Prize, 115, 129, 231, 243, 275, 342

Noll, A. Michael, 11, 16, 117, 121, 126, 138, 167, 205, 354, 427

nomadism, 77, 79, 176, 252, 384, 411. *See also* travel

Nomura, Yoshio, 125, 349, 412

Nori, Samul, 76, 184, 232

nostalgia, 2, 170, 192, 206, 238, 300

nothingness, 35, 89–90

nudity, 17, 30–32, 102, 115, 129, 210, 213, 323–326, 328–329

Nurmi, Paavo, 239

Ockeghem, Johannes, 133, 254

O'Connor, John J., 12–13, 333, 372–373, 379–382

O'Donnell, Heather, 23

oil (petroleum), 77–78, 160, 166, 176, 178, 242, 246–253, 300, 330. *See also* ecology; energy

Oingo Boingo, 183

Oldenburg, Claes, 256, 338

Olympic Games, 81–82, 190, 191, 235–240, 421. *See also* Berlin; Seoul

onceness, 79–80, 186

Ono, Yoko, 21, 72, 116, 191, 211, 320, 338, 427

opera, 13, 29, 116–117, 118, 132, 134, 142, 201–203, 355, 363, 378

Orlovsky, Peter, 224

Ormandy, Eugene, 177

Orwell, George, 180, 183, 186, 222–223, 233, 276, 419

Osterkamp, Sven, 393

Oswald, Marina, 51

Othmer, David, 219

"Pacific Basin Festival," 231

Paik, Nam June, works

 Allan 'n' Allen's Complaint, 5, 7, 12–13

 Amitie 7, 355

 Apology of John Cage, 349

 Audiotapes, 4

 Bagatelles americaine, 67–69

 Bye Bye Kipling, 75–78, 83, 84, 183, 188–192, 230–235, 239, 379

 Chinese Memory, 7, 391, 392

 Chip Olympics, 80, 83, 235–240 (see also Paik, Nam June, works: Wrap Around the World)

 Cutting My Arm, 9

 A Day Project, 204–207

 Décollage (with Vostell), 9

 Dichtung und Wahrheit, 4

 Documenta 77, 188

 Do It Yourself. Answers to La Monte Young, 67, 387

 Ego Machine, xviii

 Electronic Opera, 201–203

 Electronic Superhighway: Continental U.S., Alaska, Hawaii, 17

 Electronic Video Recorder, 97

 Etude for Piano, 67

 Etude platonique No. 1, 67

 Etude Platonique no. 2 for 10 Rooms and a Beautiful Girl, 67

 Etude platonique No. 3, 63

 Experiment with David Atwood, 11, 13, 16

 Fin de Siecle II, 17

 Fish Flies on Sky, 17

 Global Groove, 11–17, 78, 81, 142–144, 235, 364, 365, 370, 384, 392

 Good Morning, Mr. Orwell, 13, 75, 77–79, 85, 179–182, 185–187, 222–229, 230, 233, 234

 Guadalcanal Requiem, 5, 12–13

 Half-time, 40, 67

 Hommage à John Cage, 4, 67, 340, 346

 Junk Room, 4

 Living with the Living Theatre, 5, 7, 12, 381

 Magnet TV, 11, 16

 Medium is Medium (with Piene), 344

 Megatron/Matrix, 17

 Merce and Marcel, 337

 Merce by Merce by Paik, 12

 Metro-Music, 69

 Modulation in Sync, 4

 The More the Better, 5, 17

 Moving Theatre, 24

 Moving Theater No. 2, 71

 My Jubilee ist Unverhemmet, 33

 Omnibus Music No. 1, 8, 24, 39

 One Candle, Candle Projection, 17

 One for Violin Solo, 8

 Opera Sextronique, 9, 29, 241, 329

 Originale, 8

 Orwell, Revised, 187

 Our World, 75

 Participation TV, 82

 Prepared Scroll, 8

 Random Access/Paper TV, 4

 Robot Family, 17

 Robot K-45, 17

 Robot Opera, 27–28

 Room for Charlotte Moorman, 4

 Selling of New York, 207–210

 Sonata quasi una fantasia for Billie Kluver, 100–114

 Space Rainbow, 73, 75–76, 82–83

 Suite 212, 211–215, 392

 Symphonie No. 5, 41–62

 Symphony for 20 Rooms, 10, 22, 24, 53, 65–67, 72, 91

 Tango Electronique, 82

 Tangun as a Scythian King, 4

 Tokyo Matrix, 179

 Tribute to John Cage, 12, 372

 TV Bra for Living Sculpture, 8, 33, 212, 213

 TV Buddha, 17, 78

 TV Cello, 17

 TV Chair, 17

 TV Clock, 11, 17

 TV Crown, 82

 TV Garden, 17, 179, 187

 TV Penis, 9

 Urmusic, 8

 Video Commune, 13

 Violin with String, 8

 V-yramid, 17

 World First Video-Tape Monthly Magazine, 122

 Wrap Around the World, 73, 75, 80, 83, 235–240, 380–381

 You Can't Lick Stamps in China, 216–217, 392

 Young Penis Sinfonie, 72

 Zen for Film, 11, 78, 94

 Zen for Head, 8

 Zen for TV, 11, 17, 78, 84, 146

Paik-Abe Video Synthesizer, 11, 13, 16, 87, 98, 145–146, 147, 165, 167, 169, 174, 205. See also video synthesizer

painting, 118, 126, 132, 166, 256, 265, 334, 337, 352, 409–410, 411. See also art; specific painters

Palestrina, Giovanni Pierluigi da, 36, 346

Parent, Bob, 212

Paris, 30, 65, 180, 182–183, 211, 218, 222–226, 235, 237, 252, 261, 272, 276, 329, 340, 366, 419. See also Centre Georges Pompidou

Partch, Harry, 255

Pasadena Art Museum, 166

Pascal, Blaise, 80, 89, 186, 254, 310

Pasteur, Louis, 99

patriotism, 94, 310, 340, 350. *See also* fascism; propaganda; war; World War II; *specific countries*

Patterson, Ben, 91, 94

peace, 15, 83, 115, 143–144, 156, 274–275, 329, 364–365

Pfaff, Peter Maurus, 259, 351

philosophy, 78, 89–90, 131–132, 141, 177, 181, 207, 243, 254, 317, 325, 337, 346, 383–392, 418

photography, 265

physics, 78, 89–90, 115, 136, 186, 230, 337

piano, 8, 12, 22, 33, 54, 60, 63, 67, 73, 127, 133, 183–184, 188, 190, 195, 217–218, 221, 259, 328, 339, 343, 344, 350

prepared, 4, 5, 9, 10, 65, 91, 197, 346–347, 370

video and, 145, 147

Picabia, Francis, 329

Picasso, Pablo, 28, 56, 71, 75, 120, 125, 142, 203, 256, 272, 276–277, 323, 329, 335, 347

Piene, Otto, 31, 344, 427

Pileggi, Frank, 31–32, 427

Pinochet, Augusto, 30, 276

Pisar, Judith, 183

Plato, v, 37, 78, 89, 128, 174, 243

Pocket Theater, 328

poetry, 1, 18, 128, 149, 176, 182, 243, 392–393, 410

Poincaré, Henri, 79, 173, 179, 317, 427. *See also* mathematics

Poland, 177, 253, 270, 415

Polaroid, 129, 170, 206

police, 105, 107, 119, 202, 259, 319, 321, 329, 340

politics, 1–9, 18, 78, 92, 99, 134, 144, 181, 183, 191, 230, 241–242, 271–322

Pollock, Jackson, 28, 142

Pompidou Center. *See* Centre Georges Pompidou

Port-a-Pak, 170, 206

postindustrial society, 34, 83, 159, 177, 181, 189, 204, 252–253, 256, 270, 329–331. *See also* capitalism

poverty, 157, 242, 341. *See also* economics; funding

Power, Robert, 157

Poya, 411–412

Prague Spring, 30

Pratt Institute, 354

Princeton University, 137, 140, 334

printing press, 34, 265, 414, 416

process (artistic), xvii, 2, 4, 8, 10–11, 13, 35, 37, 66, 67, 70, 73, 75–76, 84, 184. *See also* art; destruction

propaganda, 77, 89, 197, 236, 250, 278–322, 353

protest, 9, 18, 189, 419. *See also* hippies; police; politics; Vietnam War

Proust, Marcel, 126, 131, 141, 156, 166, 346

Public Broadcasting System (PBS), 11, 13, 161, 171, 172, 183, 185, 187, 188, 207, 230, 365, 374, 376, 405

Puccini, Giacomo, 28

Qin Shi Huang, 403

Queens College, 353

Rabinowitz, Sherrie, 85, 179, 186–188, 226, 232, 424

racism, 79, 85, 266–269, 343

Radhakrishnan, Sarvepalli, 131

Radical Software, 141, 146, 147–151

Radiguet, Raymond, 296

radio, 70, 97, 110, 140, 150, 152, 165, 171, 200, 207, 265, 270, 346, 350, 354

Radio Free Europe, 127

Radio Stockholm, 332

Rand Corporation, 336

random access, 172, 173–176, 265, 361

Rauschenberg, Robert, 193, 232, 257, 285

readers. *See* audiences

Reagan, Ronald, 82, 382

Red Square, 80, 188, 382

Reed, Lou, 190

Rei Tsu, 398

Reich, Steve, 182, 427

Reich, Wilhelm, 427

Reischauer, Edwin O., 141, 279

religion. *See* Bible; Buddhism; Christianity; Judaism; spirituality; Zen

Renoir, Pierre-Auguste, 33, 142, 292, 330

Restany, Pierre, 186, 188, 192, 218, 266, 267, 269, 427

revolution (political), 29, 35, 90, 135, 178, 181, 216, 272–276, 342, 392. *See also* China; communism; Marxism; politics; protest; Russia

Rhee, Syngman, 77, 105, 107, 248

Rice, Michael, 145, 364, 365–367, 427

Rickert, Heinrich, 254

Riedle, Anton, 259

Riefenstahl, Leni, 190, 196, 379, 382

Riegler, Fritz, 260

Rimbaud, Arthur, 60, 170, 206, 346

Rinzai school, 393

Rio de Janeiro, 101, 114

Risset, Jean-Claude, 137, 427

Robbins, Al, 188, 427

Robespierre, Maximilien, 99

robots, 4, 17, 27–28, 110–114, 139. *See also* cybernetics; technology

Rockefeller Foundation, 11–13, 81, 87, 130, 164–165, 193–194, 207, 235, 352, 365, 374–378, 405

Rodin, Auguste, 175

Roeder, Margarete, 36, 427

Rogers, Ginger, 193

Rokin Gallery, 32

Roosevelt, Franklin D., 246–247, 305, 326

Rose, Barbara, 366

Rose Art Museum, 147, 148

Rosebush, Judson, 195

Rosenberg, Harold, 178

Rosenblueth, Arturo, 123, 204, 427

Rostow, Walt Whitman, 285

Rot, Dieter, 94, 116, 427

Rothko, Mark, 251, 335, 361

Rubens, Peter Paul, 31, 262, 328, 347

Rubin Gallery, 94

Ruggles, Carl, 255

Russell, Bertrand, 131, 254, 276, 370

Russia, 81–82, 135, 175, 181, 217, 262, 271, 319. *See also* communism; Marxism; Moscow; politics; war; World War II

Ruttmann, Walter, 80

Ryan, Paul, 166, 427

Saint Phalle, Niki de, 186, 223–224, 428

Saint-Saëns, Camille, 36, 59, 326

Sakamoto, Ryuichi, 73, 76, 80, 184, 188, 190, 191, 231, 232, 237, 428

Sakuramoto, Yuzo, 386

Salisbury, Harrison, 415

samurai, 180, 387

Sanborn, John, 193, 231

Sand, George, 337

Sandin, Daniel, 16, 192, 231

Sankaijuku, 192

Sartre, Jean-Paul, 78, 80, 89, 90, 94, 124, 126, 131, 141, 143, 181, 186, 189, 225, 243, 258, 337, 341

Sasuke, Sarutobi, 79, 83, 180, 182

satellite, 4, 7, 12–13, 15, 73–84, 87, 89, 149, 155, 179–192, 222–226, 230–232, 236, 276, 380, 384. *See also* broadcasts; television; video art and, 12, 83, 179–182, 184–189 communication and, 77, 79–80, 82, 83, 155–156, 187, 335 delay and, 224, 226, 230, 232

Satie, Erik, 126, 327–328, 339, 428

Schlossberg, Edwin, 208

Schmela, Alfred, 340, 343–344, 428. *See also* Galerie Schmela

Schmied, Wieland, 227

Schmit, Tomas, 91, 94, 115, 428

Schneider, Ira, 166, 428

Schneller, Oliver, 23

Schoenberg, Arnold, 22, 33, 54, 131, 156, 175, 177, 196, 347, 368, 411, 428

Schomburg Center for Research in Black Culture, 214

Schöning, Klaus, 35, 428

Schubert, Franz, 133, 145, 174, 194

Schuller, Gunther, 259

Schumann, Robert, 65, 142, 428

Schumpeter, Joseph, 156

Schweitzer, Albert, 136, 428

Schwitters, Kurt, 255, 256, 346

science, 16, 31, 117, 120, 123, 138, 162, 177, 180, 203–205, 243, 263, 275, 353. *See also* computers; intellectualism; mathematics; technology; *specific scientists*

science fiction, 79, 85, 177, 193, 226, 267

Sedlmayr, Hans, 140, 259

Segal, George, 10

Seibu Museum, 192, 266

Seoul, 4–5, 78, 81–82, 163, 179, 183, 198, 233–237, 248–251

Setos, Andy, 231

sexual intercourse, 50–54, 66, 95, 104, 115, 127, 150, 152, 244, 251, 254, 296–297, 312, 341

sexualization, 30–31, 38, 47, 56, 404

Shakespeare, William, 39, 120, 184, 203

shamanism, 31, 78, 177, 237, 268, 340–342, 384, 411. *See also* Beuys, Joseph; mysticism

Shankar, Ravi, 134, 428

Shen Buhai, 388

Shen Tzu, 386

Shiji, 383, 385–386, 387, 390, 392, 411, 420, 421

Shiomi, Mieko, 32, 134, 274, 342, 428

Shirer, William, 283

Shu Tiao, 401–402

SIGGRAPH, 231

Silicon Valley, 77, 185

Silman, Lydia, 369

Sima Qian, 383, 385, 388, 420, 421

Simon, Norton, 166

Sin Sung Electronics, 195

Smithsonian American Art Museum, 1–2, 17

Smolin Gallery, 9, 93

socialism, 263, 276, 330, 338, 406. *See also* communism; politics; revolution; Russia

social media, 15, 80. *See also* communication; media; technology; telephone

Socrates, 37, 130, 180, 320

Sohm, Hans, 140, 270–272, 428

SoHo (New York), 4–5, 87, 178, 266, 271, 338–339, 342–343, 372

Solway, Carl, 17

Sonsbeek exhibitions (Arnhem), 146–147

Sony, 139, 173, 188, 191, 247, 274, 283, 368, 379
sound, in electronic media, 8, 10, 18, 22, 37,
 91–92, 152, 184, 192, 199, 201, 347, 370
Sowol, Kim, 393, 413
Soyer, Raphael, 214
space (astronomic), 54, 82, 142, 177, 321. *See
 also* NASA; satellite
Spinoza, Baruch, 78, 128, 243, 373
spirituality, 26, 66, 79, 191, 243, 250–251, 338–
 340. *See also* shamanism; Zen
split screen, 76, 184, 225, 239, 367
Spoerri, Daniel, 94
sports, 190, 232–240. *See also* Olympic Games
Squeeze Zoom, 195, 223–224
Stalin, Joseph, 67, 193, 272, 276, 326, 338. *See
 also* Russia
Stalingrad, 34, 247–248, 262
Steen, Jan, 262, 267
Stein, Gertrude, 126, 207, 253
Steinecke, Wolfgang, 346–347, 428
Sternberg, Josef von, 196, 335
Stewart, David C., 360–361
Stockhausen, Karlheinz, 8, 22, 37, 66–67, 72,
 91, 126, 133, 167, 204, 254, 259, 343, 347,
 351, 370, 428
Stockholm, 89, 93, 121, 348
Stokowski, Leopold, 196
Stony Brook, State University of New York at,
 130, 135–140, 338, 351
Stravinsky, Igor, 196, 259, 347
Stuckenschmidt, Hans Heinz, 346
Studio Barcot, 183
Stussgen, Johannes, 337
Stuttgart, 117, 140, 334
Sullivan, Dan, 149
Sun Ki-Geon, 191
Sun-Tze, 264
Suo Suo, 400–401
surrealism, 262, 366, 418
Suzuki, Daisetsu Teitaro, 35, 94, 126, 131, 136,
 191, 257, 386–387
Switzerland, 156, 238, 364
symbolism, 125, 127, 153, 288
symmetry, 36, 93
symphonies, 22–23, 50, 72, 91, 113, 177, 180,
 220, 237, 335, 341

Takahashi, Yuji, 190
Takami, 296
Tambellini, Elsa, 344
Tappan, Olivia, 145
Taylor, Elizabeth, 199
TBS (network), 135, 198
Tchaikovsky, Pyotr Ilich, 25, 341
technology, 83, 141, 168, 187, 263
 art and, 16–22, 99, 116, 120–121, 126, 193, 195,
 345, 350–351, 353, 366

communication and, 13, 15, 17, 150, 176, 263,
 265, 414
 humanization of, 17, 33, 82, 165
 politics and, 5, 18, 78, 320
Telecom Japan, 192
telecommunications, 77, 80, 159–160, 331, 376.
 See also communication; satellite
telephone, 36, 101, 114, 124, 150, 153–154,
 163–164, 180, 256, 263, 331, 395. *See also*
 communication; satellite
 video, 118–119, 147, 188, 202, 360
television
 American, 82, 125, 312
 art and, 1, 10, 75, 92, 208–210, 371
 audiences of, 9, 122, 188, 230–234
 cable, 82, 135, 148, 151, 155, 158, 160, 163, 179,
 188–189, 241, 276, 370
 color, 98, 101–102, 114, 117, 260, 351, 354, 368
 commercials on, 128, 149, 153, 207
 educational, 117, 154–159, 354
 experimental, v, 94, 179, 198
 future of, 32, 170, 362
 global, 81, 127, 235–240, 364–365, 379
 live, 185–186, 222, 235–240
 music and, 10, 98
 public, 154–155, 159, 160, 165, 193, 225, 370
 silent, 33, 128
 two-way, 80, 82, 153, 158, 222, 235, 370, 374
 (*see also* communication: two-way)
Temple, Shirley, 77–78, 163, 248, 253
Tenney, Jim, 105, 107, 116, 121, 126, 137, 334,
 428
Tereshkova, Valentina, 56, 428
Thames Television (London), 270
Theil, Henri, 339
Thoreau, Henry David, 164, 180, 296, 315
time, 11, 13, 91, 126, 166, 254
 consciousness of, 148, 156, 166, 174, 192, 419
 live broadcast and, 180, 222, 230, 232, 380
 machine time, 125, 145, 153
 space and, 132, 170, 177, 178, 254
 video and, 145, 147, 166, 174–177, 178, 187
Time (magazine), 142, 362, 415
Times (London), 122, 356
Times Square, 80, 188, 382
Tinguely, Jean, 186, 223–224, 345, 428
Tisdall, Caroline, 267
Tocqueville, Alexis de, 177, 320
Tokyo, 5, 75–77, 83, 93, 166, 179, 183–184, 197,
 234–237, 246, 257, 258, 260, 339, 366, 369
Tokyo Metropolitan Art Museum, 179
Tokyo Rose, 77
Tolstoy, Leo, 127, 129, 131, 177, 338
Tomkins, Calvin, 11, 232, 428
Tone, Yasunao, 183, 411
Toscanini, Arturo, 35, 257, 339
Toynbee, Arnold J., 131

Toyoda, Minoru, 246

translation, 163, 181, 191, 223, 385–386, 388, 393, 420, 421

transportation, 159, 251–252, 263–265, 395, 414. *See also* horses

travel, 2, 4–5, 7–8, 77, 159–160, 164, 217, 320, 333, 386

Treaty of Rome, 142

Trotsky, Leon, 185, 276

Trowbridge, Frank, 38, 91, 428

Tsukuba, International Exposition (1985), 274, 275

Tsung Tzu Chi, 411–412

Tsuno, Keido, 193

Tudor, David, 36–37, 91, 102, 115, 133, 184, 190, 428

TV Asahi, 183, 192

Twiggy, 31

twins, 76–77, 184, 220, 226, 228, 232

Tzu-ch'o, 390

Uchida, Hideo, 93, 94, 105, 428

Uecker, Günther, 146, 344, 428

Ueno Museum, 407

United States. *See also* New York City; postindustrial society; World War II
art in, 255–257, 330
consumerism and, 251–252, 313, 316, 319
economics, 159, 161, 244, 246, 354

University of Bonn, 351

University of California at Los Angeles (UCLA), 374

University of California at San Diego, 231

University of Massachusetts, 364

University of Munich, 23, 32, 78, 87, 383

University of Southern California, 160

University of Tokyo, 4, 192, 259

USCO, 138

utopianism, 2, 13, 15, 75–76, 82, 87, 94, 101, 108, 121, 134, 142, 164, 178, 242, 300

Valéry, Paul, 131, 141, 150, 250, 428

Van Assche, Christine, 179, 184, 267, 429

VanDerBeek, Stan, 116, 184, 338, 345, 354, 429

Van Tieghem, David, 76, 184, 429

Varèse, Edgard, 131, 181, 211, 367

Vasulka, Woody and Steina, 16, 261, 429

Vautier, Ben, 30, 94, 153, 343, 429

Venice, 4, 37, 68, 129, 165, 188, 274, 411

Vertov, Dziga, 80

video, 1, 5, 10, 187, 362. *See also* broadcasts; communication; satellite; technology; television
as art, 76, 79, 82, 87, 127, 132, 150, 174–175, 186, 377
color, 174

computers and, 117, 119, 168, 195, 201, 203, 360–361
costs, 11, 128, 139, 379–381
culture and, 16, 82, 144, 202, 218
experimental, 187–188
memory and, 172–173, 377
multiple-channel, 17, 144–145
time and, 148, 174–177, 178, 192–193, 206, 254–255

Video Common Market, 15, 83, 142–144

video games, 15, 18, 172

video synthesizer, 98, 165, 170, 185, 204–208, 256, 355, 364, 365–369. *See also* Paik-Abe Video Synthesizer

Vietnam War, 9, 18, 127, 143, 157, 193, 247, 272, 275–276, 298–301, 321, 322, 419. *See also* politics; United States; war

viewers. *See* audiences

Viola, Bill, 193

violin, 8–9, 54, 63–64, 194. *See also* music

virtual reality, 275, 331, 332

Vivaldi, Antonio, 33, 361

von Braun, Wernher, 248, 313

von Neumann, John, 125, 194

Vostell, Wolf, 9–10, 32, 56, 72, 89, 91, 93, 116, 272, 333, 350, 429

Wagner, Richard, 25, 28, 33, 126, 201, 325, 328, 412

Walker Art Center, 353

Wang Pu, 405

war, 55, 141, 278–322, 397, 405. *See also* Korean War; patriotism; propaganda; Vietnam War; World War II

Warhol, Andy, 126, 327, 344

Washington Post, 155, 253

Watari, Shizue, 192, 262, 339

Watson, Burton, 385, 386

Watt, James, 402

Watts, Bob, 94

Wayne, John, 119, 144, 202, 368

WDR (Westdeutscher Rundfunk), 179, 204, 222–227

Webern, Anton, 25, 39, 67, 72, 109, 258, 263, 327, 429

Wegman, William, 188, 429

Welin, Karl-Erik, 91, 133, 134, 429

Welles, Orson, 171, 207

Wên Jên Hua, 407

Wenzel, Jakob, 273

Westkunst, 35

WGBH (Boston), 13, 16, 143, 145, 147, 160, 165, 171, 205, 207, 218, 344, 359, 364–371

White, Theodore H., 181, 415

Whitney Museum of American Art, 7, 9, 179, 186, 195, 218, 219, 419